Reading American Art

Reading American Art

Edited by Marianne Doezema and
Elizabeth Milroy

Yale University Press New Haven and London

Designed by Rebecca Gibb. Set in New Caledonia type by G & S Typesetters, Inc. Printed in the United States of America by Thomson-Shore, Inc., Dexter, Michigan.

Library of Congress Cataloging-in-Publication Data

Reading American art / edited by Marianne Doezema and Elizabeth Milroy.
p. cm.
ISBN 0-300-07348-8 (cloth : alk. paper). — ISBN 0-300-06998-7 (pbk. : alk. paper)
1. Art, American. I. Doezema, Marianne, 1950– . II. Milroy, Elizabeth, 1954– .
N6505.R4 1998
709'.73 — dc21
97-18004
CIP

A catalogue record for this book is available from the British Library.

The paper in this book meets the guidelines for permanence and durability of the Committee on Production Guidelines for Book Longevity of the Council on Library Resources.

10 9 8 7 6 5 4 3 2

Contents

Editors' Preface

We have conceived this anthology primarily for use by instructors and students of introductory survey courses in the history of the visual arts in the United States from the colonial period to 1945. We offer it as an alternative to the muddy photocopies and interminable copyright negotiations to which all of us who teach in this field have had to resort in order to provide our students with useful reading assignments.

The compilation is the result of a rigorous selection process from hundreds of monographs, journal articles, and exhibition catalogue essays. We drew on our own teaching experience and on sample syllabi and reading lists provided by colleagues who also regularly teach survey courses. As we anticipated, the process was challenging and intriguing, not least because of the many disciplinary issues it raised, ranging from which media most instructors include in survey courses, which constituencies are treated, and how categories such as high art/low art or fine art/folk art are defined and tested to such fundamental but thorny questions as what in fact we mean by the term *American art*. We have appreciated the willingness of so many of our colleagues to discuss these issues with us, in long telephone conversations and in written responses to the evolving table of contents.

In the past two decades, the study and analysis of American art have matured, assuming greater interpretive rigor and theoretical sophistication. As a result, the structure of the standard survey course is undergoing reassessment. The current dominant model for the American survey course primarily addresses the colonization of the European fine arts traditions in the New World.

The twenty essays reprinted here exemplify recent scholarship that treats topics defined by this model and that can be used by students to fullest advantage.

We selected essays first published within the past two decades in order to provide readers with a historical perspective on an especially dynamic period in the history of the field. We endeavored to combine essays written by renowned senior scholars with those of younger scholars, and we included essays by scholar-curators as well as academics, to acknowledge the significant contributions that museum professionals have made to American art historiography.

The essays illustrate the many interpretive methodologies that have broadened and enriched the perspectives from which scholars view works of art—methodologies that include iconology, social history, structuralism, psychobiography, and feminist theory. We do not claim to have achieved complete inclusiveness with respect to the many theoretical approaches now employed by scholars in the field, any more than we could have attempted to represent every artist or movement. The principal aim of this anthology is to signal the fundamentally interdisciplinary character of most current American art historiography, now typically indebted to theoretical models devised and/or refined within American studies and cultural studies. From the outset we intended to select essays that combine close analysis of specific art objects or groups of objects with discussion of how these objects operated within their cultural contexts. The authors seek to assess how paintings, sculptures, prints, drawings, and photographs have carried meaning within American society. They describe how the conceptualization, production, and presentation of works of art both inform and are informed by prevailing attitudes to the role of the arts and the artist in American culture. From each essay, students can learn invaluable lessons in research methods, critical analysis, and expository writing.

The essays are arranged chronologically by subject, in keeping with the standard structure for survey course syllabi (and standard survey texts). Instructors and students are invited to choose the essays that most closely suit their needs. Each essay can stand alone, though certain themes recur throughout the collection to undergird topical or methodological commonalities. For example, Craven, Staiti, Wallach, and Oedel and Gernes examine the role of class in arts patronage. Hight and Buick treat constructions of race. Kasson, Pollock, Hills, Todd, and Chave examine issues of gender in the construction of imagery as well as its reception. Stein, Johns, Troyen, and Leja apply formal and iconographic analyses to explore modes of artistic self-representation. Leja also draws upon psychoanalytic theory to build his interpretation of Jackson Pollock's early compositions, as does Prown for works by Winslow Homer.

Many colleagues offered advice and encouragement throughout this project. We wish to thank first and foremost the contributors, who generously agreed to

the republication of their essays and who patiently performed or endured necessary abridgments or revisions. We extend our sincere gratitude also to colleagues who shared insights and observations, in particular Sarah Burns, Carol Clark, Michael Plante, and Rebecca Zurier.

Special thanks to Meghan Freed, Julie Furber, and Virginia Graham at Mount Holyoke College and Jackie Rich and Amanda Zucker at Wesleyan University for cheerfully and efficiently typing and photocopying manuscripts. Finally, we would like to express our appreciation to Judy Metro and her associates at Yale University Press for their support and assistance.

1 The Seventeenth-Century New England Mercantile Image: Social Content and Style in the Freake Portraits

Wayne Craven

Painting in colonial New England began in the 1660s, some thirty to forty years after the earliest settlements were established there. In the English tradition, portraiture was virtually the exclusive theme. The subjects were merchants, ministers, and civil officials, along with their wives and children. Boston was the center of activity for the region, and evidence now suggests that the town possessed, at one time or another, several men capable of taking likenesses after about 1664. They have been called "limners," but the term does not mean untrained "primitives." Rather, they were trained artists, working in an established tradition. Patronage of their talents evolved slowly at first; for portrait painting to exist as a profession there had to be sufficient wealth and patronage to employ the practitioner regularly at his craft. In New England—indeed, in any North American colony—that situation did not exist until the second quarter of the eighteenth century. Although the middle class had patronized artists in England, the early colonists had no money for such a luxury. Economic contingencies, not a distaste for art, prevented the rise of painting in the New World during the first decades of settlement.

The early likenesses were executed by someone who had probably come to the Bay Colony fully prepared to make his living in some way other than painting portraits, even if he had been trained in that art in England. In Massachusetts he would have turned to painting of a utilitarian nature—signs, furniture, houses, and so forth. When the need arose, he would put his former training to use, but by and large the opportunity to do so was infrequent. The early portraitists were familiar with the style of the art of their homeland. They were, in

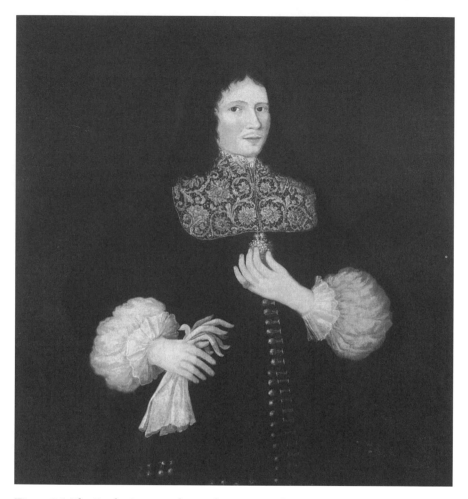

Figure 1.1 The Freake Limner, *John Freake*, c. 1674. Oil on canvas, 42½ × 36¾ inches. Worcester Art Museum, Worcester, Mass., Sarah C. Garver Fund.

fact, gifted artists, aesthetically sensitive to such formal aspects of art as line, color, design, and pattern. By no means were the early New England portraits the work of amateurish hacks.

We now have a list of about forty portraits believed to have been executed in or around Boston before 1700.[1] Of these, many would agree that the two masterpieces are the *John Freake* and the *Elizabeth Freake and Baby Mary* of about 1674 (figs. 1.1, 1.2). These portraits offer an excellent case study for the type of image that emerged amid a community that was fast becoming dominated by the mercantile spirit.[2]

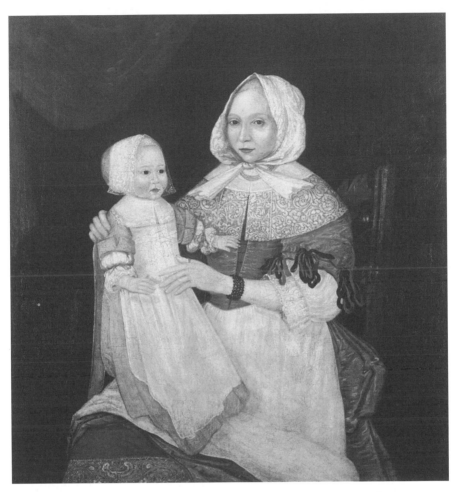

Figure 1.2 The Freake Limner, *Elizabeth Freake and Baby Mary*, c. 1674. Oil on canvas, 42½ × 36¾ inches. Worcester Art Museum, Worcester, Mass., gift of Mr. and Mrs. Albert W. Rice.

John Freake (1635–75) was born in England but by 1658 had immigrated to Boston, where he became a merchant, lawyer, and a man of property and means. He owned two houses as well as a brewhouse, a mill, some land at Fort Hill, and a partial interest in at least six ships. An inventory of his estate valued his property at well over two thousand pounds, a large sum by the standards of the day.[3] In 1661 he married Elizabeth Clarke (1642–1713), daughter of Thomas Clarke, also a merchant of Boston, and the Freakes were very much a part of the mercantile establishment when they had their portraits painted.

The Freake portraits may have been painted as early as 1671, at which time no child was present in the picture of Mrs. Freake.[4] The infant was added and several changes made in the figure of the mother in 1674; little Mary was born on May 6 of that year, and an inscription in the lower left reads "Aetatis Suae 6 moth," in reference to the child's age.

These are family portraits—that is, familial icons—and this provided ample utilitarian and societal value for their existence. They were intended to celebrate marital domesticity and family lineage as well as social position. Family life was sacred, and colonial American portraits, particularly in pendant portraits of man and wife, of parents with children, or of children alone, were hymns to that divinely blessed institution.[5] The sensual yet spiritual relationship of man and wife is evident in Anne Bradstreet's poem "To My Dear and Loving Husband," written in 1678, only a few years after the Freake portraits were painted:

If ever two were one, then surely we.
If ever man were loved by wife, then thee;
If ever wife was happy in a man,
Compare with me the woman if you can.
I prize thy love more than whole mines of gold,
Of all the riches that the east doth hold.

The Freake portraits were odes to powerful values that found approval in scripture, in Calvin's writings, and in Protestant sermons of England and New England.

The Freake and related portraits also express another idea that had Calvinist support—the doctrine of prosperity, or God's blessing, for diligence at one's calling, which was manifested in material rewards. Such portraits raise a number of issues about affluence, pride, and the continual upward pressure on the limits between moderation and ostentation.

Freake had prospered as a merchant, attorney, and shipowner, and he may be seen as an archetypal counterfoil to the old-guard establishment of the ministers and the Massachusetts General Court, which still schemed, in the 1670s, to petrify life according to the will of the colony's founding fathers. For example, when the commissioners of King Charles II were in Boston in 1666, Freake petitioned that their authority be accepted, thereby indicating his preference for crown rule in place of the oligarchy that the ministers and religious zealots were anxious to maintain. Furthermore, this up-and-coming young merchant was at times in partnership with the wealthy, vain, and hedonistic Samuel Shrimpton. A rebel against the authority of the old-guard theocrats, Shrimpton asserted his right to strive for personal fortune in opposition to those who maintained that a collective spiritual well-being should be the colony's highest priority. Men such

as Freake and Shrimpton, although pious in their own way, represented the headstrong will of the mercantile sector to break the hold of the theocratic power base in order to redirect the course of increasing prosperity. They sided with other ascending merchants to form a social elite within the colony. That early mercantile elite, by 1670, was contributing to the collapse of the old Puritan regime. Thus Freake's portrait is thoroughly secular and should not be seen as expressing the spiritualistic Puritanism of the founding fathers.

John Freake's portrait is a three-quarter-length, largely frontal view, with the head turned slightly to our right. The subject, who looks at us directly, is a handsome young man with pleasant features; he wears a neatly trimmed little mustache, but his chin is clean-shaven. There is a suggestion of a smile, and the countenance expresses self-confidence and self-consciousness in about equal measure.

No feature should be overlooked or considered inconsequential in studying the iconography of a portrait. Freake's hair, for example, tells us certain things about the man. First of all, it is his own—not a wig—and second, it is shoulder-length; it contains a social statement that was compatible with this merchant's brand of religion. Freake chose not to wear the great lovelocks of Cavalier society, which William Perkins had criticized as a symbol of frivolous extravagance and a "foreign trick," and which William Prynne had called "a vile abuse . . . an incitation to lust . . . and Sodomy." [6] Freake's fellow townsman John Hull, the silversmith, condemned the wearing of long hair as a sin on a level with gambling, drinking, and idleness, while William Woods was fined by the General Court in 1676 for "wearing his haire long as a womens haire." [7]

But if Freake wished to avoid association with lovelock society, neither did he want to be shown as a Roundhead, which would have connoted a commitment to Puritanism. Short hair had been the emblem of the Puritan in anti-Puritan plays at the court of Charles I, and courtiers had joked that one should never trust a man if one could see his ears. Moreover, short-cropped hair was imposed on men of the lower class as a badge of their inferior social standing. For example, in 1675 the Massachusetts General Court told John Gatchell, convicted of building on public land, that his fine would be reduced by half if he would "cut off the long hair off his head into a civil frame" [8]—that is, cut it to the length proper for a man of his low station.

What all of this means in connection with the portrait of John Freake is that, by the length and style of his hair, the subject did not want to imply that he was of the rakish Cavalier set with its low morals; nor did he want to make a declaration, through a Roundhead cut, of a strong commitment to Puritanism; and he certainly did not want to be associated with the lower class, identified in part by short-cropped hair and associated with idleness and poverty, both of which were

sins. Instead, he is shown with the medium-long, shoulder-length hair of a gentleman—which within his community meant that he held an honored position at the peak of the social and economic pyramid.

John Freake's attire bears further testimony to his prosperity and therefore, in a mercantile community, to his rank among men. His costume is one of comeliness, which Calvin condoned, and not austerity, which Calvin dismissed as unnecessary; Freake and his kind, after all, lived by the code of Calvinist virtues. His coat is a rich brown, not the black so often associated with zealous Puritans; it has full, ample sleeves, it flairs gracefully from the waist, and it is cut from a fine velvet fabric. The stylishness and neatness of its tailoring suggest sartorial refinement expressed in a moderate fashion design; it is neither extravagant nor mean, and so places its wearer, appropriately, somewhere between Cavalier society and the indolent, indignant poor. The coat has a decorative row of silver buttons, of which at least twenty can be seen down the front, while more adorn the pocket flaps. The buttonholes are nicely embroidered with silver thread. This is very similar to the coat and buttons in the English portrait of Sir John Clerk, Baronet (1675) by John Scougall, suggesting that Freake was imitating the fashions of the English peerage, when those fashions were of a moderate design.[9]

John Freake, the prosperous gentleman-merchant, wears other items that bear witness to a moderate love of finery. His white shirt, made of fine muslin, has fashionable puffed sleeves with crenelated cuffs. In his right hand he holds a pair of long-cuffed gloves, another designation of gentleman status. On the little finger of his left hand he wears a large ring, which appears to be made of gold. The same hand fondles an ornate silver brooch of superb design—the work of a very gifted silversmith—which reveals Freake's enjoyment of decorative baubles made of precious metals; it was probably an imported piece. The final ornamentation for the sake of "comeliness" is the beautiful lace collar; fine lace of that quality had to be imported from the Continent, and it appears to be of "Spanish" design but of Venetian workmanship.[10] The collar Freake wears is the antithesis of the simple white, squared collar associated with Puritan garb, and it again testifies to his separation from any stringent dress code set up by that sect. This exquisite detail would make it difficult to deny the subject's pride in personal appearance and his joy in the materialistic pleasures brought him by his God-blessed, Calvin-condoned prosperity.

In the companion portrait of Mrs. Freake and her infant daughter, Mary, those same characteristics bring several socio- and religio-economic problems into even clearer focus. Close inspection places in question a number of previously held assumptions about life in seventeenth-century New England.

Elizabeth Freake is a pleasant-looking young woman but plain of feature. A

few strands of her blond hair are visible on her forehead, but the rest of her hair is "bound up" beneath a white lace hood. A slight smile suggests a good nature, contentment, even self-satisfaction. About her neck hangs a triple strand of pearls, and her other jewelry includes a four-strand garnet bracelet on her left wrist and a gold ring on the thumb of the left hand. She wears a dress of heavy moire or taffeta, which is a warm silver gray. It reveals a bright red-orange velvet underskirt richly adorned with gold guipure. Red-orange laces are seen at the bodice and large red and black bows decorate the sleeve, from which emerges the white puffed sleeve of a blouse with a crenelated lace ruffle. About her shoulders is a narrow white collar, to which is appended a broad band of very handsome lace.

Considering the several beautiful and fine fabrics, the numerous instances of colorful or intricate decorative details, and the three pieces of jewelry, Mrs. Freake's costume could hardly be called austere, or even reserved. It is evident from this portrait that fine fabric, fashion, and color were enjoyed among prosperous Protestant folk, and Elizabeth Freake's attire refutes any notion that all seventeenth-century New England women wore reserved and unadorned black, white, and gray dresses out of dedication to austere Puritan principles.

Where did the fabrics worn by Mrs. Freake come from? Their fineness suggests that they were imported, for taffeta, brocade, and lace were high-quality, specialty goods that were seldom attempted by colonial weavers by 1675.[11] Not only the English fabrics but fancy stuffs from the Continent and the far reaches of the Anglo-American trading system were imported, and in such quantities as to indicate considerable demand for them. Mrs. Freake's taffeta may well have come from France; the lace, from Spain, Venice, or the Netherlands; the brocade, from England; the pearls, from the Orient; and the garnets of the bracelet, from India. New England merchants of the 1670s had ready access to worldwide markets, either directly or through trade with intermediaries, and both they and their wives were willing to forgo the fancy stuffs that could brighten and refine their lifestyles. In spite of ministerial admonitions about too much worldliness, the merchants were not becoming ungodly, as long as they did not become ostentatious by their own—not the ministers'—standards.

The pleasures of prosperity were too powerful for either the pulpit or the bench to withstand. As the merchants and their wives pressed the limits of what was tolerated as being within moderation, the ministers and the magistrates felt compelled to restrain them. The sermons and laws aimed at stultifying the hedonistic urges that came with mercantile affluence reveal that the pressure was very real. But it should be remembered that such sermons and laws were directed only at placing limits upon, and seldom at outlawing totally, the enjoyment of material things. The disputation was always over where the line be-

tween moderation and ostentation was to be drawn, and much of Protestantism's success among an upwardly mobile, prospering middle class was due to its flexibility in setting that line. In essence, the clergyman-magistrate group and the affluent merchants were not in disagreement, for most merchants were themselves offended by ostentation, which they saw as economically imprudent as well as morally sinful—and the ministers and magistrates certainly condoned the prosperity that came from the pursuit of one's Christian calling.

The Puritan old guard had difficulty convincing many of the people that their indulgences were destroying God's little plantation in New England and that they would ultimately be carried off to hell because of them. The merchants and their wives knew their Calvinist theology. In Calvin's writings they read passages in which the Reformer said prosperity was God's reward for diligence at one's secular calling, while other sections declared that "comeliness" in attire was perfectly acceptable. The ineffectiveness of laws designed to restrict indulgences is demonstrated by a few lines from Governor John Winthrop's *History of New England,* in which he noted that although the General Court had ordered the church elders to urge their flocks to be less ostentatiousness in attire, little could be done, "for divers of the elders' wives, etc., were in some measure partners in this disorder."[12]

In 1679, only a few years after the Freake portraits were painted, the General Court again tried to legislate, on moral grounds, against excessive pride in apparel, declaring it to be a great evil for which God would visit transgressors with "loathsome diseases." That law, too, had little effect among the merchant families.

Then, as now, it was difficult to legislate moral issues and enforce laws effectively. But even civil, economic laws were flouted when they stood between the affluent upper middle class and its acquisition of the material goods it craved. Laws were enacted in England (and supposedly enforced in the English colonies as well) to protect the home industries in cloth and lace making. As early as 1622, Parliament passed a law prohibiting the importation of Continental laces,[13] but as King Charles I was the worst offender of all, most of his subjects felt no compunction about breaking the law. Laces were smuggled into England in loaves of bread, in Turkish turbans, and in coffins that were later dug up to retrieve the contraband.[14] The prohibited laces and fabrics were similarly smuggled into New England in prodigious amounts.

When John, Elizabeth, and even little Mary Freake are shown wearing a goodly amount of imported lace, it means that they were determined to create a lifestyle according to their own terms; the Parliament in England could not prevent them from obtaining the material stuffs they desired, any more than their own clergy could dictate to them the fashion of their attire. This further indi-

cates that it was the merchant class with its indomitable spirit, rather than the clergy, that would ultimately establish the character of colonial life in New England. The secularism of the merchant class, not the spiritualism of the ministers, formed the foundation for most colonial portraiture in the region. The stereotype of the seventeenth-century Puritan holds true only of old men and ministers. Already present in the Freake portraits are the socio-economic foundations of the materialism and affluence underlying John Singleton Copley's and Charles Willson Peale's portraits of the mercantile class of a hundred years later.

From the perspective of the merchant class, piety and prosperity were completely compatible, and the two were united through the doctrine of prosperity, which proclaimed the validity of one's secular calling, diligence at which God rewarded in a material way. The merchants saw themselves as living according to the Christian virtues that Calvin had defined and that were particularly suited to the middle class. If New England had not been founded as a haven for Puritan zealots, a confrontation between merchants and clergymen probably would not have arisen; the two worked in harmony, for example, in contemporary Holland. In North American colonies, where Anglicanism prevailed, the confrontation was not as intense. But as the seventeenth century progressed in New England, an adversary relationship developed that was in reality an internal struggle for control of the course of life. The rancor of the ministers and magistrates increasingly suggests a petrification of mores as the old guard tried to retain the faith and morals of the founders of their colony. Many a lament was heard from the pulpit, well into the eighteenth century, that the religious zeal and piety that had inflamed the souls of the founding generation had been lost. Colonial merchants dutifully listened to such wailing and gnashing of teeth on Sunday morning; but when they had their portraits painted, they wanted the artists to include symbols of the material goods and social position that their honest hard work had earned. Indeed, the prosperity shown in their portraits was a visible expression of their piety.

The furniture in Mrs. Freake's portrait also set a precedent for much later colonial portraiture. The table, chair, and curtain, in their own subtle way, make a complementary reference to prosperity and materialism. Hereafter, we will frequently find the unobtrusive inclusion of a portion of a table or chair or of some other well-crafted object as a quiet indication of the subject's affluence, social position, and good taste. Such a motif, in the Elizabeth Freake portrait, is the forerunner of the beautiful table in Copley's colonial masterpiece, *Mr. and Mrs. Isaac Winslow* (1774). These symbols of prosperity and materialism are a very important part of the iconography of the colonial American portrait, whether they be a silver inkstand, a porcelain bowl with fruit, a pewter teapot, or an exquisitely wrought card table. The chair in which Mrs. Freake sits is of the

finest, most costly type then found in colonial New England homes and is sometimes referred to as a Cromwellian chair. The colorful upholstery is of woven wool, in imitation of exotic fabrics from the Middle East; Turkey work, as it was called, was produced in England and exported to the colonies, where the chair itself was probably made. The inventory taken after John Freake's death indicates that fourteen such chairs were in the Freake household.[15] Such furniture surely dispels the myth that seventeenth-century New England interiors were purposefully drab.

Objects such as the chair in Mrs. Freake's portrait are indeed emblems of the success, relative affluence, and social position of the upper-middle-class New England mercantile aristocracy. Together with the laces, taffetas, and velvets, the silver buttons and the brooch, the pearls and garnets, and the hair styles, they report to the viewer the things the Freakes wanted to be known about themselves. The faces, rendered in an uncomplicated, straightforward naturalism, preserve the likenesses of the sitters, and the hair, attire, and household objects expand upon the stories of their lives. In the style of the portraits we find similarly interesting expressions of their taste, nationalistic feelings, and affiliation with middle-class cultural traditions.

Notes

This essay was first published, in slightly different form, as a section of chapter 4 of *Colonial American Portraiture* (New York: Cambridge University Press, 1986).

1. The pioneering work on seventeenth-century New England portraits is Louisa Dresser, *Seventeenth-Century Painting in New England* (Worcester, Mass., 1935); since then she has published "Portraits in Boston, 1630–1720," *Journal of the Archives of American Art* 6 (July–October 1966): 1–34; and "The Background of Colonial Portraiture: Some Pages from a European Notebook," *Proceedings of the American Antiquarian Society* 76 (April 1966): 19–58. See also Lillian B. Miller, "The Puritan Portrait: Its Function in Old and New England," in *Seventeenth-Century New England* (Boston, 1984), 63:153–84.

2. On these portraits, see Dresser, *Seventeenth-Century Painting*, 81–83, and Jonathan Fairbanks et al., *New England Begins: The Seventeenth Century*, 3 vols. (Boston, 1982), 3:460–62. See also Susan Strickler, "Recent Findings on the Freake Portraits," *Worcester Art Museum Journal* 5 (1981–82): 49–55.

3. Suffolk County Probate Records, Court of Probate, Boston, 5:294.

4. For a reconstruction of the original image of Mrs. Freake and an analysis of X-ray studies of the picture, see Dresser, *Seventeenth-Century Painting*, 165–67, and Fairbanks et al., *New England Begins*, 3:460–61 and fig. 61.

5. See P. W. Thomas, "Two Cultures? Court and Country Under Charles I," in *The Origins of the English Civil War*, ed. Conrad Russell (New York, 1973), 189. See also

Levin L. Schucking, *The Puritan Family: A Social Study from the Literary Sources* (New York, 1970), and Gerald Moran and Maris Vinovskis, "The Puritan Family and Religion: A Critical Reappraisal," *William and Mary Quarterly*, 3d ser., 39 (January 1982): 29–63. For a discussion nearly contemporary with the Freake portraits, see A. Marsh, *The Ten Pleasures of Marriage* (London, 1682), reprinted with an introduction by John Harvey (London, 1972), with illustrations of the twenty original plates; the plate opposite p. 188 shows a seated woman with a child on her lap, very similar in composition to the image of Mrs. Freake and her daughter. See also Carl Degler, *Out of Our Past* (New York, 1970), 13.

6. For Perkins's quote, see *A Godly and Learned Exposition of Christ's Sermon in the Mount* (Cambridge, 1608), 170; for Prynne's quote, see William Prynne, *Histrio-Mastix. The Players Scourge, or, Actors Tragedie . . .* (London, 1633), index, n.p., under "Haire."

7. John Hull, *The Diaries of John Hull*, in *American Antiquarian Society Transactions and Collections* 3 (Worcester, 1857): 211. For the William Woods case, see Robert St. George, "'Set Thine House in Order': The Domestication of the Yeomanry in Seventeenth-Century New England," in Fairbanks et al., *New England Begins*, 2:180.

8. Quoted in Thomas Jefferson Wertenbaker, *Puritan Oligarchy* (New York, 1959), 174.

9. The portrait of Sir John Clerk is at Penicuick House and is reproduced in Ellis Waterhouse, *Painting in Britain, 1530 to 1790*, 5th ed. (New Haven, 1994)), pl. 102.

10. Frances Morris, *Notes on Laces of the American Colonists* (New York, 1926), 7.

11. Bernard Bailyn, *New England Merchants* (Cambridge, Mass., 1979), 74.

12. Quoted in Degler, *Out of Our Past,* 10.

13. Hudson Moore, *The Lace Book* (New York, 1904), 23.

14. Esther Oldham, "Sheer Beauty: Early Lace Fans," *Antiques* 82 (August 1962): 163.

15. Suffolk County Probate Records, Court of Probate, Boston, 5:294. See also the Turkey-work couch of about 1698 now at the Essex Institute, Salem, Mass., illustrated in Jonathan Fairbanks and Elizabeth Bates, *American Furniture, 1620 to the Present* (New York, 1981), 40. For an English couple of about the same date, see Fairbanks et al., *New England Begins*, 3:442 and 535, and pl. 31.

2 Character and Class: The Portraits of John Singleton Copley

Paul Staiti

There are two ways of understanding portraiture—either as history or as fiction. *Charles Baudelaire, 1846*

[Copley's portraits] illustrate the men and women of a day when pride, decorum, and an elegance, sometimes ungraceful but always impressive, marked the dress and air of the higher classes. . . . It appears to have been a favorite mode either with the artist or his sitters, to introduce writing materials, and to select attitudes denoting a kind of meditative leisure. The *otium cum dignitate* is the usual phrase. A rich brocade dressing-gown and velvet skullcap—a high-backed and daintily carved chair, or showy curtain in the background, are frequently introduced. "Sir and Madam" are the epithets which instinctively rise to our lips in apostrophizing these "counterfeit presentments." *Henry T. Tuckerman, 1867*

Henry T. Tuckerman understood the anthropology in portraiture. Throughout the lead biography in his landmark history of American artists, he saw registered in John Singleton Copley's 350 American portraits the social habits and desires—the "air," as he phrased it—of colonial elites.[1] In the passage above he mentioned some of the visual signs that made a Copley portrait socially effective: the display of clothing, furniture, manners, and leisure. He could have gone on to list more of the objects that draped, landscaped, and decorated the eighteenth-century portrait, for they too were specific sites where character and class were made manifest. The turn of a hand, the cut of a dress, the breed of an animal, the species of a flower, and the color of hosiery were all signs that allowed viewers to be persuaded of the social attainment of a Jeremiah Lee (Wadsworth Atheneum, Hartford), the orientalizing sexuality of a Margaret Kemble Gage (see fig. 2.7), or the antimaterialist discipline of an Eleazer Tyng (see fig. 2.8).

In writing about Copley as a society painter, Tuckerman argued, in effect, that it is insufficient to consider this artist's stature in the history of American art merely as a matter of exquisite technique. Certainly, Copley's appeal had something to do with his unprecedented skill in transcribing material things onto

canvas: he could make paint look like polished mahogany or clear glass or reflective satin. But that descriptive ability, for which he was justly renowned, does not adequately account for why the merchant and professional classes so avidly sought his services in the two decades before the Revolution.

In addition to dazzling descriptions, Copley, before Charles Baudelaire put it in words, offered the elite persuasive fictions. With his deft hands and social perspicacity, he fashioned sitters into the personae they wanted to project. Copley adroitly choreographed bodies, settings, and objects into visual biographies—"counterfeit presentments," in Tuckerman's phrase—that had the power to calibrate social position in graphic ways that were legible to a community. As a result, patrons came to Copley for portraits that were venues where they might avouch a sense of themselves in the hierarchical and circumscribed social theater of colonial Boston. Typically displayed in the halls, parlors, and dining rooms of homes decorated with Chippendale-style furniture, rococo tea sets, and other objects selected for the purpose of self-articulation, Copley's portraits became centerpieces in the stagecraft of the eighteenth-century persona.[2]

Copley's pictures were authenticating narratives. That is, they not only derived from but also helped constitute class in Boston, and to a lesser extent in New York, during the late colonial period. With that expanded purview in mind, a number of questions will be raised in the pages ahead that all have to do with how a person was measured visually. How did the artist fashion a merchant, a wife, a dowager, a betrothed, a minister, an artisan, a girl? Through what visual codes were character and class read? Why and how were particular objects used in the interpretive program of a visual biography? What, in short, was portraiture's contribution to the production of social identity in the consumer society of late colonial America?[3]

> Dined at Mr. Nick Boylstones, with the two Mr. Boylstones, two Mr. Smiths, Mr. Hallowel and the Ladies. An elegant Dinner indeed! Went over the House to view the Furniture, which alone cost a thousand Pounds sterling. A Seat it is for a noble Man, a Prince. The Turkey Carpets, the painted Hangings, the Marble Tables, the rich Beds with crimson Damask Curtains and Counterpins, the beautiful Chimny Clock, the Spacious Garden, are the most magnificent of any Thing I have ever seen. *John Adams, 1766*

To the discerning eye of John Adams, Nicholas Boylston's home was a dazzling visual domain composed of luxurious material possessions. Though Adams had gone to Boylston's on a late-winter evening in 1766 with the Stamp Act crisis on his mind, his diary entry for that visit only fleetingly refers to the dinner debate that took place over Parliament's right to tax the colonies. Most of the entry

instead catalogues Boylston's riches in detail and in animated and explicit language: Turkey carpets, chimney clocks, crimson dyes, marbletop tables, and damask curtains and counterpanes. After admitting to silently tabulating the breathtaking cost of the furniture as he walked from room to room, Adams revealed the linkage between objects and social identity in late colonial Boston in an astonishing sentence. He concluded that such a magnificent setting was not merely appropriate to a rich merchant but surely also was a sign that Boylston was the "noble Man" and the "Prince" whom he thought he had encountered that night.[4]

When Copley painted Boylston in 1767 (fig. 2.1), he, like Adams, represented the person on the basis of things, the quality and dimensions of personhood rising and expanding as the quality and abundance of the objects displayed proliferate. In the picture, Boylston's face is largely inscrutable as a bearer of meaning. But everything else is telling.[5] The source of the merchant's livelihood is indicated by the large ship sailing on turbulent seas and by the book marked "LEDGER" that literally buttresses his arm and metaphorically sustains his extravagant habits of living, details that lay concrete claim to elite status. Boylston's refined tastes and extraordinary wealth are declared by his banyan made of expensive English silk damask and by his turban, both of which would be worn when the sitter was at leisure at home. Elegantly posed and lavishly dressed, looking more like a sultan than a businessman, he is not encumbered by the vicissitudes of work. Yet the material benefits of his business—regal leisure and costly fabrics—are abundantly displayed in this presentation of the achieved self. Boylston is meant to be judged on the basis of these elements. Viewers' eyes are to caress the silks and weigh the ledgers; they are to notice the right arm opening the banyan to show a magnificent vest that is unbuttoned for the gratuitous display of even more expensive fabric underneath. These things are the inanimate markers that are supposed to reflect well on the "essential person."

Copley and Adams were not alone among eighteenth-century Americans in equating luxury goods with character and social status.[6] For everyone understood that the path to high enfranchisement in pre-Revolutionary Boston was studded with emblematic expressions of being.[7] The merchants, and the artisans who served them, everywhere read the visual signs that announced exalted class: Georgian houses, export ceramics, silk fabrics, Chippendale furniture, chased silver, flower and fruit gardens, polite behavior, ample food, and even body fat. This was a face-to-face society that monitored things. It loved objects and facts and numbers and money. And with a quarter of a patrician's income spent on items handcrafted for one's home or one's back or on one's portrait, material goods and the display of those goods became the outward signs of the quest for prestige and power. This practice of equating things and people

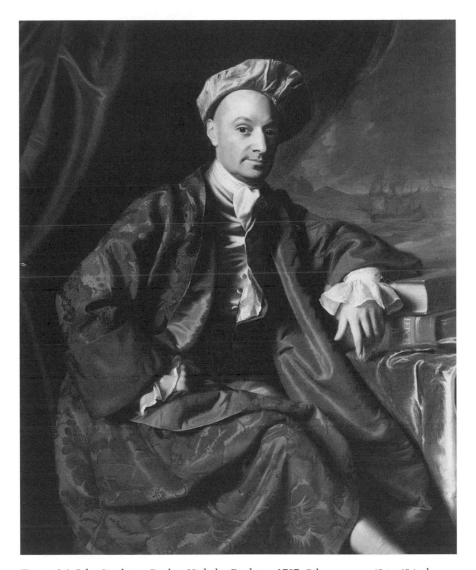

Figure 2.1 John Singleton Copley, *Nicholas Boylston,* 1767. Oil on canvas, 49 × 40 inches. Courtesy of the Harvard University Portrait Collection, Cambridge, Mass., bequest of Ward Nicholas Boylston, 1828.

exemplifies what anthropologists and consumer historians call the power of goods to transform the self.

Who a person was—or seemed to be—was a matter of reading what that person possessed. Objects in Copley's portraits thus were not emblems in the traditional iconographic sense of the word, for their interpretation was not strictly codified or explicitly determined in written texts, such as books of em-

blemata.[8] Instead, they were props fashioned by the artist into images that ful-filled the desire of elite clients who wanted to assert their position and social identity in materially potent ways that were visible to eighteenth-century view-ers. Gentlemen and gentlewomen needed signs that collectively were the in-dex of the social self: social graces, eating skills, proper carriage, body control, knowledge of the arts, informed taste in fashion, carved furniture, and pow-dered wigs. As agents in an interpretive system, the signs Copley presented were not merely bystanders in a picture, for these things had the cultural power to personify, to endow a sitter with the social, civic, or personal attributes he or she sought. And all forms of visual display in eighteenth-century British North America, from pictures to teapots, were bearers of identity and class definition.[9]

With a few notable exceptions that are discussed below, it is not known whether Copley's sitters owned the clothing, dogs, fruits, jewels, fountains, flow-ers, vases, and columns with which they are shown in their portraits. Knowledge of such facts of ownership might be revealing insofar as it would indicate the degree of a painting's deviation from reality and thus the degree of its fictional-ity. But this knowledge or the lack thereof has no bearing on an essential as-sumption about Copley's portraiture: that his pictures are not and ought not to be construed as visual probate records. Instead, the objects in the portraits, owned by the sitters or not, should be understood as metonymic, in the sense that they are sites into which character and class have been displaced. They are the rhetoric—not the record—of self-representation in eighteenth-century America.

To be effective in a materialist culture—to acquire a social voice—those ob-jects had to be taxonomic as well as metonymic. That is, they had to be classi-fiable and legible, both individually and collectively, for interpretive reckoning by eighteenth-century viewers. A study of a few classes of objects should indi-cate how they operated in an interpretive system that was the result of collabo-ration among Copley, his sitters, and contemporary viewers.

The object most visible in Copley's emblematic language is the body itself, for its condition and control reflected the status of gentlemen and gentlewomen. Copley frequently focused on distinctive markings as attributes that served to individualize a person. He did nothing, for example, to hide physical anomalies, such as the smallpox scars on Miles Sherbrook's face (Chrysler Museum, Nor-folk, Virginia), the hairy wen on Nathaniel Allen's cheek (Honolulu Academy of the Arts), the bend in Henry Pelham's earlobe (see fig. 2.6), the scar on Thomas Mifflin's forehead (Historical Society of Pennsylvania, Philadelphia), the moles on the faces of Elizabeth Lewis Goldthwait (Museum of Fine Arts, Boston) and James Allen (Massachusetts Historical Society, Boston), the fleshiness behind Myles Cooper's ear (Columbia University, New York), or the swollen tissue of

Epes Sargent's old right hand (National Gallery of Art, Washington). On the contrary, he made a spectacle of these features by centralizing them in compositions and placing them in a bright, descriptive light. "Warts and Moles," as John Dryden wrote in his introduction to Copley's edition of Charles-Alphonse Dufresnoy's *De Arte Graphica,* were capable of "adding a Likeness to the Face" and were "not therefore to be omitted."[10] Marks on the body had the power to endow pictures with the stamp of authenticity. William Carson of Newport pointed this out to Copley in 1772 upon seeing the artist's portrait of his wife: "I discover new beautys every day, and what was considered as blemishes, now, raises the most exalted Ideas of the perfection of the Painter 'and painting to the life'. . . . Strange objects strongly strike the senses, and violent passions affect the mind."[11]

In a similar way, fat was a marker of individuality and struck the senses strongly in many of Copley's portraits of wealthy men, but it was also a class marker. The vast stomach of Jeremiah Lee, to name just one of Copley's overweight subjects, proudly strains against his waistcoat and overloads narrow shoulders and diminutive legs. Copley often opened overcoats and latched hands, like Moses Gill's (Museum of Art, Rhode Island School of Design, Providence), onto broad hips in order to amplify the appearance of corpulence. Fat, on these pictorial occasions, is the leitmotif of a composition that expands outward from the volume of a stomach, its curvature articulated and exaggerated by ripples of shining satin fabric cinched together by waistcoat buttons. On some of these occasions, in the portrait of Nathaniel Sparhawk (fig. 2.2), for example, pentimenti indicate that Copley may have inflated a belly artificially in what amounts to a pictorial equivalent of the prosthetic stomach pads and calf pads that were sometimes used to reshape the anatomies of English and American gentlemen.

Fat in these portraits would have been read in the eighteenth century as salutary. It was perceived as protecting the body from injury, preserving the muscles, and filling interstices of the torso in such a way as to give shape, symmetry, and beauty.[12] Moreover, it was a sign of wealth, for only the well-to-do had sufficient and rich enough food to produce fat. A laborer's meals centered on bread, but the diet of prosperous merchants and landowners was more varied, including meats and sugar, and more abundant. Indeed, in the decades before the Revolution, as American elites became less provincial and more anglicized, they indulged in great dinners in the English style and constituted the largest market in the world for imported English foods.

Because the conduct, as well as the condition, of the pictured body was the site for the inscription and enactment of values of status, in painting the elite Copley's job was to present men and women comporting themselves in a visually

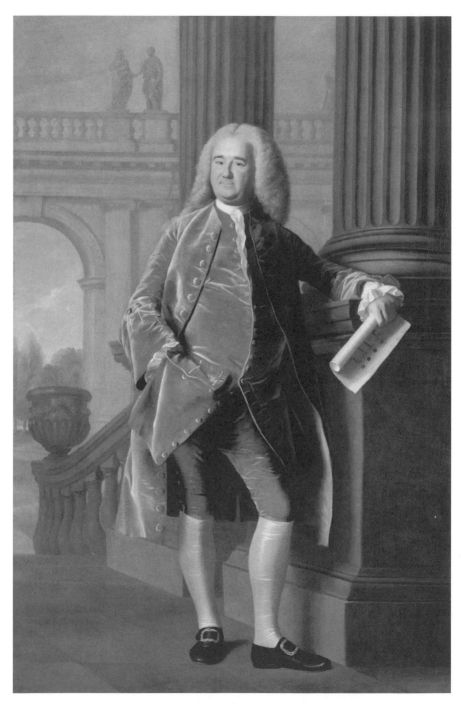

Figure 2.2 John Singleton Copley, *Nathaniel Sparhawk,* 1764. Oil on canvas, 90 × 57½
inches. Courtesy of the Museum of Fine Arts, Boston, Charles H. Bayley Picture and Paint-
ing Fund.

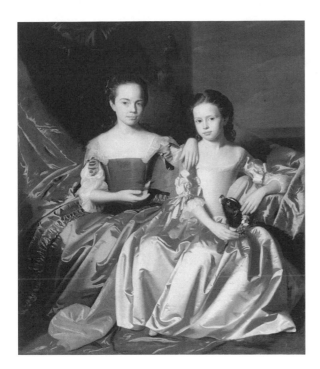

Figure 2.3 John Singleton Copley, *Mary and Elizabeth Royall*, c. 1758. Oil on canvas, 57½ × 48 inches. Courtesy of the Museum of Fine Arts, Boston, Julia Knight Fox Fund.

elegant manner that spoke like an official biography of their refinement and high moral character.[13] Increasingly in the middle decades of the eighteenth century, appropriate comportment for colonial elites meant behaving as they thought English aristocrats behaved. And so Copley's figures for the most part reflect idealized contemporary codes of conduct, despite the notoriously angular legs and awkward hips that are the products of an artist who was an autodidact. Guided by polite society's almost theatrical art of bodily demeanor, Copley chose to depict his sitters as moderate and pleasing by presenting their bodies in a controlled, graceful, and composed way, radiating ease and serenity, and avoiding what one etiquette master called "odd motions, strange postures, and ungenteel carriage":[14] hence the easy walk of Theodore Atkinson Jr. (Museum of Art, Rhode Island School of Design), the Royall sisters' relaxed arms and hands (fig. 2.3), Epes Sargent's graceful leaning posture, Nathaniel Hurd's self-contained outline (Cleveland Museum of Art), and Mary Charnock Devereux's serene, contemplative repose (Museum of New Zealand Te Papa Tongarewa, Wellington). Few of Copley's figures sit or stand "bolt upright," at one extreme, or "too negligent and easy," at the other, for the true eighteenth-century man of fashion "makes himself easy, and appears so, by leaning gracefully, instead of lolling supinely."[15]

Copley knew firsthand the codes of polite behavior because he was himself trained by his English-born stepfather, Peter Pelham (1695–1751), who taught classes in manners in Boston. Pelham, in turn, would have been familiar with, and sensitive to, the contemporary English behavioral theory that reached its culmination in Lord Chesterfield's *Letters to His Son*.[16] Pelham, Chesterfield, and other etiquette masters in this period viewed manners as social theater acted out for peers and inferiors. Unconcerned with the moral imperatives that motivated traditional courtesy literature, contemporary writers used manners as a form of self-fashioning that was a conventionalized fiction of the self, calculated to profit the individual more than society. In Copley's visual culture, the body was another agent of social persuasion, another piece of capital equipment to be exploited.

Under Pelham's tutelage, Copley would have learned recent theories not only of bodily carriage but also of facial etiquette. According to the new courtesy literature, the ideal facial expression should be "moderately cheerful" and should affect the whole face, especially the mouth, which should be trained to have a "gentle and silent smile."[17] True to that theory, Copley's sitters as a rule veer neither into melancholy nor into gaiety. Instead, their slight smiles, full eyes, and generally placid faces that are devoid of incident project a genteel sense of inner peace, confidence, grace, and moderation.

The cloth that draped and enfolded the bodies of Copley's sitters, like the bodies themselves, was a potent sign of personhood. When, for example, Copley painted Mary and Elizabeth, the daughters of Isaac Royall (see fig. 2.3), the extraordinarily successful rum merchant from Medford, he enveloped them in luxurious materials. The picture, the largest and most ambitious of the artist's early canvases, is about fabrics as much as faces. Dozens of yards of imported English satins cascade upon them, wrapping their bodies, furniture, and space in what Royall undoubtedly hoped would be read as a pageant of his family's wealth.

Fruits and flowers, as well as fabrics, were active agents in Copley's staged presentations of character and class. Copley sometimes used flowers as simple adornments to the hair or the décolletage of a dress. But he more frequently and more prominently featured flowers by representing women holding blossoms and bouquets or presenting them pridefully to the viewer.

Copley also called attention to the horticultural craftsmanship of the women he depicted with fruits. In his portrait of Hannah Fayerweather Winthrop, for example, the painter arranged a nectarine branch so as to display the fruit and leaves but also and more pointedly to show that the stem is cut precisely, suggesting that she has been grafting or experimenting with hybrids (fig. 2.4). The fruit and cut branch that she offers the viewer is associated with scientifically

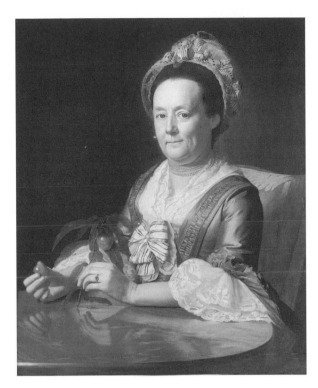

Figure 2.4 John Singleton Copley, *Mrs. John Winthrop (Hannah Fayerweather)*, 1773. Oil on canvas, 35½ × 28¾ inches. The Metropolitan Museum of Art, New York, Morris K. Jesup Fund, 1931.

managed cultivation: it is from a nectarine, which in the eighteenth century was typically grafted onto peach stock.[18]

It is not known whether all of the women Copley portrayed with flowers and fruits gardened. But certainly Copley himself must have been an accomplished gardener. He had Newton Pippin apples and New York watermelons on his Beacon Hill property and was advised to consult John Hancock next door about acquiring trees for his estate.[19] And certainly some of his sitters had renowned gardens. Thomas and Lydia Hancock, for example, planted their acreage on Beacon Hill with plum, peach, apricot, nectarine, pear, mulberry, and cherry trees imported from England and available in Boston shops that boasted of "hundreds of grafted and inoculated English fruit trees."[20]

Whenever cultivated flowers and fruits were shown in a portrait, they were meant to be understood as the product of a woman's discipline, science, handiwork, and thus character. Women did not merely grow flowers, they reared them, much as they did children, or as they themselves had been raised.[21] Such a linkage between gardening and moral education grew out of the writings of John Locke, who claimed that fine character is nurtured, not innate.[22] A child, in his sensationalist theory, comes into the world a tabula rasa that, like a plant, is

cultivated into an adult. "Moral Seeds," wrote Richard Steele, a follower of Locke's, "produce the novel Fruits which must be expected from them, by . . . an artful management of our tender Inclinations and first Spring of Life."[23] In his pictures Copley portrayed women in terms of a Lockean analogy, defined with and by plants, namable by genus and species, and cultivated or grafted according to horticultural science. The plants, like their gardeners, were elite species, and, as gems of the colonial garden, they were metaphors for their owners, who understood the ties between the social order and natural law. Gardens, and the cultivated flowers they produced, were analogous to civilization and the superior character it nurtured.

Copley used flowers and fruits as gendered objects that express feminine accomplishment, virtue, and class distinction. He displayed masculine prowess with a different set of gendered objects: business ledgers, transatlantic ships, and quill pens. Animals, however, were the province of both men and women, though a particular species of animal was often assigned to one sex or the other. For example, birds usually accompany woman sitters. They are exotic, typically parrots and hummingbirds, which trumpeted class privilege because they were imported from the Caribbean and Latin America. Almost invariably Copley showed birds in transaction with women, the objective being the display of the sitter's, not the bird's, skill.[24] Most audacious among the demonstrations of female skill of this sort are the portraits in which birds have alighted on their mistresses' hands: for example, Elizabeth Ross (fig. 2.5) has a white dove that balances itself on her finger by raising its wings.

The trained bird, like the cultivated flowers and fruits in Copley's pictures, reflected, by means of a Lockean analogy, on the semblance of the essential woman. Though Locke was not widely read in midcentury America, his theory penetrated the behavioral pedagogy of the colonies. For instance, polite girls and young ladies in America were encouraged as part of their education to train birds. Writing in 1777 in *The Young Ladies School of Arts*, Hannah Robertson recommended a number of activities that would improve character. She offered detailed instructions on how to make gum flowers that imitate "roses, tulips, anemonies, ranu[n]culas, plainthos, daisies, auriculas" and on how to clean shells from India and the Red Sea and arrange them in decorative grottoes. She also gave instructions on the keeping and care of tamed birds, detailing how young Americans could breed, cage, nest, and feed canaries and even how they might wean chicks away from a mother hen.[25] Copley's Mary MacIntosh Royall (see fig. 2.3) clearly was one of the young girls of the era who was trained according to a Lockean method like Robertson's. The viewer observing Miss Royall calmly balance a quivering ruby-throated hummingbird on a fingertip is

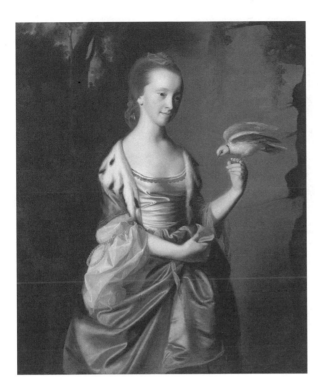

Figure 2.5 John Singleton Copley, *Elizabeth Ross (Mrs. William Tyng)*, c. 1767. Oil on canvas, 50 × 40 inches. Courtesy of the Museum of Fine Arts, Boston, M. and M. Karolik Collection of Eighteenth-Century American Arts.

meant to understand that exceptional stunt as a sign of the young lady's exceptional character. Even though Mary may never have conducted such an impressive trick, in the fictional spaces of Copley's picture the bird serves to lay claim to the sitter's moral accomplishment.[26]

Dogs also figured in Copley's vocabulary of Lockean tropes on the character of women. All the dogs he depicted are house pets that are objects of affection, rather than laboring or sporting animals: for instance, the dog that nestles in Mary Sherburne Bower's lap (Metropolitan Museum of Art, New York), the one that wears a floral necklace and admires Elizabeth Royall, and the inquisitive creature that watches an anonymous young lady (*Young Lady with a Bird and Dog*, 1767, The Toledo Museum of Art). The dogs in these three portraits are all King Charles spaniels, which were exported to America and considered symbols of high status.[27] In England, spaniels and also hounds and greyhounds were breeds whose ownership was restricted by law to the aristocracy. Though that law did not apply to America, in the colonies the King Charles spaniel was nonetheless associated with the English court and the seventeenth-century Cavalier rulers, Charles I and Charles II. Ironically, these kings had epitomized

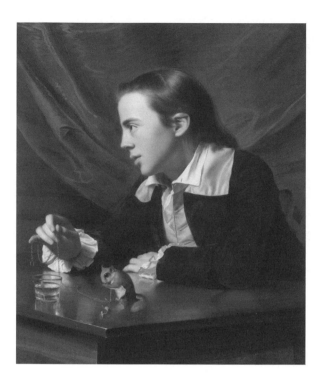

Figure 2.6 John Singleton Copley, *Boy with Squirrel (Henry Pelham),* 1765. Oil on canvas, 30¼ × 25 inches. Courtesy of the Museum of Fine Arts, Boston, gift of the artist's great-granddaughter.

profligacy and unseemly luxury for the original American Puritans, but in the 1760s the nonutilitarian dog named for the second Charles was a potent emblem for elite American women who sought ways to declare their privileged and leisured status through images that spoke of pampering and training animals.

As spaniels were the province of upper-class girls and women, squirrels were the sport of privileged children, usually boys (fig. 2.6). "Boys frequently nurse this beautiful and active animal," stated an eighteenth-century encyclopedia.[28] Unlike dogs, they were not born and bred as fully domesticated house pets but instead were wild animals brought into a civilized state through training, which again, following Lockean pedagogy, in turn improved the trainer. In Copley's portraits all the squirrels, like their masters, have been civilized. Yet the rodents are nevertheless held in check with training collars and chains. Henry Pelham, for example, loosely holds a chain to an "easily trained"[29] flying squirrel that nibbles on the meat of nuts, the shells of which litter a polished table.

The chains attached to pet squirrels were themselves tropes applied to childhood. In 1784 Benjamin Franklin wrote a parodic epitaph on the squirrel Mungo, who led a luxurious life and was fed daily "the choicest viands by the fair hands of an indulgent mistress." But in his quest for more freedom, the squirrel wandered away, only to be met by "the merciless fangs of wanton cruel Ranger,"

a dog. Franklin ended his tongue-in-cheek story with a parable that sheds some light on the broad meaning of Copley's chained squirrels. "Who blindly seek more liberty," Franklin wrote, "whether subjects, sons, squirrels or daughters, that apparent restraint is real liberty, yielding peace and plenty with security."[30] Both Franklin and Copley, writing and painting in the tradition of Locke, understood the powerful linkage in America between the methods of training animals and the moral development of children. Restrained yet free, like his squirrel, Henry Pelham's face radiates the peace that is the reward of the new Enlightenment belief in the nurturing and protection of youth.

The squirrels, dogs, fruits, flowers, and fabrics in Copley's portraits could all have been owned by his sitters. Though specific documentation about the majority of his sitters is not available, it is known that squirrels and flowers were found in the homes of the elite in Boston, New York, and other cities and towns before the Revolution. But sometimes in picturing a person Copley created a situation that was overtly fictional by using props that could not have been owned by his subject. In these works fictional objects set a theatrical stage for a sitter's role playing. In his eight-foot portrait of Nathaniel Sparhawk (see fig. 2.2), for example, Copley configured the justice of the Inferior Court of Common Pleas in a superior pose set against uncommon architecture.[31] A merchant from Kittery, Maine, Sparhawk had experienced mixed fortunes despite his marriage into the wealthy Pepperrell family in 1742. At one point, in 1758, he had to put up his property for auction, the colonial equivalent of bankruptcy. However, the following year he was rescued by the death of his father-in-law, William Pepperrell, an English peer, who left his fortune not to Sparhawk but to Sparhawk's wife and their son.

Nonetheless, Copley's grand portrait commemorates Sparhawk's ascendancy to the apex of class structure, social position, and wealth. Its extraordinary scale and size must reflect a conscious effort on the part of Copley and Sparhawk to challenge—and surpass—John Smibert's monumental painting of Sir William Pepperrell (Peabody Essex Museum, Salem, Massachusetts), one of five portraits of the heroes of the siege of Louisburg, which took place during King George's War of 1740–1748. In fact, a total of three of the great Louisburg portraits, originally commissioned from John Smibert and Robert Feke to be placed in civic spaces, were hanging in Sir William's house in Kittery when he died and therefore would have been familiar to Sparhawk.

Compared to these pictures, which glorify civic disinterestedness and military acumen, Copley's *Nathaniel Sparhawk* is purely self-congratulatory. It exalts only the class ambitions of the sitter, to the degree that some passages veer into the preposterous. Dressed in expensive silk velvet and arranged in a pose based on an English mezzotint by James McArdell, Sparhawk leans against the

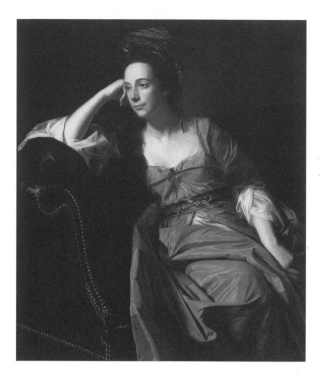

Figure 2.7 John Singleton Copley, *Mrs. Thomas Gage (Margaret Kemble)*, 1771. Oil on canvas, 50 × 40 inches. The Putnam Foundation, Timken Museum of Art, San Diego.

plinth of a colossal fluted column unknown in America. Pentimenti show that the buttons of his waistcoat were moved to the right in order to inflate the curve of his stomach, converting a skinny man into the preferred image of a fat squire who has the taste—as well as the means and the appetite—to eat like a king, in mimicry of the English. In his left hand he holds an architectural drawing for some grand building that cannot be identified. And, most audaciously, he stands before a stunning classical arcade far more reminiscent of sixteenth-century Italy than eighteenth-century Maine. It is the implausibility of Sparhawk's pictorial circumstances that speaks to his real desire to be perceived as a gentleman in the manner of his aristocratic father-in-law, Sir William.

In his stunning portrait of Margaret Kemble Gage (fig. 2.7), wife of Thomas Gage, who was commander in chief of the British army in North America, Copley presents the sitter uncorseted and wrapped in a brilliant red taffeta caftan, confecting her as an exotic Turkish woman.[32] Copley embellished the oriental metaphor by adding to the costume a silk hair scarf that looks like a turban and a blue belt that is cinched high and embroidered in a floral design. Moreover, along the same orientalizing line, he constructed a languid sexuality for his sitter, manifested in her dreamy eyes and in her glossy brown hair that escapes the

loosely fitted scarf and cascades sensually over her shoulder and chest. It is a sexuality situated in the gesture of the left hand that holds the dress and presses up against her thigh; in the sinuous curves of the camelback sofa, itself a furniture form from west Asia; and in a lolling pose so relaxed and expressive of idleness and self-indulgence as to challenge contemporary codes of polite bodily conduct.

The portrait calls up the notion of the courtesan. Yet it is clear that the pictured persona of the harem woman has nothing to do with Mrs. Gage's normal conduct or dress: her turban is lightly attached, as if a studio accessory; a proper eighteenth-century chemise peeks through the openings of the caftan; and a fine, brass-tacked American sofa of about 1770 frames her performance. Mrs. Gage plays her role lightly.[33] Like the character Charlotte in George Colman's play of 1776 *Man and Wife,* she might, in anticipation of her performance in a costume party, be prepared to slip "on [her] dress, which is a blue Turkish habit, directly after dinner, and in that . . . shall expect you about seven o'clock."[34]

It was understandable that Mrs. Gage might wish to be portrayed in *turquerie,* for that was the thing to do in England. In English elite culture going Turkish had been and was a custom best exemplified by the portraits of and writings by Lady Mary Wortley Montagu, who occasionally played the role of an oriental woman in public.[35] It was also popular to act out Turkishness in the context of another English elite custom, the masquerade, at which the harem woman was a popular disguise because, of all the identities a woman could assume, it offered the most exotic and erotically liberating possibilities.

But in America actually assuming Turkish dress and taking part in masquerades would have been daring if not impossible.[36] Margaret Kemble Gage could not walk the streets of New York with such bodily or sartorial abandon, nor could she entertain at home that way. Nor could she attend the sexually liberating masquerades that were available to her contemporaries in England. Nonetheless, she was an elite Englishwoman by marriage and continued to think of herself as such. And that is where Copley entered. His project was to construct for her an imagined self, a desired role, a public face that American social practice could not condone but that representational practice could. In the fictive spaces of Copley's portrait, a faux sultana could participate, if only two-dimensionally, in the intoxicating English vogue for masquerading, dressing up, and role playing.

At stake in the portrait was one of Mrs. Gage's social identities. Here Copley fashioned for her an image meant to gain purchase not only with the guest in her home but also, however tacitly, with the sitter herself and, undoubtedly, with the society in which she was situated. This image was the tool Margaret Kemble

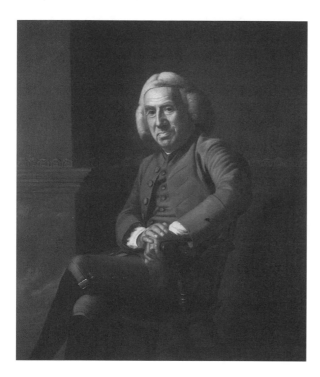

Figure 2.8 John Singleton Copley, *Eleazer Tyng*, 1772. Oil on canvas, 49¾ × 40⅛ inches. National Gallery of Art, Washington, D.C., gift of the Avalon Foundation.

Gage used to connect with a social group from which she was distanced. It made the portrait a material artifact that could generate a social discourse that otherwise did not exist for her. It was one of the masks she wore in the dramaturgy of social life.

As much as luxury objects defined class and character in the portraits of Sparhawk, Gage, and Boylston, the denial of ostentation could be just as telling. Copley's portrait of Eleazer Tyng (fig. 2.8), for instance, is brutally unadorned. Yet the sitter was a wealthy landowner who had inherited his family's seventeenth-century estate on the Merrimac River. Why would he not engage in the lavish anthropological display that was the pictorial convention of his class? Probably because Tyng, who was Puritan and eighty-two years old at the time the portrait was painted, came from an older, more modest, less flamboyant, less anglicized culture than Copley's younger elites.

Moreover, Copley and Tyng seem to have declared plainness a virtue, for the astringency of the sitter and his accoutrements contradicts the values that inform, say, Copley's portrait of Nathaniel Sparhawk (see fig. 2.2). This astringency is evident in the green Windsor chair on which Tyng is posed, a simple country piece far removed from the rococo furniture in high English style in

Copley's more lavish pictures. Tyng's suit, too, is simple, made of homely wool broadcloth, not silk or velvet. His stockings are black, instead of the more fashionable white. His full white shirtsleeves are those of a loose-fitting worker's smock, similar to the one worn by Paul Revere in his portrait (Museum of Fine Arts, Boston). And, to complete the image of a workingman from a simpler time, there is dirt under his fingernails.

Copley's project in his portrait of John Hancock (fig. 2.9) carried the act of simplification into the realm of politics. The written accounts of Hancock's life tell a consistent story: he was among the most fashionable, socially flamboyant, and politically ambitious figures in pre-Revolutionary Boston. In the year Copley painted his portrait, Hancock inherited his uncle Thomas's fortune, his mansion on Beacon Hill, and the House of Hancock, the largest trading firm in the port city. In Boston Hancock was conspicuous for wearing lavender suits, driving a bright yellow carriage, and exercising an extravagantly expensive taste for English goods.

Yet Copley's Hancock is an ascetic man. He wears a stylish but simple dark blue wool frock coat, the plainness and practicality of which sharply contrast with the opulence and frivolity of the brightly colored velvet garments that he favored. He sits on an outdated Queen Anne chair of about 1740. His environment is devoid of any markers that might reveal him as a leisured person—he is not at home, nor surrounded by the luxurious things that he admired and owned. Most startling, given Hancock's reputation for ignoring the financial details of his uncle's sprawling business, he is portrayed tending account books, holding a quill pen, with an inkstand nearby, ready to make entries in his ledger or just finished with the task.

In the context of a culture that viewed luxury objects as signs of elite class, Hancock's portrait would seem to deny his true status in the community. The open ledger that is filled with entries represents a numerical itemization of his mercantile activity. But otherwise the picture says little about his status, almost every material index of his social position having been omitted. Compared to his ultrarich merchant peers, such as Nicholas Boylston (see fig. 2.1), who are presented as princes in their sumptuous portraits by Copley, Hancock looks like a minor trader, a small-businessman who tends his own books and is proud to be shown as such.

What would have motivated Copley to fashion Hancock into a modest, unadorned, disciplined man who has denied himself the trappings of wealth and class that were available to him and were deemed essential elements of portraiture by current representational practice? Why, in the year of his promotion to the summit of wealth and class structure in Boston, would Hancock

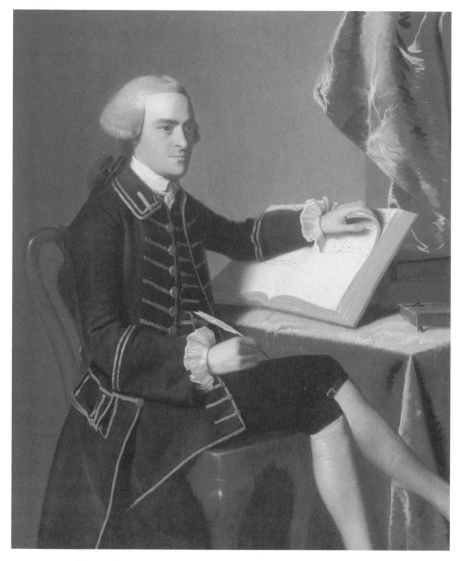

Figure 2.9 John Singleton Copley, *John Hancock*, 1765. Oil on canvas, 49½ × 40½ inches. Courtesy of the Museum of Fine Arts, Boston, deposited by the City of Boston.

approach Copley for a portrait that fraudulently presents him as the house accountant?

One can only speculate. It is possible that his choice of this guise was politically motivated. Hancock was beginning to seek public office in the mid-1760s. At a time when demagogues such as Samuel Adams were launching blistering

attacks on privilege and when populist mobs were demolishing the houses of Thomas Hutchinson, Andrew Oliver, and other elites in power, the politically ambitious and materially flamboyant Hancock was particularly vulnerable to shifting public opinion. Adams, for example, called for the disempowerment of the elites at the precise moment they were extravagantly flaunting their wealth by indulging their taste for great urban mansions, ornate furniture, elaborate weddings, grandiose portraits, and a ceaseless and, to radicals, seemingly grotesque mimicry of the English, financed by the exploitation of workers and the poor.[37]

The situation was perilous for Hancock, but he was a brilliant tactician. In the disintegrating Boston of 1765 he presented himself as a self-sacrificing man of the people. He participated in the boycott of English goods, at the risk of ruining his own trading firm. And he spouted radical rhetoric, calling for the beheading of all holders of royal office. Unlike many of his ever more isolated elite peers who became increasingly wrapped up in the social rituals of an earlier, safer era, Hancock anticipated how he might be a leader in a new political era by publicly identifying with the laboring classes. Through both verbal and visual rhetoric this patrician was able to project an image of republican virtue, frugality, and simplicity.

Privately he believed in class structure, distrusted those he thought beneath himself, rebuked the mobs for sacking Hutchinson's house, retained all the perquisites of his class, and was more concerned with his commercial interests than with individual rights.[38] Nonetheless, his crafty political gambits worked, winning him immense popularity and election to the General Court in the midst of the Stamp Act crisis of 1766 and later to the positions of governor of Massachusetts and president of the Continental Congress.

The gulf between the private and public Hancock, between the elegant patrician and the man of the people, is bridged by the critical agency of Copley's portrait. Why did Copley portray Hancock as a worker, unadorned and almost old-fashioned? Because of Hancock's self-protective yet self-promotional need in 1765 to be seen as a new representative man. Hanging in Hancock's politically resonant home, the site of countless political events, the portrait surely identified him as a wealthy man, even though no luxurious objects are included in it. The very large size of the picture (roughly 50 by 40 inches) and the thick ledger filled with numbers that is displayed in it indicate this status. However, set in his house amid an extraordinarily rich ensemble of the finest American and English decorative arts, the picture must have seemed out of place. With its disciplined forms, astringent composition, simple props, and working-man's ethos, it speaks in the ethical and aesthetic language of the antimaterialist,

neo-Puritan, nascently republican culture that sprang up and began to find a voice in 1765 and propelled a revolution a decade later.

Until 1765 Hancock had been a politician manqué who coveted high office. But that year, when he contemplated running for one of four seats on the General Court, Hancock commissioned a portrait from Copley that expresses a new kind of virtue, crafted from republican wool. The picture can be considered an agent in his populist gambit, which took many forms. He made the decision— honored only temporarily, in 1765—to cease acquiring foreign goods. He had his ship carry the order that overturned the Stamp Act to Boston, where he personally announced the news of the repeal to the public. He mounted fireworks in celebration of the repeal on the lawn of his mansion and provided glasses of Madeira for the crowds there. And he chose the visual motif of a working elite for himself in Copley's portrait, which, in the demonology of John Hancock, is the equivalent of a log-cabin myth. These acts of antimaterialist purification, these self-congratulatory rituals of self-conscious denial, were the manifest signs of what the new public man in America would become.

Copley's portrait of Hancock and his pictures of other colonial men and women epitomize Tuckerman's notion of the "counterfeit presentment." Whether fashioning the image of a simple man such as Hancock or a grandee such as Nathaniel Sparhawk, arranging Mrs. Gage's masquerade, or constructing a Lockean analogy between the cultivation of flowers and of women, Copley was engaged in the audacious tooling of identity for those elite American men and women who felt compelled to be perceived as more than they were. As Jonathan Richardson claimed in his *Theory of Painting* in 1715, this ability to "raise the character; to divest an unbred person of his rusticity, and give him something at least of a gentleman," to, in other words, fashion, embellish, and even distort while retaining his likeness, "is absolutely necessary to a good face-painter; but it is the most difficult part of his art, and the least attained."[39]

Visual certification of character and class was especially important in a colonial society in which position could not be secured by inherited title. "In Europe," wrote Benjamin Franklin, one's birth "has indeed a Value; but it is a Commodity that cannot to be carried to a worse market than that of America."[40] In Boston elites somehow had, literally, to earn status and authority by accumulating wealth and other forms of accomplishment and had to prove their power on a daily basis by displaying the kinds of things and images that emblematized class. With traditional sources of status "surrounded and squeezed," as historian Gordon Wood puts it, colonial Americans were measured "by cultivated, man-made criteria having to do with manners, taste, and character."[41]

These material attributes, which allowed for the deduction of character and

class, were exactly the meritocratic criteria that led themselves to manipula-
tion in the hands of Copley, who was the master imagist of eighteenth-century
America. His artistic genius lies not merely in an inexplicable ability to teach
himself how to paint as well as he did or to make his art look modern but also in
his peerless understanding of the codes of patrician representation that were
current in Boston and, by extension, in London. He, as no one before and few
afterward, could provide clients with what they wanted, and sometimes provide
them with even more than they could imagine they wanted.

Copley understood implicitly an early modern condition according to which
the material appearance of character becomes the demonstrable proof of char-
acter. He postulated, de facto, that personality could be made available from the
details of personal affectations, that character was immanent in material appear-
ances, and that the reading of things assembled in a portrait was tantamount to
knowing the essential person who was pictured. His project in portraiture was
not the creation of accurate likenesses but the production of authenticating nar-
ratives about people. As such, he was part of a perceptual conspiracy, also en-
acted by other craftsmen of his period, which presented the artifices of body
form and luxury objects as natural representations of character.[42]

Since it claimed identity through an assemblage of discrete elements, Cop-
ley's representation of a person's character could be disassembled by a viewer
into an inventory of an individual's appearances and possessions. Copley's inter-
pretive method assumed that personal identity is visible and additive, instead of
concealed and ineffable, that status was a projection, not just a possession. It as-
sumed, moreover, that viewers had the ability to scrutinize, to make distinctions
between objects and thus between individuals. Copley must have realized that
in his culture this was the analytical means by which people evaluated one an-
other, by which, to invoke the mercantile language of the era, individuals au-
dited individuals. This was Copley's method. And surely it was the method that
John Adams used to assess Nicholas Boylston's character the evening he visited
him in the winter of 1766.

This emphasis on the field of semantic display was Copley's radical con-
tribution to the anthropology of personhood in pre-Revolutionary America.
When he was at his best in assembling the signs of a person, in his portraits
of Nicholas Boylston, Nathaniel Sparhawk, and Margaret Kemble Gage, for ex-
ample, he pushed the codes for the representation of character into realms pre-
viously unknown in America. It is not his descriptive technique alone but
Copley's unsurpassed ability to reify the bourgeoisie's mythic perception of itself
that is the critical basis for the claim that he is the supreme portraitist of the
colonial era.

Notes

This article is an abbreviated version of an essay that first appeared in *John Singleton Copley in America,* exh. cat., Metropolitan Museum of Art, ed. Carrie Rebora and Paul Staiti (New York, 1996), 53–77. Locations are provided for paintings that were illustrated in the original publication but are not reproduced here.

The first epigraph is from Charles Baudelaire, "Salon of 1846," in *Art in Paris, 1845–1862: Salons and Other Exhibitions Reviewed by Charles Baudelaire,* trans. and ed. Jonathan Mayne (1965; rpt. New York, 1981), 88. The second is from Henry T. Tuckerman, *Book of the Artists: American Artist Life* (New York, 1867), 75–76.

1. Gordon Wood defines the elite as the class of gentlemen and gentlewomen, "the better sort," as they were called then. People who were mechanics, artisans, laborers, and those without property were "the lower sort" (Gordon S. Wood, *The Radicalism of the American Revolution* [New York, 1992], pp. 24–42).

2. Probate inventories in Suffolk County, Mass., for instance, overwhelmingly place family portraits in the semipublic spaces of the first floor of a house.

3. I admire the critical language and interpretive methods of Marcia Pointon's *Hanging the Head: Portraiture and Social Formation in Eighteenth-Century England* (New Haven, 1993). I am using the words *character* and *social identity* interchangeably. By those words I mean to follow Colin Campbell's definition of "character as the name for that entity which individuals constantly strive to create out of the raw material of their personhood. It is thus not equatable with personality, as that term usually covers the sum total of an individual's psychic and behavioural characteristics, nor is it something which can simply be understood as the unproblematic outcome of dominant culture patterns or processes of socialization. On the contrary, character covers only that portion of the conduct of individuals which they can be expected to take responsibility for, and is the entity imputed to underlie and explain this willed aspect of their behaviour. As such it has an essentially ethical quality not possessed by the concept of personality" (Colin Campbell, "Understanding Traditional and Modern Patterns of Consumption in Eighteenth-Century England: A Character-Action Approach," in *Consumption and the World of Goods,* ed. John Brewer and Roy Porter [London, 1993], 45).

4. *Diary and Autobiography of John Adams,* ed. Lyman H. Butterfield (Cambridge, Mass., 1961), 1: 294.

5. Pointon discusses this briefly in *Hanging the Head,* 6–7.

6. In discussing the relationship between luxury goods and social differences, I am following the theoretical and historical writings of a number of scholars, particularly Pierre Bourdieu, *Distinction: A Social Critique of the Judgement of Taste,* trans. Richard Nice (Cambridge, Mass., 1984); see esp. his chapter "The Dynamics of the Field," 226–56. I have also been influenced by the sociological theory of Colin Campbell, *The Romantic Ethic and the Spirit of Modern Consumerism* (Oxford, 1987); as well as by Richard Sennett, *The Fall of Public Man* (Cambridge, Mass., 1976); and Erving Goffman, *The Presentation of Self in Everyday Life* (Garden City, N.Y., 1959). Mihaly Csikszentmihalyi and Eugene Rocheberg-Halton concisely state the premise at work in this essay: "All people can, and presumably most people do, use symbolic objects to express dimly perceived possibilities of their selves to serve as models for possible goals"

(Mihaly Csikszentmihalyi and Eugene Rochberg-Halton, *The Meaning of Things: Domestic Symbols and the Self* [Cambridge, 1981], 28). Anthropologists Mary Douglas and Baron Isherwood equate the symbolic value and the use value of objects in *The World of Goods: Towards an Anthropology of Consumption* (New York, 1979). Grant McCracken calls goods "tokens in the status game" in his *Culture and Consumption: New Approaches to the Symbolic Character of Consumer Goods and Activities* (Bloomington, Ind., 1990), 17. The most intelligent overviews of the theory of objects and status are Jean-Christophe Agnew, "Coming up for Air: Consumer Culture in Historical Perspective," in Brewer and Porter, *Consumption and the World of Goods*, 19–39; and Ann Smart Martin, "Makers, Buyers, and Users: Consumerism as a Material Culture Framework," *Winterthur Portfolio* 28 (Summer–Autumn 1993): 141–57. T. H. Breen writes specifically about the relationship between goods and identity in eighteenth-century America; see his excellent essays "'Baubles of Britain': The American and Consumer Revolutions of the Eighteenth Century," *Past and Present* 119 (May 1988): 73–104; "An Empire of Goods: The Anglicization of Colonial America, 1690–1776," *Journal of British Studies* 25 (October 1986): 467–99; and "The Meaning of 'Likeness': American Portrait Painting in an Eighteenth-Century Consumer Society," *Word and Image* 6 (October–December 1990): 325–50.

7. Richard L. Bushman believes that viewers in the eighteenth century were able to read a person's character cumulatively, through one visual opportunity after another (Richard L. Bushman, *The Refinement of America: Persons, Houses, Cities* [New York, 1992], 61–99).

8. Roland E. Fleischer has attempted to read the portraits in the traditional, iconic way in "Emblems and Colonial American Painting," *American Art Journal* 20, no. 3 (1988): 2–35.

9. Wood, *Radicalism of the American Revolution*, 32.

10. Quoted in Kenneth Silverman, *A Cultural History of the American Revolution: Painting, Music, Literature, and the Theatre in the Colonies and the United States from the Treaty of Paris to the Inauguration of George Washington, 1763–1789* (New York, 1976), 23.

11. William Carson, letter to Copley, Aug. 16, 1772, in Guernsey Jones, ed., *Letters and Papers of John Singelton Copley and Henry Pelham, 1739–1776* (Boston, 1914), 187–88.

12. See Thaddeus Harris, "Fat," in Thaddeus Harris, *The Minor Encyclopedia; or Cabinet of General Knowledge* (Boston, 1799), 2: 250.

13. The best recent study of manners is Bushman, *Refinement of America*, 30–60, 63–69. Bushman points out that the self-conscious control of the body was the most visible way in which a gentleperson expressed himself or herself.

14. Lord Chesterfield [Philip Dormer Stanhope], *Letters to His Son*, 3d ed. (New York, 1775), 1: 39, quoted in Christina Dallett Hemphill, "Manners for Americans: Interaction Rituals and the Social Order, 1620–1860," (Ph.D. diss., Brandeis University, 1988), 191.

15. Chesterfield, *Letters to His Son*, 1: 86, quoted in Hemphill, "Manners for Americans," 192.

16. Chesterfield was first published in America in 1775, but his influence had permeated Anglo-American society before then; see Bushman, *Refinement of America,* 36.

17. Chesterfield, *Letters to His Son,* 1: 86, quoted in Hemphill, "Manners for Americans," 193.

18. Mrs. Winthrop's son, James, chronicled the dates his nectarines bloomed and fruited in Cambridge; see Ann Leighton, *American Gardens in the Eighteenth Century: "For Use and for Delight"* (Boston, 1986), 235.

19. Henry Pelham advised his half-brother that Hancock "can supply you with every Fruit Tree, flowering Tree except the Tul[ip] shrub or Bush, that you want" (Henry Pelham, letter to Copley, Sept. 10, 1771, in Jones, *Letters and Papers,* 158).

20. For the Hancocks, see W[illiam] T. Baxter, *The House of Hancock: Business in Boston, 1724–1775* (Cambridge, Mass., 1945), 67. The advertisement comes from the *Boston News-Letter,* Oct. 22, 1772.

21. For the idea of rearing, see Mrs. Anne Grant, *Memoirs of an American Lady, with Sketches of Manners and Scenery in America As They Existed Previous to the Revolution,* 2 vols. (London, 1808).

22. Both Locke and Jean-Jacques Rousseau repeatedly used the metaphor of cultivating plants to describe the proper pedagogical approach for the raising of gentlemen and gentlewomen. See Jay Fliegelman, *Prodigals and Pilgrims: The American Revolution against Patriarchal Authority, 1750–1800* (Cambridge, 1982), 31–35.

23. Richard Steele, *The Spectator* 3 (London, 1750): 406. Americans had been introduced to the metaphorical association of gardening and moral education directly by Locke's writings, particularly his *Some Thoughts Concerning Education* (London, 1693), and indirectly through popular English literature in eighteenth-century America, including Daniel Defoe's epic on the subject of education, *Robinson Crusoe* (1719).

24. The only portrait of a male by Copley that includes birds is *Thomas Aston Coffin,* ca. 1758 (Munson-Williams-Proctor Institute, Museum of Art, Utica, N.Y.). Though this picture seems to negate a thesis of gendered emblems, when he was painted Coffin was only about five years old, unbreeched, and thus not yet a subject for full masculine imagery.

25. Mrs. Hannah Robertson, *The Young Ladies School of Arts* (New York, 1777), 125. In addition, Robertson wrote "On the Nature and Signification of Colours," advising on the appropriate use of color in drapery (for example, "azure, signifies constancy," p. 25); and "On Emblems" (for example, "The Dove is mild and meek, clean of kind, plenteous in increase, forgetful of wrongs, for when their young ones are taken from them they mourn not," p. 27).

26. For birds symbolizing civility, see Grant, *Memoirs of an American Lady,* 1: 166–68.

27. King Charles spaniels are now known as English toy spaniels. See Mary Forwood, *The Cavalier King Charles Spaniel* (London, 1967).

28. *Encyclopedia; or a Dictionary of Arts, Sciences, and Miscellaneous Literature* (Philadelphia, 1798), 10: 712–13.

29. Ibid., 713.

30. Benjamin Franklin, "Epitaph on Miss Shipley's Squirrel, Killed by Her Dog," *Pennsylvania Gazette,* Nov. 10, 1784.

31. For a thorough discussion of the picture, see Carol Troyen, "John Singleton Copley and the Grand Manner: Colonel Nathaniel Sparhawk," *Journal of the Museum of Fine Arts* (Boston) 1 (1989): 96–103.

32. See Aileen Ribeiro, "Turquerie: Turkish Dress and English Fashion in the Eighteenth Century," *Connoisseur* 201 (May 1979): 17–23; and Pointon, *Hanging the Head,* 141–57.

33. Terry Castle, *Masquerade and Civilization: The Carnivalesque in Eighteenth-Century English Culture and Fiction* (Stanford, Calif., 1986), 4–5.

34. George Colman, *Man and Wife,* in *The Plays of George Colman* (London, 1777), act 2, p. 31.

35. On Lady Montagu, see Pointon, *Hanging the Head,* 141–57.

36. See Bruce C. Daniels, "Sober Mirth and Pleasant Poisons: Puritan Ambivalence Towards Recreation and Leisure in Colonial New England," *American Studies* 34 (Spring 1993): 17–28; and Bruce C. Daniels, "Frolics for Fun: Dances, Weddings, and Dinner Parties in Colonial New England," *Historical Journal of Massachusetts* 21 (Summer 1993): 1–22.

37. On the subject of wealth and poverty in Boston, see Gary B. Nash, *The Urban Crucible: Social Change, Political Consciousness, and the Origins of the American Revolution* (Cambridge, Mass., 1970); and Jackson Turner Main, *The Social Structure of Revolutionary America* (Princeton, N.J., 1965).

38. As Nash puts it, in 1765 Hancock was not "risking his life and fortune for a return to arcadian simplicity" (*Urban Crucible,* 224).

39. Jonathan Richardson, *An Essay on the Theory of Painting* (London, 1715), 172.

40. *The Writings of Benjamin Franklin,* ed. Albert Henry Smyth (New York, 1907), 8: 605.

41. Wood, *Radicalism of the American Revolution,* 32.

42. Pointon eloquently claims that objects were "components in a language, in a vast repertoire of signifiers. . . . The subject of the portrait participates in the production of meanings that are not defined by reference to standards of likeness" (*Hanging the Head,* 112).

3 Charles Willson Peale's Expressive Design: *The Artist in His Museum*

Roger B. Stein

Although I am friendly to portraying eminent men, I am not friendly to the indiscriminate waste of genius in portrait painting; and I do hope that your son will ever bear in his mind, that the art of painting has powers to dignify man, by transmitting to posterity his noble actions, and his mental powers, to be viewed in those invaluable lessons of religion, love of country, and morality; such subjects are worthy of the pencil, they are worthy of being placed in view as the most instructive records of a rising generation. *Benjamin West to Charles Willson Peale, 1809*

Any work of art is a moment in the life of its culture, but some capture that moment with a special richness and complexity. The large-scale self-portrait by Charles Willson Peale (1741–1827) entitled *The Artist in His Museum* (1822; fig. 3.1) is such a work. A self-conscious cultural statement, it stands at the end of the amply documented life of a major artist and crystallizes in its particular ways some of the shapes of American culture at a crucial point of transition, just as Peale and his world were giving way to a new "romantic" America.

In an obvious sense, all portraits are cultural and historical documents, biographical statements about the life of an individual. This is especially true of a self-portrait, since the artist is shaping the materials of his or her own life and externalizing them, making them publicly available on the canvas. Over the course of his lifetime Charles Willson Peale painted a number of self-portraits, of which at least eighteen are known. Although undoubtedly some of these self-portraits were relatively private acts, for his own instruction or for family and friends, *The Artist in His Museum* was a direct response to a public commission.[1]

The museum that he had founded in the 1780s and to which he had devoted a large proportion of his enormous energies over almost forty years had finally become in fact, as it had always been in intent, a public institution; and the trustees of the newly incorporated Philadelphia Museum in their meeting of July 19, 1822, had asked the eighty-one-year-old Peale "to paint a full length likeness of himself for the Museum."[2] He responded with alacrity and set to

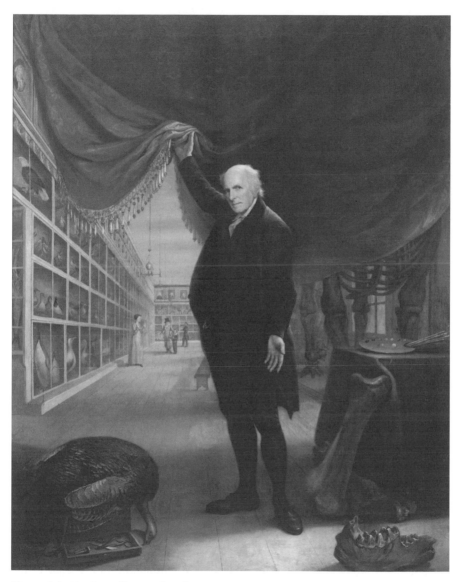

Figure 3.1 Charles Willson Peale, *The Artist in His Museum*, 1822. Oil on canvas, 103½ × 80 inches. Courtesy of the Pennsylvania Academy of the Fine Arts, Philadelphia, gift of Mrs. Sarah Harrison, the Joseph Harrison, Jr., Collection.

work immediately, and his energetic efforts over the seven weeks it took him to complete this huge 103½-by-80-inch canvas are richly recorded in a wealth of documents—letters to relatives and friends, a retrospective autobiographical account, and finally and most important, the completed work itself—all of which can define for us as they did for Peale the web of relations between the artist and his world, between a particular self and the culture in which he was such an involved participant.

The autobiographical act of self-definition is at one and the same time an act of public relatedness, an attempt to locate himself personally and pictorially within his times and for the largest possible audience. The completed painting was hung initially in the museum and, after 1878, on the walls of the Pennsylvania Academy of the Fine Arts. It has appeared in many exhibitions, and the image has been reproduced in countless books, articles, and catalogues on American art and culture. This familiarity and popularity are themselves testimony to the painting's function as a public image—comparable in kind, if not quite in degree, to Gilbert Stuart's Athenaeum portrait of Washington or, more nearly, to Asher Durand's double portrait of Thomas Cole and William Cullen Bryant, *Kindred Spirits*—a shared and sharable cultural re-presentation of a man in his time and place.

The Emblematic Portrait

The historical archaeology required to understand Peale's 1822 cultural statement demands not only that we dig up, identify, and label the constituent parts presented to us but also that we reconstruct the vision, focusing our attention on how and why the parts are related on the canvas. Peale himself was unmistakably clear on the primacy of the pictorial organization as he worked out the conception and execution of the painting. The task was not merely to gather around the figure separate elements, associated in some random way with his public experience as founder of the museum. On July 23, only four days after the trustees acted, Peale wrote to his son Rembrandt: "My next object in writing is [to] try your invention of a composition of a large whole length portrait. . . . I think it important that I should not only make it a lasting Monument of my art as a Painter, but also that the design should be expressive that I bring forth into public view, the beauties of Nature, and art, the rise & progress of the Museum."[3] The first task, thus, was compositional: how to give shape to the only requirement, that the work be a full-length portrait. Beyond this the task was not merely to make the work his best artistic effort but that "the design should be expressive," that in the organization of images the formal pattern should be itself a mode of shaping meaning.

This idea crops up again and again in his letters. By August 4 the prepared

canvas is before him, and he writes to another son, Rubens, that he is "studying the composition. The design which I have thought best, as simply shewing that I have brought subjects of Natural History into view, is by representing myself putting a Curtain aside to shew the Museum."[4] Or after the work was completed he writes to Thomas Jefferson of the commission, beginning, "I have made the design as I have conceived appropriate."[5] In all cases Peale's first attention is to composition and "design," the mode of organizing meaning on the canvas. Where and in what attitude to place the figure, what the "scene" was to be, what particular elements to include and for what reasons of time and individual significance, how to solve problems of perspective, what sources might be useful as examples (Rembrandt suggested a Thomas Lawrence portrait currently on exhibit in New York)[6]—all these questions followed from or were subsequent to the problem of design. In simplest terms, Peale's emphasis reminds us that a painting is a construction in a two-dimensional space, a patterning of elements on the canvas, and that even the clearly powerful ego satisfaction involved in representing oneself publicly must, in the painter's eyes, be controlled by the pictorial need to map the constituent parts in a meaningful series of relationships on the canvas.

This truism of pictorial practice must not be seen as an alien technical matter to the historian of culture, for Peale's decision that "the design should be expressive" offers us a clue to the understanding of his intellectual, scientific, and aesthetic universe. The design of the painting, I will ultimately suggest, is coterminous with the design of Peale's universe. The form and shape of the painting are not merely means to convey meaning; they are themselves bearers of meaning, and the student of culture cannot separate the constituent elements from the "design" without missing how Charles Willson Peale's painting re-presents its culture. As for the second repeated note in Peale's emphasis on "design" that its function is to "bring forth into public view the beauties of Nature and art"—that also suggests not only a subject matter, "nature" and "art," but a mode of making them available to the viewer, the full understanding of which depends ultimately upon our recapturing the dynamics of Peale's particular version of Lockean epistemology.

Two cases in point should make initially clear Peale's focusing of the biographical data, the source material of his life as founder and director of the museum, around the needs of "design" and bringing forth of "the beauties of Nature and art." The commission clearly indicated that the setting for the portrait should be the museum itself, which after its earliest years in his house on Lombard Street in Philadelphia and then in Philosophical Hall had been located since 1802 in the second floor of the State House, the building we know as Independence Hall. The Long Room, a hundred-foot-long chamber running the

Figure 3.2 Titian Ramsay Peale, *Interior of Peale's Museum,* 1822. Ink and water-color sketch on paper, 14 × 20¾ inches. Photograph copyright 1977 The Detroit Institute of Arts, Founders Society Purchase, Director's Discretionary Fund.

length of the building, was the obvious setting since it housed the larger share of the museum's exhibits. Peale employed his drawing machine to establish the perspective lines of the room. He set his son Titian "at work to fill it up with his water colors, and he has nearly finished an admirable representation," he writes in his letter of August 4 to Rubens. But even a brief comparative glance at the sketch (fig. 3.2) and the finished painting (see fig. 3.1) indicates that Peale has altered "reality" to meet the needs of his design. The perspective has been opened up into the foreground at the base of the painting. The cabinets between the windows on the outside wall to the right, which contained cases of insects, minerals, and fossils, a group of landscape paintings, a series of busts above, and the organ case (visible about halfway down the room in the sketch), have all been displaced by the partially hidden skeleton of the mastodon and other animals, brought in from quite another room in the building, as museum visitors would have quickly recognized.

Into the big space at the lower left opened up by Peale's manipulation of the perspective he has introduced the dead turkey on a taxidermist's chest. This turkey was one of the specimens that Titian, who along with another son, Linnaeus, was now administering the museum, had brought back from his experience as artist-naturalist with the Stephen Long expedition to Missouri, to be stuffed and included in his father's collection. The documentation of elements in

the painting to their sources in Peale's life is an almost endless task, for the work is richly associative, and the turkey is one particular choice that Peale has made to fill the space that the widening of the perspective has produced.[7]

However, understanding its biographical source does not explain its larger significance within the painting for Peale and his culture; and beyond its value as a separate object lies its dynamic function within the design in bringing forth the beauties of nature and art. Its foreground role for the viewer is as a still life, *nature morte,* but it is dead nature that will be transformed within the space of the canvas and the museum into an artistically framed object in one of the cases behind it, to be revitalized by the beauty of art in several senses. Our perception of this is part of the complex spatial interplay, a cognitive game that Peale controls to define for the viewer the significance of each separate object within the world of the artist and his museum.

The first important clue to Peale's method lies in his notion of the kind of portrait he has created. The convention within which Peale was working became explicit in his unpublished third-person autobiography: "Peale thought as he was required to make this Portrait, that he would not make a picture such as are usually done in common Portraits, and having made some studies he determined to have the light received from behind him, and putting himself in the attitude of lifting up a curtain to shew the Museum—emblematical that he had given to his country a sight of nature history in his labours to form a Museum."[8] By defining this special portrait as "emblematical," Peale illuminates his method in this work and underlines his allegiance to a long tradition.

The emblem is an Italian Renaissance creation—a pictorial image with a verbal commentary that interprets it and creates meaning by explicating the often complex and frequently arbitrarily organized visual image or images. The visual thus comes to stand for some idea not because it illustrates its subject perceptually, in a narrative or realistic or discursive or psychologically expressive manner, but through our acceptance conceptually of the wittily contrived arbitrary pattern. Andrea Alciati and Cesare Ripa were the progenitors of a century or more of emblem books, gatherings of such witty and learned images and texts. Linked initially to heraldic devices and, in the seventeenth century, to poetic conceits ("Make me, O Lord, thy Spinning Wheele compleate," intoned the Puritan poet Edward Taylor), the emblem tradition flourished equally in southern and in northern Europe, where the engraved Dutch versions far outshone in aesthetic quality their often visually crude Italian sources. Emblems became part of the visual language of history painting and portraiture as well, even long after the visual image had lost its explicit verbal commentary. The cultural audience for whom they were created could be depended upon to understand that a column in a portrait stood for firmness and steadfastness, a dog for fidelity, a Phrygian

cap for liberty, a figure with snakes in its hair for discord. In the emblematic portrait the conceptual controls the perceptual, asks us to know the value of its subject through these images, which surround it and stand for attributes, ideas, and values of the sitter. The emblematic portrait requires the viewer's knowledge of a system of meanings and his or her active engagement to create intellectual coherence and meaning out of the images so arranged—rather, that is, than merely perceiving persons in their living space at a particular moment in historical time.[9]

Despite the emphasis of earlier American art historical scholarship on the "realism" of American portraiture, we need to recognize that Peale was, like John Singleton Copley and others, thoroughly familiar with the emblematic tradition.[10] At several points he attributed his inspiration to becoming a portraitist to seeing the large full-length emblematic portrait of Charles Calvert, Fifth Lord Baltimore (fig. 3.3), now attributed to the Dutch artist Herman Van der Myn, which in the eighteenth century hung in the Annapolis State House. One can see this emblematic portrait as the distant ancestor (reversed) of *The Artist in His Museum*. The figure stands before the elegantly raised drapery with his baton of authority gesturing into the background, at his back a covered table, and beyond that an Indian with bow. The deep space defines a coastline with ships on the horizon, standing for the maritime present of the colony, while the Indian defines the interior wilderness and savage past of America. The middle

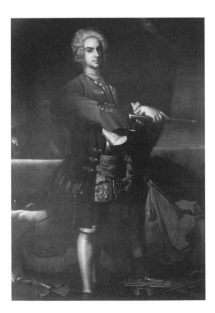

Figure 3.3 Herman van der Myn, *Charles Calvert, Fifth Lord Baltimore*, c. 1730. Oil on canvas, 106 × 67⅛ inches. The Peale Museum, Baltimore City Life Museums.

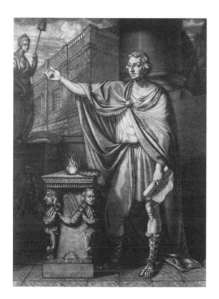

Figure 3.4 Charles Willson Peale, "Worthy of Liberty, Mr. Pitt scorns to invade the Liberties of other People." Mezzotint by C. W. Peale, on laid paper, 22⅞ × 14¾ inches. Published London, c. 1768. Courtesy of the Winterthur Museum.

third of the canvas groups together emblems of colonial authority and the white man's aristocratic power: his hat, his sword, the gathered flags, his elegant embroidered waistcoat echoed in the embroidered Baltimore heraldic device on the figured drapery of the table. On the floor at his feet, by contrast, we find what seem to be images of Indian authority—a shield, arrows, and a ceremonial sword. Political and social power relations are thus defined by the spatial location of particular emblematic elements grouped in an intellectually coherent though arbitrary order around the controlling figure.

If this public image offered to Peale one noble example of the possibilities of the grand style of emblematic portraiture, his two years in England offered him the opportunity to study other emblematic portraits, to know Joshua Reynolds and see his work in that vein and to hear him argue, at least informally, for the grand style, which meant for Reynolds, as it did for others, adaptation and imitation of classical elements and drawing upon the emblematic tradition.[11] The consequences of this became clear when Peale returned to America in March 1769 with his most traditional effort at an emblematic portrait: the large eight-by-five-foot oil painting and the mezzotint engraved version of a portrait of William Pitt (fig. 3.4).

The Whig Parliamentary leader and spokesman for the colonial cause had not had time to pose for the American, who had been commissioned by Edmund Jenings to paint Pitt's portrait for the gentlemen of Westmoreland County, Virginia; and Peale chose to depict him not in contemporary dress, as William Hoare had done, nor in the robes of state, as Copley and West would

later do in their death scenes of the Earl of Chatham. Instead Peale drew upon Joseph Wilton's statue of Pitt dressed as a Roman, in toga and tunic, and surrounded Pitt with a wealth of emblems to locate him politically for his American audience as the spokesman for colonial liberties. Hoping to achieve fame and financial reward for the painting, he completed in London the mezzotint engraving of the large work to bring home with him and struck off at the same time a broadside to accompany the mezzotint. "The Principal Figure," the broadside explained, "is that of Mr. Pitt, in a Consular Habit, speaking in Defense of the Claims of the American Colonies, on the Principles of the British Constitution." [12] It went on to point to verbal elements in the work—the Magna Carta in Pitt's hand, the banner placed between the heads of Sir Philip Sydney and Hampden (whom he identified) on the sacred altar of liberty, which reads "Sanctus Amor Patriae Dat Animum" (The sacred love of one's country gives spirit)—and to supplement these, as emblematists frequently did, with quotations from other intellectually related sources (in this case, from Montesquieu). The view of Whitehall, an elegant architectural backdrop (traditional in such portraiture), is identified in the broadside for its political relevance to the emblematic program. He further identifies and explicates complex emblematic groupings like that of the shadowy Indian—we recall the Calvert portrait's use of the Indian—sitting beneath the statue of a British Liberty with Phrygian cap, who is "trampling under Foot the Petition of the Congress at New-York." "An Indian is placed on the Pedestal, in an erect Posture, with an attentive Countenance, watching, as America has done for Five Years past, the extraordinary Motions of the British Senate—He listens to the Orator,[13] and has a Bow in his Hand, and a Dog by his Side, to shew the natural *Faithfulness and Firmness of America.*"

The interplay of word and image within the portrait, and of broadside and picture more fully, make this a rich emblematic commentary on the current political crisis. As an independent work of art, the painting and its mezzotint must be judged awkward performances, spatially crowded and rhetorically stilted. The existence of the elaborate broadside guide to the work suggests Peale's didactic intention in assisting his potential audience to read the emblematic program. Sales of the mezzotint were small, despite the political appeal of Pitt and Peale's emblematic clarity. He did, however, complete a second version of the large-scale portrait for the sophisticated politicians of the Annapolis State House.[14]

Peale's 1770 portrait of his friend John Beale Bordley (fig. 3.5) suggests both his persistence in the emblematic mode and his sensitivity to his native American context. It was a sequel to the Pitt portrait intended for the same patron, Edmund Jenings, almost as large (84½ by 58½ inches), similar in structure, with the figure gesturing toward the statue that holds the Phrygian Liberty cap

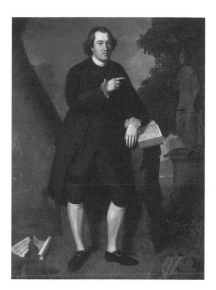

Figure 3.5 Charles Willson Peale, *John Beale Bordley*, 1770. Oil on canvas, 84½ × 58½ inches. Copyright 1997 Board of Trustees, National Gallery of Art, Washington, D.C., gift of the Barra Foundation, Inc.

and in this case also the scale of justice. Where Pitt holds the Magna Carta, Bordley leans on the book which notes in Latin that the laws of England have been changed, and at his feet is a ripped sheet with the legible inscription "Imperial Civil/Law—Summary/Proceeding," an angry counterpart of the Pitt, where Liberty tramples underfoot the petition of the Congress at New York. But the contrasts are equally striking. A curving tree trunk replaces the Doric column of the Pitt, and the setting is rural America rather than urban London or Rome, for Bordley represented the agricultural gentry of a prosperous America. His "altar" is a large rock, and the peach tree, the house under construction in the background (Bordley's own, at Wye Island on Maryland's Eastern Shore, was of a different construction), the sheep and pack driver—all thus emblematize the rural wealth of America now in danger of forfeiture by British colonial policy.[15]

Peale even took care that in fulfilling his patron's desire for native American material, he would give it a function that went beyond the merely topographical. He placed a flowering jimson weed—named, he writes Jenings, "from Jamestown (Virginia), where they were found in abundance on the first settling of that place"—at the foot of the statue, mentioning to Jenings that it was known to cause madness and violent death to those who eat it. As Charles Sellers rightly emphasizes, such a choice is no accident but "a warning similar to the rattlesnake's banner 'Don't tread on me,' . . . that to devour the American plant [itself a visual pun on plantation?] will lead to madness and death." In the jimson weed, the historical past becomes present, and American natural history is

turned to political purposes. Peale had learned well the emblematic mode of portraiture. From copying Old World usages he began to refashion it partially to native American purposes.[16] In *The Artist in His Museum* some fifty years later he would set a similar gesturing figure into a context that would, by the canons of Reynoldsian imitation, combine the beauties of nature, which the Bordley portrait emphasized, with those of art—an art freed from the directly imitative neoclassicism of statues and columns and altars and togas. The exterior of Whitehall would be exchanged for the interior of Independence Hall, but the mode of relating the component parts of the picture would still be essentially that of the emblematic portraiture he had learned as a young man.

In the years after 1770 Peale's portraits were often less complex, and there was less demand for full-scale emblematic portraits.[17] The outlet for his emblematic inclination lay more especially in a range of patriotic purposes. The political and military struggles of the war for independence had their conceptual and aesthetic counterpart in a national search for an adequate system to express and propagandize the emerging United States of America. In his later autobiography Peale noticed that as early as 1765 he had helped to make "emblematical ensigns" as a part of the Newburyport, Massachusetts, public protest against the Stamp Act, and in 1775 he was called upon to design an emblematic flag for the Baltimore Independent Company as the colonies prepared for war.[18] In the later years of the war, Peale made frequent emblematic contributions to the development and popularization of a national public iconography, and this persisted after the war as well.

Peale's repeated excursions into the emblematic for political purposes— sometimes relatively simple transparent paintings, sometimes elaborate programs on triumphal arches, theatrical performances for Washington's procession northward toward his inauguration, or other kinds of emblematic displays— have been amply documented,[19] but the importance of these activities needs clarifying. In the first place, they remind us that artistic activity in the eighteenth century was by no means limited to what we now call the "fine arts" of painting, sculpture, and architecture. English court masques from the time of Inigo Jones on, Dresden court parades, waterworks and fireworks, like those for which Handel wrote music, and the arrangement of gardens at Stowe, Stourhead, and Versailles typically drew upon the emblem tradition and the leading artists of the day to shape and execute their vision.[20]

In the second place, Peale's efforts were part of a search for American national emblems, an aesthetic contribution to a process of national self-definition that involved the reinterpretation and adaptation of traditional emblems and the creation of new ones to define the emerging nation. Finally, if the emblematic tradition had its origins in a sophisticated courtly tradition, clearly in the eigh-

teenth century and perhaps especially, though by no means exclusively, in Peale's America, it had been translated as well into popular terms for a larger audience. The emblematic could be found in cartoons and broadsides, on currency and newspaper mastheads, as well as in portraits, on the pediments of public buildings, and in collections of poetry and prose from Ben Franklin's broadsides to Joel Barlow's *Columbiad*. Although scholars of American art history have tended to emphasize the native (that is, realistic, hard, linear) qualities of American art, it seems clear that the larger American audience during Peale's lifetime was also more or less familiar with reading experience emblematically.[21] Thus to read these works in emblematic ways is not a hermetic and anachronistic mode of analysis imposed upon the works but a recapturing of the late eighteenth- and early nineteenth-century cognitive modes that Peale shared with his patrons, whether gentlemen or the wider republican audience he increasingly sought.

Peale was of course not alone as a practitioner of emblematic portraiture; and of all the American national heroes subject to emblematic treatment, surely George Washington is the most important. The decades after his death saw an outpouring of graphic mourning pictures, apotheoses, and statues, from Canova's ill-fated North Carolina likeness to the notorious Horatio Greenough Olympian *Washington* for the national capitol. Peale had five separate sittings with Washington from 1772 to 1795. In most of the works produced out of these opportunities the background is empty or a simple landscape, without curtains, columns, and other conventional accessories. But the 1779 sitting clearly resulted in an emblematic portrait (fig. 3.6). Peale the designer here drapes the fallen Hessian flags of Trenton to the right, the British flags of Princeton to the left, a version of the American flag in the sky above, two cannons emphasizing the two battles. The raw landscape contains a train of marching prisoners and barren trees—not only, one suspects, a realistic temporal clue but an emotional statement from Peale, who hated war and conflict and searched always for harmony. Nassau Hall stands on the horizon—again, not only as an index of location but as an image of the seat of learning that could produce intellectual harmony.[22]

This public portrait, though commissioned for the chamber of the Supreme Executive Council of Pennsylvania, spent most of its early years in Peale's possession, in the 1780s in his first portrait gallery on Lombard Street. After 1802, when Peale moved into the old State House, the portrait remained there (even though the government had removed to Harrisburg) on one of the end walls of the Long Room next to the equally large-scale 1779 emblematic portrait of Conrad Alexander Gérard, the French minister to America, with its statues of America and France entwined in flowers.[23] These portraits are not visible in

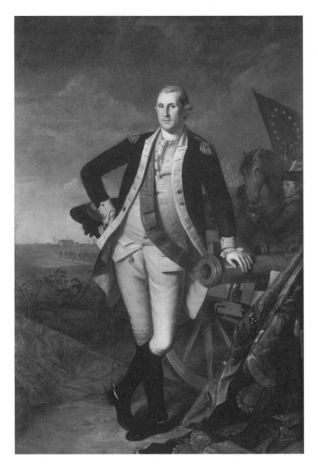

Figure 3.6 Charles Willson Peale, *George Washington at Princeton,* 1779. Oil on canvas, 94 × 59 inches. Courtesy of the Pennsylvania Academy of the Fine Arts, Philadelphia, gift of Maria McKean Allen and Phebe Warren Downes through the bequest of their mother, Elizabeth Wharton McKean.

either Titian's sketch or the finished canvas of *The Artist in His Museum.* Their absence suggests that they had been crowded out of the Long Room by the ever-present need for more space for newly acquired objects in the museum, or else that Peale chose to "remove" them from the wall in the final picture, perhaps to avoid their drawing the viewer's attention too clearly or forcefully to that perspectival focal point or to avoid their competing as separate emblematic statements within the total pattern of the picture. A third, equally intriguing, possibility is that these large portraits are hung at the other end of the Long Room, that is, behind where we as viewers are standing. We cannot finally know Peale's reasoning on this particular issue, in the absence of documentary evidence, but we can point to the several grounds here upon which Peale's choice to exclude *Washington* and *Gérard* might be based, grounds that clearly did shape his decisions more generally in this picture: historical (the "actual" situa-

tion of the Long Room in 1822), pictorial (the formal need to create a coherent, visually satisfying design), emblematic (the relation of parts to a total program of meaning), and epistemological (the relation of the viewer outside to the view within the canvas).

The portraits that are visible on the walls in *The Artist in His Museum* are not large-scale emblematic portraits of the type we have been discussing but head-and-shoulders works, mostly without background, in what came to be the standard museum format of about 22 by 19 inches, mounted in uniform oval gilt frames. The design within Peale's Museum in his 1822 self-portrait lay not in the isolated significance of individual portraits but in the pattern of the whole, in the use of the portraits within a total program, in the role they play in bringing "into public view the beauties of Nature and art." In *The Artist in His Museum* individual heads are not recognizable, though it seems likely that the military one closest to us, in the upper left-hand corner, is that of Baron de Kalb. If so, this is particularly appropriate, for Peale's portrait collection began, in at least one version of the history of the museum, with the Kalb portrait, completed only two months before his death after the battle of Camden in 1780. The argument about the function of the object to denote the museum's origin is reinforced spatially by the placement directly below him, in the vertical strip of the doorway under the eagle, of another such object, the Allegheny Paddlefish, with its inscription: "With this article the Museum commenced, June 1784." As Peale's portrait gallery of the 1780s expanded into the more comprehensive museum housed in the State House, the portraits came to function as instances of measuring past and present military heroism, public and private merit—in politics, natural philosophy, and even longevity (age itself as a human merit and standard). The collection focused primarily on national figures, but because Peale was an international *philosophe* in attitude, it included as well some French and German heroes, such as Lafayette, Baron Cuvier, and Alexander von Humboldt. Peale's printed guides to the paintings offered biographical précis with pointed indications of the public merit and moral character of these individuals, and the collection thus becomes a visual expression of the age's concern with biography.[24]

The emblematic tradition within which Peale frequently worked thus needs to be seen not as an occasional aberration or an unfortunate European heritage that sometimes tainted his "Americanness" as an artist, but as a substantial part of Peale and his generation's way of seeing and knowing, their cognitive equipment and their way of visually and verbally shaping their understanding of their universe. During the 1820s Peale had a renewed interest in painting self-portraits: In three half-lengths he shows himself with a palette or brush "in the character of a painter," in another with a mastodon bone as a public lecturer.

The commission to do the large-scale *Artist in His Museum* produced initially and rapidly another half-length in which he tried out in a preliminary way his unusual scheme for backlighting the head.[25] The task, in the final work, was to fill in the space behind, to articulate in the painting with the emblematic mode fully at his command the meaning of the museum.

"The Beauties of Nature"

The history of Peale's Museum, the growth of its collection, its absorption of Peale's energies to the point where he abandoned painting almost completely during the years 1798–1804, and the connection of the activities and achievements of the museum to those of other institutions and individuals, cooperatively and competitively, is a story that has often been told. Similarly, the strains and tensions between the museum's scientific and didactic purposes or between the Peales' roles as curators and cataloguers and their roles as artists and promoter-showmen—these also are are well known. What must concern us here is the significance of the elements Peale selected from that long and complex story for inclusion within the picture, so that we may understand how his choices function to make the design of *The Artist in His Museum* "expressive."

One choice, implied in the commission, is so obvious as to be easily overlooked: Peale's decision to show "the beauties of Nature" indoors, within the museum walls, rather than in their original outdoor setting. In this painting Peale has studiously eliminated the exterior world, not only by enclosing us within the perspective lines of the Long Room but by arranging what we do see to reinforce that sense of enclosure. The turkey from the Long expedition is, we have noted, limp and dead, awaiting taxidermic transformation into a piece of museum statuary. The cases along the left wall offer us views of other birds; they barely give us a glimpse of the natural setting that the Peales painted on the walls of those cases to locate the birds and animals within their habitats for the museum visitor.

Clearly this was a choice; Peale's interest in "Nature" was not confined to its role within the museum. A number of his portraits had included landscape settings. During his 1801 boat trip up the Hudson in search of the mastodon bones he had excitedly sketched view after watercolor view of the passing scenery as the boat moved toward Newburgh,[26] and the key pictorial record of that venture, the 1806–08 "Mammoth Picture," was a painting with an outdoor setting. As he approached his official retirement in 1810, he purchased land in the suburbs of Philadelphia near Germantown and created "Farm Persevere," later "Belfield." Here he not only carried on agricultural experiments in consultation with Thomas Jefferson and other gentleman farmers and scientific agriculturists but also, like Jefferson at Monticello, laid out an elaborate emblematic garden

with statues, walkways, grottoes, and pedestals with appropriate mottoes—a complex program modeled upon English gardens of the first half of the eighteenth century. Belfield is important in our present context because Peale consciously eliminated it from *The Artist in His Museum*. In Titian's sketch, Peale's Belfield landscapes are clearly visible in the right foreground, but these emblems of his life of rural retirement have been excluded from the final work, their place taken by the table, the curtain, and the skeleton of the mastodon.[27]

Comparison of the preliminary watercolor (see fig. 3.2) with the final painting (see fig. 3.1) makes clear that Peale has redesigned the exhibition space of the Long Room for pictorial purposes. He has preserved the regularity of his perspective lines on the left, even though he has opened them up at the base. But instead of contrasting these to the predominantly vertical lines and illuminated box forms of the outside window wall on the right, as we see them recorded in the watercolor, he has draped the curtain on that side, confining the strong light primarily to the area in front of the curtain and filling in the lower half of the foreground with the pile of bones and the table. Behind them stands the skeleton of the mastodon, with the intertwined heads of the llama, deer, and other quadrupeds vaguely visible between the mastodon's legs. In thus arranging his material, he gave up the possibility of juxtaposing the more purely geometrical and rectilinear design of the museum to the soft curves of the black-dressed central figure of himself, and offers us instead in the museum space a counterpoint of light-gridded pattern on the left and the dark and murky irregular shapes on the right.

The overall patterning is reinforced by his sensitive treatment of color and detail. The deep red of the damask curtain is brighter in intensity on the left side, and the gold-fringed bottom of the curtain is confined also to the left half, where it is carefully related in hue and placement to the band of gilt that frames the two rows of portraits. Indeed, the little decorative band that separates the portraits from the four rows of bird cases below is a stylized gold and red fan pattern, which specifically echoes in two dimensions both the red and gold color and the lacy pattern of the curtain and its fringe. The other strong gold note in the picture is the Quaker lady, placed directly under the vertical line from which hangs a golden gas lamp. Color links her with the left side, though her hands are raised in a gesture of wonder at the vision across the room. She is looking at the mastodon.

Peale controls the viewer's perceptual experience by reorganizing the museum space. Through the conceptual patterning, the emblematic significance of the two sides of the picture, he found an appropriate pictorial language for expressing the meaning of the museum. This was indeed part of an ongoing process for Peale, and by no means an isolated pictorial problem. There is

considerable evidence that over the years, in the constant arrangement and re-arrangement of the museum from one location to another and as new materials were added, Peale was especially sensitive to spatial arrangement as a mode of shaping meaning and—equally important—the visitor's perception of meaning. He took pride in the "elegant appearance" of the Long Room, the rows of gilt-framed portraits, the cases "neat without being gaudy," the framed catalogue, which "makes a beautiful division" of the shelves from end to end of the room.[28]

The significance of his aesthetic pride comes clear in his introductory lecture on natural history of 1799. He contrasts the modern awareness of the earth with that of the ancients, who "had to remember all creation as it were in a Mass; jumbled together." The modern mind, in possessing a system of classification and arrangement, gains "possession of the master key of a grand Pallace by which we can step into each of the apartments, and open any of the Cabinets, to become acquainted with their contents."[29] Peale's architectural metaphor here is not merely decorative. The linguistic equation of mental processes with spatial arrangement is a central clue to reading the architectural arrangement of Peale's Museum and its crystallization eventually in *The Artist in His Museum*. It is Peale's mode of using space as a language to replicate the parity he believed to exist between the order of the natural universe and that at least potentially within the human mind itself.

Hence the importance of reading the museum not merely as a collection of objects but as shaped space. Others have emphasized Peale's sense of pictorial design in the museum. Sellers links the museum to Peale's interest in moving pictures—"a new kind of painting," in Peale's words. We may note that Peale's placement not only of identifying labels but of discursive statements, mottoes, and biblical injunctions at strategic points again bespeaks the visual-verbal em-blematic habit. The words not only label or duplicate the visual; they offer a running counterpoint, and the musical metaphor becomes literal in the organ concerts held regularly in the Long Room or the anthems that became part of even the printed version of Peale's lectures, for the aim of learning is the recog-nition of the harmony of the universe. Even the 1802 admission ticket to the museum had an arrangement of birds on the left side, an American bison to the right, the paddlefish and crustaceans at the base and at the top, and, in the middle of a sunburst that looks back to centuries of pictorial icons of Deity, the open book, plainly inscribed "Nature," with a scroll below: "explore the won-drous work."[30]

When Peale reopened the museum in its earlier Lombard Street location in the fall of 1797 after a recurrence of the yellow fever epidemic in Philadelphia, he tried to reassure potential visitors of the salubrious location of the spot and emphasized how "the works of Nature" were "so well calculated to delight the

mind and enlarge the understanding," as if these mental processes were needed, implicitly, as a bulwark against the irrational assault of diseased Nature.[31] Three years later, at the University of Pennsylvania, in his introductory lecture to a series entitled "The Science of Nature," he makes clear that the museum's purpose is "that of manifesting by those works the goodness and wisdom of the Creator, in making every being in the best form to ensure its happiness, obtaining its support, with its connections and dependence toward the support of other beings;—In short, to display by visible objects the harmony of the universe."

Peale's teleological premises were, of course, not his alone but shared with his generation and all those who believed in the great chain of being. Not only do individual works give evidence of a benevolent creative power. We behold them in their interconnectedness, and that is made known to our consciousness not by an act of faith but through God's—and after Him, Peale's—"displaying" them to us.[32] The elements of the design of both the museum and its avatar, the 1822 painting, are already there in his suppositions of 1800. The Long Room itself extended some hundred feet across the front of the State House, located at the spatial center of the urban civic core of Philadelphia, an experiential index of its conceptual centrality to human life. Within the museum the arrangement was to be governed by the need to order human perception and understanding. The epistemological model is Lockean. The Creator is known not through innate ideas or through faith, but through the mind's rational processing of the sensory data of visible objects presented in such a way as to ensure clear discrimination of the signs, without confusion or distraction.

Finally, as many have pointed out, Peale's insistence that the objects be "classically arranged" is his clue that the ordering principle is that of Linnaean biology. He acknowledged that indebtedness again and again in his lectures. Linnaeus (1707–78) had "opened the book of nature to a wondering world" and had traveled "to acquire knowledge, that knowledge be defused into classical arrangement, which will be admired for ages," as he put it in 1813.[33] The arrangement is Linnaean "not because I have chosen it, but because the world has proved that Linnaeus had judiciously adopted it."[34] The order exists in the world, it is not imposed upon it. Linnaeus's classificatory system of orders and genuses, the classes of creation, is, in Peale's estimation, an observation and ordering of the truth of the visible universe. Lockean empiricism posited the reality of the phenomenal world, that things are not merely outward signs of the noumenal, or manifestations of the essential; but Lockean epistemology had also located the problem of knowing within the human mind, that tabula rasa registering and ordering the sensory data, "simple ideas," which it received from the visible universe.

Linnaeus's Lockean premises are clear in the introduction of his *Systema*

Naturae: Man "is able to reason justly upon whatever discovers itself to his sense; and to look with reverence and wonder, upon the works of Him who created all things."[35] "Sense" is the organ of perception; reason the discriminating power of the mind to sort and judge. The object in nature "discovers itself"— that is, it makes itself available through the senses—to that perceiving and reasoning mind which, once it has performed those acts, may "look with reverence and wonder, upon the works of Him who created all things."[36] One must insist upon the specific dynamics of the Lockean epistemology here because it is ultimately recapitulated in Peale's *Artist in His Museum* in the tiny figures in the background. The man sees, as the birds in the cases discover themselves to his sense; the father and son with a book reason justly upon the significance of the arrangement visually available in the cases and verbally ordered in rational sequences in the catalogue in the child's hand, while the lady closest to us stands with hands raised in a gesture of wonder (her Quaker religion implies the "reverence"). The visual sign system in the picture is an exact replication of the underlying Lockean/Linnaean epistemology.

Linnaeus's statement had gone on to make even clearer the theological implication: "That existence is surely contemptible, which regards only the gratification of instinctive wants, and the preservation of a body made to perish." Mere sensory stimulation was not enough, though the emphasis is not on the traditional body-soul split but on the decay of nature. Linnaeus concludes: "It is therefore the business of a thinking being to look forward to the purposes of all things; and to remember that the end of creation is, that God may be glorified in all his works." No Westminster catechism here, no decision, as Thoreau was to wryly put it, that men "have somewhat hastily concluded that it is the chief end of man here to 'glorify God and enjoy him forever.'"[37] The point of empiricism was not transcendence out of the natural world; it was circular, to know God through his works.[38]

In the 1799 lecture Peale recorded for his audience a moment in his own experience that reinforces the point in these Lockean religious terms: "Never shall I forget my disagreeable sensations, when a naturalist, my friend, demanded of me, why I called a toad, ugly?—My conscience instantly smote me for presuming to depreciate the works of *Divine Wisdom;* and from that moment became convinced, that everything is beautiful in its kind; and I have now a continued pleasure in the contemplation of many things which once appeared disgusting and terrible to me."[39] This is no ecstatic moment, no mystical awakening as a transparent eyeball, no transcendental longing of the moth for the star. Its closest analogue is not Emerson or Kant or Poe but Jonathan Edwards in his description of the effects of grace as a "new sense" upon the Lockean self in his "Personal Narrative": "After this my sense of divine things gradually in-

creased . . . the appearance of every thing was altered. . . . And scarce any thing, among all the works of nature, was so sweet to me as thunder and lightning; formerly, nothing had been so terrible to me."[40] Edward's sense of deity is more direct and powerful, and Peale's more mediated, but it is a matter of the degree to which the movement from sense to understanding leads on to passionate feeling within a common set of Lockean premises, not of kind. They share the perceptual recognition of the order of God's universe, the recording of feelings that move from disgust and terror to delight and pleasure in contemplation, from the perceptual to the conceptual and thence to an aesthetic recognition of the order and beauty of the visible creation. For Peale and his Quaker lady, this recognition has an aesthetic label not part of Edward's theological vocabulary. It is the perception of "the sublime."

But the perception of the sublime, located in the vision of the mastodon on the right side of the painting, can be fully understood only in the context of its counterpart in the beautiful order, "classically arranged," on the left-hand side behind the Quaker lady. Peale's usage of *classical* may seem at first rather odd to our ear, since the cases, portraits, and even the bench are notably lacking in pediments, triglyphs, Ionic pilasters, and the like, though such were the decor of the Assembly Room below, where the Declaration of Independence was signed.[41] Peale is using the term adjectivally in a strict scientific sense, as pertaining to *classus*, the Linnaean mode of identifying objects through their relationships to others of a similar kind, according to sexual differentiation and observable characteristics. Linnaeus's approach was empiricist, dependent upon clear seeing; but it was also based upon a static conception of the universe rather than a dynamic one. Linnaeus had regularized the species empirically into clearer groupings, though the idea of a fixed number of species, unvaried since the Creation, none added, none disappearing, goes back to Aristotle and was part of the heritage of eighteenth-century classifiers and theorists of species, in America as well as in Europe. In this sense, one may say that Peale's notion of "classical" arrangement has not completely lost its ancient Greek connotations.[42] Furthermore, insofar as "classical" is not aesthetically merely a matter of decorative orders but of an attitude toward space, an emphasis on harmonious proportion and balance, then this idea, especially in its Renaissance revival through vanishing point perspective, is clearly operative in the Peale Museum and the Peale picture, from the initial work of his "drawing machine" in the watercolor sketch of the room to its remaining elements in the final painting, especially in the deep perspective space to the left.

The regularity of the perspectival system on the left frames the cases of birds, visibly arranged in their Linnaean classes, thus pulling together the several senses of the term *classical.* Although only vaguely sketched in the painting, the

progression is readable to the viewer in the painting as well as in Titian's sketch: from the top rank of raptors (the vultures, hawks, owls—signalized for us in the eagle), to the colorful songbirds in the second rank, and on down to the ducks and the penguins and pelicans of the lower orders of birds on the bottom rank. In the museum, as we have earlier noted, the cases were distinguished with descriptive labels through a numbering system keyed to a printed guidebook (apparently largely ignored by most visitors). Brief perceptual recognition of the forms, taxonomic identification, is not enough; one needs a "closer view" (which obviously its static position in a museum case affords) that allows us to see and to understand the telos of each creature and its place in the great chain of being—its location in the grid of museum space.

Most of the birds are simply too small or too sketchily painted to operate for the viewer as individual emblems leading us through perception "to lift up our hearts and minds in love and admiration to the great first cause."[43] Surely the problem of scale (in this second, more particular sense) was itself one reason why Peale eliminated the cases on the opposite wall from the final picture. The minerals and fossils and insects required at certain points mounted microscopes to see and hence to understand their significance, and if the "great scale of Nature" needs to be perceived from the lowest to the highest order, from the fossil past to the available present, from the tiniest insect to the largest carnivore, the painter who operates within these Lockean premises has still to define these relationships and make available their meanings within the visual capacities of paint on canvas and the perceptual capacities of the human viewer.

Peale's recognition of this restriction is available to us in his softened focus on some of the objects and his highlighting of others. The natural order of the birds is also knowable to us through his representative selection of the turkey boldly placed in the left foreground. The turkey, as a western expedition specimen, extends our understanding in complex ways. Alive it had roamed the woods, dead it will be aesthetically transformed, reborn through the magic and restored through the science of taxidermy, and funneled from the open space of our world into its place within the beautiful grid of the Linnaean system. But clearly the American wild turkey had further significance as Peale's 1822 choice for the avatar of the Linnaean world. It was already a national emblem, a clear alternative to the bald eagle placed conspicuously directly above it. Franklin, as is well known, preferred it to the rapacious eagle as the national bird; and there may be an unconscious irony, in the "great scale of Nature," in placing above the raptors portraits of *Homo sapiens*—many of whom are military heroes. But the turkey was already identified with American rural experience. One year after the paintings, Fenimore Cooper would make the traditional "turkey shoot" an important scene in the Christmas festivities of Templeton in *The Pioneers*. In 1825 Titian's

drawing of the turkey, which he had brought to his father's museum, was engraved for inclusion in the Charles Lucien Bonaparte supplement to Alexander Wilson's *American Ornithology,* published in the same year. John James Audubon, who had also worked briefly on the Bonaparte supplement, went to Florida, where it is likely his own original painting of the wild turkey was completed. By the middle of 1826 Audubon was in England to arrange for the printing of his greatest contribution to American natural history and American nationalism, the elephant folio *Birds of America.* Audubon chose for the first plate of this serial publication the wild turkey and sent the first group of five plates to his wife in the United States in March 1827.[44] The point is clear enough: Charles Willson Peale's emblematic choice of the turkey in *The Artist in His Museum* was part of a nationalistic celebration of the vitality of the American wilderness.

Unlike the eagle placed above, which is assertive if not quite defiant, the turkey is not yet hierarchically posed within the painting. But even bowed in death, awaiting transformation, as an American species with rich connotations identifying it with American experience, it functions within the picture as part of the American nationalist's response to Buffon and those European naturalists who had underestimated North America's contributions to natural history, some in fact arguing that species degenerated in scale and longevity in the New World. The nationalistic argument in terms of species is well known. It was articulated and documented in the learned journals of the day; Jefferson had argued it in his 1785 *Notes on Virginia;* Peale's notes and lectures on natural history, including the "Walk with a Friend," contain many passages contradicting Buffon's charges. Indeed, the argument was sufficiently well known that Washington Irving had used it as deadpan humor in the introductory chapter of *The Sketch Book* (1819).[45] One must not overstate Peale's own position. He was an internationalist, not a narrow or strident nationalist, and the museum included portraits of Humboldt, Cuvier, and Buffon, and specimens from the whole world. But the harmony of the universe that he sought obviously could not be understood by ignoring the special contributions of the new nation and the old earth of this hemisphere.

All of which points us inevitably toward the mastodon on the right side of *The Artist in His Museum,* which clarifies this argument in important ways. The jawbone and leaning leg bone in the right foreground pictorially balance the turkey to the left. They offer us an initial emblematic comparison—of the American past to the American present, a movement from the "beautiful" order of the classically lit cabinets and portraits to the dark and obscure "sublime" of the prehistoric past. Two highlights fall on the teeth of the jawbone and on the painter's palette, to which the leg bone directs our vision, and beyond the partially visible

mounted skeleton of the mastodon (itself a work of nature completed by art, the missing bones having been carved of wood by William Rush) we can make out a llama, a deer, an elk, and a bear dimly visible between the legs.[46]

The function of the jawbone to the scientific community was clear. Osteological evidence had led Cuvier to define the American find as a "mastodonte," a prehistoric ruminant (like the deer and llama of the present?) rather than a carnivore, as Peale and others had originally thought.[47] Thus the bones locate meaning scientifically, temporally, nationally, and spatially within the picture.

Verbal evidence about the mastodon is scattered throughout the Peale papers. Peale's first exposure to the bones had been as Philadelphia artist, commissioned in 1783 to make drawings of the Morgan collection of bones for the visiting German physician Charles Frederick Michaelis. These drawings include one of a jawbone that Cuvier studied and reproduced in his 1806 *Annales.*[48] This experience has frequently been cited as another germ of Peale's Museum, and thus its appropriate foreground place in a painting depicting the "rise and progress" of the museum, with the palette placed strategically above. Among the wealth of verbal materials on the mastodon we may single out here the most complete account, Rembrandt Peale's *Historical Disquisition on the Mammoth, or Great American Incognitum,* published in London in 1803 when Peale's son was exhibiting there one of the two skeletons they had exhumed in the previous two years. Rembrandt's ninety-page pamphlet was available, for sale and in framed cases on the wall of the museum for all to read (if they had the energy!) while gazing in wonder at the original evidence. The pamphlet was dedicated to his father, who had placed the "Mammoth—the first of American animals, in the first of American Museums."

Rembrandt emphasized at the outset the violent agitation of the earth's surface and quoted Cuvier at length on the contrast between the order of present nature and the disorder and confusion of the fossil past: "These traces of desolation have always acted on the human mind." For Cuvier as well as for the Americans, it was not merely the facts but their effects upon the perceiving consciousness that were at issue. Rembrandt quoted, with obvious nationalistic relish, Buffon's earlier allusion to the "pretended MAMMOTH, a fabulous animal, supposed to inhabit the regions of the north where are frequently found bones, teeth, and tusks resembling those of the elephant," and then went on to point out Buffon's "several errors." To the abbé's distress at the idea that any race might become extinct, Rembrandt countered that "we are forced to submit to concurring facts as the voice of God—the bones exist—the animals do not!" He identified the word *mammoth* explicitly with the American finds "as a term well appropriate to express its quality of supereminent magnitude," and told his readers of the skeleton in the Philadelphia Museum, "where it will remain a

monument, not only of stupendous creation, and some wonderful revelation in nature, but of the scientific zeal, and indefatigable perseverance, of a man from whose private exertions a museum has been founded, surpassed by few in Europe, and likely to become a national establishment, on the most liberal plan." Taxonomy bends before the perception of sublime creation, the bones are identified with his father's scientific zeal, and both linked to the museum as an American national achievement.[49]

The *Disquisition* moves on to describe narratively the exhumation of the bones, and then to engage questions of theory and comparative evidence, and ends by moving from scientific discourse to the legendary American Indian traditions concerning the mastodon. Fact gives way to myth, rational osteological discrimination to the sublime rhetoric of the Indian orators in the American wilderness. Noting that another form of Indian legend could be found in Jefferson's *Notes on Virginia,* Rembrandt concludes that whatever caused the destruction of the species also destroyed "those inhabitants from whom there might have been transmitted some satisfactory account of these stupendous beings, which at all times must have filled the human mind with surprise and wonder."[50] Our background figures in *The Artist in His Museum* thus do more than replicate Lockean epistemology; they form part of the drama of historic time: the man examines the present directly, the father and son study the past through the achievement of a written system of classification, the Quaker lady reexperiences in the museum the "surprise and wonder" felt by those who lived in the prehistoric past.

One further visual-verbal constellation is needed to understand fully the place and function of the mastodon within the 1822 painting, and that is Peale's earlier pictorial celebration of the great event that brought it to the museum. The 1806–08 "Mammoth Picture," as Peale himself referred to it, is well known today as *The Exhumation of the Mastodon* (fig. 3.7). The work is familiar to students of American art and American culture more generally, though it is hard to categorize, for it is at one and the same time a history painting commemorating a great American event; a realistic genre piece of the digging up of the bones from John Masten's marl pit, with accurate depictions of the apparatus and the process, including such details as the tempting jug that held the reward to any besogged worker who came across a new bone; a group portrait of Peale's family and friends, not all of whom were there at the Masten farm (including Peale's dead second wife, Elizabeth, as well as his current third wife, Hannah); and, obviously, a landscape as well, with the threat of a thunderstorm that all feared would wipe out the scientific efforts. The work has also been perceptively discussed as a unique combination of all of these and more: a harnessing together of disparate elements to create a nontemporal unity that defines a relation between

Figure 3.7 Charles Willson Peale, *The Exhumation of the Mastodon, 1806–8*. Oil on canvas, 50 × 60½ inches. The Peale Museum, Baltimore City Life Museums.

the chain of being in nature (understood in terms of catastrophist geological theory) and in Peale's personal history (dramatized in the extended family portrait). Peale brought space and time together to create a conceptual unity of meaning.[51]

For our purposes, thus, it is important to recognize the "Mammoth Picture" as emblematic in both conception and execution. In a letter as early as 1804 Peale had described a "large historical, emblematical Picture, in which I shall introduce the Portraits of my children."[52] But it is equally important, in terms of *The Artist in His Museum,* to understand the contribution of the "Mammoth Picture" to the argument about the relation between pictorial design and natural history. If the role of the mastodon in Peale's intellectual universe and his museum was to excite wonder by its vast size, its obscure origins, its links to an earlier mythic past now disappeared, and yet at the same time to serve as a prehistoric link in the great chain of American being, it had multiple functions to perform. The American past was to be made available for the use of the present, our "heritage" in the American land clarified in this era of political experimentation. The structure and pattern of natural history were to be filled out, within which arguments about extinct versus still-existing species (as Thomas Jefferson

believed), or about Peale's "mammoths" versus Cuvier's "mastodontes," could be argued by reasonable men.

At the same time this creature offered to viewers aesthetically the experience of the sublime—clarified increasingly in the eighteenth century as a term to describe overwhelming size, indefiniteness, obscurity, and evidence of the unmediated power of deity (the Noachic origins of catastrophist geological theory ensuring the harmony here of religion and science). As Edmund Burke had redefined the aesthetic of the sublime in Lockean terms more as a psychological process of perceivers than as a quality of objects, the sublime meant the experience of awe—with security (without such a security of vantage point, awe and wonder could turn into pure fear and terror). That point had been made clearly enough by Peale's friend Jefferson in his two early statements of the sublime in the *Notes on Virginia* (1785): the excursus on the Natural Bridge and that on the passage of the Potomac through the Blue Ridge Mountains at Harpers Ferry.[53]

The great achievement of Peale's "Mammoth Picture" in these terms is the way in which it finds a pictorial design to express these very different implications of his natural history discoveries. In its place in the museum in the mammoth room, it offered answers to frequent visitors' questions about the process of the exhumation and how it was carried out. It also brought the outdoor world and the experience of "nature" indoors, as a necessarily scaled-down version of the habitat backgrounds that the Peales painted behind their other stuffed specimens. The painting organizes our understanding of nature in special ways. The dark and murky foreground puts us on the brink of the marl pit, where this recovery of the sublime past is taking place. The dark right-triangle to the lower left of the picture matches an equally dark one to the upper right, wherein the natural sublime is manifest in the present. The crack of lightning and the dark and turbulent skies (to which the second Mrs. Peale directs the attention of the child Titian) threaten the work in process, and on the hillside behind the scaffolding the two frightened horses run wild.[54]

But the central point to be made about the "Mammoth Picture" is that our experience of the natural sublime—whether of the prehistoric past in the pit below or of the vital present in the landscape beyond—is controlled and ordered by the geometric and rational design of the well-lit middle distance, which binds the dark triangles and gives constructive unity to the composition. The scattered workers of the lower left crystallize into the near frieze of the Peale family and others in a band across the far side of the pit, and the great pyramidal construction of the waterwheel organizes and grids the whole, in easily read two- and three-dimensional geometric patterns. The formal design of the canvas is Peale's way of dramatizing the triumph of human rational order

over the sublime. As Peale wrote, his brother James stands with hands out "in an action of wonder at the exploring work,"[55] but James's gesture is carefully contained within two arms and a cross support of the central pyramid and contrasts to the quiet meditation of the isolated figure of Alexander Wilson to the left in front of the regular triangular prism of the wooden equipment tent.

As these figures indicating the range of human response foreshadow the figures in *The Artist in His Museum,* so does the design of the canvas express Peale's earlier sense of how to bring the sublimity of the mastodon and our sublime experience of nature within Enlightenment rational modes of thought, how to perceive and then to reconstruct pictorially the harmony and order of the universe. Peale believed that order existed, that the bones would contribute to rather than shatter our conceptual image of the great chain of being—a chain that the buckets and wheel, with their human motive force inside, make visually manifest. (The wit of this was surely not lost on Peale, however descriptively accurate his depiction may have been of the millwright's device.)[56] In an alternative expression of catastrophist theory, Peale would copy in 1819 Charles Catton's print *Noah and His Ark*[57] as an explicitly biblical statement, emphasizing again the harmony of created beings around the patriarch (Peale the museum director was himself seventy-eight at that time) rather than the catastrophic convulsion of the deluge that had buried the mastodon in the marl pit.

What finally needs emphasizing is that Peale's sense of design is ultimately pictorial. Within the exhumation scene Peale and his artist sons Rembrandt and Raphaelle hold the life-size drawing of the bones; in a larger sense, the "Mammoth Picture" itself reduces the multiple functions of the mastodon to pictorial unity through the expressive design of a canvas of which he is at once creator and, inside it, the gesturing artist-director-scientist-entrepreneur. The lines from here to *The Artist in His Museum* are clear and direct. In their basic dynamics they are not, we may note, Peale's alone, for they echo those of his friend Jefferson in the sublime passages in the *Notes.* Jefferson had proceeded topographically from the ordered world of natural creation in Virginia to confront two sublime spectacles. Trying to bring these experiences under control, he had moved from rational statement and measurement through an agitated prose that dramatized the sudden "avulsions" of the earth under the effects of the deluge, which produce dizziness, strain, and headache upon the narrative consciousness. Order was restored through the aesthetic organization of the scene into "picture," as the eye moved from "fore-ground, . . . inviting you, as it were, from the riot and tumult roaring around, to pass through the breach and participate in the calm below. Here," says Jefferson, in that crucially ambiguous phase, "the eye ultimately composes itself."[58] As with Peale in the "Mammoth Picture," the sublime is brought under control aesthetically through ordering the landscape

and giving it pictorial design. Peale's aesthetic strategy is thus part of a shared vision.[59]

We return thus to the right side of *The Artist in His Museum* with a clearer sense of the implications of Peale's choices here: to dramatize "the sublime," by contrast to the ordered beautiful classification of the left side of the picture, as an obscure, partially glimpsed image of immensity. It is available for the wonder of the Quaker lady but only partially for us. The osteological evidence of jawbone and femur is visible in the foreground, but the fully reconstructed skeleton remains behind the half-lifted curtain under the control of the artist-director-entrepreneur of the museum. Natural history has been transformed into pictorial emblem in the new mode—not as Phrygian cap or garlanded statue or togaed gesturing figure; American natural history itself now serves emblematic purposes.

It was the function of the emblem to teach, to transform an image into an object of contemplation from which we were to learn. Peale's Museum was centrally didactic in intent. His lectures in 1799 and 1800 were part of that process. We may conclude our discussion of the role of natural history to Peale's universe and to his paintings by catching the formulation of his young colleague John Godman, Rembrandt Peale's son-in-law, who lectured at the museum in the 1820s.[60] In 1829 Godman argued thus to his audience:

> We desire, as far as practicable, to solicit your attention to the study of nature through some of her most interesting works; to excite your wishes to become acquainted with the living beings scattered in rich profusion over the earth, to call forth your admiration at the endless variety of form, the singular contrivance, the beautiful adaptation, the wonderful perfection exhibited throughout animated nature, and thence to win your observation to their habits and manners, the benefits they confer upon mankind, their relations to each other, and their subordination in the system of the universe. . . . The enlightened student of nature can never forget the omnipresence of Deity—it is everywhere before his eyes, and in his heart—obvious and palpable;—it is a consciousness, not a doctrine; a reality, not an opinion, identified with his very being, and attested to his understanding by every circumstance of his existence.[61]

Godman's lecture deserves quoting at length, because it captures dramatically the didactic impulse of the museum and the perceptual process—so alive in the progression of verbs—which it asked of visitors. From soliciting the attention to exciting the wishes to calling forth their admiration and thence to winning their observation, the language is undiluted Locke. When in the second part Godman wants to insist upon the theological function of Enlightenment

knowing, he must make clear that it is not only "before his eyes"; it is "in his heart." This is not yet the romantic triumph of heart over head, but rather an integration of knowing within the self: "a consciousness, not a doctrine." What Godman's rhetoric understands is that Lockean epistemology located the problem of knowing not in objects, however skillfully arranged and labeled and described, nor in some dogmatic credo, some "doctrine," but in consciousness itself. It is this that Jefferson was grasping for in his Harpers Ferry passage when he said that "here the eye ultimately composes itself," although his specific phrasing teeters on the edge of romantic solipsism. And it is in these terms that Peale's *Artist in His Museum* needs finally to be understood, not merely as one of the last in a long series of emblematic portraits, nor as the exemplification of a doctrine or set of ideas about American natural history as it was gathered in the museum, but as a shaping of consciousness, a way of seeing, a mode of cognition.

The Picture as Aesthetic Strategy

The Artist in His Museum calls attention to itself as a picture, and we must come to terms with this, the ultimate shape of his expressive design. In this respect also, as with its role as portrait and as a visualization of his ideas on natural history, the operative context is important. *The Artist in His Museum* is a gallery picture, a type of painting with a long tradition, especially in northern Europe, in which is depicted a room filled with works of art, with various people posed in relation to one another and to the collection of art objects. Madlyn Millner Kahr, who has documented the genre, comments, "The most obvious effect of a gallery picture is to immortalize a collection as an expression of the personality of the collector. Since many of the pictures [in the sixteenth- and seventeenth-century works she discusses], however, do not reflect real collections at all, or else take liberties with collections that existed, the artist's personality may have come into play more forcefully than the patron's."[62] As Kahr points out, these paintings were commissioned as a means of ennobling the patron and emphasizing his status as an aristocratic lover of beauty and the liberal arts, for these works and the world depicted within the painting were to be appreciated not just for their craft, as the work of artisans, but as exemplifications of the arts of the mind. The painter, in carrying out the commission, was thus associated and concomitantly "ennobled," his craft in copying and organizing the work (the *disegno externo*) put to the higher purpose of celebrating art as an expression of nobility of mind (the *disegno interno*).

The utility of this pictorial tradition to Charles Willson Peale in carrying out the commission of the Philadelphia Museum trustees should be readily apparent. On the one hand, Peale immediately saw the task as a portrait of himself in

the museum displaying its exhibits, the "beauties of Nature and art." It was the trustees' clear intent to honor the collector; to Peale it offered an opportunity to display and to elevate the status of his collection. The unity of the painting is not simply descriptive, as a realistic view of a particular place, but conceptual, a selection and reorganization of elements of the collection to create a mental image of the order and harmony of the universe as Peale understood it. Peale's palette and brush are visible on the table, and the taxidermist's box suggests the craft involved in mounting the natural specimens; but the emphasis of the picture—visually focused for us by Peale's careful backlighting of his head (an innovation in this portrait of which he was especially proud)—is on the mental harmony, the *disegno interno,* that the picture creates and emblematizes.

However, the limitations of the European tradition to the American painter are equally significant. Unlike Velázquez or Rubens and David Teniers II, Peale was not a dependent artisan seeking to ennoble his profession and himself through royal or aristocratic patronage, but a polymathic citizen seeking to engage the interests of the American public. Although institutional control of the museum had passed from Peale to a public board of trustees, Peale's patron had always been the public. Unlike his European predecessors, the painter in the picture as well as the painter of the picture was the collector and not his servant or hireling. This is clear if we compare Peale to his artistic contemporary in England, Johann Zoffany. In *Tribuna of the Uffizi* (1772–78), Zoffany wittily brought together elegant aristocratic British cognoscenti around a selection of the artistic riches of Florence and placed them all in complex relation in one gallery of the Uffizi; in *Charles Townley and his Friends* (1782) he gathered into one ideal room the classical statuary that Townley had collected for his own contemplation and for the limited pleasure of a select group of connoisseurs.[63] By contrast, Peale's efforts, in the museum and in the picture, were directed not at ennobling the collector at the expense of an envious populace but at bringing the beauties of nature and art into public view. The pictorial evidence is clear: the gesturing figure in *The Artist in His Museum* lifts the curtain and invites us in. We seem to have easy entrance into the picture.

And that carries us to the third consideration about the gallery painting and its significance for the Peale picture: It focuses our attention on Peale's links to the Dutch and Flemish tradition of northern European painting. What particular access Peale had to this special kind of painting, in originals or copies or in engraved versions, is at present not fully clear. It is clear that seventeenth-century northern paintings were available in America during Peale's lifetime and perhaps especially in the Philadelphia area. The Joseph Bonaparte collection in Bordentown, New Jersey, contained examples of Dutch and Flemish work; Robert Fulton's collection included similar work, as did other contemporary

American collections like that of Robert Gilmor, Jr. in Baltimore, and exhibitions at the Pennsylvania Academy and elsewhere within Peale's circuit. The proliferation of still-life painting among the extended Peale family (including brother James and his progeny) for several generations clearly implies a familiarity with the Dutch and Flemish tradition, and Raphaelle especially was a practitioner of trompe l'oeil or "deception" pieces in the Dutch manner. Other contemporary Philadelphia artists shared these interests. William Birch and his son Thomas, a specialist in seascapes, borrowed Dutch formulas in that mode, and in 1824 Charles Willson Peale visited the Washington studio of Charles Bird King, another practitioner of Dutch-inspired trompe l'oeil and *vanitas* still lifes, and commented on seeing there also landscapes and "emblematical" pieces. Although the story is still incomplete, the evidence of Philadelphia's familiarity with the seventeenth-century northern tradition is clear. Besides, the issue, with respect to *The Artist in His Museum,* is not of mechanical "influence" of one or more particular "sources" but of relationships of vision and affinities of intention and execution.[64]

The aim of the Peale picture, like that of the Peale Museum, was public accessibility, but accessibility of a special kind: "that the Design should be expressive that I bring forth into public view, the beauties of Nature and art, the rise and progress of the Museum." The Lockean empiricist in him was convinced that the truth of the harmony and order of the universe was available to the rational mind through the experience of sense data as these are received and ordered by consciousness. Obviously for the painter in him as well, retinal impressions were primary, the necessary means for shaping within the mind through emblem, natural classification, and aesthetic theories of the sublime and beautiful some conceptual unity of meaning. But the pictorial strategy for bringing his material "into public view" was still an open question.

Peale's answer was to make the process of seeing self-consciously part of the expressive design of the canvas, to call our attention to our visual experience, rather than to make his picture a transparent window into the universe. In this respect, his work bespeaks its especially northern rather than Italian Renaissance heritage.[65] It is true that Peale developed his picture from a perspectival drawing worked out with his "machine," which his son Titian then filled in with narrative details; but at a later stage he altered the vanishing point perspective, bending it out awkwardly (by Italian Renaissance standards) to accommodate other needs of the picture and thus calling attention to both perspective and the painting itself as pictorial constructions. When contrasted to the huge figure of the artist, the diminutive scale of the background visitors—especially when these figures are placed against the bent perspectival grid of the cases—feels exaggerated to our eyes, more like looking through an optical instrument than a di-

rect experience of the world. Clearly the "actual" dimensions of the Long Room, one hundred feet from end to end, created the problem, but there were other possible ways to compensate; Peale's solution feels particularly northern. It is true that the lines of the floorboards carry the eye from our viewer's space through the picture to the background spectators, and the blurring of objects as we look back or into the murky shadows to the right reinforces the experience of perceptual movement into deep space, but Peale cuts against this through the device of the curtain, which forces us back to the surface of the canvas and makes us aware of the picture plane.

The curtain is central to an understanding of the painting, its meaning, and its significance as an experienced art object. The curtain's function is metonymic. It has lost its simple, essentially static function in countless portraits as "drapery" on one side of the figure offering contrast of texture and a suggestion of elegance (balancing sometimes a view on the other side), and becomes instead dramatic in several senses. Peale's lifting of the curtain places him in the pictorial role of director (the visual pun was surely intentional), admitting us the audience to a show in his theater, the Peale museum. The language is precise: Peale was the theatrical entrepreneur of his museum, and a master of special effects (transparencies, fireworks, organ interludes, lecture-demonstrations), and always had to tread a fine line between science and showmanship—between attracting audiences to the museum with oddities and instructing them in Linnaean classification.[66] The gesture of the director is not agitated or melodramatic but graceful and elegant, as we follow the line from his calf upward through the Hogarthian S-curve, the Line of Beauty that he so frequently employed.[67] It is a movement befitting an introduction to rational entertainment; and the drama he offers us here looks rather static (the figures, and perhaps especially the stylized Quaker lady, seem like parts of a tableau), for the drama that Peale offers us through the senses is finally acted out in the human mind.

Yet in a more immediate sense the curtain here, as in any theater, defines the boundary between inside and outside, between the constructed world of art and artifice, and life. Our stage language is not only responsive to the thespian side of Peale and to the rich theatrical life of urban Philadelphia, where Peale lived and worked through most of his adult life (rural Belfield was just an interlude). It is also responsive visually, both to the new popular genre of paintings of theatrical scenes in the eighteenth century throughout Europe (especially of the new bourgeois theater), and to the consequent emphasis, within these paintings on a relatively shallow stage on which the figures play their parts on the canvas. In *The Artist in His Museum,* Peale's stage is, at least theoretically, deep, but the curtain focuses our attention self-consciously on the picture plane behind which we are permitted to see certain staged tableaux or dramas.[68] One final point

about the curtain: Peale's explicitly dramatic image makes clear the other me-
tonymic usage that he shares with his northern European forebears. In theatri-
cal terms a stage curtain is also a "canvas," and although the deep red-flowered
fabric here looks more like damask, the visual pun remains and its intent is clear:
The curtain in the painting, now partially lifted, is parallel to and, at least at the
top, ambiguously close to the picture plane. It thus doubles our awareness of
"picture." It is not only the borderline between life and art; it is itself a painted
replication of the canvas that is Peale's pictorial surface.

What, then, are the implications of this complex aesthetic and epistemologi-
cal system of the Peale picture? *The Artist in His Museum* self-consciously
transforms nature into art in and through the painting. Immediately contiguous
to our space as viewers in the world lies the brilliantly lit untransformed jaw-
bone of the prehistoric predecessor, a fragment of ancient "nature." Behind it
are two other fragments with the light of the outside world separating them
from the jawbone. On the other side lies inanimate dead present nature, the
turkey awkwardly framing with its body the tools of taxidermic transformation,
just as the socket curve of the mastodon femur echoes the painter's palette on
the table above it. Between these emblems of nature and art, of past and pres-
ent, near the surface of the canvas stands the artist-scientist-director, who has
the capacity to transform nature into art: to reanimate the turkey into an artisti-
cally alive exhibit in a framed case, artfully to reconstruct the whole skeleton of
the past out of the fragments available to us in "life." The artist and his curtain
do indeed stand at the juncture of life and art, between the raw and the cooked,
as it were.

Beyond the curtain we can see the effects of such transformation under the
Enlightenment aesthetic of Peale: nature's creatures framed in cases by art for
human visitors, outstanding examples of whose species are also arrayed in the
row of portraits above, differences of scale carefully balanced right and left
(missing from the picture on the far right, we have noted, are the smallest-scale
objects with their attendant microscope). Differences of sex, age, and aesthetic
response to the sublime and the beautiful are also carefully balanced, facing
right and left, with the man educating the boy moving out toward us, the view-
ers, who are being educated by looking in. The formal patterning of the
epistemological process has all the elegant order of an eighteenth-century
dance—and all the quiet wit of the age of which *The Artist in His Museum* was
one of the last expressions.

Charles Willson Peale was not a naturally humorous person and could be at
times rather sententious and grave. As for "the word witt," he wrote to his
daughter Angelica in 1813, "I have never loved the character of witty per-
sons. . . . They do not always consider whether a saying might not hurt the feel-

ings of another, and in my opinion, one ounce of good nature is of more real value than a pound of witt, nay of 1000."[69] Such a statement speaks both to Peale's kindness and to his moral desire to assist his fellow human beings. Though it dissociates him from the age's propensity toward vicious and cutting wit, barbed humor, it does not deny that as artist he was capable of that verbal and visual play with reality, that enlightening twist of our vantage point on experience, which is a measure of true wit in the finest sense.

Peale's wit in *The Artist in His Museum* is a conscious exploration of the boundaries between life and art, between nature and science, between the visual and verbal, between the simple ideas of the senses and the complex organization of the mind. In the cognitive games he plays in the painting he continues and extends the epistemological inquiries not only of Locke and his philosophical followers but also of Leeuwenhoeck and his microscopes, Hoogstraten and his painted perspectival boxes, Jan de Heem and his extraordinary trompe l'oeil *natures mortes,* Vermeer and his pearly drops of partly focused sunlight on a blue gown. While West, Copley, Allston, and Vanderlyn explored the Italian and French heritage of the grand style, Peale the northerner wittily dramatized the complex dynamics of human consciousness. In this process, as Jefferson said, "the eye ultimately composes itself."[70]

Notes

This is an abridged version of an essay published in *New Perspectives on Charles Willson Peale: A 250th Anniversary Celebration,* ed. Lillian B. Miller and David C. Ward (Pittsburgh, 1991), 167–218. That version was in turn based on an article in *Prospects* 6 (1981): 139–85. Selected notes have been updated for the present publication.

Epigraph: Quoted in William Dunlap, *History of the Rise and Progress of the Arts of Design in the United States,* ed. Frank W. Bayley and Charles Goodspeed (1834; Boston, 1918), 1: 92–93. See also Lillian B. Miller, Sidney Hart, and David C. Ward, eds., *The Selected Papers of Charles Willson Peale and His Family,* vol. 2: *The Artist as Museum Keeper, 1791–1810* (New Haven, 1988) [cited hereinafter as *Selected Papers* 2], 1218–23.

1. See the full descriptive account in Charles Coleman Sellers, *Portraits and Miniatures by Charles Willson Peale,* American Philosophical Society, *Transactions,* n.s. 42, pt. 1 (Philadelphia, 1952) [cited hereinafter as *P&M*], 158–63.

2. Quoted in ibid., 160.

3. Charles Willson Peale to Rembrandt Peale, July 23, 1822, in Lillian B. Miller, Sidney Hart, David C. Ward, and Leslie Reinhardt, eds., *Selected Papers of Charles Willson Peale and His Family:* vol. 4: *His Last Years, 1821–1827* (New Haven, 1996) [cited hereinafter as *Selected Papers* 4], 164–65.

4. Charles Willson Peale to Rubens Peale, Aug. 4, 1822, *Selected Papers* 4: 170.

5. Charles Willson Peale to Thomas Jefferson, Oct. 29, 1822, *Selected Papers* 4: 193.

6. This portrait (107 × 69½ inches) of Benjamin West was commissioned by the American Academy of Fine Arts. West is shown in his robes as president of the Royal Academy, standing full length with drapery behind and to the right of him and gesturing to the viewer's left at a small version of Raphael's *Death of Ananias* on an easel while lecturing on "the immutability of colors." Completed by Lawrence after West's death in 1820, it reached the AAFA in New York in 1822, where Rembrandt Peale saw it. It is now owned by the Wadsworth Atheneum, Hartford, Conn.

7. For the documentation of the turkey and the eagle, referred to subsequently, see the earlier version of this essay in *New Perspectives on Charles Willson Peale,* ed. Lillian B. Miller and David C. Ward (Pittsburgh, 1991), 167–219, nn. 8, 58, and 59.

8. Horace Sellers Transcript of Charles Willson Peale, Autobiography, in the Peale-Sellers Papers, American Philosophical Society, Philadelphia, 446.

9. For the Renaissance tradition of emblems, see Mario Praz, *Studies in Seventeenth Century Imagery,* 2d ed. (Rome, 1964); and Rosemary Freeman, *English Emblem Books* (London, 1948). For a critique from the point of view of German scholarship, which modifies Freeman's emphasis on the arbitrariness of the emblem, see Peter M. Daly, *Literature in the Light of Emblem* (Toronto, 1979), esp. 1–102.

10. My own conviction is that the emblematic mode was a continuing one in American art, from the seventeenth century well into the nineteenth. See Roland Fleischer, "Emblems and Colonial American Painting," *American Art Journal* 20 (1988): 2–35; Roger B. Stein, "Thomas Smith's Self-Portrait: Image/Text as Artifact," *Art Journal* 44 (Winter 1984): 316–27, and Stein, "Picture and Text: The Literary World of Winslow Homer," in *Winslow Homer: A Symposium, Studies in the History of Art* 26 (Washington, D.C., 1990), 36–41.

11. Did Peale hear Reynolds's First Discourse before the new Royal Academy on Jan. 2, 1769, two months before he returned to America? Reynolds recommended to young students "an implicit obedience to the *Rules of Art,* as established by the practice of the great MASTERS. . . . That those models, which have passed through the approbation of ages, should be considered by them as perfect and infallible Guides, as subjects for their imitation, not their criticism" (*Seven Discourses Delivered in the Royal Academy by the President* [1778; London, 1971], 13). That Peale had listened to this or similar advice is clear from the "imitation" in the Pitt portrait discussed below. For Reynolds's use of the emblematic, see E. H. Gombrich, "Reynolds's Theory and Practice of Imitation," in his *Norm and Form: Studies in the Art of the Renaissance* (London, 1966), 129–34. Ronald Paulson, in his brilliant discussion of continuities and change in the emblematic tradition, locates Reynolds as a transitional figure, moving away from the manipulation of shared emblematic understanding and usage to a more generally associative expressive usage; see Paulson, *Emblem and Expression: Meaning in English Art of the Eighteenth Century* (London, 1975), esp. 80–94. In what follows, I would want to locate Peale also within the transition, while insisting on his intermittent use of the specifically emblematic.

12. *P&M*, 172–73.

13. Peale had already noted that Pitt "makes a figure of Rhetoric"—that is, that even

his posture stands emblematically for a specific traditional quality. In addition, Frank H. Sommers III has suggested that the figure is an allusion to Brutus, the Roman martyr, thus enriching its emblematic significance ("Thomas Hollis and the Arts of Dissent," in *Prints in and of America to 1850,* ed. John D. Morse [Charlottesville, Va., 1970], 151–55). For the classical pictorial context, see the Brown University exhibition catalogue *The Classical Spirit in American Portraiture* (Providence, 1976).

14. *P&M,* 273.

15. Charles Coleman Sellers, *Charles Willson Peale with Patron and Populace: A Supplement to Portraits and Miniatures by Charles Willson Peale with a Survey of His Work in Other Genres,* American Philosophical Society, *Transactions,* n.s. 59, pt. 3 (Philadelphia, 1969) [cited hereinafter as *P&M Suppl.*], 55–56; Charles Coleman Sellers, *Charles Willson Peale* (Philadelphia, 1969) [cited hereinafter as *CWP*], 83–86.

16. *P&M Suppl.,* 55; *CWP,* 86; and Sidney Hart, "A Graphic Case of Transatlantic Republicanism," in Miller and Ward, *New Perspectives,* 73–81; for a discussion which demonstrates that the Schuylkill River background of Peale's portrait of John Dickinson, done in the same year as the Bordley portrait, is politically emblematic, see Karol Ann Peard Lawson, "Charles Willson Peale's *John Dickinson:* An American Landscape as Political Allegory," American Philosophical Society, *Proceedings* 136 (December 1992): 453–86.

17. For two recent essays that helpfully modify this perspective, see David Steinberg, "The Portraitist as Divine," in Miller and Ward, *New Perspectives,* 131–43; and Ellen G. Miles and Leslie Reinhardt, "'Art Conceal'd': Peale's Double Portrait of Benjamin and Eleanor Ridgely Laming," *Art Bulletin* 78 (March 1996): 57–74.

18. *P&M Suppl.,* 11, 14; *CWP,* 111; Charles Willson Peale to John Pinckney, January/February 25, 1775, in Lillian B. Miller, Sidney Hart, and Toby A. Appel, eds., *Selected Papers of Charles Willson Peale and His Family,* vol. 1: *The Artist in Revolutionary America, 1735–1791* (New Haven, 1983) [hereinafter *Selected Papers* 1], 138–39; for an example, see *Selected Papers* 1: 369.

19. See esp. *P&M Suppl.,* 9, 16–33, 40–41, 47–48.

20. The exhibition *The Splendors of Dresden: Five Centuries of Art Collecting* (National Gallery of Art, Washington; Metropolitan Museum of Art, New York; and San Francisco Art Museums, 1978–79) made the point by devoting one section to court activities; the section on the Electoral Kunstkammer, dated to 1560, with its combination of pictures, statues, tools for gardening and the chase, mineral specimens, and scientific instruments, suggests another distant source for the arrangements organized in the background of *The Artist in His Museum;* and more recently, Joy Kenseth, ed., *The Age of the Marvelous,* exh. cat. (Hanover, N.H., 1991).

21. The newspaper accounts of Peale's transparent paintings, triumphal arches, and the like—in some cases our only sources for information about this occasional work, since it has disappeared, as it was intended to—are clear in their "emblematic" labeling of these activities. See the quotations cited by Sellers in *P&M Suppl.; Selected Papers* 1: 354, 361, 367, 370.

22. For the sequence of Peale Washington portraits, see *P&M.,* esp. 225. Peale had close intellectual and political connections at the time with President John Witherspoon and the astronomer David Rittenhouse of Princeton, whose portraits he took (*P&M,*

181–82, 252–53). Peale's 1783 revision of his 1779 *Washington*, in which he includes also the death of General Mercer (Princeton University; *P&M*, 234–35), echoes in some ways his former teacher Benjamin West's *Death of Wolfe* (1771). Copley's *Death of Chatham* and *Death of Major Peirson* (1782–84), completed just as Peale was finishing his new *Washington*, also focus on the death of a hero, as do John Trumbull's slightly later *Death of General Warren* and *Death of Montgomery* (1786).

23. *P&M*, 86; *CWP*, 175–77. The view of Independence Hall in the background of the Gérard portrait made it inevitably part of an inside-outside game for visitors to the Long Room.

24. *Historical Catalogue of the Paintings in the Philadelphia Museum, Consisting Chiefly of Portraits of Revolutionary Patriots and Other Distinguished Characters* (1813).

25. *P&M*, 160, 162, 163.

26. *P&M Suppl.*, 33–34; eight of them are reproduced in *CWP*, pls. VIII–IX; see also *Selected Papers* 2: 323–27.

27. The description of Peale's Germantown farm may be found in Jessie J. Poesch, "Mr. Peale's 'Farm Persevere': Some Documentary Views," American Philosophical Society, *Proceedings* 100 (December 1956): 545–56; see also Jessie J. Poesch, "Germantown Landscapes: A Peale Family Amusement," *Antiques* 72 (November 1957): 434–39. Peale's manuscript letterbooks, Belfield Daybook, and autobiography contain the records of the estate. See also *Selected Papers* 3. For a recent discussion of the garden in its American context, see Therese O'Malley, "Charles Willson Peale's Belfield: Its Place in American Garden History," in Miller and Ward, *New Perspectives,* 267–82; for the English context, see Paulson, *Emblem and Expression,* esp. 19–34.

28. Charles Willson Peale, "Walk with a Friend in the Philadelphia Museum," MS, Historical Society of Pennsylvania; for a recent extended study of this subject, see David R. Brigham, *Public Culture in the Early Republic: Peale's Museum and Its Audience* (Washington and London, 1995), and the older Charles Coleman Sellers, *Mr. Peale's Museum: Charles Willson Peale and the First Popular Museum of Natural History and Art* (New York, 1980).

29. MS lecture, "The Theory of the Earth: Linnaean System of Animals and Moral Reflections on Man," Academy of Natural Sciences, Philadelphia.

30. This is one version; variants exist. See the reproductions in Charles Coleman Sellers, *Charles Willson Peale* (Philadelphia, 1947), 2: 270. Sellers, in *Mr. Peale's Museum,* discusses the organ (p. 196), the tickets, and the source of the Book of Nature emblem (pp. 15, 154, 218); biblical mottoes (pp. 216–20) were apparently—at least in part—the deist's strategy to draw into the museum a sectarian Christian audience.

31. Quoted in *CWP,* 284. Charles Brockden Brown made Philadelphia during the yellow fever epidemic the setting for his *Arthur Mervyn; or Memoirs of the Year 1793* (Philadelphia, 1798).

32. *Discourse Introductory to a Course of Lectures on the Science of Nature . . . Delivered . . . November 8, 1800* (Philadelphia, 1800), 48, 32.

33. Peale, "Walk with a Friend," cited in Clive Bush, *The Dream of Reason: American Consciousness and Cultural Achievement from Independence to the Civil War* (London, 1977), 79.

34. *Discourse, 1800,* 48.

35. Linnaeus's work was translated by William Turton and published in seven volumes between 1802 and 1807 as *A General System of Nature.* This passage is quoted in Bush, *Dream of Reason,* 196. See *Selected Papers* 2: 630n for Peale's ownership of Turton's work.

36. Quoted in Bush, *Dream of Reason,* 197.

37. Henry David Thoreau, *Walden,* chap. 2.

38. Cf. Emerson in *Nature:* "A fact is the end or last issue of spirit. The visible creation is the terminus or circumference of the invisible world" (chap. 4, "Language"). One should not overemphasize the differences between Locke and the transcendentalist strain. It is Edgar Allan Poe who is the real enemy of Lockean empiricism.

39. *Introduction to a Course of Lectures on Natural History Delivered . . . November 15, 1799* (Philadelphia, 1800), 14.; in *Selected Papers* 2: 266.

40. *Jonathan Edwards: Representative Selections,* ed. Clarence H. Faust and Thomas H. Johnson (New York, 1962), 60–61.

41. See Irma B. Jaffe, *Trumbull: The Declaration of Independence* (New York, 1976), 67–73 and plates. Note also that the specifically classical forms of the busts in the Long Room, visible in the Titian Peale sketch, have been eliminated from the final painting. They are identified in Poesch, "Precise View," 344–45.

42. On Linnaeus, see esp. James L. Larson, *Reason and Experience: The Representation of Natural Order in the Work of Carl von Linné* (Berkeley, Calif., 1971), and Frans A. Stafleu, *Linnaeus and the Linnaeans: The Spreading of Their Ideas in Systematic Botany, 1735–1789* (Utrecht, 1971). On the American scene, Daniel Boorstin, *The Lost World of Thomas Jefferson* (New York, 1948) is still useful. See esp. chap. 1, "Nature as the Work of Art."

43. The language here follows Peale, "Walk with a Friend."

44. See n. 8 above.

45. For a useful summary of the early national argument, see Ralph N. Miller, "American Nationalism as a Theory of Nature," *William and Mary Quarterly,* 3d ser. 12 (1955): 74–95; for Jefferson's *Notes on Virginia,* see the well-indexed edition of William Peden (Chapel Hill, N.C., 1955). Irving speaks, in "The Author's Account of Himself," of his delight in going to Europe to see "the gigantic race from which I am degenerated."

46. In the MS "Walk with a Friend," Peale drew special attention to the American elk, "not known by Buffon" and to be differentiated from the moose, and also to the *Cervus virginianus:* "Its well turned and delicate limbs, stately carriage and smooth skin, render it the Admiration of most foreigners that visit the Museum." (Look at the "well turned and delicate limbs" of Peale himself in the picture!)

47. Whitfield J. Bell, Jr., "A Box of Old Bones: A Note on the Identification of the Mastodon, 1766–1806," American Philosophical Society, *Proceedings* 93 (May 1949): 177.

48. Ibid., 169–77.

49. Rembrandt Peale, *An Historical Disquisition on the Mammoth, or Great American Incognitum, an Extinct, Immense, Carnivorous Animal, Whose Fossil Remains Have Been Found in America* (London, 1803), iv–v, 4, 9, 10, 15–16; also in *Selected Papers* 2: 544–81.

50. Ibid., 91.

51. For this earlier unified view of the painting, see Abraham Davidson, "Charles Willson Peale's Exhuming the First American Mastodon: An Interpretation," in *Art Studies for an Editor: Twenty-five Essays in Memory of Milton S. Fox* (New York, 1976), 61–70; for other views, see Lillian B. Miller, "Charles Willson Peale as History Painter: *The Exhumation of the Mastodon*," in Miller and Ward, *New Perspectives*, 145–67; and Laura Rigal, "Peale's Mammoth," in David C. Miller, ed., *American Iconology: New Approaches to Nineteenth-Century Art and Literature* (New Haven, 1993), 18–38.

52. Charles Willson Peale to Mrs. Nathaniel Ramsay, Sept. 7, 1804, in *Selected Papers* 2: 753; see also *P&M Suppl.*, 37.

53. Jefferson, *Notes on Virginia*, 19, 24–25. These passages were well known to Americans and to foreign visitors such as Brissot de Warville, the comte de Volney, Richard Cobden, and Augustus John Foster. George Washington had an oil painting of Harpers Ferry by George Beck at Mount Vernon by 1797; Rembrandt Peale did a watercolor sketch of Harpers Ferry (ca. 1811; Peale Museum, Baltimore), then turned it into an oil painting and a lithograph for public consumption about 1827. Herman Melville could count on general public knowledge of the reference, when he likened the leap of the great white whale to the Natural Bridge (*Moby-Dick*, chap. 133). See Wilbur H. Hunter, "The Peale Family and Peale's Baltimore Museum," *Pennsylvania Magazine of History and Biography* 1965: 318.

54. The wild steed motif as index of the sublime was to become familiar. George Stubbs had already used it frequently in England in his horse-lion confrontations (see Basil Taylor, "George Stubbs: 'The Lion and Horse' Theme," *Burlington Magazine* 107 (1965): 81–86. Thomas Cole used it in his otherwise bucolic *View of the Catskills: Early Autumn* (1837, Metropolitan Museum of Art, New York). It became a popular folkloric image as well; see George Kendall, "A Superb Wild Horse," in *Humor of the Old Southwest*, ed. Hennig Cohen and William B. Dillingham, 2d ed. (Athens, Ga., 1975), 92–93. Melville captures it in his image of the white steed of the prairies, land alternative to Moby-Dick in the famous "Whiteness of the Whale," chap. 42. It has of course biblical origins in Revelations 6, which Benjamin West explored in a variety of pictorial ways (and continues in popular culture as, for example, the Lone Ranger's "Silver").

55. Sellers Transcript of Peale, Autobiography, quoted in Davidson, "Peale's *Exhuming*," 62; the autobiography also has an extended account of the exhumation process.

56. It is worth noting in this respect that both the technology of the wheel pump and the artistry of the picture have precursors, extending back at least to the woodcuts of the sixteenth-century metallurgist Agricola. See Herbert C. Hoover and Lou H. Hoover, trans., *De Re Metallica, from First Latin Edition of 1556* (rpt. New York, 1950), esp. book 6 with its plates. I am grateful to my former colleague Bert Hansen, who called this to my attention.

57. The image is reproduced in *P&M Suppl.*, 44–45, 102.

58. Jefferson, *Notes on Virginia*, 19.

59. It needs to be compared with the pyramidal order in the middle ground that John Singleton Copley establishes in *Watson and the Shark* (1778), equally an imposition of human geometric control over the experience of the sublime confrontation between shark and helpless Watson in the foreground—though there are differences, especially

in the background. See my "Copley's *Watson and the Shark* and Aesthetics in the 1770s," in *Discoveries and Considerations: Essays in Early American Literature and Aesthetics Presented to Harold Jantz,* ed. Calvin Israel (Albany, 1976), 85–130; for a different reading of the social meaning of *Watson* but also based upon the assumption that meaning is encoded in pictorial structure, see Albert Boime, *The Art of Exclusion: Representing Blacks in the Nineteenth Century* (Washington, D.C., 1990), chap. 2, "Triangular Trade and Triangular Compositions."

60. See Sellers, *Peale* (1947), 2: 355–56; for Godman's discussion of the mastodon, see John Godman, *American Natural History* (Philadelphia, 1826), 2: 204–52.

61. John Godman, *Addresses Delivered on Various Public Occasions* (Philadelphia, 1829), 110, 128–29. I quote it from the suggestive chapter "Philadelphia Science and the Artist-Naturalist" in William H. Truettner, *The Natural Man Observed: A Study of Catlin's Indian Gallery* (Washington, D.C., 1979), 68. Truettner's study is helpful in locating Peale in relation to the next—and finally very different—generation.

62. Madlyn Millner Kahr, "Velázquez and *Las Meninas,*" *Art Bulletin* 57 (June 1975): 225–46, at 239. Kahr's essay includes a wealth of illustrations of the northern European gallery pictures with which Velázquez's work is linked.

63. Both works are discussed and illustrated, with special reference to emblematic strategies, in Paulson, *Emblem and Expression,* 138–48, 152–58.

64. The Bonaparte collection is frequently noted in the literature of American art history; Peale's sketch of the academy walls displaying Fulton's collection, in a letter of Nov. 13, 1807, is reproduced in *P&M Suppl.,* 107. Lillian B. Miller, *Patrons and Patriotism: The Encouragement of the Fine Arts in the United States, 1790–1860* (Chicago, 1966), mentions numerous northern European works in collections; and the published catalogues of the American Academy of Fine Arts, the National Academy of Design, and the Pennsylvania Academy of the Fine Arts contain considerable raw data. A guide to these materials is *The National Museum of American Art's Index to American Art Exhibition Catalogues: From the Beginning through the 1876 Centennial Year,* compiled by James L. Yarnall and William H. Gerdts et al., 6 vols. (Boston, 1986)—though of course attributions to particular artists are open to question. For the Peale Family and still life, see Lillian B. Miller, ed., *The Peale Family: Creation of a Legacy, 1770–1870* (New York, 1996), and William H. Gerdts and Russell Burke, *American Still-Life Painting* (New York, 1971), chap. 2; for Peale's comment on King, see Andrew J. Cosentino, *The Paintings of Charles Bird King* (Washington, D.C., 1977), 80. Lance Humphries's work on Robert Gilmor is forthcoming. Three works that emphasize the Dutch influence are H. Nichols B. Clark, "A Taste for the Netherlands: The Impact of Seventeenth-Century Dutch and Flemish Genre Painting on American Art, 1800–1860," *American Art Journal* 14 (Spring 1982): 23–38; H. Nichols B. Clark, *Francis W. Edmonds: American Master in the Dutch Tradition* (Washington, D.C., 1988); and Sarah Burns, *Pastoral Inventions: Rural Life in Nineteenth-Century American Art and Culture* (Philadelphia, 1989).

65. The boldest—and perhaps exaggerated—statement of this distinction is Svetlana Alpers, *The Art of Describing: Dutch Art in the Seventeenth Century* (Chicago, 1983).

66. This process was acted out in the movement of the museum itself from the Lombard Street residence to Philosophical Hall, with a great parade (*CWP,* 264–65), from

thence to the statehouse; eventually, part of it went to P. T. Barnum's American Museum. On the continual tension between science and showmanship, see Sellers, *Mr. Peale's Museum,* and Brigham, *Public Culture in the Early Republic.*

67. The obvious point of comparison is with William Sidney Mount's *The Painter's Triumph* (1838; purchased by the Philadelphia publisher Matthew Carey and now in the Pennsylvania Academy of the Fine Arts).

68. The origins of this pictorial strategy are Dutch and Flemish bourgeois interiors of the seventeenth century, developed in the French eighteenth century in the paintings of Jean-Baptiste Greuze, by the Scot David Wilkie, and in the U.S. in the second decade of the nineteenth century by John Krimmel. See Patricia Hills, *The Painter's America: Rural and Urban Life, 1810–1910,* exh. cat. (New York, 1974), 2–9.

69. Quoted in *CWP,* 474n10.

70. For the "Aftermath" of the picture, its immediate reception, and the works linked to it by both Charles Willson Peale and his son Raphaelle, see the final section of the earlier version of this essay in Miller and Ward, *New Perspectives,* 204–08 and notes.

4 Thomas Cole and the Aristocracy

Alan Wallach

This essay concerns the relationship between Thomas Cole and his patrons and the ways in which that relationship affected or conditioned the artist's work. Although what happens between artist and patron can have a pattern and a history of its own, it cannot be grasped apart from other historical patterns and relationships. Thus I begin this account not with Cole or his patrons but with the class to which his patrons belonged. I begin, in other words, with the general circumstances that framed the historical particulars: the facts that preceded and determined patronage, and without which patronage would have been unimaginable.

In the early years of the American republic, no question more sharply split the dominant classes than the question of democracy. Democracy marked the dividing line between the two political parties of the period, the Democrats and the Federalists. The Democratic party—the party of Jefferson, Madison, Monroe, and Jackson—preached equality and the rights of man. Over a thirty-year period, beginning in 1801, it succeeded in establishing the forms of political democracy almost everywhere in the United States (the question of slavery aside). The Federalists, led by Washington, Adams, and Hamilton, sought to maintain a system of aristocratic privilege. They believed that property and political rights went hand in hand and that those without property had no reason to make political claims upon the state. Today such beliefs appear untenable. But for the Federalists aristocracy was neither a pretense nor an affectation. In many ways it corresponded to the existing social reality.[1]

It should be said that at its inception the United States was a society explicitly divided into classes. According to their birth, education, and wealth, men saw

themselves as commoners or gentlemen and treated one another accordingly. S. G. Goodrich's account of a Ridgefield, Connecticut, town meeting early in the nineteenth century provides us with some idea of how the class system typically functioned:

> At an early hour Col. Bradley was there, for he was punctual in all things. He sat apart in a pew with about half a dozen other men, the magnates of the town. In other pews were the leading federalists—persons of high character, wealth and influence. They spoke a few words to each other, and then relapsed into a sort of dignified silence. They did not mingle with the mass: they might be suspected of electioneering—of seeking to exercise an influence over the minds of the people. That was too degrading for them: it might do for General King, and the other democrats who could condescend to such things. These circulated freely in the aisles, giving the warm right hand of fellowship to all they met, especially the rabble. Nevertheless the federalists had privately determined a few days before on whom they would cast their votes, and being a majority, they carried the day.[2]

Although the Federalists disdained the electoral process, leaving it to their lieutenants, in government they argued openly and vigorously for their beliefs. As late as 1821, James Kent, a famous legal authority and chancellor of the State of New York, attempted to remind his colleagues in the state legislature that "to the beneficence and liberality of those who have property, we owe all the embellishments and the comforts and the blessings of life."[3] There was no reason, he argued, to believe that the poorer classes had anything to contribute to the management of the state. Even a quarter of a century later, in his preface to *The Chainbearer,* a novel directed against the anti-rent movement in upstate New York, James Fenimore Cooper still maintained that society could not do without its traditional hierarchy: if the "great landholders," as he put it, lost their privileges, society would fall under the tyranny of "the country extortioner and the country userer."[4]

Almost up to that moment, the American political system sustained such beliefs. In the early years of the republic, the majority of Americans, not counting women or slaves, did not possess the right to vote. The Constitution nowhere guaranteed male enfranchisement, and initially property qualifications for voting were everywhere in force. In New York State a man had to possess $250 worth of freehold property to vote in a gubernatorial or senate election. This meant that probably less than 40 percent of the state's male population enjoyed the right to participate in the electoral process.[5]

The Federalist creed centered on the preservation of aristocratic privilege

and traditional property rights. Such an ideology, because it was bound hand and foot to the status quo, offered no vision beyond the immediate interests of a section of a class, and it stood in stark contrast to the promise of political equality that was being made elsewhere. By 1800 aristocracy was becoming untenable as a social doctrine and aristocratic ideology was already in the process of disintegration. As time passed, an ever-increasing proportion of the dominant classes came to believe that their rule and interests could be more readily secured through a more democratic political arrangement. In this their thinking was abetted by the rise of a democratic and often radical-minded class of artisans and workers.

By 1840 the last traces of Federalism would vanish from the American political scene. But in 1800 the Federalists still possessed enormous political strength: a Federalist occupied the White House; the system of electoral privilege was still intact.

In many ways, the New York State Federalists epitomized the old aristocracy. The party's leaders were prosperous merchants, bankers, financiers, lawyers, land speculators, and owners of vast estates. At the turn of the century they dominated the state's politics and ran its most powerful institutions. Their church was the very well endowed Episcopal Church, their college Columbia College. Wealth and power were everywhere allied on the Federalists' side. In the state the party's leaders were men like John Jay, Alexander Hamilton, Rufus King, Gouverneur Morris, Cadwallader Colden, Stephen Van Rensselaer, and Josiah Ogden Hoffman. Federalists owned the New York banks, ran the stock exchange (located in the Tontine Coffee House) and presided over the courts.[6]

Although bankers and merchants dominated the party, landowners probably did the most to uphold its aristocratic claims. Many were descended from the original Dutch settlers: among them the Schuylers, the Van Rensselaers, the Van Vechtens, the Van Der Heydens. As an Englishman might be known as lord of a manor, so they took for themselves the Dutch name *patroon*. Their privileges jealously guarded by custom and law, they enjoyed a quasifeudal relationship with their tenants, who, like European peasants, were often tied to the land by a traditional system of rents and obligations.

In addition to the patroons, Federalists of English descent owned large tracts of land in upstate and western New York, and they often reigned over them in lordly fashion: Judge Jonas Platt of Plattsburg is a good example; or Gouverneur Morris of Morrisania, or Judge William Cooper of Cooperstown, master of Ostego Hall and father of James Fenimore Cooper. These landed Federalists lived in imitation of their English counterparts even down to such particulars as the practice of fox hunting with hounds and the possession of a family coat of arms.[7]

Although the aristocracy dominated the state throughout the colonial and early federal period, it could not forever prevail against a rising tide of democratic sentiment. Historian Dixon Ryan Fox has analyzed the aristocracy's fall from power: the slow disintegration of the Federalist party after Thomas Jefferson's election to the presidency in 1800, the ensuing political and ideological crisis intensified by Federalism's opposition to the War of 1812, the rise of Jacksonian democracy during the 1820s, and the formation of the Whig party, made up of Jackson's opponents, during the 1830s. Fearful of democratic "leveling" and haunted by memories of the French Revolution, the New York aristocracy fought tooth and nail to maintain its privileges and its hold on the state. Nonetheless, it steadily lost ground during the 1800s and 1810s, and in 1821 it suffered a major setback when a state constitutional convention put an end to the property qualifications that had previously limited white male suffrage. In a revealing argument made during the debate, State Chancellor James Kent, Federalism's renowned legal authority, opposed the extension of suffrage on the grounds that it "has been regarded with terror, by the wise men of every age, because in every European republic, ancient and modern, in which it has been tried, it has terminated disastrously, and been productive of corruption, injustice, violence and tyranny. And dare we flatter ourselves that we are a peculiar people, who can run the career of history, exempted from the passions which have disturbed and corrupted the rest of mankind?"[8] Kent's argument ultimately derived from a body of eighteenth-century English political writings in which democracy was portrayed as a fatal threat to the harmonious balance of a republic.[9] This classical republican argument might appear to be self-serving, but Kent and the other members of the aristocratic party were also sincere in their belief that democracy would precipitate the republic's demise.

The aristocracy's claims survived Federalism's decline in only one realm: culture. Political democracy put at least a formal end to inherited political and social prerogatives. The possession of culture, however, could be used to help perpetuate, in a new form, old claims of superiority. It would furnish a compensation of sorts for the withdrawal of more overt marks of status and social distinction.[10]

The increasing emphasis the aristocracy placed on culture provided enormous impetus for Thomas Cole's career. From his first appearance as a landscape painter in New York in 1825 until his death in 1848, he enjoyed unprecedented popularity and steady patronage, which at first was almost entirely confined to members of the old Federalist elite.

Cole's roots lay in the Lancashire "middling" class. His father had been unsuccessful as a woolens manufacturer, and his failure forced Cole to leave school at a young age for employment as an engraver at a calico printworks. The artist's

biographer, the Reverend Louis L. Noble, recalled Cole's experience there: "From the rude character of many of his fellow-operatives, his moral sense, which from the earliest childhood, was most delicate and lively, forbade him to form any intimate acquaintances with those of his own age."[11] This fear of sliding into the working class, here couched in terms of cultural distance and moral superiority, was widely shared by the small Lancashire manufacturers who were being driven into bankruptcy by the depression that followed the Napoleonic wars. Cole's family escaped to the United States in 1818, when Cole was seventeen, but Cole never lost his horror of the industrial revolution. He had experienced its terrors first-hand, and perhaps not the least of them was the humiliation of forced association with "rude fellow-operatives."[12]

A journalist named William Stillman remembered Cole possessing a "strongly individual English mind."[13] It is perhaps hard to overestimate the effect the English class system had on him. He had learned to think of himself as a gentleman. Whatever his actual circumstances, his belief was unshakable. It formed the core, the alpha and omega of his identity.

And this, I believe, provides us with a central clue to Cole's early success and to the patterns that his patronage assumed. Because of his background and his view of himself, Cole identified in crucial ways with the values and beliefs of the Federalist aristocracy. Thus he would attempt to realize in imaginative terms ideas and beliefs that the aristocracy derived from its social position and historical experience.[14] I wish to be very clear about this point. I am not saying that Cole was cynical; on the contrary, it was precisely his sincerity that made him valuable to his patrons.

In 1825 Cole sold his first landscape to George W. Bruen, a merchant and member of the American Academy of Fine Arts. A few months later, after his first sketching trip to the Catskills, Cole was brought to the notice of Col. John Trumbull. Trumbull was by then an aging member of the Federalist aristocracy. Both his father and brother had been Federalist governors of Connecticut, and he was well connected in the small world of the Federalist power elite. Although Trumbull's own career as a painter had floundered, as president of the American Academy he was very much in a position to advance Cole's career if he chose.[15]

The Academy had been founded a quarter-century earlier by influential members of the ruling elite such as Dr. David Hosack, Stephen Van Rensselaer, Rufus King, George Clinton, Aaron Burr, and Robert Livingston. Yet despite considerable membership, the Academy functioned only sporadically. Its failure can be attributed in part to its stiff twenty-five-dollar membership fee, which excluded most artists from its ranks, and in part to the autocratic and embittered personality of its president. Trumbull was something of an anomaly since he was at once an artist and, by family background and education, a member of the

class that patronized artists. He often resolved this contradiction by resorting to a sort of high Tory irascibility. At the time Cole first encountered him, he was notorious for having spurned a plea made by one of the Academy's directors on behalf of two students. The students had come early one morning to copy from the Academy's collection of casts only to find the copying room locked. In the presence of William Dunlap, Trumbull had informed the startled director that *"the gentlemen* have gone to a great expense importing casts" and that the students "have no property in them. They must remember that beggars are not to be choosers."[16]

Toward Cole, however, Trumbull responded with unstinting generosity. His praise of Cole's early landscapes was lavish and revealing. To Dunlap he reported that "this youth has done what I have all my life attempted in vain." Dunlap, with unintended irony, wrote that the paintings exceeded "all that this praise had made me expect."[17] Trumbull's enthusiasm may have been prompted in part by a shrewd guess that the younger artist could help reverse the Academy's sinking fortunes. In any case, his praise and the publicity that quickly followed set Cole's career in motion. Acting, in effect, as agent for his aristocratic friends, Trumbull arranged an exhibition of Cole's work at the American Academy's rooms and put the artist in touch with the wealthy amateurs of the Academy and other members of his circle. Cole's list of patrons often included the notation "enquire of Mr. Trumbull." Similarly, Cole's correspondence attested to Trumbull's pervasive influence.[18]

Trumbull stood at the center of Cole's expanding patronage network. In attempting to trace Cole's patrons of the 1820s and 1830s, we find again and again direct links with Trumbull or Trumbull's close associates among members of the Academy. Thus it was through Trumbull that Cole became acquainted with Daniel Wadsworth, the son of a great Hartford merchant and the future founder of the Wadsworth Atheneum. In 1825 Wadsworth admired Cole's *Kaaterskill Falls*, which Trumbull had purchased from the artist for twenty-five dollars. Wadsworth's commission for a second version (fig. 4.1) was the first of five works Cole executed for him, including a topographical view of his country house, Monte Video.[19] Through Wadsworth Cole received a commission from Henry Barnard, a Hartford lawyer and "passionate Whig,"[20] and one from the writer S. G. Goodrich, who had several times met Trumbull himself at Wadsworth's house in Hartford.[21]

Cole's patrons were landowners, merchants, bankers, lawyers, and wealthy professionals. To describe them in detail would be tedious; but we may gain a sense of their character and outlook by briefly examining the lives of the two best known.

Figure 4.1 Thomas Cole, *Kaaterskill Falls,* 1826. Oil on canvas, 25¼ × 35¾ inches. Wadsworth Atheneum, Hartford, Conn., bequest of Daniel Wadsworth.

Philip Hone (1780–1851), whose diary remains an important source of information for the period, was one of the first to buy Cole's paintings. A correct and high-minded man, more at ease as a public figure than as a private individual, Hone had retired at forty-one from the auction business and settled down to a life of politics, public service, and fashionable society. He was, the *New York Herald* wrote at his death, "always considered a leader of the *ton.* Indeed, it has been said that if an order of nobility had existed in this country, Mr. Hone would have claimed the right of being numbered in their ranks. His bearing, through courteous towards his fellow citizens, was aristocratic and self-confident . . . he was never a popular man with the masses."[22] Hone championed the Whig party from its inception and played a role as an alderman and as a one-term mayor of New York. But his real importance to the Whigs lay in his work as a party organizer and political advisor. Daniel Webster was his "intimate companion"; Henry Clay, John Quincy Adams, and Chancellor Kent were among his closest friends.

Besides politics, Hone devoted himself to philanthropy. This involved for the most part the aristocracy's favorite institutions and charities. He served as a vestryman of the fashionable Trinity Church, and he was a trustee or director of the Mercantile Library, Columbia College, the New-York Historical Society, the Seaman's Fund, New York Hospital, and the Bloomingdale Asylum. No doubt he considered his membership in the American Academy as yet another opportunity

to advance the public good. Still, his enjoyment of art was probably genuine. He owned one of the finest collections of "modern," or contemporary, painting in New York, and his nationalistic enthusiasm for works by Cole and other American painters helped make collecting American art fashionable.[23]

Stephen Van Rensselaer (1764–1839), often simply called "the Patroon," was another early patron. Scion of a family dating back to the first Dutch settlements, he was at his death the nation's greatest landowner and one of the state's wealthiest men. His fortune derived from a precocious aptitude for business. Upon coming of age in 1785, he worked out, with the help of his brother-in-law Alexander Hamilton, a scheme for settling the vast estates he had inherited. This involved the use of a contractual device of doubtful legality known as the "incomplete sale." Settlers were attracted to Rensselaerwyck by the prospect of owning farms. Upon arrival they signed an agreement with the Patroon that usually allowed them a seven-year grace period in which to establish themselves. Once established, however, they discovered that under the terms of the agreement they could never purchase the land outright but were, in fact, the Patroon's tenants and subject to a host of obligations. Van Rensselaer and Hamilton modeled the "incomplete sale" upon leases used by earlier patroons. It required yearly payments of wheat and poultry as well as a number of days of work each year repairing roads (an obligation reminiscent of the corvée). Moreover, tenants could not sell their leases without turning back to the Patroon 25 percent of the sale price.[24]

Van Rensselaer, aware of the enormous advantages he enjoyed, was careful never to enjoy them too well. His moderate policies earned him the name "good Patroon," and he was eulogized for having "had none of that morbid appetite for wealth which grows ravenous by what it feeds on."[25] But his heirs paid a price for his name. Stephen IV and William Paterson, who divided Rensselaerwyck between them, were obliged by the terms of their father's will to collect the enormous arrears that had accumulated during his lifetime. This touched off the Anti-Rent Wars that shook Albany for more than a decade. With them the last vestiges of aristocratic privilege came violently to pieces.

Among members of the old Federalist elite, Van Rensselaer had an exceptional awareness of his class's difficulties and duties and, to an even greater degree than Philip Hone, he responded to the call of public service. Although he was unsuccessful as the Federalist candidate for governor in the disastrous election of 1801, he remained until his death the aristocracy's "leader in society and politics," serving in the state legislature and the U.S. House of Representatives. Polite and unassuming, he was, in the words of one biographer, " a dignified and knightly figure" and was often said to be "loved for his simple tastes, democratic behavior, and genial manners."[26] Like Hone, Van Rensselaer was director or

trustee of a host of institutions. He too was a founding member of the American Academy, and between 1825 and 1829 he purchased at least two and perhaps as many as four paintings from Cole, to whom he wrote directly, signing his letter with an abrupt and commanding "Van Rensselaer."[27]

Cole's success with the Federalist elite confirmed Trumbull's expectations. Trumbull had seen in Cole's paintings a realization of his own way of seeing and experiencing landscape. In other words, Trumbull intuited in Cole's work something that fulfilled his own artistic aspirations and needs, and he guessed, rightly as it turned out, that others with a similar background and outlook would respond in a similar manner. (Of course, he didn't employ such terminology. In recommending Cole, he spoke of the younger artist's "uncommon merit," his skill," his "taste."[28]). Thus at this point we must ask: what sort of needs did Cole's paintings fulfill?

Considering their relative inexperience, Cole's patrons had remarkably settled tastes. They believed that art must ally itself with patriotism and morality; they distrusted anything that smacked of extravagance or luxury, which they associated with Old World decadence; and they had little tolerance for the fantastic or the idealized, insisting that modern landscape painters paint "real" landscapes. Within these limits, aristocratic patrons followed the lead of their British counterparts. Thus they often couched their preferences in terms of British aesthetic theory, resorting to associationalism and the familiar aesthetic categories of the sublime, the beautiful, and the picturesque.[29]

Cole could paint landscapes that were patently "American," and this satisfied his patrons' demand for patriotic subject matter. But he also managed to suffuse his landscapes with a variety of romantic feeling that was unlike anything that had appeared in American art. Trumbull knew what he was talking about: his own attempts to paint a sublime Niagara looked leaden by comparison with Cole's work. The productions of contemporary topographical landscapists like Thomas Birch or Alvan Fisher, although often extremely skillful, lacked Cole's intensity and refinement of feeling. By comparison with the work of a deliberately romantic contemporary like Thomas Doughty, however, Cole's paintings seemed specific and "real." Doughty's scenes usually dissolved into a hazy indefiniteness and exuded an obvious, calculated sentimentality. Cole was far more precise in his evocations of landscape and far more authentic in his expression of romantic feeling.

That feeling was either subtly nostalgic or saturated with potential violence. The American landscapes Cole first painted often appeared virtually untouched—inhabited, perhaps, by a furtive deer or crossed by a solitary traveler or Indian. The America Cole portrayed in these early paintings was rarely the America of his own time. Rather, it was "real" landscape cast in the past tense:

the land restored to its pristine appearance. Thus in his *Kaaterskill Falls* of 1826 Cole eliminated the observation platform and guard rails that had been set up to guide the steps of nature lovers; and at the falls' edge he inserted in place of the contemporary tourist a member of an older tribe long vanished from the region.[30]

Let me put the matter somewhat differently: Cole began by painting American scenery in a manner that appealed to the aristocracy's growing capacity for nostalgia. Classes or social groups in decline often exhibit a tendency to dwell upon the past. By portraying American scenery as it might have appeared decades earlier, Cole evoked a time when the frontier was up the Hudson and the land, unthreatened by the inroads of commerce and industry, offered limitless opportunities to an aristocracy in the making. The "realism" of Cole's paintings, upon which his patrons so insisted, only served to make the evocation more convincing.

Cole shared with his aristocratic patrons a historical vision that was retrospective and nostalgic. Such a vision could engender powerful longings for the untouched wilderness of the early frontier. But it could also involve a sense of a more complex historical development, a sublimated or mythic version of the actual history of aristocracy's slow rise and precipitous fall. Thus nostalgia for America's primitive beginnings could alternate with longings for an idealized agrarian society—a society presided over by an aristocratic elite. Like his patrons, yet with even greater fervor, Cole yearned for such an agrarian utopia. But inevitably he was caught between myth and reality, between a romanticized version of the past and the reality of an unromantic present. The ideal society he imagined was no longer possible. The days of aristocratic ascendancy were over. Almost everywhere industrialization and democracy had triumphed.

The aristocratic outlook I have been describing made itself felt almost everywhere in Cole's work. For example, the violence and anguish he brought to his paintings of sublime nature resulted as much from a sense of history as from a penchant for romantic psychodrama. Into his portrayals of the sublime Cole infused a sense of doom and tragic grandeur. Nature was at once a violent escape from the nightmare of history and a sublimated version of the same nightmare; an abrupt denial of historical experience and yet, at times, a celebration of whatever history of heroism aristocracy could claim. In Cole's hands the sublime became a vehicle for evocations of wild American nature untouched by settlement or industry; for recreations of the dramatic struggle to tame the wilderness, as in his painted illustrations to the novels of James Fenimore Cooper; and for depictions of the violence the process of civilization could wreak on nature, and vice versa.[31]

Cole brought the same historical pessimism to bear in paintings encompassing the beautiful and the picturesque. Thus his pastorals that translated into the

idiom of American landscape the tradition of Claudian pastoral: here pathos re-
sulted not so much from a sense of the transforming effects of time as from an
apprehension of the violent changes material progress would bring. The scene
was often softened by a haze of nostalgia, as if Cole were recalling the appear-
ance of a landscape already destroyed. Thus his *View on the Catskill, Early Au-
tumn* of 1837 had about it the atmosphere of a lost Arcadia. Six years later, as if
to confirm his forebodings, Cole painted a second version in which he included
a recently built rail line as well as a prominent tree stump—ubiquitous symbols
of industry, settlement, and material progress.[32]

Even Cole's topographical landscapes could be imbued with a sense of histor-
ical loss. In 1839, when Stephen Van Rensselaer's heirs decided to sell off their
Watervliet estate, William P. Van Rensselaer hired Cole to paint a final, back-
ward glance. In his commissioning letter William wrote that he knew of no artist
"who can do justice to nature like yourself."[33] Cole did not disappoint him. The
paintings he produced, nostalgic yet deliberately restrained in their nostalgia,
were elegies for an aristocracy and a way of life forever lost.

We come now to Cole's history paintings. In these works the artist made explicit
the aristocratic outlook embodied in his landscapes. The *Course of Empire* se-
ries (figs. 4.2–6) furnishes an obvious example. Completed in 1836, it was Cole's
most ambitious work and the fullest expression of his historical beliefs, in partic-
ular his belief in the cyclical theory of history. From this theory he derived the
shape of his series as well as its message.

The cyclical theory of history achieved popularity in the aftermath of the
French Revolution. During the 1820s and the 1830s it remained current in a
number of popular literary works, most notably Byron's *Childe Harold.* What ac-
counted for the theory's appeal? Like most historical theories, the cyclical the-
ory could be adapted to a variety of outlooks, but it proved especially well suited
to the ideological needs of aristocracy in decline. The theory could be used to
explain the course of contemporary history and, at the same time, to oppose and
condemn that history. It thus could speak for those who felt that revolution or
democracy or material progress had brought the world to the brink of disaster.

The theory asserted that moral law governs history, engendering endless
cycles of rise and fall. These cycles result from man's inherent sinfulness. Thus,
according to the theory, wealth gives rise to avarice while political liberty leads
to pride and limitless ambition. These violations of moral law in turn hasten the
cycle forward to disaster. Civilizations become corrupt and fall. Centuries pass
and new civilizations arise to begin the cycle once more.

We can begin to grasp Cole's intentions in *The Course of Empire* by consid-
ering in some detail *The Consummation of Empire,* the series' largest and most

Figure 4.2 Thomas Cole, *The Course of Empire: The Savage State,* 1834. Oil on canvas, 39¼ × 63¼ inches. Collection of the New-York Historical Society.

important painting (fig. 4.4). *The Consummation* portrayed in allegorical terms the results of democracy and industry. With its vast crowds hailing the triumphant return of a popular hero (Jackson in antique garb?), it suggested democracy sliding into demagogy and mob rule.[34] At the same time, *The Consummation* moralized economic progress. Cole meant the painting to embody "all that can be combined to show the fullness of prosperity."[35] Thus he depicted a great city ("*a la mode* N York," he wrote, only half in jest[36]) overflowing with wealth and luxury. *The Consummation* was, in effect, a conservative moralist's picture of laissez-faire capitalism: the system, no longer inhibited by traditional social or religious restraints, prospers, but its growing accumulation of wealth is accompanied by increasing pride and avarice and a corresponding loss of moral fiber. Thus *The Consummation* represented the corrupting process that leads directly to the empire's downfall. In *Destruction* the weakened empire succumbs to invading barbarians (immigrants? rebellious workmen? rioters?) who rape, plunder, and ruin. Cole's moral becomes even clearer when we contrast *The Consummation* with the preceding *The Pastoral of Arcadian State*. This shows an agrarian or pastoral utopia—an ideal society in which men live harmoniously with nature and each other. In the context of cyclical history *The Pastoral State* stood for aristocracy's recent past, a *temps de l'harmonie* now gone.

Cole's depiction of the cyclical process closely paralleled the views that had been set forth in 1821 by the members of the old Federalist elite. They too had

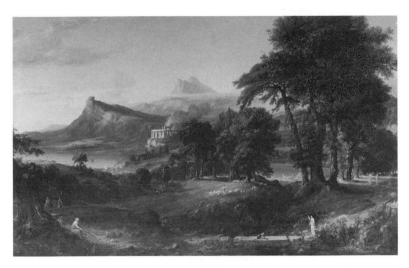

Figure 4.3 Thomas Cole, *The Course of Empire: The Pastoral or Arcadian State,* 1834. Oil on canvas, 39¼ × 63¼ inches. Collection of the New-York Historical Society.

used a moralizing vision of history to oppose the expansion of democracy and the growth of industry. They too had suggested that democracy would let loose "passions which have disturbed and corrupted the rest of mankind."[37] And they had predicted that corruption would set in motion a tragic historical cycle of the sort Cole later portrayed.

The aristocracy had maintained that the cyclical process could be arrested, or at least retarded. This was their rationale in resisting popular rule. *The Course of Empire*, conceived after the aristocracy had gone down to political defeat, was far more pessimistic. In the series cyclical history was never contingent, its outcome never in doubt. Thus the series could not be read as a warning, as if Cole were calling for a rebirth of morality in order to stave off disaster. Rather, the series flatly asserted that disaster was inevitable, that the nation was doomed. This was harsh prophecy, and to be accepted at all by Cole's contemporaries it needed to be reduced to something more sentimental: a lesson in resignation, perhaps, or a dissertation on the futility of worldly endeavor. Indeed, the melancholy *Desolation*, which served as the series' finale, performed such a reduction. But the series as a whole was more fatalistic than sentimental, and its fatalism offered little in the way of consolation. Or rather, what consolation it offered was the consolation of all determinist schemes: the cold comfort of knowing that human destiny lies beyond the reach of human will, that past and future simply obey history's one or two unchanging laws.

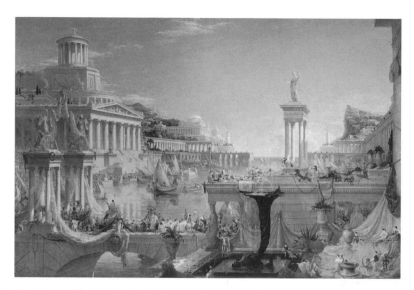

Figure 4.4 Thomas Cole, *The Course of Empire: The Consummation of Empire,*
1835–36. Oil on canvas, 51¼ × 76 inches. Collection of the New-York Historical
Society.

The Course of Empire embodied two interconnected themes: history's cycles
and mankind's inherent sinfulness. Cole returned to these themes again and
again. They constituted, throughout his career, an outlook and an obsession.

Man's fall was the theme of Cole's first series, *The Garden of Eden* and the *Expulsion from the Garden.* Later, in the evangelical *Voyage of Life* series (figs. 4.7–10), the artist preached a sermon in pictures on sin and salvation. Shortly before his death, he was at work on a second Bunyanesque series, this one entitled *The Cross and the World.* Like The *Voyage of Life,* The *Cross and the World* contrasted the road to salvation—"the way of the cross"—with the vanity and hopelessness of "the way of the world."[38]

As part of a dominant ideology, the theme of sin and Christian salvation applied, at least in theory, to all classes, appealed to all tastes. But cyclical history, Cole's other obsession, required an aristocratic outlook for its meaning to be fully appreciated. Cole understood the different implications of his themes. Anticipating a popular audience for *The Voyage of Life,* he deliberately resorted to techniques derived from popular art.[39] By contrast, such works as *The Departure* and *The Return* and *Past* and *Present* epitomized a rarefied aristocratic outlook and taste.

The two series represented in allegorical disguise the situation of aristocracy in decline, idealizing aristocratic strength and authority while mourning the

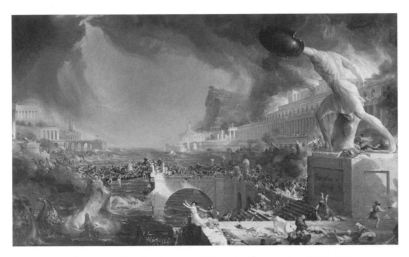

Figure 4.5 Thomas Cole, *The Course of Empire: Destruction*, 1836. Oil on canvas, 33¼ × 63¼ inches. Collection of the New-York Historical Society.

passing of that strength, that authority. They thus provided an aristocratic audience with a way of coming to terms with feelings of loss and defeat. The two series have been called "gothic elegies."[40] They were, more precisely, elegies for America's fallen elite.

Cole painted *The Departure* and *The Return* for William Van Rensselaer, the Patroon's second son and heir to half the Van Rensselaer estate. This commission led to Peter G. Stuyvesant's order for *Past* and *Present*. Like his friend Van Rensselaer, Stuyvesant was a wealthy landlord of high social standing.[41] Patronage of this sort might suggest that a demand existed for Cole's history paintings. But in reality the artist's eagerness to create historical works far outstripped the demand. This turned his career into a tormented search for patronage, the artist forever engaged in the humiliating business of writing prospectuses and describing in fine detail historical subjects he hoped to paint. These efforts almost always failed. Even the ultra-aristocratic William Van Rensselaer resisted Cole's proposal for *The Departure* and *The Return*, although he liked the paintings well enough once they were completed.[42]

Cole's career revolved around this impasse: the artist wanting support for his history paintings, his aristocratic patrons generally withholding it. Patronage is now often conceived of in terms of the patron's benevolence or good will. Such a conception implies that patronage involves nothing more than a harmonious working out of a mutually profitable exchange. But the artist-patron relationship is never so simple. It is defined more by contradictions and conflicting interests

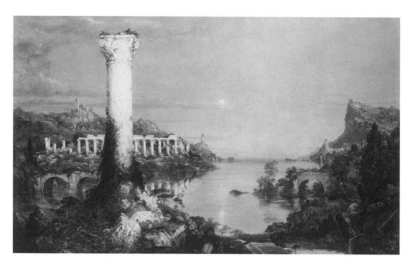

Figure 4.6 Thomas Cole, *The Course of Empire: Desolation,* 1836. Oil on canvas, 39¼ × 63 inches. Collection of the New-York Historical Society.

than by any sort of harmony. The impasse at the center of Cole's career throws some of those conflicts into relief: the needs that generated patronage as well as the interests and ambitions that made patronage impossible.

On the surface, Cole's relations with his aristocratic patrons started out harmoniously enough. The artist demonstrated his ability to satisfy even the most demanding aristocratic taste, and his patrons responded with traditional noblesse oblige: as the American Academy was their academy, so Cole was their artist, and they watched over his career, especially its earlier phases, with a concerned and jealous eye. They invited him into membership in their clubs; on occasion they entertained him in their homes; and almost unfailingly they treated him with gentlemanly respect. Taste, it might be said, prompted their actions. But the category "taste" disguised a host of interested motives. These were rarely articulated. Instead the aristocracy justified its support for Cole's art in patriotic terms, as usual equating its particular interests with those of the nation as a whole.[43]

Cole identified with the aristocracy but enjoyed neither its privileges nor its social rank. Thus he came to understand the rules of patronage in a way his aristocratic patrons could not. Being a gentleman, he would tolerate no disrespect, nor would he suffer any overt reminder of his inferior status. But he also knew what genteel pretensions of equality were worth. Although he might disagree

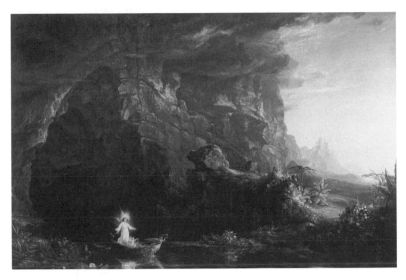

Figure 4.7 Thomas Cole, *The Voyage of Life: Childhood,* 1839. Oil on canvas, 52 × 78 inches. Munson-Williams-Proctor Institute Museum of Art, Utica, N.Y.

with a patron's taste or attempt to influence a choice of subject, he was always careful to strike a prudent balance between self-assertion and the deference his patrons expected.[44] This may have galled him, but it never drove him to the error of underestimating his debt to them. Patronage, as he knew, put him in a situation in which all his actions acquired a double meaning. Did he feel gratitude toward a patron? No matter; expressions of gratitude, heartfelt or not, could secure a patron's loyalty. Did he wish a particular commission? Perhaps a little flattery would help. Sentiment never blinded him. He took his patrons' measure with a cool, self-interested eye. Even the lofty Van Rensselaer family was not exempted. In December 1837, Cole informed his wife that he had *"axed* [William Van Rensselaer] $1000 a piece"* for the two paintings of *The Departure* and *The Return.*

The built-in compulsions of the artist-patron relationship go some way toward explaining Cole's behavior. He was, of necessity, dependent upon his patrons, and he got what he could out of them. Yet we would be wrong to conceive of Cole's interests in purely material terms. Much more was at stake: a career, a whole identity as an artist.

Most nineteenth-century artists arrived at their careers via an education that defined them at every step of the way. Cole began his career by defining himself. He had no teachers, no formal education. What technique he possessed he acquired from the study of books and paintings, and from a laborious process of

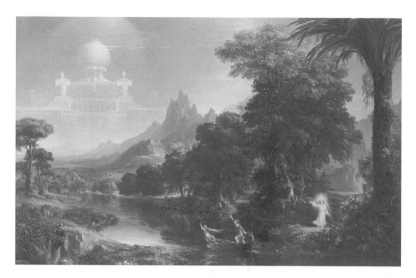

Figure 4.8 Thomas Cole, *The Voyage of Life: Youth,* 1840. Oil on canvas, 52½ × 78½ inches. Munson-Williams-Proctor Institute Museum of Art, Utica, N.Y.

trial and error.[46] His contemporaries were amazed that he was self-taught, but this is not what concerns us. An autodidact constructs an identity within himself. A fully worked-out identity probably existed in Cole's mind long before it made itself felt in the world. By conventional standards he was entirely, even astonishingly, successful. This unusual success might at first have led to feelings of omnipotence, as if he could will any identity he chose. But eventually it might have had just the opposite effect, intensifying his frustration, for in terms of the identity he had imagined he had only partially succeeded. Certainly it was frustration, not feelings of inadequacy or fulfillment, that marked his career.

As part of his self-education Cole imbibed the prevailing art ideologies of the day. Very early he studied Reynolds's *Discourses* or similar texts. From them he acquired his faith in Neoplatonic aesthetic theory as well as his belief in the traditional academic hierarchy that placed history painting at the summit of artistic aspiration. He became, in short, an academic without the benefit of an academy. This allowed for unusual spontaneity and inventiveness, but it also loaded him with a set of impracticable values. To these he clung to the end of his days.

Cole's early, traumatic experience of the industrial revolution determined the direction his artistic and intellectual development would take. The growth of industry was always a pressing issue: it represented for him the central crisis of contemporary society, and in almost all of his undertakings it was never very far from his thoughts. The problem was to understand industrialization, to find

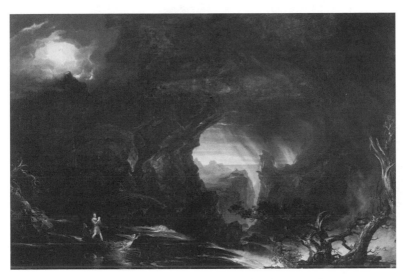

Figure 4.9 Thomas Cole, *The Voyage of Life: Manhood,* 1849. Oil on canvas, 52 × 78 inches. Munson-Williams-Proctor Institute Museum of Art, Utica, N.Y.

some way to make something comprehensible out of his experience of it. This was the attraction of theory: it could pull together the bits and fragments of experience and shape them into a coherent whole. Theory could provide a means of redeeming experience, of gaining power over it.

This, in part, explains Cole's attraction to cyclical theory. But we still must ask: why did he choose this particular theory? I have said that Cole came to cyclical theory via his identification with the aristocracy. Now I can put the matter more precisely: because of his background he identified with the aristocracy at the moment in its history when it had been most opposed to industrialization. It was just at that moment that it had resorted to the cyclical theory of history to justify its position. Of course, Cole was also deeply attracted to the theory's other features, perhaps above all to the way it fused politics, economics, and religion into a comprehensive historical perspective. The theory explained not only the past but, like all historical theories, the present. Yet without its implicit condemnation of the industrial revolution, it never would have appealed to him.

Because it so well answered his needs, accommodated his beliefs, Cole adopted the cyclical theory, grasping it with an autodidact's intensity. Cyclical history became an idée fixe. He never gave it up. This was not the case with his aristocratic patrons. Because they derived their ideas of history from their experience as members of a class, they could be far more flexible. Their own history

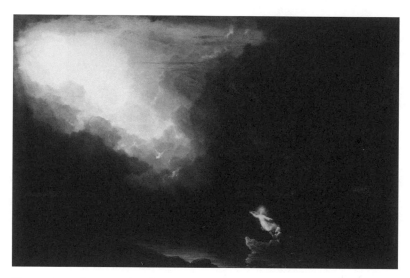

Figure 4.10 Thomas Cole, *The Voyage of Life: Old Age,* 1840. Oil on canvas, 51¾ × 78¼ inches. Munson-Williams-Proctor Institute Museum of Art, Utica, N.Y.

consisted of adapting to circumstances, and they tailored their beliefs accordingly. Thus they often practiced a reflexive intellectual opportunism, entirely reversing their ideas when convenient. Their attitude toward industrialization furnishes, in this respect, a striking illustration.

The New York Federalists had always been devoted to trade and finance, but in the early 1820s they still viewed industry as a threat to their interests, in particular the interests of landed property.[47] Within a few years, however, their attitude underwent a dramatic change. Manufacturing had begun to return substantial profits, and the New York Federalists were not slow in discovering that there was no real antagonism between the interests of manufacturing and those of land ownership. Prominent Federalists enrolled in the movement for "domestic industry." Even the Patroon, the landowners' knightly standard-bearer, was moved to found the Rensselaer School (today Rensselaer Polytechnic), which was devoted to training young men in the application of science to industry. The decade beginning in 1825 witnessed a rapid expansion of manufacturing and a windfall in profits. By the decade's end, all save the most obdurately conservative members of the aristocracy had arrived at the conclusion that manufacturing was as respectable as any other way of making money.

This change of attitude connected with others. The members of the old elite had learned that in the long run the destruction of aristocratic privilege, even the destruction of aristocratic ideology, did not spell their ruin as a class. Their

worst fears failed to materialize. Thus they no longer had any need of a cyclical theory of history to explain or justify their position. They might recall with nostalgia a more genteel time or bemoan their loss of privilege, but they did not feel as apprehensive as they once did about the future.

For Cole, the results of these changes amounted to disaster. He had arrived at his belief in cyclical history a few years after most of his aristocratic patrons had discarded it. Thus when he began to seek from them support for *The Course of Empire*, none was forthcoming. In the end he had to look elsewhere for patronage.

The response to the series was also symptomatic of the aristocracy's changed outlook. Cole exhibited the paintings in New York in the fall of 1836, and he was gratified, as he noted in his journal, that the series gave "universal pleasure." With its sublime landscapes and its wealth of fascinating detail, *The Course of Empire* offered up all the pleasure of popular spectacles like the panorama. Cole's intentions, however, were not widely appreciated. Before the exhibition the artist had gloomily forecast that "very few will understand the scheme of [the paintings]—the philosophy that may be in them." As it turned out, sympathy, not understanding, was the missing ingredient. If anything, the series was too well understood, or so we may conclude from the most widely read criticism of it. This appeared in the *New-York Mirror*, a popular weekly devoted to culture and the arts, and read by the whole of fashionable society. ("Worth a dozen of the *Knickerbocker*," grouched Philip Hone, a *Mirror* devotee.) The *Mirror* published a total of five notices, including one that appeared more than a year in advance of the series' New York debut.[52]

In his earliest article the *Mirror*'s critic professed limitless admiration for "our great, our truly great landscape-painter," and for the as yet unfinished *Course of Empire*: "Claude never conceived any thing so truly poetick." Once Cole exhibited the series the critic continued to applaud the artist's abilities and poetry, but he disputed the cyclical theory of history at every opportunity, again and again insisting that the artist had merely shown "*that* which *has been* in all past times." To Cole's pessimism he opposed the official optimism of the day. This rested on the twin ideological pillars of American democracy and American material progress. The critic maintained that democracy was the antidote to the cyclical process, thus entirely undermining Cole's intentions. Describing *The Consummation*, he argued that "the climax in the course of man's progress, which Mr. Cole has here represented, is *that* which *has been*, and was founded on the usurpation of the strong over the weak: the perfection which man is hereafter to attain, will be based upon a more stable foundation: political equality; the rights of man; the democratick principle; the *sovreignty of the people*." Democracy and material progress would bring about an "empire of love," the result

of mankind's advance along "the road to greater *and greater* perfection." Of such utopian imaginings did the gospel of progress consist, but there was now almost no one from the old aristocracy who would publicly dispute such claims.

What sympathy there was for Cole's series came from expected quarters: the remnants of the ultraconservative landlord faction. Thus the series' exhibition inspired William Van Rensselaer to express his "admiration for the genius exemplified in the 'Course of Empire,'" which made him "extremely desirous of possessing two landscapes from [Cole's] pencil."[53] A year after Cole's death, James Fenimore Cooper produced a lengthy account of the series for Noble's biography of the artist. This account was, without doubt, the most sympathetic critical treatment the series ever received. Cooper began by endorsing the cyclical theory (which had played so large a role in his own writings), and then went on to heap enormous praise on Cole's paintings: "Not only do I consider the Course of Empire the work of the highest genius this country has ever produced, but I esteem it one of the noblest works of art that has ever been wrought. . . . The day will come when, in my judgment, the series will command fifty thousand dollars."[54]

One question remains: under what conditions did Cole manage to obtain backing for his history paintings?

Generally speaking, two motives govern patronage. The patron wants works of art that reflect or promote his way of looking at the world. (This is often complex; for example, today a patron's Weltanschauung may include not only history but also the history of art.) Or the patron wants works that will function as status objects. In this case art symbolizes wealth, taste, good breeding—in short, membership in a particular social group or subgroup.[55]

In theory, these two motives—ideology and status—are distinct; in practice, however, the distinctions tend to blur. Patron are rarely in the habit of sorting out their motives. Often the needs that motivate patronage can be hidden from the patron himself and tracing motives becomes a frustrating business. This was not the case with the patrons who commissioned Cole's largest series, *The Course of Empire* and *The Voyage of Life*. Their motives can be deduced from the circumstances surrounding their commissions and, to some extent, from the works themselves.

The Voyage of Life was commissioned by the banker Samuel Ward.[56] Ward came from an aristocratic New England family impoverished by the Revolution. He began his working life in 1802, at age sixteen, and before he was twenty he was the director of Nathaniel Prime's banking house. Under the name Prime, Ward and King, the firm achieved a worldwide reputation, and by the 1830s Ward was New York's "leading private banker."[57] Ward played a central role in

the bank wars that began with the panic of 1837, and in alliance with Albert Gallatin he succeeded in defeating Nicholas Biddle's attempts to raid the New York money market and close the city's banks. But his efforts cost him his health; by the end of 1839 he was dead.

Ward belonged to the transition from the aristocracy of birth to the aristocracy of money. Although he moved easily in the world of the old Federalist elite, his instincts were sharper, his character more austere and religious, his methods more rigorous and unsparing. He maintained a close social tie with the Astors (his son Sam married John Jacob Aster's granddaughter Emily), who were already well known for their ruthlessness. Thus he used his connections with the aristocracy to develop a fashionable neighborhood in the area around the intersection of Broadway and Bond Street, selling lots to judges, clergymen, bank directors, and merchants (Philip Hone was one of the buyers).

Yet great wealth made Ward uneasy. His wife's death in 1824 precipitated a crisis of conscience.[58] He underwent an unexpected conversion, becoming an ardent "Evangelical" or low church Episcopalian. His home took on a puritan aspect. Tobacco was banned, his wine cellar was locked. "He became all of a sudden a total abstinence man," recalled the worldly Philip Hone, "at a time of life when the experiment was dangerous."[59] He also became in 1831 first president of the New York Temperance Society. His contributions to charity grew. Previously he had given to the aristocracy's usual causes. Now he "turned his attention to the moral and religious conditions of the poor."[60] His interest in education also increased. He had been a trustee of Columbia College and an active member of the New-York Historical Society, both favorite institutions of the old elite. Now he worked to establish new schools. He was a founder of New York University and the Stuyvesant Institute. Religious education especially concerned him. He donated large amounts to Bishop McIlvaine's Kenyon College and to other Episcopalian educational and missionary efforts.

Ward owned an art collection that included portraits of his ancestors by Smibert and Copley as well as a number of Spanish paintings with mythological and religious subjects: the dying Hercules, the penitent Magdalene.[61] These were installed in the picture gallery attached to his Bond Street mansion. Ward probably thought of his paintings very much in terms of education and spiritual uplift. He used his gallery as a "Meditation Room" and saw to it that it played a role in his children's upbringing. By the late 1830s he probably wanted a work of art that accorded with his own religious outlook; or at least he believed that a work like The Voyage of Life would be a useful addition to his collection. The circumstances under which he met Cole were not recorded. However, artist and patron seem to have been made for each other. Cole never practiced a piety as elaborate as Ward's, but he held similar religious views. He was partial to the

Episcopal Church and, coming from a background of religious dissent, he too inclined to low church evangelism.

Thus the artist found the patron he had been looking for, and the patron found the artist he needed. *The Voyage of Life* would perfectly suit Ward's evangelical temper. Moreover, the series would be (and was) a fitting response to the ongoing financial panic. With its feverish drama of a helpless voyager learning lessons in the futility of worldly aspiration and saving himself through faith in the Almighty, the series gave pious shape to the hopes and fears of thousands during the 1840s and 1850s—turbulent times of economic uncertainty and increasing social unrest. But to Ward the series offered no solace: his death came long before the series was completed.

Religious belief inspired Ward's patronage. There is no reason to believe that he expected to gain much prestige from his commission, or at least no more prestige than went with an additional proof of his already well-known piety. This was not the case with Luman Reed, Cole's patron for *The Course of Empire*. For Reed, prestige was almost all that mattered.

Reed (1784–1836) had risen from clerk in a Coxsackie store to successful merchant in the wholesale grocery trade, from which he retired with a fortune at the age of forty-eight. Art collecting was by then his chosen entrée to respectability. He began by buying old masters of doubtful authenticity. In 1832 Philip Hone held an exhibition of American paintings from his collection, and Reed, taking a cue from the fashionable Hone, switched to living American artists. The collection he rapidly amassed was housed in a specially constructed gallery of his Greenwich Street mansion. The gallery, which was opened to the public once a week, was half museum, half patriotic shrine; besides the collection of American landscape and genre paintings, it featured Asher B. Durand's portraits of all seven Presidents, not excepting Andrew Jackson, whose features Durand had painted from life.[64]

Reed met Cole shortly after the artist's return from Europe in November 1832. Cole had mounted an exhibition of his latest work at the American Academy; Reed visited the exhibition and soon afterwards obtained an introduction to the artist. This led to a commission for an Italianate landscape. Cole probably already knew of Reed's interest in American artists. In any case, he soon came to see in Reed an opportunity to realize his plans for *The Course of Empire*. The work of persuasion was quickly accomplished. In September 1833, Cole was writing Reed with characteristic tact about "the desire you expressed that I should paint pictures to fill one of your rooms," and describing "a favorite subject that I [have] been cherishing for some years." Reed immediately replied that he was "gratified" to offer Cole an opportunity to execute "a favourite design."[65]

As his gallery took shape, Reed became more and more deeply involved with Cole and the other artists he employed. He enjoyed their company on a regular basis, visiting Cole at his Catskill home and traveling to Boston with Durand in order to meet Washington Allston. In his letters Reed kept telling Cole that Durand "certainly is one of the few of the finest good fellows in this world."[66] This sort of closeness and bonhomie would have been unimaginable in Cole's more aristocratic patrons. For Reed, however, the company of artists compensated for a lack of education and social grace. With his artists he could play the part of a humble Maecenas, applauding their efforts and gratefully acceding to their requests.

Reed closely followed Cole's progress on *The Course of Empire,* supplying emotional as well as lavish financial support. His enthusiasm for the series was, if anything, too warm: "If you have changed [*The Consummation*] to please yourself better, it must produce the same feeling in me to a much greater extent."[67] As the project neared completion, artist and patron corresponded with increasing frequency. And yet, despite his concern for all the details of the work, Reed gave no indication in his letters that he sympathized with, or even comprehended, Cole's purpose.

For Reed it was enough to be known as a benefactor of American art. This was his goal, and it was for this that he was known and remembered. And yet his commission for *The Course of Empire,* although it very well suited his needs, turned patronage into a comedy of incomprehension. Or perhaps we might see in it a minor tragedy, one in which ideology takes its usual revenge. For what else are we to say of a situation in which a self-made merchant paid a small fortune to a self-taught artist for paintings that elaborately mourn the passing of an aristocracy to which both merchant and artist aspired and to which neither could ever belong?

With *The Course of Empire* and *The Voyage of Life,* the interests of artist and patron coincided, at least to some degree. But Reed and Ward were exceptions. At his death Cole was working on *The Cross and the World,* the series which he intended to be larger than anything he had previously attempted. *The Cross and the World* had no patron—or rather the patron was the artist himself.

What can we conclude from this? Historians have emphasized Cole's frustration. Looking back, the artist saw his career as one long rebuff, a squandering of his talent, and he knew where to lay the blame. "I am not the artist I should have been, had taste been higher," he wrote in a now famous *cri de coeur.* "For instead of indulging myself in the production of works such as my feelings and fancy would have chosen—in order *to exist* I have painted to please others."[68] These words sound like an epitaph for Cole, or perhaps for any artist. Yet Cole's

patrons would not have read them with any feelings of remorse. They were not in the habit of losing sight of their interests, and they knew with some precision of what use an artist might be to them. Noblesse oblige required no more than what they had done. They had nurtured the artist to serve their needs, not his. In the end it was their needs, their taste that always mattered.

Notes

This essay is a shortened version of an article published in *Arts Magazine* 56 (November 1981): 94–106.

1. See Dixon Ryan Fox, *The Decline of the Aristocracy in the Politics of New York, 1801–1840,* ed. Robert V. Rimini (1919; rpt. New York, 1965); and Arthur M. Schlesinger, Jr., *The Age of Jackson* (Boston, 1945), chap. 2, "End of Arcadia."

2. S. G. Goodrich, *Recollections of a Lifetime* (New York City and Auburn, N.Y., 1857), 1: 239. Goodrich came from a Federalist background and in his youth moved in the highest aristocratic circles. In his *Recollections* he argued that Federalism was "useful and necessary in its day." But he was also aware of Federalism's built-in defects. Hence the humor that pervades his account and the understanding he shows of the fundamental differences between Federalists and Democrats.

3. Cited in Fox, *Decline,* 34.

4. J. Fenimore Cooper, *The Chainbearer* (New York, 1873), viiif.

5. See Fox, *Decline,* 146f. For a more detailed account of voting qualifications, see Douglas T. Miller, *Jacksonian Aristocracy, Class and Democracy in New York, 1830–1860* (New York, 1967), 11f.

6. See Fox, *Decline,* 34.

7. See ibid., 31–56; also see Henry Christman, *Tin Horns and Calico* (New York, 1945), 1–14.

8. In Nathaniel H. Carter, William L. Stone, and Marcus Gould, *Report of the Proceedings and Debates of the Convention of 1821* (Albany, 1821), 220.

9. A great many authors have dealt with eighteenth-century British political theory and its impact on American political thought. See, for example, Gordon S. Wood, *The Creation of the American Republic* (Chapel Hill, 1969), esp. the chapter on republicanism (pp. 46–90). See also the writings of J. G. A. Pocock, in particular *The Machiavellian Moment: Florentine Republican Thought and the Atlantic Tradition* (Princeton, 1975).

10. See Fox, *Decline,* 416–18. De Tocqueville, who visited the United States in 1831–32, witnessed first-hand the aristocracy's retreat, which he described with characteristic hyperbole: "The rich prefer to abandon the [political] lists rather than carry on an often unequal struggle with the poorest of their fellow citizens. Unable to take a place in public life analogous to the one they occupy in private, they abandon the former for the latter. They form within the state something like a private society which furnishes its own special tastes and enjoyments." Alexis de Tocqueville, *De la démocratie en Amérique* (Paris, 1951), 1: 183 (my translation).

11. Louis L. Noble, *The Course of Empire, Voyage of Life and Other Pictures of Thomas Cole, N.A.* (New York, 1853), 16. For Cole's family and the Lancashire middling class, see A. Wallach, "The Ideal American Artist and the Dissenting Tradition: A Study of Thomas Cole's Popular Reputation" (Ph.D. diss., Columbia University, 1973), 108–23.

12. The story of a mortifying fall from one's real or imagined station in life is a familiar one for the nineteenth century: for example, Dickens's obsession with the year he spent as a child working in a blackening warehouse while his father was imprisoned for debt.

13. William J. Stillman, *The Autobiography of a Journalist* (Boston, 1901), 1: 112.

14. In attempting to work out the relationship between the artist and his patrons, I have relied on Marx's theoretical formulations between a class and its "political and literary representatives." See Karl Marx, *The Eighteenth Brumaire of Louis Napoleon,* anon. trans. (New York, 1963), 51.

15. Information about Cole's beginnings in New York from Noble, *Course of Empire,* 53–59; William Dunlap, *History of the Rise and Progress of the Arts of Design in the United States* (1834: rpt. New York, 1969), 2: 359f. For Trumbull, see Irma B. Jaffe, *John Trumbull: Patriot Artist of the American Revolution* (Boston, 1975).

16. Dunlap, *History,* 2: 279f. (italics in the original).

17. Ibid., 360.

18. See Cole's notebook dated 1825, Detroit Institute of Arts (hereafter DIA), no acquisition number, pp. 36f. Howard Merritt, "'A Wild Scene,' Genesis of a Painting," *Baltimore Annual* 2 (1967, published 1969): 11f., first drew attention to Cole's debt to Trumbull and reprinted the text of a letter dated Nov. 14, 1825, in which Trumbull informed Rober Gilmor, Jr., of Baltimore that "a young man of the name T. Cole has just made his appearance here from the interior of Pennsylvania who has surprised us with landscapes of uncommon merit." Gilmor became one of Cole's most important backers. Merritt printed the extensive Cole-Gilmor correspondence as an appendix to his article (hereafter Cole-Gilmor correspondence). Throughout his life Cole remembered Trumbull as his "true and early friend," as he said in a letter to Benjamin Silliman of Nov. 11, 1839 (collection of the Historical Society of Pennsylvania), cited by Ellwood C. Perry III, "Thomas Cole's Ideas For Mr. Reed's Doors," *American Art Journal* 12 (Summer 1980): 38.

19. The Trumbull and Wadsworth families had been allied since the mid-eighteenth century, and Daniel Wadsworth was married to Faith Trumbull, John Trumbull's niece. For the works Cole executed for Wadsworth, see Esther Seaver, *Thomas Cole, 1801– 1848, One Hundred Years Later,* exh. cat. (Hartford, 1948), 5f., 20f.; Howard Merritt, *Thomas Cole,* exh. cat. (Rochester, 1960), 22. For Wadsworth's correspondence with Cole, see the Cole Papers, New York State Library (hereafter NYSL), available on microfilm at the Archives of American Art.

20. Dumas Malone, ed., *Dictionary of American Biography* (New York, 1943), 1: 621–26 (hereafter *DAB*); see the letter of introduction from Daniel Wadsworth to Thomas Cole, Feb. 10, 1835, Cole Papers, NYSL.

21. Goodrich, *Recollections,* 2: 122–24. Goodrich purchased Cole's *Daniel Boone and His Cabin at Great Osage Lake* of 1826 (Mead Art Museum, Amherst College); see Merritt, *Cole,* 22.

22. Cited in Allan Nevins's preface to Philip Hone, *Diary* (New York, 1929), x. Biographical information from Nevins's preface and *DAB*, 9: 192.

23. See Hone, *Diary,* 839; Cole's letter to Hone of Nov. 27, 1833, Cole Papers, NYSL; Dunlap, *History,* 1: 360.

24. Information from William Bertrand Fink, "Stephen Van Rensselaer" (Ph.D. diss., Columbia University, 1950); Fox, *Decline,* 32f.; Christman, *Tin Horns and Calico,* 1–24. Van Rensselaer, even more than most Federalists, had reason to revere Hamilton's memory. A portrait of 1825 attributed to Chester Harding shows Van Rensselaer with Ceracchi's bust of Hamilton as well as a painting-within-a-painting of Federalism's long dead founding father. See *Catalogue of American Portraits in the New-York Historical Society* (New Haven and London, 1974), 2: 832f.

25. Daniel D. Barnard, *A Discourse on the Life, Service and Character of Stephen Van Rensselaer* (Albany, 1839), 35.

26. Fox, *Decline,* 4, 32f.; *DAB*, 19: 211f.

27. See letter to Cole, July 5, 1828, Cole Papers, NYSL; notebook, DIA, 39.558a, pp. 30, 36.

28. See Trumbull's letter to Gilmor cited above, n. 18.

29. Robert Gilmor was probably the most articulate and demanding of Cole's patrons. His ideas are readily available in his extensive correspondence with the artist. For an early study of Cole and Gilmor's views and their implications for the history of American art, see Barbara Novak, "Thomas Cole and Robert Gilmor," *Art Quarterly* 25 (Spring 1962): 41–53. An enormous amount has been written about Cole and aesthetic theory. See, for example, Earl A. Powell III, "Thomas Cole and the American Landscape Tradition," *Arts Magazine* 52 (February 1978): 114–23; 52 (March 1978): 110–17; and 52 (April 1978): 113–17.

30. Information about *Kaaterskill Falls* from Merritt, *Cole,* 22.

31. The parallels between Cole and Cooper have been often studied. See, for example, Donald Ringe, "James Fenimore Cooper and Thomas Cole: An Analogous Technique," *American Literature* 30 (March 1958): 26–36.

32. Kenneth J. LaBudde, "The Rural Earth: Sylvan Bliss," *American Quarterly* 10 (Summer 1958): 152f., was the first to study the relationship between the two paintings. For discussions of the paintings and train and tree stump symbolism, see Barbara Novak, *Nature and Culture: American Landscape and Painting, 1825–1875* (New York, 1980), chap. 8; and Kenneth W. Maddox, "The Railroad in the Eastern Landscape: 1850–1900," in *The Railroad in the American Landscape,* exh. cat. (Wellesley, Mass., 1981), 17ff.

33. See letter of July 18, 1839, from William P. Van Rensselaer to Thomas Cole, Cole Papers, NYSL. The two paintings are in the Albany Institute of History and Art.

34. Cole may have had in mind the frenzied welcome—"a dozen Fourth of July celebrations rolled into one"—accorded the President on his visit to New York on June 12, 1833. Gore Vidal draws a striking picture of the event in *Burr* (New York, 1974), 30f. For Jackson's reputation, which inspired charges of demagogy, see John William Ward, *Andrew Jackson, Symbol for an Age* (New York, 1955). I would add that the idea that democracy leads to demagogy and mob rule was a standard feature of Platonic and Neo-

platonic thought. Plato's arguments against the development of democracy in Athens furnished authoritative precedents for later aristocratic apologias.

35. From Cole's prospectus for the series in his letter to Luman Reed, Sept. 18, 1833, Cole Papers, NYSL.

36. Letter to Luman Reed, Sept. 7, 1835, Cole Papers, NYSL (Cole's italics).

37. See above, n. 14.

38. See Merritt, *Cole*, 42f.

39. See Alan Wallach, "The *Voyage of Life* as Popular Art," *Art Bulletin* 59 (June 1977): 234–41.

40. Ellwood C. Parry III, "Gothic Elegies for an American Audience: Thomas Cole's Repackaging of Imported Ideas," *American Art Journal* 8 (November 1976): 26–46. This article reviews Cole's literary and pictorial sources for the two series.

41. Information from the *Catalogue of American Portraits the New-York Historical Society* (New Haven and London, 1974), 2: 783f.

42. William P. Van Rensselaer commissioned Cole to paint two landscapes in a letter of Dec. 10, 1836, but serious discussion only began the following fall. In reply to Cole's letter (Oct. 15, 1837) describing the series, William wrote (Oct. 19, 1837) that he was not particularly interested in the subject but consoled himself with the thought that "the agreeable impression made by a picture depends on the artist entirely: I remember an old painting very much admired & prized representing a man at work on a corn on another's toe." What Cole made of this mixture of philistinism and flattery history does not record. Van Rensselaer, however, apologized in a subsequent letter (Nov. 1, 1837). All letters are in the Cole Papers, NYSL.

43. See Lillian B. Miller, *Patrons and Patriotism* (Chicago, 1966), 8–23, for a discussion of the "nationalist apologia."

44. This is most fully revealed in the Cole-Gilmor correspondence.

45. Letter to Maria Cole, Dec. 6, 1837, Cole Papers, NYSL (Cole's italics). The letter continues: "Was not I courageous? He said he had not anticipated any amount so great but now he saw the pictures and knew what labour they had cost me he was satisfied."

46. In "The Ideal American Artist and the Dissenting Tradition," 187–89, I discuss Cole's use of William Oram's *Precepts on the Art of Colouring in Landscape Painting* (London, 1810). This book, probably more than any other, provided Cole with a basis, a "schema," for his painting.

47. See Fox, *Decline*, chap. 10, for a more detailed account of the history summarized here.

48. Cole described his plans to Gilmor in a letter of Jan. 29, 1832, written from Florence, Cole-Gilmor correspondence, 72–74. Gilmor somewhat reluctantly agreed to accept Cole's *Wild Scene* (Baltimore Museum), a first version of *Savage State*, as payment for the money he had advanced the artist for his European trip. But Gilmor had no interest in sponsoring the series. It is likely that Cole also approached Daniel Wadsworth.

49. Journal for Oct. 29, 1836, in Noble, *Course of Empire*, 223. The series also netted the artist more than $1000 in exhibition receipts.

50. Letter of March 6 (misdated March 26), 1836, NYSL, in ibid., 216f.

51. *Diary*, p. 86.

52. *New-York Mirror* 12 (April 18, 1835): 330; 14 (Oct. 22, 1836): 135; 14 (Oct. 29, 1836): 142; 14 (Nov. 5, 1836): 150; and 14 (No. 12, 1836): 158.

53. Letter of Dec. 10, 1836, Cole Papers, NYSL. Van Rensselaer also mentions that his brother-in-law, a Mr. Wilkins, "has a small painting by you which pleased me exceedingly." But it was, doubtless, *The Course of Empire* that most impressed him.

54. Letter to Louis L. Noble, Jan. 6, 1849, DIA; printed in Noble, *Course of Empire*, 224–35, with a few passages omitted.

55. For a discussion of the relationship between history and art history as it evolved in the eighteenth and nineteenth centuries, see Carol Duncan and Alan Wallach, "The Universal Survey Museum," *Art History* 3 (December 1980): 448–69.

56. For biographical information about Ward, see *DAB*, 19: 438f.; Louise Hall Tharp, *Three Saints and a Sinner* (Boston, 1956), 1–74; and Julia Ward Howe, *Reminiscences, 1819–1899* (Boston and New York, 1899).

57. See Schlesinger, *Age of Jackson*, 252f., 264; and Joseph A. Scoville, *The Old Merchants of New York City* (New York, 1889), 2: 196.

58. See Howe, *Reminiscences*, 43–55, on Ward's conversion.

59. Hone, *Diary*, 433.

60. "Samuel Ward," *National Encyclopedia of American Biography* (New York, 1895), 435.

61. See Tharp, *Three Saints*, 74.

62. The only document concerning the commission is the "Agreement between Samuel Ward of New York and Thomas Cole . . ." of March 21, 1839, Cole Papers, NYSL. For further information about the series, see Seaver, *Thomas Cole*, 27–30, and Merritt, *Cole*, 34–37.

63. Information about Reed's life from *DAB*, 15: 453; Wayne Craven, "Luman Reed, Patron: His Collection and Gallery," *American Art Journal* 12 (Spring 1980): 40–59; Russell Lynes, "Luman Reed, A New York Patron," *Apollo* (February 1978): 124–29. For an account of Reed's life that suggests the sort of posthumous reputation he achieved via his gallery, see Scoville, *Old Merchants*, 5: 35f.

64. Craven, "Luman Reed," 46f. The gallery also included a collection of minerals, seashells, etc. See Ellwood C. Parry III, "Thomas Cole's Ideas for Mr. Reed's Doors," *American Art Journal* 12 (Summer 1980): 33–45. Parry suggests that the inclusion of natural history made Reed's gallery a *Wunderkammer*. No doubt Reed's inspiration came from the Peale Museum in Philadelphia, which similarly combined art, patriotic portraiture, and natural history.

65. Cole to Reed, Sept. 18, 1833, Cole Papers, NYSL; Reed to Cole, Sept. 23, 1833, DIA. The commission for an Italianate landscape is mentioned by Noble, *Course of Empire*, 173.

66. Letter to Cole of June 16, 1835; compare letter of Jan. 6, 1836, where Reed uses almost the identical formulation. Both letters are in the Cole Papers, NYSL.

67. Letter of Jan. 15, 1836, Cole Papers, NYSL.

68. Undated fragment, probably ca. 1847, Cole Papers (box 4, folder 2), NYSL (Cole's italics).

5 "A Correct Likeness": Culture and Commerce in Nineteenth-Century Rural America

David Jaffee

> Were I to begin life again, I should not hesitate to follow this plan, that is, to paint portraits cheap and slight, for the mass of folks can't judge of the merits of a well finished picture. . . . Indeed, moving about through the country . . . must be an agreeable way of passing one's time . . . it would besides be the means of introducing a young man to the best society and if he was wise might be the means of establishing himself advantageously in the world. *John Vanderlyn, letter to John Vanderlyn, Jr., 1825*

In 1825 John Vanderlyn, an academic artist, wrote to his nephew in upstate New York, encouraging him to join the ranks of itinerant portrait makers "moving through the country," who were providing "cheap and slight" images for the "mass of folks." Images of the "primitive sort" of portrait makers abound in the collective American consciousness. Academics and antiquers agree upon a vision of self-sufficient farmers and isolated country craftsmen. Instead, John Vanderlyn offers a unique vision of the steady commercialization of the northeastern countryside.[1]

A "correct likeness" of the rural North in the several decades after the War for Independence portrays the lives of rural Americans in the context of their changing agrarian society. Culture and commerce changed together during these years when itinerant artisans and their enthusiastic customers abounded in the villages of the northern United States. Careers in commerce were followed by changes in domestic decor when both rural producer and consumer aspired to bring "elegance" into the ordinary farmhouse. The lives and works of rural portrait makers provide a perspective on the process of commercialization in the countryside, for in their careers they followed the path of numerous other village artisans who emerged from a rural economy, and in their likenesses they offered striking images of the stenciled chairs and colorful shelf clocks with which farmers filled their households when they aspired to urbane gentility in a rural idiom.

Artisan-entrepreneurs were crucial in transforming the rural North during these years. The absence of a rigid artisan system in the countryside, together

with a growing population increasingly interested in consumer goods, enabled displaced farm boys to pick up a variety of trades and travel along a myriad of roads in search of what John Vanderlyn called "the means of establishing [oneself] in the world." They reworked production in numerous crafts and promoted consumption in a dynamic village scene. By drawing on their training as artisans, and by using the power sources and labor organizations already at hand to develop simple, time-saving inventions, country craftsmen facilitated the manufacture of mass consumer goods for a widening circle of customers. They began to manufacture chairs, clocks, carpets, and books, as well as portraits, and to introduce rural denizens to products previously accessible only to urban dwellers and the local gentry. These rural artisans moved gradually but steadily toward the status of artisan-entrepreneurs: market-oriented purveyors of "cultural" commodities who both anticipated and helped pave the way for the back country's industrial revolution.[2]

A few provincial limners like Reuben Moulthrop were able to satisfy the limited demand of those at the top of village society for "correct" portraiture at the close of the eighteenth century. In the new century the numbers of these rural artists with their popularly priced offerings dramatically increased when peddlers such as Chester Harding and James Guild took to the road and brought together producer and consumer in distant villages in an era of developing tastes. Obtaining their artistic training from the pages of design books or from brief encounters with portraitists "of the primitive sort," portrait makers like Rufus Porter traversed the countryside, creating countless images ranging from stark black-and-white silhouettes to colorful full-length oil paintings. Critics like John Neal shared in the euphoria that greeted an inexperienced audience's desire for colorful commodities of all sorts—chairs, clocks, and carpets, too—previously only available to urbanites or aristocrats. In the second quarter of the nineteenth century, itinerants like Erastus Salisbury Field became innovators in a village vernacular to meet the demand (and lower the price) for their offerings. These artisan-entrepreneurs experimented with the rapid (sometimes mechanically aided) manufacture of likenesses with stylized designs that standardized their products, but they distinguished their subjects by the inclusion of personal items. They traveled the backroads of the rural North to cultivate a ready market for their services among "middling" craftsmen, innkeepers, and improving farmers who sought symbols of middle-class identity.

The experience was not without its ironies. Enterprising portrait makers seemed to welcome the new opportunities presented by the intensification of craft production. Some even embraced the daguerreotype after its invention in 1839. Few could have imagined that the very innovations they helped advance would eventually make their calling obsolete. Yet, in the meantime, along with

their audience, they helped forge a new and commercialized rural art world. In a modern nostalgia for a vanished time and place—peopled with Yankee peddlers and primitive painters—the moderns have overlooked some puzzling questions about this golden age of homespun. When and how did a world of scarcity suddenly give way to a new world of abundance? Why and how did an industrial order, ruled by manufacturers and filled with consumers, so dramatically replace a vast region populated with agriculturalists? Finally, the most vexing question of all remains: How was the War for Independence followed by an equally revolutionary cultural revolution, a Village Enlightenment, which transformed rural America from a region resistant to change into one eager to embrace it?[3]

A handful of limners was evidently sufficient to satisfy the demands for portrait making in eighteenth-century New England society. The village gentry, eager to satisfy their social designs, drew upon the outlines of the academic art of the period. In the closing years of the century, figures like Winthrop Chandler and Ralph Earl found the wealthy country set in New York, Connecticut, Massachusetts, and Vermont eager to have their family portraits painted. Chandler translated for his neighbors the available forms of "correct" portraiture into their own idiom. He profiled the severe New Englanders with bold line and colorful design—the stock devices of the provincial artisan—and added individualizing details such as books, furniture, and clothes (fig. 5.1). The next generation of artisan-entrepreneurs would continue Chandler's quest to satisfy rural tastes with an artisan's training.[4]

The provincial elite wanted a family record, similar in purpose to, but grander in style than, the genealogies bound into treasured bibles or hung on bare household walls. When the younger Reverend Mr. Robbins of East Haven, Connecticut, first commissioned limner Reuben Moulthrop to paint his parents' portraits in 1801, he had no idea that such an ostensibly simple undertaking would involve substantial delays or details. Moulthrop needed more than a decade to complete a series of seven portraits, for which he received thirty dollars. He was continually coming in and out of the Robbins household. "My study was resigned up and looked like a painters' shop," the elder Reverend Mr. Robbins impatiently wrote to his son, "he is constantly in the hall with all his apparatus &c.," but his work is "much admired." Completion of the portraits restored the sanctity of the Robbins' home only temporarily; the popularity of the portraits brought a steady stream of curious visitors, "day after day as into a Museum—all agree are admirably drawn."[5]

Those able to afford the services of Chandler or a Moulthrop were the magistrates and ministers: the established gentry in village society who found in such family icons the means to display their personal possessions and family status while decorating their homes in one of the few permissible modes in this still

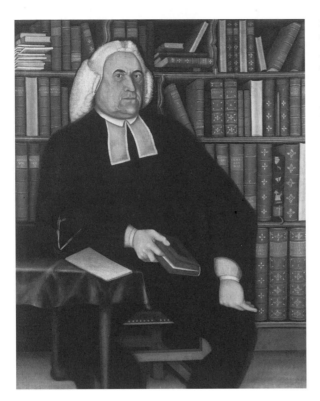

Figure 5.1 Winthrop Chandler, *Rev. Ebeneezer Devotion*, c. 1770. Oil on canvas, 54½ × 43½ inches. Devotion House, Brookline Historical Society, Brookline, Mass.

intensely Puritan culture. Just as the steady sequence of generations of Robbinses called to the pulpit provided vocational continuity, so the portraits (the Reverend Thomas Robbins hoped) would yield visual evidence of family traditions. A "gallery" of notable Robbinses introduced into rural society the cosmopolitan images heretofore available only to the urban elite, and provided the village population with a model to emulate. Still, the rural portraitist remained on the periphery of a metropolitan culture in which the urban-elite looked abroad and the local townspeople busied themselves with their everyday concerns. Aspiring eighteenth-century limners, few in number and limited in influence, were the forerunners of later generations of portrait makers.

In the opening decades of the nineteenth century the limner of the previous century gave way to artisan-entrepreneurs who, by their geographic and social mobility, banished local isolation and conservatism in the rural North and promoted consumption. In 1825, as part of this Village Enlightenment, an anonymous rural encyclopedia came off the presses in Concord, New Hampshire. Entitled *A Select Collection of Valuable and Curious Arts, and Interesting Experiments Which are Well Explained, and Warranted Genuine, and May be Pre-*

pared, Safely and at Little Expense, this work covered various topics in the arts, manufactures, and science of interest to "improving" country craftsmen. The author, Rufus Porter, painter and promoter, represents in his far-reaching travels and speculations an example of the artisan-entrepreneur's critical role in the change penetrating the countryside during this period.[6]

As a publicist for ideas of rural design, Rufus Porter transmitted the rules necessary to paint landscapes on walls or to change the color of animals. These were no idle speculations of academicians but specific recipes garnered from Porter's experience and reading. In his work—both writing and painting— Porter placed repetition and rule at the very heart of the country vernacular. He made sure-footed suggestions for introducing into every American home the "embellishments" that John Neal, America's first art critic, thought would eventually improve American art. Porter emphasized color and line, both accessible to precise measurement in careful proportions. The farmhouse frescoes he envisioned had no room for the romantic shadowing or sublime scenery of the cosmopolitan set.

Indeed, "improving" villagers wanted working farms and practical details on their walls. Just as some rural artisans used machines (such as lathes) to produce ever-greater quantities of chairs and clocks, enterprising artists like Porter experimented with new machines and techniques (such as stencils) to massproduce images. It was the same basic process of accelerating the manufacture of consumer goods. There existed "a decided disposition for painting in this Country," John Neal wrote in 1829; "you can hardly open the door of a best room anywhere, without surprizing or being surprized by the picture of somebody plastered to the wall, and staring at you with both eyes and a bunch of flowers." Such portraits, "wretched as they are," flourished "in every village of our country," not as luxuries for the rich but as familiar household furniture, embellishing the homes of ordinary people.[7]

Rufus Porter offered the readers of his *Select Collection* both recreation and "improvement in useful knowledge" (fig. 5.2). A section of "Landscape Painting on Walls of Rooms" starts not with a discussion of the beauties of the natural scene but with the direction to "dissolve half a pound of glue in a gallon of water." Porter's book derived from earlier volumes such as Hezekiah Reynolds's *Directions for House and Ship Painting,* where Reynolds wrote for "the Cabinet and Chair Maker, the Wheelwright, the House and Ship Joiner," but recognized others whose taste and genius might make them interested in the practice of "this useful and ornamental Art." These art instruction books were itinerant instructors in print. Porter's popular *Curious Arts* (which went through five reprintings) taught the arts founded on craft techniques and practiced by laymen. For Rufus Porter, like his readers, "the arts," "experiments," and "expense"

Figure 5.2 Rufus Porter, *Portrait of a Man*, 1830–35. Watercolor and ink, 4 × 3 inches (unframed). Abby Aldrich Rockefeller Folk Art Center, Williamsburg, Va.

were not odd words incongruously collected into an eye-catching title. This artist-inventor was the rural counterpart to Robert Fulton, promoter of the steamboat, and Samuel F. B. Morse, creator of the telegraph. These individuals moved easily between the worlds of art and science, finding their spatial and mechanical imaginations to be thoroughly compatible with their creative and entrepreneurial efforts. By his early twenties Porter had demonstrated expertise as author, artist, and inventor. He counted a "camera obscura" among his innovations. Other inventions were more fanciful—for example, a "horseless carriage" and an "airship."[8]

Porter found his greatest success on the road. Accompanied by a young relative named Joe, he strolled into villages with his brightly decorated camera box and hawked his handbill of reasonably priced portraits (fig. 5.3). The artisan-entrepreneur sketched his subjects with the aid of the camera obscura, a dark box fitted with a lens and mirror to throw the sitters' image onto a sheet of paper and mounted on a handcart festooned with flags. Porter and Joe traveled from village to village, offering the public a full range of "correct likenesses," produced with Porter's mechanical aids and guaranteed to provide satisfaction. A typical Porter announcement of 1832 promised:

> The Subscriber respectfully informs the Ladies and Gentlemen of Haverhill and its vicinity, that he continues to paint correct Likenesses in full Colours for two Dollars at his room at Mr. Brown's tavern, where he will remain two or three Days longer.
>
> (No Likeness, No Pay.)
>
> Those who request it will be waited on at their respected places of abode.

He advertised his profiles at twenty cents apiece, producing perhaps twenty silhouettes in an evening by the use of a profile machine for the features; or the popular side view in which "full colours" were added to the stark profile (although the construction of the ears and clothes was skimpy); or his most detailed full view in which the camera obscura reduced his artistic labors to a mere fifteen minutes. These last images cost three times as much as the side view but still showed the subject's ears in full profile, a short cut preserved from his side views. Copies came cheap. Porter's *Select Collection* gave instructions for "the construction and use of a copying machine" or pantograph, which reduced, enlarged, or copied images. The client could choose an affordable original along with as many copies as desired. Porter created a standardized product with the aid of his mechanical inventions and labor-saving techniques. Rural clients got just as much "art" as they were willing to pay for.[9]

As the demand for embellishment diffused through the countryside and through various social strata in the second quarter of the nineteenth century, a

Figure 5.3 Handbill for Rufus Porter, 1820–24. Broadside, 8⅝ × 5⅛ inches. Courtesy of the American Antiquarian Society, Worcester, Mass.

new look appeared in rural design. Itinerants were encouraged to seek further schooling and assume a more professional bearing. Country tastes became more sophisticated and village residents began demanding more polished products from their local vendors. When Fitchburg, Massachusetts, was visited in 1832 by a practitioner of "the noble art of painting," there was great cause for rejoicing among its citizenry. An entire generation had grown up admiring portraits and venerating the vocation of painting likenesses. The anonymous author of an article on "painting" in the *Fitchburg Gazette* noted the uplifting effects of popular portraiture on the rural folk. The mysteries of painting no longer involved the mere copying of features but went well beyond to "transferring to canvas . . . the feelings of the heart." The appearance of gentility was available to all from this "gentleman now stopping in our village." Paintings that could produce such results were created in a standardized manner. By the 1830s, the visitor to the painter's studio remarked that "some half dozen or more" likenesses resting along the walls of the rural salon, "tho' unfinished," would clearly in their final form become the distinguished visages of their intended patrons. Families were invited to the painter's village salon to obtain "a valuable picture" as well as "a

correct likeness," for there would rarely be such an opportunity "in a village like ours" to participate in the "craze" for household decorations.[10]

Decorative display predominated over geometric perspective in rural portraiture. Whereas the academic artist valued profound psychological insight and varieties of shadows and shading, the rural portrait maker aimed at a plain style in which simplicity and even stark linearity accompanied broad expanses of color and texture. An individual such as Erastus Salisbury Field was able to achieve enormous success within the confines of such rural rules of design. In 1839 Field combined aesthetic and economic motifs in his masterpiece *Joseph Moore and His Family* (fig. 5.4). In the year this portrait was made Field had moved with his family to the home of his wife's parents in the village of Ware, Massachusetts. Living across the street with his wife and children (two of whom were the orphans of his wife's sister) was Joseph Moore from Windham, Maine, hat maker in winter, itinerant dentist in summer, and professor of religion all year round. No one figure or piece dominates; the viewer's eye jumps from the black-and-white-clad subjects to the numerous, profusely painted possessions. The Moores' furnishings arrest attention with their exuberant colors and prominent position; Field carefully balanced children around the adults. The tilted perspective and bright colors of the carpet draw the eye downward from the symmetrical windows at the top of the picture. Field successfully juggles all these items around the stenciled furniture—chairs, stands, and mirror—that completes his study of the Moores' decor. But in 1839, when Field recorded his celebration of the itinerant artisan's achievement—his striking portrait of rural craftsman Moore and his family—a new era was beginning. It was also in 1839 that Samuel Morse returned from Paris with Daguerre's invention.[11]

In 1839 the daguerreotypist's art replaced the "correct likeness" with "perfect likenesses." When T. S. Arthur considered the enthusiasm for photography in 1850, he observed: "From little Bess, the baby, up to great-grandpa!, all must now have their likenesses; and even the sober Friend, who heretofore rejected all the vanities of portrait-taking, is tempted to sit in the operator's chair, and quick as thought, his features are caught and fixed in a sunbeam. In our great cities a Daguerreotypist is to be found in almost every square; and there is scarce a county in any state that has not one or more of those industrious individuals busy at work catching 'the shadoe' ere the 'substance fade.'"[12]

The "Hall of Portraits," formerly the exclusive province of kings and nobility, was now priced to suit every pocketbook and fit comfortably in any room. Daguerreotypes appeared in every corner of the cluttered Victorian household. Although their diverse subjects assumed poses that paralleled the homogeneity of the new national culture, their owners—especially the members of the new

Figure 5.4 Erastus Salisbury Field, *Joseph Moore and His Family*, 1839. Oil on canvas, 82¾ × 93¼ inches. Courtesy of the Museum of Fine Arts, Boston, gift of the M. and M. Karolik Collection of American Paintings, 1815–16.

elites emerging in village society—were members of a generation that expected continual change and returned to the "operator's" chair several times over their lifetime for up-to-date "perfect likenesses" (fig. 5.5). The speed of the photographic process, "quick as thought," matched their desire to record a vanishing set of individuals, places, and modes of life.[13]

The unabated rage for portraits led several painters into attempts to incorporate the new technology. Others, like Erastus Field, at first tried to copy the photograph's appeal and attempted a more realistic likeness. But the photograph's cheaper price and greater verisimilitude put the ordinary portrait maker at a severe disadvantage. A daguerreotypist's broadside from western Massachusetts in 1841 argues that "the value of a portrait depends upon its accuracy, and when taken by this process it must be accurate from necessity, for it is produced by the unerring operation of physical laws—human judgment and skill have no connection with the perfection of the picture. . . . It is evident that the expressions of the face may be fixed in the picture which are too fleeting to be caught by the painter."[14]

Figure 5.5 T. S. Arthur, *The Daguerreotypist.* Courtesy of the Library of Congress, Washington, D.C.

As the availability and portability of the photograph fueled the "craze" for portrait making sweeping the North, other changes occurred in the rural world. The commercial art world of the nineteenth-century countryside grew out of a pioneer soil. The transformation of the late eighteenth- and early nineteenth-century countryside accelerated with the rapid entry of village residents into commercial enterprise. Pioneers of this era began to clear forests to make way for family farms. Crafts had always supplemented a farmer's livelihood and a sizable number of artisans made their living in new frontier towns. One Vermont observer noted how these migrants exchanged their humble "necessaries": "The manufactures carried on in Vermont were, for many years, such only as the immediate wants of the people rendered indispensable, and in general each family were their own manufacturers. . . . The only trades which were deemed

indispensable, were those of the blacksmith, and the shoemaker, and these were for the most part carried on by persons who labored a portion of their time upon their farms."[15]

The shift toward a more elaborate consumerism, which had taken several generations in the eighteenth century, advanced more rapidly on the nineteenth-century frontiers: "As by the condition of the people improved, they by degrees extended their desires beyond the mere necessaries of life; first to its conveniences, and then to its elegancies. This produced new wants, and to supply them, mechanics more numerous and more skillful were required, till at length, the cabinet maker, the tailor, the jeweler, the milliner, and a host of others came to be regarded as indispensable."[16] Even likenesses became a familiar sight on the frontier.

Enterprising farm boys of this generation drew upon their inexperienced audience's amazement at seeing their image appear at the farmhouse door, while artisan-entrepreneurs used their wide range of skills in crafts and commerce to promote painting in rural America. James Guild offers an unusually detailed description of one farm boy's progress in the countryside in the first quarter of the nineteenth century. His *Journal* begins with his first merchandising venture in 1818, when he departed from rural Vermont. By 1824 he was an artist working in a London studio. While his rapid rise in his profession from peddler to profile maker to professor of penmanship to professional artist was certainly not the common experience of every individual who strapped on a peddler's pack to try his luck on the backroads of the rural North in these years, Guild's early adventures probably bear a close resemblance to those of many itinerants in this period and place. He fled the family farm for the West and pursued several trades during his travels in Ohio as a peddler. In encounters with more experienced practitioners of rural arts he picked up instruction in profile making and penmanship and immediately offered his services to the next available and inexperienced soul.[17]

The desire of rural folks to enlighten their minds and embellish their homes encouraged itinerant instructors. Guild's first success at deception encouraged him in further efforts. At a museum in Albany he claimed to have had musical training and his imposture paid off with an offer to join a band for a month and also receive instruction in cutting profile likenesses. Soon he was able to call himself "a profile cutter." Still unsatisfied in his desire to advance his stature and enlarge his pocketbook, Guild sought to rise further in the painting profession. Guild relates how his entry into "a painter's shop, one who painted likenesses" convinced him that "his profiles looked so mean" that he immediately offered five dollars for instruction in "how to distinguish the coulers." Equipped with his new-found skills and one of "Mr. Goodwins paintings for a sample," he set off

"to exert his skill in painting." When he encountered a young lady who would wash his shirt, Guild reciprocated by "daubing on paint on a piece of paper." While his initial foray into painting portraits "could not be called painting," Guild later recalled, for it looked more "like a strangle cat," he informed his patron that "it looked like her and she believed it." Having joined the painting profession, Guild continued on his way, drawing likenesses and teaching school, touting himself as a professor of penmanship. He served, in short, as an itinerant instructor in the useful and elegant arts for a new rural clientele that did not yet demand from retailers of culture either specialized knowledge or fixed residences. Quickly picking up what training they needed, Guild and others capitalized on both rural folk's passion for self-culture and their lack of sophistication.[18]

Artist and audience shared in their "discovery of a new sense." Encouraged by a receptive public, venturesome portraitists undertook more advanced training and gradually assumed the mantle and calling of the professional artist. Other country artisans sought further instruction from academic artists in the cities and returned to the rural regions to ply their trade. Yet rural portrait makers often entered the revered world of art without the rigorous apprenticeship of their provincial predecessors or the solemnity of their academic peers. Chester Harding, for example, soon to be among America's most celebrated portrait painters, in 1806 moved with his family from New England to western New York, "then an unbroken wilderness." When he reached nineteen he thought that "there must be an easier way of getting living" than clearing the "heavily timbered forest." First he looked to chair turning with his brother. When a local mechanic invented a spinning head and offered Harding the rights to sell the patent in Connecticut, opportunity seemed to present itself and Chester "jumped into my wagon, whipped up my horse, and was soon out of sight of what, at that moment, seemed all the world to me." For the next few years Harding supported himself by plying a wide range of rural crafts and commerce along the country backroads. He peddled clocks, established a chair manufactory, and tried tavern keeping. Harding did a stint as a house painter in Pittsburgh and in slow seasons painted signs, a skill allied with gilding, which he had picked up during his days as a chair maker. Next he fell in with a portrait painter named Nelson, one of "the Primitive sort."[19]

Wonder and a sense of mystery came over these "farmers' boys" when they encountered works of art. Harding's mentor Nelson used a copy of the "Infant Artists" of Sir Joshua Reynolds for his sign, incongruously inscribed: "Sign, Ornamental and Portrait Painting executed on the shortest notice, with neatness and despatch." Harding wrote that "painting heads" was the real marvel. After seeing the painter's work, Harding commissioned likenesses of himself and his wife, "and thought the pictures perfections." Taking home what was in fact a

rather crude representation, he pondered by day how it was possible for a man to produce "such wonders of art" and dreamed by night of commencing such a project. Finally, "I got a board; and with such colors as I had for use in my trade, I began a portrait of my wife. I made a thing that looked like her. The moment I saw the likeness, I became frantic with delight; it was like the discovery of a new sense. I could think of nothing else. From that time, sign-painting became odious, and was much neglected." Chester Harding had found his calling. Higher commissions and growing confidence accompanied him on each stage of his journey.[20]

Harding never received any formal art instruction. He attained his increasing proficiency in portraiture by admiring and copying those works of art available in the hinterlands to an itinerant craftsmen: at first those of his mentor in Pittsburgh, "one of the primitive sort," then those of the Kentucky native, Matthew Jouett, who had spent four months in Gilbert Stuart's Boston studio. Finally Harding went to Philadelphia, taking lessons in drawing at the Pennsylvania Academy of the Fine Arts and "studying the best pictures, practicing at the same time with the brush." Harding advanced in the painting profession by drawing upon his patron's desire to emulate eastern traditions.[21]

Harding was drawn to the frontier by a letter from his brother, a chair maker in Paris, Kentucky, who informed him that a portrait maker there was receiving "fifty dollars a head." This price seemed "fabulous" to Harding, but he decided to seek his fortune in the West. He set up a studio, painted his first portrait, and made "a decided hit." Soon he was receiving commissions from the leading citizens in the towns of Paris and Versailles, whose very names indicate the aspirations of the inhabitants. In the next six months, he reported painting nearly a hundred portraits at twenty-five dollars a head. Harding's mounting ambitions outstripped his abilities, as seen in his first large full-length group portrait (fig. 5.6), so he interrupted his travels to study in Philadelphia. The villagers—producers and consumers—were never loathe to take advantage of outside opportunities. They grafted their urban experiences and some cosmopolitan products onto the solid trunk of village culture.[22]

In Philadelphia, a chastened Harding quickly found out his proper station in the art world: "I had thought . . . that my pictures were far ahead of Mr. Jewitt's [sic], the painter my brother had written me about, who received such unheard-of-prices, and who really was a good artist." Harding's estimation of Jouett's work rose, for "their excellence had been beyond my capacity of appreciation." When he returned to Paris in 1821, he found the state of Kentucky in a financial crisis. He set off for Cincinnati, where he found no sitters. Then he moved on to St. Louis, where a letter of introduction to William Clark, Indian agent and gov-

Figure 5.6 Chester Harding, *The John Speed Smith Family*, 1819. Oil on canvas, 100 × 78 inches. Collection of the J. B. Speed Art Museum, Louisville, Ky., gift of William Stucky.

ernor of the territory, secured him an "auspicious . . . beginning," and for fifteen months he was kept constantly at work.[23]

In 1820, Harding made a pilgrimage to paint America's most famous backwoodsman, Daniel Boone (fig. 5.7). He found the elderly Boone "living, some miles from the main road, in one of the cabins on an old-block-house . . . lying in his bunk." He explained the purpose of the visit to the old frontiersman and made a pencil sketch and a small oil study on canvas. Boone "was much astonished at seeing the likeness. He had a very large progeny: one granddaughter had eighteen children, all at home near the old man's cabin; *they* were even more astonished at the picture than the old man himself." Harding produced at least two portraits of Boone; one was a half-length figure wearing a bearskin jacket, and the other a life-sized full-length standing figure holding a rifle, with a dog at his feet. This last image he painted on a table oilcloth, perhaps because it was the only available material large enough for his purpose. Harding was witnessed in his rural salon by George Caleb Bingham, who wrote many years later, after he himself had attained great fame as an artist, of the momentous

Figure 5.7 Chester Harding, *Daniel Boone*, 1820. Oil on canvas, 22 × 17 inches. Massachusetts Historical Society, Boston, gift of George Tyler Bigelow, 1861.

appearance in this frontier town of a renowned artist and of "the wonder and delight with which his words filled my mind impressed them indelibly upon my then unburdened memory."[24]

When Harding returned to St. Louis, the enterprising artist's first order of business was the production and marketing of an engraving of the full-length Boone portrait (fig. 5.8). He may have learned his craft along the rural roads of America, but he had quickly realized the value of combining cosmopolitan training with a rural venue. He advanced his personal fortunes by drawing upon his inexperienced audience's aspirations for emblems of status and a new nation's desire for symbols of stature.

In 1835, in the hinterlands of New York, country editor William Stoddard reflected in his newspaper, the *Rural Repository,* on the state of the arts in America and the countryside's progress toward a national culture. In the traditional hierarchy of the fine arts of portrait, landscape, and history painting, Stoddard viewed portrait painting as "the pioneer of the more exalted arts," the forerunner of "an elevated taste." The *Rural Repository,* a mix of craft traditions

Figure 5.8 James Otto Lewis, *Col. Daniel Boone*, n.d. Stipple engraving after Chester Harding, 11¾ × 8⅟₁₆ inches (image). St. Louis Art Museum, St. Louis, Mo.

and elite aspirations representing a unique document of American culture, closed with a ringing appeal for a new canon based on the most traditional form of ancestor worship. "Need I say more for art," wrote Stoddard, that "permits posterity to stand in the presence of Washington [as painted by Gilbert Stuart] . . . and in this vast household of liberty, makes the remotest descendants familiar with forms and faces of those who laid down all for their country, that it might be dear to their children." Aspirations for identity came from the nascent middle class of the villages, a class only gradually forging its social configuration and still wedded to a rural artistic idiom that stenciled its "elegant" ornamentation and flattened its subjects' features.[25]

The Village Enlightenment in the rural North was thus no simple diffusion of urban goods but a wider cultural movement in the new age of abundance. The bourgeois ethos of antebellum America grew out of rural roots. The diffusion of cultural commodities in this Village Enlightenment of the early nineteenth

century led to a greater desire for display and a confirmation of taste. Enterprising artisan-entrepreneurs used their craft knowledge to offer emblems of status to rural Americans in the first half of the nineteenth century. For the social reality of the nineteenth-century countryside was far more complex than our simple endpoints of farm and factory or neat categories of rural and urban would indicate.[26]

Notes

This is a revised version of an essay first published in *Folk Art and Art Worlds,* ed. John Michael Vlach and Simon J. Bronner (Ann Arbor, Mich.: UMI Research Press, 1986).

Epigraph: John Vanderlyn to John Vanderlyn, Jr., Sept. 9, 1825, in Barbara C. Holdridge and Lawrence B. Holdridge, *Ammi Phillips: Portrait Painter, 1788–1865* (New York, 1968), 14.

1. The literature on portrait makers is voluminous. See Beatrix T. Rumford, ed., *American Folk Portraits: Paintings and Drawings from the Abby Aldrich Rockefeller Folk Art Center* (Boston, 1981); Jean Lipman and Tom Armstrong, eds., *American Folk Painters of Three Centuries* (New York, 1980); John Michael Vlach, *Plain Painters: Making Sense of American Folk Art* (Washington, D.C., 1988); Ellen Miles, ed., *The Portrait in Eighteenth-Century America* (Newark, Del., 1993) and Caroline Sloat, ed., *Meet Your Neighbors: New England Portraits, Painters, and Society, 1790–1850* (Amherst, Mass., 1992).

2. See David Jaffee, "Peddlers of Progress and the Transformation of the Rural North, 1760–1860," *Journal of American History* 78 (September 1991): 511–35.

3. On changes in the cultural infrastructure of the countryside, see Gordon S. Wood, *The Radicalism of the American Revolution* (New York, 1992) and Richard L. Bushman, *The Refinement of America* (New York, 1992).

4. For Chandler, see Lance Mayer and Gay Myers, eds., *The Devotion Family: The Lives and Possessions of Three Generations in Eighteenth-Century Connecticut* (New London, Conn., 1991). Also see Elizabeth Mankin Kornhauser, *Ralph Earl: The Face of the Young Republic* (New Haven, 1991).

5. "Reuben Moulthrop, 1763–1814," *Connecticut Historical Society Bulletin* 20 (1955): 50–51.

6. Rufus Porter, *A Select Collection* . . . (Concord, N.H., 1825), iii–iv. See Jean Lipman, *Rufus Porter, Yankee Pioneer* (1968; rpt. New York, 1980).

7. John Neal, "American Painters and Painting," *Yankee and Boston Literary Gazette* 1 (1829): 45; also see John Neal, *Wandering Recollections of a Somewhat Busy Life* (Boston, 1868).

8. Rufus Porter, *Select Collection*, iii–iv; Hazekiah Reynolds, *Directions for House and Ship Painting* (1812; rpt. Worcester, 1978), 5–6.

9. Advertisement in Lipman, *Porter,* 5; Rumford, *Portraits,* 169–72, for details of Porter's production of portraits.

10. "Painting," *Fitchburg Gazette,* Feb. 14, 1832.

11. Mary C. Black, *Erastus Salisbury Field, 1805–1900* (Springfield, Mass., 1984); see also Rumford, *Portraits,* 93–99.

12. T. S. Arthur, "American Characteristics, No. V. The Daguerreotypist," *Godey's Lady's Book,* May 1849: 352–53.

13. See Alan Trachtenberg, *Reading American Photographs: Images as History, Mathew Brady to Walker Evans* (New York, 1989).

14. Broadside by Anson Clark reproduced in Edna Bailey Garnett, *West Stockbridge, Massachusetts, 1774–1974* (Great Barrington, Mass., 1976), 109. Compare Field's *The Smith Family,* painted twenty years after *The Moore Family* and after Field began painting from photographs; Rumford, *Folk Portraits,* 100–102.

15. Zadock Thompson, *History of Vermont, Natural, Civil, and Statistical in Three Parts* (Burlington, Vt., 1853), 213–14.

16. Thompson, *History,* 214.

17. James Guild, "Journal," *Proceedings of the Vermont Historical Society* 5 (1937): 251, 257–59.

18. Guild, "Journal," 277, 281.

19. Chester Harding, *A Sketch of Chester Harding, Artist,* ed. Margaret Eliot White and W. P. G. Harding (1890; rpt. New York, 1970), 5–6, 11, 13, 17, 18. See Leah Lipton, *A Truthful Likeness: Chester Harding and His Portraits* (Washington, D.C., 1985); William Dunlap, *A History of the Rise and Progress of the Arts of Design in the United States* (1834; rpt. New York, 1969), 2: 289–93.

20. Harding, *Sketch,* 18.

21. Ibid., 24. On Jouett, another portraitist, see William Barrow Floyd, *Jouett-Busch-Frazer, Kentucky Artists* (Lexington, Ky., 1968).

22. Harding, *Sketch,* 22–23; Lipton, *Truthful Likeness,* 54.

23. Harding, *Sketch,* 22–26.

24. Ibid., 26–27.

25. William B. Stoddard, *Rural Repository* 11 (1835), quoted in Ruth Piwonka, *Painted by Ira C. Goodell* (Kinderhook, N.Y., 1979), 3.

26. The reference to the concept of a Village Enlightenment is from David Jaffee, "The Village Enlightenment in the Rural North, 1760–1860," *William and Mary Quarterly* 48 (July 1990): 327–46. The bibliography on consumerism and the development of a bourgeois material culture during the eighteenth and nineteenth centuries is extensive. American studies include Bushman, *Refinement of America* and Cary Carson et al., *Of Consuming Interests: The Style of Life in the Eighteenth Century* (Charlottesville, Va., 1994).

6 *The Painter's Triumph:* William Sidney Mount and the Formation of a Middle-Class Art

William T. Oedel and Todd S. Gernes

In his day William Sidney Mount (1807–68) was a highly acclaimed American artist, "one of the few . . . that deserve to be called painters." His paintings were "of a strictly national character; the pride and boast not only of his native Long Island, nor yet of . . . New-York, solely, but of the whole country." Mount's art is deceptively elementary, seeming to offer thematically benign and stylistically naive images of life down on the farm in the antebellum period. Mount was unique among front-rank American artists in that he refused to study in Europe, fearing that abroad he might lose his nationality.[1] Depending on one's orientation, his willful lack of firsthand familiarity with the Western tradition invests his art with either a lamentable lack of expertise or a laudable lack of affectation. It is possible, however, through a reconstruction of Mount's cultural context, to view his art as his American audience viewed it: original, comprehensible, nationalistic, forceful, and timely. It is original because Mount asserted modern subject matter while synthesizing the grand tradition, the Dutch bourgeois tradition, and American vernacular experience. It is comprehensible and nationalistic because he asserted an unmistakably American genre of local color in positive terms, renouncing the assumption that the efficacy of an American art depended on the degree to which it adhered to European standards. It is forceful and timely because Mount asserted the values of an emerging entity—the American middle class.

The mid-nineteenth century, 1820–60, was a period of tremendous cultural anxiety. Relentless industrialization, immigration, and urbanization undermined the old order, destabilizing a vast class of Americans. As the subversion of tradi-

tional standards generated ideological activity, a middle class that was neither elitist nor vernacular stepped into focus. Increasing numbers subscribed to a view that identified vice with the impersonal, foreign world of machines and immigrants, and virtue with the domestic sphere of home and family. In seeking to control the new, unsettling environment by institutional means, the middle class became a moral community dedicated to perfecting the nation through temperance, abolition, the asylum movement, and other reform crusades. Such values as patriotism, observance of the Sabbath, abstinence, domesticity, modesty, honesty, frugality, industriousness, tidiness, and self-improvement began to have an impact on how middle-class people used their spare time, and the middle class worked to extend those values to the larger community through such voluntary associations and urban institutions as "public schools, lyceums, libraries, museums, and parks." The goal was a homogeneous (white, Protestant) society, a "classless" citizenry whose value system was conspicuously distinguished "from the presumed idleness, extravagance, and dissipation of both the rich and the poor."[2]

Morality, reformism, and middle-class yearnings for social and cultural homogeneity are fundamental to the art of William Sidney Mount. The simplicity of his style, the accessibility of his subject matter and presentation, and the comic import of many of his character types and their interactions do not obscure his reformist attitude. His letters and diaries are peppered with exhortations to exact discipline and self-improvement, and he dealt with temperance in several paintings, domesticity in others, and industriousness and self-culture in many more. Frequently he couched his convictions in terms of contrasts in character types, asking the viewer to weigh the evidence and make a moral choice or, as many of his themes are ambivalent, a moral inquiry. He did, then, play the role of educator and cultural critic, propounding freedom by individual example and arguing through his art for the establishment of a new order based on an emerging middle-class consciousness or ideology.[3] The purpose of this study is to provide a cultural context for Mount's art, to identify Mount with the same moral and humanitarian reformism that generated middle-class consciousness, to define Mount as an educator with a mission, and to demonstrate how Mount transformed the grand tradition of art into plain language with immediate and potentially broad appeal.

Much has been written about the populist nature of Mount's art and its embodiment of democratic principles in the Jacksonian era. His aims are manifest in his diaries: "Paint scenes that come home to everybody. That every one can under stand"; "I must paint such pictures as speak at once to the spectator, scenes that are most popular—that will be understood on the instant"; "Paint pictures that will take with the public . . . never paint for the few, but for the

Figure 6.1 William Sidney Mount, *The Painter's Triumph,* 1838. Oil on mahogany panel, 19½ × 23½ inches. Courtesy of the Pennsylvania Academy of the Fine Arts, Philadelphia, bequest of Henry C. Carey.

many. Some artists remain in the corner by not observing the above." His most populist statement (which brings to mind his immersion in popular music) came in the draft of a speech prepared for the National Academy of Design in 1861: "Painting of familiar subjects has the advantage over writing, *by addressing itself to those who can not read or write of any nation whatever.* It is not necessary for one to be gifted in languages to understand a painting if the story is well told. It speaks all languages—is understood by the illiterate and enjoyed still more by the learned."[4] Such statements, however, attest not so much to a populist dedication to the common man or the working class as to a capitalist drive and pragmatism, a reformist impulse, and a conviction in a homogeneous society that pertain to middle-class ideology.

Mount's philosophy of the function of art in American society is contained in the small panel from 1838 which he entitled *Artist Showing His Work,* but which we know now as *The Painter's Triumph* (fig. 6.1). He painted it on commission

Figure 6.2 Alexander Lawson after William Sidney Mount, *The Painter's Study*. From *The Gift: A Christmas and New Year's Present for 1840*, ed. Miss Leslie (Philadelphia, 1839), facing p. 208. Harris Collection of American Poetry and Plays, Brown University Library.

for the Philadelphia publisher Edward L. Carey, who promoted the establishment of national middle-class art through such enterprises as *The Gift*. That was one of the ornate but affordable, front-parlor species of literature called gift books that featured fiction, poetry, and prints. Indeed, Mount's picture was engraved for *The Gift* in 1839 under the title *The Painter's Study* (fig. 6.2) and was the inspiration for the short story that accompanied it. The copresentation of image and text was a powerful communicator, and thus educator, for the middle class; it had the effect of leveling elitist "unnatural" barriers to social interaction.[5] To Mount and Carey, an American art had to be accessible: the American painter's "triumph" was in equating art with life, mediating between elite and popular cultures.

Mount assured the accessibility of his images in part by typifying his characters and themes. The social relationships that he represented in *The Painter's Triumph* speak of the new order. The artist is, as Mount noted, "showing his picture to a country man—farmer." The farmer is particularized by his whip and clothes; hat, neckerchief, vest, and loose-fitting, cuffed trousers—all in good condition—denote the prosperous yeoman. In contrast, the painter projects the

Figure 6.3 William Sidney Mount, *Bargaining for a Horse,* 1835. Oil on canvas, 24 × 30 inches. Collection of the New-York Historical Society.

urban, cultured type in his "indoors" dress: cravat and frilled shirt, tailed coat, and tapered, tight-fitting pantaloons with stirrups.[6] The contrast establishes that the farmer is a visitor from the natural, physical world outside the artificial, intellectual studio world. Although the figures may represent specific individuals, their identities are unimportant. They are objectified, typecast as character actors. *The Painter's Triumph* is about William Sidney Mount as the new American artist type, but the figure of the painter is not a portrait of Mount. Similarly, the identity of the farmer is of no consequence, but that he is a farmer—and that we can easily see he is a farmer—is crucial to the painting's meaning.

By using typified characters, Mount could instantly convey large amounts of cultural information. In both *The Painter's Triumph* and the earlier *Bargaining for a Horse* (fig. 6.3), which Carey also published as an engraving in *The Gift* in 1839, Mount pictured the then most familiar American character type, the Yankee farmer. Disseminated largely through the comic theater, it was the first in a cast of social types that symbolized the nation at home and abroad.[7] The Yankee character was popular partly because he projected traits that inspired both admiration and condescension. He was naive, but in his ignorance of European and urban customs the Yankee made those customs appear ridiculous in contrast to his own earthy good sense. Endowed with bedrock values, he was the

fully autonomous individual, who intuitively rejected arbitrary standards of authority and behaved on his own terms.

The ingenuousness of the Yankee character type is apparent in *The Painter's Triumph*. The farmer stands as surrogate for every man, assuring, in a kind of conspiracy with the artist, access to the fine arts for all in the democratic society. Even as one of Mount's "favorite" themes was "artists looking over pictures with their friends," it is remarkable that a farmer is the artist's friend and that the farmer should want access to the studio.[8] The artist is visibly excited to show his art to the farmer, and the farmer shares that excitement. In an exultant stance, the artist brandishes brushes and palette in the air, as he gestures with his right hand toward a particular point in the large canvas on the easel. Set on the floor against the easel is a small board, a portable support that almost certainly is a field study for the canvas, an oil sketch made from nature. The farmer bends forward with his hands on his knees to get a closer look. In keeping with the "show-me" Yankee character, the farmer can look toward the board, which records experience familiar to him, in order to verify the corresponding point on the canvas, by which the artist has transformed experience into art and history.

The studio is both a workroom and a sanctum of the muses presided over by no less authoritative a figure than Apollo via the drawing nailed to the wall. In the middle of this world stands the artist. He is keeper of the grand tradition of Western civilization—as encapsulated in the drawing of the Apollo Belvedere— and interpreter of that tradition in his time and place. Although the head of the Apollo is directed away from the easel, toward, one assumes, some loftier drama, the grand tradition is not to be seen as irrelevant to the modern artist. The drawing has disproportionate weight within the composition, is underscored by the artist's pose as well as the arrowlike maulstick and its shadow, and is linked by that stick to the portfolio on the floor from which it likely derived. Near the portfolio in the corner rests a smaller sketchbook or journal, establishing further that the artist's vision is informed by study of both art and nature.

Mount respected the grand tradition, regarding it as the arbiter of taste and propriety. He read ancient history and literature, studied (as late as 1833) plaster casts of ancient sculpture, researched the techniques of the old masters, and was familiar with the philosophy of Sir Joshua Reynolds. Having acquired a classical education, however, he valued originality, veracity, accessibility, and national character as the criteria for art. In *The Painter's Triumph* the drawing of the Apollo signifies the "controlling reason"—the acquired, encultured standard—by which the artist regulates the erratic, daily conduct of human affairs.[9] As guardian of the grand tradition, Apollo may be indifferent to this encounter in the studio, but his presence rightly tempers the artist's vision and ennobles

his achievement. In conceiving of a democratic art, Mount does not reject the grand tradition; instead, under the sign of Apollo, he reinvents classical principles for the modern demos during the age of the Greek revival.

Mount elaborates on the real-ideal dynamic in his composition. The relationships among sketchbook, portfolio, and drawing are visually and thematically hierarchical; so, too, are the relationships between field study and studio composition and between farmer and artist. As the viewer scans from floor to ceiling, the metaphorical transition is from real to ideal, mortal to immortal, present to future and past simultaneously. Thus, in the lower "zone," Mount equates the field study propped against the easel, the farmer, and the sketchbook in the corner; the whip serves as the hyphen connecting sketchbook and field study through the witness of the farmer. Behind the splay-legged farmer is a Windsor chair, suggesting in its own splay-legged contact with the studio floor the grounding of the farmer-observer in the real, mortal world of the present. In contrast, in the upper zone, Mount equates the large studio composition on the easel, the artist, and the drawing of Apollo. The artist's head (intellect and genius), arms and hands (dexterity), and palette and brushes (tools) are the links between drawing and canvas, grand tradition and contemporary relevance. The artist's pose, in contrast to the farmer's, is open and not at all ponderous, as only his left leg seems to bear weight in a stance reminiscent of ancient heroic sculpture.[10] If the farmer pertains only to a lower, earthbound world, the artist, as the fulcrum of the composition, belongs in part to that world and in part to a higher realm that transcends present experience and mortality. Mount validates the interdependence of these relationships by formal means, creating an oblique inner frame, whose corners are sketchbook and drawing on the one side, field study and finished canvas on the other.

While the actors on Mount's stage perform different roles, the viewer is impressed by a generic quality in the faces and expressions of both farmer and artist that documents Mount's theatrical, comic bent and his penchant for masking. As an accomplished role player who projected himself into his paintings, Mount here put on his farmer's mask and costume at the same time he donned his artist's mask and costume. Through masking he revealed his own split personality, his ambivalence specifically toward the city of New York and the country of Long Island. In the city, where he resided during the winter, he attended the theater, exhibited and sold his art, came into contact with a social and artistic elite. In the country, he made his sketches and did his painting. Mount had difficulty reconciling the two worlds: he found the city crowded and unwholesome, but he was bored on the family farm at Setauket.[11] In his art, however, he could meld the two sides of his nature; in *The Painter's Triumph* he made common ground for his two worlds.

Figure 6.4 Phrenological diagram. From Johann Gaspar Spurzheim, *Phrenology; or, The Doctrine of the Mental Phenomena,* vol. 1 (Boston, 1832), frontispiece.

Mount differentiated the character types of artist and farmer by using his knowledge of phrenology, the pseudoscience that purported to reveal an individual's character and the comparative eminence of certain faculties by analysis of the configuration of the skull. Mount owned the 1836 Boston edition of *The Outlines of Phrenology* by Johann Gaspar Spurzheim, the basic text on this subject that engaged the middle-class imagination at midcentury and was nearly required reading for artists. The reader was invited to identify the organs of various faculties on a marked plaster bust and to gauge the prominence of each cranial "bump" (fig. 6.4). In *The Painter's Triumph* Mount portrayed the artist in phrenologically sound terms, stressing features that distinguish the painter, such as widely spaced eyes, arched brows, and protrusions of the forehead above the brows.

According to Spurzheim, Individuality (22) entailed the "knowledge of external objects," which "assists artists in the particulars of their art." Configuration (23), Size (24), Weight and Resistance (25), and Coloring (26) were all deemed

Figure 6.5 *P. P. Rubens*. From Johann Gaspar Spurzheim, *Phrenology; or, The Doctrine of the Mental Phenomena*, vol. 1 (Boston, 1832), pl. 11, fig. 1.

crucial for painters. Perhaps mindful of his own deficiency as a colorist—a deficiency that he labored to overcome and of which he was routinely reminded by critics—Mount emphasized this faculty in the peculiarly arched eyebrows of the artist. "The organ of coloring," Spurzheim explained, "is situated in the middle of the arch of the eye-brow. Its greater development is proclaimed by a full and much arched eye-brow; this external sign, however, is less certain than when the arch is drawn upwards and outwards, so that its outer part is more elevated than its inner." Spurzheim illustrated a portrait of Rubens, the colorist's colorist, which could have served Mount as a model for his portrayal of the artist (fig. 6.5). The faculty of Locality (27) also benefited the artist, as "it makes the traveller, geographer, and landscape-painter, recollect localities." Order (28) gave "method and order to objects . . . as they are physically related." Calculation (29) could "be applied [not only] to size, but also to form, color, and melody," and was pronounced when, as in Mount's portrayal of the artist, "the external angle of the eye-brow is much pressed downwards." Spurzheim defined the organs of Time and Tune (31, 32) as essential to both painting and music.[12]

Mount's interest in phrenology was well known and must have informed his art broadly. Phrenology was a codification of reality that enabled the artist to create a character type appropriate to a particular social drama. It was a tool for the artist, furthering his understanding of nature and his claim to scientific authority, more than it was a map or overlay for the viewer. Phrenology was one determinant of a new literacy based on empiricism, a verifiable language of

signs whose purpose was to codify the norm, undesirable deviations from the norm (such as criminality and lunacy), and desirable variations within the norm (such as genius or specialized talent). Since it held to classify deficiencies as well as normative and positive traits, phrenology was understood as a diagnostic, and thus potentially remedial, reformist agent.[13]

The pseudoscience of elocution was another vehicle for reform central to Mount's formula for a democratic art. Based on the English model, American elocution encoded body language and hand gestures in a system of readily identifiable signs that could transcend the barriers of language and create a standard for public address in an age of oratory. One authority described gesture as "the handwriting of nature," which is "universally legible, without pains or study." Such terms appealed to Mount, who portrayed the artist in *The Painter's Triumph* in a pose denoting enthusiasm and the farmer in an attitude denoting that he has started from repose, both physical and intellectual, having risen from his chair to lean forward in attention (figs. 6.6, 6.7). The painter holds his head high, projecting pride and courage, and extends his arm in authority. The intensity of the painter's enthusiasm for his work is measured in his emphatic gesture: "The greater the *extension* of the arms, . . . the more they express . . . energy of sentiment and feeling, and the more *epic* the character of the gesture."[14] The taxonomy of elocution provided a basic vocabulary of gesture that informed Mount's act of painting and his viewer's act of seeing. Mount employed the principles of both elocution and phrenology—two reformist, behavioral "sciences"—affording homogeneous patterns of conduct for the middle class—in forging an art accessible to a broad public.

Mount's artist—and Mount himself—is a secular equivalent of the preacher, propounding reform through individual example and moral suasion. Indeed,

Figure 6.6 *Enthusiasm.* From Henry Siddons, *Practical Illustrations of Rhetorical Gesture and Action* (1822; rpt. New York, 1968), fig. 48.

Figure 6.7 *Starting from Repose*. From Henry Siddons, *Practical Illustrations of Rhetorical Gesture and Action* (1822; rpt. New York, 1968), fig. 8.

Mount's conception of a democratic art parallels innovations in pulpit oratory emerging at the same time. The unrehearsed, spontaneous quality of the artist's enthusiasm and his direct relationship with his audience find counterparts in the "new measures" of revivalist preaching, as promulgated especially by Charles G. Finney in rural New York in the 1820s and 1830s. In his widely circulated *Lectures on Revivals of Religion* (1835) Finney urged preachers in their sermons to emphasize the second person, short sentences, simple language, parables from daily life, and an extemporaneous manner of delivery punctuated by impassioned gestures. Despite his later interest in spiritualism, Mount was not a religious evangelist; as a moralist with a mission, however, he developed devices of presentation that had much in common with modern tactics of evangelist preaching.[15]

Having made his point so economically in *The Painter's Triumph,* Mount did not need to reveal what is painted on the canvas. Its size and proportions suggest a figural scene or landscape, while the sizes and proportions of the canvases turned toward the wall at left and right suggest a landscape and a portrait, respectively.[16] In this way Mount may have envisioned the painter as a master in three main branches of realism. The figures, props, and composition attest that the proper concern of the American artist is to draw on the grand tradition in order to discover beauty and truth—a measure of the ideal—in present experience; his concern is to educate, to offer moral instruction. The artist's "triumph" is in mediating between contending forces: city and country, culture and nature, the elite and the vernacular, reason and intuition, "fine" art and "common" experience, concept and percept, past and present. As he assimilates these energies, Mount creates a middle-class aesthetic based on classic, democratic ideals of order, accessibility, and moral rectitude.

His classic bias is made clear in the design of the painting, which is planar, measured, and harmonious—an idealizing intellectual exercise. Mount constructs a stagelike box space and uses a bare-bones perspective grid of orthogonal floorboards and rectilinear forms to impel focus upon the artist's head.[17] In a manner typical of many Dutch Baroque painters, he allows the human interaction to circumscribe, centralize, and interiorize the field, so that even his outdoor scenes read as rooms or stages (see fig. 6.3); rarely does he suggest by his design that the activity extends beyond the frame. The result is that his scenes are accessible to the viewer, who feels comfortable within these spaces scaled to human proportions and who finds company in these rooms.

Mount was knowledgeable about Dutch and Flemish painting, which he studied primarily through prints, just as he studied the work of William Hogarth, Thomas Rowlandson, George Morland, and David Wilkie. Dutch art of the seventeenth century was an apt model for his art, as it embodied compatible national characteristics and asserted the direct study of nature and daily life over idealized formulas. The Netherlands that had emerged after independence was, like Jacksonian America, a Protestant, materialistic, mercantile nation that esteemed personal liberty, promoted moral and humanitarian reform, and gave identity to a middle class. In *The Painter's Triumph* Mount actualized many of the formal and thematic terms defined in genre interiors and courtyard scenes by Pieter de Hooch, Jan Steen, Adriaen van Ostade, and especially David Teniers the Younger, with whom commentators frequently compared him.[18]

While Mount's subject and pictorial construction derive from a type established by Rembrandt and his followers, they find current parallels in *The Flatterer and the Painter,* an engraving in *Select Fables* by Thomas and John Bewick (fig. 6.8). The Bewicks' illustrated fables, conceived for popular consumption in London in the late eighteenth century, were reprinted and widely available in the early nineteenth century. Mount may have known of them; certainly his painting resembles the Bewicks' print in the shallow space, the reference to the classical tradition in the background, and the arrangement of easel, artist, visitor, and chair. Equally pertinent as a parallel for Mount is that the Bewicks' designs illustrate moralizing sermonettes; in this case the text advises, "Flattery can never corrupt any man, who does not flatter himself first."[19] Mount stocked his journals with such moralizing, reformist adages, and they were central to his paintings: *The Painter's Triumph* is emblematic of the artist's moral obligation to produce art available to the emerging middle class.

One may appreciate the radical import of Mount's democratizing principle by comparing *The Painter's Triumph* with *The Artist,* an engraving published in *The Boudoir Annual,* another gift book, in 1845 (fig. 6.9). The British painter Alfred Edward Chalon depicted two figures within a shallow, stagelike space,

Figure 6.8 Thomas Bewick and John Bewick, *The Flatterer and the Painter*. From Thomas Bewick and John Bewick, *Select Fables; with Cuts, Designed and Engraved by Thomas and John Bewick, and Others, Previous to the Year 1784* (Newcastle, 1820), p. 303. Mortimer Rare Book Room, Smith College, Northampton, Mass.

but there the similarities end between the European and American images. Chalon's studio is cluttered with academic props, standard aids for the artist working within the grand tradition: a generous sweep of drapery, antique sculpture, an array of still-life objects, arms, and armor. Such props, with the significant exception of the drawing of Apollo, are absent from the spartan, tidy workroom of Mount's artist, who has drawn his inspiration from daily life and transformed the grand tradition into a modern, middle-class idiom. In Chalon's illustration, Mount's capitalist artist has become a Renaissance troubadour; his prosperous farmer on the go has become a languid, aristocratic young woman. Mount's artist is busy at work, literally "showing his work"; he is committed both to creating art and to making money by creating art which will appeal to the vast, largely untapped market of the middle class. Chalon's artist is at "play," having left a "Madonna and Child" on the easel to accompany his visitor in song. The passage opposite Chalon's studio scene summarizes the traditional public conception of the artist: "His delicate and trained perception clothes all things with an ideal halo, concealing what is rude, and heightening the beautiful, as a veil before a lovely form, or the mist upon a mountain, when the sun goes down. Imagination creates for him a heaven on earth . . . it were worth whole years of vulgar life to dwell one hour with glorious dreams that haunt that humble chamber. There, . . . love, music, and the pencil recreate an Eden." For many American artists in 1840—notably in this vein Washington Allston, Robert W. Weir, and William Page, or Thomas Cole and Thomas Doughty in their more lyrical moods—the purpose of art was in effect renunciatory and escapist; art was to substitute a palliative, fanciful ideal for "vulgar" reality. Mount charted a new order, a middle ground.[20]

Figure 6.9 John Sartain after Alfred Edward Chalon, *The Artist*. From *The Boudoir Annual 1846* (Boston, 1845), facing p. 87. Harris Collection of American Poetry and Plays, Brown University Library.

Mount's paintings became widely known not so much through the elite media of exhibitions and critical reviews as through the popular, mass-produced media of prints, disseminated either as discrete artworks suitable for framing or as illustrations in books. *The Gift,* the annual for which *The Painter's Triumph* was engraved, was one of those gift books that united image and text for popular entertainment and edification. The gift book itself was a compromise between elite and popular cultures. It was mass-produced, yet it was just expensive enough to indicate status and refinement. The wide distribution of the gift books brought American art out of the few galleries of the period and made it available to a middle-class audience. Before the Civil War, middle-class readers demanded images and texts with a specifically American identity, and the local-color sketch—illustrations and stories that incorporated American scenery, customs, and language—fulfilled that nationalistic need. The local-color sketch is usually associated with direct observation from nature, but many writers of gift-book fiction and poetry responded imaginatively to art rather than directly to nature. Gift-book illustration often determined the accompanying story or poem: that is, the letterpress played off the engraved images rather than the reverse. Gift books, therefore, constitute a body of literature written largely by amateur, naive authors as imaginative responses to images by professional artists.[21] Mount was a popular artist in this industry, as his scenes of modern

country life were ideal subjects for local-color fiction. Engravings after his work, with poetic and fictional accompaniments, were strewn across the field of gift-book literature.

Andrew Allen Harwood, who wrote "The Painter's Study" for *The Gift* as the text for Mount's picture, was an amateur writer, author of a few short stories and some nonfiction. In "The Painter's Study" he referred to himself as a "historian," a detached narrator, yet his reliance on local gossips and village philosophers gave him a sympathetic insider's perspective on popular culture. Harwood's puckish story opens "on a pleasant evening of the summer of 1838, in a snug parlor of a neat cottage upon the banks of the Susquehanna," the residence of Mr. and Mrs. Loftus Shockley and their artistically inclined son, Herbert. The Shockleys receive word that a wealthy kinsman in England has died, leaving Herbert a large sum of money, on the condition that he marry his British cousin Isabel Brenton. Herbert is in love with Edith St. Clair, an American, and refuses to consider anyone else. Loftus Shockley, however, had been taken down a peg by the crisis of 1835, which left him near bankruptcy and forced him to move away from Philadelphia to a "small country seat" in the interior of the state. "Flinty-hearted" Shockley decides that the family cannot make do without the inheritance and, by manipulating the sentiments of Edith's parents, ends the couple's engagement. Herbert is induced to marry Isabel, and he travels to New York to sit for his portrait, which will be sent ahead to her in England. Herbert arrives at the studio of Raphael Sketchly, who is in the process of showing his work to farmer Eliphalet Dobbs. Herbert arranges to have his portrait taken, and Dobbs, not to be outdone, commissions his own portrait. The two paintings are confused by Sketchly's Irish assistant, Dennis O'Blurr. Isabel receives Dobbs's likeness instead of Herbert's, and, "to judge by his countenance," she assumes that her American cousin is a rustic barbarian who eats fish with a knife, cools his tea in his saucer, and spends "his life in the habitual perpetration of a thousand similar unforgivable Americanisms recorded in the veracious pages of Mrs. Trollope, the Rev. Mr. Fidler, D. D. and other scrutinizers of 'domestic manners.'" Rather than submit herself to "such a savage," Isabel forfeits her share of the inheritance by breaking the engagement and marries a wealthy British soldier, the gallant Captain De Lancy. Herbert marries Edith, and the newlyweds, honest and fairminded to the core, visit their British cousin and give her an equal share of the estate. The artist's studio, meanwhile, is so transformed by a burgeoning clientele into a "resort of beauty and fashion" that Sketchly employs an Italian immigrant, Luca Fa Presto (Fast Luke) to help him meet the new demand for his work.[22]

Harwood's fictional response to Mount's painting is broadly interpretive,

as he narratively fills in the painting's silences with cultural information. For example, the crisis of 1835 is not referenced in the painting but is one of the motivating forces in the story. Harwood's mention of the "memorable pressure in the money market" would have resonated for readers who were especially sensitive to economic instability and downward mobility after the Panic of 1837. Herbert, in spite of his father's financial and social reorientation in the hinterland, cultivates a knowledge of "nature, literature, and art" as a tribute to his "gallantry."[23] The fear of downward mobility, then, is partly dispelled by the conviction that a cultivation of taste can lead to upward mobility.

The reader never fully sympathizes with Harwood's characters because they are local-color stereotypes, but Harwood's types, like Mount's, function metaphorically, conveying layers of cultural meaning in rapid succession. Loftus Shockley embodies the kind of vulnerability and anxiety that generated the formation of middle-class consciousness. He can be economically shocked, humbled, and toppled from his lofty social status by a mere fluctuation in the economy. Herbert and Edith represent the new middle class. Through a process of self-cultivation, which involves the consumption of art and literature, they are able to transcend economic uncertainty. Once removed from the elitism of their British kinsmen, carefully distinguished from the utilitarian vulgarity of Farmer Dobbs, Herbert and Edith occupy a social and aesthetic middle ground, defining a new order between two undesirable extremes.

Raphael Sketchly also straddles two extremes, disclosing the problem of a democratic art—the tension between "mere" beauty and utility. As Herbert walks into the artist's studio unexpectedly, he witnesses the scene depicted in *The Painter's Triumph:* "The door stood half-open and discovered the *tableau vivant,* which, thanks to the gifted pencil of Mount, and the skilful burine of Lawson, figures as a frontispiece to our tale." Sketchly explains to Dobbs the painting on the easel, "a highly successful delineation of the scenery near his own quiet home on the Hudson":

> "See there," said Mr. Raphael Sketchly, overlooking entirely in his enthusiasm the presumable incapacity of his auditor to comprehend the technicalities and mysteries of art, "how nicely nature has herself composed the picture, how well it is balanced, what a noble breadth of effect! mind how warm and transparent I've kept that shadow! how that light sparkles upon the sail in the river! what a delicious pearly gray that mountain opposes to the evening sky! just observe, too, the variety of mellow tints upon that broken plaster on the gable of the house!"
>
> "Nat'ral as life," said Dobbs; "but you might have made the gable a bit smarter, for we're a going to mend and whitewash it in the fall."

"Don't do it, I entreat you," exclaimed the horrified artist, "you'll ruin the effect!"

"Must though," insisted Dobbs, "our folks thinks it's a kinder shabby, and I guess we're rich enough to fix it."[24]

Harwood thus interprets the scene in Mount's painting as representing a discussion between a "*genus irritabile*" and a "utilitarian." The artist's conception of nature is essentially romantic: he seeks the picturesque "effect" of the broken plaster on the house. The farmer's vision is pragmatic: he finds in the broken plaster evidence of neglect. As Dobbs is an archetypal Yankee farmer, Sketchly is a peculiarly American painter in his anxiety; his very name signifies a blending of elite and popular forms. Like Mount, Sketchly combines Old World aestheticism (here the picturesque) and New World pragmatism (here in the choice of subject matter) to create an art accessible to the middle-class American. However, just as both Mount and Harwood describe the farmer in ambivalent, ironic terms as a comic, but admirable figure, they also mock the artist-figure's *posture artistique,* the affectation in bearing, dress, and rhetoric that continues to associate even a painter of the picturesque with the tradition of academic idealism encapsulated in Chalon's studio scene. The tension, the dissonance generated by interaction between artist and farmer, and between beauty and utility, will result in a new order of art that renounces both elitism and vulgarity.

At the end of the tale Harwood aligns Herbert and Edith with Isabel and Captain De Lancy by having Herbert return Isabel's forfeited portion of the inheritance. "This act of justice," Harwood avows, "was also one of patriotism, as it prevented an Irish blunder from being mistaken for a Yankee trick."[25] Thus, Herbert and Edith and Isabel and De Lancy are distinguished from both the bungling immigrant and the shrewd native. Herbert and Edith, through the wonder of art, have moved upward on the social scale, becoming part of the new middle class. By uniting the American couple and the British couple at the end of the story, Harwood implies that aristocratic status and democratic status can have common roots in a cultural if not a political sense. Sketchly, even if unintentionally, has acted as mediator between artistocracy and democracy, between elite and popular cultures, and has created an art of the middle ground.

The story reflects the means by which American middle-class people come in contact with art and the benefits that exposure to art brings in refinement and upward mobility. The story also reflects the cultural anxiety of the American middle class, which during the Jacksonian era confronted economic uncertainty and downward mobility, massive immigration, urbanization, sectionalism, and the problem of distinguishing a class identity. Sketchly—and Mount himself—becomes the model for an American artist who is cultural mediator between an

old world, elite tradition and a new, democratic order. Local color, in painting as in literature, becomes an acceptable middle-class aesthetic, combining localism and nationalism to forge an American identity.

The Painter's Triumph ultimately is a moralizing, reformist argument for education and cultural literacy. The artist symbolizes urbanism, the farmer agrarianism. At a time when these two cultural forces were in contention, overturning the old order in their conflict, Mount represents them as in harmony, brought into an amiable equilibrium and interaction through art. Similarly, he brings into harmony the grand tradition of art, which is intellectualizing and elitist, and a genre of daily experience, which is instinctual and democratic. He assures accessibility to his art by making it legible, not only in its classic formal properties of clear space, clear light, clear lines, and naturalistic colors, but also in its signs: the accessories, the character types, the phrenological and elocutionary codes derived from popular handbooks. If Mount's formula for mediation between extremes seems to entail a straightforward averaging, such a scheme is, indeed, encoded in the very structure of *The Painter's Triumph.*

What are the artist and the farmer striving for? The artist, who is fluent in both the discourse of classicism and the discourse of the vernacular, intends to create an art based on classical principles, which is nonetheless intelligible to the common man. As the farmer's link with the grand tradition, he means to educate the farmer, without the man really knowing it, by devising a formal language and subject matter that the farmer can understand. This device and the artist's enthusiasm awaken the farmer, enticing him from intellectual repose. The artist performs this service for the practical, self-centered purpose of earning money in capitalist society, for the altruistic purpose of educating a fellow citizen, and for the nationalistic purpose of celebrating native culture. He does this, too, in order to harmonize and homogenize his society by leveling the extremes of both elitism and anti-intellectualism. The farmer is also an educator in his way, as it was he who in the broad sense brought the artist on a ride into the country to discover local color. Still, Mount makes clear that it is the artist who will take a leading role in educating the citizenry, uplifting taste, defining cultural standards, and sounding the moral tone of the nation. The reforming power of art will harmonize the sometimes discordant but vital forces of democracy.

Reformism is central to Mount's art, but class conflict as such is not his concern. Mount's farmer is not the oppressed peasant or the gullible country bumpkin, duped for the gratification of a self-serving gentlemanly class or an anxious bourgeoisie.[26] Mount draws hierarchical relationships in his painting only to erase them. The artist controls his environment and stands above his audience, but he does not stand apart from his audience or above his debt to the grand tradition. If the artist rejects "the people," he will fail in his democratic and moral

mission; if he rejects the grand tradition, he will fail in his artistic mission. He places the gentility that he embodies within the farmer's grasp in a context of conciliation and assimilation. In a sense the artist is empowering himself in a society that places him in an ambiguous position. The artist's role in a democracy with a low demand for art is that of both an educator and an advertiser or self-promoter.

Mount's corpus of paintings, like his corpus of journals and correspondence, reads like a capitalist, secular sermon or a reformist treatise on self-culture and moral suasion that is appropriate to both his mercantile patrons and his middle-class audience of hard-working consumers.[27] Be industrious, modest, and responsible, he advises through his paintings, assuming the same moral ground as the preacher; avoid liquor and gambling; esteem family and community; acquire an education; eschew greed, but value and preserve private property; set an example of virtue in private and public conduct; work for the common good, aware that in a democracy each citizen has something to offer and that the health of society depends on the health of each individual member. Of all these standards, Mount places the largest premium on work and mental discipline, which are the central themes in *The Painter's Triumph,* as they are, for example, in *Farmers Nooning* (1836; Museums at Stony Brook) and *Bargaining for a Horse.* In *The Painter's Triumph* the artist's work and mental discipline have produced a fine drawing of the Apollo Belvedere, a sketchbook, a portfolio, a tidy, no-nonsense workplace, and an unusual success (apparent in both his dress and his relationship with the farmer). Mount does not locate the artist in the farmer's cornfield as witness to the work ethic; instead, and to many no doubt ironically, the work ethic is played out in the studio. As each instructs the other, artist and farmer are coworkers, if not coequals, in the democracy. Mount's artist is the artist-citizen, spokesman for the middle class.

Notes

This essay is a shortened version of an article that appeared in *Winterthur Portfolio* 23 (Summer/Autumn 1988): 111–28.

1. W. Alfred Jones, "A Sketch of the Life and Character of William S. Mount," *American Whig Review* 114 (August 1851): 122, 124; Alfred Frankenstein, *William Sidney Mount* (New York, 1975), 49.

2. John S. Gilkeson, *Middle-Class Providence, 1820–1940* (Princeton, 1986), 10, 53.

3. Mount addressed reformist issues in other major paintings of the 1830s: *The Breakdown* (1835; Art Institute of Chicago), *The Sportsman's Last Visit* (1835; Museums at Stony Brook), *The Truant Gamblers* (1835; New-York Historical Society), and *The Long Story* (1837; Corcoran Gallery of Art). Although moderate in his views toward

reform—he was ambivalent about abolition and abstinence—Mount was allied with the reformist movement of perfectionism in his belief in individual self-improvement. See John L. Thomas, "Romantic Reform in America, 1815–1865," in *Ante-Bellum Reform,* ed. David Brion Davis (New York, 1967), 153–76.

4. Diary entries Aug. 29, 1846, July 1, 1850, and Feb. 1854, in Frankenstein, *Mount,* 143, 241, 165, 354–55.

5. In 1840 Mount referred to the painting as "artist showing his work"; in 1843 he exhibited it at the National Academy of Design as *Artist Showing His Work;* in 1854 he recorded it as "Artist showing his own work. . . . Painted on mahogany. . . . Price of the picture $250.00/frame and box 24.00." Carey acknowledged receipt on Sept. 11, 1838. On Oct. 14, 1838, Mount wrote: "I sent a picture to Mr. Carey . . . about five weeks since. He is delighted with it." Frankenstein, *Mount,* 54, 59, 483, 29, 470; Alfred Frankenstein, *Painter of Rural America: William Sidney Mount* (Washington, D.C., 1968), 25.

6. "I am painting a picture representing a painter showing his picture to a country man—farmer. It is thought to be my best" (diary entry, July 21, 838, in Frankenstein, *Painter of America,* 25).

7. Francis Hodge, *Yankee Theatre: The Image on the Stage, 1825–1850* (Austin, 1964); Joshua C. Taylor, *America as Art,* exh. cat. (Washington, D.C., 1976), 39–70; Elizabeth Johns, "The Farmer in the Works of William Sidney Mount," *Journal of Interdisciplinary History* 17 (Summer 1986): 271–75.

8. Edward P. Buffet, "William Sidney Mount: A Biography," *Port Jefferson* (N.Y.) *Times,* Dec. 1, 1923–June 12, 1924, chap. 20.

9. Mount noted that he painted the "Artist Showing His Own Work . . . indoors and by two windows. I could reach to the top of the light with my hand" (diary entry, Nov. 14, 1852, in Frankenstein, *Mount,* 249). For Mount's grounding in the grand tradition, see ibid., 20, 25; Barbara Novak, *American Painting of the Nineteenth Century: Realism, Idealism, and the American Experience* (New York, 1971), 144–51. For "controlling reason," see David B. Lawall, *Asher Brown Durand: His Art and Art Theory in Relation to His Times* (New York, 1977), 171–91.

10. Patricia Hills, *The Painter's America: Rural and Urban Life, 1810–1910,* exh. cat. (New York, 1974), 12.

11. On May 12, 1838, probably about the time he began work on the painting, Mount wrote to his brother Shepard from Stony Brook: "I have lived in this place over four years in succession and I never knew it to be so lonesome to me as it now appears. I begin to grow tired of this part of the Country. It is too retired, quite so for an Artist" (Frankenstein, *Mount,* 102).

12. Johann Gaspar Spurzheim, *Phrenology; or, The Doctrine of the Mental Phenomena* (Boston, 1832), 324–43. *The Outlines of Phrenology* that Mount owned was an abridged version of this text. Donald D. Keyes, "William Sidney Mount Reconsidered," *American Art Review* 4 (August 1977): 128; David Cassedy and Gail Shrott, *William Sidney Mount: Works in the Collections of the Museums at Stony Brook* (Stony Brook, N.Y., 1983), 24. For criticism of Mount as a colorist, see Jones, "Sketch of Mount," 126. One cannot demonstrate that Mount took equal care in particularizing the features of the farmer according to phrenological prescriptions. The organs of faculties that one

might associate with the farmer as a character type—such as domestic affections, preservative and regulating faculties, and moral and prudential sentiments—resided at the back of the head and above the forehead to the crown. It is clear, however, that the farmer does not possess the artist's protruding brow and arched eyebrows or, therefore, the intellectual powers of perception and reflection that such features would indicate to the phrenologist.

13. In discussing *The Power of Music* (1847; Century Association)—not *Music Is Contagious*, as he noted erroneously—Jones observed, "the phrenological hobby of the artist is apparent in the musical bump of the negro, whose organ of tune . . . has been much developed" (Jones, "Sketch of Mount," 125). The celebrated English phrenologist George Combe toured the United States in 1838–40; Mount may have heard him lecture in New York. In 1849 a friend presented Mount with Combe's autograph, which he valued (Mount to George Hart, Dec. 2, 1849, as cited in Frankenstein, *Mount*, 236). For phrenology and reform, see John D. Davies, *Phrenology: Fad and Science, a Nineteenth-Century American Crusade* (1953; rpt. Hamden, Conn., 1971).

14. J. P. K. Henshaw, *Henshaw's Sheridan: Lessons on Elocution* (Baltimore, 1834), 95; Jonathan Barber, *A Practical Treatise on Gesture* (Cambridge, Mass., 1831), 15, 109–11. For elocution, see Karl R. Wallace, ed., *History of Speech Education in America* (New York, 1954); John Stephens Crawford, "The Classical Orator in Nineteenth Century American Sculpture," *American Art Journal* 6 (November 1974): 56–72. For poses, see Henry Siddons, *Practical Illustrations of Rhetorical Gesture and Action* (1822; rpt. New York, 1968), 54, 348.

15. Whitney R. Cross, *The Burned-over District: The Social and Intellectual History of Enthusiastic Religion in Western New York, 1800–1850* (New York, 1981), esp. 173–75; David S. Reynolds, "From Doctrine to Narrative: The Rise of Pulpit Storytelling in America," *American Quarterly* 32 (Winter 1980): 479–92; William G. McLoughlin, *Revivals, Awakenings, and Reform* (Chicago, 1978), 122–30. For Mount's involvement with spiritualism, see Frankenstein, *Mount*, 285–97.

16. That the painting on the easel is a portrait of the visiting farmer is speculated by Bryan Jay Wolf, *Romantic Re-vision: Culture and Consciousness in Nineteenth-Century American Painting and Literature* (Chicago, 1982), 138. Jules Prown argues that the painting "must represent something familiar, some aspect of the real world in realistic terms" (Jules Prown and Barbara Rose, *American Painting from the Colonial Period to the Present*, new ed. [New York, 1977], 75). The device of the turned canvases evinces both Mount's wit and his own studio practice. He wrote to Charles Lanman on Feb. 20, 1841: "When I go into a painter's studio I never turn his canvasses round without a permit from the Artist." On Nov. 25, 1847, he wrote in his diary: "In my practice I invariably turn my picture round to the wall after I have done painting, and also set a picture aside for some time if I do not feel in the humour for painting" (Frankenstein, *Mount*, 109, 181).

17. See the discussion of Mount's classicism in Novak, *American Painting*, 106–08, 138–51; Lisa Fellows Andrus, *Measure and Design in American Painting, 1760–1860* (New York, 1977), esp. 146–47.

18. Donald D. Keyes, "The Sources for William Sidney Mount's Earliest Genre Paintings," *Art Quarterly* 32 (Autumn 1969): 258–68; Catherine Hoover, "The Influence of

David Wilkie's Prints on the Genre Paintings of William Sidney Mount," *American Art Journal* 13 (Summer 1981): 4–33; Barbara Novak, "Influences and Affinities: The Interplay between America and Europe in Landscape Painting before 1860," in R. J. Clark et al., *The Shaping of Art and Architecture in Nineteenth-Century America* (New York, 1972), 27–41; H. Nichols B. Clark, "A Taste for the Netherlands: The Impact of Seventeenth-Century Dutch and Flemish Genre Painting on American Genre Painting, 1800–1865" (Ph.D. diss., University of Delaware, 1982), esp. 200–208.

19. Seymour Slive, "Rembrandt's 'Self-portrait in a Studio,'" *Burlington* 106, no. 740 (November 1964), 482–87. Thomas Bewick and John Bewick, *Select Fables; with Cuts, Designed and Engraved by Thomas and John Bewick, and Others, Previous to the Year 1784* (Newcastle, 1820), 304.

20. *The Boudoir Annual 1846* (Boston, 1845), 87. For the changing characterization of the "ideal" artist in the 1830s–1850s, see Neil Harris, *The Artist in American Society: The Formative Years, 1790–1860* (New York, 1966), 218–51, where he concludes that the shift in emphasis is from an elitist to a middle-class type.

21. David S. Lovejoy, "American Painting in Early Nineteenth-Century Gift Books," *American Quarterly* 7 (Winter 1955): 361. See also Frederick Winthrop Faxon, *Literary Annuals and Gift-Books: A Bibliography with a Descriptive Introduction* (Boston, 1912); Ralph Thompson, *American Literary Annuals and Gift-Books, 1825–1865* (New York, 1936); Benjamin Rowland, Jr., "Popular Romanticism: Art and the Gift Books," *Art Quarterly* 20 (Winter 1957): 364–81; and E. Bruce Kirkham and John Fink, *Indices to American Literary Annuals and Gift Books, 1825–1865* (New Haven, 1975). Thompson, *American Annuals*, 38. Prominent authors of the literature of domesticity wrote fiction and poetry for gift books: Catharine Beecher, Lydia Maria Child, Sarah Josephine Hale, Catherine M. Sedgwick, and Lydia Sigourney. William Cullen Bryant, Ralph Waldo Emerson, and Nathaniel Hawthorne were among other professional writers who contributed to gift books. See Bradford A. Booth, "Taste in the Annuals," *American Literature* 14 (November 1942): 301.

22. Andrew Allen Harwood, "The Painter's Study," in *The Gift: A Christmas and New Year's Present for 1840,* ed. Miss Leslie (Philadelphia, 1839), 213–15, 208, 219, 220. The great-grandson of Benjamin Franklin, Harwood was a career officer in the U.S. Navy, served on the sloop *Hornet* in suppression of the African slave trade, and retired as rear admiral (obituary, *New York Times*, Aug. 29, 1884, sec. 2, p. 3).

23. Harwood, "Painter's Study," 212.

24. Ibid., 216, 217.

25. Ibid, 221.

26. See Karen Halttunen, *Confidence Men and Painted Women: A Study of Middle-Class Culture in America, 1830–1870* (New Haven, 1982). As an observer of what Halttunen calls "the theatricality of social relationships," Mount in his art offered standards for genteel behavior, but did not, as did Richard Caton Woodville, highlight hypocrisy and the manipulation of appearances.

27. See, for example, Davis W. Clark, *Mental Discipline; with Reference to the Acquisition and Communication of Knowledge, and to Education Generally* (New York, 1847).

7 "Doomed to Perish": George Catlin's Depictions of the Mandan

Kathryn S. Hight

In the spring of 1830 George Catlin, a moderately successful portrait painter in Washington and Philadelphia, left his eastern practice for the frontier city of St. Louis. His objective, as he recorded later, was to paint Indians still "in a natural state."[1] In the third decade of the century little was known about life along the Missouri River, which was to be Catlin's principal destination. Pictures of native people living beyond the Mississippi could be counted on the fingers of two hands. Even the land itself was known only superficially, despite the Lewis and Clark report published a decade and a half earlier.

In five trips in six years, from 1830 to 1836, Catlin produced for easterners a marked increase in visual information on the people living on or near the Missouri River. He made enough sketches during his five trips for a painting collection of more than 450 oil portraits and scenes. These pictures, which formed the basis for his traveling Indian Gallery, have often been called definitive views of Missouri and Upper Plains life in the early nineteenth century.[2] Catlin has been called one of America's first ethnologists and recognized as a leading visual historian of Plains peoples.[3] Despite that characterization, his work in light of the politics of nineteenth-century Indian affairs has hardly been examined. This is a significant scholarly omission given that in the spring in which Catlin made the decision to go west and in the city from which he departed, the most serious national discussion on the fate of Native Americans to date was in full sway.

Catlin's memoirs reveal that he was aware of the issues at the heart of the debate in Congress. They suggest that he was not only cognizant of the emerging national policy but that he accepted it. Some of his paintings and the way in

which he used them in his books and Indian Gallery—including those of the Mandan—can be seen today as presenting the public not so much an ethnological report as a validation of the most widely embraced theory behind the national Indian policy established that spring.

The policy, formalized as Catlin left for the West, established a federally supported program of Indian removal. On April 24, 1830, as Catlin was leaving Washington, the United States Senate passed a bill making official the removal of Indians living east of the Mississippi. By May 26, as Catlin reached St. Louis, President Andrew Jackson signed into law "an act to provide for an exchange of lands with the Indians residing in any of the States or Territories and for their removal West of the river Mississippi."[4]

The Indian Removal Bill, as it has come to be called, resulted in the forced transplantation of more than thirty thousand Native Americans. It has received nearly universal condemnation by succeeding generations of scholars and analysts. George Catlin and others sympathetic to Indian conditions supported passage of the bill, however, because of its humanitarian encasement propounding the concept of Indians as a vanishing race.[5]

Out of a nineteenth-century quasiscientific European theory that viewed man's earthly tenure as a progression grew the idea that Indians were, like ancient Britons, an early stage in the evolutionary history of man. It was argued by numerous scholars and poets that Indians, like their European counterparts two millennia before, would disappear, wither in the presence of the more advanced stage now represented by contemporary Europeans. In the early years of the nineteenth century the idea was nurtured by many nationalistic writers who wanted to find native candidates to serve as material for a distinctive American epic myth.[6] By 1830 Indians in poetry and in other written sources were heralded as America's equivalent to ancient Britons.

In politics as in poetry the vanishing-people myth also appeared. Andrew Jackson was a forceful proponent of such an idea. In December 1829, just a few months before Catlin left for the West, Jackson stated: "Surrounded by whites with their arts of civilization, which by destroying the resources of the savage doom him to weakness and decay, the fate of the Mohegan, the Narragansett, and the Delaware is fast overtaking the Choctaw, the Cherokee and the Creek. That this fate surely awaits them if they remain within the limits of the States does not admit of a doubt. Humanity and national honor demand that every effort should be made to avert so great a calamity."[7] By the spring of 1830 a majority of the members of Congress could, in the name of humanity and national honor, vote to stave off calamity for the Indians through the concept of removal. The idea that Indians exposed to European civilization were destined to decay became a common refrain. It was noted in a variety of sources, publications, and

speeches that Indians were unable to cope with the encroaching "progressive" civilization. Among the reasons given was their moral and physical inferiority: they were viewed as childlike because they were unable to resist white man's temptations, especially alcohol. Because they succumbed readily to European diseases, they were dubbed physically weaker; their societies, it was noted repeatedly in the press, were unable to withstand the musketed superiority of white invasions.

By 1828 Thomas McKenney, first head of the Office of Indian Affairs and one of the Indians' most sympathetic supporters in Washington, had acquiesced to the vanishing-Indian theory. He, along with a growing number of seemingly well-intentioned individuals, saw removal as the only way to prevent their immediate extinction. In an address in December 1829 to the Indian Board for Emigration, Preservation and Improvement of the Aborigines of America. McKenney summed up the growing opinion among people sympathetic to Indians: "We once . . . thought it practicable to preserve and elevate the character of our Indians, even in their present anomalous relations to the States but it was distance that lent this enchantment to the view. We have since seen for ourselves, and that which before looked like a flying cloud, we found on a near inspection to be an impassable mountain. . . . If the Indians do not emigrate, and fly the causes which are fixed in themselves, and which have proved so destructive in the past, they must perish."[8] Within five months this position enabled the bill to pass.

Jackson's and McKenney's words were echoed in Catlin's memoirs. Catlin reveals that he left for the West assuming that Indians were doomed, that removal was the only humanitarian course to follow, and that even that course was only a temporary measure to slow their inevitable extinction. Catlin's objective in painting Indians, therefore, as he wrote in the opening of his treatise, was "to fly to their rescue, not of their lives or their race (for they are doomed and must perish) but to the rescue of their looks and their modes, at which the acquisitive world may hurl their poison and every besom of destruction, and trample them down and crush them to death; yet phoenix like they may rise from the stain on a painters palette and live again upon the canvass, and stand forth centuries yet to come, the living monuments of a noble race."[9]

No group painted by Catlin fulfilled his prophetic words better than did the Mandan. While he was staying at Fort Union in the late summer of 1832, Catlin painted inhabitants of the Mandan villages along the Missouri River in what is today North Dakota. He lived among them for several weeks, sketching both portraits and scenes, including a number of the O-Kee-Pa ceremony, a sacred ritual known to have been witnessed by only two white men, Catlin and the agent at Fort Union, at the time. Five years later, in 1837, just as Catlin was be-

ginning to tour with his Indian Gallery, the Mandan villages that he had painted were nearly completely wiped out as smallpox raged up the Missouri River.[10]

The Mandan had thus fulfilled Jackson's, McKenney's, and Catlin's prophecy that Indians exposed to white civilization would succumb. Their fate, however, appears to have been received as a special omen for the painter. Catlin's father noted in 1838 that while George mourned "the dreadful destiny of the Indian tribes by the smallpox," he nevertheless would find that "that shocking calamity will greatly increase the value of his enterprise and his works."[11] The objective of painting untouched Indians in their "wild and unsophisticated state in order to erect a monument to a dying race and a monument to myself" was realized sooner than expected.[12] As Catlin's father callously—though perhaps realistically—noted, the pictures of the Mandan fulfilled both expectations.

Catlin set the stage of the Indian Gallery presentation of his Mandan pictures by reminding his audience that the Mandan were a "strange, yet kind and hospitable people whose fate, like that of all their race is sealed; whose doom is fixed to live just long enough to be imperfectly known and then fall before the fell disease or sword of civilizing devastation."[13] Catlin then noted that all was not lost; he pointed out that the Mandan now rose from decimation, phoenix-like, through the magic of paint.

In his Indian show, which toured America and Europe from 1837 to 1845, in his illustrated memoirs of his frontier adventures, and in the brochures for the show itself, Catlin featured the vanished Mandan. His decision to do so did not lack purpose. His show and books were intended, as the playbill for a Boston appearance in August 1838 indicated, to "entertain and instruct" city people attracted to scenes and tales of the "Far West" (fig. 7.1). To lure a paying audience to the displays, Catlin promised views of exotic aspects of life in the West: dances, villages, the strange O-Kee-Pa ceremony. From the list in the playbill, it can be gathered that Catlin felt that a potential audience could be persuaded to see entertaining images of people who were colorful and dramatic but who no longer threatened white civilization. His show would be a vicarious adventure— "Twelve Buffalo Hunting Scenes" were announced in bold letters—among "the wildest Tribes of Indians, in America."

Catlin clearly assumed that his audience would not be averse to assurances that the Indians—Mandan and others—were a disappearing race. In the Boston playbill, for example, the only identifiable Indian individuals mentioned were nationally famous men recently defeated and captured by superior white forces: Black Hawk and nine of his principal warriors—"painted at Jefferson Barracks, while prisoners of war"—and Osceola, Mick-E-No-Pah, Cloud, Coa-Ha-Jo, and King Philip—all captured or defeated chiefs of the Seminoles. None of these individuals had much to do with the "Far West" supposedly central to the Indian

Figure 7.1 George Catlin, *Catlin's Indian Gallery,* 1838. Playbill. Courtesy, American Antiquarian Society, Worcester, Mass.

Gallery displays, but they were useful in reminding the Boston audience that the Indian "threat" was, along with the Indian people themselves, a "vanishing" worry.

Neither Catlin's portrait of Black Hawk, painted at Jefferson Barracks, St. Joseph, Missouri, in 1833, nor his portrait of Osceola (fig. 7.2), painted at Fort Moultrie Prison in South Carolina, fitted his general objective of recording the western Indian in his native habitat.[14] Both men were from east of the Mississippi and neither, imprisoned as they both were at the time the portraits were taken, represents the free and bold natural man Catlin claimed to be documenting. Both, however, had become national celebrities for their respective roles in confrontation between whites and Indians. They were the best-known Indians in the United States at the time Catlin was developing his gallery. Both leaders, having lost their wars with United States military forces, could now be featured as praiseworthy adversaries, men of honor and bravery, gallant losers in the inexorable march of the new American society to its destiny of conquest of the

Figure 7.2 George Catlin, *Osceola*, 1841. Engraving. Catlin, *Letters and Notes . . .* (London, 1841), no. 298. Henry E. Huntington Library and Art Gallery, San Marino, Calif.

continent. As mythic protagonists in the American drama of conquest, their images were welcomed in Catlin's gallery.[15]

The portrait of Osceola is particularly instructive in looking at the role of Catlin's Indian paintings and his Indian Gallery in the national Indian policy of the era. At the time the portrait was painted, Osceola was in dismal circumstances, but no hint of his hardship appears in the finished work. It is the portrait of a thirty-four-year-old man in robust health showing no sign of sickness or the helplessness of a man defeated in war and tricked into captivity. Catlin presented a heroic portrait of an epic figure in elaborate costume and classical stance. Osceola even holds a long gun—hardly plausible under the circumstances of his imprisonment. The fact that he was doomed would have been known by all gallery visitors at the time of the painting's first display.

Catlin had been offered the opportunity to paint the portrait of the great Seminole chief shortly after his capture and imprisonment in the winter of 1837–38. For that purpose the artist left his touring Indian Gallery briefly in

January 1838 to journey to Fort Moultrie. Neither the resulting portrait, perhaps Catlin's finest work, nor the way that it was exhibited suggests the sinister, even bizarre circumstances surrounding its procurement. At the time of the sketching, Osceola was not only in prison but, according to all sources (including Catlin's family chronicler, Marjorie Roehm),[16] a very sick man. After incarceration in St. Augustine, Florida, Osceola was taken from his home territory to South Carolina. For reasons never substantiated, he was accompanied by Dr. Frederick Weedon, his "friend" and physician. Dr. Weedon also became Catlin's friend during the sitting sessions, and after Osceola's death it was he who supplied the material about the last hours of Osceola's life that Catlin included in his Indian Gallery lectures and in his book. Dr. Weedon was also— as many historians of the event fail to note—the brother-in-law of Gen. Wiley Thompson, whose murder by Osceola was credited with starting the Seminole War. Compounding the strangeness of the relationship between Weedon and Osceola is the fact that, according to Weedon's great-granddaughter, the doctor secretly beheaded the chief immediately after his death and took the head with him on his return to St. Augustine, where it remained in his study for several years.[17]

Nothing about these circumstances is revealed in the portrait. Nor is there any suggestion that the man posing for Catlin would die only a few days after the work was finished. Catlin had come to the "rescue" not of a living man but of a "living monument of a noble race." Like the vanished Mandan, the vanished Osceola as a highlighted image in the Indian Gallery suggests further that the show was a touring reinforcement for the "vanishing race" theory. For a profit at the door, Catlin had discovered that a disappearing people could with impunity be transformed into entertainment.

This transformation can be seen especially well in several works involving the Mandan. The image Catlin chose as the frontispiece and introduction to his illustrated memoirs is a scene depicting himself painting the Mandan chief Mah-To-Toh-Pa (fig. 7.3). In the work the artist stands at an easel adding the finishing touches to his portrait of the chief,[18] who poses before a group of tipis. A group of male Indians stand and sprawl about, watching the painter work. Catlin, wearing a fringed coat, tailored pants, hunting cap, and perhaps moccasins, holds a palette in his left hand and with his right brushes the center of the nearly completed portrait.

The scene is not what it appears to be. Although Catlin implied that it was a record of an actual event, and described the painting of the chief in his memoirs, a comparison of the written description and the frontispiece reveals many discrepancies. In Catlin's memoirs, Mah-To-Toh-Pa is described as dressed in a costume that included a belt with a tomahawk and a scalping knife and as wearing

The Author painting a Chief at the base of the Rocky Mountains.

G. Catlin.

Engraved and printed by Tofswill & Cº 24, Budge Row London.

Figure 7.3 George Catlin, *The Author Painting a Chief at the Base of the Rocky Mountains,* 1841. Engraving. Catlin, *Letters and Notes . . .* (London, 1841), frontispiece. Henry E. Huntington Library and Art Gallery, San Marino, Calif.

about his neck a bear-claw necklace. None of these appears in the painting. In addition, Catlin wrote that he painted the portrait indoors, not outside, and that women and children, not men, surrounded the chief.[19] What Catlin actually painted was a collage drawn in part from an actual event, in part from a staged happening, and in part from the artist's imagination. Its message was to generalize Mah-To-Toh-Pa and to suggest not so subtly that the fate of the vanished Mandan would soon be the fate of all Indians (and in fact in many editions of the book the title of the frontispiece was the more general title shown here).

Catlin suggested this dénouement in several ways. By deleting the power symbols of the chief, he was featuring Mah-To-Toh-Pa as a romantic legend rather than as a threatening warrior. The painting shows the chief and his warriors as doomed, mythic Indians living, as Catlin described them in his memoirs, a primitive and childlike existence, "with minds . . . unexpanded and uninfluenced by the thousand passions and ambitions of civilized life."[20] An even more generic view of Indians emerges in the backdrop of the picture, which is entirely ersatz and emblematic. The tipis and woodlands of the background are symbols for Indians in general but have little to do with the Mandan, who lived along the Missouri River banks. Furthermore, they did not use conical bison-hide lodges; their homes were spherical earth structures (fig. 7.4). Catlin knew that and described them correctly in his *Letters and Notes on Manners, Customs, and Conditions of the North American Indians:* "Their present villages are beautifully located . . . in the midst of an extensive valley on an extensive plain (which is covered with a green turf, as well as the hills and dales, as far as the eye can possibly range, without a tree or bush to be seen) . . . rising from the ground, and towards the heavens, domes (not 'of gold' but) of dirt—and the thousand spears (not spires) and scalp poles &c., &c., of the semi-subterraneous village of the hospitable and gentlemanly Mandans."[21]

Like ancient Greeks or medieval knights, with whom Catlin's memoirs frequently associated Indians, the Mandan thus became characters in a national mythic drama. The frontispiece was in fact drawn from a dramatic event that occurred on the second night of Catlin's Indian Gallery show in London in 1841. In a series of tableaux vivants, the second tableau, according to Catlin's memoir, showed "Mr. Catlin at his easel, in the Mandan Village (painting the portrait of Mah-To-Toh-Pa, a celebrated Mandan Chief). The costumes of the chief and the painter are the same that are worn on the occasion."[22] Behind the players a large Crow lodge, part of the gallery exhibit, would have been visible and hence an association would have been made between the tipi and Indian performers. Romantic evocations that developed from the stage vignette were more appealing for the frontispiece than was factual information from a distant frontier. The staged event as the source of the picture explains, too, Catlin's natty garb, which

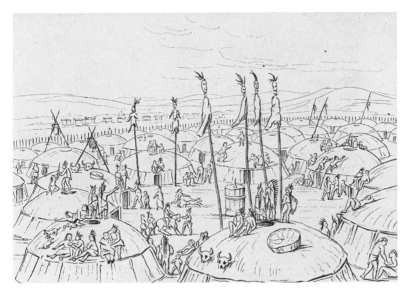

Figure 7.4 George Catlin, *Mandan Village,* 1841. Engraving. Catlin, *Letters and Notes . . .* (London, 1841), no. 47. Henry E. Huntington Library and Art Gallery, San Marino, Calif.

seems far removed from the frontier. In quality and workmanship, the painter's buckskin garment appears to be more the work of London tailors than of a seamstress in St. Louis. The cap in particular is more reminiscent of those worn by hunters in the paintings of George Stubbs than of one worn by a frontiersman just ending weeks of rough travel in a primitive skiff on the Missouri River. The clean and well-cut clothing worn by the impresario was clothing that well-to-do patrons of the gallery or book could imagine themselves wearing as they enjoyed a vicarious frontier excursion.

Catlin had gotten the idea for his living pictures while he himself was dressed as a Sac warrior at a London society ball.[23] He subsequently enlisted his nephew Burr to dress as a Plains chief and stalk his gallery, frightening English ladies to the delight of all. A London newspaper, the *Morning Post,* reported on Burr's success: "During our visit on Saturday the company were startled by a yell, and shortly afterwards by the appearance of a stately chief of the Crow Indians stalking silently through the room, armed to the teeth and painted to the temples, wrapped up in a buffalo robe on which all his battles were depicted, and wearing a tasteful coronet of war—eagle quills. This personification was volunteered by the nephew of Mr. Catlin, who has seen the red man in his native wilds, and presents the most proud and picturesque similitude that can be conceived of a savage warrior."[24]

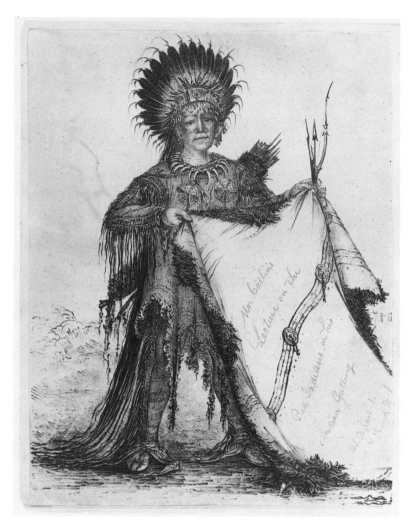

Figure 7.5 *Mr. Catlin's Lecture on the Red Indians in His Indian Gallery,*
c. 1842–43. Playbill for the London exhibition. Gilcrease Institute of American
Art and History, Tulsa, Okla.

So successful was the theatrical appearance of Burr that Catlin painted him
in an eclectic costume of Mandan and other western chief's paraphernalia and
used that work in the early 1840s as the cover for the brochure announcing
Catlin's Indian Gallery (fig. 7.5). All the iconographical symbols for a western
fantasy are in view: the eagle's-quill war bonnet, the painted buffalo robe, a
"grizzly" bear-claw necklace, bows and arrows, a fringed tunic, leggings, and

moccasins. The symbols of war and power not included in the earlier scene of Catlin himself painting the Mandan chief could apparently be included here because it was all fantasy. Burr was only an actor in costume, not a living challenge to white society. Like the patrons who supported both the Indian Gallery and Catlin's books, Burr is dressed up for an evening's adventure—an alternative fantasy to a knight of the Round Table or a Roman or Greek warrior. The costume was put together from objects collected by Catlin along the Missouri but was worn as theatrical attire, out of context and released from the meaning that the objects held for their original owners.

Catlin's use of material and actors for an artful fictive construct of life in the "Far West" was perhaps different only in degree from much "western" scientific ethnology of the last century. He spoke no Indian language, spent only brief periods with any group, and did not document his collected items in any scientific way. Nonetheless, Catlin's images were as widely seen as any pictures of Indians in the nineteenth century. Few in the United States or Europe had any better information than that received from him. Not uncharacteristically as the ethnologist he claimed to be, Catlin produced what has been called "serious fiction." He took from the Mandan and the far-western territory images and artifacts and wove them nearly seamlessly with his own and his nation's sociopolitical beliefs and needs. Since the status of "participant observer" gave his interpretations credibility, his views and reports were embraced as reality.[25] Thus, as the reservation system developed in nineteenth-century America, the graphic images in words and paint of a race doomed to perish except as entertainment—false though the concept was—served to abet the disastrous isolation of native people.

Notes

This essay originally appeared in the *Art Journal* 49, no. 2 (Summer 1990).

1. George Catlin, *Letters and Notes on Manners, Customs, and Conditions of the North American Indians: Written during Eight Years of Travel amongst the Wildest Tribes of Indians of North America in 1832, 33, 34, 35, 36, 37, 38, 39* (London, 1841), 1:2–9.

2. John Ewers, "George Catlin, Painter of Indians and the West," in *Annual Report of the Smithsonian Institution, 1955* (Washington, D.C., 1956).

3. See Robert Berkhofer, *The White Man's Indian: Images from Columbus to the Present* (New York, 1978); Ewers, "George Catlin"; William H. Goetzmann, *Exploration and Empire: The Explorer and the Scientist in the Winning of the American West* (New York, 1966); and William H. Truettner, *The Natural Man Observed: A Study of Catlin's Indian Gallery* (Washington, D.C., 1979).

4. *Register of Debates in Congress,* 21st Congress, 1st Session (Washington, D.C., 1830), 382.

5. Brian E. Dippie, *The Vanishing American: White Attitudes and U.S. Indian Policy* (Middletown, Conn., 1982), 61–65. This work provides a thorough discussion of the idea of the vanishing race as applied to American policy toward Indians in the United States in the nineteenth century.

6. William H. Cracroft, "The American West of Washington Irving: The Search for a National Tradition" (Ph.D. diss., University of Wisconsin, 1969), 12.

7. "Andrew Jackson," in James D. Richardson, *A Compilation of Messages and Papers of the Presidents, 1789–1902*, 10 vols. (Washington, D.C., 1903), 2:457–58.

8. Thomas L. McKenney, "Address" (1829), in *Memoirs: Official and Personal* (New York, 1846), 240–41.

9. Catlin, *Letters and Notes,* 1:16.

10. Ibid., 1:87–123.

11. Putnam Catlin to Francis Catlin, March 18, 1838, in Marjorie Catlin Roehm, *The Letters of George Catlin and His Family: A Chronicle of the American West* (Berkeley, Calif., 1966), 27.

12. Catlin, *Letters and Notes,* 1:16.

13. Ibid., 1:103.

14. Figs. 7.2, 7.3, and 7.4 are reproduced from Catlin's *Letters and Notes.* For this work Catlin had most of his Gallery paintings translated into engravings. An oil portrait of Osceola, dated 1838, is owned by the American Museum of Natural History, New York.

15. For a full discussion of these images, see Kathryn S. Hight, "The Frontier Indian in White Art, 1830–1876: The Development of a Myth" (Ph.D. diss., University of California, Los Angeles, 1987), 95–102.

16. Roehm, *Letters,* 126–28.

17. Mary McNeer War, "Disappearance of the Head of Osceola," *Florida Historical Quarterly* 33 (January–April 1955): 213–15.

18. In the first edition of *Letters and Notes,* the title of the frontispiece was *Painting of the Mandan Chief. . . ;* in later editions *The Author Painting a Chief at the Base of the Rocky Mountains* was used. The Rocky Mountains were hundreds of miles from the Mandan site.

19. Catlin, *Letters and Notes,* 1:102–13.

20. Ibid., 1:105.

21. Ibid., 1:80–81.

22. George Catlin, *Catlin's Notes of Eight Years' Travel and Residence in Europe, with His North American Indian Collection* (New York, 1848), 1:69–71.

23. Ibid., 70.

24. Catlin, p. 211.

25. See James Clifford, *The Predicament of Culture: Twentieth-Century Ethnography, Literature, and Art* (Cambridge, 1988), 10. Clifford raises important questions about the gathering and explanation of cultural artifacts and beliefs. In the nineteenth century and too often even today, he suggests, the cultural biases of the ethnologist observer and the biases of the receivers and givers of that information are insufficiently examined. Clifford's discussion of the role, now under scholarly review, of the "participant observer" is replete with examples from many cultures.

8 Narratives of the Female Body: *The Greek Slave*

Joy S. Kasson

No nineteenth-century artwork tells us more about the cultural construction of gender than Hiram Powers's *The Greek Slave* of 1844 (fig. 8.1). This life-sized standing nude woman whose hands are chained in front of her both displayed the beauty of the female body and, thanks to a cluster of narrative details, invited spectators to tell themselves a complex and disquieting story. The chain suggested violence and degradation, but the woman's expression was pensive and tranquil. These seeming contradictions spoke to some of the most fundamental concerns of its viewers, who responded to *The Greek Slave* with an outpouring of words—poetry, reviews, letters, and diary entries—that outline some of the deep conflicts within nineteenth-century culture.[1]

The Greek Slave reached an unprecedented audience. Over the course of fifteen years, Powers produced six full-length versions of the statue, numerous three-quarter-sized replicas, and scores of busts, many of which found their way into American homes and art collections.[2] Thousands of viewers saw the work when it was displayed at the Crystal Palace Exhibition in London in 1851; a decade later, the plaster model could still be seen by visitors to Powers's studio in Florence. Traveling exhibitions brought the sculpture to more than a dozen American cities, where it was viewed by more than a hundred thousand people. With great fanfare, the Cosmopolitan Art Association offered a full-length version of the sculpture in a raffle for subscribers and then bought it back again at an auction attended by five thousand spectators.[3] In the middle years of the nineteenth century, no American artwork was better known.

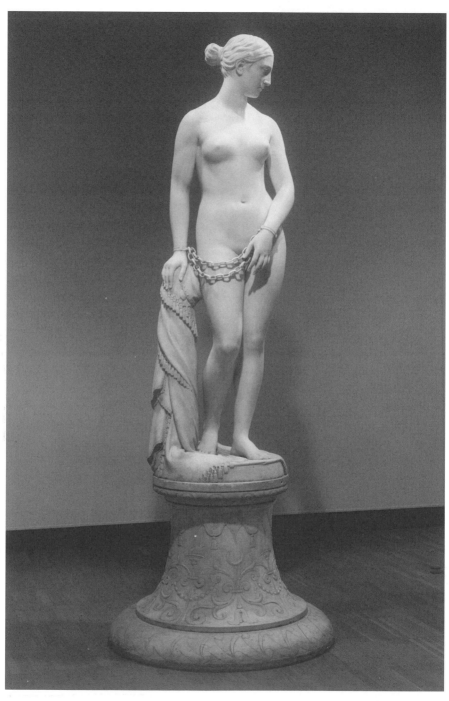

Figure 8.1 Hiram Powers, *The Greek Slave*, 1851, after an original of 1844. Marble, 65½ inches. Yale University Art Gallery, Olive Louise Dann Fund.

By the end of the century, *The Greek Slave* had become synonymous with re-
spectable, even staid, taste. Henry James, remembering its popularity in small
and inexpensive reproductions, wryly described it as "so undressed, yet so re-
fined, even so pensive, in sugar-white alabaster, exposed under little domed
glass covers in such American homes as could bring themselves to think such
things right."[4] Yet James's oxymorons—undressed yet refined, exposed yet pro-
tected under glass—suggest some of the ambivalence with which this sculpture
was received. A nude woman in chains represented an explosive subject, shock-
ing, titillating, potentially even pornographic, and the explanations by which
Powers and his supporters sought to shape his viewers' response to the sculpture
help us trace outlines of an ideology of gender as it came under pressure in
nineteenth-century America. The problem of how to understand *The Greek
Slave* was in some sense the problem of how to understand woman, in her com-
plex spiritual and sensual nature. In their comments on this sculpture and the
narratives they constructed to explain the enormous appeal it exercised upon
them, Powers and his contemporaries sketched their sense of the symbolic sig-
nificance of the female body. And since, as Mary Douglas has pointed out, im-
ages of the human body often reveal shared assumptions about the body politic,
a careful examination of the reception of *The Greek Slave* also offers some insights
into the complexities of a changing culture in nineteenth-century America.[5]

Powers's own views on the meaning of his celebrated statue are well docu-
mented. An entertaining talker and inveterate explainer, he offered detailed
comments in letters and interviews on the genesis of the statue and the way it
should be read. From the beginning, the construction and interpretation of a
narrative was central in the artist's thinking about his sculpture.

When he began work on *The Greek Slave*, Powers was still a newcomer to the
art world, hoping to move from notoriety as an adept portrait maker to success
as a sculptor of ideal subjects. His first venture into the realm of the ideal re-
vealed both the rewards and pitfalls of his aspirations toward a "higher" form of
art. *Eve Tempted* (1842) received praise from the distinguished Danish sculptor
Bertel Thorwaldsen and was much admired by visitors to Powers's studio in
Florence.[6] But a prospective buyer later canceled his order, accused by his own
brother of "indiscretion" in seeking to bring a nude sculpture home to "a quiet,
old fashioned, utilitarian place" like Albany, New York.[7] The implications of this
experience were clear: to succeed with an American audience unaccustomed to
nudity in art, Powers would have to find a way to fit his conception of the ideal
to an "old fashioned, utilitarian" frame of reference.

In *Eve*, Powers depicted a biblical figure whose nudity had an obvious sanc-
tion in an authoritative and morally irreproachable text, but the subject still

seemed too daring to some viewers. Eve, depicted with the forbidden fruit cradled in her hand, might have seemed to "old fashioned" Albany too active, too clearly culpable, too much the temptress (fig. 8.2). For *The Greek Slave*, Powers invented his own story, one which redressed this problem by stressing his subject's powerlessness rather than power. To "utilitarian" American culture he offered a modern tale of pathos and violence—the story of a contemporary Greek woman captured by invading Turks, abducted from her own country, and sold into slavery. The narrative had historical and literary echoes, for American and European interest in the Greek war of independence had run high; Byron had died supporting the cause of Greek independence, and Shelley wrote compassionately of Greek slave women.[8] But Powers did not draw his subject from a specific literary source. Rather, he created his own fiction. Visual details carefully informed the audience that the subject was a pious, faithful woman: a locket and a cross hanging on her abandoned clothing suggest a lost love and a sustaining Christian faith. Stripped naked, displayed for sale in the market place, her hands chained, the Greek slave, unlike Eve, was absolved from responsibility for her own downfall.

In constructing a narrative frame for his ideal sculpture, Powers demonstrated a finely tuned appreciation for the moral and intellectual context in which his work would be reviewed. Drawing perhaps on his experiences designing exhibits for the wax museum in Cincinnati, Powers had a keen sense of his audience and its expectations. He was particularly aware of the highly charged mixture of curiosity and suspicion that accompanied any public display evoking erotic or even sensual associations.

American audiences had been notably prudish in their response to nudity in art. Earlier in the century Adolph Ulrich Wertmüller's *Danae and the Shower of Gold* (1787) had caused a scandal when it was exhibited in New York and Philadelphia, as had other painted nudes in the first quarter of the century.[9] A pair of French paintings depicting the temptation of Adam and Eve and the expulsion from the Garden of Eden were criticized for their nudity during an American tour in 1832–35.[10] Horatio Greenough's *Chanting Cherubs* (1831) had been attacked as immodest when it was displayed in New York, and his bare-chested *Washington* ridiculed.[11] When Powers sent *The Greek Slave* on a tour of American cities in 1847, he made sure the sculpture was accompanied by texts that would instruct and direct the viewers' gaze. Press notices, poems, tributes by American diplomats and travelers stressed the propriety, even the nobility, of Powers's undertaking. The American tour, which earned twenty-three thousand dollars in receipts, thus introduced a large audience not only to a work of art but to a series of narratives, ostensibly describing the sculpture, but also

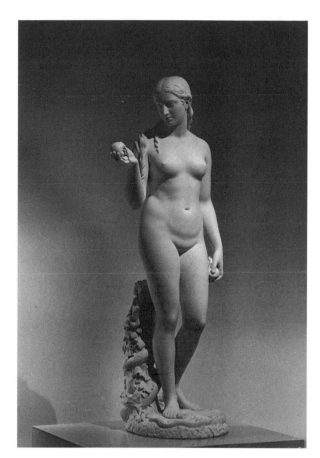

Figure 8.2 Hiram Powers, *Eve Tempted*, 1842. Marble, 68⅞ inches. National Museum of American Art, Smithsonian Institution, museum purchase in memory of Ralph Cross Johnson.

defining a morally and socially acceptable framework for the consideration of the explosive subject of a woman's body and woman's nature.

In *The Greek Slave*, Powers presented an attractive female subject that would simultaneously invite and repel erotic associations. His earliest description of the statue, in a letter to his benefactor, John Preston, recognized the need to balance a powerful appeal to the senses with an equally strong protection against charges of immorality. Perhaps thinking of the controversy aroused by the unembarrassed nudity of his *Eve*, Powers defended *The Greek Slave* by pointing out the greater modesty of its pose. Although the statue was nude, he wrote, "her hands [will be] bound and in such a position as to conceal a portion of the figure, thereby rendering the exposure of the nakedness less exceptionable to our American fastidiousness. The feet also will be bound to a fixture and the face turned to one side, and downwards with an expression of modesty and

Christian resignation."[12] Although Powers later changed some of the details, this description contains the crucial elements that made *The Greek Slave* a success: nudity combined with modesty, constraint, and Christian resignation.

By the time his statue was ready for public exhibition, Powers had refined his notion of how its nudity might be made acceptable to its audience. In an interview published at about the same time *The Greek Slave* was delivered to its first owner, Powers tried to define the moral uses of nudity in art. "It was not my object for interest's sake to set before my countrymen demoralizing subjects, and thus get even my bread at the expense of public chastity," he declared. He went on to insist that "a pure abstract human form tempered with chaste expression and attitude" was "calculated to awaken the highest emotions of the soul for the pure and beautiful." He even tried to argue that since the "society of chaste and well educated women has a tendency to exalt the mind," redeeming feminine influence is not "limited to the face alone," a suggestion whose humor was undoubtedly unintentional.[13]

In this same interview, Powers commented on the importance of narrative in the struggle to control the powerful emotions generated by his nude subject. Audiences could best experience the uplifting effects of the pure abstract form when they had access to a story that encased the nude figure in a protective web of explanation.

> The slave has been taken from one of the Greek islands by the Turks, in the time of the Greek Revolution; the history of which is familiar to all. Her father and mother, and perhaps all her kindred, have been destroyed by her foes, and she alone preserved as a treasure too valuable to be thrown away. She is now among barbarian strangers, under the pressure of a full recollection of the calamitous events which have brought her to her present state; and she stands exposed to the gaze of the people she abhors, and awaits her fate with intense anxiety, tempered by the support of her reliance upon the goodness of God. Gather all these afflictions together, and add them to the fortitude and resignation of a Christian, and no room will be left for shame.[14]

Powers now gave a more elaborate and nuanced narrative, focusing on the imagined emotions of his subject. In this description, he also instructed his audience on how to view a nude figure. Redirecting the viewer's gaze from the female subject's body to her face, he gave his audience something other than the woman's nudity on which to focus. His emphasis now fell not on the modesty of the slave's pose described in his letter to Preston, but on the narrative details that explained her situation.

Powers knew that his viewers were already prepared to respond emotionally to a story in which a character very much like themselves was threatened by a mysterious Other, in this case the "barbarian strangers" who conquered Greece, the cradle of Western civilization. Observing that the Turks considered this Greek woman too valuable to be thrown away, Powers suggested that other things of value might be in danger of being reduced to the status of a commodity and even thrown away in a conflict with another culture. Many nineteenth-century observers were fascinated by the often unsettling glimpses of foreign cultures brought to them through the expanding European colonial empires.[15] When cultural differences suggested that gender identity and sexual practice might be relative rather than universal, the very basis for Western civilization seemed to be at risk. Commentators were thus intrigued and disturbed by the institution of the harem, which suggested attitudes toward sexuality and female identity that were profoundly different from accepted Western ideas.[16]

Powers knew that his audience would be able to embellish the imaginative context to explain the nature of the threat faced by the Greek slave. Literary Orientalism abounded in the nineteenth century and included such poetry as Byron's "The Bride of Abdyos" (1813) and Thomas Moore's "Lalla Rookh" (1817) and such operas as *The Caliph of Baghdad,* which played in New York in 1827, and Mozart's *Abduction from the Seraglio.*[17] A classic work of English pornography, *The Lustful Turk* (1828), portrayed the sexual awakening of English girls captured by a Turkish bey; among the women of his harem is a Greek girl pining for her homeland.[18] Travel accounts of the seraglio and writings on sexual hygiene agreed with the pornographers that "Turkey is literally the empire of the senses" and suggested that Turkish women were seduced by luxury into a world outside morality.[19]

The French painter Jean-Auguste-Dominique Ingres had been painting scenes from the Turkish baths since the beginning of the century and had worked in Florence in the same studio as sculptor Lorenzo Bartolini, who later became Powers's friend.[20] In 1839, Ingres painted a composition, *Odalisque with the Slave,* that made explicit the luxuriant sexuality that Westerners associated with the Turkish harem (fig. 8.3); the acquiescent, reclining figure suggests a world in which the female body exists only for man's pleasure. The painting was widely known in a contemporary engraving, and Ingres produced another copy in 1842.[21] In the same year that Powers began *The Greek Slave,* French sculptor James Pradier exhibited an *Odalisque* wearing a turban and looking back over her shoulder with a seductive glance (fig. 8.4).[22] Powers and his viewers were thus surrounded with a profusion of images that depicted the harem as the epitome of Eastern sensuality.

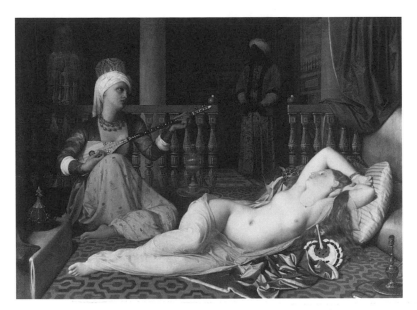

Figure 8.3 Jean-Auguste-Dominique Ingres, *Odalisque with the Slave*, 1840. Oil on canvas, 28⅜ × 39⅜ inches. Courtesy of the Fogg Art Museum, Harvard University, Cambridge, Mass., bequest of Grenville L. Winthrop.

Art, pornography, and much reform literature shared a male perspective, viewing the harem culturally and sexually as the world of forbidden desire. The sensuous odalisques of Ingres or Pradier challenged the viewer to define his own responses, to decide whether he was similar to or different from the "lustful Turk." Popular Orientalism allowed Western observers to flirt with their own sensuality, still keeping it at arm's length as "foreign" or "exotic." As Edward Said has convincingly shown, Westerners have often seen in the Orient a projection of their own fears and desires.[23] For women viewers, Orientalism offered a glimpse of a world of passion and desire that was largely repressed in their own environment. In the figure of the odalisque, nineteenth-century women could contemplate a female sexuality that was doubly foreign, springing from another culture and coming to them as seen through men's eyes.

In alluding to the Turkish harem, Powers plunged his audience into an alluring and alarming world, a place of enslavement and sensual gratification, a forbidden realm in which viewers confronted their own erotic impulses. Yet, as he suggested in the interview published in 1845, the device of the imaginary Turkish captors enabled his audience to participate in the gaze of sensuality and to distance themselves from it simultaneously. By objectifying improper viewing, the unseen "barbarian" Turks absolved the audience from responsibility for her

plight. The viewers to whom the sculpture was addressed, the men and women of the nineteenth-century West, accepted the distinction between themselves and her captors and agreed to view her in a different way. Thus Powers could invite his audience to look without embarrassment at *The Greek Slave*, leaving intact the suggestion that the female nude would under other circumstances be synonymous with shame.

Powers, furthermore, offered viewers an opportunity to experience powerful emotions without having to contemplate a scene of violence and degradation. He expected his audience to be able to imagine both a past and a future for the Greek slave far removed from the tranquility and contemplativeness of the present moment. Powers did not, like Ingres or Pradier, depict a woman of the harem. He chose instead a subject that played upon his audience's assumptions about the harem without actually portraying it. His Greek slave pauses on the threshold of a momentous change in her life; her future in the harem is the great unstated drama that gives the sculpture its poignancy.

Similarly, viewers could imagine a violent past that brought the Greek slave to her present plight. Twenty years later, a Czechoslovakian artist would paint a picture that made explicit the horror and passion at which Powers had only hinted. Jaroslav Čermák's *Episode in the Massacre of Syria* (1861) depicts a woman struggling with two men who are trying to carry her away (fig. 8.5). Like the Greek slave, she has been stripped of her clothes, and a cross lies at her feet; in this ferocious painting she is surrounded by the corpses of her husband and child. The painter contrasts the whiteness of her skin with the swarthiness of her

Figure 8.4 James Pradier, *Odalisque*, 1841. Marble, life size. Musée des Beaux-Arts, Lyon.

Figure 8.5 Jaroslav Čermák, *Episode in the Massacre of Syria*. Engraving. Edward Strahan [Earl Shinn], *The Art Treasures of America*, 3 vols. (Philadelphia, 1880), vol. 1, facing p. 137.

captors, who grasp her thighs and bind her arms. By 1879, when the painting was reproduced in *The Art Treasures of America,* it had found its way into the respectable collection of T. A. Havemeyer of New York.[24] Whereas Powers felt it necessary to muffle the drama that gave *The Greek Slave* its poignancy, later artists and patrons were willing to confront more directly what one commentator called the "hot energy" of the scene.[25]

Popular response to *The Greek Slave* indicated how well Powers had judged his audience and its imperatives. Soon after its completion, the first version of the statue was shipped to England, where its owner, Capt. John Grant of Devonshire, placed it in the showroom of Graves and Company, in Pall Mall. Here the sculpture attracted much attention, partly because it represented the debut of a previously unknown American sculptor.[26] The early reviews praised the work as "charming" and "sweet," and noted Powers's technical accomplishments.[27]

The event that established *The Greek Slave* as one of the most celebrated of American art productions, however, was the tour of American cities arranged by Powers in 1847–48. An American patron, James Robb of New Orleans, had offered to buy a replica of the statue in July 1847. Powers had on hand a copy he

had executed for an English patron, Lord Ward, and he decided to send it to America under the management of Miner Kellogg, an American artist Powers knew in Florence, to earn fame and fortune by public exhibition before it was delivered to Robb. Eventually, this arrangement caused many legal complications and bitter recriminations between Robb, Kellogg, and Powers over who owned which version of the sculpture and who deserved what portion of the proceeds of the exhibition.[28] But the exhibition tour brought the sculptor favorable publicity throughout the United States and outlined the terms in which it would subsequently be discussed.

Miner Kellogg proved to be a shrewd and knowledgeable art publicist who clearly understood that American audiences would accept a potentially erotic subject only if it was encased in a suitably moral narrative. Under his guidance, *The Greek Slave* attracted favorable reviews, which were promptly gathered together into a pamphlet that was distributed to viewers in each of the cities where the statue was displayed. The pamphlet, published in 1848, included a biography of Powers by the popular orator and politician Edward Everett, testimony to the sculptor's technical skill by an Italian artist, A. M. Migliarini, an excerpt from a travel book, *Scenes and Thoughts in Europe*, by G. H. Calvert, and miscellaneous poems and reviews from English and American journals.[29] With such a guidebook, viewers in cities across the United States were soon admiring *The Greek Slave* as an exemplar of beauty and morality. Perhaps because of its successful American tour, *The Greek Slave* was given a place of honor in the American section of the Crystal Palace Exhibition in London in 1851, thereby establishing its standing in the international art world.

The most important single item in the 1848 pamphlet was an enthusiastic review by an influential clergyman, which Kellogg reprinted in full. The Reverend Orville Dewey, a Unitarian minister and associate of William Ellery Channing, had preached in Boston, New Bedford, and New York and was well known for the warmth and vigor of his oratory. "Palpitating with emotion," preaching with "fervid and tender appeal," Dewey himself seemed to understand the value of dramatic expressivity in the service of spiritual ends.[30] He was the ideal spokesman for the idea already formulated by Powers that art, properly seen, could arouse viewers to a higher state of moral consciousness.[31] In an article entitled "Powers' Statues" in the *Union Magazine of Literature and Art*, Dewey compared *Eve* and *The Greek Slave* to the standard examples of excellence in ancient sculpture, the Apollo Belvedere and the Venus de Medici, and pronounced Powers's superior. "There is *no* sentiment in the Venus, but modesty. She is not in a situation to express any sentiment, or any *other* sentiment. She has neither done anything nor is going to do anything, nor is she in a situation, to awaken any moral emotion. . . . There ought to be some reason for exposure

besides beauty." Insisting that Powers's sculpture expressed more than "the beauty of mere form, of the moulding of limbs and muscles," the clergyman explained that the sensuous appeal of the statue was justified by its higher moral purpose.

Dewey particularly emphasized the centrality of narrative to the interpretation of art. The story, he insisted, was more important than the appearance of the sculpture itself. Indeed, Dewey suggested that the "sentiment" evoked by the sculpture could change the very way the viewer looked at it. In looking at *The Greek Slave*, Dewey asserted, the receptive viewer—the Christian, he might have added, rather than the "barbarian"—ceased to see a nude sculpture at all. "The Greek Slave is clothed all over with sentiment; sheltered, protected by it from every profane eye. Brocade, cloth of gold, could not be a more complete protection than the vesture of holiness in which she stands." Whereas Powers had suggested that the viewer's gaze could avoid the subject's body and focus on her face, Dewey went one step farther, suggesting that the viewer could see *The Greek Slave* without seeing her body at all. The artist is able "to make the spiritual reign over the corporeal; to sink form in ideality; in this particular case, to make the appeal to the soul entirely control the appeal to sense."[32]

Despite such disclaimers, however, many other commentators revealed the statue's powerful appeal to their senses. Male viewers often wrote what amounted to love poetry when reflecting on *The Greek Slave*. "Why hauntest thou my dreams," asked one poet, describing the "maiden shape" and "lustrous brow," finding her "Severe in vestal grace, yet warm / And flexile with the delicate glow of youth."[33] Another writer sidestepped the captivity theme to imagine the marble maiden coming to life in the presence of true love:

Ah, then I know should gush the woman's tears!

The marble eyelids lift—the pale lips should
Quick pant, as Love his flashing pinion bent.[34]

By removing the chain and imagining a welcomed lover, this poet allowed himself to experience the feelings of desire that other commentators had associated with the "barbarian" masters of the harem.

Female viewers could also participate in a pleasurable recasting of the narrative. One woman remarked that she could now for the first time understand the story of Pygmalion. "I could imagine the devotion with which the statue was gazed upon day after day . . . until he grew mad with love from the creation of his own genius!"[35] This comment legitimated the emotions of love and desire that the male viewer might be expected to feel. At the same time, interestingly, it suggested a corresponding response by the woman who is the focus of desire.

Viewing the "rosy tinge flushing the pure marble," the result of the light reflecting off the crimson drapery that surrounded it, the writer of the paragraph found herself responding with the same emotions she attributed to the Greek slave: "I could have wept with a perfect agony of tears."[36] Presumably the awakening Galatea felt some such emotion upon coming to life in Pygmalion's arms.[37]

The Greek Slave thus served viewers as a focus for their intensely ambivalent interest in the human body and female sexuality in particular.[38] As Peter Gay has argued, nineteenth-century reticence about sexuality does not mean that sexuality was not an important force in people's lives. "It is a mistake to think that nineteenth-century bourgeois did not know what they did not discuss, did not practice what they did not confess, did not enjoy what they did not publish."[39] In *The Education of the Senses*, volume 1 of *The Bourgeois Experience, Victoria to Freud*, Gay traces a history of sexual expressiveness in European and American bourgeois culture, arguing that works of nude sculpture like *The Greek Slave* played an important role in providing morally sanctioned erotic pleasure.[40]

Other modern critics have commented on the importance of *The Greek Slave* as a focus for sexual fantasy among its viewers, male and female. Like the popular literature that could be read in gift books and annuals and in the journals that reviewed *The Greek Slave*, the narrative suggested by the statue offered viewers an opportunity to identify with the desired-love-object-as-victim, as well as with her pursuer.[41] Suzanne Kappeler has argued that pornography is defined by conventions of representation in which the author and the spectator share an illusion of power over the victim.[42] Without suggesting that *The Greek Slave* was actually pornographic, we may speculate that the subject of a woman in bondage provided a similar kind of excitement for male spectators. Women spectators may have responded to the sculpture as a fantasy of domination. In fact, E. Anna Lewis reported sinking into a trance for five hours, and Clara Cushman declared that the sculpture put her into "a train of dreamy delicious revery, in which hours might have passed unnoticed."[43] Both these observers reported an experience that paralleled that of the slave herself: an emotional captivity, which they experienced as satisfying and pleasurable.

Furthermore, *The Greek Slave* provided, in an environment of self-conscious respectability, some of the same stimulation as the illicit forms of entertainment that were beginning to develop in American cities in the 1840s: dance halls with scantily clad or naked performers, restaurants that hung paintings of nude women on their walls, and the "model artist" shows, where naked women engaged in tableaux vivants illustrating scenes from history, literature, or even the Bible.[44] One writer reported in 1850 that he had visited an establishment called "Walhalla," where he saw a "brawny female" impersonating Venus, Psyche, the biblical Susannah surprised by the Elders, and the Greek slave.[45] Even as

pornography reached toward high culture for a veneer of respectability, a work like *The Greek Slave* that claimed for itself a high moral ground nonetheless provided audiences with a vehicle for the expression—and the repression—of deeply felt desires.

That desire was an important component of *The Greek Slave*'s appeal is suggested by one of Powers's most personal reminiscences. After hearing that his statue had been exhibited in Woodstock, Vermont, his birthplace, Powers wrote to a cousin, Thomas Powers, about an "oft-repeated dream" he used to have when he lived there as a child. "I used to see in my sleep . . . a white, female figure across the river, just below your father's house. It stood upon a pillar or pedestal; was . . . to my eyes very beautiful, but the water was between me and it, too deep to ford, and I had a strong desire to see it nearer, but was always prevented by the river, which was always high."[46] In this account of his childhood dream, Powers explicated his own conflicts of desire and repression. Drawn to the beautiful white figure (he does not allow himself to say whether it was clothed or naked), but prevented from reaching it by a deep and dangerous river, Powers was left with a sense of longing so profound that he remembered it some thirty years later. Female beauty seemed infinitely desirable but hopelessly unattainable, and the effort to face it directly would take him into waters "too deep to ford," metaphorically as well as literally.

Exhibitors seemed to recognize at least tacitly the erotic potential of the statue, for it was sometimes displayed with special viewing times for women and children.[47] But most commentators took special pains to deny the sculpture's sensual appeal. Hence the importance of the words *chaste* and *chastity* in poems about and descriptions of *The Greek Slave*. "O chastity of Art!" proclaimed the writer of the prize ode to Powers's *Greek Slave*, winner of a contest in the *New York Evening Mirror*. "Beneath her soul's immeasurable woe, / All sensuous vision lies subdued." The writer goes on to celebrate "Her pure thoughts clustering around her form, / Like seraph garments, whiter than the snows."[48] Dewey's insistence that the nude sculpture was clothed in morality was echoed by numerous other commentators. "Unclothed, yet clothed upon," began a poem by Unitarian minister James Freeman Clarke; he continued, ". . . She stands not bare— / Another robe, of purity, is there."[49] This insistence that the nude sculpture is really clothed, and that a woman who is about to be sexually violated is chaste, seems paradoxical, to say the least. A Freudian critic might see in this insistence on purity a repressed eroticism, with the viewers denying their own sense of the danger and appeal of the nude as a physical force by focusing on the opposite qualities of spirituality and ideality.

Many observers followed the lead of Powers and Dewey by insisting that the Greek slave's spirituality was essential to her appeal. Although an occasional critic

wished she showed more anger and defiance (like the subject of Čermák's later painting), most observers praised her for her tranquility and found it appealing.[50] Art critic and poet Henry Tuckerman described the Greek slave as almost superhuman in her transcendence of her painful situation:

Do no human pulses quiver in those wrists that bear the gyves
With a noble, sweet endurance, such as moulds heroic lives?

Half unconscious of thy bondage, on the wings of Fate elate
Thou art gifted with being high above thy seeming fate!

Words of triumph, not of wailing, for the cheer of Hope is thine,
And, immortal in thy beauty, sorrow grows with thee divine.[51]

Tuckerman's poem stresses the subject's aloofness, her isolation in a spiritual state that puts her beyond the reach of her worldly woes. In this narrative, as in some of the others that reveal the writer's attraction to the female subject, the subject's remoteness and self-possession are seen as part of her appeal. In this sense she seems to embody the aspect of female sexuality that Freud described in his essay "On Narcissism: An Introduction": "Women, especially if they grow up with good looks, develop a certain self-containment which compensates them for the social restrictions that are imposed on them in their choice of object. Strictly speaking, it is only themselves that such women love with an intensity comparable to that of the man's love for them. . . . Such women have the greatest fascination for men . . . for it seems very evident that another person's narcissism has a great attraction for those who have renounced part of their own narcissism and are in search of object-love."[52] Freud suggested that female self-containment might originate as a response to social restrictions; the Greek slave in her dire extremity certainly could be seen as symbolizing the restraints placed on all women in society. If female narcissism was especially attractive to men who had renounced a measure of their own narcissistic impulses, as Freud suggested, then *The Greek Slave* might have been expected to speak particularly strongly to the bustling culture of nineteenth-century America which, a numerous commentators lamented, allowed so little time for aesthetic cultivation or reflection.[53]

In their ambivalent attitude toward the female body—as beautiful but dangerous, to be admired but not to be seen—Powers and his supporters reflected the complex and contradictory attitudes toward human sexuality that characterized antebellum America. As Stephen Nissenbaum has pointed out, American anxiety about the integrity of the body, and in particular about the dangers of sexuality, sprang into full force in the decade of the 1830s.[54] Medical literature of the same period stressed female vulnerability, woman's delicate nervous

system, and the way in which modern life posed a threat to her role as wife and mother.[55]

The Greek Slave addressed this anxiety about the body and sense of female vulnerability. Literally imperiled by a dangerous sexuality, the female subject represents woman's body at risk. The first published engraving of the sculpture made it seem leaner, less robust, and more conventionally pretty than it was, all of which suggested that the engraver responded to a sense of the subject's vulnerability and portrayed her more like a pale and wan heroine than a Venus-like figure (fig. 8.6).[56] By the 1830s, as Nancy Cott has suggested, the doctrine of female passionlessness had begun to gain widespread popularity, giving women moral authority at the cost of repression of their sexuality.[57] Of course, sexuality did carry risks for nineteenth-century women, ranging from death in childbirth to venereal disease.[58] The figure of *The Greek Slave*, chained and acquiescent in the face of imminent sexual violation, served as an epitome of female sexuality as many understood it at the time: resigned, aloof, passionless, and endangered.

The slave has also been deprived of her ability to serve as a wife and mother. Several of the written narratives focused on this aspect of the story: torn from her family and her home, the Greek slave represented the fragility of woman's domestic life, as well as of her physical integrity. One writer, E. Anna Lewis, reported the train of thoughts that rushed through her mind as she gazed at the statue: "The history of her fallen country, her Greek home, her Greek friends, her capture, her exposure in the public market place; the freezing of every drop of her young blood beneath the libidinous gaze of shameless traffickers in beauty; the breaking up of the deep waters of her heart; then, their calm settling down over its hopeless ruins."[59] Similarly, some of the poetry inspired by *The Greek Slave* stressed her separation from home and family. According to one poet, her

> . . . expressive, drooping,
> Tender, melancholy eyes, are vainly
> Looking for that far-off one, she fondly
> Loves in her deep sorrow, and her weary
> Heart is throbbing, with dear memories of
> Her distant, happy cottage-home in Greece.
> Alas! The spoiler came, and ruthless, tore
> The lily from its pearly stem, to bloom
> In base Constantinople's foul Bazaar![60]

Here the language of ravishment is applied to the removal of the young woman from her home, and the reader's emotions are carefully focused on past domesticity rather than future sexual exploitation.

Figure 8.6 Hiram Powers, *The Greek Slave*. Engraving. *Art Journal* 12 (1850): facing p. 56.

Construction of a sentimentalized, domestic past placed the Greek slave more securely in the realm of respectability, but it also reminded viewers of their own fears of domestic disarray. If, as Nissenbaum has argued, heightened anxiety about illness and sexuality correspond to enormous changes in the everyday life of most Americans—the shift from a household economy to a market economy and the creation of a woman's sphere apart from the world of work—

the image of a slave's disrupted domestic idyll might have resonated with the concerns of its audience as much as the suggestion that she faced physical danger. The note of nostalgia and regret for a lost past, barely suggested by Powers himself, appears so frequently in popular responses to the sculpture as to suggest that Powers had tapped a deeper vein than he knew.

Many of the narratives about *The Greek Slave* comment specifically on the fact that she is about to be sold in the slave market. One art historian has argued that the sculpture evoked the issue of American slavery and reflected Powers's abolitionist views.[61] The connection was evident to some observers: when *The Greek Slave* was displayed at the Crystal Palace Exhibition in 1851, the British magazine *Punch* published an engraving showing a black woman chained to a pedestal, with the caption "The Virginian Slave. Intended as a companion to Power's 'Greek Slave'" (fig. 8.7).[62] However, *The Greek Slave* was as popular in New Orleans, home of one of its purchasers, as in Boston, and much of its audience was apparently oblivious to the ironies of driving past American slave marts to shed tears over the fate of the white marble captive. Just as the sculpture might be said to have displaced its viewers' sexual anxieties, so it displaced their anxieties about slavery as well.

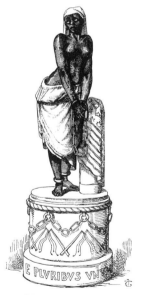

THE VIRGINIAN SLAVE.
INTENDED AS A COMPANION TO POWER'S "GREEK SLAVE."

Figure 8.7 "The Virginian Slave. Intended as a companion to Power's 'Greek Slave.'" Engraving. *Punch* 20 (1851): 236.

An abolitionist framework was apparently far from the minds of New York newspaper readers in 1857, when the Cosmopolitan Art Association publicized its auction of one of the copies of *The Greek Slave* by humorously suggesting that the sale recapitulated the plight of the sculpture's subject. "THE GREEK SLAVE TO BE SOLD," proclaimed the headline in the *Cosmopolitan Art Journal,* and the article added that the "renowned statue" was about "to be brought to the ignominious block."[63] Indeed, the journal reprinted a facetious commentary from the *New-York Evening Express* deploring the sale of "not only a slave, but a woman; not only a woman but a young and exquisitely beautiful one— white as driven snow, with a most faultless form and most perfect features. Was ever such a thing heard of!" Apparently without recognizing that abolitionists might make the same comments about the quadroon markets of New Orleans, the journal frivolously seems to dismiss the idea of a serious antislavery interpretation of the sculpture, but its tone also suggests discomfort with the implied connection between viewing and possessing. Perhaps when the statue was treated as a commodity, the nineteenth-century audience sensed a dissolution of the distinction between themselves and the lustful Turks. "And still more awful," continued the article, "for a week before the sale this slave will be exposed, perfectly nude, in the most public places in the city . . . that all the rich nabobs may feast their eyes upon her beauties, and calculate how much she would be worth to ornament their palatial residences up town."[64] Sale of the statue, in this sense, is not so different from sale of the slave, and in both cases viewing is as much an act of appropriation as owning.

To extend the argument further, the position of *The Greek Slave* as a market commodity suggests the contention by Claude Levi-Strauss that women function in the social structure both as signs and objects of value, as a result of their role as signifying exchange between men.[65] The viewers' fascination with an image of a woman displayed for gaze and sale may reflect the position of women in culture generally, subject to observation and commodification. The special understanding claimed by such female viewers as Clara Cushman may suggest a broader sense in which the Greek slave, exposed and vulnerable, seemed an appropriate symbol for women in American culture.[66]

Finally, the recurrent comments on the "mart" in which the Greek slave stands for sale recall the fears of such critics as Henry Tuckerman and James Jackson Jarves that the commercial spirit was overwhelming other values in nineteenth-century American culture. In the *Book of the Artists*, Tuckerman lamented the dehumanizing effects of "the hard struggle for pecuniary triumphs."[67] Art, he suggested in his book, might provide and escape from the impersonal world of commerce. In his poem on *The Greek Slave*, Tuckerman had

characterized her as standing among "a herd of gazers, . . . a noisy mart," in imagery that recalled his description of Wall Street.[68] The rise of commercial culture brought about many changes in American life, and the image of a victim sacrificed to commerce struck a responsive chord on many levels.

Much of the energy behind the narratives generated by *The Greek Slave*, narratives constructed by the artist, his defenders, viewers, and critics of all sorts, centered on the subject's relationship to the exercise of power. On one hand, the sculpture seemed to depict the epitome of powerlessness: a woman completely at the mercy of others, stripped of her clothing, as well as her culture (represented by the locket, the cross, and the Greek liberty cap laid aside with her clothing on the post beside her). On the other hand, Powers and his supporters all insisted that the female subject transcended her suffering to become an example of spiritual power.

The chain is the clearest expression of her powerlessness. Although some reviewers criticized Powers's use of the chain, arguing that it was historically inaccurate as well as physically improbable (had her captors unchained her to undress her, then chained her again?), others recognized immediately its symbolic importance.[69] As sculptor John Rogers observed, "Look at Powers Greek Slave—there is nothing in the world that has made that so popular but that chain. . . . *There are plenty of figures as graceful as that and it is only the effect of the chain that has made it so popular.*"[70] The chain suggested hopeless constraint, overwhelming odds. It helped to hide the genitals of the statue even while it explained why they were exposed.

Interestingly enough, however, many of those who commented on *The Greek Slave* during the height of its popularity saw this enslaved female subject as a symbol of spiritual power. For many observers the narrative became one of the triumph of faith over adversity. "It represents a being superior to suffering, and raised above degradation by inward purity and force of character," declared the introduction to the pamphlet that accompanied the sculpture on its American tour. "The Greek Slave is an emblem of all trial to which humanity is subject, and may be regarded as a type of resignation, uncompromising virtue, or sublime patience."[71] For most observers, this spirituality gave the Greek slave a measure of superiority over her captors. The readers of these pamphlets apparently accepted the notion that the apparent powerlessness of this victimized woman could, from another point of view, be seen as a position of spiritual superiority, ascendance, even triumph.

Even the chain, the symbol of her powerlessness, to some commentators also represented her power. "What is the chain to thee, who has the power / To bind in admiration all who gaze upon thine eloquent brow and matchless form?" asked

Lydia Sigourney. "We are ourselves thy slaves, most Beautiful!"[72] For Elizabeth Barrett Browning, the slave's moral power had revolutionary implications:

> . . . Appeal, fair stone,
> From God's pure heights of beauty against man's wrong!
> Catch up in thy divine face, not alone
> East griefs but west, and strike and shame the strong,
> By thunders of white silence, overthrown.[73]

Like Browning, other commentators saw in the sculpture the possibility of a violent reversal of roles: the strong could be overthrown. Numerous observers elaborated upon *The Greek Slave*'s potential for working a transformation. A reviewer in the *New York Courier and Enquirer* reported that the statue's beauty "subdues the whole man. . . . Loud talking men are hushed . . . and groups of women hover together as if to seek protection from their own sex's beauty."[74] In this passage the language of conquest applied to the slave in the narrative version of her situation is directed toward the viewer, who is in turn conquered by her: the audience is subdued, held; they yield, they are hushed, they seek protection. A poet in the *Detroit Advertiser* made the analogy explicitly:

> In mute idolatry, spell-bound I stood
> MYSELF THE SLAVE, of her, the ideal of
> The Sculptor's inspiration! For I felt
> I was indeed a captive.[75]

In all of these examples, an encounter with the statue deconstructed the very notions of power and powerlessness, suggesting to its viewers change, overthrow, and the reversal of roles. The revolutionary implications sensed by Elizabeth Barrett Browning were not only political but social and suggested the uneasiness that underlay the delineation of gender in a transforming nineteenth-century culture.

Visual depictions of the experience of viewing *The Greek Slave* stressed the dignity and authority, and by extension the power, of the image. Although only the size of a small woman (65½ inches high), the statue appears to tower over the figures of the spectators in many engravings such as the one published in 1857 showing *The Greek Slave* on display in the Dusseldorf Gallery in New York (fig. 8.8). Spectators stand respectfully around the larger-than-life-sized sculpture. Although men elsewhere in the gallery are wearing hats, the men closest to *The Greek Slave* have removed theirs. Two groups are conversing quietly; a young girl walking past in the foreground has stopped in her tracks and looks back, fascinated. The catalogue of the Cosmopolitan Art Association, which sponsored the exhibition depicted in this engraving, emphasized the atmosphere of

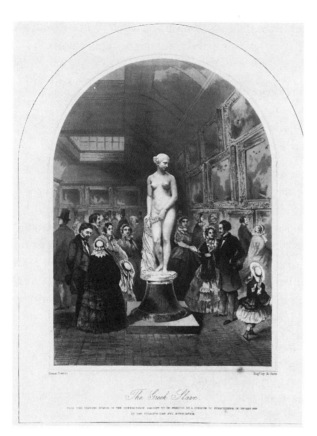

Figure 8.8 *The Greek Slave*. Engraving. *Cosmopolitan Art Journal* 2 (December 1857): between pp. 40 and 41.

decorum, even reverence, that surrounded the sculpture. "Its presence is a magic circle, within whose precincts all are held spell-bound and almost speechless," one review read.[76] "It is curious to observe the effect produced upon visitors," wrote another viewer. "They enter gaily, or with an air of curiosity; they look at the beauteous figure, and the whole manner undergoes a change. Men take off their hats, ladies seat themselves silently, and almost unconsciously; and usually it is minutes before a word is uttered. All conversation is carried on in a hushed tone, and everybody looks serious on departing."[77] Such descriptions, of course, were prescriptive, informing readers of the attitude and decorum that would be expected of them in the art gallery. The descriptions, like the engraving, stressed the weight and solemnity of the occasion. Furthermore, the engraving emphasized the relationship between the women in the audience and the sculpture. Unlike other depictions of art spectatorship published at about the same time, this engraving shows women actively looking at the sculpture, appearing to explain and interpret it to their male companions, who look not at

the sculpture but at them. The sculpture appears larger than life, and its proximity enlivens the women who surround it.

Although overtly an image of submission and resignation, *The Greek Slave* thus suggested to its viewers a suppressed possibility of resistance, of overthrow, of the empowerment of the powerless. It is for this reason that the sculpture, judged vapid and bland, static and derivative by the standards of twentieth-century taste, seemed so vivid and moving to its contemporaries. *The Greek Slave* seethed with meanings for nineteenth-century viewers, who articulated many of their interpretations in the form of narratives: stories of loss and danger, faith and triumph. The narratives told the story of the female body as their authors understood it—vulnerable, dangerous, and endangered, representing beauty and shame, attractive in its self-absorption but threatening to overwhelm the viewer. By extension, they told the story of the body politic, which was undergoing transition to a commercial culture amid contemplation of unsettling changes in gender roles and family life. The contradictory meanings embodied in *The Greek Slave*—eroticism indulged and denied, passion and passionlessness, power and powerlessness—were the meanings with which its viewers themselves struggled in a rapidly transforming culture.

Notes

This is an abridged version of "Narratives of the Female Body: *The Greek Slave*," chapter 3 of *Marble Queens and Captives: Women in Nineteenth-Century American Sculpture* (New Haven and London: Yale University Press, 1990).

1. *The Greek Slave* has been much discussed by art historians, but few commentators have carefully examined the written record to analyze precisely what nineteenth-century viewers saw when they looked at the sculpture. See William H. Gerdts, *American Neoclassic Sculpture: The Marble Resurrection* (New York, 1973); Samuel A. Roberson and William H. Gerdts, "'. . . So Undressed, Yet So Refined . . .': *The Greek Slave*," *The Museum* 17 (Winter–Spring, 1965): 1–29; Linda Hyman, "*The Greek Slave* by Hiram Powers: High Art as Popular Culture," *College Art Journal* 35 (Spring 1976): 216–23; and Vivien Green [Fryd], "Hiram Powers's *Greek Slave*, Emblem of Freedom," *American Art Journal* 14 (Autumn 1982): 31–39.

2. See Roberson and Gerdts, "'. . . So Undressed, Yet So Refined.'"

3. See *Cosmopolitan Art Journal* 2 (December 1857): 40.

4. Henry James, *William Wetmore Story and His Friends* (Boston, 1903), 1:114–15.

5. Mary Douglas, *Purity and Danger: An Analysis of the Concept of Pollution and Taboo* (New York, 1966), 120–24.

6. Frances Trollope, *A Visit to Italy* (London, 1842), 1:144–45. See Sylvia Crane, *White Silence: Greenough, Powers, and Crawford, American Sculptors in Nineteenth-Century Italy* (Coral Gables, 1972), 196.

7. Isaiah Townsend to Hiram Powers, Nov. 4, 1841, quoted in Donald Martin Reynolds, *Hiram Powers and His Ideal Sculpture* (New York, 1977), 135.

8. Green [Fryd] discusses some of the literary responses to the Greek war for independence in "Hiram Powers's *Greek Slave.*" Greek captive women form the chorus in Shelley's verse play *Hellas.* See Percy Bysshe Shelley, *Hellas: A Lyrical Drama,* ed. Thomas J. Wise (1822; rpt. London, 1886).

9. William H. Gerdts, *The Great American Nude: A History in Art* (New York, 1973), 40–41, 44ff.

10. Kendall B. Taft, "Adam and Eve in America," *Art Quarterly* 23 (Summer 1960): 171–79.

11. Nathalia Wright, *Horatio Greenough: The First American Sculptor* (Philadelphia, 1963), 71–75.

12. Hiram Powers to Col. John Preston, Jan. 7, 1841, quoted in Reynolds, *Hiram Powers,* 137–38.

13. C. Edwards Lester, *The Artist, the Merchant, and the Statesman, of the Age of the Medici and of Our Own Times* (New York, 1845), 1:86–87.

14. Quoted in ibid., 1:88.

15. See, for example, the poignant description of a Western observer's combined horror and fascination at witnessing an Indonesian immolation ceremony so carefully analyzed by Clifford Geertz in "Found in Translation: On the Social History of the Moral Imagination," in *Local Knowledge: Further Essays in Interpretive Anthropology* (New York, 1983), 36–54.

16. Malek Alloula has recently analyzed the Western male fascination with the concealed women of the harem, combining titillation, voyeurism, and a desire to control what they could not understand. See *The Colonial Harem* (Minneapolis, 1986).

17. Julius Mattefield, *A Hundred Years of Grand Opera in New York, 1825–1925: A Record of Performances* (1927; rpt. New York, 1976), 81.

18. See the description of this novel in Steven Marcus, *The Other Victorians: A Study of Sexuality and Pornography in Mid-Nineteenth Century England* (New York, 1966), 197–216.

19. See William W. Sanger, *The History of Prostitution: Its Extent, Causes and Effects Throughout the World* (1859; rpt. New York, 1939), 442–43. See the accounts of travel to the seraglio described in N. M. Penzer, *The Harem* (London, 1936), esp. chap. 2.

20. See Reynolds, *Hiram Powers,* 262–67, 279–90, for a discussion of Ingres' influence on Powers.

21. See Georges Wildenstein, *The Paintings of J. A. D. Ingres* ([London], 1954), 210, 213.

22. See *Statues de Chair, Sculptures de James Pradier (1790–1852)* (Geneva and Paris, 1985–86), 131–33.

23. Edward Said, *Orientalism* (New York, 1978).

24. Edward Strahan [Earl Shinn], *Art Treasures of America,* 3 vols. (Philadelphia, 1879–82), 1:140. In its pose and subject, the painting also suggested the well-known subject of the rape of the Sabine women.

25. Ibid., 1:135.

26. A later review in the London *Art-Journal* reflected on that earlier exhibition: "We had not even heard of the name of Hiram Powers, and were consequently astonished to find so fine a work from one whose fame had not already reached the shores of England." "The Greek Slave," *Art-Journal* 12 (1850): 56.

27. "Greek Slave: Sculpture," reprinted from *Literary Gazette*, in *Eclectic Magazine* 5 (August 1845): 568.

28. The pamphlet *Vindication of Hiram Powers* offers testimonials to Powers's integrity in his dispute with Robb. Kellogg defended Powers in *Justice to Hiram Powers;* he stated his case against Powers in Miner Kellogg, *Mr. Miner K. Kellogg to His Friends.*

29. For example, the pamphlet published in Philadelphia was *Powers' Statue of the Greek Slave, Exhibiting at the Pennsylvania Academy of the Fine Arts.* Virtually identical pamphlets were published in New York, Boston, and New Orleans.

30. Quoted from the entry on Dewey in *The National Cyclopaedia of American Biography* (New York, 1894), 5:47.

31. Eleven years earlier, in a travel book called *The Old World and the New,* Dewey had made some awkward and thoroughly conventional comments about art. Orville Dewey, *The Old World and the New,* 2 vols. (New York, 1836), 2:108. Perhaps Kellogg helped him to refine his critical vocabulary.

32. Orville Dewey, "Powers' Statues," *Union Magazine of Literature and Art* 1 (October 1847): 160–61.

33. Augustin Duganne, "Ode to the Greek Slave, Dedicated to the Cosmopolitan Art and Literary Association," in *The Cosmopolitan Art Association Illustrated Catalogue, 1854* (New York, 1854), 25.

34. L. E., "To Powers' 'Greek Slave.'" *Cosmopolitan Art Journal* 2 (March and June 1858): 68.

35. Clara Cushman in *Neal's Saturday Gazette*, quoted in *Powers' Statue of the Greek Slave,* 18.

36. Ibid.

37. See the description of the treatment of the Pygmalion story in Marina Warner, *Monuments and Maidens: The Allegory of the Female Form* (New York, 1985), 227–28.

38. In James Joyce's novel *Ulysses,* Leopold Bloom inspects the private parts of classical statues to satisfy a similar curiosity. Joyce, *Ulysses* (rpt. New York, 1961), 176, 201.

39. Peter Gay, "Victorian Sexuality: Old Texts and New Insights," *American Scholar* 49 (Summer 1980): 377.

40. Gay, *The Education of the Senses,* vol. 1 of *The Bourgeois Experience, Victoria to Freud* (New York, 1984), 396–98.

41. See Hyman "*The Greek Slave* by Hiram Powers," 216–23.

42. Suzanne Kappeler, *The Pornography of Representation* (Minneapolis, 1986).

43. Anna E. Lewis, "Art and Artists of America," *Graham's Magazine* 48 (November 1855): 399. Clara Cushman, from *Neal's Saturday Gazette.*

44. See Christine Stansell, *City of Women* (New York, 1986), 175, for a description of one such tableau, Susannah and the Elders.

45. G. G. Foster, *New York By Gas-Light* (New York, 1850), 12–13.

46. Hiram Powers to Thomas Powers, n.d., quoted in Reynolds, *Hiram Powers,* 141.

47. An announcement of such a showing is reproduced in Roberson and Gerdts, "'. . . So Undressed, Yet So Refined,'" 16.

48. Duganne, "Ode to the Greek Slave," 25.

49. James Freeman Clarke, "The Greek Slave," quoted in Roberson and Gerdts, "'. . . So Undressed, Yet So Refined,'" 18.

50. One critic demanded, "How can she stand thus serene and erect, when the sanctity of her nature is outraged by this exposure? Where is the bending and shrinking of her form, that expression in every feature and limb of her unutterable agony, which should make the gazer involuntarily to turn away his eyes . . . ?" W. H. F., "Art Review, The Greek Slave," *The Harbinger* 7 (June 24, 1848): 62. But another writer rebuked this critic in a later edition of the same journal, saying that a "cry of anguish would be a very poor subject for a work of art, and . . . the artist would naturally choose the serene moment following, when the triumph of the spirit was revealed in Godlike resignation." John Dwight, "Greek Slave," *The Harbinger* 7 (July 8, 1848): 78.

51. Henry Tuckerman, "The Greek Slave," *New York Tribune,* Sept. 9, 1847, quoted in *Powers' Statue of the Greek Slave,* 12.

52. Sigmund Freud, "On Narcissism: An Introduction," *The Standard Edition of the Complete Psychological Works of Sigmund Freud,* 24 vols., ed. James Strachey and Alan Tyson (London, 1957), 14:88–89.

53. Bram Dijkstra has commented on the theme of female narcissism in nineteenth-century European and American art. He discounts claims for women's spirituality as part of a repressive misogyny that constituted a "cultural war on women." It should be evident that I view the cultural matrix as more complex and conflicted. Dijkstra, *Idols of Perversity: Fantasies of Feminine Evil in Fin-de-Siècle Culture* (New York, 1988).

54. Stephen Nissenbaum, *Sex, Diet, and Debility in Jacksonian America* (Westport, Conn., 1980).

55. Carroll Smith-Rosenberg and Charles Rosenberg, "The Female Animal: Medical and Biological Views of Woman and Her Role in Nineteenth-Century America," *Journal of American History* 60 (September 1973): 332–56. See also John S. and Robin M. Haller, *The Physician and Sexuality in Victorian America* (Champaign, Ill., 1974).

56. See *Art-Journal* 12 (1850): facing p. 56.

57. Nancy Cott, "Passionlessness: An Interpretation of Victorian Sexual Ideology," *Signs* 4 (1978): 219–36.

58. See Sheila Ryan Johansson, "Sex and Death in Victorian England: An Examination of Age- and Sex-Specific Death Rates, 1840–1910," in Martha Vicinus, ed., *A Widening Sphere: Changing Roles of Victorian Women* (Bloomington, Ind., 1977), 163–81. See also Allan M. Brandt, *No Magic Bullet: A Social History of Venereal Disease in the United States since 1880* (New York, 1985).

59. Lewis, "Art and Artists of America," 399.

60. W. H. Coyle, "Powers' Greek Slave," *Detroit Advertiser,* quoted in Roberson and Gerdts, "'. . . So Undressed, Yet So Refined,'" 18.

61. Green [Fryd], "Hiram Powers's *Greek Slave.*"

62. *Punch* 20 (1851): 236.

63. *Cosmopolitan Art Journal* 1 (June 1857): 132.

64. *New-York Evening Express,* quoted in ibid., 133.

65. Claude Levi-Strauss, *The Elementary Structures of Kinship* (Boston, 1969); see discussion of this idea in Gayle Rubin, "The Traffic in Women: Notes on the 'Political Economy' of Sex," in Rayna R. Reiter, ed., *Toward and Anthropology of Women* (New York, 1975), 157–210. Also see Teresa de Lauretis. *Alice Doesn't: Feminism, Semiotics, Cinema* (Bloomington, Ind., 1984), 18–22.

66. Clara Cushman in *Neal's Saturday Gazette.*

67. Tuckerman, *Book of the Artists,* 25.

68. Tuckerman, "Greek Slave," quoted in *Powers' Statue of the Greek Slave,* 12.

69. See the debate over *The Greek Slave* in *The Harbinger,* cited in n. 50.

70. Quoted in David H. Wallace, *John Rogers, The People's Sculptor* (Middletown, Conn., 1967), 70.

71. *Powers' Statue of the Greek Slave,* 3.

72. Lydia Sigourney, "Powers's Statue of the Greek Slave," in *Poems* (New York, 1860), 112.

73. Elizabeth Barrett Browning, "Hiram Powers' 'Greek Slave,' *Poems, 1850* in *The Complete Works of Elizabeth Barrett Browning,* 6 vols., ed. Charlotte Porter and Helen A. Clarke (New York, 1900), 3:178.

74. Quoted in ibid., 16.

75. W. H. Coyle, quoted in Roberson and Gerdts, "'. . . So Undressed, Yet So Refined," 17.

76. *New York Courrier and Enquirer,* quoted in *Cosmopolitan Art Association Catalogue 1854,* 26.

77. Ibid.

9 The Ideal Works of Edmonia Lewis: Invoking and Inverting Autobiography

Kirsten P. Buick

Born to a Chippewa mother and an African American father, Mary Edmonia Lewis (ca. 1843–after 1909) is the first documented American woman sculptor of African Indian descent. Her work has a far-reaching cultural significance because it is inflected by each modifier, both singly and in combination, that can be used to describe her: "American," "woman," "sculptor," "African American," and "Native American." Yet, while the subjects of her sculptures are African American and Native American women, invoking her autobiography, their features follow idealized, western European models. Why did Lewis eschew ethnological models? Why does it matter?

Lewis's Freedwomen
Twentieth-century interpretations are unsatisfactory and tentative. Many scholars have observed that the women Lewis portrayed do not "look African" or "look Indian." Their long, straight hair, their keen European features, and the white marble of their "skin" belie their subject matter. Yet the issue of ethnicity is either a stated paradox that is left unexplained or is read against Lewis, with claims that she had no real care for "her people."[1]

Attention is also directed to gender. Criticism of Lewis's *Forever Free* (fig. 9.1), for example, has often regarded the relative positions of the male and female as reinforcing gendered stereotypes of male "aggression" (note also the raised arm) and female "passivity." In her reading of the antithetical positions of the male and female, Jean Fagan Yellin describes the male's hand as resting "protectively" on the woman's shoulder, while his other hand is raised "in a triumphant gesture."

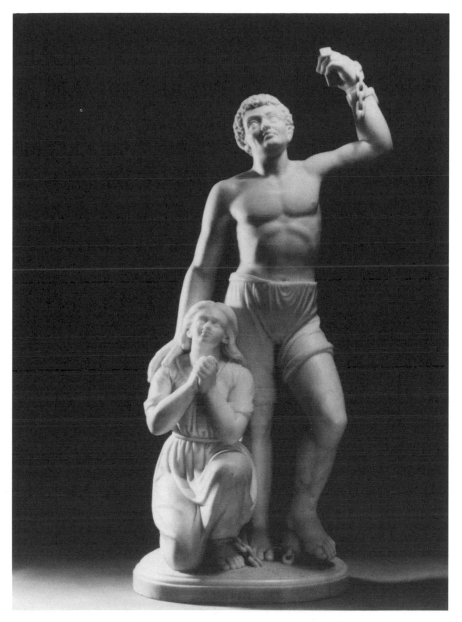

Figure 9.1 Edmonia Lewis, *Forever Free*, 1867. Marble, 41¼ inches. Howard University Art Gallery, Washington, D.C.

In Albert Boime's analysis, the male places his hand "condescendingly" on the woman's shoulder. Despite differing interpretations of the touch, for both scholars the issue is male agency in the face of female passivity. Frances K. Pohl explains the group in these terms: "The subservient position of the woman in *Forever Free* may have been a subtle commentary on the struggles that lay ahead for African-American women within their own community."[2]

As interpreted by these scholars, *Forever Free* is a visual testament of a patriarchal society in which the female is subordinated to the male. While it is tempting to examine *Forever Free* in light of recent developments in race and gender studies, we must also interpret it with regard to the aspirations of nineteenth-century African Americans. In this view, the sculpture presents a reconstructed image of the African American family after slavery and becomes a subtle commentary on the hopes for the newly liberated population.

It is important to remember that Victorian expectations about the role of women applied to free black people as well as to white people, and in this sense Lewis's freedwoman is connected to all women. Like her European American counterpart, the African American female was expected to observe a set of prescriptives found throughout the literature of the nineteenth century that defined the Cult of True Womanhood. Simply stated, she was supposed to be domestic, submissive, pious, and virtuous. As Judith Sealander has shown, before the Civil War the African American press employed images reflecting the Cult of True Womanhood to protest the constant violation of woman's "true" nature under slavery. The enslaved African American woman lived in the midst of a paradox, for while she, as the ideal woman, was "a soothing helpmate to her husband," she might also need to be "wily and physically courageous . . . able to murder her master, hide out in swamps, and ford rivers." Freedom brought a new paradox. As James Oliver Horton has explained: "During the nineteenth century, as now, Black liberation was often defined in terms of the ability of Black women and men to become full participants in American life. Ironically, this not only meant the acquisition of citizenship rights, almost all of which were applied only to men, but also entailed an obligation to live out the gender ideals of American patriarchal society. . . . All women were expected to defer to men, but for Black women deference was a racial imperative."[3]

Does *Forever Free* represent a commentary on oppression or subordination, or a conformity to gender ideals of the times? With emancipation, former slaves could marry and live in families. If we reexamine Lewis's statue as a representation of the birth of the African American "family" after slavery, the freedwoman's posture can be seen to reflect the qualities ascribed to the "True Woman"—submission, piety, and virtue.

Within this new family that emancipation created, the male also had a role to fill. Like his white counterpart, he was entrusted with the protection of his family. In *Forever Free,* the male's stance and his raised arm, interpreted as either triumphant or aggressive, signify this potential to protect and thus mark his new status as the head of a family. Horton explains that for African American men "the ability to support and protect their women became synonymous with manhood and manhood became synonymous with freedom. Often slaves demanding their freedom used the term 'manhood rights.' Manhood and freedom were tied to personal power."[4] If we read Lewis's work as a unit instead of as a reflection of opposing forces—domination versus subordination, or man versus woman—we see that, as Yellin claims, the male's hand rests "protectively" on the female's shoulder. No longer is she the white man's property. Instead, and in terms of nineteenth-century gender ideals, she belongs to the man who has the capacity to protect her. There is no evidence in the work itself that Lewis was critical of their relationship or commenting on female oppression. Nor did the viewing public perceive it thus.

Completed in Rome in 1867, *Forever Free* was the second "ideal work"—a sculpture based on a narrative from literature, mythology, or the Bible—that Lewis made in Europe. Created four years after President Lincoln issued the Emancipation Proclamation on January 1, 1863, it was also Lewis's second contribution to the celebration of liberty. She originally titled the sculpture *The Morning of Liberty,* but inscribed on the front of its base are the words "Forever Free" from the proclamation's text.[5]

The woman is dressed in a simple, belted shift. She kneels on one knee and clasps her hands as if in prayer. With head tilted and chin raised, she gazes upward. Her long hair is without curl and flows from a center part, and her nose, viewed in profile, is straight. Around her left ankle are a manacle and chain, which seem to bind her to the base of the statue. At her side stands the man, dressed only in soft-looking cloth shorts. He stands in a classic contrapposto pose; under his left heel are the ball and chain that once restrained him. Although a manacle encircles the wrist of his raised arm, in his hand he holds the broken manacle and chain that have come from his ankle. His right hand rests on the right shoulder of the woman, who leans into his right leg. He, too, gazes upward. His hair is a tight cap of curls.

A formalist reading of *Forever Free* supports the figures being read as a unit rather than in opposition. Together, they form a compact silhouette made up of a series of discrete triangles, beginning with the horizontal triangle defined by the man's upraised arm and right shoulder and expanding into the vertical triangle created by his head at the apex and his bent left leg and female companion

at the base. The overall triangulation of the figures is reinforced and echoed by the pyramidal shape of the female. Though she kneels and he stands, their bodies are in perfect harmony. They gaze in the same direction, and the tilt of their heads—his to the right and hers to the left—creates a sense of intimacy reinforced by his touch on her shoulder. Despite the separate chains that bind them, the pair exhibits, through the rhythms of their individual bodies, the indivisible "bonds" of their commitment to one another.

By October 18, 1869, Lewis had returned to the United States to attend the sculpture's dedication at Tremont Temple in Boston after its removal from its exhibition site at the gallery of Childs and Company. At 7:30 P.M., for an admission fee of twenty-five cents, the public was admitted to the ceremony in which the statue was formally presented to the Reverend Leonard A. Grimes, a prominent abolitionist minister. The dedication was a carefully staged event that included singing and, according to one newspaper account, a "colored performer" who played the organ. Prominent male abolitionists, both white and black, were featured speakers—the Reverends J. D. Fulton and R. C. Waterston, William Lloyd Garrison, William Craft, and William Wells Brown.[6] According to Elizabeth Peabody, writing for the *Christian Register:*

> All who were present at Tremont Temple on the Monday evening of the
> presentation to Rev. Mr. Grimes of the marble group "Forever Free,"
> executed by Miss Edmonia Lewis, must have been deeply interested. No
> one, not born subject to the "Cotton King," could look upon this piece of
> sculpture without profound emotion. The noble figure of the man, his
> very muscles seeming to swell with gratitude; the expression of the right
> now to protect, with which he throws his arm around his kneeling wife;
> the "Praise de Lord"—hovering on their lips; the broken chain,—all so
> instinct with life, telling in the very poetry of stone the story of the last
> ten years.[7]

At this gathering *Forever Free* represented an appropriate testimony to the abolitionist argument that slavery destroyed the integrity of the family, perverting for those enslaved the biologically determined male and female functions within society.[8] Grimes, to whom the statue was dedicated, was a particularly fitting choice. Born a free person of African descent in Leesburg, Virginia, in 1815, he had dedicated his life to helping runaway slaves and was particularly known for his work in reuniting families torn apart by enslavement.[9]

Grimes and the other abolitionists at the dedication believed that the abolition of slavery would set male and female roles to rights. For them and for Lewis, freedom was seen as a masculinized process. Until the African American

man was free to establish a black patriarchy, the woman, they believed, would remain enslaved, as Lewis presented her in *Forever Free*. For white abolitionists, however, there were limits, suggested by the way the *Christian Register* chose to interpret the male figure's upraised arm. The potential for aggression in this gesture was neutralized with one paradoxical description: his "muscles seem[ed] to swell with gratitude." In this interpretation, the fear of black male violence emerges as an uncomfortable subtext, much as it does in the vernacular thanksgiving "Praise de Lord" ascribed to the figures. The black male's piety, this reading implied, would constrain any violent tendencies.[10]

While her art seems to support the gender ideals of her era, Lewis herself (fig. 9.2) did not conform to these ideals. Her odd clothes, her denial of marriage, her decision to sculpt—all contravened Victorian conventions. Yet these were the same choices that had been made by the other women sculptors who had preceded her to Rome—Harriet Hosmer, Anne Whitney, and Louisa Lander. But in her sculptures, Lewis not only selected subjects who conformed to Victorian gender ideals; she also depicted these women in an idealized way. Like the woman in *Forever Free*, the woman in Lewis's first ideal work, *The Freedwoman on First Hearing of Her Liberty*, was presented in a kneeling pose.

In 1866, Henry Wreford, columnist for the *Athenaeum*, described *The Freedwoman*, which is now lost: "She has thrown herself to her knees, and, with clasped hands and uplifted eyes, she blesses God for her redemption. Her boy, ignorant of the cause of her agitation, hangs over her knees and clings to her waist. She wears the turban which was used when at work. Around her wrists are the half-broken manacles, and the chain lies on the ground still attached to a large ball. 'Yes,' [Lewis] observed, 'so was my race treated in the market and elsewhere.'"[11] Here Lewis chose to depict what is perhaps the oldest personification of family in all of Western art—mother and child. With the end of slavery, mother and child were no longer property that could be separated and sold. The African American woman could fulfill her proper role as mother to her child, the most valued role a woman could play within nineteenth-century gender norms.

One year after the *Athenaeum's* review, a writer for the *Freedmen's Record* noted the similarity between the women in *The Freedwoman* and *Forever Free*. "Many of our readers will he glad to hear from Edmonia Lewis. She sent us a photograph of a new design for a group called 'The Morning of Liberty,' representing a standing male figure, casting off his chains and a young girl kneeling beside him. The design shows decided improvement in modelling the human figure, though the type is less original and characteristic than in the 'Freedwoman,' which she sketched in the Spring. Her next step will be to combine the merits of the two and give us a really valuable group."[12]

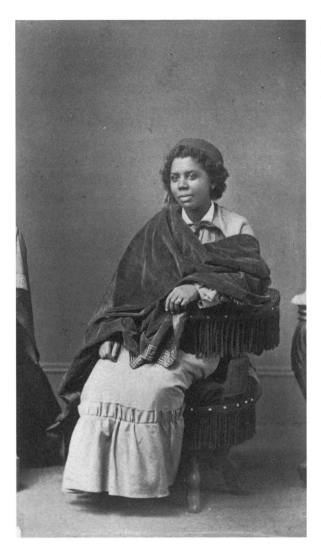

Figure 9.2 Henry Rocher, *Edmonia Lewis,* c. 1870. Albumen silver print, 3⅝ × 2⅛ inches. National Portrait Gallery, Smithsonian Institution, Washington, D.C.

Both freedwomen are posed to underscore their submissive, pious character, validated by their newfound freedom to act out normalized gender roles. Both are part of a family.

Lewis's Bondwomen

In contrast, Lewis's *Hagar in the Wilderness* represents the frustration of normalized gender roles within the body of one female figure (fig. 9.3). It is an allegorical statement about the abuses suffered by black women when a black patriarchy is not in place to protect them.

Figure 9.3 Edmonia Lewis, *Hagar in the Wilderness,* 1875. Marble, 52⅝ inches. National Museum of American Art, Smithsonian Institution, Washington, D.C., gift of Delta Sigma Theta Sorority, Inc.

Hagar, the Egyptian bondwoman to Sarah and Abraham, appears twice in the Old Testament (Gen. 16:1–16, 21:9–21) and once in the New Testament (Gal. 4:22–31). In the Old Testament story, Sarah, who is barren, sanctions the impregnation of Hagar by Abraham. Ultimately Hagar and her son, Ishmael, are sent away to wander in the wilderness. Because Egypt was coded as black Africa among abolitionists and colonizationists in the nineteenth century, Hagar was a particularly pertinent allegory of chattel slavery and the indignities that black women suffered.[13]

Lewis's treatment of the subject skillfully manages to allude to each appearance of Hagar in the Bible. The first time Hagar appears, she has become pregnant and is perceived by her mistress, Sarah, as making a mockery of her barrenness. Abraham gives Sarah full authority over Hagar, and Sarah deals "hardly with her" (Gen. 16:6). As a result, the pregnant Hagar flees into the wilderness, where she is comforted by the angel of the Lord near a fountain of water. This may be the moment at which Lewis depicted Hagar. She is pregnant with Ishmael. The jug at her feet suggests the fountain at which the angel found

her. The angel tells Hagar to return and submit to Sarah. Then God makes ninety-year-old Sarah fertile, and she also bears a son, Isaac. When Sarah finds the two boys playing together, she insists that the bondwoman and her son be sent away. They again wander in the wilderness, and when their water is gone Hagar places Ishmael under a shrub so that she will not see him die (Gen. 21: 15–16). Once again, in the midst of her despair, she is visited by an angel of the Lord. If this is Lewis's scenario, Hagar is once again alone, but her son is nearby; the jug at her feet symbolizes her search for water.

Finally, in the New Testament, Hagar is invoked as an allegory to differentiate between those who are free within the Spirit and those who are enslaved by the flesh (Gal. 4:24). Paul writes, "Cast out the bondwoman and her son: for the son of the bondwoman shall not be heir with the son of the freewoman" (Gal. 4: 30). In Lewis's allegory, Hagar, with the presence of her son implied, represents the despair and dismantling of the African American family under slavery. Where there is no male to protect, the mother and child are disinherited. The normalized condition of patriarchy has been inverted.

This was not Lewis's first depiction of Hagar. Another sculpture of this bondwoman, completed in 1870, was exhibited in Chicago that year. It is now lost, but we do have Lewis's comment on it: "I have a strong sympathy for all women who have struggled and suffered. For this reason the Virgin Mary is very dear to me."[14]

In *Hagar in the Wilderness,* Hagar, like Lewis's second freedwoman in *Forever Free* (and presumably like her first), clasps her hands, but unlike her sisters, Hagar is troubled. Her brow is furrowed. She stands and she is alone, trapped by slavery's invisible bonds. But while all three women express themes specific to the plight of African Americans, they look like Europeans, with straight hair and classically straight noses. Though depicted as white, they represent Lewis's desire to broaden the category of "woman" to include women who were not European American.

Lewis's Indian Women

It is significant that Lewis's Indian woman, Minnehaha, while dressed as a Native American, also displays features that are European. Lewis very consciously manipulates significant details of her appearance. Her bust of Minnehaha (fig. 9.4) and the Minnehaha of *The Marriage of Hiawatha* (completed in 1868 and 1871, respectively) have noticeable bumps in their noses, but Minnehaha's profile in the ideal work *The Old Indian Arrowmaker and His Daughter* (fig. 9.5), completed in 1872, is markedly different.[15] Here the nose is straight. Clearly, Lewis's women bear only the trappings of a specific ethnicity. Aside from Hagar, whose bonds are allegorical, all of her African American women

Figure 9.4 Edmonia Lewis, *Minnehaha*, 1868. Marble, 12⅛ inches. From the collection of Bruce Johnson. Photograph by Keith Kreger.

wear chains, manacles, and iron balls, while her Native American women wear animal skins, beads, and feathers.

Conversely, in Lewis's works, men signify ethnicity. As carriers of specific identities, they are the "bearers of meaning."[16] The man in *Forever Free* has the curly hair associated with an African heritage, and his features are slightly broader than those of the woman. Likewise, the old man in *The Old Indian Arrowmaker and His Daughter* and the male figure of *Hiawatha* (fig. 9.6), the bust on which her later work *The Marriage of Hiawatha* (fig. 9.7) was based, display the high cheekbones and hooked noses commonly associated with Indians. Why did Lewis "whitewash" her black and red female figures? Her decision to obliterate "color," like her positioning of the female figure in relation to the male, was again influenced by the Cult of True Womanhood, which crossed all racial boundaries. In addition, it was common artistic practice in the nineteenth century to depict Native American women according to Greek ideals, while African American women were rarely depicted at all.

Art and Self

Lewis's decision to "neutralize" her women while racializing the men was a great deal more complex than making her heroines acceptable, sympathetic figures to the dominant culture. Her decision was a direct result of how she wanted herself to be perceived as an artist and as a person.

Under slavery, Hazel B. Carby points out, African American women "gave birth to property and, directly, to capital itself in the form of slaves, and all slaves inherited their status from their mothers." But because she has shed all markers that would identify her as chattel, Lewis's freedwoman in *Forever Free* can no

Figure 9.5 Edmonia Lewis, *The Old Indian Arrowmaker and His Daughter,* 1872. Marble, 12½ inches. National Museum of American Art, Smithsonian Institution, Washington, D.C., gift of Mr. and Mrs. Norman B. Robbins.

longer be a carrier of property or even of racist stereotypes. She is indeed free. The "purging" of blackness was also a well-worked if problematic theme in anti-slavery fiction, as Karen Sánchez-Eppler has argued: "The very effort to depict goodness in Black involves the obliteration of Blackness." In fact, the tragic mulatta, invented by the white abolitionist Lydia Maria Child, was, according to Carolyn L. Karcher, just white enough to bridge the gap between black and white women. Her very whiteness, in fact, symbolized the "penetration" of her body by the white master. A sympathetic figure, she existed between two worlds but belonged to neither. The Indian woman, too, had to be "cleansed" of her identity to be acceptable. Pocahontas was perhaps the most famous of these mediating heroines. Within discourses of American culture, the Indian woman who was not a "princess" was a "squaw" (the rough equivalent of the stereotype of "mulatta" versus "whore").[17]

Examining the intersection of slavery with the rhetoric surrounding the meaning of "blackness" is one way to interpret Lewis's sculpture, and it provides

a likely explanation for Lewis's decision to purge color. By eliminating ethnic identity, Lewis eliminated the stereotype as well. But the question remains as to why she eschewed ethnological models only for her women. In answer, it may help to rephrase the question this way: What would Lewis have risked if she had sculpted obviously black or obviously Indian women?

For the daughter of a Chippewa and an African American, the risk was that the public would view the works as self-portraiture. Clearly Lewis did not want viewers to make any correlations between her women and her "self." In a sense, she suppressed "autobiography" so that she could not be read into her sculptures. Lewis's ethnicity, or "blood," as it was termed in the nineteenth century, was an obsession with her reviewers and interviewers. Speculations as to whether her Indian or African heritage was dominant, for example, appeared in articles by Child and in a biographical sketch by William Wells Brown.[18] As a result, Lewis identified with her freedwomen, with Hagar, and with Minnehaha on the level of discourse only—through interviews and reviews of her work. She refused to be victimized by her own hand.

In an interview with Henry Wreford, Lewis invoked the authority of her heritage: "My mother . . . was a wild Indian, and was born in Albany, of copper colour, and with straight Black hair. There she made and sold moccasins. My father, who was a negro . . . saw her and married her. . . . Mother often left her home, and wandered with her people whose habits she could not forget, and thus we her children were brought up in the same wild manner."[19]

To maintain authority over her voice, Lewis had to authenticate her position as an objective observer and to safeguard her position of power as an artist.[20]

Figure 9.6 Edmonia Lewis, *Hiawatha*, 1868. Marble, 14⅛ × 8 × 5¼ inches. From the collection of Bruce Johnson. Photograph by Keith Kreger.

Figure 9.7 Edmonia Lewis, *The Marriage of Hiawatha*, 1871. Marble, 31½ inches. Cincinnati Art Museum, Cincinnati, Ohio, on loan from a private collection.

Like other black women who entered the public arena in the nineteenth century, Lewis found that credibility, in the form of objectivity, was very difficult to achieve.

This perspective becomes clearer by examining the strategies adopted by African American women autobiographers. Beth M. Doriani, who has studied two autobiographical accounts by black women—Harriet Jacobs's *Incidents in the Life of a Slave Girl: Written by Herself* (1861) and Harriet Wilson's *Our Nig: or, Sketches from the Life of a Free Black* (1859), published as a novel—points out that female slave narratives are entirely different from male slave narratives. Male narratives masculinized the meaning of freedom and recounted their journey from "bondage to independence" as one from slavery to freedom and manhood. The journey was marked by the achievement of literacy and the physical mastery over the slaveholder; it was a gradual emergence into personhood and self-reliance.

The emergence of the black woman into personhood was an altogether different matter. Unlike black male narrators who could "buil[d] his story around a presentation of himself that emphasized . . . the qualities valued and respected

by white men," for black women a presentation of self based on the qualities valued by white women was not possible for two reasons. First, the sexual abuse black women suffered had to be addressed, but in as detached a manner as possible, lest they alienate their audience. Above all, narratives by female slaves had to be rooted in "facts." "The most reliable slave narrative therefore would be," writes James Olney, "the one that seemed purely mimetic, one in which the self is at the periphery instead of the center of attention . . . transcribing rather than interpreting a set of objective facts."[21]

Second, because the history of sexual abuse was a matter of public record, black women had to wrest for themselves a sense of morality that (while not equal to) was as legitimate as that prescribed for white women. As a result, they engaged and subverted the "sexual morality found in the white women's genres, daring their readers to confront the complexity of morality and virtue. In doing so, they bent the conventions to their other purpose, the creation of selves consistent with their own experience as black women. They show that the world of the black woman—as a person inextricably bound up with others yet responsible for her own survival, emotionally, economically, and politically—demands a revised definition of true womanhood, a revision of the nineteenth-century white woman's social and literary stereotype as well as that of the black woman, the 'tragic mulatta.'"[22]

Like Jacobs and Wilson, Lewis had to rely on white abolitionists for support and success. By "whitening" the features of her African American and Indian American women, Lewis obtained a distance from them and a measure of objectivity—and therefore credibility, not only with her patrons but as an artist who worked in the neoclassical style. Thus, instead of taking her Indian subjects directly from her mother's people and naming them as such, she opted to interpret Native American culture through the mediating figure of a white male author, Henry Wadsworth Longfellow. In selecting a female figure from Longfellow's sentimental *Song of Hiawatha,* Lewis chose to represent what was perhaps the most sympathetic treatment of the indigenous population to be sanctioned by the dominant culture.[23] Although her iconography was highly personal and directly relevant to her life, she maintained a distance from it by refusing to portray Minnehaha as an Indian. Quite literally, Lewis placed herself "on the periphery of the action."[24]

Through a complex process of invocation and inversion, Edmonia Lewis achieved a "creation of self through subversive interplay" with her viewers' expectations. She came into "personhood" by drawing on and reshaping the prevailing aesthetic—the neoclassical style conveyed in white marble—to illustrate sentimental literature and her heritage as an Indian, as well as those themes pertinent to the black experience in America. Yet Lewis remains a presence that is

paradoxically absent in her work: she is present as an "artist," as the creator of art, but she is absent as the "subject" or "object" of her art. She invoked auto-biographical readings of her works while inverting those expectations by following mainstream modes of representation in her idealized (read, "white") depictions of women. Lewis was not unlike the author of the slave narrative, for whom, as Charles T. Davis and Henry Louis Gates have noted, "the narrated, descriptive 'eye' . . . was put into service as a literary form to posit both the individual 'I' of the Black author, as well as the collective 'I' of the race. Text created author, and Black authors hoped they would create, or recreate, the image of the race in European discourse."[25]

Lewis undeniably manipulated the neoclassical idiom to suit her purposes. Just as her freedman stands and her freedwoman kneels at the threshold of a "normal" life under the gender conventions of the day, Lewis sought to enter the debate over who could legitimately represent those conventions in a voice both authoritative and autonomous.

Notes

A version of this essay was originally published in *American Art* 9, no. 2 (Summer 1995): 4–19. The author wishes to thank Helen Jackson.

1. Jacqueline Fonvielle-Bontemps wrote that Lewis "never sculpted a black figure, though many of her statues dealt with racial or sexual repression as a theme. She glorified abolition as a movement and individual abolitionists, but not black people. . . . Her friends were all white." Fonvielle-Bontemps, *"Forever Free": Art by African American Women, 1862–1980* (Normal, Ill., 1980), 16. Yet another scholar wrote that "where [Lewis's] pieces lose power is in the style she adopted and the material she used: the neo-classical style, with its emphatic focus on Greek idealization, and the pristine whiteness of the marble, which supports the narrowness of the style—so that a black face must appear white and be carved according to the principles of beauty which are white, 'fine' features as perfection." See Michelle Cliff, "Object into Subject: Some Thoughts on the Work of Black Women Artists," in *Visibly Female: Feminism and Art: An Anthology,* ed. Hilary Robinson (London, 1987), 150.

2. Jean Fagan Yellin, *Women and Sisters: The Antislavery Feminists in American Culture* (New Haven, 1989), 173–75; Albert Boime, *The Art of Exclusion: Representing Blacks in the Nineteenth Century* (Washington, D.C., 1990), 170–71; Frances K. Pohl, "Old World, New World: The Encounter of Cultures on the American Frontier" and "Black and White in America," in Thomas Crow et al., *Nineteenth-Century Art: A Critical History* (London, 1994), 182; see also pp. 144–81, 183–86.

3. Judith Sealander, "Antebellum Black Press Images of Women," *Western Journal of Black Studies* 6 (September 1982): 2, 159–65; James Oliver Horton, "Freedom's Yoke: Gender Conventions among Antebellum Free Blacks," *Feminist Studies* 12 (March

1986): 70; see also 51–69, 71–76. See also Barbara Welter, "'The Cult of True Woman-hood,' 1820–1860," *American Quarterly* 18 (June 1966): 151–74; Linda M. Perkins, "The Impact of the 'Cult of True Womanhood' on the Education of Black Women," *Journal of Social Issues* 39 (1983): 17–28; Shirley J. Yee, "Black Women and the Cult of True Womanhood," *Black Women Abolitionists: A Study in Activism, 1828–1860* (Knoxville, 1992), 40–59; Jim Cullen, "'I's a Man Now': Gender and African American Men," and Catherine Clinton, "Reconstructing Freedwomen," in *Divided Houses: Gender and the Civil War,* ed. Catherine Clinton and Nina Silber (New York, 1992), 76–91, 306–19, respectively.

4. Horton, "Freedom's Yoke," 55

5. The Emancipation Proclamation stated that "all persons held as slaves . . . shall be then, thenceforward, and forever free." For the theme of "forever free" in the popular poetry and song of the day, see Boime, *Art of Exclusion,* 163–66.

6. "Presentation to the Rev L. A. Grimes," *Boston Daily Evening Transcript,* Oct. 19, 1869, sec. 4, p. 5; and "The Marble Group," *Boston Daily Evening Transcript,* Oct. 18, 1869, sec. 2, p. 2. Archive of Col. Merl M. Moore, Falls Church, Va.

7. [Elizabeth Peabody], *Christian Register* (ca. 1869), quoted in Phebe Ann Hanaford, *Daughters of America; or, Women of the Century* (Augusta, Me. 1882), 316.

8. See Kristin Hoganson, "Garrisonian Abolitionists and the Rhetoric of Gender, 1850–1860," *American Quarterly* 45 (December 1993): 556–95.

9. See William Wells Brown, *The Black Man: His Antecedents, His Genius, and His Achievements* (New York, 1863), 217–20.

10. Piety as it was applied to the African American male was a complex issue in the nineteenth century. It was a quality sometimes ascribed to the infantile (as opposed to the savage) black man—innocent and on the threshold of manhood. See Michael Hatt, "'Making a Man of Him': Masculinity and the Black Body in Mid-Nineteenth-Century American Sculpture" *Oxford Art Journal* 15, no. 1 (1992): 22–23. Piety was also associated with blacks as a race. According to Harriet Beecher Stowe, blacks were "natural" Christians; see Harriet Beecher Stowe, *Uncle Tom's Cabin, or, Life Among the Lowly,* (1852; rpt. New York, 1965). See also Arthur Riss, "Racial Essentialism and family Values in 'Uncle Tom's Cabin,'" *American Quarterly* 46 (December 1994): 513–44.

11. Henry Wreford, "A Negro Sculptress: Rome, February, 1866," *Boston Athenaeum,* March 3, 1866: 302.

12. *Freedmen's Record* 3 (January 1867): 3.

13. Harriet Beecher Stowe, for example, described Sojourner Truth interchangeably as African, Libyan, Ethiopian, and Egyptian; see Harriet Beecher Stowe, "Sojourner Truth, the Libyan Sibyl," *Atlantic Monthly* 11, no. 66 (April 1863): 473–81. Cleopatra's race was also the subject of an ongoing debate in the nineteenth century. See George M. Fredrickson, *The Black Image in the White Mind: The Debate on Afro-American Character and Destiny, 1877–1914* (New York, 1971), 74–75, 79; and Robert J. Young, *Colonial Desire: Hybridity in Theory, Culture and Race* (New York, 1995).

14. Edmonia Lewis, quoted in Laura Curtis Bullard, "Edmonia Lewis," *Revolution* 7 (April 20, 1871): unpaginated.

15. In *Old Indian Arrowmaker and His Daughter* we know that the daughter is

Minnehaha because of Longfellow's poem and because the piece closely resembles a Currier and Ives print of the same subject. See Cynthia D. Nickerson, "Artistic Interpretations of Henry Wadsworth Longfellow's 'The Song of Hiawatha,' 1855–1900," *American Art Journal* 16 (Summer 1984): 49–77.

16. Laura Mulvey, "Visual Pleasure and Narrative Cinema," in *Issues in Feminist Film Criticism,* ed. Patricia Erens (Bloomington, Ind., 1990), 29. Mulvey uses the term "bearers of meaning" to describe the female's function within narrative cinema: woman exists as a spectacle, an erotic object who often interrupts narrative. Lewis, by contrast, inverted this formula by sculpting a nude male who, both masculinized and eroticized, functions as spectacle and who, by virtue of his hair, carries the mark of race. See also Manthia Diawara, "Black Spectatorship: Problems of Identification and Resistance," in *Black American Cinema,* ed. Manthia Diawara (New York, 1993), 211–20; bell hooks, *Black Looks: Race and Representation* (Boston, 1992); Cheryl Butler, "The Color Purple Controversy: Black Woman Spectatorship," *Wide Angle* 13, no. {{FR}}3/4 (1991): 62–69; and Jane Gaines, "White Privilege and Looking Relations: Race and Gender in Feminist Film Theory," in Erens, *Issues,* 197–214.

17. Hazel V. Carby, *Reconstructing Womanhood: The Emergence of the Afro-American Woman Novelist* (New York, 1987), 25; Karen Sánchez-Eppler, "Bodily Bonds: The Intersecting Rhetorics of Feminism and Abolitionism," *Representations* 24 (September 1988): 39; Carolyn L. Karcher, "Rape, Murder, and Revenge in 'Slavery's Pleasant Homes': Lydia Maria Child's Antislavery Fiction and the Limits of Genre," in *The Culture of Sentiment: Race, Gender, and Sentimentality in Nineteenth-Century America,* ed. Shirley Samuels (New York, 1992), 58–72. See also Judith Wilson, "Optical Illusions: Images of Miscegenation in Nineteenth- and Twentieth-Century Art," *American Art* 5 (Summer 1991): 89–107; and Patricia Morton, *Disfigured Images: The Historical Assault on Afro-American Women* (New York, 1991). For stereotyped images of Indian women as "squaws" and "princesses," see Rayna Green, " 'The Pocahontas Perplex': The Image of Indian Women in American Culture," in *Unequal Sisters: A Multicultural Reader in U.S. Women's History,* ed. Ellen C. DuBois and Vicki L. Ruiz (New York, 1990), 15–21; Julie Schimmel, "Inventing 'the Indian'," in *The West as America: Reinterpreting Images of the Frontier 1820–1920,* ed. William H. Truettner (Washington, D.C., 1991), 149–89; and Åsebrit Sundquist, *Pocahontas & Co.: The Fictional American Indian Woman in Nineteenth-Century Literature: A Study of Method* (Atlantic Highlands, N.J.; 1987).

18. See also Lydia Maria Child, "A Chat with the Editor of the Standard," *Liberator,* Jan. 20, 1865: 12; Child, "Edmonia Lewis," *Broken Fetter* 4 (March 3, 1865): 25–26; William Wells Brown, *The Rising Son; or, The Antecedents and Advancement of the Colored Race* (Boston, 1874), 465–68.

19. Wreford, "Negro Sculptress," 302.

20. Film theory is particularly germane to understanding Lewis's frame of reference as a black female spectator. As important as what and how she chose to sculpt was what she chose not to sculpt—half-naked black and Indian women or the depressed and dying male Indians or savages that were so popular in the nineteenth century.

21. Beth Maclay Doriani, "Black Womanhood in Nineteenth-Century America: Sub-

version and Self-Construction in Two Women's Autobiographies," *American Quarterly* 43 (June 1991): 201–12; and James Olney, "'I Was Born': Slave Narratives, Their Status as Autobiography and as Literature," in *The Slave's Narrative,* ed. Charles T. Davis and Henry Louis Gates, Jr. (New York, 1985), 158. See also Tunde Adeleke, "Black Biography in the Service of a Revolution: Martin R. Delaney in Afro-American Historiography," *Biography* 17 (Summer 1994): 248–67; and Joanne M. Braxton, *Black Women Writing Autobiography: A Tradition within a Tradition* (Philadelphia, 1989).

22. Doriani, "Black Womanhood," 207.

23. Artistic interpretations of Longfellow were common in nineteenth-century American art. See Nickerson, "Artistic Interpretations," 49–77. An equally sympathetic figure, but one more subject to "princess" stereotypes, was Pocahontas. Lewis, to the best of my knowledge, never sculpted Pocahontas, although there is evidence that she asked the abolitionist Lydia Maria Child for background information about her. Lewis probably inquired about Pocahontas not to sculpt her but to ingratiate herself with Child, on whom Lewis partially depended for monetary support. See Lydia Maria Child to Harriet (Winslow) Sewall, July 10, 1868, Robie-Sewall Papers, Massachusetts Historical Society.

24. Doriani, "Black Womanhood," 208.

25. Ibid., 200; Davis and Gates, *Slave's Narrative,* xxvi.

10 "The Kiss of Enterprise": The Western Landscape as Symbol and Resource

Nancy K. Anderson

In the summer of 1870 American landscape painter Sanford R. Gifford, in company with fellow artists Worthington Whittredge and John F. Kensett, traveled to the Colorado Rockies aboard the recently completed transcontinental railroad.[1] Both Whittredge and Kensett had ventured west on earlier journeys, but for Gifford the 1870 trip was a first. An accomplished landscape painter in search of new subject matter, Gifford had come west to "mine" the landscape as surely as any argonaut who came looking for California gold. For Gifford and other landscape painters who came west on trails blazed by forty-niners, the western landscape was a natural resource, a raw material, that could be used to construct seductively beautiful works of art that reflected, in both direct and subtle ways, the material and spiritual needs of the culture that gave them birth.

Gifford and his companions arrived in Denver in August 1870. Their timing was fortuitous, for in Denver Gifford met Ferdinand Vandeveer Hayden, director of the United States Geological Survey. In Hayden the twin enthusiasms of the age of exploration were united. A serious and exacting scientist, Hayden was also an unabashed believer in the beneficial effects of progress. A man of enormous energy, Hayden had begun "surveying" the West before the government gave the activity official bureaucratic sanction. As early as 1862 he declared that his ambition was to lead a government-sponsored geological survey that would "lay before the public such full, accurate, and reliable information . . . as will bring from the older states the capital, skill, and enterprise necessary to develop the great natural resources of the country."[2] When the geologist and the artist met in Denver, Hayden was about to depart for Wyoming Territory to lead a

survey party on just such a mission and he invited Gifford to join the group as his guest. Recognizing a golden opportunity, Gifford quickly accepted Hayden's offer. Within days the two men had arrived at the survey party's base camp near Cheyenne. There Gifford met another member of the team, William H. Jackson, a professional photographer, whom Hayden had persuaded to join the survey with a promise of remarkable scenery and free board. Finding they shared interests in both photography and painting, Gifford and Jackson quickly struck up a friendship.

On August 7, 1870, despite a "cold sleety rain," the survey party broke camp.[3] Two days later Jackson took the photograph that serves as the point of departure for the discussion that follows. Seated before castellated buttes near Chugwater Creek in southeastern Wyoming, Gifford, his color box on his lap, is at work on an oil sketch of the landscape before him. Jackson's photograph, a sophisticated work of art in its own right, documents the first step in the process whereby the raw material, the western landscape, was transformed into both a work of art that conveyed cultural messages and a commodity exchanged in a commercial market.

Years later Jackson turned the tables and had a similar record made of his own pursuit of the western landscape. This self-conscious attempt to document the "truth" of the image secured in the field was carried to its limit when Christian Jorgensen, a California landscape painter, had himself photographed (in full western costume) painting a plein air landscape while standing, with admirable aplomb, aboard a portable studio hitched to a team of horses (fig. 10.1).

Figure 10.1 Unidentified photographer, *Christian Jorgensen in Yosemite*, c. 1905. Albumen print, 4 × 5 inches. Bancroft Library, University of California, Berkeley.

Such insistent efforts by artists to document their confrontation with the western landscape represent thinly veiled attempts to promote their work as an accurate (that is, literal) transcription of the landscape. In fact, for artists like Gifford the plein air sketch was simply the first step in a much longer process that was far more often than not completed far from the western frontier.

In studios like those of Gifford's contemporaries Albert Bierstadt and Thomas Hill, artists who had traveled west combined and edited the field sketches, color studies, and photographs they had gathered, to produce paintings that in their constructed artifice carried cultural messages. As unique and isolated objects, however, the finished paintings do not disclose the artist's compositional and editing decisions. We see only what is on the canvas, we do not see what has been excised, and conversely, we may not be conscious of what fabricated elements have been added.

To explore the range of meanings conveyed by western landscapes produced during the nineteenth century, groups of images related to different but representative western landscape subjects (Wyoming's Green River cliffs, the Colorado River and Grand Canyon, and the Donner Pass) have been selected as the focus of discussion. By juxtaposing drawings, sketches, photographs, popular illustrations, advertisements, and studio paintings that represent these subjects, some of the process whereby artists edited raw material and constructed western landscape paintings to convey certain messages becomes clear—as does the nature of the message.

Looking at nineteenth-century paintings with twentieth-century eyes carries unavoidable risk, for the modern viewer is privy to history's judgment, while his nineteenth-century counterpart (both artist and viewer) was charting a new course on untrodden land. Thus many nineteenth-century landscape images, whether photographs, drawings, or illustrations, document practices that modern viewers would characterize as exploitative, destructive, and appallingly shortsighted. As modern viewers, however, we must set aside our own concerns (particularly environmental concerns) and recall that following the Civil War, when capital and labor were freed from destructive conflict and redirected toward what was viewed as constructive growth, the American West functioned as both an iconic symbol of national identity and a resource to be used in transforming the nation from a wilderness republic into an industrial power.

This is not to say that thoughtful observers were unaware of the price of progress. On the contrary, numerous travelers (including artists) who ventured west during the second half of the nineteenth century commented on "denuded" mountains and ravaged forests; others deplored the effects of mining. As early as 1858, for example, one visitor to California expressed dismay at the devastating

effects of hydraulic mining: "The result is a most horrid desolation, of which every line of natural beauty is gone forever. If some camp of demons had been pitched for a year, tearing the earth by their fury, and converting it to the model of their own bad thought, they could hardly make it look worse."[4]

These were not, however, the scenes that appeared in nineteenth-century western landscape paintings. The destruction that progress often left in its wake was rarely addressed overtly in studio paintings. Skillfully crafted and consciously composed for a market interested in the West (often as an investment), most western landscapes carried a conciliatory message implying that the natural and technological sublime were compatible, that the wilderness landscape Americans had used to define themselves and their nation since the seventeenth century could endure as a cultural icon while being converted to economic use.[5]

Such carefully composed messages were frequently directed at particular audiences, for landscape paintings were commercial as well as aesthetic objects. Thus Legrand Lockwood, a wealthy New York financier, who paid Bierstadt fifteen thousand dollars for *The Domes of the Yosemite*, which he installed in his home, and James Lick, who commissioned a series of California landscapes from Thomas Hill for his luxury hotel in San Francisco, saw in western landscapes images that complemented their entrepreneurial drive.[6] Heavily invested in the development of western resources, such patrons were the principal buyers of large panoramic landscapes that celebrated the grandeur (and potential) of the land that for them had literally become El Dorado.

Others, lacking the resources of Lockwood or Lick and unable to buy original paintings, were nevertheless induced by the heroic western landscapes of artists like Bierstadt and Thomas Moran to travel great distances to see the mountains and canyons that had inspired the paintings. The tourists who figure so prominently in William Hahn's *Yosemite Valley from Glacier Point* (1874) testify to the power of the images through which such natural wonders were initially introduced to eastern audiences and to the commercial bonanza the West represented when transformed into a tourist mecca (fig. 10.2).

Like the miners, loggers, farmers, and ranchers who traveled cross-country to capitalize on the material resources of the American West, artists like Gifford, Bierstadt, and Moran journeyed west to mine the landscape for the raw materials from which they fashioned studio paintings. The photographs, lithographs, engravings, illustrations, and advertisements discussed here document the awesome scenic grandeur and enormous economic potential of the West as well as the technological achievements of man as he set about conquering the land and converting its riches to his own use. Minimizing the conflict between the spectacular natural beauty of the land (by midcentury an indelible part of America's

Figure 10.2 William Hahn, *Yosemite Valley from Glacier Point*, 1874. Oil on canvas, 27¼ × 46 inches. California Historical Society, San Francisco, gift of Albert M. Bender.

self-definition) and the inevitable changes that accompanied the conversion of minerals, forests, and water, the message of many studio paintings was that the natural and technological sublime were compatible, that the West could endure as both a symbol and resource.

Green River, Wyoming

In July 1868, in an area where fur trappers once held their annual rendezvous and Capt. Benjamin Bonneville built his first fort, the modern age, in the form of the Union Pacific Railroad, arrived on the banks of the Green River in Wyoming Territory.[7] In a heated race with their Central Pacific counterparts, the construction crews of the Union Pacific were laying between one and three miles of track daily across the Wyoming plains. Leapfrogging from one supply terminus to the next, engineering and construction crews had successively passed through Cheyenne, Laramie, and Benton on their way to Green River. For two decades before the arrival of the railroad, emigrants following the Oregon Trail to the Promised Land had exercised caution in fording the Green River. High water and fickle current had been known to upturn even a heavily loaded wagon. The men of the Union Pacific, however, were about to take the threat out of the Green River with elevated steel rails. Conquest was at hand; the road to the future would be smooth and fast.

Traveling with the men of the Union Pacific was Andrew Joseph Russell, a professional photographer who had taken on the task of documenting the progress of the railroad. In 1869 fifty of Russell's photographs were published

Figure 10.3 Andrew Joseph Russell, *Temporary and Permanent Bridges and Citadel Rock, Green River,* 1868. Albumen print, 8⅝ × 11½ inches. Yale Collection of Western Americana, Beinecke Rare Book and Manuscript Library, New Haven, Conn.

under the title *The Great West Illustrated.* One of these, *Temporary and Permanent Bridges and Citadel Rock, Green River* (1868), records the inevitable encounter between the natural and technological sublime in the American West (fig. 10.3).

Russell's photograph clearly celebrates the triumph of technology and human will over a hostile environment. At the far right, the temporary wooden trestle, which allowed the Union Pacific to continue its race to Promontory, Utah, supports crew members and a smoking engine. Near the center of the photograph, additional crew members pose atop stone battlements built to support the more permanent bridge. In the distance, towering above all, is Citadel Rock, one of the distinctive sandstone buttes through which the Green River carved its path. With an artist's eye, Russell selected his view so that the magnificent rocky tower shaped by the forces of nature is juxtaposed with man-made structures (the water tower and stone bridge supports), which mimic its form. Acknowledging both the technological triumph of the railroad and the scenic grandeur of the Green River landscape, Russell's photograph records change and progress. As a mediating or conciliatory image, the photograph also suggests that the natural

and technological sublime could coexist, that the landscape that had long claimed mythic status in the American imagination was not compromised by the tracks and trestles of the future's messenger.

The domestic changes the railroad brought were seen in a wholly positive light by Eli Sheldon Glover, who produced a view of Green River City published by the Chicago Lithographic Company sometime after the Union Pacific and Central Pacific railroads were joined at Promontory on May 10, 1869. Looming above the burgeoning city, as it did in Russell's photograph, is Citadel Rock. At the far left is the completed bridge, which was under construction when Russell took his photograph. The very image of prosperity, Green River City could boast, according to the caption provided by the lithographer, "a School House and Church, several Stores, a First-Class Hotel, and a Brewery." While the castellated buttes surrounding the city speak of the sublimity of the western landscape, schoolhouses, churches, and pleasure boats on the river suggest that the domestication of Green River has begun in earnest. The railroad, economic lifeblood of the community, is firmly established with a major switching yard visible near the riverbank. Two trains, one heading east and the other west, steam off at opposite ends of town. A promotional image, the lithograph carries the additional claim that Green River City is located at "the center of the most picturesque portion of the country through which the Union Pacific Railroad passes." Potential travelers are advised that "beautiful Rocky Mountain Specimens of all kinds can be procured" in Green River City. With the advent of the railroad the Green River landscape became quite literally a commodity available for purchase.

In 1871, two years after the transcontinental railroad had been completed and well after Green River City had claimed its place on the map, Thomas Moran journeyed west for the first time. About to join Hayden's expedition to Yellowstone, Moran traveled by rail as far as Green River. Stepping off the train, he found himself standing before a landscape unlike any other. The striated sandstone cliffs with their yellow, orange, red, and lavender bands were ideally suited to a painter who found his inspiration in the color of J. M. W. Turner. Like Yellowstone and the Grand Canyon, Green River was a subject to which Moran would return repeatedly over a period of forty years.

Unlike the images produced by Russell and Glover, Moran's Green River paintings did not overtly applaud the technological achievement of the railroad or the advent of civilization in the Far West. Instead, Moran focused almost exclusively on the sublimity of the landscape, editing out nearly every reference to change instigated by man.

When Moran arrived in Green River City, civilization had already taken root, but even in his earliest drawings his attention was drawn to the striated cliffs

sculpted by ancient forces of wind and water. A small watercolor inscribed "First sketch made in the West at Green River, Wyoming 1871" contains only the broadest notion of the landscape's primary features: the sandstone cliffs, languid river, and sparse trees. There is no sign of human life and not the slightest hint that a hotel and brewery are already in operation a short distance away. What is evident, however, is Moran's early fascination with the colors of the Green River landscape. Although measuring only about four by eight inches, Moran's watercolor sketch is filled with the silver, lavender, and pink that later became far more intense when translated to oil.

The following year Moran returned west to complete a commission for illustrations to be published in *Picturesque America* (1872–74). Once again he traveled to Green River and again he completed a watercolor sketch duplicating the point of view of his earlier study. Larger by several inches (6³⁄₁₆ × 11¹¹⁄₁₆ inches), the second sketch includes far more geologic detail and, in the far distance, a diminutive train. An acknowledgment of recent change, the train is, however, so small that it is barely visible. For Moran, neither the railroad nor the burgeoning town that had sprung to life beside the railroad tracks threatened the vast and awesome grandeur of the landscape, for in his art he was free to edit and invent, preserving on canvas the mythic landscape endowed by history with symbolic as well as economic value.

Excised from Moran's Green River landscapes are the bridge celebrated in Russell's photograph and all buildings, whether schoolhouse, hotel, or brewery. Added to the landscapes are bands of exotically clad Indians moving diagonally through the foreground toward camps on the distant horizon (fig. 10.4). Far from anthropological specimens, however, Moran's Indians inhabit a dreamscape. As he reworked the Green River imagery over a period of years, Moran continued to paint the shimmering landscape of El Dorado as if nothing had changed.

The evolution of Moran's Green River imagery came to full fruition in *Green River Cliffs, Wyoming* (1881, fig. 10.5). When juxtaposed with the artist's first sketch of the Green River landscape, completed a decade earlier, *Green River Cliffs, Wyoming* demonstrates the extent of Moran's studio manipulation. The sandstone buttes have grown in stature, dramatic plays of light and shadow direct the viewer's eye toward the setting sun, and a reconfigured foreground becomes a stage for an Indian caravan winding its way toward a distant village. An ambitious reworking of a landscape he had first sketched a decade earlier, *Green River Cliffs, Wyoming* offers insistent assurance that the ancient grandeur that had inspired the earliest chroniclers of the West remained intact.[8]

Such paintings struck a popular chord and numbered among the artist's most commercially successful works. True testament to the marketability of the

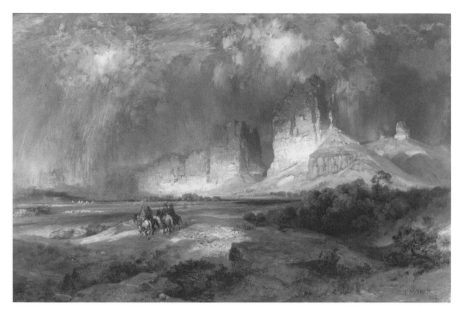

Figure 10.4 Thomas Moran, *Cliffs of the Upper Colorado River, Wyoming Territory*, 1882. Oil on canvas, 16 × 24 inches. National Museum of American Art, Smithsonian Institution, Washington, D.C., bequest of Henry Ward Ranger through the National Academy of Design.

subject came in 1881, when a chromolithograph after one of Moran's Green River paintings was published by Prang and Company. Banking on the popular appeal of the image to sell large runs of lithographs, Prang invested commercially in Moran's carefully composed assurance that the grandeur of the West had not been compromised by the advent of technological progress.

Colorado River and Grand Canyon

In the spring of 1871, John Wesley Powell and the men who would accompany him on his second descent of the Colorado River pushed a flatcar to the east end of the then completed Green River Bridge and unloaded the three handcrafted boats that would carry them on their journey downriver. Built to Powell's specifications in Chicago, the boats had been shipped by rail to Green River City, where Powell, who had become a folk hero after his harrowing descent of the Colorado in 1869, waited to launch a second expedition.[9] Although he had done well just to survive the earlier descent, Powell was eager to undertake a second, for he had seen enough of the stratified walls through which the Colorado River carved its path to know that he had discovered a geologist's dream. The corrosive action of the river had exposed thousands of years of geologic history.

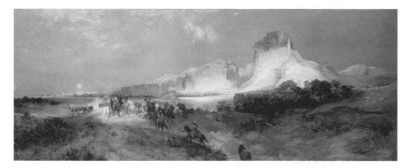

Figure 10.5 Thomas Moran, *Green River Cliffs, Wyoming,* 1881. Oil on canvas, 25 × 62¼ inches. Private collection.

Although not a member of Powell's expedition party, Moran came west to see the Grand Canyon in 1873 (after the descent had been completed) at Powell's invitation. On Hayden's expedition to Yellowstone two years earlier, Moran had been fascinated by the colors and canyons of what some called "Coulter's Hell." He returned east and composed a seven-by-twelve-foot painting, *The Grand Canyon of the Yellowstone,* which so captivated members of Congress that they appropriated ten thousand dollars for its purchase. Aside from establishing Moran's reputation, the picture had done much to aid Hayden in his efforts to secure continued funding for his survey expeditions.[10]

Following that early triumph, Moran began to entertain the notion of painting a pendant for the Yellowstone picture. After listening to Powell describe the Grand Canyon, he rightly suspected that he might find in the canyons of the Colorado River a subject equal in stature to Yellowstone. Powell invited Moran to join him in the Southwest as early as the spring of 1872, but Moran was unable to accept the offer until the summer of the following year.

Early in August 1873, accompanied by John Hillers, who had assumed the role of photographer during the second part of Powell's river expedition, Moran stood above the Grand Canyon for the first time. He later described the moment in a letter to his wife: "On reaching the brink the whole gorge for miles lay beneath us and it was by far the most awfully grand and impressive scene that I have ever yet seen."[11] Moran spent two days sketching near the rim of the canyon at Toroweap. Intrigued by the colors and configuration of the river and its canyons, Moran quickly made preliminary pencil sketches. Elegant in their spare line and brevity, the sketches are dotted with color notes. One such study bears the inscription: "The general color of the canon is a light Indian red. The upper surfaces gray intermixed with red & going to a yellowish red at the bottom

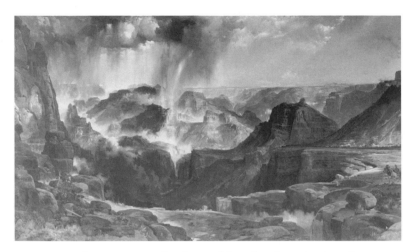

Figure 10.6 Thomas Moran, *The Chasm of the Colorado,* 1873–74. Oil on canvas, 84⅜ × 144¾ inches. U.S. Department of the Interior, Office of the Secretary, Washington, D.C.; on loan to the National Museum of American Art.

of the Canon. The near rocks of the foreground are a flesh color with gray surfaces and man holes with water pockets. Where water lines enter the Canon they are generally white from lime water from the levels above." Later, with Powell serving as his guide, Moran stood above the canyon (on a plateau the expedition leader had named for himself), gazing out from the spot that Powell felt was "the greatest point of view in the Grand Canyon."[12] Moran had found the source for a landscape that could hold its own with his earlier Yellowstone panorama.

While Moran and Powell stood above the canyon a loud, violent thunderstorm swept above them. Sheets of rain dropped from roiling thunderclouds, and as the rain struck the sunbaked canyon walls a heavy, hot mist rose from the rock. Moran later cast the thunderstorm as chief protagonist in *The Chasm of the Colorado* (1873–74), the seven-by-twelve-foot painting he began shortly after his return east (fig. 10.6). *The Chasm of the Colorado* is a painting rich in meaning and intricately tied to the thesis of Powell's thoughtful and progressive publication *Report on the Lands of the Arid Region of the United States* (1878).[13]

Powell's report was the culmination of years spent in the field as a practicing geologist. Although hailed as the Conqueror of the Colorado, Powell had actually done far more than simply ride the white water. He had measured, mapped, and studied the Colorado in an attempt to decipher the geologic textbook the river had laid bare. Among the conclusions he reached was one that challenged the boosters who promoted rapid settlement of the Southwest despite the se-

vere limitations imposed by climate and geography. Powell declared that the low level of rainfall in the Southwest required cooperative land and water management. He understood that the usual system of distributing land for settlement (often 160 acres marked off on a grid) was not suitable for an area where the single most important resource was water. Powell's topographical studies along the course of the Colorado River taught him that water was both a destructive and redemptive force. The same river that carved a channel through rock, that ate away at the earth's surface leaving enormous chasms, also brought life. Although Moran's enormous painting of the Grand Canyon exalts (in the tradition of nineteenth-century American landscape art) the sheer grandeur of the land itself, *The Chasm of the Colorado* also reflects Moran's understanding of Powell's thesis, for the active components in the picture are water and light, elements that sustain life. The storm and river threaten and nourish simultaneously.

Despite Moran's declaration that he had found the subject for his picture while standing above the canyon at Powell's Plateau, *The Chasm of the Colorado* is a composite, a painting constructed from sketches, photographs, and recollections, rather than a strict topographical view. Powell recognized Moran's method and applauded the results, describing the painting as "a most composite picture; a picture of many pictures."[14]

Because of their close association during the early stages of the painting's conception, Moran must have been particularly pleased when Powell praised the picture for its truth: "Mr. Moran has represented the depths and magnitudes and distances and forms and color and clouds with the greatest fidelity. But his picture not only tells the truth . . . it displays the beauty of the truth."[15] The "truth" Moran's painting told was not universally admired. Although not attacked by critics, *The Chasm of the Colorado* was not received as enthusiastically as *The Grand Canyon of the Yellowstone*. Nearly every reviewer expressed some reservation about the picture. Clarence Cook, writing in 1874 for the *Atlantic Monthly*, spoke for many when he described the picture as "wanting almost entirely in the beauty" that had distinguished Moran's earlier Yellowstone painting.[16] Such remarks, however, did not dampen the enthusiasm of Congress. In June 1874 Moran exhibited the painting at the Corcoran Gallery of Art in Washington, D.C.; the following month Congress appropriated ten thousand dollars to purchase the picture. Although clearly a landscape celebrating a uniquely American scene, the painting also made a subtle argument for a cautious and rational approach to the development of the Southwest, an idea that Powell championed with little success.

Moran's Green River, Yellowstone, and Grand Canyon landscapes brought the artist substantial financial and professional rewards. They also brought him contracts with railroad companies anxious to promote travel by advertising the

scenic wonders that could be seen en route. The most profitable of Moran's corporate relationships was undoubtedly that with the Atchison, Topeka, and Santa Fe Railway, which began late in the 1870s but came to fruition in 1901, when the line was extended to the Grand Canyon.[17] In a cooperative arrangement involving the exchange of pictures for travel and lodging, Moran's paintings of the canyon were placed in parlor cars, hotels, and corporate offices. More important, however, were the images that appeared in guidebooks, on posters and calendars, and as chromolithographs. These were distributed widely during various promotional campaigns for the railroad, but they also served to promote the work of Moran. Neither the artist nor the picture-buying public seemed to tire of his Grand Canyon paintings. Following the completion of the railroad spur to the canyon in 1901, Moran returned to the area annually until his death in 1926. During that period he produced hundreds of Grand Canyon paintings for a market that owed at least part of its strength to the tireless promotional efforts of the Atchison, Topeka, and Santa Fe.

Perhaps no other artist matched Moran's success in marketing the Grand Canyon, but the geologic textbook Powell had discovered in the canyons of the Colorado attracted other survey parties and offered numerous artists and photographers the opportunity to document and interpret a landscape unique in its beauty and contribution to science. Among the most talented of those who came to glimpse geologic time, to measure, map, observe, and photograph, were Timothy O'Sullivan and William Henry Holmes.

Employed at various times by geologists Clarence King and George Wheeler, O'Sullivan produced a number of extraordinary photographs along the Colorado River. His feel for the panoramic view that contained passages of startling detail is most clearly evident in a photograph taken along the Green River, the upper tributary of the Colorado. In O'Sullivan's image huge swaths of striated stone are upended as if twisted and spun with a giant spatula. Barely dusted with soil and scrub foliage, the rocky cliffs testify to the convulsive birth of the river basin.

In a second image of the Colorado River Canyon, taken near the mouth of the San Juan River in Arizona, O'Sullivan placed his camera above the chasm in a position echoing the point of view Moran offered in *The Chasm of the Colorado*. Standing on the rim, looking down into a maze of canyons, O'Sullivan captured the counterpoint of light and shade that defines the massive stone walls blocking clear passage to the river at the center of the image. In the foreground at the right, O'Sullivan found a slight section of delicately layered rock exposed by wind and rain. Silhouetted against the deep shadow of a canyon wall, the sharp, brittle layers are stacked in a vertical timeline.

O'Sullivan's beautifully composed photographs are a fitting reminder that many of the images secured on government-sponsored expeditions were so

stunning in their documentation that aspirants for government funding, including Hayden, King, Wheeler, and Powell, recognized their promotional value and capitalized on their power of persuasion. Landscape photographs taken on government expeditions regularly found their way to Capitol Hill just as discussions regarding future appropriations came to the floor.

In addition to photographers, nearly every survey party that traveled west in the 1870s and 1880s included at least one topographical artist. Of these, perhaps none was more talented than William Henry Holmes. Beginning in 1872 and continuing through the decade, Holmes was closely associated with Hayden. In 1872 Holmes was a member of Hayden's Yellowstone expedition, and the following year he accompanied Hayden on a reconnaissance mission to the canyons of the Colorado. Four years later much of his work was published in Hayden's *Atlas of Colorado.* In 1881 Holmes returned to the Grand Canyon in company with Maj. Clarence E. Dutton, who was charged with continuing the geological studies begun by Powell a decade earlier. On this trip Holmes completed the preliminary drawings for the extraordinary illustrations that accompanied Dutton's classic study *Tertiary History of the Grand Cañon District* (1882). Panoramic in scope, Holmes's illustrations raised topographical drawing to an art form.

One of Holmes's illustrations, *The Grand Cañon at the Foot of the Toroweap—Looking East,* offers a view not far from the spot where Moran first looked down into the depths of the chasm. No one, however, would confuse Holmes's drawing with a work by Moran. Crisp and linear, Holmes's view unites the precision of science with the poetry of art. During the 1880s and early 1890s, while others carried on the work he had begun in the canyons of the Colorado River, Powell continued to write, lecture, and exhort in an attempt to persuade lawmakers to face the reality of the southwestern climate and plan accordingly. Powell offered a blueprint for the rational management of "arid land" that advocated the division of the West into water districts to be administered by groups empowered to allocate water for the good of the greatest number. It was a revolutionary idea that flew in the face of promoters who preached the redemption of the West through irrigation. In 1893, at the second International Irrigation Congress in Los Angeles, Powell stood before the assembled dreamers and stated in blunt terms that there was not enough water to "redeem" more than 12 percent of the Southwest regardless of the number of ditches and dams built.[18] It was not a message they wished to hear. Recently described as "a model of ecological realism in an unsympathetic age of unbounded expectations," Powell's proposal was ignored.[19] Instead, the boomers set out to conquer the Southwest through irrigation, and control of the Colorado River was key to any plan promising to turn the desert into a garden.

Shortly after the turn of the century two entrepreneurial engineers built a canal that channeled Colorado River water to a southern California desert known as the Salton Sink. Renamed, with ironic appropriateness, Imperial Valley, the area quickly became one of the richest agricultural regions in the country.[20] The early canal proved unsatisfactory, however, and shortly after the desert had been turned into a garden, calls for greater control over the water source were heard. The result was Hoover Dam. Proposed in 1904 and completed in 1936, the dam was an engineering marvel that altered forever the Colorado River and the land it drained.

In 1893, when he spoke before the International Irrigation Congress, Powell issued a stern warning: "I tell you gentlemen you are piling up a heritage of conflict and litigation over the water rights for there is not sufficient water to supply the land."[21] Time has proven Powell correct, for the Colorado River has inspired more litigation than any other river in the country. The continued court battles stem from the fact that in the American West water is the most valuable resource. Thus, ironically, the landscapes that carry the Colorado River story to its conclusion are those appearing on fruit crates shipped from southern California orchards. Employing a method not unlike that used by Moran, the commercial artists who created the crate labels composed images that transmitted messages about the lifeblood of the West, water. In *Splendid* (ca. 1935), an idyllic agricultural paradise recedes behind a cascade of brightly colored lemons (fig. 10.7). As Kevin Starr notes in *Inventing the Dream* (1985), California recreated itself between 1880 and 1920, turning deserts into winter gardens with borrowed water.[22] Colorado River water sustained the regimented rows of citrus trees that transformed the mythical land of milk and honey into a marketable reality.

Figure 10.7 Unidentified artist, *Splendid,* c. 1935. Chromolithograph, 8¾ × 10¾ inches. The Oakland Museum, Oakland, Calif., History Department.

Desert Bloom (ca. 1938), a second example of California's commercial land-scape, promotes desert-grown grapefruit and bears in the lower-left corner the trademark of the Mutual Orange Distributors. In bold letters at the center of the insignia are the words "Pure Gold." Although the history of the Far West is punctuated with numerous "rushes" for gold and silver, the real gold of the West was liquid and in short supply. Well before the end of the first decade of the twentieth century the white water Powell had ridden through geologic time had been tamed. The dreamscapes promoted on fruit crates were advertisements for an invented land sustained by water diverted from the Colorado River.

Donner Pass

In April 1868, just months before the construction crews of the Union Pacific reached the Green River in Wyoming on their way to Promontory, their coun-terparts from the Central Pacific celebrated the successful passage of the first train over the most daunting obstacle in the path of the transcontinental rail-road, the Sierra Nevada. From the outset, the planners and funders of the rail-road enterprise had recognized the severity of the test posed by the mountains, for the allocation of $16,000 per mile jumped to $48,000 for rails laid through mountainous regions.[23] Even this added provision, however, did not cover the expense incurred in blasting through the granite wall of the Sierra Nevada. Nine tunnels were eventually bored through the Sierra Nevada; the summit mile alone was estimated to have cost $350,000.[24]

Progress was also hampered by heavy snow in the High Sierra. The winter of 1866–67, when construction crews were attempting to reach the summit, was one of the severest on record. Work continued despite hazardous conditions, but construction engineers recognized that even during winters far less harsh, cu-mulative snowfall would prevent trains from passing over the Sierra. To counter this threat engineers proposed building snowsheds over the most vulnerable stretches of track, thus allowing trains to pass through what effectively became snow tunnels.

Newspaper reporters, alert to the adventure inherent in a tale of men against nature, kept their readers informed regarding the battle being waged between the railroad crews and Sierra snow. Thus it was common knowledge that the original snowsheds were a total failure. Poorly designed, they plummeted down a mountainside during the first heavy snowfall. When a later design met with greater success, construction forged ahead. Eventually, thirty-seven miles of snowsheds were built at cost of more than two million dollars. By the fall of 1869, when the sheds were finished, sixty-five million board feet of timber had been consumed in their construction.[25]

The festivities accompanying the completion of the sheds were recorded with naive charm in a painting by Joseph H. Becker, a staff artist for *Leslie's Illustrated Weekly Newspaper* who traveled west aboard the first cross-Rockies Pullman train in 1869. During a six-week stay in California, Becker made a number of studies of the Chinese workers who formed the backbone of the labor force that built the Central Pacific Railroad and the snowsheds. In Becker's painting they may be seen cheering the safe passage of a train through the sheds that were quickly touted as an engineering marvel and described at length in California guidebooks.

Public interest in the conquest of the Sierra was also spurred by the fact that the mountain pass through which the railroad made its way carried the name of the Donner party, the ill-fated group of emigrants that became trapped in the High Sierra by early snow during the winter of 1846–47.[26] Their tale of starvation and cannibalism had become the best known of many stories chronicling the dark side of the journey to the Promised Land.

The Donner tragedy resulted from a combination of bad advice, inexperienced leadership, delayed travel, and early snow. The construction of the snowsheds represented, therefore, a special kind of triumph, for it was snow that had killed some members of the Donner party and had driven others to eat the flesh of their companions in order to survive. Like the crews of the Union Pacific who had taken the danger out of crossing the Green River, the men of the Central Pacific, with their tunnels and snowsheds, robbed the Sierra Nevada range of much of its destructive power. In a confrontation pitting nature against technological ingenuity, the Central Pacific claimed victory. As might be expected, numerous travel writers, photographers, and artists made their way to the site of such a triumph. Among the most important of these was Albert Bierstadt, who produced a major painting of the Sierra summit near Donner Lake early in the 1870s (fig. 10.8).

Bierstadt traveled to California for the first time in 1863, six years before the completion of the transcontinental railroad. Journeying overland by stagecoach, he crossed the Sierra on precipitous mountain roads. Eight years later he returned to California aboard the recently completed transcontinental railroad.[27] Within days of his arrival in San Francisco, however, he retraced his steps, heading for Donner Pass in company with Collis P. Huntington, vice president of the Central Pacific Railroad.

Although Huntington eventually became one of the "Big Four" railroad barons, he arrived in California inauspiciously.[28] Like thousands of others, he came west with the forty-niners, but after one day in the gold fields he concluded that his fortune lay elsewhere. Returning to Sacramento, he opened a hardware store catering to the needs of miners and prospered. Eventually

Figure 10.8 Albert Bierstadt, *Donner Lake from the Summit*, c. 1873. Oil on canvas. Collection of the New-York Historical Society.

Huntington and his partner in hardware, Mark Hopkins, joined dry-goods merchant Charles Crocker and grocer Leland Stanford to form the partnership that succeeded in launching the Central Pacific Railroad.

By 1871, when he joined Huntington in San Francisco, Bierstadt had made a name for himself in painting large, panoramic views of the western landscape. Huntington, who had undoubtedly seen some of these works, commissioned Bierstadt to produce a painting of the area near Donner Pass, where the railroad had faced its greatest challenge. Late in July, Huntington traveled to the site with the artist to select the point of view from which he wanted the picture painted. After this initial trip Bierstadt returned to the site several times to complete the sketches he needed to compose the six-by-ten-foot canvas.

As was his practice, Bierstadt allowed reporters to visit his studio and comment on works in progress. Thus a writer preparing a profile of the artist for *Scribner's* in March 1872 described the unfinished painting and reported that in making studies of the early morning sun above Donner Lake, "Bierstadt rose morning after morning at four o'clock, until he had secured the desired effect of light and shade and color."[29] Subsequent reports kept the public informed of Bierstadt's progress so that by January 1873, when the painting was exhibited for the first time (in San Francisco), hundreds of people turned out to see what they had been reading about for months. Among the most perceptive of the California observers was the critic for the *Overland Monthly*, who described the point

of view as several hundred feet above the Central Pacific Railroad, at the summit of the Sierra:

> This point was chosen at the instance of the gentleman for whom the picture was painted, because right here were overcome the greatest physical difficulties in the construction of the road, while the immediate vicinity was the scene of the most pathetic tragedy in the experience of our pioneer immigration, for it was on the shore of Donner Lake that the Donner party were caught in the winter snows, and suffered horrors worse than the death which overtook so many of them. The two associations of the spot are, therefore, sharply and suggestively antithetical: so much slowness and hardship in the early days, so much rapidity and ease now; great physical obstacles overcome by a triumph of well-directed science and mechanics.[30]

More than twenty years before Bierstadt and Huntington made their pilgrimage, the Sierra summit had figured prominently in William S. Jewett's early painting *The Promised Land—The Grayson Family* (Berry-Hill Galleries, New York). Described as having "just emerged from the wilderness," Andrew Jackson Grayson and his family look down from the summit of the Sierra Nevada "upon the promised land lying in its still beauty like the sleeping Princess of the story, waiting but the kiss of Enterprise to spring into energetic life. There below them is not only the field for industry and enterprise, but a panorama of natural charms destined to inspire poets, to glow on the canvas of painters, and to take on the magic of human association and tradition."[31] By the time Bierstadt began his painting of Donner Lake, enterprise had embraced not only California's sleeping valleys but also her granite peaks.

Although commissioned by one of the leading railroad promoters of the age, Bierstadt's painting does not include a single railroad car. At first glance, in fact, *Donner Lake from the Summit* appears to be another of the artist's panoramic views of spectacular western scenery. In the far-right corner, however, are snowsheds, those man-made structures that allowed the railroad, the mechanical harbinger of the modern age, to speed to the Pacific Coast despite snow drifts as high as sixty feet. Contemporary photographs by Russell and Carleton E. Watkins confirm the topographical accuracy of the view, as do Bierstadt's own preliminary sketches of the site, including *View of Donner Lake, California* (1871–72), which focuses on the precariously perched snowsheds (fig. 10.9). In the final painting, however, the sheds are but a tiny thread strung along the rugged flank of a mountain peak. Ethereal Donner Lake, cast in the golden glow of the rising sun, is the center of attention.

The absence of overt references to the railroad was applauded by several San

Figure 10.9 Albert Bierstadt, *View of Donner Lake, California,* 1871–72. Oil on paper, 29 × 21 inches. Fine Arts Museums of San Francisco, gift of Anna Bennett and Jessie Jonas in memory of August F. Jonas, Jr., 1984.54.

Francisco critics. A writer for the *Evening Bulletin,* for example, commented: "The railroad, with its enveloping snow-shed, is indicated plainly enough without any obtrusion of its ugliness, the puff of blue smoke that the train left as it plunged into a short tunnel suggesting with a touch of beauty all that is not seen. It is wonderful to think that a railroad was ever laid along the face of this forbidding cliff."[32] Another critic, for the *Overland Monthly,* wrote, "Through a tunnel in this rocky battlement the cars pass; but the hard fact of the railroad is only hinted by a puff of smoke, and by an unobtrusive sketch of the line of snowsheds."[33]

Bierstadt's solution to the problem posed by the "hard fact of the railroad" was masterful, for he managed to celebrate both the natural sublimity of the western landscape and the technological sublimity of the railroad. By allowing only snowsheds in his painting, Bierstadt focused not on the railroad itself (by 1871 the railroad was old news) but on the physical objects that continued to speak of the struggle and ultimate triumph associated with the construction of the railroad through the Sierra Nevada. Bierstadt's subtle reference to the rail-

road was a powerful endorsement of the transcontinental enterprise, for if the artist's evidence was to be believed, the beauty of the Sierra had not been compromised by the arrival of the railroad. The message was clear: it was possible to build a railroad without destroying the scenic quality of the landscape through which it passed.

By design *Donner Lake from the Summit* served as a splendid promotional tool for the transcontinental railroad. All the alpine scenery Bierstadt included in his composition was by implication available for viewing by passengers traveling west in the deep-pile comfort of Pullman Palace cars. Before being added to Huntington's private collection (where it was undoubtedly seen by numerous investors in the West), the painting was placed on exhibition in several cities, where it functioned as an effective advertisement for the scenic rewards awaiting those who traveled to the Pacific by rail.

Donner Lake from the Summit drew so much attention in the press (particularly in San Francisco) that inevitably other artists were drawn to the site. Among them was William Keith, who responded to the beauty of the Sierra with a looser stroke and brighter palette in *Donner Lake* (ca. 1878–79). Remarkable for its radiance, Keith's view is one of many paintings spawned by Bierstadt's example. By the end of the 1870s Donner Pass had become so inextricably linked with the triumph of the railroad that even without the tangible evidence of the snowsheds the association was clear.

On his first trip to the Pacific Coast, Bierstadt was accompanied by Fitz Hugh Ludlow, a talented member of New York's literary set. Following their return east, Ludlow reported on the overland journey in a series of articles published in the *Atlantic Monthly*. In one of these, "Through Tickets to the Pacific," he described the railroad as "the greatest popular enterprise in the world" and went on to exclaim, in language worthy of a publicity agent: "Our foremost scientific men, for the sake of the great national enterprise, have taken their lives in their hands, going out to meet peril and privation with the cheerful constancy of apostles and martyrs."[34] Ludlow's celebratory point of view regarding the construction of the railroad was one that those who directed the enterprise wisely chose to exploit. Both the Union Pacific and Central Pacific had in their employ professional photographers assigned to document the construction of the railroad.

From 1864 to 1869 Alfred A. Hart, the official photographer for the Central Pacific, documented the labored progress of the construction crews battling the Sierra Nevada. In Hart's photographs, the snowsheds take on the grandeur of a cathedral under construction. In one image, notable as much for its formal as its documentary quality, crew members pose in front of a snowshed only partly completed. Testifying to the massive amount of timber required to build the

Figure 10.10 Unidentified photographer, *Etta at Opening of Snowsheds,* c. 1905. Cyanotype, 2½ × 3⅞ inches. California State Railroad Museum, Sacramento.

snow tunnels, Hart's photograph ironically juxtaposes the support structure of a shed with living examples of the fir and pine trees that were destroyed in huge numbers to build the snowsheds.

In another remarkable photograph Hart reversed the direction of his lens and placed his camera inside one of the sheds. Parallel rails lead from the sheltered passage of the snowshed into a landscape that quickly dissolves into light. No more fitting image could be offered by the company that advertised a safe journey to the promise that was California.

The same snowsheds present in Bierstadt's panoramic painting and Hart's photographs were translated into yet another medium for purposes of promotion. Two views, one from the interior showing the timbered structure and a second, an aerial view presenting a succession of sheds winding around the edge of a mountain, were used as poster illustrations by the Central and Union Pacific Railroads to promote the "Great American Overland Route." The sheds (called "snow galleries") were also illustrated in numerous editions of George Crofutt's popular guidebook *New Overland Tourist and Pacific Coast Guide* (1878–79), which described in some detail the sights along the routes of various rail lines. In a passage applauding the technological achievement of the snowsheds while reassuring travelers of their safety, Crofutt noted, "The mighty avalanches which sweep down the mountain sides in spring, bearing everything before them, pass over the sloping roofs of the sheds and plunge into the chasms below, while beneath the rushing mass the cars glide smoothly along, the passengers hardly knowing but that they are in the midst of an enormous tunnel."[35]

Aside from celebrating the conquest of nature, the strategy of turning the snowsheds into an attraction rivaling the alpine scenery of the Sierra may have been a ploy intended to counter the unfortunate fact that while the snowsheds allowed the train to pass over Donner Pass despite deep snow they obscured much of the view just as the train passed through the most spectacular scenery

on the route. Complaints became so frequent that during the summer the side paneling on some sheds was removed to restore the view.

An early twentieth-century photograph by an unidentified photographer suggests that effort to promote the snowsheds as attractions rivaling the spectacle of Sierra scenery met with some success. Simply titled *Etta at Opening of Snowsheds,* the image shows a young woman outfitted in a traveling costume, standing on the railroad tracks before one of the Central Pacific snowsheds (fig. 10.10). The technological conquest of the Sierra (as represented by the iron rails and snowsheds) has displaced the landscape as the subject of a tourist view.

Notes

This is an excerpt from an essay first published in *The West as America: Reinterpreting Images of the Frontier, 1820–1920,* exh. cat. National Museum of American Art, ed. William H. Truettner (Washington, D.C.: Smithsonian Institution Press, 1991).

1. For information regarding Sanford R. Gifford's trip west in 1870, see Ila Weiss, *Poetic Landscapes: The Art and Experience of Sanford Gifford* (Cranbury, N.J., 1987), 130–33; and Nancy Dustin Wall Moure, "Five Eastern Artists Out West," *American Journal* 5 (November 1973): 15–31.

2. Quoted in Peter B. Hales, *William Henry Jackson and the American Landscape* (Philadelphia, 1988), 68.

3. Ibid., 72.

4. Horace Bushnell, "California: Its Characteristics and Prospects," *New Englander* 16 (February 1858): 158–59.

5. Leo Marx, *The Machine in the Garden* (New York, 1980), 194.

6. For an account of Legrand Lockwood's commission of *The Domes of the Yosemite,* see Gordon Hendricks, "Bierstadt's *The Domes of the Yosemite,*" *American Art Journal* 3 (Fall 1971): 23–31. For the placement of paintings by Thomas Hill in the Lick House, see Marjorie Dakin Arkelian, *Thomas Hill: The Grand View* (Oakland, Calif., 1980), 14.

7. For a comprehensive account of the building of the Union Pacific Railroad, see Robert G. Athearn, *Union Pacific Country* (Lincoln, Neb., 1976).

8. Although the provenance of *Green River Cliffs, Wyoming* remains unclear, another of Moran's large Green River pictures, *The Mirage* (1879, Stark Museum of Art, Orange, Tex.), was owned by Reginald Vanderbilt, one of the chief railroad financiers of his day.

9. For detailed accounts of John Wesley Powell's expeditions, see his *Canyons of the Colorado* (1895), reprinted as *The Exploration of the Colorado River and Its Canyons* (New York, 1961); Frederick S. Dellenbaugh, *A Canyon Voyage: The Narrative of the Second Powell Expedition down the Green-Colorado River* (1908; rpt. New Haven, 1962); William Goetzmann, *Exploration and Empire: The Explorer and the Scientist in the Winning of the American West* (New York, 1966); and Wallace Stegner, *Beyond the Hundredth Meridian: John Wesley Powell and the Second Opening of the West* (Boston, 1954).

10. See Joni Kinsey, "Creating a Sense of Place: Thomas Moran and the Surveying of the West" (Ph.D. diss., Washington University, 1989), 89–160.

11. *Home-Thoughts, from Afar: Letters of Thomas Moran to Mary Nimmo Moran* (East Hampton, N.Y., 1967), 39.

12. Quoted in Thurman Wilkins, *Thomas Moran: Artist of the Mountains* (Norman, Okla., 1966), 86.

13. Kinsey, "Creating a Sense of Place," 241–316.

14. Wilkins, *Moran,* 92.

15. Ibid.

16. Ibid., 93.

17. Kinsey, "Creating a Sense of Place," 316–48.

18. Donald Worster, *Rivers of Empire: Water, Aridity, and the Growth of the American West* (New York, 1985), 132.

19. Ibid., 133.

20. For an account of the development of Imperial Valley, see Carey McWilliams, *California: The Great Exception* (1949; rpt. Santa Barbara, Calif., 1976), 293–316.

21. Worster, *Rivers of Empire,* 132.

22. Kevin Starr, *Inventing the Dream: California through the Progressive Era* (New York, 1985), 134.

23. Lucius Beebe, *The Central Pacific and the Southern Pacific Railroads* (Berkeley, Calif., 1963), 120.

24. Albert D. Richardson, *Beyond the Mississippi: From the Great River to the Great Ocean. Life and Adventure on the Prairies, Mountains and Pacific Coast* (Hartford, 1867), 464–65.

25. Keith Wheeler, *The Railroaders* (New York, 1973), 106.

26. For a full account of the Donner party disaster, see George R. Stewart, *Ordeal by Hunger: The Story of the Donner Party* (New York, 1936).

27. According to the *Daily Alta,* July 21, 1871, Albert Bierstadt arrived in San Francisco on July 20, 1871.

28. For Collis P. Huntington's role in the railroad enterprise, see Oscar Lewis, *The Big Four: The Story of Huntington, Stanford, Hopkins, and Crocker, and of the Building of the Central Pacific* (New York, 1938).

29. D. O. C. Townley, "Albert Bierstadt, N.A.," *Scribner's Monthly* 3 (March 1872): 608.

30. "Two California Landscapes," *Overland Monthly* 10 (March 1872): 286.

31. Benjamin Parke Avery, "Art Beginnings on the Pacific," *Overland Monthly* 1 (July 1868): 30–31.

32. *San Francisco Evening Bulletin,* Jan. 11, 1873.

33. *Overland Monthly* 10 (March 1873): 287.

34. Fitz Hugh Ludlow, "Through Tickets to the Pacific," *Atlantic Monthly* 14 (November 1864): 604.

35. George A. Crofutt, *Crofutt's New Overland Tourist and Pacific Coast Guide* (Chicago, 1878–79), 183.

11 *The Gross Clinic,* or *Portrait of Professor Gross*

Elizabeth Johns

In early 1875 Thomas Eakins turned a canvas of rowing studies upside down and covered it with a composition sketch for a portrait of the widely admired Philadelphia surgeon Dr. Samuel D. Gross.[1] Eakins had finished with painting scenes of leisure, even leisure that was morally pursued, and—with the exception of a brief foray years later into boxing and wrestling themes, and one painting about swimming—he would not take up the idea again.[2] Instead, he would record sitters and activities whose power stemmed from what had more endurance as "heroic." And, as he had in the rowing pictures, he would find this excellence in people and work that he knew, or that, with introductions, he could come to know.

No painting could have announced his resolution more prominently than the large work depicting Dr. Gross (fig. 11.1). Not only was it imposing in scale—almost ominous in prospect as a blank canvas to be covered—but truly epic in theme. Even when he had barely blocked it in, Eakins expressed confidently that the painting would be "very far better than anything I have ever done."[3]

For Gross's portrait, Eakins joined an elaborate setting and carefully selected details to give full meaning to Gross's work as a surgeon. The details are rich indeed. At the focal point of the painting, Gross holds in his right hand a blood-covered scalpel; he has just turned away from his patient and surgical assistants in order to lecture to his students in the amphitheater. The young patient lies on his right side, his knees pulled up near Gross.[4] His head is at the far end of the table under the anesthesia-soaked gauze, his sock-clad feet at the near end; a long incision has been made in his left thigh from which Dr. Gross is about to

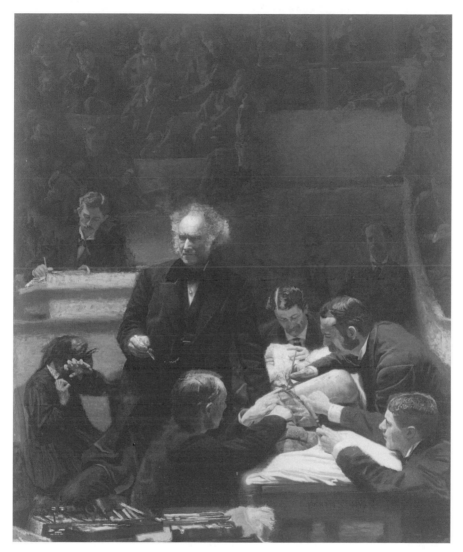

Figure 11.1 Thomas Eakins, *The Gross Clinic*, 1875. Oil on canvas, 96 × 78 inches. Jefferson Medical College of Thomas Jefferson University, Philadelphia.

remove a piece of dead bone.[5] An anesthesiologist and a team of four surgeons, one of whom is obscured behind the figure of Gross, assist in the surgery.[6] The anesthesiologist, Dr. Joseph W. Hearn, presides over the administration of chloroform;[7] on the middle right the intense figure of Dr. James M. Barton, Gross's chief of clinic, bends to his task of absorbing bleeding in the interior of the incision;[8] and at the lower right Dr. Daniel Appel holds a retractor in his right hand

to secure one side of the incision, while in his other hand he holds an instrument ready for Gross. At the lower left of the table is Dr. Charles S. Briggs, who grips the young man's legs to keep them in position during the surgery; and, obscured behind Dr. Gross at the upper left side of the table, another member of the assisting team holds a second retractor.

In front of Gross, at the lower left of the painting, is a tray of instruments and gauze. Behind him, at the middle left of the painting, the mother of the patient,[9] dressed in black, seems to shrink in her chair and raises her left arm to shield her eyes from the scene. Above her, at a brightly lit lectern in the first row of the amphitheater, Dr. Franklin West records the clinic proceedings. In the right middle distance of the painting, in the doorway to the amphitheater behind the operating table, stand two figures: in a relaxed posture, Hughey O'Donnell, the college orderly, and in a more intense pose, Gross's son, Dr. Samuel W. Gross, himself a surgeon. In the amphitheater audience, the twenty-one figures are all portraits, but only two have been identified: a young man who later became a poet and writer, Robert C. V. Meyers, leaning forward near the top railing, and Eakins himself, the first figure on the lower right, looking on the scene with pencil and pad in hand.

The scene is dramatic and intense. Gross does not occupy the precise center of the painting. Instead, he, his patient, and, by implication, the operation they are bound up in together form a large triangle, with the absolute center of the picture falling just off Gross's shoulder above his patient. At that plane the painting has the sharpest focus: from the blurred instruments in the foreground tray the focus clears until it reaches its most precise point in Gross's scalpel and the incision in the patient's leg.[10] The figures seated in the amphitheater fill out the picture but remain subordinate in the dim light. Indeed, lighting is Eakins's most dramatic tool. It sets apart from the dark clothing and dusky room the highlighted forehead and hand of Gross; the white of the bed sheets, anesthesia-soaked gauze, shirt cuffs of the assisting surgeons and thigh of the patient; and the clinic recorder's podium, hand, and notebook. This emotion-charged lighting emphasizes actual conditions in Jefferson's surgical clinics. There as everywhere else surgeons wore dark street clothes to operate until the general acceptance of asepsis in the late 1880s, and they performed surgery under skylights at mid-day on sunny days.[11]

Although tonal extremes dominate the painting, especially when it is viewed under unfavorable lighting and behind glass, or when it is studied in reproduction, Eakins suffused both lights and darks with a warm, unifying color. The warmth begins with the thin red underpainting with which he prepared the canvas. The red in the doorway and in the depth of the amphitheater brings the distances close, and in the foreground the heads and hands of the participants,

their flesh tones built on the underlying red, radiate immediacy and human presence. With direct touches of several local colors Eakins reported the details of the surgical setting. The instrument cases in the left foreground are lined with bright green and blue felt; a warm red layer underneath brings the areas into harmony with the rest of the picture. Pinks, blues, and purples describe blood-stained dressings at the very left of the table, and on the right of the table is gauze stained with the reds and pinks of fresh blood. Underneath the end of the operating table are the reds and purples describing the box of sand or sawdust traditionally placed there to catch the blood of the operation.[12] Even in local color, it is red that dominates, drawing the viewer across the painting and into the center: from the red of the pen of Franklin West on the left, across to Eakins's own pen on the right, to the dressings and surgical gauze in the foreground; then, in the center group, to the blood on the shirt cuffs of the assisting surgeons and on Gross's coat, in the incision of the patient, and, climactically, on Gross's hand and scalpel. In the blood-covered scalpel, Eakins brought together his most intense color and his sharpest focus.

In brushwork Eakins was no less varied, no less hard-working, than he had been in the rowing paintings. But he was considerably more self-confident. This sureness began with his studies for the painting. The composition study (fig. 11.2) is quick and deft, laid on with knife and brush to establish the composition as well as the tonal contrasts. He virtually sculpted his study for the head of Gross, painting it with a palette knife and juxtaposing the planes of opaque under-flesh tones to create not a surface but vigorous, even jarring, three-dimensional form. Certainly Dr. Gross did not have much time to pose, and, indeed, Eakins took

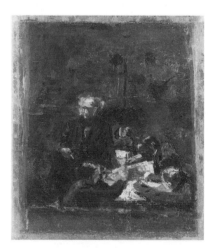

Figure 11.2 Thomas Eakins, *Composition Study for the Portrait of Professor Gross*, c. 1875. Oil on canvas, 26 × 22 inches. Philadelphia Museum of Art, given by Mrs. Thomas Eakins and Miss Mary Adeline Williams. Courtesy of the University of Pennsylvania.

photographs to complement his posed studies.[13] But in his study of Gross there is no deference to the certainty of a photographed image; there is instead a profound commitment to human bone and flesh, to that which moves and changes and can only be caught by boldness.

No perspective study for the entire painting exists. Although Eakins probably made one—on the canvas at least—his studies of heads suggest that with his work on this painting, he had passed a major point. From then on it would be the material reality of bone and flesh that would receive the hard work, the planning. Although his work was never to be without plan (to the end of his life, he made perspective studies and, to transfer sketch to canvas, used grids), Eakins was always to show more respect for the body than for abstract space. Indeed, in the portrait of Dr. Gross his preoccupation with the way bodies do things rather than with perfectly measured space led to a noticeable awkwardness in his central grouping around the patient: he had to show the thigh of the patient in order to demonstrate this type of operation; he had to put a surgeon behind Dr. Gross who would logically reciprocate the work of Dr. Appel in the right foreground; and he had to show the location of every hand involved in the surgery. Eakins eclipsed nothing—indeed, even exaggerated the knee of the surgeon behind Gross: the demands of a real situation took precedence over design, material over grace.

In this painting Eakins continued to explore ways in which he could use the brush. Across the canvas of the *Portrait of Professor Gross* are tight, precise strokes describing Gross's scalpel, opaque build-ups on the highlighted foreheads of the surgical team and of Dr. Gross, thin glazing over cheek hollows and eye cavities, dry-brushed wisps of Dr. Gross's hair, sketchy and thin strokes describing the surgeon's costumes, and short brushings scrubbed over the podium and the amphitheater wall. With the portrait of Gross Eakins had fully developed his repertory of expressive brushwork.

In his large cast of characters Eakins set forth a range of delicately nuanced expressions that was also new in his work: neither the delicacy nor the range had appeared—nor indeed had been called for—in his earlier paintings. As the hero of the painting, Gross emanates control, and his arrested pose conveys the thought that he insisted must dominate the physical activity of an operation. His white hair stands around his head like an aura; his eyes are in deep shadow (the pupils, in fact, lost). In his distant look Gross seems larger than life—his personality subordinate to his role. The other figures, in contrast, contribute very personal qualities. At the opposite pole of Gross's self-possession is the emotional surrender of the child's mother. The anesthesiologist almost smiles in his benign look at the face of his patient. Dr. Briggs, the surgeon on the lower left, holds the calves of the young patient with the gentle fatherliness that is consistent with

Eakins's rendering of his thinning hair and the aging contour and chin line of his face. The experienced Dr. Barton probes in the incision with scrupulous concentration; and the young surgeon on the right, just graduated from the Medical College, looks up at Dr. Gross with reverence.

The members of the audience—painted with only a few thin strokes—convey the many attitudes of students and witnesses.[14] Some lean forward, some place their elbows on the seat railings behind them, others prop or cross their legs, one grasps the handrail above the entranceway and leans his head against his hands; all focus on the arena with expressions ranging from solemnity to wistfulness. Eakins presents himself as short-haired and young, looking with direct intensity at Dr. Gross. He and the recorder are the only people using writing materials.

Eakins's presence in Gross's audience would seem simply to testify to his first-hand observation of the material for his painting. Actually, clinic audiences frequently contained members of the general public. Thus on one level Eakins's presence in Gross's clinic, like that of his friend Meyers and perhaps also some of the unidentified members of the audience, reflects this community interest. But it also points to two other phenomena, as did Eakins's presence in *The Champion Single Sculls:* first, he had been familiar with the surgical context for a long time, and second, he was such an expert that he was qualified to paint it.

He had come to a general familiarity with the medical world in high school. There his scientific courses in natural history, chemistry, and physics were taught by physicians who shaped their instruction in the natural sciences to reflect their primary—and medical—interest in the human body. Eakins studied human anatomy in detail in his natural history class, for instance, and in his course in "mental sciences" he learned about the physiology of vision and hearing. Students were encouraged to supplement their scientific instruction at the high school by attending anatomical and surgical clinics in the many medical facilities throughout the city; no one assumed that the students would go on to medical training, simply that an educated person should know human anatomy.[15] But the students did learn a special point of view, and they met specialists. Eakins, like his fellow students, absorbed a medical vocabulary of ideas and of words, and an introduction to the wider Philadelphia medical community. More conspicuously than did his friends, however, Eakins drew on it the rest of his life. The physician who taught Eakins chemistry and physics, B. Howard Rand, M.D., and who left Central High School in 1864 to join Dr. Gross on the Jefferson medical faculty, in fact posed for Eakins's first seated, formal portrait in 1874—thirteen years after Eakins had graduated from the high school.[16] It was the work with which he prepared himself to paint Dr. Gross, and he labored over it. Indeed, the painting (fig. 11.3) was a proving ground for textures, colors,

Figure 11.3 Thomas Eakins, *Portrait of Professor Rand,* 1874. Oil on canvas, 60 × 48 inches. Jefferson Medical College of Thomas Jefferson University, Philadelphia.

and brushwork that he polished almost without subordination to tell the story of Professor Rand: from the microscope on the extreme left to the bright pink shawl in the right foreground, from the brilliant figured rug on the floor to the dark cat under Dr. Rand's hand. A year later, Eakins was able to order and rank his details.

In 1862, once Eakins had made his decision to become an artist, he was not content with the generalist's knowledge of anatomy that he had absorbed in high school. He became a specialist, and he did so in a manner crucial to his painting of Dr. Gross: he studied anatomy with surgeons. For surgeons, precise anatomical knowledge was of such importance that they learned it through dissection and then reaffirmed it again and again by practicing dissection before each operation. For Eakins's first instruction in anatomy beyond his high school work, he enrolled in the anatomical lectures that accompanied his drawing class at the Pennsylvania Academy of the Fine Arts in 1862; those lectures, although taught by the physician A. R. Thomas, were couched for artists.[17] In 1864 he undertook more strenuous work, enrolling in the anatomy course of the surgeon Joseph Pancoast at Jefferson Medical College; not only was the instruction more rigorous because it was offered for medical students, but it called for dissection by

the students. Since the course was preliminary to the students' training as surgeons, they also attended surgical lectures and observed surgical clinics. At Jefferson they could see Dr. Gross lecture daily at eleven, and at noon on Wednesdays and Saturdays they could observe the two- to three-hour clinics over which he, and occasionally other surgeons, presided. Eakins, even after his study at Jefferson, did not feel he had finished: in Paris, from 1866 to 1869, he continued anatomical work, taking advantage of the opportunities to dissect and to watch surgical clinics at the Paris hospitals and at the Ecole de Médecine. Finally, after his return from Europe, he attended at least one more series of anatomical lectures and dissections—again at Jefferson Medical College, this time in 1874. There his apprenticeship ended. He had earned the credentials to paint the surgery in *The Portrait of Professor Gross* in 1875; to become the chief preparator/demonstrator in 1876 for the surgeon W. W. Keen, M.D., in Keen's lectures on anatomy at the Pennsylvania Academy of the Fine Arts; and to teach anatomy and dissection himself. He had joined an inner circle of professionals who knew precisely what was beneath the surface of the body and, more, who could tell from observation of a particular surface what anomalies they would find underneath as well.

Eakins was absolutely clear as to why he had studied anatomy: he was to tell an interviewer a few years later about his practice and teaching of dissection: "No one dissects to quicken his eye for, or his delight in, beauty. He dissects simply to increase his knowledge of how beautiful objects are put together to the end that he may be able to imitate them."[18]

Thus, Eakins was at home in a Jefferson clinic. Before 1875 he had not undertaken a picture so demanding as his portrait of Gross, and it was the upcoming Centennial exhibition that encouraged him to do so. Entries had been solicited from all over the world, for in one respect at least the exhibition was to be like world's fairs that had begun earlier in the century: it would recognize the international march of progress. But primarily the Centennial aimed to celebrate progress specifically American, and excellence exclusively American. Since the exhibition was to be in Philadelphia, cradle of so much of the nation's history, Philadelphia exhibitors had a unique chance to emphasize their city's contributions to American life.

Eakins seized that chance—almost the only artist to do so. For Philadelphia had very early been a major medical center. And in 1875, Dr. Gross, anatomist and surgeon of the top rank, was admired in Philadelphia medical circles, in the sphere of medical practice in America, and even in medical centers of Europe. Surgery had become in the nineteenth century a major professional opportunity for heroism.

A review of some of the history of surgery illuminates Eakins's choice of it as

a subject and, within that choice, the meaning of the particular operation in which Gross is engaged.

Traditionally, medical practice had been—and, of course, in its largest dimensions is still—divided into two provinces, one the responsibility of the physician, the other that of the surgeon. Although the distinction did not become codified until the Middle Ages, even in the classical era there was a line drawn between practice that was essentially internal, pursued by a physician who diagnosed and prescribed medicine for what he could not see, and practice that was primarily external, pursued by a surgeon who cut away cysts, pulled decayed teeth, and set bone fractures. With the establishment of university education in the Middle Ages, medicine—the discipline of the physician—became a liberal art, one which was practiced as an intellectual activity; surgery, on the other hand, was simply a skilled craft that called for manual work. Physicians came to be considered learned and aristocratic; surgeons, uneducated, of low social class. The more complicated surgical procedures, lithotomies and amputations, caused horrible pain, and the instruments associated with them—especially the scalpel—were disdained by the public. Such instruments were distinctively not the province of theory-oriented physicians.

During the Renaissance and thereafter, however, the new respect in all disciplines for the material world and for the process of investigation encouraged surgeons in their efforts to improve their surgical capabilities and to raise the intellectual and social status of their work. They became expert anatomists—dissecting with the scalpel, of course—and arrived at new understandings of the interior of the body. The famous picture by Rembrandt of Dr. Tulp (fig. 11.4)

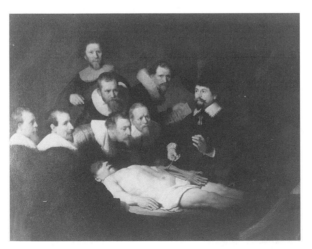

Figure 11.4 Rembrandt van Rijn, *The Anatomy Lesson of Dr. Nicholas Tulp,* 1632. Oil on canvas, 18½ × 25 inches. Mauritshuis, The Hague. Photograph by Editorial Photocolor Archives.

delivering an anatomy lesson to a group of surgeons shows the new dignity that such guilds enjoyed. By the late eighteenth century, particularly in France, surgeons had come to be respected not only for their anatomical knowledge but for the manual dexterity that had enabled them to make impressive strides toward new operations—progress that was from some points of view more impressive than that made during the same period by physicians.

Then two developments secured the admiration in which surgeons were to bask after about 1800 and throughout most of the nineteenth century: scientific studies by a small group of brilliant surgeons working in Paris revolutionized both the practice and the teaching of surgery; and the French Revolutionary government proclaimed that both surgeons and physicians would be educated in the university—thus equalizing their status. Informed with new knowledge of how disease spread within the body, surgeons began to undertake operations they had never earlier even contemplated (although not until late in the century were they to operate on the lungs or the abdominal cavity). With a new "clinical" method of instruction they taught students by performing surgery in their presence and then monitoring, again with student audiences, the recovery or decline of the patient. They practiced and taught as "scientific" surgeons, who took no traditional outcome for granted but kept detailed records of the consequences of each procedure. They began to emphasize the effect of surgery on the entire body of the patient and taught their students that a surgeon was fundamentally a physician, concerned with the relationship of a local surgical problem to the general health.

By the 1820s the honor that French surgeons enjoyed was at a height, and students and trained surgeons came to Paris from all over Europe and America to study French surgery and the French method of teaching. There were detractors, of course—the caricatures of Daumier are the best evidence of that for in the first part of the century even greatly improved surgical procedures, especially before the use of anesthesia, were often brutal. But surgeons mounted an impressive campaign for recognition. Editors of general periodicals featured biographies of surgeons; printmakers issued editions of portraits of surgeons; compilers of collections of engravings of eminent men began to include surgeons along with physicians in their selection of men eminent in medical life; the French government erected public monuments to famous surgeons. Surgeons began to write the history of their discipline and to stipulate the moral as well as the intellectual character that had identified surgeons throughout history. By the 1840s this character could be read like a litany, in interviews with famous surgeons, in necrologies, even in histories of surgery: surgeons were typically of humble birth, had taught themselves to read, and had worked indefatigably to enter the competition for surgical training; once educated they had

operated brilliantly, never lost their rural humility or, what was more important, their piety, and, their social potential fully developed by education and science, they moved easily at all social levels. French surgeons put themselves forward, in short, as the very embodiment of Enlightenment values and egalitarian opportunities taken seriously—as heroes of modern life.[19]

American surgeons were not yet in so fortunate a position. They had had to struggle simply for basic training, and in many areas of the country the distinction between physicians and surgeons was still a luxury. Philadelphia played a prominent role in the struggle of American medical men for training and recognition, and during Eakins's lifetime it actively cultivated (and indeed continues to do so) a sense of proprietorship about its early contributions to American medicine. Eakins's painting of Dr. Gross was as rooted in his pride in Philadelphia as was *The Champion Single Sculls*.

Before Philadelphia made its early contribution, medical care in the American colonies had been provided by men trained in the great medical centers of Great Britain and of Holland—notably London, Edinburgh, Dublin, and Leyden—and, as in any rural area, by people without special training who simply developed medical skills. Philadelphia, in its strong position in the mid-eighteenth century as a center of rising wealth, boasted a number of foreign-trained physicians who saw the desirability of providing medical training in the colonies, and they took several steps to develop Philadelphia as a medical center. As early as 1739 a physician returning from study in England delivered a course of anatomical lectures in the city. In 1751, Benjamin Franklin, the physician Thomas Bond, and a group of other dedicated citizens worked together to establish the Pennsylvania Hospital; and then in 1765 a group led by the physician John Morgan founded a medical school that was to become part of the University of Pennsylvania, modeling the educational program of the school, because of the training of the physicians that would teach there, on the system of the University of Edinburgh medical school. The establishment of medical education in Philadelphia led to a slowly growing cadre of professional men who early in their history encouraged each other to carry out research, first as members of the American Philosophical Society, which sponsored scientific studies, and then within their own professional society, the College of Physicians of Philadelphia, formed in 1787. In this atmosphere of support, members of the faculty of the medical college at the University of Pennsylvania made the pioneering publications in America in a variety of fields of medicine: psychiatry, anatomy, surgery, materia medica, and therapeutics.[20]

Philadelphians were also notable in the establishment of American medical periodicals. Early publications in medicine had appeared sporadically in New Haven and Boston, and a regular periodical had begun publication in New York

in 1797. Philadelphia entered the field in 1804 and soon was contributing a number of journals. One of these, the *Journal of Foreign Medical Science,* played a central role in transmitting to Philadelphians and other readers the advancements in French surgical research. Another, founded in 1820, became as the *American Journal of the Medical Sciences* one of the most distinctive continuing medical journals in the country, and throughout the century kept Philadelphia at the center of American medical publication.

Although as late as 1876 the New York physician Austin Flint credited Philadelphia with maintaining the medical leadership of America it had established so early, by that time the city had long since been joined by Boston and New York, and then New Haven, Charleston, and cities to the west, in offering students and professional colleagues anatomical instruction, medical training, professional societies, and publications.[21] This spread of training and talent to several major medical centers encouraged scientific industry among American medical men, and they began to make original contributions to medicine and surgery. Two of the surgical contributions, conspicuous even in the large framework of Western surgical progress, were particularly important to American surgeons' self-confidence: first, the discovery of anesthesia in Boston in 1846, making possible intricate, time-consuming surgery that was unthinkable when the patient was conscious—and that turned European eyes to America for the first time—and second, several pioneering gynecological procedures. Other advances brought American medicine to international attention: the Civil War resulted in American improvements in the treatment of gunshot wounds, the setting up of hospital facilities, and the keeping of records, all of which were studied by European physicians. Finally, the founding after the Civil War of the National Medical Library set an example in bibliographic resources that was emulated in Europe.

Distinctive though the contributions were earlier in the century, American medical progress until considerably after the Civil War was a conscious struggle for autonomy from foreign training and literature. Even major surgical contributions were made in awareness of the domination by the long English and European traditions of American medical training, literature, and research. Americans felt that Englishmen especially, as previous colonial superiors, underestimated the potential of American scientific contributions—indeed, of all American contributions. In 1820 the acerbic Englishmen Sydney Smith wrote in the *Edinburgh Review:* "Who reads an American book? or goes to an American play? or looks at an American picture or statue? What does the world yet owe to American physicians or surgeons?" The Philadelphia-based *American Journal of the Medical Sciences* incorporated the last fling of the taunt—"What does the world yet owe to American physicians or surgeons?"—into its title page

masthead and kept it there throughout the century.[22] It was a powerful rallying point for American surgeons and physicians, who, with their colleagues across the Atlantic never far from their consciousness, worked vigorously to provide medical training on this continent, to stimulate their colleagues to research and writing, and to participate in American life as professionals meriting the highest social and intellectual respect.

Perhaps given extra encouragement by an American anti-British sentiment that increased after the war of 1812 and by the stubborn class consciousness that persisted in British surgery, Americans were prominent among the foreigners who flocked to Paris to attend surgical clinics, ward visits, and anatomical and surgical lectures—all available free to anyone with a passport.[23] They brought back the ideal of clinical teaching; they translated French texts for teaching and published French research in their American journals; they celebrated the democratic image of the French surgeon as profoundly appropriate for America. One American surgeon, writing a book in 1843 about his years of study in Paris, found a crowning lesson for aspiring Americans in the career of the great French surgeon Guillaume Dupuytren, who had risen from poverty to a rank in the aristocracy (and whom Gross was to cite as having been without question France's most eminent surgeon): "Had not *Monsieur* Dupuytren been compelled from poverty to trim his student's lamp with oil from the dissecting room, he never would have succeeded in becoming Monsieur le *Baron* Dupuytren."[24]

In emulating the French example, Philadelphia medical men were again distinctive leaders. In 1825, the surgeon George McClellan founded Jefferson Medical College. Establishing it in well-publicized rivalry with the medical college of the University of Pennsylvania (which had been modeled on the medical school at Edinburgh), he proposed that two tenets—French-inspired—would guide the curriculum: equal access to a medical education (he and others claimed that admission to medical training at Pennsylvania depended on "connections") and instruction carried out by the clinical method (at Pennsylvania, students were taught by the more private method of being assigned to follow the practice of one physician or surgeon). Taking the French ideal as Jefferson's guide, McClellan claimed that basic training for surgeons and physicians would be the same, that the practice of medicine was founded on fundamental principles common to both its branches.

Dr. Gross was in one of the earliest classes of students at the new college. When he entered in 1826, he had already pursued an introductory medical education despite discouraging difficulties. Born in 1805 near Easton, Pennsylvania, to highly moral, hard-working, and humble German-speaking parents, Gross had had what he later called "the strongest desire" to be a "doctor" since early

childhood. His father died when Gross was only nine, and his education was primarily at his own direction; after teaching himself mathematics, Greek, Latin, and English, he began medical study but went from one preceptor to another, disillusioned with their ignorance of classical and foreign languages and lack of scientific knowledge. Finally, on the recommendation of his last preceptor, he went to Philadelphia. There, in the fall of 1826, stimulated by the reputation of Professor McClellan for "brilliant achievements" in surgery, he enrolled at Jefferson Medical College. Two years later, after clinical course work in anatomy and surgery, complemented with long hours of dissection and courses in therapeutics, Gross received his medical degree.

He embarked on a career that fulfilled every dimension of the ideal surgeon. In his first two years of practice he translated four European texts and published the results of his own substantial original research on bone diseases. Over the next twenty-five years he taught at medical colleges in Cincinnati, Louisville, and New York, published a text on pathological anatomy, and conducted and published research on wounds of the intestines that was to prove invaluable in the treatment of Civil War wounded. In 1856, at age fifty-one already a man of national reputation, Gross was elected to the Professorship of Surgery at Jefferson Medical College and returned to Philadelphia. For the next twenty-six years, until he retired in 1882, he continued to work in many dimensions. He taught and operated brilliantly, dissecting almost daily; he edited and wrote for a major medical journal; he published voluminously, from short articles to major addresses to his two-volume *System of Surgery* that went through six editions; he maintained a large office for private practice. His writings and texts were known abroad; and he was honored with foreign degrees. In person Gross was both authoritative and compassionate, always conscious of his responsibilities as a human being; all his life he spoke of himself not as a surgeon but as a physician.

In choosing Dr. Gross as his sitter, Eakins selected a surgeon who was ideal not just in Philadelphia eyes but also by international standards: a man of humble origins, trained in the French clinical—the scientific—tradition, an untiring worker, and a brilliant researcher and writer. Dr. Gross was at the center of a community—a community of people, of values, of techniques, of history. Eakins's picture about that community rose through specific detail to make a general statement about Gross, Philadelphia and America, and modern surgery.

Eakins built his picture of Gross to illustrate the principles by which Gross and his community had worked: principles that Gross never took for granted but enumerated before his students in clinical sessions and formal addresses and put down for his reader in his *Autobiography*.

The first involved the fundamental role of clinical instruction in the training

at Jefferson Medical College. In his inaugural address as Professor of Surgery in 1856, Gross traced the heritage of the Jefferson clinics directly to those established in France. Not only was he proud that the Jefferson clinics, like those in Vienna, Padua, Berlin, and Edinburgh, had sprung from the very source of the clinical method, but he exulted that Jefferson in turn had become a model: that the many hospital clinics in existence in Philadelphia by 1856 had been formed on the example of Jefferson, so that "there is no city in the world, Paris and Vienna not excepted, where the young aspirant after the doctorate may prosecute his studies with more facility or advantage than in this."[25]

And clinical instruction as Jefferson offered it, according to Gross, provided for the best possible training of the future physician or surgeon. Advantageous as were the "hospital clinics" elsewhere in Philadelphia and throughout Paris in rounding out the student's familiarity with severe medical and surgical problems, it was also the case that hospital patients usually suffered from such grave problems that the student was unlikely to encounter them in general practice. Further, the acute condition of the hospital patient often prevented doctors from transporting him to the hospital amphitheater, where large numbers of students could study the symptoms or observe the surgery. If the attending physicians carried out the examination and surgery in the hospital wards, at the patient's bedside, only three or four students nearest the bed could actually learn from the procedure. Thus the "college clinic"—that offered at Jefferson— was best; first, because the patients were usually ambulatory, so that the student saw "every variety of chronic disease, both medical and surgical," and second, because the student could see the professor conduct a preliminary examination, diagnose, and prescribe. If the professor performed an operation, the student could see "the disposition and functions of the assistants, the arrangement of the instruments, the position of the patient, and the different steps of the procedure, from its commencement to its termination, including the dressings, and the replacement of the sufferer in his bed." Even though the college clinic specialized in common medical and surgical problems, Jefferson students saw their share of serious problems, too. Next door to the amphitheater, and connected to it with a passageway, were rooms in which care could be provided for as many as fifteen patients. If a relative could not stay around the clock to care for a patient, the professors and students of the college did.[26]

Another principle that underlay Gross's career—indeed had made it possible—and one that Gross reminded his students of frequently, was that Jefferson Medical College was the champion of the ordinary citizen. This was no idealistic claim. By the beginning of the Civil War, Jefferson had become the largest medical school in America, graduating more than one-fourth of the medical students in the country.[27] It attracted students from all states of the Union,

from Mexico, and from Canada. In his first address in 1871 as president of the newly formed Jefferson Alumni Association, Gross celebrated with his fellow alumni the college's historically egalitarian character: "[Jefferson Medical College] has been emphatically the school of the people and of the profession at large, dependent upon no clique, combination of interests, or hereditary prestige for support and countenance. She has been, in every sense of the term, a self-made institution. . . . She rose from humble beginnings by rapid strides to gigantic proportions, outstripping, in the number of her pupils, every school of the kind in the country."[28]

Two of Gross's ideals were more personal. One was the importance to him of being a surgeon who taught. He noted that the most distinguished surgeons in recent history had almost inevitably held teaching positions, and that teaching usually made a researcher a better writer.[29] Even more important to him was the range of influence that the teacher of surgery had. He could inculcate into his students basic medical principles, and Gross matter-of-factly praised himself as a teacher who insisted that students know the principles underlying whatever particular instance they were dealing with. He taught his students to have a profound respect for knowledge, but only that which had been verified; and he set down his testimony in his *Autobiography:* "I never dealt in hypothesis, conjecture, or speculation." But the most important aspect of his influence as a teacher, Gross felt, was on the lives of the patients his students would treat. Writing of the poise with which he had addressed thousands of students in clinics over his career, Gross asked his reader: "Who would not, inspired by the occasion, be eloquent when he is addressing himself to a body of ingenuous students, in quest of knowledge designed to heal the sick, to open the eyes of the blind, to make the deaf hear, to enable the lame to walk, and to loose the tongue of the dumb? I never enter the lecture-room without a deep sense of the responsibility of my office—without a feeling that I have a solemn duty to perform—and that upon what I may utter during the hour may depend the happiness or misery of hundreds, if not thousands, of human beings."[30]

For Gross, neither the process nor the teaching of surgery was a performance. During the first part of the century, before the introduction of anesthesia, surgeons performed amputations and other operations with a haste that kept the acute suffering of the patient to a minimum; in clinical sessions many surgeons openly yielded to the temptation to make this haste as dramatic as possible—and with calculated gestures they won applause and cheers from the colleagues and students who were their witnesses.[31] Reminiscences and contemporary accounts of surgery in the Jefferson clinics in the 1860s and 1870s show that the taste for drama was not lost even then. Such clinics, in which surgeons took turns performing three or four spectacular operations, each surgeon

introducing the next as the "hero" of the upcoming demonstration, were held at the beginning of the college term when medical institutions were competing with each other for enrollment, or when famous surgeons from other cities or from abroad were visiting.[32] But Dr. Gross was not dramatic, and he would not permit such an atmosphere in his clinic. He wrote in his autobiography: "Nothing was more offensive to me than applause as I entered the amphitheater, and I never permitted it after the first lecture. I always said, 'Gentlemen, such a noise is more befitting the pit of a theatre or a circus than a temple dedicated, not to Aesculapius, but to Almighty God, for the study of disease and accident, and your preparation for the great duties of your profession. There is something awfully solemn in a profession which deals with life and death; and I desire at the very threshold of this course of lectures to impress upon your minds its sacred and responsible character.'"[33]

On this ideal he was as insistent to his colleagues as he had been to his students. In his *System of Surgery* he spelled out the proper atmosphere for a surgical undertaking: "The operation is proceeded with, slowly, deliberately, and in the most orderly, quiet, and dignified manner. All display as such, is studiously avoided; ever remembering, in the language of Desault, that the simplicity of an operation is the measure of its perfection. No talking or whispering should be permitted on the part of the assistants, and as to laughter, nothing could be in worse taste, or more deserving of rebuke. Every important operation should be looked on as a solemn undertaking, which may be followed in an instant by the death of a human being, whose life, on such an occasion, is often literally suspended by a thread, which the most trivial accident may serve to snap asunder."[34]

Gross's pride in Jefferson, his sense of the origin and the superior contribution of clinical instruction, his celebration of democratic opportunity in surgery—each of these found its way into Eakins's image. Trained in the teaching tradition with such an important heritage, born not to privilege but to discipline and hard work, Gross was not only shaped by Jefferson but in return gave its ideals their fullest confirmation. Thus Eakins showed him in the Jefferson surgical clinic, surrounded by students, who will rise to prominence in the very way Gross did, by hard work. Gross is assisted by an operating team several of whom were Jefferson graduates. The presence of the clinic recorder emphasizes the scientific modernity of the work: there is no authoritative anatomical text, as in the format of the anatomy lesson (typified by Rembrandt's *Anatomy Lesson of Dr. Tulp,* where the text is open at the feet of the cadaver), but a record to be passed on to the future. And Eakins sets forth Gross's more personal ideals, too: Gross considered his role as a teacher to subsume his work as surgeon; and Eakins shows Gross about to lecture on what he is doing, his act of explanation and interpretation being larger than his act of doing. Second, in the painting the

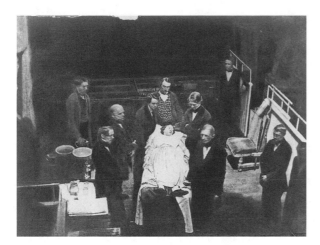

Figure 11.5 *An Operation under Ether at Massachusetts General Hospital,* c. 1850. Daguerreotype. National Library of Medicine, Bethesda, Md.

operating amphitheater over which Gross presides is indeed like a temple of healing hushed by a respectful, even reverent, quiet. From the point of view of the student, before whom Gross was so anxious to have everything laid out, the painting leaves nothing unclear: the disposition of the presiding surgeon, of the assistants, the arrangement of the patient, the location and display of the surgical instruments—precisely what each person is doing and with what. (fig. 11.5, a photograph of a surgical operating team in the 1850s, also sets forth meticulously the persons and equipment necessary for the procedure).

And Eakins makes very clear what the operation is. Like everything else in the painting, Eakins chose it to pay tribute to a particular quality of Dr. Gross.

One further principle was fundamental to Gross's practice, and that was his sense of the history of surgery. His clinical and formal lectures were dotted with references to past surgeons and techniques.[35] He wrote historical essays about surgeons, focusing early in his career on American surgeons who he thought deserved recognition; then turning his attention to the great sixteenth-century surgeon Ambroise Paré, who was honored then as now as the father of French— and in many ways of modern—surgery; and finally, during the months when Eakins was painting his portrait, writing two extended essays that have become landmarks in the history of American medical literature. One of these was a history of medical literature in America, the other a history of America surgery.

With a wide knowledge of the character of surgical procedures that extended even to those recorded by classical authorities, Gross was acutely sensitive to the rapid changes being made in surgery during his lifetime. In 1867 he exulted that recent progress in surgery had been "without a parallel in any age. . . . It would almost seem as if the millennium were actually close at hand. Look where we

may, progress, rapid and brilliant, nay, absolutely bewildering, literally stares us in the face, and challenges our respect and admiration." [36] Yet while Gross, like his colleagues, exulted in the new surgical procedures that scientific work in anesthesia, pathology, and medical instrumentation was permitting surgeons to perform, he also identified "conservative" surgery as one of the profession's most important recent developments. [37] Not a particular operation, but a philosophical approach to surgery, "conservative" surgery derived from the conviction that to amputate, so long as there was any other option, was to admit failure as a surgeon. The practice of conservative surgery applied primarily to diseases in the limbs; it often involved a long period of waiting for nature to take a positive course before the surgeon took drastic action. But the conservative attitude could illuminate the general practice of the surgeon; and in the mid-century years across Europe as well as America conservative surgeons occasionally accused their colleagues of being impatient, of being "too fond of the knife." [38]

In Eakins's portrait of him, Dr. Gross is performing conservative surgery. The operation underway, for the removal of a piece of dead bone from the thigh, is the last stage of Gross's treatment of his patient for osteomyelitis, or infection of the bone. A problem virtually eradicated by the introduction of sulfonamides and antibiotics in the 1930s, osteomyelitis was characterized by infection of the longer bones of the body, such as the femur, tibia, and humerus, to which few people but the young between the ages of five and twenty-two were susceptible. [39] Infection usually set in after a sudden chill, causing the patient to experience high fever and excruciating pain. Until the late eighteenth century surgeons routinely responded to osteomyelitis by amputating the limb just above the infection. However, through dissections and observation of ongoing cases, English surgeons discovered that the infected part of the bone, if left alone, would simply die and then slowly separate itself from the bone shaft (often penetrating the skin), leaving intact a shaft that would regenerate itself and resume its normal function. If the separation process proved too long, surgeons could intervene with resection and cut the diseased portion away from the healthy shaft. In either case, amputation would not be necessary. For his own competence in the procedure, Gross had drawn most notably on the work of the American surgeon Nathan Smith, who in the 1830s wrote a seminal paper on the subject that described his own long experience. [40]

Although his colleagues and many lay admirers esteemed Gross for the brilliance and tact of his lithotomies and complicated amputations, Gross himself felt his work on bone diseases to have been of superior importance. Whereas lithotomies and amputations were standard surgical procedures, in each instance of osteomyelitis the problem was slightly different, and solving it appealed to Gross's pride in being a physician. Gross had studied osteomyelitis for his first

original publication, in fact, and in his *Elements of Surgery* of 1859, he set forth in detail careful procedures for treatment of the disease in its various manifestations.[41] In his clinics at Jefferson during the 1860s and 1870s, the treatment of diseased or dead bone occupied him more than did any other single surgical procedure.[42]

The problem demanded a great deal of patience: the surgeon did not dispatch his patient quickly as he would if he had removed a cyst or performed an amputation. For instance, the *Philadelphia Medical Times* reported on December 17, 1872 the successful conclusion of the necrosis of the humerus of a young patient whom Gross had been treating at the Jefferson clinic for a year and a half. During this time the boy had visited Gross's clinic "a number of times," and Gross waited for nature's own work on the disease to make it possible for his surgery to be most successful. From time to time, the report notes, Gross had removed small pieces of dead bone, "but did not find the necrosed portion sufficiently separated, or the involucrum [new, living bone] strong enough to maintain the shape and usefulness of the arm after an operation." On the clinic day reported, Gross determined that the healthy bone was at last sufficiently strong, and the reporter quotes Gross's lecture as he performed the surgery: "The patient being well influenced [by the anesthesia], we will enlarge this opening [made by nature on the surface of the skin, through which a piece of protruding dead bone would eventually pass] down to the bone and remove the necrosed portion. We will then carefully scrape out the cavity to remove all the carious particles of bone and unhealthy granulations that would interfere with the reparative process."[43] Such a procedure, such an explanation—except that the bone being treated is the femur, in the thigh—is taking place in Eakins's painting.

Although surgery for the removal of dead bone was tedious, it was not life-threatening. As early as 1830 Gross's authority Nathan Smith had written, on the basis of his years of experience with this type of surgery, "[even in the most advanced stages of osteomyelitis when the surgery demanded was some of] the most laborious and tedious, both to myself and the patient, which I have ever performed, yet I have never known any untoward circumstances to follow such operations, of which I have performed a great many."[44]

And surgery for the removal of dead bone did not create what Gross's faculty colleagues called a "show" clinic. Because Eakins was so attentive to the principles on which Gross conducted his work, his picture takes a remarkable place in the history of images about surgeons.

A standard early point of comparison, of course, is Rembrandt's *The Anatomy Lesson of Dr. Tulp*.[45] A group portrait with Dr. Tulp as the most important figure, the painting is certainly not too removed from Eakins's intentions in that

respect. Rembrandt was careful to show, as was Eakins two and a half centuries later, the precise nature of the procedure underway: the demonstration of certain muscles of the arm by a master surgeon to other surgeons. But what is being taught in Rembrandt's image, of course, is anatomy, not surgery. The standard anatomical text is open in the foreground to guide the instruction. And in 1632 there was no awareness that one could use that instruction for the performance of a particular operation. What the image celebrates is not healing but empirical investigation. And earlier, less imposing images had also set forth scenes of investigation: images of private dissections are found in manuscripts in the Romanesque period; and the well-known woodcut by van Calcar of Vesalius performing a public dissection in the amphitheater at Padua in 1543, which served as the frontispiece for Vesalius's famous work on anatomy, *On the Fabric of the Human Body,* was one of many such images in the Renaissance.

In the early nineteenth century, with the well-publicized advances in French surgery and the rise of the French surgeon to prominence, French artists began to explore ways in which surgeons might be depicted, both in history paintings and in portrait formats. An early subject was the surgeon Guillaume Dupuytren (whose career was admired by Americans), who won considerable renown for his operation for cataracts. In 1820 an anonymous artist pictured him in the hospital ward with one of his successes after cataract surgery; Charles X, who had made him a baron in recognition of his achievements, is shown on a visit to the ward to see the removal of the bandages of one of Dupuytren's patients. The patient, a woman, throws up her hands in delight that she can see; Dupuytren, the proud surgeon, stands modestly near her. Another image, part of a historicizing portrait, appeared in 1843 in the *Plutarque française;* this one honored the surgeon-pathologist M.-F. X. Bichat, whose research in the dissection laboratory on the character of disease (which cost him his life at age thirty-one) had made the single most significant early contribution to French surgical progress. The artist chose to show Bichat posed in a Napoleonic stance by a discussion table, the cadaver modestly covered, texts nearby to show that Bichat's research had led to a substantial increase in knowledge. These images of Dupuytren and of Bichat show the environment and the results of the surgeons' work; but they do not show that work in process.

With the revival of interest in Rembrandt in the 1840s, artists turned to the format of the anatomy lesson, both for historicizing paintings and for compliments to living surgeons. The Belgian painter Edouard Hamman chose the theme for his widely admired historical tributes to the anatomist Vesalius: one showing Vesalius delivering a famous public lecture in Padua in 1546, the other showing Vesalius about to undertake private anatomical study (engraved by

Wisener, Bibliothèque Nationale, Paris). Anatomy lessons also honored con-
temporaries. Among the portrait medallions, allegorical scenes, and landscapes
several Parisian artists did in 1859 for the all-purpose lounge of the interns at
Hôpital de la Charité was an anatomy lesson with each participant a member of
the professional or intern staff of the hospital. Articles in journals informed the
public about hospital life and often included wood engravings of dissections or
anatomical teaching. Even at the Salons, artists occasionally exhibited scenes of
autopsies.

From the point of view of Eakins's achievement, the most pertinent image in
the format of the anatomy lesson was a painting by F.-N.-A. Feyen-Perrin exhib-
ited at the Salon in 1864 (fig. 11.6). With this painting the artist honored one of
Paris's most famous surgeons, Armand Velpeau, the chief surgeon at Charity
Hospital. As Eakins had done in Philadelphia at Jefferson (and in Paris, perhaps
at Charity Hospital), Feyen-Perrin had attended dissections and clinics at the
hospital. Thus Feyen-Perrin drew on his own experience to show Velpeau pre-
siding at a dissection surrounded by a number of onlookers. A lithograph (in the
collection of the National Library of Medicine) with identifications of the on-
lookers shows the company to have been a diverse one: other surgeons on the
staff of Charity Hospital, medical students, poets, and artists—including Feyen-
Perrin himself. Although Velpeau presides over the dissection with grandeur,
dissecting is an activity that is not as central to his identity as a surgeon in 1846
as it had been to Dr. Tulp in 1632. Of course, anatomical knowledge of the most
detailed kind was absolutely essential for the nineteenth-century surgeon, but
what defined the modern surgeon's essential achievement, and especially that of
Velpeau, was his pioneering and brilliant role in actual operations and his teach-
ing in surgical clinics. Yet Feyen-Perrin chose to present Velpeau in the role of
an anatomist, even with a text in evidence, and, what is more, to show him be-
fore an unblemished cadaver before the dissection has even begun. Even more
noticeable is that nowhere in evidence in the painting is the anatomist's and the
surgeon's tool, the scalpel. Classically balanced, discreetly lighted, the painting is
a decorous one. But in defining the essence of modern surgery—its heroism—
it serves as little more than a group portrait.

Against this background, Eakins's image of Gross is explicit.

He painted it to no order but his own. As Gross was no mere anatomist,
Eakins did not choose an outdated convention to honor him. Gross's place was
in the college clinic, performing surgery, where the scalpel and the blood were
at the center of the procedure—the scalpel, the tool of investigation and of
healing, and the blood, the flag of the living being on the operating table. More-
over, the surgery that defined Gross as a modern surgeon was not the heroic

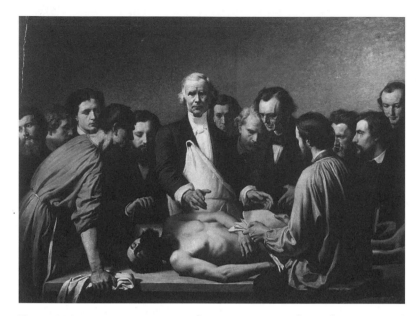

Figure 11.6 F.-N.-A. Feyen-Perrin, *The Anatomy Lesson of Dr. Velpeau,* 1864. Oil on canvas, 67 × 91¾ inches. Musée des Beaux-Arts, Tours. Photograph by Bulloz.

amputation or the bladder-stone removal that had been practiced by earlier surgeons for centuries, but a quiet surgical procedure that in its capacity to improve the life of a patient illustrated incisively the benefits of the evolution of surgery. Including the patient's mother to assure that his audience would not miss the youth of Gross's patient, Eakins makes a point that could be made only with this operation: the happy outcome of the surgery in Gross's clinic is a child with a whole leg instead of a stump. Dr. Gross and other conservative surgeons of the modern community have, in effect, applied to their own work the motto of Paré: "I dress the wound, God heals it."

Considering what he had painted earlier, and that he was only five years into his painting career, Eakins exercised an impressive authority in carrying out this project: at least six very busy surgeons besides Dr. Gross sat for him, as well as a number of students. Soon after he finished the painting Eakins painted a small black and white watercolor of it on which to have based an autotype and an edition of prints. Some of these he perhaps gave as mementos to the people who sat for him. Autotypes that survive today are those Eakins autographed and gave away years after the painting was completed: the work remained, in his own estimation as well as that of future generations, one of his finest achievements.

Even during his lifetime Eakins was not alone in his assessment of the work.

Although the Centennial jury, offended by the work's directness, refused to hang the painting in the regular art exhibition section—a decision for which we have no recorded reaction from Eakins—under the sponsorship of Gross himself the painting was exhibited in the medical section of the Centennial. There it took a proper place along with other medical exhibits—many of them related to the surgery in the painting—medical texts, and portraits of eminent medical men (fig. 11.7).[46] Nearly seven hundred physicians and surgeons from other cities and countries, in Philadelphia for an international congress, visited the medical exhibit and saw in Eakins's painting what a Nashville surgeon declared in his major address: "It was as late as 1820 that the taunt was uttered, 'What does the world yet owe to an American physician or surgeon?' [Yet, less than fifty years later] a French surgeon said to an American student, 'You ought to be proud of America, for she wields the sceptre of the whole world's surgery.'"[47] Eakins had caught ideals that were crucial to the entire medical community, and in 1878, after a new Jefferson hospital was opened, the Alumni Association of the college bought the painting and hung it in their museum.[48]

Sympathetic critics in the art community also recognized Eakins's achievement and gave it high praise. Eakins first exhibited the autotype of the painting, in fact, at an art exhibition at the Penn Club, founded just earlier to honor distinguished intellectual and professional leaders. The critic who reviewed the exhibition wrote of the image as one "of great learning and great dramatic power" and, later, on the exhibition of the painting itself at Eakins's dealer's, wrote further: "We know of nothing in the line of portraiture that has ever been

Figure 11.7 Ward of Model Post Hospital, Medical Department, Philadelphia Centennial Exposition, showing installation of *The Gross Clinic*, 1876. Photograph courtesy of the Library of Congress.

attempted in this city, or indeed in this country, that in any way approaches it. . . . This portrait of Dr. Gross is a great work—we know of nothing greater that has ever been executed in America."[49]

Yet in other situations, starting with Eakins's submission of the painting to the Centennial jury, the painting was not cordially received.[50] It made people uneasy, even angry. For the first time Eakins had two publics, "insiders" and "outsiders." These publics were divided not so much on whether they liked his painting as on whether they would acknowledge that a painter could insist that he had responsibilities that were beyond their ken. Eakins took his responsibilities as earnestly and self-consciously as Gross took his and was not swayed from that seriousness even though over the years his public of disgruntled outsiders grew.

And over the years surgery changed. In fact, in only a very few years progress obscured the earlier modernity of Gross.[51] Within a short time of his retirement, surgeons had accepted aseptic procedures and were operating in white gowns and with sterile instruments; they were entering the abdominal and lung cavities and making their first probes into the brain. Philadelphia surgeons and physicians had contributed notably to this progress, and Eakins painted many of them over the years in their various medical capacities as scholars, and lecturers, and, simply, as seated human beings. Not until fourteen years after his portrait of Gross did he paint his second, and only other, clinic portrait. In 1889 the medical class graduating from the University of Pennsylvania commissioned him to paint a portrait of Dr. D. Hayes Agnew, who was retiring that year. Agnew and Gross were almost contemporaries, Gross being only thirteen years older than Agnew and retiring only seven years ahead of him. Within the later years of these men's careers, surgery had changed at a breathtaking pace. Gross had retired before the most outwardly notable of these changes—the practice of asepsis—had won general acceptance, but Agnew had adapted to the new ways. Keenly sensitive to these changes, on receipt of the commission Eakins decided not to paint a conventional portrait of Agnew but to enlist the help of assisting surgeons and medical students to show the distinguished surgeon in the context of the newer surgical clinic.

In the *Agnew Clinic* (fig. 11.8) surgeons wear white; the sterilized instruments are in a covered case; a nurse is prominently in attendance; the pyramidal structure of the Gross clinic scene is transformed into a horizontal format that shows the teamwork more characteristic of recent surgery, which had to some extent replaced the individual heroism of Gross. The painting is much lighter in palette than that of Gross, revealing not only Eakins's generally higher key during these years but the physical circumstance that by 1889 surgery was performed under widely dispersed artificial illumination. And, painted in a rush, the work in many areas is thin. *The Agnew Clinic* is larger than the *Portrait of*

Figure 11.8 Thomas Eakins, *The Agnew Clinic*, 1889. Oil on canvas, 74½ × 130½ inches. University of Pennsylvania School of Medicine. Photograph, Philadelphia Museum of Art.

Professor Gross, but it derives its meaning, in Eakins's career, at least, primarily from its relationship to that earlier painting. It is a relationship grounded in change.

Soon progress that amazed Agnew had been surpassed, and eventually even the clinic faded into history. Surgeons abandoned it for teaching altogether as they began to appreciate the risk of infection from lecturing during surgery. Nostalgia for the clinic set in and, with the passage of time, the interest of the medical community in the portrait of Gross—and the interest of Eakins too— shifted from its focus on the surgical hero to its documentation of the near leg- endary clinic over which Gross had presided. By 1904, when Eakins exhibited the painting at the Universal Exposition in St. Louis, he was calling it the "Clinic of Professor Gross." After Eakins's death his friend wrote about the painting as "Dr. Gross' Clinic." It was but a short journey from there to the *Gross Clinic,* which the painting has been called ever since.

The confidence with which Gross presided in 1875—the self-conscious hero- ism of his career as a surgeon—had, in fact, its underside. Gross wrote to one of his favorite students after he had entered professional life himself: "God knows surgery is not a sinecure, but a most corroding, soul-disturbing profession."[52]

Sanford C. Yager, writing in the *Cincinnati Lancet and Observer,* explained why this was the case: "[The medical profession is] the most difficult, obscure, and complicated of all human learning. No other occupation in life involves such varied and minute knowledge, such careful observation of nature, such constant and absorbing study, such heavy responsibilities. The principles of other sci- ences are founded upon inanimate matter, are, therefore, well defined and not subject to change; and can be calculated on with certainty. Medicine, on the con- trary, has to do with that which is in continual turmoil, and subject to a thousand

varying circumstances and affecting causes. Our science rests upon human life: than which nothing is more uncertain."[53]

This profound respect for the uncertainty of human life was increasingly to characterize Eakins's approach to portraiture. Like the surgeon who had to know what was inside the body in order to understand the meaning of what he saw outside, Eakins did not only know the visible dimensions of the body; as he matured he became increasingly sensitive to the invisible strains of spirit that moved it. Dr. Gross was inconceivable in his clinic without the blood that showed his full knowledge of and concern for the changing, living body; Eakins was to be inconceivable as a portraitist without the shadows, the slackening skin, the heavy shoulders that revealed his full awareness of the journeying human spirit.

Notes

This is an abridged version of an essay first published in *Thomas Eakins: The Heroism of Modern Life* (Princeton, N.J.: Princeton University Press, 1983).

1. A photograph of the X ray of this composition sketch, revealing the rowing studies, is on p. 173 of Theodor Siegl, *The Thomas Eakins Collection* (Philadelphia, 1978).

2. I except from the category "scene of leisure" Eakins's painting of 1879, *A May Morning in the Park*, now called *The Fairman Rogers Four-in-Hand* (Philadelphia Museum of Art). Coaching was not an egalitarian activity, but one pursued by the wealthy; Eakins painted the subject on the commission of coach owner Fairman Rogers, whose intellectual acumen and energy he very much admired, and he developed the painting primarily as a study of motion.

3. To Earl Shinn, April 13, 1875, Friends Historical Library of Swarthmore College.

4. Eakins's first reviewer, William J. Clark, criticized this part of the painting as a "decided puzzle" in his review of April 28, 1876, in the Philadelphia *Evening Telegraph.* "The only objection to the picture that can well be made on technical grounds," Clark conceded near the end of his enthusiastic review, "is in the management of the figure of the patient. The idea of the artist has obviously been to obtrude this figure as little as possible, and in carrying out this idea he has foreshortened it to such an extent, and has so covered it up with the arms and hands of the assisting surgeons, that it is extremely difficult to make it out."

5. The surgical operation was specified in the catalogue of the exhibition of the Centennial as "an operation for the removal of dead bone from the femur of a child"; see "Report on the Participation of the War Department in the International Exhibition," in *Report of the U.S. Board on Behalf of U.S. Executive Departments at the International Exhibition*, 2 vols. (Washington, D.C., 1884), 137.

6. Although Clark wrote in his review in 1876 that all the participants were portraits of actual persons, even the witnesses in the audience, identifications were first made in print by Charles Frankenberger, "The Collection of Portraits Belonging to the College," *Jeffersonian* 17 (November 1915): 1–10; Frankenberger did not identify any members

of the audience. Ellwood C. Parry (in the *Jefferson Medical College Alumni Bulletin* 16 [June 1967]: 2–12 and the *Art Quarterly* 32 [Winter 1969]: 373–90) discusses the now somewhat obscure figure behind Gross. The obscurity today is due at least partially to the darkening of the paint and the consequent merging of the dark clothing of this figure with that of Gross; when the painting was just completed, the figure provoked no critical comment. The tasks in this particular operation make the obscured assistant essential.

7. Gross discusses his preference of chloroform at his clinics at Jefferson Medical College in his *System of Surgery: Pathological, Diagnostic, Therapeutic, and Operative*, 2 vols., 6th ed. (Philadelphia, 1882), 1: 559; and his typical assignments of tasks to assisting surgeons at 1: 486. For biographical and professional material on Hearn and on the anesthetist in Eakins's later surgical clinic, *The Agnew Clinic*, see J. E. Eckenhoff, "The anesthetists in Thomas Eakins's 'Clinics,'" *Anesthesiology* 26 (1965): 663–66.

8. In *System of Surgery*, 1: 489, Gross discusses the tourniquet that he used in order to assure that such surgery would be relatively bloodless.

9. In 1876 Clark identified the woman less specifically as "a female relative." In January 1918, in a memorial tribute in the *Art World*, "Thomas Eakins," p. 291, William Sartain identified her as the mother.

10. Clark described Eakins's intentions thus: "The picture being intended for a portrait of Dr. Gross, and not primarily as a representation of a clinic, the artist has taken a point of view sufficiently near to throw out of focus the accessories, and to necessitate the concentration of all his force on the most prominent figure." *Evening Telegraph*, April 18, 1876.

11. Edward Louis Bauer, *Doctors Made in America* (Philadelphia, 1963), 104, indicates that the amphitheater, torn down in 1877, seated six hundred students. Jefferson Medical College announcements, preserved in the National Library of Medicine, Bethesda, show surgical lectures and clinics to have taken place between 11 and 3; Gross, *System of Surgery*, 1: 487, specifying the best time for surgery as between 11 and 3, discusses the need for bright sunlight.

12. John Chalmers Da Costa, *Selections from the Papers and Speeches* (Philadelphia, 1931), discusses the operating arena and arrangements in "The Old Jefferson Hospital," pp. 204–19, and "Last Surgical Clinic in Old Jefferson Hospital," 334–52.

13. Alexander Stirling Calder, in *Thoughts on Art and Life* (New York, 1947), 6, reports that when he entered a competition in 1894 to execute a standing sculptural portrait of Gross, he went by Eakins's house to get negatives of the "very fine photographs of Dr. Gross [that Eakins had made] for his own use."

14. According to Clark, the audience was composed of "students and other lookers-on."

15. For a discussion of the medical emphasis at Central High School, with detail about the backgrounds and interests of Eakins's teachers, see Joseph S. Hepburn, "Medical Annals of the Central High School of Philadelphia with a Historical Sketch of Medical Education in Philadelphia," *Barnwell Bulletin* 18, no. 72 (October 1940). See Franklin Spencer Edmonds, *History of Central High School* (Philadelphia, 1902), 164–65, for the reminiscences of Eakins's fellow student T. Guilford Smith, who later became an industrialist, of his visits during his student years to the Philadelphia School of Anatomy (a private dissection facility) and to the hospital surgical clinics. Joseph Boggs Beale noted in his diary (at the Historical Society of Pennsylvania) that he and his

brother watched Gross's clinics (Oct. 15, 1864; also Nov. 5, 1864), and John C. Da Costa remembered his early years of dropping in to Jefferson's clinics before he had any idea of studying surgery ("Last Surgical Clinic," 339).

16. An earlier portrait that may have been a formal image, however, has been lost: at the Union League Art Reception of 1871 (where Max Schmitt exhibited *The Champion Single Sculls*), a work by Eakins entitled simply "Portrait" was exhibited by M. H. Messhert. Professor Rand retired from the Jefferson faculty in 1873 (disabled, unfortunately, by an accident in his chemical laboratory—see Bauer, *Doctors Made in America*, 153–54); Eakins perhaps painted the portrait as a retirement tribute. Rand accepted the portrait and later gave it to Jefferson.

17. Beale records that the class had 80 to 100 students, and that for some of the lectures Thomas met the class at a medical amphitheater (Diary, Jan. 16, 1861).

18. William C. Brownell, "The Art Schools of Philadelphia," *Scribner's Monthly* 18, no. 5 (September 1879): 745.

19. For examples of this hagiography, an international phenomenon, see Félix Guyon, "Eloge d'Auguste Nélaton," *Bulletin et mémoires de la Société de Paris* 2 (1876): 76–95; Francis Dowling, "Some of the Former Medical Giants of France," *Lancet-Clinic* (Cincinnati) 104 (1910): 604–13; and R. J. Mann, "Of Guillaume Dupuytren, Who Feared Nothing but Mediocrity," *Mayo Clinic Proceedings* 42, no. 12 (December 1977): 819–922.

20. The work most well known in Europe was that of the Quaker Benjamin Rush (1745–1813) in psychiatry, published in 1813. Particularly notable from Dr. Gross's point of view was the work by Casper Wistar (1760–1818) in anatomy and Philip Syng Physick (1768–1805) in surgery.

21. Austin Flint, address to the International Congress of Physicians and Surgeons, published in the *Philadelphia Medical Times* 6 (Sept. 16, 1876): 603.

22. E. B. Krumbhaar, in "Early Days of the American Journal of the Medical Sciences," *Medical Life* 36 (1929) 240–56, discusses the effect of the Edinburgh challenge (*Edinburgh Review* 33 [January–May, 1820]: 79–80).

23. For the American excitement with the new ways and the opportunities in Paris, see August K. Gardner, *Old Wine in New Bottles: or Spare Hours of a Student in Paris* (New York, 1848). *Galignani's New Paris Guide for 1868* (Paris, 1868), 131–33, stressed the open nature of hospitals and clinics for visitors.

24. F. Campbell Stewart, *Hospitals and Surgeons of Paris* (Philadelphia, 1843), 214–15. Among the Philadelphians who studied in Paris were Dr. Gross's own teacher at Jefferson, Thomas Dent Mütter, and William W. Keen, with whom Eakins worked as his demonstrator of anatomy.

25. Gross, *An inaugural address introductory to the course on surgery in the Jefferson Medical College of Philadelphia, delivered Oct. 17, 1856* (Philadelphia, 1856), 25, 30. The clinic in the form in which Gross and his contemporaries practiced it had been established in 1841.

26. *Inaugural address*, 31, 29. Da Costa, " Old Jefferson Hospital," 214.

27. See John S. Billings, "Literature and Institutions," in *A Century of American Medicine, 1776–1876*, ed. Edward H. Clarke (Philadelphia, 1876), 359. By 1876 Jeffer-

son had graduated 6,668 students, the University of Pennsylvania Medical School 8,845; the two schools led the country. Between 1850 and 1860 Jefferson graduated more students than the University of Pennsylvania, with a high point of 269 graduates in 1854. For comments by Gross, see *An address delivered before the Alumni Association of the Jefferson Medical College of Philadelphia, at its first anniversary, March 11, 1871* (Philadelphia, 1872), 9.

28. Gross, *Address*, 8.

29. Gross, *History of American Medical Literature from 1776 to the Present Time* (Philadelphia, 1876), 61.

30. Gross, *Autobiography*, 1: 160–61.

31. See H. E. Sigerist, "Surgery at the Time of the Introduction of Antisepsis," *Journal of the Missouri State Medical Association* 32 (May 1935): 169.

32. John Chalmers Da Costa discusses these clinics in "Old Jefferson Hospital," 204–91, and "Last Surgical Clinic," 334–52.

33. Gross, *Autobiography*, 1: 162.

34. Gross, *System of Surgery*, 1: 488.

35. These references may be found in the numerous reports of Gross's clinics published in the *North American Medico-Chirugical Review, 1856–1861*, and in the *Philadelphia Medical Times* in the 1870s. The manuscript clinic reports of John Roberts, "Reports of the Surgical Clinics of Professor S. D. Gross in the Jefferson Medical College, for the Term Commencing Oct. 6th, and Ending Dec. 30th, 1874," located at the College of Physicians of Philadelphia, are rich in historical references.

36. Gross, *Then and Now: A Discourse Introductory to the Forty-third Course of Lectures in the Jefferson Medical College of Philadelphia* (Philadelphia, 1867), 4.

37. Ibid., 18–19.

38. American medical literature, particularly, was dotted with such accusations. See *North American Medico-Chirugical Review* 1, no. 2 (March 1857): 316 and 211; and, for an English point of view, Samson Gamgee, "Present State of Surgery in Paris," *Lancet* (London) 1867: articles beginning on pp. 273, 295, 392, 483.

39. Acute osteomyelitis (derived from the roots "osteo" for bone, "myelon" for marrow, and "itis" for infection) resulted in necrosis or death of the diseased area. A discussion that places the treatment of osteomyelitis in historical perspective is Richard H. Meade, *An Introduction to the History of General Surgery* (Philadelphia, 1968), 34. For discussions contemporary with Gross, see Gross, *System of Surgery*.

40. "Observations on the Pathology and Treatment of Necrosis," in Nathan R. Smith, ed., *Medical and Surgical Memoirs by Nathan R. Smith* (Baltimore, 1831), 97–127. Gross praised Smith in his *Autobiography*, 2: 208–9; and in *History of American Medical Literature*, 35–36.

41. Gross, *The Anatomy, Physiology, and Diseases of the Bones and Joints* (Philadelphia, 1830). He discussed it in detail in his *Elements of Pathological Anatomy* (Boston, 1839); and then in *System of Surgery* (1859 and subsequent editions).

42. This may be ascertained by following clinic reports in the *Philadelphia Medical Times* and in the Jefferson Medical College archives (the archives record begins in 1877, with the opening of the new hospital).

43. *Philadelphia Medical Times* 2 (Dec. 7, 1872): 151–52.

44. Smith, *Medical Surgical Memoirs,* 120–21. The postoperative record for amputations, on the other hand, was grim: in his *System of Surgery* (1882), 546, Gross reported the calculation by James R. Lane that the mortality rate for 6,000 cases was 36.92 percent.

45. In reproduction, the image of *The Anatomy Lesson of Dr. Tulp* was well known to Philadelphians. It was printed on the graduation certificate of the Philadelphia School of Anatomy (one such certificate is filed in the Medical History section of the Library of the College of Physicians of Philadelphia); and Eakins's friend Will Sartain wrote his father from Paris that he thought Philadelphians would subscribe to another copy of the painting by Bonnat, who had just made one for the National Museum of Copies in Paris (Sartain Collection, Historical Society of Pennsylvania, Aug. 31, 1872).

46. The Centennial catalogue of the medical exhibition reads: "This room also contains . . . a painting of Prof. Samuel D. Gross, loaned for the Exhibition by that gentleman, viz: No. 15. An oil painting by Eakins, of Philadelphia, representing Professor Gross performing an operation for the removal of dead bone from the femur of a child, in the amphitheater of the Jefferson Medical College, No. 16. A small photograph of the same" ("Report on the Participation of the War Department in the International Exhibition," 137). Other medical portraits included those of Physick; and texts those of Gross and Paré; see "Report on the Participation," 214, 227, 229, and passim. It is a historical irony that Feyen-Perrin's *Anatomy Lesson of Dr. Velpeau* was exhibited at the Centennial—in the French section—apparently to no objections.

47. Nashville surgeon Paul F. Eve's address is recorded in the *Philadelphia Medical Times* 6 (Sept. 16, 1876): 607. The remark "America wields the sceptre" attained a certain currency: in his *Autobiography,* for instance, Gross reported that in 1868 the French surgeon Pierre Marie Chassaignac had told him that "America at this moment wields the surgical sceptre of the world" (1: 319). About the same time, J. E. Erichsen wrote the highly complimentary "Impressions of American Surgery," *Lancet* (London) 2 (1874): 717–20 (rpt. in Gert H. Brieger, ed., *Medical America in the Nineteenth Century* [Baltimore, 1972]).

48. *Philadelphia Press,* March 9, 1878.

49. The critic was William J. Clark, writing in the *Daily Evening Telegraph,* on March 8and April 28, 1876.

50. The New York papers the *Herald* and the *Tribune,* for example, reacted very negatively to the painting (March 8, 1879) when Eakins exhibited it there at the second annual exhibition of the Society of American Artists. See Gordon Hendricks, "Thomas Eakins's *Gross Clinic," Art Bulletin* 51 (March 1969) for quotations. In good-natured recognition of the "objectionable" aspects of the painting, some of Eakins's students parodied it in a tableau about 1876; a photograph of that parody, and another one of a spoof on an anatomy lecture, are in the collection of the Philadelphia Museum of Art. See Siegl, *Eakins Collection* for reproductions.

51. In fact, Gross was one of the last physicians of his scope and depth to advocate bloodletting, a procedure that many had abandoned decades earlier. Gross delivered a "discourse on bloodletting considered as a therapeutic agent" at the annual meeting of

the American Medical Association in Louisville, Kentucky, on May 5, 1875 (printed by Collins, 1875). Public interest in the rapid changes in surgery was notable. See W. W. Keen, "Recent Progress in Surgery," *Harper's New Monthly Magazine* 79 (October 1889): 703.

52. John Janvier Black, *Forty Years in the Medical Profession* (Philadelphia, 1900), 94.

53. Sanford C. Yager, "The Medical Profession," *Cincinnati Lancet and Observer* 9 (1866): 592–93.

12 Winslow Homer in His Art

Jules D. Prown

A work of art is a historical event. It is something that happened in the past. But unlike other historical events, a work of art continues to exist in the present; it can be reexperienced. As a surviving historical event, a work of art is primary evidence of both its time and place and the individual artist who created it. This suggests that by interpreting a work of art as a statement from the past we can learn something about both the culture and the individual artist who brought the work into being. This raises the old issue of intentionality—we can interpret a picture, but is our interpretation what the artist *intended* to say, or are we *misinterpreting*, misreading it, imposing our own ideas upon a mute, defenseless object? My contention is that a work of art consists of intended and unintended statements and is of interest both in what it intends to say and in what is conveyed unconsciously by its deeper structures. The problem is one of cultural perspective, the danger of imposing late twentieth-century values on an object created in another time and place. I believe that this problem can, to some extent, be put into perspective by adhering to a close analytical reading of the image, moving from objective description to deductions derived from empathetic engagement with the object, to creative speculation and interpretation in which our late twentieth-century perspective can become a scholarly advantage, permitting insights without distorting the objective data gathered earlier.[1]

In the case of artists who are closely attuned to their own cultures, works of art can be expressions of broad cultural belief. With an artist as idiosyncratic as Winslow Homer (1836–1910), the work of art seems more an expression of personal belief, of an individual psyche. As a result, a close analysis of Homer's

works tends to be less cultural art history and more intellectual and psycho art history than might be the case with other artists. Interpreting the content of works of art is standard art historical procedure. But, obviously, since most art historians, including myself, are not qualified psychoanalysts, psycho art history is highly speculative. Art historians *are*, however, skilled in reading visual evidence. Thus it is preferable to speculate in this direction, with plenty of caveats and a clear awareness of the dangers of overreading, than not to venture any interpretation at all.

The underlying argument of this essay, which focuses on Homer's painting *Life Line* (fig. 12.1), is that:

- Winslow Homer is deeply invested in his art, consciously *and* unconsciously;
- explication of the conscious or intentional elements in his works leads to an understanding of his philosophical stance, the substantial beliefs that inform his art;
- a reading of the unconscious elements leads to an understanding of Homer's psychological makeup; and, in the end,
- Homer's psychological makeup, which contained elements of which he was almost certainly not aware, contributed powerfully to the imagery through which his credo, his philosophy, was expressed.

When it was first exhibited at the National Academy of Design in 1884, *Life Line* was widely admired. Dating from a period in which Homer had become increasingly reclusive, the painting synthesizes a number of persistent, underlying themes that run through his early works and anticipates his late mythic images. In 1881 Homer settled in England, spending almost two years in the small fishing village of Cullercoats on the northeastern coast. On his return to America late in 1882, Homer, who had previously lived in New York, settled in a small studio in Prout's Neck, Maine, which served as his home for the rest of his life. In the summer of 1883 he visited Atlantic City, where he witnessed a demonstration of a breeches buoy. The breeches buoy in the painting results from that trip to Atlantic City; the cliffs in the background of the painting are at Prout's Neck.

Life Line represents a woman and a man dangling above a rough sea in a breeches buoy between a ship foundering on the rocks and a rocky shore. From a pulley riding on a hawser, four ropes are attached to a lifesaver from which suspended canvas breeches hold the man in a seated position. The woman sits on the front edge of the buoy, as if on the man's lap, but in fact separated from him by the lifesaver. His arms encircle her waist, as he is encircled by the lifesaver. The man's face is completely obscured by a fluttering scarf. On the left, the ship's sails flap in the gale, a rope lies limp in the water. On the right, tiny figures scurry along the top of the cliff; the rope beneath the hawser is taut.

Figure 12.1 Winslow Homer, *Life Line*, 1884. Oil on canvas, 28¾ × 44⅝ inches. Philadelphia Museum of Art, The George W. Elkins Collection.

A number of lines, especially diagonal, converge to form wedge shapes pointing to the center of the composition: the lines of the thick hawser and the thinner pull line meeting at the pulley; the ropes passing in front of the two figures; the intersection of woman's arm and torso; and the crossing of the trough of water rising from the lower left, the cresting waves on the left and right, and the top of the rocky cliff that descends from the upper right-hand corner. The composition is bisected by a vertical axis from the pulley through the rope to the woman's hand. Spatially, the left-hand side of the composition is open into the distance; recession on the right side is blocked by the cliff.

Color and value contrasts, as well as the converging lines, direct the viewer's eye to the center of the composition—not to the figures at first, but to the pulley above their heads, a small, dark triangle silhouetted against a white spume of spray. Our eye is subsequently attracted to the figures by the red scarf, the only brilliant area of color in a picture otherwise dominated by muted tones: mostly greens, occasionally touched with or moving into blue, and a few areas of brown and flesh color.

It can be inferred that the hawser on which the pulley rides is connected on the right side to the shore and on the left to the ship. On the shore, rescuers have detected the ship in distress, secured a breeches buoy to it, and are engaged in the rescue. We can deduce that the buoy is traveling from ship to shore

(left to right) by the drops of water hanging from the hawser to the right of the pulley, while to the left the hawser has been wrung dry by the pulley's passage; the taut pull line to the right, implying the presence of people on the shore; and the man's orientation, which is revealed by the configuration of his hat. The direction is also suggested visually by the shoreward swing of the central group and the drift of the red scarf.

The figures on shore rush around—anonymous, but there—not themselves immediately threatened, but engaged in the work of saving others. We do not know if there are people on the ship, but it is possible that someone assisted the girl into the lap of the rescuer. If there are people aboard the ship, they are, like the figures ashore, anonymous. Altogether, there is a cooperative enterprise of faceless people—those on the shore who sent out the buoy and haul the figures to safety, those who may remain on the boat and can retrieve the apparatus, and the man in the saddle whose face is obscured by the scarf. Only the woman's face can be seen and that is blank, expressionless, reflecting her numbed consciousness.

The two passengers have just been drenched by the breaking wave on the right, and will soon be doused again by the wave gathering on the left. One senses the effort of the pull from left to right as the people on shore haul against the weight of the breeches buoy, an interplay of force and resistance implied by the undertow that draws back beneath the breaking wave and past the man's right leg to gather itself into a new wave on the left. There is also a strong downward tug of gravity on the central figures suggested by the sag of the hawser, the suction of the water enveloping the man's leg, and the fall of the woman's right arm toward the water. The pulley is the focal point where these lateral and downward forces converge. Various lines and ropes indicate the intersecting forces, but equally important are the attachments and clasps that make the rescue work, that allow the pull to the right to overcome resistance and gravity: the hawser is anchored to ship and shore; the pulley sits on the hawser; the pull lines are tied to the eye of the pulley; a single clamp holds the pulley and the breeches buoy together; the man's body is supported by the breeches; his arms are wrapped around the woman's body. Every element depends on another; if a single part gives way, all is lost. Indeed, everything relies on the weakest link, and that probably is the human link: the man's hands clasped together supporting the woman's weight.

The same theme of interdependence marks several of Homer's early works, such as *Snap the Whip* (fig. 12.2). A frieze of boys with hands linked stretches across the picture surface and recedes into pictorial space, echoing the diagonal recession of the landscape. Several sturdy boys anchor the whip, intermediate figures run to build up speed, and two boys at the end of the chain tumble in the direction of the vanishing point toward two young girls, one of whom holds a

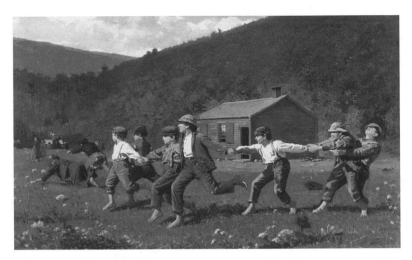

Figure 12.2 Winslow Homer, *Snap the Whip*, 1872. Oil on canvas, 22 × 36 inches. The Butler Institute of American Art, Youngstown, Ohio.

hoop. The object of the game, unlike *Life Line*, is to break connections. The field is dotted with wild flowers, but also with stones. The exhilaration of running and falling is spiced by the danger of the stones. The boys at play explore the physical world—centrifugal force, gravity, the limits of speed, the hurt of rocks. The game is only possible through cooperation, individuals joining together to achieve a desired result. There is joy in joining together, but there is also the thrill of breaking away, of flying off on one's own. The boys learn through experience and, symbolically in the game, those snapped from the whip are flung out of community, a playful "dry run" at growing up and going off on their own.

Community in Homer's iconography is, under normal circumstances, an aspect of the world of children. The reverse of the theme of interdependence, more frequently sounded in Homer's work, is that of isolation. Grown-ups, having left childhood behind, are dispossessed of fellowship; they are condemned to aloneness as part of the adult condition. Adults are isolated, even when in the company of others, as in *Eagle Head, Massachusetts* (also known as *High Tide*, 1870, Metropolitan Museum of Art), where the figures face in different directions like points on a compass. In *The Country School* (fig. 12.3) the composition is divided laterally into adult and children's zones at the window sill line. The teacher is isolated in the upper realm of the windows through which is glimpsed the outside world, which seems to divert her attention; the children's zone is subdivided on either side of the central axis of the teacher's body into boy and girl zones.

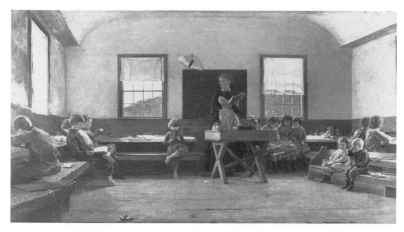

Figure 12.3 Winslow Homer, *The Country School,* 1871. Oil on canvas, 21⅜ × 38⅜ inches. St. Louis Art Museum, St. Louis, Mo., museum purchase.

Breezing Up (fig. 12.4) is a rare image in which an adult enjoys community by being privileged to join in the play, to recapture the joys and companionship of boyhood, the world of *Snap the Whip*. Even though there is no eye contact, as there is none in *Snap the Whip*, the man and three boys are linked together in the shared activity of harnessing the elements and controlling the forces of nature for their mutual pleasure. Wind fills the sail that the man in the red shirt holds fast with a line, controlling the powerful thrust and channeling it into the forward motion of the boat. The oldest boy in the stern similarly holds the rudder firm against the rush of the water to steer the boat, and all the figures lean the weight of their bodies against the heeling of the boat. They go as far as they dare in pressing sail and rudder against wind and water without capsizing the boat. The aim is to control the elements to achieve maximum speed and exhilaration, and it can only be done, as in *Snap the Whip*, through group effort, through community.

Another note struck in *Life Line* that recurs through Homer's work, like interdependence and isolation, is that of transition, of being in passage. In *The Morning Bell* (fig. 12.5) the isolated girl in red moves toward a dilapidated mill with broken windows on the left, away from a group of women whispering behind her back. She traverses a boardwalk with a flimsy handrail and a jerry-built support tacked to a pine tree above a muddy mill pond. The walkway leads toward an unknown brown area off to the left that seems less pleasant than the green realm filled with flowers in the right foreground. The metallic lunch pail in the girl's hand and the bell-like configuration of her skirt, with her feet forming a

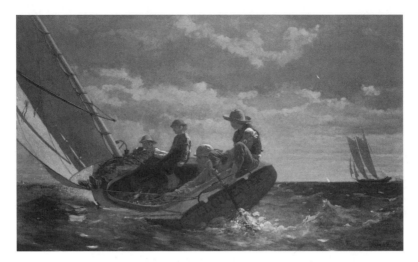

Figure 12.4 Winslow Homer, *Breezing Up (A Fair Wind),* 1876. Oil on canvas, 24⅛ × 38⅛ inches. Copyright 1997 Board of Trustees, National Gallery of Art, Washington, D.C., gift of the W. L. and May T. Mellon Foundation.

clapper, suggest an association with the swinging bell (beyond the ridge of the mill) whose peal must fill the air; her hat and the vertical line that passes through it from the rickety ramp in the foreground point toward a tiny bird flying above the forest. Her body moves toward the mill, but her thoughts seem to go off in another direction, seeking freedom, like the sound of the bell or the flight of the bird.

Word play suggests that *The Morning Bell* may be about a belle—a young girl—in mourning, which, even if only subconsciously, enhances a tone of sadness. She is in passage along a path like the balance on a transit beam; it is as if at some point the ramp will tip toward the mill. The composition is like *The See Saw* (ca. 1870, Canajoharie Library and Art Gallery, Canajoharie, New York), but there the world is the child's world of community and play. Tilting this way and that, there is danger, but it is controlled, a playful exploration, as in *Snap the Whip* and *Breezing Up,* of the realities of the physical world. It is playing in preparation for life. The boy will become a man, and in *The Morning Bell* the girl has become a woman. (As my colleague Bryan Wolf has suggested, *The Morning Bell* is about rites of passage and the uneasy aspects of growing up.)

In *Life Line* these themes of passage, interdependence or community, and isolation are addressed. The man and woman in transit are alone together, far removed from the tiny figures on the shore and from any who might remain on the ship. Their isolation is heightened by the veils of spray rising around them.

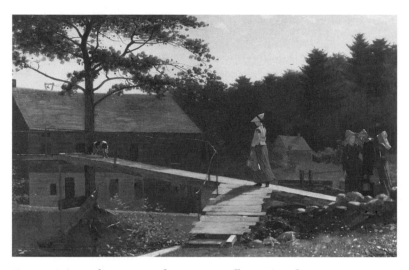

Figure 12.5 Winslow Homer, *The Morning Bell,* c. 1872. Oil on canvas, 24 × 38¼ inches. Yale University Art Gallery, bequest of Stephen Carlton Clark, B.A. 1903.

Moreover, despite the intertwining of their bodies, in certain ways each figure is alone. The man looks away toward the shore, his view of the woman obscured by the scarf. She swoons, her eyes closed; she cannot see him either. Even physical contact is obstructed by the lifesaver that separates them. And yet, despite their peril, despite their isolation, despite their limited perceptions, the clasped couple exudes an unexpected aura of sensuality and perhaps even a sense of physical pleasure as they rock to and fro together on their dangerous passage.[2]

Compositionally, the picture is divided like *The Country School* into two zones, here marked by gender rather than age, passive and slack to the left of the pulley, active and taut to the right, echoing the respective situations of the woman and man. To the left, the ship is helpless, battered by the wind and waves against the rocks, its loose sails and ropes fluttering; the retrieval line, descending in a graceful S-curve from the pulley, lies unused in the water; the water itself is a bland slate-green sheet; the woman's body hangs limp. To the right, the small figures on the cliff are active; the pulley is reeled in along the hawser by the taut pull line; the man in the breeches buoy holds fast to the insensate woman and kicks out his left leg to balance her weight; the water bubbles as the breakers hit the shore in front of the projecting cliffs. The man is tense, his body working in concert with the ropes, the pulley, and the breeches buoy to support the woman's weight and overcome the adversary forces of nature.

Although the woman is inert, semiconscious, lacking control over her own

body, she has some effect on the man, if only pictorially. Echoing the billowing sail of the helpless ship and the torn lower part of her dress that flutters beneath his left leg, the red scarf tied to the rope to signal the location of the breeches buoy seems to emanate from her bosom, indeed from the general area of her heart, crossing his face and obscuring it from view. The interplay of her open arms and closed legs with his enclosing arms and open legs unites the figures physically into a single fleshy unit. We see her face and also the full, almost voluptuous form of her body beneath the water-soaked dress. We do not see his face; he is anonymous. She is clamped in his grasp, her torso in his arms, her legs hanging down beneath his legs. Given the evident pull of gravity, he must feel the weight and perhaps even the warmth of her body, despite the intervening buoy. Gravity pulls her down between his legs; his left leg falls over her shredded dress that blows beneath it, echoing the encirclement of his arms around her body.

There are suggestive sexual elements present—vague in the case of the horizontal rock form thrusting out from shore between the rope and the hawser, or the explosion of the vertical spume from the valley of the waves that crash against the rocks, but quite explicit in the flash of her flesh between his legs as her skirt is slightly hitched up the downward slide of her body, or the exposed flesh of his clasped hands between her arm and torso, with his thumb thrust into her armpit.

The man is conscious of the woman, but concentrates on his work. She seems unconscious, yet her left hand firmly grasps the rope of the breeches buoy. Is she in fact completely insensate or does she feel the warmth and strength of the man, the support and rocking motion of the breeches buoy?

The primary movement in *Life Line* is lateral, along the plane established by the path of the pulley. There is, however, a strong intersecting movement into pictorial space suggested by the trough of the wave. It leads at the far end, behind the pulley, to the rising wraithlike cloud of spray where the wave smashes against the rocks. The action that takes place between us and the column of vapor is literally intermediary—we pass through it in the foreground to get to the background. This stimulates the kind of empathetic identification with the figures in which I have already indulged. Homer was the first to empathize, and it is difficult to avoid the suspicion that if we were to unveil the face hidden by the red scarf, we would find Winslow Homer. Sublimating his deep-seated desires, Winslow Homer, a lonesome man, a compulsive painter of women by the sea, seems to project in *Life Line* a fantasy in which he becomes intimately involved, literally wrapped up, with a woman, but in an altruistic, indeed heroic way. She is helpless and vulnerable, but he is a gentleman. In the same way, one

suspects that Homer identified with the similarly anonymous male in his *Croquet Scene* of 1866 (Art Institute of Chicago). Hidden by a circular brimmed hat and kneeling Sir Walter Raleigh–like before an elegant lady in red, the gentleman holds together two balls that are about to be thwacked by the lady's mallet. This image and its quite explicit sexual innuendoes have been sensitively explored by David Park Curry in *Winslow Homer: The Croquet Game*.[3]

In *Life Line* Homer seems to indulge in a schoolboy's fantasy that conflates heroism, damsel saving, and sex, a fantasy marked by a large measure of frustration. The hero is bound in by ropes, and the life buoy is an effective chastity belt; he can make contact only indirectly. If he jabs his thumb into her armpit, it is a venial pleasure as symptomatic of his frustration as of his desires. The scarf that hides his face seems to signify frustration at his inability to participate openly and fully, and perhaps a certain anxiety associated with women or sex as well. Homer suggests that the woman, too, may have her own sexual fantasy. Reflective of the compositional passivity of her half of the picture, her fantasy has overtones, however slight, of rape or violence forced upon her by an anonymous lover/ravager/savior. Despite her apparent swoon, she is not completely unconscious; she is grasping the rope, even suggestively, with her left hand. The latent sexuality of the scene is reinforced by the movement of the pulley slipping over the turgid hawser.

Sexuality is indirect in *Life Line*, rather "Victorian." Art historically, there is a tradition of the sexual imagery of the swing—all of that to-ing and fro-ing, that pleasurable rocking motion. Depictions of such prurient activity range from indirect titillation in scenes by Fragonard or Lancret,[4] with pull ropes on the swings being used like the pull lines in *Life Line*, to outright eroticism in the amorous illustrations of Thomas Rowlandson, where the suggestive backward and forward motion of the swing is significantly associated with the shoreline,[5] invoking the similar, metaphorically suggestive backward and forward motion of waves and undertow. *Life Line* is in the tradition of swing imagery and shares in its sexual implications.

The man and woman are between the ship and the shore; they are also between us and the spray in the background. First Homer then the viewer empathize with the figures who sway before our eyes in a perilous coupling. The interdependence we have noted within the composition in fact extends forward to include us. The figures in the picture have many sensations, which we experience empathetically, but they cannot see. The woman's eyes are closed; his appear blindfolded; at least he cannot see her—the blind Homer. But we can see the clear outline of her body, the bare flesh of her knee, his thumb in her armpit. They have sensations of touch, hearing, smell, and taste, which we can

experience only empathetically, but they cannot see. Only the viewer has sight and is required to complete the picture, to have all senses operating, to see the significance of what is happening.

The red scarf that glows dramatically against the drab, lifeless context of water, rock, and sky can be read as a flag of danger, an appropriate signal for the center of the picture. But red as a representation of blood is also a sign of life, of warmth and passion, a symbol of sensate living beings struggling against an inorganic natural threat. The couple dangles somewhere between a conscious world of danger and a subconscious world of sexuality. The evident theme of *Life Line* is the power of nature to threaten and extinguish life and the ability of individual human beings to pool their strength, experience, courage, intelligence, and ingenuity (in the form of the breeches buoy) to secure safety through cooperative effort. Homer's adult human beings are adrift in the universe; they are islands unto themselves. They represent the human predicament. The natural world in which they find themselves is neither benign nor malign—it is morally neutral. But when nature threatens man, the opportunity arises to connect with other people, to meet the challenge. This connectedness which, in Homer's paintings, children enjoy naturally in their engagement with the natural world through play but which adults have lost, can be retrieved by engaging the natural world in the face of danger. Danger in the adult world is more threatening than stones in a field or a capsized boat, more ominous. The note of danger is struck in *Life Line* not only by our reading of the situation but indirectly, viscerally, by such elements as the pulley silhouetted against the white vapor, its dark shape resembling a skull, with holes as eyes. Quite literally, everything depends on (or from) the pulley, and the pulley suggests death. But danger provides the opportunity for human beings to act in concert. In *Life Line* the woman needs the man, and they both need the people on shore in order for their lives to be saved.

When humans cooperate to save lives in a confrontation with nature, they establish their humanity. The humanism of interdependence is underlined by the exchange of human feelings, including sexual attraction. The act of saving is a human act. *Life Line* is about lifesaving, but it is also about a loftier kind of saving, about Salvation. In saving lives the rescuers effect physical salvation, and, by implication, perhaps spiritual salvation as well. The column of spume visually connects the sea with the sky, as the clasp connects the pulley with the breeches buoy. In the clasp, the force is a downward thrust to be contained; in the vapor, movement is upward and the connection is a passage, not a clasp. The rising cloud represents the transubstantiation of water into vapor, of liquid into gas, of sea into sky, of matter into spirit. The philosophical statement inherent in *Life Line* is that human effort to overcome the life-extinguishing threat of an indifferent universe, to save lives, represents a kind of salvation that is analogous to

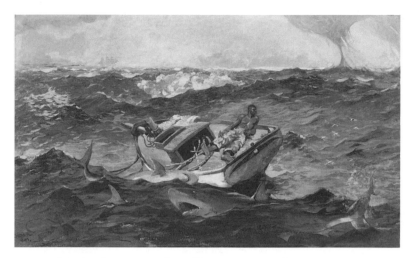

Figure 12.6 Winslow Homer, *The Gulf Stream,* 1899. Oil on canvas, 28⅛ × 49⅛ inches. Metropolitan Museum of Art, New York, Catharine Lorillard Wolfe Fund, 1906.

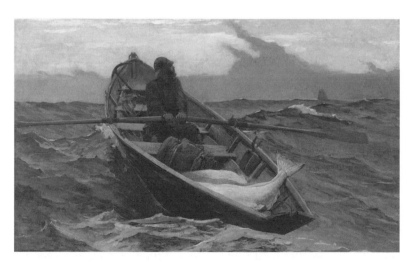

Figure 12.7 Winslow Homer, *The Fog Warning,* 1885. Oil on canvas, 30 × 48 inches. Courtesy of the Museum of Fine Arts, Boston, Otis Norcross Fund.

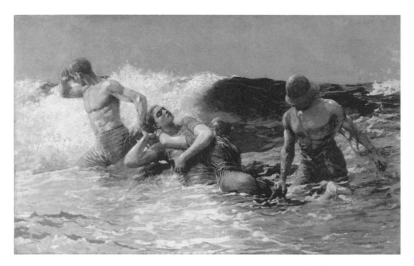

Figure 12.8 Winslow Homer, *Undertow*, 1886. Oil on canvas, 29¹³/₁₆ × 47⅝ inches. Sterling and Francine Clark Art Institute, Williamstown, Mass.

the form of salvation linking heaven and earth suggested by the rising spume. We, the viewers, add sight and bear witness to the human drama unfolding before us. We gain an understanding of the physical world and our relationship to it as vulnerable and mutually dependent human beings. But we also pass beyond the figures to the spray: literally, like the man in the breeches buoy, and figuratively, like the vapor cloud, we too have our feet in the water but our heads in the sky. We the viewers connect the material with the ethereal and are in passage from this world to the next. Homer's message is that salvation lies not in ignoring the natural world but in coming to grips with it as directly as possible.

In Homer's later paintings, darker in mood, there is less expression of the optimism of community and more emphasis on the loneliness of the human condition. And when a human connection is not available, as is the condition of the black in *The Gulf Stream* (fig. 12.6), all is lost. *The Gulf Stream* echoes the composition of the earlier *Breezing Up:* a boat points diagonally toward the left, but here no wind fills the sail; the mast is snapped and there is no sail; no rudder controls the direction of the boat, the rudder is gone; and there is no community, even of boys. Nature is in control here—water, waterspout, and sharks. The lack of eye contact that had simply injected a disconcerting and only slightly ominous note in Homer's early paintings becomes here disastrous missed vision as a boat on the horizon sails in one direction while the lone figure looks off in the other. This is a grim conclusion to imagery that began optimistically with

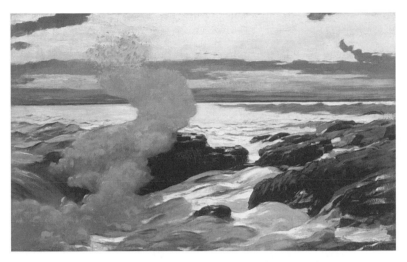

Figure 12.9 Winslow Homer, *West Point, Prout's Neck,* 1900. Oil on canvas, 30¹⁄₁₆ × 48¹⁄₈ inches. Sterling and Francine Clark Art Institute, Williamstown, Mass.

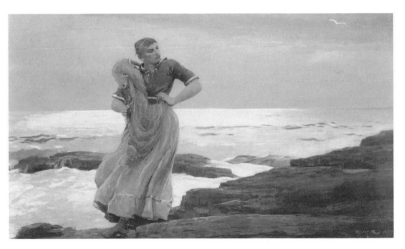

Figure 12.10 Winslow Homer, *A Light on the Sea,* 1897. Oil on canvas, 28¼ × 48¼ inches. Corcoran Gallery of Art, museum purchase, Gallery Fund.

Breezing Up in the mid 1870s and continued more seriously but still affirmatively with *The Fog Warning* (fig. 12.7) in the mid-1880s. Here, the fisherman is alone in his similarly placed dory. The fog is rolling toward him, but he has firm control of the oars and his boat, and as he looks over his shoulder he makes visual contact with his mother ship—community and safety are there.

There may seem to be a disparity between the small, personal, psychosexual expressions manifest in a painting like *Life Line* and Homer's larger expressions of philosophical or religious belief. But these aspects of his work seem intimately connected. Homer was an inveterate painter of women by the edge of the sea. He seems to have identified women with the sea in some deeply felt, mythic way. In *Undertow* (fig. 12.8), another image of connectedness and salvation, his women are hardly mermaids; they may not emerge from the sea exactly like Venus: they are cast up by the sea like the girl in his early wood engraving *The Wreck of the Atlantic* (*Harper's Weekly,* April 26, 1873). Homer's women seem to emanate from the sea like the spray from waves crashing on rocks. The sexual implications of the motion of the waves, and that conjunction of water and rock of which the two halves of *Life Line* stand as a virtual emblem—soft and slack on the female side, taut and active on the male—are echoed in *Undertow,* where the soft curves of the sculptural female bodies contrast with the angularity and the oddly military pose of the almost marching and saluting muscled figure on the left who is hauling his catch from the sea while a wave crashes into foam behind him. There are sexual implications here, as there are in *Life Line,* where, as wave crashes against rock, the explosion of the spray behind the two figures is almost ejaculatory. For Homer this imagery seems not carnal but a dramatic moment of epiphany, a celebration of the life force.

Repeatedly, Homer produced images in which a woman or women are prominently placed in the foreground in juxtaposition with the sea and, increasingly in later works such as *West Point, Prout's Neck* (fig. 12.9), there are complementary images of the sea in which the same prominent compositional role in the foreground is played by the rising spume. Ultimately they become fused, as in *A Light on the Sea* (fig. 12.10): the women take on the sinuous form of rising spume, and the spume, a symbol of transubstantiation, of matter become spirit, seems to become an abstract incarnation of the female principle. There is a complex conflation of women, water, sexuality, and salvation in Homer's late works.

I have tried to suggest here some of the larger implications of Homer's art, but these are only suggestions, not proofs. It seems certain that Homer's paintings are informed by a deep investment of the artists' own psychological makeup in the creation of imagery that embodies larger statements about the nature of

the human condition, including ruminations on themes of isolation and community, life and death, matter and spirit, and the transitions that connect or mark a passage from one state to the other. A close reading of the paintings suggests these meanings, but it also suggests that much work remains to be done in order to explicate the deeper meanings of Winslow Homer's art.

Notes

This is a revised version of an essay first published in *Smithsonian Studies in American Art* 1 (Spring 1987): 30–45.

My thoughts about Winslow Homer have been sharpened over the years through discussions in seminars with students and colleagues. I am especially indebted to David Lubin and Bryan Wolf.

1. For a more extended discussion of this procedure and the theory behind it, see Jules D. Prown, "Mind in Matter: An Introduction to Material Culture Theory and Practice," *Winterthur Portfolio* 17, no. 1 (Spring 1982): 1–19.

2. The sensuality of the image was noted even at the time of the painting's first exhibition. A critic in the *New York Times* wrote on April 5, 1884. "She is a buxom lassie. . . . Mr. Homer . . . has done the very unusual thing of uniting cleverness of conception and good composition with a sensuousness, a feeling for physical beauty in the woman's form." Quoted in Gordon Hendricks, *The Life and Works of Winslow Homer* (New York, 1979), 175–77.

3. David Park Curry, *Winslow Homer: The Croquet Game* (New Haven, 1984).

4. See Donald Posner, "The Swinging Women of Watteau and Fragonard," *Art Bulletin* 64 (March 1982): 75–88.

5. Gert Schiff, Introduction, *The Amorous Illustrations of Thomas Rowlandson* (n.p., 1969), pl. 17.

13 Mary Cassatt: Painter of Women and Children

Griselda Pollock

With almost no exceptions . . . she only painted one subject: children, and the role she gave in the majority of her canvases to the mother of the baby was ordinarily a secondary role in order to define the emotional intention and to emphasize by means of dark or light touches of costume or by means of the justness of her movement the general, overall harmony. *Achille Segard*

In summing up Miss Cassatt's complete works, there are . . . more portraits and figure studies of women than of mothers and children. It is only because of her unique approach to the maternity theme that she is known primarily as a painter of mothers and children. *Adelyn Breeskin*

After all a woman's vocation in life is to bear children. *Mary Cassatt, 1926*

Mary is at work again, intent on fame and money she says. . . . After all a woman who is not married is lucky if she has a decided love for work of any kind and the more absorbing the better. *Mrs. Cassatt, the artist's mother, to Alexander Cassatt, the artist's brother, July 23, 1891*

Mary Cassatt was both a woman painter and a painter of women. What this means and how she came to concentrate on portrayals of women are not easily explained. A glance at the first two extracts quoted above suffices to show the differences of opinion between even her most diligent and sympathetic biographers. The last two quotations place the problem in its precise historical context, for they are typical expressions of late nineteenth-century ideas about women that Cassatt herself seems to have accepted, while contradicting them by her activity as a professional, dedicated, and independent artist.

Mary Cassatt was born on May 22, 1844, in Allegheny, near Pittsburgh, Pennsylvania, the second daughter and fourth surviving child of the solid upper-middle-class family of Mr. and Mrs. Robert Simpson Cassatt. Her father was a stockbroker, with a respectable position, a comfortable income, and a passion for moving from house to house, town to country, continent to continent, and inevitably up the social scale. Her mother also came from a long-established

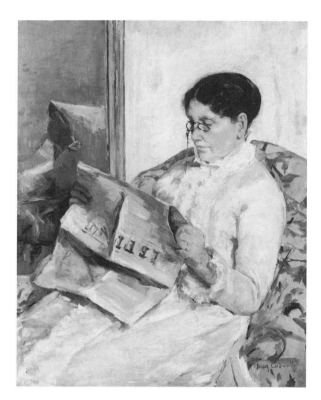

Figure 13.1 Mary Cassatt, *Reading "Le Figaro,"* c. 1878. Oil on canvas, 39½ × 32 inches. Private collection, Washington, D.C.

Pennsylvanian family and had an exceptionally fine education. She spoke French fluently and was extraordinarily well read. The portrait of her by Cassatt, *Reading "Le Figaro"* of about 1878 (fig. 13.1), is an unusual if not unique image for a mother, for Mrs. Cassatt is shown seriously engaged in an intellectual pursuit that invites comparison not with the traditional iconography of women or mothers but rather with portraits of intellectuals, for instance of eighteenth-century philosophers. In other ways, this portrait can be compared to Cézanne's portrait of his father reading *L'Evènement* (1866, National Gallery of Art, Washington), although the difference of parental sex underlines the novelty of Cassatt's imagery. In her memoirs Louisine Havemeyer, a lifelong friend of Cassatt, paid tribute to Mrs. Cassatt when she wrote: "Anyone who had the privilege of knowing Mary Cassatt's mother would know at once that it was from her and her alone that [Mary] inherited her ability. In my day, she was not young [but] she was still powerfully intelligent, executive and masterful and yet with that sense of duty and tender sympathy that she had transmitted of her daughter."[1]

Cassatt therefore had close at hand a model of intelligence and accomplishment in her mother, which seems to pervade her presentations of women, who

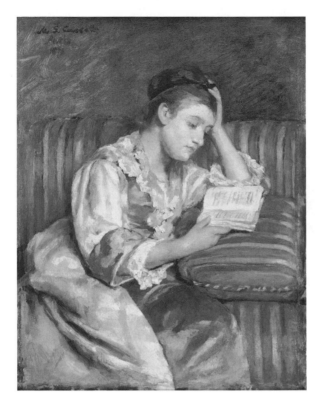

Figure 13.2 Mary Cassatt, *Mrs. Duffee Seated on a Striped Sofa,* 1876. Oil on wood panel, 13¾ × 10½ inches. Courtesy of the Museum of Fine Arts, Boston, bequest of John T. Spaulding.

are often shown reading. The painting *Mrs. Duffee Seated on a Striped Sofa* of 1876 (fig. 13.2) is one of the earliest of these and shows her debt to the old masters she studied so intensively in her youth. Fragonard comes to mind, with the eighteenth-century connotations of elegance of dress and casualness of pose. Cassatt's images of women reading soon lost their obvious dependence on old master sources and in 1877 she painted *The Reader* (Collection of Electra B. McDowell, New York), in which the book itself gains prominence, being placed firmly in the hands of the absorbed young woman, creating a kind of barrier between the spectator and the sitter, admonishing the viewer to maintain a respectful distance, silence, and quietude appropriate to the subject of the work. The theme reappears in portraits of the artist's sister, *Lydia Reading the Morning Paper* of 1878 (Joslyn Art Museum, Omaha) and *Lydia Reading in a Garden* of 1880 (Art Institute of Chicago), in which the figurine in profile, self-absorbed in mental activity, is turned completely away from the viewer, while the newspaper she reads proclaims distinct flavor of the modernity so precious to the impressionists.

The radical implications of self-absorption and sustained activity in portrayals of middle-class women cannot be sufficiently emphasized, for it was the lack of undisturbed time that so impeded the majority of women from attaining any degree of professional competence. Florence Nightingale, an older contemporary of Mary Cassatt, railed against women's oppressive lot in her essay "Cassandra," where she discussed the "odd times" that middle-class women could work undisturbed: "Women dream a great sphere of steady not sketchy benevolence. . . . For how do people exercise their moral activity now? We visit, we teach, we talk 'among the poor.' How different would be the heart for work, how different would be the success if we learnt our work as a serious study and followed it up as a profession. If a man were to follow up his profession or occupation at odd times, how would he do it? . . . Women themselves acknowledge that they are inferior in every occupation to men. Is it surprising? They do everything at 'odd times.'"[2]

Cassatt's reading women contain a very personal element verging on the autobiographical. She was herself very well read and well informed, a fact that her father proudly reported to Alexander Cassatt in a letter of December 13, 1878: "I suppose you saw that the Boston people gave Mame a silver medal. I believe she was the only woman among the silver medals. Her circle amongst artists and literary people is certainly extending and she enjoys a reputation among them not only as an artist but also for literary taste and knowledge, which moreover she deserves for she is uncommonly well-read especially in French literature."[3] However, reading and its creative counterpart, writing, were in the nineteenth century slightly more accessible to a middle-class woman than the professional practice of the visual arts. Virginia Woolf describes Jane Austen writing in her drawing room, hiding her manuscripts under the blotter when the inevitable visitors claimed her attention. One cannot conceive such possibilities for the painter.

The girl, the unmarried sister, the married woman, and the mother—the models for the paintings discussed so far—are presented without any concern to emphasize the social roles so important in nineteenth-century society. Instead, these early paintings are unified by the recurring images of self-contained and mental activities in which women were engaged—reading books and newspapers, and studying prints. These features constitute the fundamental theme of Cassatt's oeuvre. Women in her paintings rarely look out of the picture or meet the gaze of the viewer; they are absorbed in their own activities. This is even more remarkable in those subjects that reflect the more commonplace occupations of the bourgeoisie, such as crocheting, embroidering, knitting, and taking tea and visiting, which form the major part of Cassatt's work in her early maturity, from the mid-1870s to the mid-1880s.

One other activity of the middle-class woman's life that took her outside the home was theatergoing, a motif that often attracted Cassatt as it had her new friends in the impressionist circle. Impressionist iconography was deeply influenced by the call for painters of modern life made by writers throughout the nineteenth century, but most famously by the poet Charles Baudelaire, who published a seminal essay in 1863 entitled "The Painter of Modern Life." The novelty of the life of a large city, with its fashionable and artificial high society jostling depths of degradation and ugliness, called on painters to record for posterity its particular character and demanded new styles to capture the essence of modernity. Manet, Degas, and Renoir turned to public entertainments for inspiration, where the glitter of fashion shone under the artificial lights of the theater.

From 1872 on Cassatt regularly exhibited in the Salon portraits of fashionable women or figure studies, whose distinctive Spanish flavor and bold brushwork suggest a debt to the art of Edouard Manet. At the Salon of 1874 she showed a *Portrait of Mme. Cortier* (private collection), which elicited from Edgar Degas the admiring comment, "C'est vrai. Voilà quelqu'un qui sent comme moi" ("It is real [true, genuine]. There is someone who feels as I do"). In 1877 Degas was introduced to Cassatt by Léon Tourny, who had met her in 1873 in Antwerp, where they were both studying the art of Rubens. At this meeting Degas invited Cassatt to join the independent exhibiting society that had been founded in 1874 and whose members had become popularly known as the impressionists. In 1913 Cassatt told her biographer of her response: "It was at that moment that Degas persuaded me to send no more to the Salon and to exhibit with his friends in the group of impressionists. I accepted with joy. At last I could work with complete independence without concerning myself with the eventual judgement of a jury. I already knew who were my true masters. I admired Manet, Courbet and Degas. I hated conventional art. I began to live."[4]

Cassatt first exhibited in 1879 with this group, which was renamed "Un Groupe des Artistes Indépendants, Réalistes et Impressionistes" (A Group of Independent, Realist, and Impressionist Artists), showing two works, *The Cup of Tea* of 1879 (Metropolitan Museum of Art, New York) and *Lydia in a Loge, Wearing a Pearl Necklace* of 1879 (fig. 13.3). The latter's bright and luminous color and fluent brushwork, with its quintessentially modern subject, placed her immediately well within the impressionist group and compositionally recalls *The Loge* (Courtauld Institute, London), which Pierre-August Renoir had sent to the First Impressionist Exhibition. *Lydia in a Loge*, one of her first paintings set in a theater, is, however, unsatisfactory in many ways, despite the seductive sureness of her brushwork and dazzling treatment of the pale, transparent flesh tones. Renoir's painting is successful because there is an underlying identity

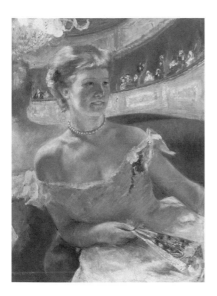

Figure 13.3 Mary Cassatt, *Lydia in a Loge, Wearing a Pearl Necklace,* 1879. Oil on canvas, 31⅜ × 23 inches. Philadelphia Museum of Art, bequest of Charlotte Dorrance Wright.

between the subject, the spectacle in the theater that the woman is watching, and the image, the spectacle the woman herself offers to the appreciative viewer outside the painting. In Cassatt's painting there are contradictions, for instance between the lack of engagement of the woman with the spectator, through the shading of her face and the direction of her gaze, and the sensuous treatment of pink silk and pearly skin to which we are drawn by the liveliness of the brushwork.

A pastel portrait entitled *Lydia Leaning on Her Arms, Seated in a Loge* of about 1879 (fig. 13.4), possibly related to the oil, is, however, a far more coherent image, with fewer distractions and inconsistencies. The mirror here reflects only the back of the figure, complementing the frontal view and creating a sense of the figure's wholeness. There is an overall material consistency in the web of pastel strokes, unifying all the textures and features, while the immediate and psychological activity of the attentive woman is conveyed by the pose, Lydia leaning forward on her arms and clasping her hands, which underlines the direction of her gaze out of the picture and away from the viewer. The display of a woman as a spectacle gives way and instead private mental activity dictates the meaning and unity of the painting, as in the series of pictures of women readers.

The strongest and wittiest of Cassatt's series of loge scenes, in which her original contribution to this motif is most apparent, is *In the Loge* of 1880 (fig. 13.5). The black figure in the foreground serves as a *repoussoir* into the auditorium, where the smaller figures, also dressed in black, punctuate the surface and link back to the young woman with her opera glasses. But as one follows the direc-

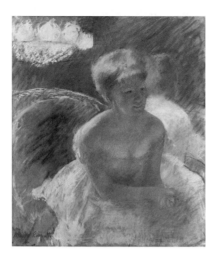

Figure 13.4 Mary Cassatt, *Lydia Leaning on Her Arms, Seated in a Loge*, c. 1879. Pastel on paper, 21⅝ × 17¾ inches. The Nelson-Atkins Museum of Art, Kansas City, Mo., acquired through the generosity of an anonymous donor.

tion of her gaze through them to look across the surface of the painting, one notices a man leaning prominently out of his box to train his opera glasses on her. The idea of woman as spectacle and viewer as spectator, which is implicit in Renoir's *The Loge* and which I suggest Cassatt's series begins to question, is made explicit in this work by inscribing a male viewer into the painting itself, while the woman is sublimely unaware of the fact that she is the object of his gaze, for her own consciousness is powerfully asserted in pictorial terms by her coloristic dominance and her structurally decisive pose at a right angle both to the male spectator within and to the viewer outside the painting.

Cassatt did not ignore the traditional attributes of femininity, of costume and fashion located in the drawing room, the secluded garden, or the loge of a public theater. Rather, she transformed them by marrying to the iconography of woman—both historical and in contemporary art, with its play on external accessories and sensual charms—the intellectual or rather inner world of thoughtful reflection and subjective identity, traditionally reserved for representations of men.

In Cassatt's work there are no more than a mere handful of portraits or figure studies of men. Apart from six portraits and sketches of her father and ten of her closest brother, Alexander, there are only three realized male portraits—an oil, *Portrait of Marcellin Desboutins* of 1879 (private collection), and two pastels, *Portrait of Moyse Dreyfus* of 1879 (Petit Palais, Paris) and *Portrait of M. O. de S.* of about 1909 (private collection)—as well as a few odd sketches. One simple explanation for this vast disproportion is that social convention made it unsuitable for a woman to be alone in a studio with a male model, except, of course, when the man in question was a close family relative, which explains the greater

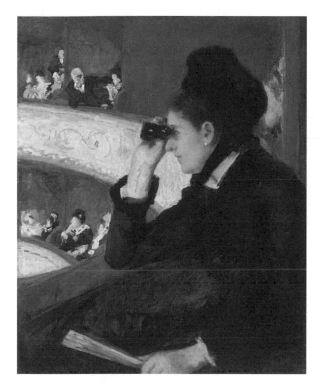

Figure 13.5 Mary Cassatt, *In the Loge*, 1880. Oil on canvas, 32 × 26 inches. Courtesy of the Museum of Fine Arts, Boston, The Hayden Collection.

number of portraits of her father and brother. Furthermore, most woman artists were denied access, on account of propriety and decency, to the male nude except in plaster casts and thus had little sound knowledge of the male figure. Cassatt's contemporary and fellow Pennsylvanian Thomas Eakins was dismissed from the staff of the Pennsylvania Academy of the Fine Arts, where Cassatt herself had studied between 1861 and 1865, for removing the loin cloth from the male model during a mixed anatomy lecture. Yet the fact that the portraits of Desboutins and Dreyfus were both painted in 1879, when Cassatt worked in her own studio outside the family home, suggests that these conventions could in fact be overcome.

It has been argued that the small number of male subjects in her works resulted from her inability to portray a man with the conviction she conveyed in images of her own sex. To some extent the pictures themselves support such an assertion, for they are often incomplete and wooden, but the relative insignificance of her male *portraits* is due more, perhaps, to the fact that she was not primarily a portraitist but a figure painter. In her figure studies that include men no lack of force can be observed. The 1873 *Toreador* (Art Institute of Chicago) is such an image, with strong color contrasts of red tie and cape and the blue and

silver embroidered jacket, while for unrelieved boldness, physical strength, and truth-to-type, the image of the boatman in *The Boating Party* of 1893–94 (National Gallery of Art, Washington) is unmatched, with the clear contours and vigorously painted face in *profil perdu* (hidden profile).

The lack of representation of men in Cassatt's oeuvre can be viewed from yet another perspective. <u>Her sex and her class placed firm restrictions on her knowledge of the world of men.</u> Despite some friendships with artists like Edgar Degas and familiarity with her retired father or visiting brothers, she lived apart from any close or daily contact with the worlds that men of her class occupied in the public spheres of business, the professions, or government, and she was absolutely cut off from the lower haunts of men of all classes in the streets of Paris and in its cafés and brothels.

But despite these very real and too often unrecognized limitations on a woman's experience of the world in which men passed so freely, there is a positive side to this particular coin, for Cassatt knew the world of women, the drawing room, and childbearing as few men in that period could have done, a dimension perceptively recognized in 1881 by the contemporary critic J.-K. Huysmans: "For the first time thanks to Miss Cassatt, I have seen the likenesses of ravishing children, quiet bourgeois scenes painted with a delicate and charming tenderness. Furthermore, only a woman can paint infancy. There is a special feeling that a man cannot achieve . . . only a woman can pose a child, dress it, adjust pins without pricking themselves. . . . This is family life painted with distinction and with love. . . . She achieves something none of our painters could express—the happy contentment, the quiet friendliness, of an interior."[5] Behind Huysmans' effusion lurks a sentimental tendency and the seeds of the disease of the "special category" for womanly subjects and for woman artists that has distorted their work and reputation. But it does contain a grain of truth. Cassatt knew the "bourgeois interior" and rarely presumed to paint what her class or sex determined that she should not know, a fidelity to the experience of class and sex not shared by the majority of male artists.

If the adult male is conspicuously absent from Cassatt's oeuvre, small boys and male infants are clearly not, for the male occurs as often as the female in Cassatt's representations of childhood. However, it would seem that Cassatt did not really emphasize sexual differentiation in the very young. The very young child not only seems to function in Cassatt's work as a miniature version of adult masculine or feminine roles but can also be read as a symbol or an analogy for the art of painting itself.

Cassatt's treatment of the child and mother elicited this comment from an early biographer, Edith Valerio (1930): "Mary Cassatt was not married, she was never a mother, and yet, there are few women painters, and scarcely any men,

who have interpreted maternity and early childhood in a language so authentic, so right, so accurate and so moving. She understood and expressed those beauties whose meanings are obscured from most mothers. The gestures, the movements which characterize earliest childhood, this slow discovery of self, of these faculties that are still untested by the world around it, Mary Cassatt rendered with unequalled charm."[6]

That charm has often obscured the more rigorous and truthful observations Cassatt made of the process of personal development as the immature, dependent, and physically undeveloped baby progresses toward becoming a separate and self-conscious individual. Max Raphael, in an essay "The Struggle to Understand Art," makes a statement on the nature of art which suggests that creative activity concerns a similar process of becoming: "It is the nature of the creative mind to dissolve seemingly solid things and to transform the world as it is into a world in process of *becoming* and *creating*."[7] Cassatt was, as Valerio pointed out, neither wife nor mother, despite her own assertion late in life that these roles were women's vocation. She was a painter, creating cultural artifacts instead of performing the procreative act. Yet as one of the main themes of her creative work she turned to the image of mother and child, the epitome of the vocation she had forsworn, which is also the moment of new lives and new identities, states of becoming and creating which her evolution as an artist in her paintings and her activities paralleled in the cultural rather than natural or biological sphere. In doing so, she radically transformed the theme of maternity.

This image, so deeply rooted in Western culture in its traditional form of Madonna and child, evolved slowly in Cassatt's oeuvre. Indeed, she may never have consciously perceived the full implications of what she produced. However, her participation in the Independent movement after 1879, with its programmatic search for thoroughly modern subjects and a novel style of painting to convey modern sensibility, provided the necessary impulse for such a departure from tradition. Both Segard and Breeskin emphasize the central importance of mother-and-child paintings, which have become her most famous motif. That may further account for her neglect, for one asks cynically how a painter of apparently so familiar a subject, so traditional a theme, who repeatedly reworked the motif in the second half of her career, could bear comparison with the radical innovations of Degas, Manet, or Toulouse-Lautrec, who brought absolutely new subjects into the history of painting. However, Cassatt's mothers and children illustrate superbly the two-sided coin of women's art. Although she was restricted by social conventions to models from the life of bourgeois women and children around her, she nonetheless used the everyday happenings of family life to forge her most significant achievement, a new image of women.

One of Cassatt's earliest recorded paintings is a pastel of about 1868, *Two*

Children at a Window (private collection), which shows a brother and sister locked in a supportive embrace, gazing out of a window into a luminous beyond. The symmetry and interlocking arms of the children cause the boy and girl to fuse into a single mass silhouetted against the light, which disguises the importance of their different sexes. But as the foreground space opens out, the masculine and feminine separate. On the right, behind the little girl, a doll lies in a small cot, while on the boy's side of the room there is a large, adult-sized desk and chair, as disproportionately large as the cot and doll are miniature. Yet the children turn their backs on the symbols of their likely future roles and look to something outside the homely room.

Cassatt herself looked beyond the domestic role that was a probable destiny for any woman of the period, and especially for a Pennsylvanian lady of good family and reasonable fortune. Instead, at sixteen, she decided to study art seriously. Painting was, however, one of the acceptable and indeed desirable "accomplishments" of middle-class women, as innumerable novels, texts on women's education, and the vast number of amateur women painters amply document. A Mrs. Ellis, a prolific writer on the subject of women's roles and duties, sounded a warning, however, in her popular *Family Monitor and Domestic Guide* against pursuing any "accomplishment" further than social necessity demanded: "It must not be supposed that the writer is one who would advocate, as essential to woman, any extraordinary degree of intellectual attainment, especially if confined to one particular branch of study. . . . To be able to do a great many things tolerably well, is of infinitely more value to a woman than to be able to excel in any one. By the former, she may render herself generally useful; by the latter she may dazzle for an hour."[8]

Cassatt did not heed such advice to develop her interests only to a limited and altruistic degree. Instead, she enrolled, apparently against her father's wishes, in the Pennsylvania Academy of the Fine Arts, Philadelphia, where she remained from 1861 until 1865, when she set off for Europe to follow her male and female colleagues to Paris to study the techniques of the old masters, who were so poorly represented in the United States. Even then Cassatt had a firm conviction of her seriousness, which she light-heartedly explained, while on a sketching tour in France, to her more conventional sister-in-law in a letter of August 1, 1869: "I am here with my friend Miss Gordon from Philadelphia and we are roughing it most artistically. . . . [Aix-les-Bains] was too gay for two poor painters, at least for one, for although my friend calls herself a painter, she is only an amateur, and you know how we professionals despise amateurs."[9]

The outbreak of hostilities between France and Prussia in 1870 obliged her to return briefly to Philadelphia, but as soon as that war and the subsequent civil war in France of 1871–72 were over, she sailed for Italy. In Parma, she concentrated

her attention on two masters of the theme of Madonna and child, Correggio and Parmigianino. The style of Correggio, a native of Parma, anticipated the Baroque and is said to have influenced eighteenth-century French art, which can be cited as a source for French impressionism. From Correggio, Cassatt learned to admire both solid draftsmanship of true line and the luminous and suggestive color that the Italian artist had combined in moving but sophisticated compositions of the Madonna and child. In Parmigianino's Madonnas and children she studied complex compositions of elongated figures in elegant poses.

Cassatt's study of Correggio and Parmigianino was complemented by a sojourn in Spain in 1873. In Seville and Madrid she looked at the work of Velázquez and in Madrid she also studied Rubens, seeing more of his pictures during a trip to Antwerp. Rubens's lush Madonnas and chubby children provided yet another confirmation of her interest in this type of composition, while Velázquez's treatment of children in, for instance, *Las Meniñas* (Museo del Prado, Madrid) explores a quite different aspect which Cassatt later developed: the juxtaposition of childishness and adult artifice.

After an initial interest in children in her paintings of the late 1860s and early 1870s, Cassatt turned to figure paintings of mature women in scenes from modern life. A visit to Paris in 1880 by her brother Alexander with his young family provided an opportunity to study and paint children from life. It may also have reawakened in her memories of what she had learned from the old masters in her travels through Europe earlier in the decade, knowledge that she had put aside to study and work with contemporary masters such as Courbet, Manet, and Degas. One of her first renderings of the mother-and-child motif was executed in 1880, *Mother about to Wash Her Sleepy Child* (fig. 13.6), in which some of the many threads of her career came together—childhood and womanhood and the stylistic influence both of the old masters and of the new avant garde.

The child sprawls loose-limbed on the mother's broad lap but is held firmly in place. The direction of its body forms an opposing diagonal to the pose of the almost massive mother, who is contained by the solid frontal rectangle of the chair which her right arm breaks into, while the frame in turn cuts across her arm, preventing any simple symmetrical reading of the painting. The opposing postures of the figures' bodies are counterbalanced by the closeness of their heads and the interlocking gaze of mother and child, which, significantly, breaks with the usual self-containment and self-absorption of Cassatt's female figures. The mother's gaze, which is so often turned away from the spectator in Cassatt's pictures, is here directed toward her offspring, whose overwhelming sleepiness is subtly conveyed by the vagueness with which the paint was applied to its face.

The breadth of handling, the large areas of white touched with blue, yellow, and pink, so beloved by the impressionists as a demonstration of their theories

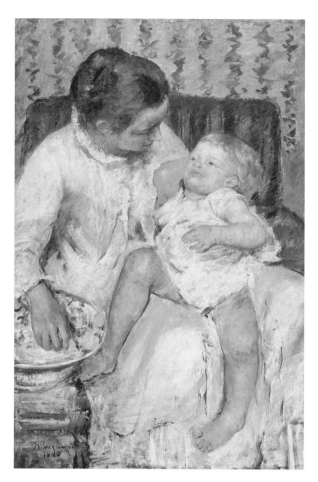

Figure 13.6 Mary Cassatt, *Mother about to Wash Her Sleepy Child,* 1880. Oil on canvas, 39½ × 25¾ inches. Los Angeles County Museum of Art, gift of Mrs. Fred Hathaway Bixby Request.

of reflected and mutually modifying colors, the Rubenesque carmine outlines of the figures still apparent beneath the layers of paint, and the directional brushwork more often associated with her contemporaries, here achieve a stylistic synthesis. Furthermore, the dynamic but monumental composition can be compared to Cézanne's portraits of Madame Cézanne; for instance, *Mme. Cézanne with a Fan* of 1879–82 (collection of Emile Bührle, Zurich). Cassatt admired Cézanne very early and brought his paintings, but he is rarely mentioned in relation to her work. Yet the comparison is illuminating. In her images of mothers and children, Cassatt used solid, balanced structures and insistent physicality of paint to capture what is most elusive, the most momentary glance, gesture, or movement. This synthesis of the immediate and the instantaneous with the permanent and the monumental, which Cézanne sought to achieve in painting the

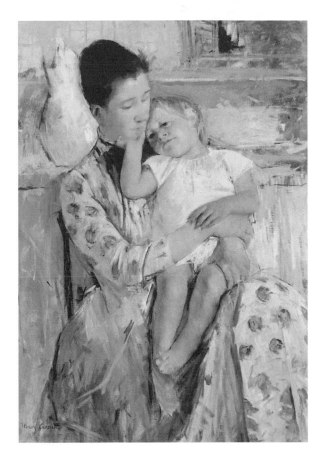

Figure 13.7 Mary Cassatt, *Emmie and Her Child,* 1889. Oil on canvas, 35⅜ × 25⅜ inches. Wichita Art Museum, Wichita, Kan., The Roland P. Murdock Collection.

infinite variations of nature's constantly changing appearance, can be found in this early rendering of a child's daily bath.

In a painting of 1889, *Emmie and Her Child* (fig. 13.7), Cassatt initiated her great phase of treatments of the maternal theme, a subject which she had only infrequently reworked in the intervening decade. Close dependence and security are conveyed by the binding gestures of the hands. Here mother and child do not look at each other, but are linked by the physical bond created by the child's hand on the mother's face while she firmly grasps its small limb. The unfinished state of the canvas provides an opportunity to study Cassatt's working method. Over a warm beige ground, broad areas of color were laid, moving from dark to light, a technique associated with old master processes. The dress, which in is completed parts is white with a red pattern, was painted over a layer of unexpected blue, a color that gives resonance to all colors affected by it, while

touches of red with its characteristic warmth and liveliness suggest a thorough study of Rubens's procedures in particular. But in the contrast of the unfinished and the completed parts of the child's legs, the transition from a chaos of color and arbitrary brushstrokes to fully modeled and realized form can be observed, a transition that unconsciously inscribes into the painting the process of life, both in terms of physical development and of the more psychological passage from the unformed immaturity of the infant to a distinct, separate, and conscious individual.

The physical closeness of the child itself to its mother is contrasted with the look of private reverie as it caresses its mother's face. That gesture recurs in a pastel of 1891, A Caress (fig. 13.8). Cassatt caught a rarely portrayed moment, a child's first intuitions of separateness from its mother as it reaches out to examine her as an object distinct from itself. With penetrating insight and sure mastery of her medium and composition, she simply and convincingly painted a crucial moment in a child's development, in its becoming a separate person while still profoundly dependent both emotionally and physically; a state that is represented pictorially by the languid and lolling pose of the infant in the lap of the mother, whose large adult hand tenderly holds his pale, soft-skinned foot.

The nude and clearly male baby with its mother, its plump healthiness and her charming sweetness, focus attention on the question of these images as a secular and contemporary form of Madonna and child. Degas' reaction to the oil painting The Oval Mirror (Metropolitan Museum of Art, New York) was reported by Cassatt to Mrs. Havemeyer: "When he saw my Boy Before a Mirror he said to Durand-Ruel 'Where is she? I must see her at once. It is the greatest painting of the century.' When I saw him he went over all the details of the picture with me and expressed great admiration for it, and then, as if regretting what he had said, he relentlessly added, 'It has all your qualities and all your faults—it is the Infant Jesus with his English nurse.'" Indeed, the structure of the painting comes closest to the religious compositions of Parmigianino. Achille Segard went so far as to suggest the alternative title The Adoration for the exquisite pastel After the Bath (Cleveland Museum of Art), but in the complex articulation of the three figures across the frieze-like composition it is the structure of a Parmigianino mother-and-child painting that is suggested rather than the underlying ideology.

Any profound association with Christian tradition is negated by the important fact that Cassatt as often painted mothers and daughters, a subject that has no prototype in religious iconography but looks back to the eighteenth century, when the distinctly secular and bourgeois celebration of family life and domestic happiness was elaborated as a subject both by figure painters like Greuze in

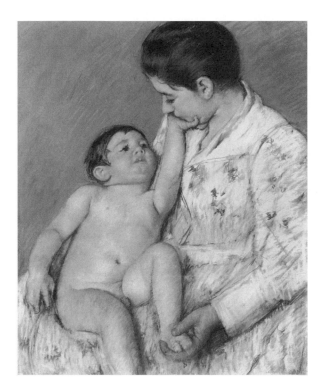

Figure 13.8 Mary Cassatt, *The Caress,* 1891. Pastel on paper, 30 × 24 inches. New Britain Museum of American Art, New Britain, Conn., Harriet Russell Stanley Fund. Photograph, E. Irving Blomstrann.

The Beloved Mother of 1795 (De Laborde collection, Paris) and by portraits, a fine and relevant example of which is Elisabeth Vigée-Lebrun's *Portrait of the Artist and Her Daughter* of 1789 (Louvre, Paris). Some of Cassatt's pastels of mothers and daughters, such as *Marie Looking up at Her Mother* (Metropolitan Museum of Art, New York) and *Pensive Marie Kissed by Her Mother* (Philadelphia Museum of Art), both of 1897, do have a touch of that sweetness and intimate charm characteristic of the eighteenth century, and of Vigée-Lebrun in particular, but one should not underestimate the undeniable, if at times uncomfortable, appeal of such pastels, which in many ways faithfully convey conventional notions of the sweetness of the ideal little girl.

The common notion that Cassatt reworked the religiously symbolic icon of Madonna and child can be replaced by the idea that she used the child and its parent to express, instead, a sense of the phases of family life. This becomes clearer when considering the series of paintings and drawings of girls executed in the 1870s and 1880s. In the pastel of about 1868, *Two Children at a Window,* a little girl is set beside her cot and dolls, an association that is made explicit in a drawing of 1876, *Little Girl Holding a Doll* (private collection). A painting of her

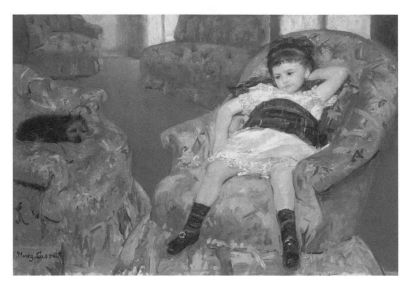

Figure 13.9 Mary Cassatt, *Girl in a Blue Armchair*, 1878. Oil on canvas, 35 ×
51 inches. National Gallery of Art, Washington, D.C., Collection of Mr. and
Mrs. Paul Mellon.

impressionist period, *Girl in a Blue Armchair* (fig. 13.9), presents a completely
novel and honest treatment of the ungainliness of a child, culled from obser-
vation of young children and incorporating the expressive innovations of com-
position to which Degas' work introduced Cassatt in the 1870s. Indeed, Degas
actually worked on this painting, as Cassatt later told the dealer Ambroise Vollard:
"I did it in '78 or '79. It was the portrait of a child of a friend of M. Degas. I had
done the child in the armchair and he found it good and advised me on the
background and even worked on it. I sent it to the American section of the Ex-
position [1878], they refused it. . . . I was furious, all the more so, since he had
worked on it." [10]

In the painting, one is precipitated abruptly into the space because the frame
cuts off the lower edges of the armchairs, but one views the room from a high
viewpoint, so that the upper limits of the frame also cut off the tops of the back-
ground sofas. Such devices indeed owe much to Degas, but here they function
to create a pictorial structure that conveys incompleteness, awkwardness, and
disproportions of scale, notably in the menacing fullness of the furnishings in
this compacted space, all of which correspond with the treatment of the child
herself, who sprawls languidly and inelegantly on the chair, while her smart
outfit and bored expression reflect Cassatt's grasp of her character. The picture

is not only of a child, but its perspective and scale suggest a child's own view. Cassatt thus achieved a complete identity between the meaning of the work and the pictorial means themselves.

The reconsideration of the theme of mothers and children exposes the central theme of Cassatt's oeuvre as phases of womanhood. Cassatt thus produced a series in which the artist examined what might be called the seven ages of women: infancy, childhood, adolescence, young womanhood, maturity, and old age, a cycle that begins again with maternity, which thus has a central place within the sequence. But it would be a mistake to see such a series as purely abstract or philosophical exercise, for, as I have tried to show, the forces that condition the nature of the phases of women's lives, which Cassatt as a middle-class woman of her time knew well, are of social and psychosocial origin. As Simone de Beauvoir wrote in *The Second Sex:* "One is not born, but rather *becomes* a woman. No biological, psychological or economic fate determines the figure the human female presents in society; it is civilization as a whole that produces this creature . . . which is described as feminine."[11]

One final painting, executed around 1905 and entitled simply *Mother and Child* (fig. 13.10), brings together all the threads of Cassatt's program as an artist and the stylistic means developed within the impressionist and postimpressionist periods of French art in order to reveal that process. It is a picture of enormous complexity and internal oppositions, which synthesizes the elements of the vocabulary of forms and meanings Cassatt had evolved throughout her career before encroaching blindness incapacitated her painting.

In this painting the mother in her fashionable finery is opposed to the unadorned nudity of her daughter. The nude had been one of the most important forms of classical, renaissance and postrenaissance art, and knowledge of anatomy, on which the painting of the nude is based, was a prerequisite for any artist who aspired to the serious pursuit of the most elevated and respected form of high art, the history painting. However, by the mid-nineteenth century the conviction of classical art dissipated and Charles Baudelaire, the theorist of "modernity," had argued, in "The Painter of Modern Life" (1863), for new treatments of the human figure that would show it nude only in places and positions in which it was so to be found in actual life—for instance, in bed or bath. As a woman, Cassatt was in no position to study the nude in either a classical or contemporary form. Nonetheless, she seems to have found a way by turning to the infant nude, with its even more taxing problems of conveying implicit anatomical structure beneath the overlay of immature fleshiness and undeveloped physique. In *Mother and Child* the image of the nude child after a bath, which Cassatt had so often portrayed in the 1890s, is infinitely more serious and

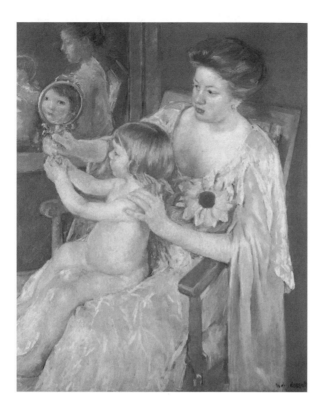

Figure 13.10 Mary Cassatt, *Mother and Child,* c. 1905. Oil on canvas, 36¼ × 29 inches. National Gallery of Art, Washington, D.C., Chester Dale Collection.

monumental by virtue of its explicit juxtaposition with the clothed adult, which creates once again the polarities of innocence and freedom opposed to artifice and convention.

A further layer of meaning is suggested by the mirror, a device that Cassatt, like Degas and Manet, had used so frequently to elaborate the spatial organization of a painting or to include the spectator by reflecting the space in which the viewer stands. However, in this work the mirror's shape echoes within the picture that which the frame of the painting itself presents to the viewer. This device, while referring to the reflective, looking-glass idea of painting, actually subverts the idea of a picture as a reflection of reality by explicitly including within the painting a mirror that offers another view of the same subject on the reflection of its plane. The mirror, possibly derived from Japanese prints, also recalls the use the old masters made of the device, and a particular link can be established between the nude and the mirror, on the one hand, and Velázquez, whose *Rokeby Venus* (National Gallery, London) springs to mind. This reference points to another iconographic tradition, that of Vanity, traditionally represented by a nude woman gazing at her own reflection in a mirror. In using the nude and

the mirror, Cassatt again profoundly transformed yet another of the long-standing images of women in European iconography.

The mother, dressed in garments that befit her class and age, holds out a mirror to her nude daughter, who looks away from the viewer, as do so many of Cassatt's women, and gazes at her own reflection in the mirror. I have previously discussed how Cassatt perceived and captured in paintings those ephemeral but truly significant moments in a child's development toward a sense of its own personal identity. Jacques Lacan has elaborated the psychoanalytic theory of infantile psychological development by introducing "the mirror phase." At this stage the child perceives its own reflection in a mirror and inevitably can only recognize that novel image as Other than itself. A child which has hitherto experienced itself only as a part of the world around it, and specifically as a part of its mother, sees itself as separate for the first time. In the subtle and puzzled expression seen in the small mirror, this painting seems an unwitting document of this decisive phase.

However, the image that is reflected in the mirror is neither consistent in perspective nor truthful as a mirror image. Such an inaccurate effect can also be found in Japanese prints. The effect of this distortion is twofold. It presents the viewer more directly with the reflected image, thus breaking the hermetic quality typical of Cassatt's faces and suggesting a greater involvement of the artist herself. Second, it gives the mirror image the appearance of a miniature, of the close-up snapshot portrait. In this way the *smaller* mirror acts as a commentary on the nature of painting.

Furthermore, although the mirror phase is experienced by children of both sexes, it is of particular relevance to the female child, whose notion of self in our society is much more narcissistically related to how she appears, how she is seen. As John Berger has written in *Ways of Seeing*, "men act and women appear":

> To be born a woman has been to be born within an allotted space, into
> the keeping of men. The social presence of women has developed as a re-
> sult of their ingenuity in living under such tutelage within such a limited
> space. But this has been at the cost of a woman's self being split into two.
> A woman must continually watch herself. She is almost continually ac-
> companied by her own image of herself. . . . And so she comes to con-
> sider the *surveyor* and the *surveyed* within herself as two constituent yet
> always distinct elements of her identity as a woman. . . . One might sim-
> plify this by saying: *men act* and *women appear.* Men look at women.
> Women watch themselves being looked at. This determines not only
> most relations between men and women but also the relation of women
> to themselves. The surveyor of woman in herself is male: the surveyed fe-

male. Thus she turns herself into an object—and most particularly an object of vision: a sight.[12]

As a woman painter, Cassatt herself surveyed, observed, analyzed, and studied the world in which she was confined. As a painter of women she slowly constructed a body of works depicting women in all the ages and phases of their well-bred lives, which radically questions that very notion of women as spectacle, as an *object* of vision, by the way in which she averted the gaze of her women from the viewer and turned their attention to their own invisible, *subjective* world, by commenting ironically on the spectacle of art in her loge pictures, such as *In the Loge* (see fig. 13.5), or by making women viewers only of their own children and miniature selves, as in the mother-and-child themes. In this late great work, *Mother and Child,* the radical implications of her work are most manifest, for she confronted the issue with absolute fidelity to both psychological and social reality, by juxtaposing the immature and presocial nude child with the future that lies before her and by presenting her fashionably dressed mother in the act of initiating her own daughter into the place in society which she herself occupies and which is her daughter's future. This rich image resulted from Cassatt's profound study of the old masters and of tradition, and from her familiarity with the call for "modernity" and stylistic innovations of contemporary art. It is clear, therefore, that her female gender and her involvement with impressionism are inseparable elements in her considerable achievements as an artist.

The two main concerns of this essay, to explain her success and her subsequent neglect, are thus also intimately related. Because she was a woman artist she has been overlooked or looked down on. But it is the very fact that she was woman that accounts for her vision and the underlying thematic unity of her work.

Notes

This essay is excerpted from the author's book *Mary Cassatt* (London, 1980). Locations are provided for paintings that were illustrated in the original but are not reproduced here.

The first epigraph is from Achille Segard, *Un peintre des enfants et des mères—Mary Cassatt* (Paris, 1913), 127. The second is from Adelyn Breeskin, *Mary Cassatt: A Catalogue Raisonné of the Oils, Pastels, Watercolors and Drawings* (Washington, 1970), 15. The third epigraph is quoted in John Bullard, *Mary Cassatt: Oils and Pastels* (New York, 1972), 11. The fourth is Mrs. Cassatt, the artist's mother, to Alexander Cassatt, the artist's brother, July 23, 1891, quoted in Nancy Moull Mathews, ed., *Cassatt and Her Circle: Selected Letters* (New York, 1984), 222.

1. Louisine Havemeyer, *Sixteen to Sixty: Memoirs of a Collector* (1961; rpt. New York, 1993), 272.

2. Florence Nightingale, "Cassandra," in Ray Strachey, *The Cause: A Short History of the Women's Movement in Great Britain* (1928; rpt. London, 1978), 405–6.

3. Robert Cassatt to Alexander Cassatt, Dec. 18, 1878, quoted in Nancy Moull Mathews, ed., *Cassatt and Her Circle: Selected Letters* (New York, 1984), 143.

4. Segard, *Peintre*, 7–8.

5. Quoted in Nancy Hale, *Mary Cassatt* (New York, 1975), 103–4.

6. Edith Valerio, *Mary Cassatt* (Paris, 1930, 6 (author's translation).

7. May Raphael, "The Struggle to Understand Art," in *The Demands of Art* (London, 1969), 199 (italics added).

8. Mrs. Ellis, "The Daughters of England: Their Positions in Society, Character and Responsibilities," in *The Family Monitor and Domestic Guide* (New York, 1844), 35.

9. Mary Cassatt to Maria Lois Buchanan, Aug. 1, 1869, quoted in Mathews, *Cassatt and Her Circle,* 61.

10. Quoted by Frederick Sweet, *Miss Mary Cassatt: Impressionist from Pennsylvania* (Norman, Okla., 1966), 29.

11. Simone de Beauvoir, *The Second Sex* (London, 1972), 9 (italics added).

12. John Berger, *Ways of Seeing* (London, 1972), 46–47.

14 Image and Ideology: New York in the Photographer's Eye

Alan Trachtenberg

At the turn of the twentieth century, New York witnessed early symptoms of the extraordinary transformation that, by the 1920s, would alter not only the appearance but the eco-political character of the urban place, its very character as "city." The moment was not lost on alert contemporaries, many of whom perceived change in several realms—in both physical and social space, for example—often without recognizing the symptomatic character of those denser crowds, sprawling peripheries, the emergent babel of tongues, without, that is, necessarily perceiving change as anti-urban in character. A pervasive image of formlessness is detectable, and a desire (often represented as a nostalgia) for order—a lament, in short, that harbored a program for positive change.[1] And what I want especially to stress and to investigate here are the ties between political and aesthetic images of order, ties between images of *polis* and of art that formed a key nexus in the intellectualist culture of the Progressive Era. I focus particularly upon the medium of photography, upon the efforts of notable practitioners to make pictures of contemporary New York—that is, to find in photography itself a principle of picturing and thus ordering urban life. I want to examine, in short, the participation of photographers in the "search for order" that characterizes the general culture of the era.

The ordering principle of photography lay ostensibly in the physical properties of the medium itself, its apparent transparency and immediacy of representation. But in fact I want to consider photographic images less as illustrations of the look of things at a particular time, and more as interpretations and projections, as pictures fraught with ideology. That is, decisions that may seem wholly

technical or aesthetic—choosing a point of view, a certain lens, a specific for-
mat, a mode of printing and of displaying (exhibiting or publishing) the image—
are decisions that implicate cultural perception and ideological determination.
Photographs, then, can be taken along with all other cultural productions as
texts, as embodiments of implicit propositions concerning reality. As Allan
Sekula writes, "A photograph communicates by means of its association with
some hidden or implied text . . . a system of hidden linguistic propositions."[2]
Taken as a dense network that in its entirety proclaims and delineates the very
terrain of the social, such propositions or proposals of the real can be said to pro-
vide the ideology of the culture—"to render," in Clifford Geertz's words, "oth-
erwise incomprehensible social situations meaningful, to so construe them as
to make it possible to act purposively within them."[3] Ideologies are therefore
"maps of problematic social reality and matrices for the creation of collective
conscience." And in light of such definitions we might begin by taking turn-of-
the-century photographers and cartographers of the *problematic* of New York,
of its collective mind as well as its increasingly distended shape.

Indeed, that the place itself, the very site of the city, had become problematic
is itself a chief proposition in the culture of New York from, say, the 1890s to
World War I. We apprehend elements of this proposition (and of its ideological
charge) throughout public discourse in the period. Adna Weber, for example,
struck a common chord in his *The Growth of Cities in the Nineteenth Century*
(1899); his very attempt to find a statistical basis for the definition of "city" pre-
supposes a crisis of meaning. Older definitions of the city, he observes, assumed
a stable relation between town and country; the modern process of "concentra-
tion" has radically disrupted those relations, playing havoc with definitions. Now,
Weber writes with some lament, "it is not altogether easy to define the distin-
guishing characteristics of a city."[4] This increasing invisibility, or illegibility, of
"city" within the urban place, thus emerges for Weber, and for turn-of-the-
century social science in general, as a prime cultural predicament at the base of
the new industrial society. The intense (and the process seemed to be gaining
momentum) concentration of industrial and financial power, the explosive spe-
cialization of functions and services and the concomitant fragmentation of ur-
ban spaces, the new mechanical systems of transportation, communication, and
coordination, and the hardening of social divisions, abetted by spreading ethnic
differences (the "other half" consisted chiefly of immigrant populations) all
seem to hold a threat without precedent, a threat to stability of ideas and feel-
ings as well as of the polity and social order.

Social science sought formulations that might serve as intellectual instruments
of guidance and control. Pragmatism itself, especially John Dewey's instru-
mentalist version of the philosophical movement, can be taken as a calculated

response to a crisis of value and meaning in the public domain. For members of groups who felt their once secure position of power (cultural as well as political) eroding, the situation seemed even more desperate and the threat more totalistic. Helplessness before what are perceived as abstract forces governing human society and destiny increasingly colors Henry Adams's thinking in these watershed years, and his *Education of Henry Adams* (1907) concludes with an image of New York just as potent as that of the dynamo as a trope for a cultural condition: "The outline of the city had become frantic in its effort to explain something that defied meaning. Power seemed to have outgrown its servitude and to have asserted its freedom. The cylinder had exploded, and thrown great masses of stone and steam against the sky. The city had the air and movement of hysteria, and the citizens were crying, in every accent of anger and alarm, that the new forces must at any cost be brought under control."[5]

Indeed, in these years the skyscraper emerged not only as the most distinctive feature of the new urban place, but as a phenomenon that typified the entire process of change, of challenge to traditional forms of building and also of explanation. Henry James underscored the tall building's role as a sign of the predominance of cultural values above all others. In *The American Scene* (1907), he speaks of the "multitudinous skyscrapers" as resembling "extravagant pins in a cushion already overplanted."[6] Representing all that is crude and vulgar in the new American terrain, they are "giants of the mere market," "crowned not only with no history, but with no credible possibility of time for history, and consecrated by no uses save the commercial at any cost." At the same time, and perhaps the ultimate mark of their arrogant appropriation of the new American scene, the "vast money-making structures" are capable of "quite horribly, quite romantically" justifying themselves, "looming through the weather with an insolent cliff-like sublimity."

It was clear that the tall building—thrown up as if by the blind, irresistible forces of the city—had become the emblem of urban confusion, of defiance of traditional meanings and controls. Writing in *Scribner's* in 1909 on "the evolution of the skyscraper" (the term *evolution* implying, with not a small degree of irony, an organic growth), the noted architectural critic Montgomery Schuyler spoke, like James, of "monuments of mere utility," whose "ultimate motive," disclosed "after the veneer of masonry had fallen from them and they were left to assert themselves in their original crudity and starkness," was nothing more or less than "faith in the dollar" and "fear of the hell of not making money."[7] Adams's skyline that defied meaning was for Schuyler quite unmistakably explicable as a sign of competitive individualism rampant. "'Commodity,'" Schuyler observes, "in the crowded centres of great cities, is as strikingly subserved by those towering structures as comity is defied." The skyscrapers represent, then,

a central issue for the entire society: shall "commodity" prevail over "comity?" Schuyler imagined a future, "not so far off, in which the multiplication and magnification of the skyscrapers will become plainly incompatible with the well-being of the communities in which individual interest is permitted to override public interest." Clearly, he concluded, although without a specific plan, "the new commercial Babels" must be brought under some superior control, for the sake of comity and the coherence of public life. Thus the new cityscape, and the sky-scraper, its most prominent emblem, provided a focus for those persisting questions of control and meaning that plagued growing numbers of Americans in these crucial years.

The cultural setting can be understood, then, as a monument in the history of what Richard Morse has called the "decomposition of the city-idea," an auspi-cious event for modernity throughout the urbanized world. The context defines itself by those visual protrusions and alterations in familiar space represented by the skyscraper, and also by those individual changes in social relations also typified by the unseen interiors, and the new forms of nonproductive labor per-formed therein. Within this setting, then, appears the man with a camera.

In March 1903, *Scribner's Magazine* featured an essay by the popular jour-nalist John Corbin entitled "The Twentieth-Century City," with "illustrations from photographs by Alfred Stieglitz." The essay argues that although American city life may well seem crude, even "grotesque," to those raised on images of European grandeur, all that is needed is the transforming eye of an artist: "What our American cities most need to render them beautiful is an artist who will body forth to our duller eyes the beauties already there."[8] Such indeed is the ex-ample intended by the inclusion of the Stieglitz illustrations—thirteen pictures, one of which adorns each page of the article. Each image represents a familiar place or scene in New York: horse-drawn cabs waiting for fares at Madison Square, the Astoria Hotel viewed in the distance down a street of fashionable brownstones, people on a bench in Battery Park. Some of the pictures have become famous in the Stieglitz canon, and thus monuments of modern photog-raphy: *Waiting for a Fare—Madison Square* (fig. 14.1), for example, and *The Hand of Man*. Already established as a public spokesman for "pictorial photog-raphy," a movement that sought recognition for the fine art capabilities of the medium, Stieglitz had been photographing on the streets of New York with a hand-held camera for about a decade. Reproductions of his work had appeared quite regularly in photographic journals, but this was the first, and uncharacter-istic, appearance of a significant number of reproductions before a general read-ing public. The event calls for particular attention, if only because it provides an opportunity to see a group of Stieglitz's city pictures as part of a larger text, an essay on the city as an opportunity for art, precisely at a particular juncture

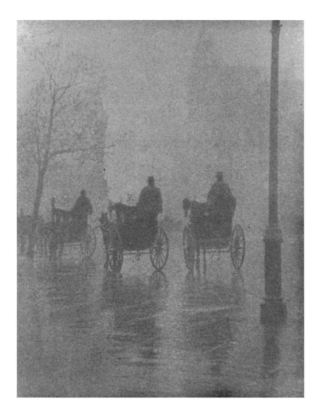

Figure 14.1 Alfred Stieglitz, *Waiting for a Fare—Madison Square*, 1902. Reproduced in John Corbin, "The Twentieth-Century City," *Scribner's* 33 (March 1903): 260.

when the very concept of "city" seemed to be eroding. Thus although the pictures, in their atmospheric tones and hues, their pleasures in wet streets and hazy vistas, may seem innocent of any ideas—let alone ideologies—their inclusion within the article inevitably implicates them in the text as participants in its message and meaning.

The message, that the apparent disorder and "crudeness" of New York can be subdued by the ordering and picturing eye of the artist, can be better grasped as a cultural program addressed to a particular sector of the reading public if it is seen as part of a more general view of New York proposed by *Scribner's* (see, for example, fig. 14.2; other publications would yield similar findings: see figs. 14.3 and 14.4) in these years. Several essays on the appearance and form of the city appeared in the turn-of-the-century period, each illustrated (by drawings or photographs), and each emphasizing a common theme: The city must be explored to be appreciated. Each attempts to excite a pride of place, especially by favorable comparison with European cities. With titles such as "Landmarks of Manhattan" (November 1895), "The Water-Front of New York" (October 1899), "The Walk Up-Town in New York" (January 1900), and "The Cross Streets of

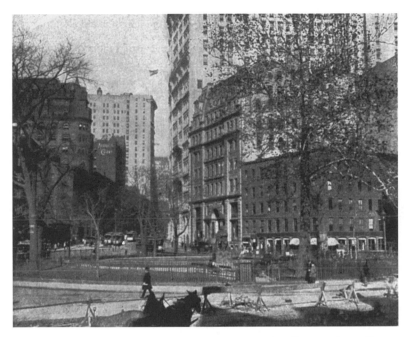

Figure 14.2 Photographer unknown. From Jesse Lynch Williams, "The Walk Up-Town," in *Scribner's* 27 (January 1900): 45.

New York" (November 1900), these essays provide a revealing setting for the Corbin-Stieglitz collaboration of 1903, particularly in their use of the mode of the tour, the descriptive account, supported by graphic illustrations, of a movement through city space. Each argues that the reader need not travel abroad in order to experience the so-called picturesque. Even among the notorious "material manifestations" of the New World City—the tall building being the most prominent among such manifestations—there is much that is "good to look at": the constantly changing lights, tones, and tints, for instance, in the "spectacular scene" from Brooklyn Bridge; the casual walk up-town that is "full of variety, color, charm, exhilaration." For the flaneur, these writings insist, New York surpasses even Paris and London. Here one encounters in the streets spectacles of the casual, the accidental, against the backdrop of the most elegant of modern buildings.

Corbin takes much the same tack in his text, only making the underlying assumptions even more explicit. For what this kind of periodical city-writing assumes is that the urban place has now become a showplace of opportunities for visual experience, for the experience especially of tints and tones, of atmospheric

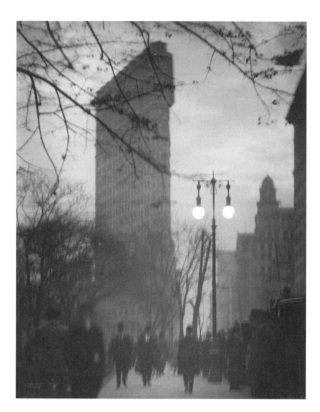

Figure 14.3 Alvin Langdon Coburn, *The Flat-Iron Building*, 1912. Photograph courtesy George Eastman House.

effects. The argument proposes an aestheticized, dematerialized city, a city in which social realities dissolve in a play of light. Thus Corbin argues pointedly: New York may be "formless" in contrast to Old World cities, but that is exactly its charm, its allure. The formless city is all the more available for appropriation by the aestheticizing eye. Moreover, and of equal importance to this argument, Corbin openly addresses himself to a new stratum of the urban population for whom such aestheticism answers to a somewhat urgent need: to transform the formless city, with its implied social and political threats, into aesthetic experience, into pictures that can then be consumed as signs of a reality from which threat has been utterly removed. "Everywhere," writes Corbin, "is new wealth, that brings the exultant sense of power; everywhere are beautiful things, to buy which is the most concrete expression of this sense; everywhere is a world of people who live in an endless intoxication of gayety, to take part in which is the obvious end of having money and spending it."[9] Unmistakably, the argument addresses this "world of people," addresses them pedagogically, presenting before their eyes the Stieglitz pictures as lessons in a mode of seeing (of framing, of

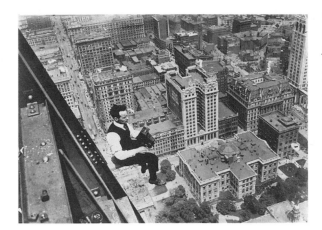

Figure 14.4 Brown Brothers, *Walter Miller Shooting from Woolworth Building,* 1912–13. Photograph, Brown Brothers Photo Archives.

selecting properly diffuse conditions of light) by which the city might become a consumable object.

Thus can we say that the Corbin text ideologizes the Stieglitz pictures, makes of their mode of representation (for instance, the prominence of haze, fog, and smoke in them) a particular interpretation of the city as a place. This is not to say that the ideology, which maps the city as a place of dematerialized aesthetic moments, absolutely governs the pictures. To be sure, taken in different contexts, the pictures can be viewed and interpreted quite differently—as examples of developments within the medium of photography itself, for instance, in regard to the use of the hand-held camera and night photography, the capturing of reflections on wet surfaces, and so on. Or they might be taken as equivalents in photography to the "Ash Can" paintings and drawings of the same years, which also took the sights of city streets (very broadly speaking) as subject matter. Yet the context of the Corbin article does suggest persuasively how what might seem to be strictly and innocently aesthetic concerns on the part of a photographer do participate perforce in a larger cultural dialectic. Furthermore, the Stieglitz pictures lend themselves so well to Corbin's argument that we are compelled to recognize a kinship, however oblique, between Stieglitz's photographic project in these years and the project represented by Corbin and others to remake the city in the imagination as a place of order, of form, of distanced experience, even in the face of perceptions of disorder, formlessness, threat.

In 1897 Stieglitz had published a portfolio of some dozen photographs entitled *Picturesque Bits of New York and Other Studies.* In the notion of the "picturesque" we can detect important features of that kinship. The term itself, applied to New York, signifies that the city is an appropriate site for a quest for

the kind of mundane and ephemeral materials that qualify for pictorial treatment as picturesque, as forming a picture. Although the term is not prominent in Corbin's essay, its meaning informs his argument and his attempt to induce the reader to take an imaginative tour of the city. Moreover, the mode of the picturesque in Stieglitz's portfolio represents a definite kind of picture, one decidedly without either the precision of detail or the wealth of visual information of such photographs as much in accord with the quest for an ordering principle that preoccupied many Americans, as they confronted the urban signs of those changes that have made the decomposing city a principal emblem of modernity.

Notes

This essay was published previously in the *Journal of Urban History* 10 (August 1984): 453–64.

1. See Alan Trachtenberg, *The Incorporation of America: Culture and Society in the Gilded Age* (New York, 1982), and Robert Wiebe, *The Search for Order, 1877–1920* (New York, 1967).

2. Allan Sekula, "The Invention of Photographic Meaning," *Artforum* 13 (January 1975): 27–45.

3. Clifford Geertz, *The Interpretation of Culture* (New York, 1973), chap. 8, "Ideology as a Cultural System."

4. Adna Weber, *The Growth of Cities in the Nineteenth Century* (New York 1899), 11.

5. Henry Adams, *Education of Henry Adams* (New York, 1931), 499.

6. Henry James, *The American Scene* (New York, 1907), 70ff.

7. Montgomery Schuyler, "The Evolution of the Skyscraper," *Scribner's Magazine* 46 (September 1909): 257–71.

8. John Corbin, "The Twentieth-Century City," *Scribner's Magazine* 33 (March 1903): 259–62.

9. Ibid., 264.

15 John Sloan's Images of Working-Class Women: A Case Study of the Roles and Interrelationships of Politics, Personality, and Patrons in the Development of Sloan's Art, 1905–16

Patricia Hills

John Sloan (1871–1951) was an early twentieth-century realist painter who embraced the principles of socialism and placed his artistic talents at the service of those beliefs. Hence, his graphic contributions to the radical socialist monthly the *Masses,* and his work as art editor, made it one of the most extraordinary publications of the pre–World War I period. But as a painter Sloan shied from political or social comment. Instead, the paintings celebrate the leisure moments of the working classes, particularly women, in such paintings as *The Picnic Grounds* of 1906–07 (fig. 15.1) and *Sunday, Women Drying Their Hair* of 1912 (Addison Gallery of American Art, Phillips Academy, Andover, Massachusetts). Sloan himself later insisted that these paintings were done with "sympathy but no social consciousness": "I was never interested in putting propaganda into my paintings, so it annoys me when art historians try to interpret my city life pictures as 'socially conscious.' I saw the everyday life of the people, and on the whole I picked out bits of joy in human life for my subject matter."[1]

It is the contradiction between these attitudes and actions that I wish to explore: on the one hand, his belief that cartoons can be politically persuasive, and on the other, his resistance to political overtones in his paintings. To do this means reconstructing Sloan's life in terms of his art, his politics, his personal psychology, and, particularly, his relationship to a key patron, John Quinn. Sloan was not alone in his attitudes. Indeed, in many ways he provides a case study of a member of the radical but wavering intelligentsia, torn between bourgeois notions of art and a socialist conception of what art must be in the decade before the United States entered World War I.

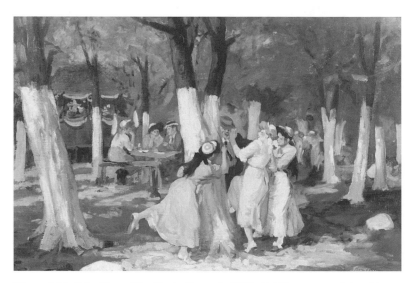

Figure 15.1 John Sloan, *The Picnic Grounds*, 1906–7. Oil on canvas, 24 × 36 inches. Collection of the Whitney Museum of American Art, New York, purchase.

In April 1904 John Sloan moved from Philadelphia to New York with his wife, Dolly. He was the last to arrive of the small, close-knit group of artist-reporters inspired and encouraged to take up painting by Robert Henri in the 1890s. Henri had come to New York in 1900 and continued his active role as a teacher. The younger men—Everett Shinn, George Luks, and William Glackens, as well as Sloan—had been squeezed out of their jobs as newspaper artists in Philadelphia because of developments in printing technology, as photographs replaced drawings as illustrations for news stories. In New York, the center of the magazine publishing industry, these experienced draftsmen and cartoonists found many opportunities for free-lance assignments. Continuing their naturalist, reportorial styles in their magazine illustrations, the four artists all became well known to art editors as specialists in depicting the picturesque charm of city life, specifically the life of the ethnic working classes.[2]

Indeed, the century's first decade was witnessing a national preoccupation with the working classes and particularly with the immigrants, by then a recognized force in shifting sociological patterns and economic structures. For industrialists this group formed a pool of cheap labor. To conservatives they posed a threat to "Anglo-Saxon" values. To reformers they lived as the squalid victims of an inhumane system that offered neither civil liberties nor social justice. To the group of artists around Henri they represented a new spirit that would infuse American life with fresh vitality.

Reviewing the magazines of the period, Frank Luther Mott concluded that a high point was reached in 1905–07, when reporters, writers, and social workers were most actively crusading against injustice, political corruption, and economic chicanery.[3] They actively constituted a "reform movement," which served as more than background for Sloan and his friends, because the very same popular magazines that ran articles by the "muckrakers" also hired the young realists as illustrators. Concern about the social unrest could be found even in art journals of the time. In 1907, when immigrations reached a peak of more than 1.25 million and the panic of that year plunged the country into a severe depression, Gustav Stickley, the designer and editor of *The Craftsman*, declared in an editorial: "Social unrest is, without question, the distinguishing characteristic of this age. Especially is this true in America, where greed and arrogance on the one hand and class hatred and jealousy on the other seem to have arrayed the people into two great factions, represented by the terms Capital and Labor. The prevailing feeling is that a relatively small class has possessed itself of the land and its treasures: that a few great corporations, mostly composed of the same men, control the main arteries of the nation's industry and commerce."[4]

Realism in art and literature has flourished in the past century whenever writers, artists, and intellectuals have articulated such views and demanded an art relevant to the mood of social advocacy. The art critic Charles Caffin, one more voice of 1907, in his important survey *The Story of American Art*, discussed the young followers of Henri in the context of changing attitudes about what constitutes "beauty." Referring to the man of the slums as "morally as well as physically deteriorated, offensive alike to our senses and our conscience," Caffin noted that nevertheless the Salvation Army responded to him, as did the artists.[5] In fact, what was formerly considered "ugly" might contain more truth about life than genteel subject matter: "The foregoing analysis of the place of so-called ugliness in art has been suggested by the effort of a few of our younger painters to shake themselves free from the fetters of prettiness and sentimentality in which much American art is confined. They are men who are interested in life as well as art, and who use the one to interpret the other. One of these is John Sloan."[6]

Caffin, who had interviewed Sloan at length while he was writing his book, focused on Sloan as the quintessential realist. He described Sloan's attraction to the "'passing show' of shops and streets, overhead and surface traffic, and the moving throngs of people, smart and squalid, sad and merry—a phantasmagoria of changing colour, form, and action. Out of the multiplied features of the scene, by eliminating some and emphasizing others, he produces a synthesis of effect, in which confusion has disappeared, but the suggestion of vivid actuality

remains. . . . It is the humanity of the scene, as well as its pictorial suggestions, that interests him. Not, however, in the way of telling a definite story, but by inference and suggestion."[7]

The paintings to which Caffin referred were genre scenes of working-class life in which figures were treated sympathetically, without condescension. In particular, Sloan celebrated the joyousness and camaraderie of women—sometimes shown singly, but usually represented in pairs or in groups, as in *Spring Planting* of 1913 (private collection) or *Sunday, Women Drying Their Hair.* In the company of men, Sloan's women function as the principal actors, engaging men in playful activities, as for example, in *The Picnic Grounds,* a scene he had observed in Bayonne, New Jersey, in 1906, and in *South Beach Bathers* of 1908 (Walker Art Center, Minneapolis).

Robert Henri also praised Sloan's special humanity and enthusiasm about the life around him in a 1910 article about the Exhibition of Independent Artists: "The artists who produce the most satisfactory art are in my mind those who are absorbed in the civilization in which they are living . . . John Sloan, with his demands for the rights of man, and his love of the people; his keen observation of the people's folly, his knowledge of their virtues and his surpassing interest in all things."[8]

Indeed, Sloan's "demand for the rights of man and his love of the people" drew him—alone of the group—into the politics of organized socialism. Sloan joined the Socialist Party in 1909; read party literature and novels, plays, and essays with socialist themes; attended lectures by Eugene Victor Debs, as well as by the anarchist Emma Goldman; participated in strike meetings with his wife; and ran for public office on the Socialist ticket. And from 1909 through 1916 he contributed numerous political illustrations and cartoons to socialist magazines and causes, culminating in his work for the *Masses* from 1912 to 1916.[9]

But given Sloan's social awareness and political involvement, why did he shy away from overt comment in his paintings? Why did he separate his painting from his cartoons? For in those years when he was associated with the Socialist Party and worked closely with his outspoken, radical colleagues on the *Masses,* such as Max Eastman, Art Young, and John Reed, there were encouragement and even demands upon him to forge a partisan painting in the same spirit as his acerbic cartoons. There were demands, that is, for him to be in the avant garde of the working-class movement.[10]

The consensus so far has been that Sloan did not produce a radical painting concerned with the class struggle and critical of capitalism because he was humanitarian and compassionate, a reformer rather than a revolutionary and, perhaps, politically naive. As far as it goes, the consensus view is true, and Sloan, by 1916, could have been so described. But the consensus view masks what must

have been a considerable struggle within Sloan to resolve the seeming contra-
dictions during the period of his greatest political involvement, from 1909 to
1916, because Sloan's stance for a time was more radical than any reformer's and
politics was the primary preoccupation of his life. Concretely, he was trying to
reconcile the demands of the working class and socialism, on the one hand, with
the demands of tradition, the academy, and a thoroughly bourgeois (at times
even bohemian) art establishment, on the other hand.[11]

At the time, the antagonism between labor and capital was sharp and active,
and Sloan was, like many intellectuals and artists of his time, caught up in the
swell of prewar working-class consciousness and revolutionary enthusiasm. But
he was also influenced by counterforces, which preached acceptance of the sta-
tus quo or, at best, a few reforms. In terms of painting, that meant adhering to
the traditional concerns of nonpartisan, "universal" art.

To press on, to attempt to find a method that would be more useful in terms
of our understanding of Sloan, his art, and his times, we should approach Sloan
as a case study of a political artist. We must look at his life as a process develop-
ing under a set of contradictions manifested in the personal, aesthetic, and po-
litical aspects of the whole man. In so doing we need to subject each to a
dialectical analysis that sorts out the primary from the secondary aspects of his
personal life, his art, and his milieu, each characterized by a particular kind of
conflict, in order to gain insight into their resolution.

The questions might then be framed as follows: Why does an artist veer from
a course in which politics is primary to one in which it becomes secondary and
then seems to fade altogether? At the time when his politics seems to be pri-
mary, how does it affect his art, and, conversely, how does the art affect his poli-
tics? How does his personal character affect them both? And, not least, what is
the content or the message of his art?

One can assume that Sloan was ready to be introduced to socialism long before
he first mentioned it in the Diary, which he began in January 1906 and kept
faithfully through 1911, with sporadic entries for 1912 and 1913.[12] Sloan began
the Diary on the recommendation of Dr. Collier Bower, a physician treating
Dolly. The Diary was meant to be an outlet for Sloan's periods of worry and de-
spondence, and also to bolster Dolly's ego, for both Sloan and Bower knew that
Dolly would read the Diary, responding to favorable references to herself.[13] To
us, the Diary is an invaluable primary source, for it chronicles Sloan's daily ac-
tivities: his working habits, his relations with magazine editors, his fees for his il-
lustrations, his paintings in progress, his conversations with friends, his reading
and evenings at the popular theater, the state of his wife's health, their trips and
vacations, and his thoughts on art, the art world, and politics.

The early years of the Diary entries are filled with notes about Sloan's walks in New York City and his impressions of working-class city people. His entry for February 13, 1906, suggests the flavor of his impressions: "Walked through the streets of the East Side. Saw a boy spit on a passing hearse, a shabby old horse. Doorways of tenement houses, grimy and greasy door frames looking as though huge hogs covered with filth had worn the paint away and replaced it with matted dirt in going in and out. Healthy faced children, solid-legged, rich full color to their hair. Happiness rather than misery in the whole life. Fifth Avenue faces are unhappy in comparison."

The working classes were to Sloan, as they were to Henri, the source of knowledge of life. After reading part of Fielding's *Joseph Andrews,* he noted on January 16, 1908, "Thinking how necessary it is for an artist of any creative story to go among common people—not waste his time among his fellows, for it must be from the other class—not creators, nor Bohemians nor dilettantes[—]that he will get his knowledge of life." Such remarks indicate a person in sympathy with the daily tasks of workers.

Sloan first mentioned "socialism" in his Diary on November 16, 1908, noting that a friend had voted on the Socialist ticket in the presidential elections of that year. On December 7, he had a long conversation on the subject with Charles Wisner Barrell, who had just written an article on Sloan's etchings for the *Craftsman.* Sloan confessed to the Diary, "He has become a Socialist and talked with me on the subject—wants me to attend a Sunday meeting in Jersey City some time. It sounds well to me. I believe my next vote will go to their candidates."

In January and again in April 1909 he had further talks with Barrell and others, recording his enthusiasms as well as reservations—remarks understandable for someone just examining new ideas. After a session of talk with Barrell on April 15, he declared: "I can't help feeling that the movement is right in the main," adding, "I am rather more interested in the human beings themselves than in the schemes for betterment. In fact, I rather wonder if they will be so interesting when they are all comfortable and happy." These words indicate an underlying romanticization of poverty, an attitude shared at the time with the other realist artists.

In May 1909 he agreed to the sale of his etchings as part of a fundraising event for the Rand School. That same month he met Herman Bloch, the art writer for the socialist daily newspaper the *New York Call,* and informed him that he "had no intention of working for any Socialist object in my etchings and paintings." This statement, made on May 5, 1909, that the etchings and paintings were not to be touched by political concerns, was a declaration he would keep inviolate. Nor, in the years to come, would pressures from his friends in the

Socialist Party change his mind on this point. But by consciously splitting his art into two categories—paintings and etchings on the one hand and illustration on the other—he initiated a dialectical struggle that would be waged within himself, that would affect his relationships with his socialist colleagues, and that would ultimately spell the direction of his art.

Because Sloan did feel that his illustrational gifts could be put to use for the socialist cause, he was soon sending voluntarily political cartoons to the *Call*. They first appeared on August 23, with the signature "Josh Nolan," Sloan's anagram in his first year of political cartooning.

Sloan also investigated socialism in his reading. An avid reader, Sloan noted books bought and read in his Diary. That May he subscribed to Traubel's *Conservator* and read Oscar Wilde's *Soul of Man Under Socialism*, as well as the 1908 platform of the Socialist Party. In response to the latter, he wrote on May 21, 1909: "Can't understand why the workers of the country were so disinterested or intimidated as not to vote en masse for these principles."

The Diary entries for the remainder of 1909 indicate Sloan's growing political awareness. Examples are numerous, but a few important points are in order:

On May 29, 1909, he argued vigorously against the antiworker sentiments of his friend Potts: "He and I argued on the Social problems of the day! He seems to think what's the use of trying to do anything to better the workers—they are not worth it. The rich have the money because they have the brains to get it— the others haven't the brains so they must pay the penalty. I feel that if 5,000 people in this city are wealthy and content and two million are unhappy, something is wrong."

Many of the entries indicate that his former world view is in struggle with newer, egalitarian ideas. On June 9, 1909, he pondered whether hierarchical differences existed between manual and mental labor: "Will the great mass of the workers, when they find the power of the united vote, stand for differences in the rewards between their ordinary labor and mental labor? Of course all will have every necessary [sic] to existence, and comfort—but should not the higher faculties have some higher reward? Or is this feeling in me, only a surviving view of the present upper class feeling?"

Sloan had become antimilitarist at the time of the Spanish-American War,[14] but his convictions against war at this time were clearly political, and he argued in his Diary on June 12, 1909, that modern wars are made by capitalists with expansionist ambitions: "I am too old or too much convinced of the Socialist antimilitary principle for this highly impossible tale [Edward Everett Hale's *The Man Without a Country*] to move me to a love of the plutocracy's government. Why should the workers fight each other in order to preserve or expand or destroy the trade relations in which they have no real interest? Suppose we agree

to call this country a province of England or France or Germany? Does it make any difference to me? or to any laboring man?" And again, commenting on a parade of September 30: "Parades like this make the 'patriotism' which furnishes soldiers, workers to kill the workers that capital may hold its upper hand."

Throughout the fall of 1909 he took many opportunities to argue vigorously with friends and strangers on behalf of socialist precepts. By December 19 he confided to the Diary: "I think . . . that I have passed the feverish stage and that it has now amalgamated with my make up. I feel much more quiet and in a sense happier minded." On December 29, 1909, Dolly and Sloan filled out forms to join the Socialist Party.[15]

The Diary for the years 1910, 1911, and 1912 continue the comments of a political nature, charting Sloan's growing sophistication and recording his attendance at various political meetings and the social visits of friends with whom he talked politics. We turn now to the entries that describe his graphic work for the socialist cause: political cartoons for George Kirkpatrick's *War—What For?*, the *New York Call*, the *Coming Nation*, and other periodicals. Some of these illustrations were done in response to immediate events, such as the drawing done the day after he had heard of the Triangle Shirtwaist Company fire, a disaster that took the lives of 154 women on March 25, 1911.

In his effective cartoon, Death and the Capitalist hold up a triangle, the sides of which are labeled "Rent," "Profit," and "Interest"—three ways that capitalists amass their fortunes (fig. 15.2). The still smoldering body of a victim is trapped inside that triangle, a reference to the Triangle Shirtwaist Company, and, by implication, inside the capitalist system. One charred arm projects toward us. Sloan's message is clear and immediately comprehensible.

Sloan did not take payment for the illustrations he sent to the *Call* and the *Coming Nation*, nor did he take payment for his *Masses* cartoons.

His desire to place his talents as an illustrator at the disposal of the socialist cause was strong and active enough so that in 1912 he joined with others in the reorganization of the *Masses*, originally founded in 1911 by Piet Vlag.[16] Sloan participated in a meeting in August in which it was decided that Max Eastman would be invited to join the staff as editor; Sloan was to be the art editor. The first issue appeared in December 1912. In the January 1913 issue, an editorial declared the editors' intentions to produce "a revolutionary and not a reform magazine; a magazine with no dividends to pay; a free magazine; frank, arrogant, impertinent, searching for the true causes; a magazine directed against rigidity and dogma wherever it is found; printing what is too naked or true for a money-making press; a magazine whose final policy is to do as it pleases and conciliate nobody, not even its readers."[17] This statement includes an obvious element of

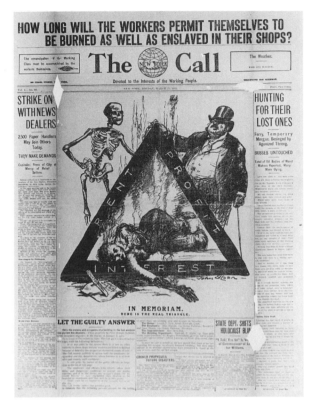

Figure 15.2 John Sloan, "In Memoriam. Here is the Real Triangle," with headline: "How Long Will the Workers Permit Themselves to Be Burned as Well as Enslaved in Their Shops?" *New York Call*, March 27, 1911. Delaware Art Museum, gift of Helen Farr Sloan.

bohemianism. The contributors had mixed motives for joining in the enterprise, and many defined their "socialism" broadly.[18]

Sixty-three illustrations of Sloan's were published in the *Masses* between December 1912 and mid-1916.[19] Many were straight drawings, such as *Bachelor Girl* in the February 1915 issue; many were satirical, such as *The Unemployed*, the March 1913 cover. Others were powerful statements of the class struggle, such as the June 1914 *Masses* cover entitled *Class War in Colorado*, depicting a Ludlow miner holding a young child and firing his gun, presumably at the National Guard or Rockefeller's agents (fig. 15.3).[20] What is radical about this illustration is that the worker is firing back; the message is defense through armed struggle and rebellion, hardly a reformist position.

In the published cartoons for the socialist publications, particularly the *Masses*, Sloan's men take an active part in on-the-job struggles, including actual brawls at street rallies and polling places. When women are active, it is as suffragists. In one instance Dolly is the model for a figure at a suffragist rally, in the illustration *She's Got the Point* in the October 1913 issue (fig. 15.4). In only one

Figure 15.3 John Sloan, "Class War in Colorado." *The Masses,* June 1914; cartoon refers to the Ludlow massacre. Delaware Art Museum, gift of Helen Farr Sloan.

instance are women singled out as the strikers, in the *Call* cartoon of January 27, 1913, entitled *Strikers and Scabs or Inferiors and Equals,* in which two strikers glare contemptuously at a female scab who emerges from the building with her boss. Usually Sloan depicts women either as victims of society (for example, in *Before Her Makers and Her Judge,* an illustration published as a double-page spread, August 1913, in connection with an article exposing the entrapment of prostitutes by the police) or as carefree and removed from political struggle (as in the July 1913 cover, *The Return from Toil,* and the November 1913 cover, *Innocent Girlish Prattle, Plus Environment*).[21]

With the outbreak of the war in Europe in 1914, Sloan entered a period of disillusionment with organized politics. He must still have been a member of the Socialist Party through 1915, because he was a Socialist candidate for a judgeship in the general election of that year. Although there is no substantial evidence, we may conjecture that his drift away from active participation begins at this time.[22] He also seems to have dissociated himself from the *Masses,* for only a handful of his drawings appeared in 1915 and 1916. His artwork for the

Figure 15.4 John Sloan, "She's Got the Point." *The Masses*, October 1913; Dolly Sloan is the figure delivering a speech at a suffragist rally. Delaware Art Museum, gift of Helen Farr Sloan.

Masses had been of three categories—straight drawings (usually vignettes of women), satirical drawings to which he would add an ironic caption, and sharp political cartoons. Max Eastman and the other editors, however, wanted to insert captions with a pungent political message beneath *all* categories without discussing their changes with him. Sloan felt that the "artistic" drawings should not be tampered with, that there was a place for nonpolitical art as well as propaganda in the magazine. Moreover, he resented Eastman's autocratic ways. The issues were two: one of form, specifically, what seemed to be Eastman's one-man control; and one of content—should the magazine wholly emphasize the socialist view or be broad in its appeal?

Meanwhile, Stuart Davis, Glenn O. Coleman, and Henry J. Glintenkamp enlisted Sloan as their spokesperson, for they too resented Eastman's doctrinaire ways, and perhaps the socialist doctrine as well.[23] Eastman and Art Young, focusing on the second issue, justified the propaganda intent of the magazine, reasoning that these were violent times; the war in Europe and the U.S. reaction had sharpened the urgency to proselytize for socialism. The issues came to a

head at two meetings, the second taking place on April 6, 1916. Sloan, knowing that many on the staff agreed with his contention that the *Masses* should speak to a general, not merely a socialist, readership, proposed that editorial decisions be collectively settled by the contributing editors at monthly meetings.[24] Eastman disagreed, arguing that committee decisions were impossibly inefficient when deadlines had to be met, and offered to submit his resignation. Sloan's proposal received a tie vote. A second meeting was held, with the hope that more members present would break the tie. They did, and Sloan's proposal was defeated; Eastman received a vote of confidence. Floyd Dell then proposed that the rebels be expelled; Art Young seconded the motion, stating, according to Eastman: "To me this magazine exists for socialism. That's why I give my drawings to it, and anybody who doesn't believe in a socialist policy, so far as I go, can get out!"[25] The vote on expelling Sloan and the others was defeated; instead, Sloan and Coleman were elected officers. The following day, however, Sloan sent his letter of resignation to Eastman:

Dear Max:

"If thy right hand offend thee, cut it off." This afternoon I played the part of one of the five fingers in the above suggested tragedy, and foolishly resisted amputation. Now, alone at night, I have decided to submit to the operation. I hereby tender my resignation as Contributing Editor of The Masses, as Art Editor of the Masses, and as Vice President of The Masses Publishing Company.

May The Masses live long and prosper is the rather sincere wish of yours truly,
JOHN SLOAN[26]

Sloan, by admitting that his was the offending hand, was acknowledging that he had factionalized the *Masses* at a time when solidarity was becoming crucial. For all his ambivalence on many issues, the decision to leave the *Masses* was clearly painful to Sloan, for he was as vigorous in his denunciation of the war as the others. Resigning with Sloan were Stuart Davis, Glen O. Coleman, and Robert Carlton Brown, the writer.[27]

Sloan had made a choice. He had created a situation of irresolvable confrontation between politics and *art*. The seeds of the confrontation had been planted when he first separated out his political cartoons from his art—and he was now choosing art.

In his retreat from socialism, however, Sloan was not alone. He had joined the Socialist Party during its "Golden Years"—at a time when many progressive New York intellectuals, writers, and artists were drawn to organizations that

urged reforms. The Socialist Club he belonged to was Branch One, nicknamed the "Silk Stocking" Branch. Although the members supported the workers' strikes, very few had personal contact with the workers. Sloan left the party at a time when thousands of others were also leaving. Sloan was adamantly antiwar; his disillusionment, shared by many, was that as an international movement socialism had failed to check nationalism and to stop the war in Europe.[28] Looking back at the period from the vantage point of 1950, Sloan reflected:

> We all felt that we were part of a crusade that would help to bring about more social justice at home and prevent the outbreak of world war. We were seriously alarmed by the new scientific discoveries which could make warfare a thing of terrible violence. . . . We did not have any doctrinaire ideas about running the world. Every time we went to a meeting, the speakers would talk about some new ideas for bringing about more justice without getting the world into the tyranny of some huge bureaucracy. Debs used to warn us that the socialist party should never have power of its own, that the ideas of the movement should be carried out through many different agencies of private and governmental types.[29]

As much as Sloan was opposed to the capitalism of early twentieth-century America, his fear of violence was even stronger. Therefore, he agreed that the Socialist Party should not try to seize political power—rather, it should seek to diffuse socialist ideas and thus change the collective consciousness.

We must return to our original question, slightly rephrased: Given that Sloan continued to isolate his etchings and paintings from partisan politics, did his choice of women as subjects—those joyous, spontaneous women—follow as a natural or logical corollary of that unwavering decision? We shall see what the evidence so far already suggests: that the answer is affirmative, with the reasons operating on levels that are cultural and sociological as well as personal.

The American cultural tradition had stressed the representation of the sociable and pleasant aspects of human intercourse. Few novels or paintings done by Americans depicted working-class strife or the ugly side of industrialization, although in Europe a handful of artists were developing the genre. The myth of America as a society free of class struggles was firmly ingrained in the minds of the culture-shapers. William Dean Howells wryly commented on American novels in 1891: "The wrong from class to class has been almost inappreciable, though all this is changing for the worse. Our novelists, therefore, concern themselves with the more smiling aspects of life, which are the more American, and seek the universal in the individual rather than the social interests."[30] Howells

knew that class antagonisms were sharpening (given the times, he could hardly avoid that reality) but admitted that in American culture the smiling aspects were the "more American."

The art critic Charles Caffin specifically focused on American paintings when he reviewed the Paris Exposition of 1900, and he found them as a group a "little fibreless and lacking in marrow." He drew the parallel of painting to fiction and found it unfortunate that the painters had "become directly infected with the prevailing pseudo-ethics of the publishers." To Caffin, their art thus seemed mannered and artificial rather than vital and lifelike: "The necessity of prettiness, of not giving offence to 'the most fastidious' and of exploiting the obvious, has been urged upon them, until it is small wonder that a great deal of American painting is characterized by irreproachable table-manners rather than by salient self-expression; by a desire to be amiable rather than convincing."[31]

In the terms of the social history of the era, the culture-shapers unquestionably presumed that women would be the bearers of those "smiling aspects" and would fulfill "the necessity of prettiness." George Santayana was later to deplore a society that relegated culture to the domain of decorum rather than to experience:

> The truth is that . . . one-half of the American mind, that not occupied intensely in practical affairs, has remained, I will not say high-and-dry, but slightly becalmed; it has floated gently in the backwater, while, alongside, in invention and industry and social organisation, the other half of the mind was leaping down a sort of Niagara Rapids. This division may be found symbolized in American architecture: a neat reproduction of the colonial mansion . . . stands beside the sky-scraper. The American Will inhabits the sky-scraper; the American Intellect inhabits the colonial mansion. The one is the sphere of the American man; the other, at least predominantly, of the American woman. The one is all aggressive enterprise; the other is all genteel tradition.[32]

Women certainly dominated the subject matter of the popular and established figure painters in New York and Boston—artists such as Edmund Tarbell, Frank Benson, William Merritt Chase, and, a decade later, William Paxton.[33] They depicted women removed from the activities of commerce and politics— genteel leisure-class women surrounded by flowers, their friends, children, and art works, defined so well and so ironically by Thorstein Veblen as "chief ornaments" of the household. Veblen had observed in *The Theory of the Leisure Class* of 1899: "Propriety requires respectable women to abstain more consistently from useful effort and to make more of a show of leisure than the men of the same social classes. It grates painfully on our nerves to contemplate the

Figure 15.5 William Mc-Gregor Paxton, *Tea Leaves*, 1909. Oil on canvas, 36⅛ × 28¾ inches. The Metropolitan Museum of Art, New York, gift of George A. Hearn, 1910 (10.64.8).

necessity of any well-bred woman's earning a livelihood by useful work. It is not 'woman's sphere.' Her sphere is within the household, which she should 'beautify,' and of which she should be the chief ornament."[34] Examples in art are Frank Benson's *Girl Playing Solitaire* (Worcester Art Museum, Massachusetts) and William Paxton's *Tea Leaves* (fig. 15.5), both of 1909.

Sloan's view of women is strikingly different, although one could argue that his very choice of women as principal subject of painting was part of this larger cultural and sociological pattern. The differences, however, are striking. In subject matter, the salient difference is one of class, with the style working in concert to produce a radically different content.[35] The genteel women in *Tea Leaves* enact the bourgeois afternoon ritual of the social call and end by being bored and distracting themselves with daydreaming about past possibilities or future fortunes. Paxton's brush gently caresses the precious, expensive objects, which harmonize, in color and texture, with these graceful and fashionable corseted young matrons, restrained by wealth, propriety, and etiquette. Quiet, hermetic, sealed off from the world by the screen behind, they suggest a time-frozen image of genteel femininity.

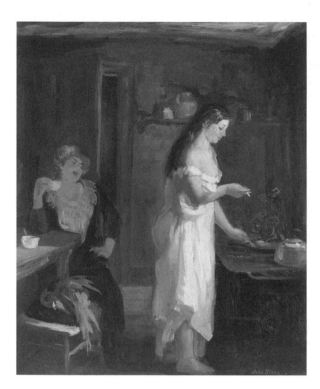

Figure 15.6 John Sloan, *Three* A.M., 1909. Oil on canvas, 32 × 26 inches. Philadelphia Museum of Art, given by Mrs. Cyrus McMormick.

Sloan's painting *Three* A.M. (fig. 15.6) was also a ritual, one he observed from his rear window. In his Diary, April 28, 1909, Sloan wrote, "A good day's work, painting on the subject that has been stewing in my mind for some weeks. I have been watching a curious two room household, two women and, I think, two men, their day begins after midnight, they cook at 3 A.M." The breakfast scene of the working-class women is less social ritual than a nutritionally necessary part of the day's beginning. The image is not static but full of disorder and movement. The thick, fluid stroke seems appropriate to the heavy young woman cooking and to the seated woman engaged in animated conversation. In particular, the loose handling of paint on the nightgown makes visually convincing her unconstrained freedom to move about within her clothing and, as suggested by the sketchily rendered open door in the background, to move as well into the spaces outside the room, even into the city. The interior furnishings—old stove, cheap tea-kettle, rude table, chair, and crockery—receive little more than a summary treatment, for Sloan is, after all, primarily concerned with the women. These women are active and involved in the present, not idly reading their fortune. Upon hearing of the painting's rejection by the jury of the National Academy of Design annual in March 1910, Sloan commented offhandedly in his

Figure 15.7 John Sloan, *Turning Out the Light,* 1905 (from "New York City Life"). Etching, 4⁹⁄₁₆ × 6⁹⁄₁₆ inches. Collection of the Whitney Museum of American Art, New York, purchase.

Diary of March 9 that the work was, after all, "sent . . . as much as a joke like slipping a pair of men's drawers into an old maid's laundry, so that its refusal I expected surely."

In the company of men, Sloan's women are the principal actors. In *The Picnic Grounds* it is the women—described on May 30, 1906, as "young girls of the healthy lusty type with white caps jauntily perched on their heads"—who tease and chase the young man around the tree. Similarly, in his etching *Turning Out the Light* of 1905 (fig. 15.7), it is the woman who activates the scene. Dressed in a nightgown, she kneels on the mattress in order to reach the gas wall fixture, while turning to smile at her companion who lies at the farther edge of the brass bed. Her gesture expresses a movement and mood that are physically and psychologically right. The picture celebrates frank and mature sexuality—projecting an image of amiable companionship rather than erotic coquettishness, of equality with the man rather than submissiveness. Across the woman's face plays a smile suggesting a state of inner well-being. The woman, as in most of Sloan's prints and paintings, is the principal player of the drama—the agent of action rather than the object. Viewing these works with the historical context in mind, we cannot say that Sloan's political beliefs are irrelevant: He believed in the

equality of women and their rights to the vote—beliefs revealed in the content of these paintings.

Five works mark the exception to Sloan's aversion to the theme of work: *Scrub Women, Astor Library* of 1910 (Munson-Williams-Proctor Institute, Utica, New York), three paintings representing women hanging wash on clotheslines— *Woman's Work* of 1911 (Cleveland Museum of Art), *Red Kimono on the Roof* of 1912 (Indianapolis Museum of Art), and *Sun and Wind on the Roof* of 1915 (Randolph Macon Women's College, Lynchburg, Virginia)—and *Spring Planting* of 1913 (private collection). Women's work in these paintings is of a special kind. The first four involve the theme of cleanliness, with women cast as working for the benefit of others—keeping libraries clean for the work of minds and clothes washed and aired for daily grooming. In *Spring Planting* one woman turns the earth with a shovel in preparation for planting while two others look on, and a third leans out from a nearby tenement window. The women's roles are to husband the earth, and thus nurture themselves and their families. As a group Sloan's paintings reveal women's work as necessary ritual cleansing and renewal, with purification and regeneration the essential content.

We should move with caution and tact toward the investigation of the psychological dimension of Sloan and try to avoid those superficial Freudian interpretations that mechanistically explain away the rich complexity of Sloan's inner life.[36] But again, we must search through the diaries, reminiscences, and biographical accounts for clues to a psychological character—Sloan's—drawn to certain themes rather than to others in his paintings of women.

Sloan seems to have had conflicting attitudes toward women. On the one hand, he shouldered responsibilities for caring for them. He quit high school in order to contribute to the support of his father, mother, and two younger sisters. His first wife, Dolly, was an alcoholic who suffered from depressions throughout the marriage, and Sloan tenderly cared for her. However, Sloan also yearned to be cared for himself. On his birthday after his mother's death, August 2, 1908, he wrote of Dolly as being his "wife and mother now." And numerous entries refer to his desire to be cared for by her, which was no doubt true, even though these passages may have been inserted to raise her sense of self-esteem.

He often thought of women as psychologically stronger than men. Observing a family in a tenement across from the rear windows of his West Twenty-third Street apartment, he witnessed a scene where a child died in its mother's arms and the men were, in Sloan's words of June 11, 1906, "powerless, helpless, stupid." On May 24, 1908, he made a lithograph that he described as a "woman, primitive, sitting with child at breast. An old idea of mine, Mother of the Man who first made himself Chief or King of Men." And for the February and March

Figure 15.8 "He Won't Be Happy 'Til He Gets It!" *The Masses,* March 1913; one of five drawings Sloan did for the February and March 1913 issues of *The Masses*— a series entitled "Adam and Eve: The True Story." Delaware Art Museum, gift of Helen Farr Sloan.

issues of the *Masses* in 1913, he made a series about Adam and Eve called "The True Story," depicting a gigantic and cheerful Eve dominating a puny, pint-sized Adam (fig. 15.8).

Another view of women that Sloan held—a view that dominated his references to women in his diary of 1906 through 1908[37]—was as people free of class worries, spontaneous, and capable of bringing joy and pleasure to their own lives and the lives of men. These references also served, of course, as verbal notes for later paintings. On June 26, 1906, he wrote: "Walked down to the East Side this afternoon, enjoyed watching the girls swinging in the Square, Avenue A and 8th Street East. A fat man watching seated on a bench interested in the more mature figures."[38] On July 20, 1906, he reported on a visit to Washington Square, where he "saw young girls at their lunch hour strolling through the park arm in arm—benches on either side filled with all sorts of men interested in them and not interested. Shade of trees, heat of sun, odors of human life and sweat."[39] For March 25, 1907, he reported: "Sat in Madison Square and watched the children at play. Two young nurse girls playing ball, watched by bums, self

and others."[40] For June 18, 1908: "I get a joy from these healthy girls (one of them on the verge of womanhood) that I can't describe—it is as big as life itself."

It misses the point to interpret Sloan's women watching, as some have, as voyeurism arising out of a blocked sexuality. It seems clear to me that Sloan's delight in women stems from his belief, perhaps even envy, that they represent pure, simple, innocent spontaneity—spontaneity often ruined by the deleterious effects of living in a competitive, industrialized, and exploitative society. In Sloan's published teaching notes, *Gist of Art,* he recorded: "I have always had enthusiastic interest in unspoiled girlhood, more in evidence in 1912 than now. Growth toward real womanhood is often checked at about this age." Of the painting *Sun and Wind on the Roof* of 1915, Sloan recalled: "An urge to record my strong emotional response to the city woman, any woman running up the colors of a fresh clean wash. Sun, wind, scant clothing, blowing hair, unconscious grace give me great joy."[41] For Sloan, joyousness, cleanliness, and unconscious grace became synonymous.

Isadora Duncan, whom he met in November 1909, made a profound impression on Sloan, who at the time was on the verge of joining the Socialist Party. When Sloan saw her dance on November 16, he was enraptured. She seemed to sum up the best of the possibilities of women and, indeed, all of humanity. His Diary reads: "We saw Isadora dance. It's positively splendid! I feel that she dances a symbol of human animal happiness as it should be, free from the unnatural trammels. Not angelic, materialistic—not superhuman but the greatest human love of life. Her great big thighs, her small head, her full solid loins, belly—clean, all clean—she dances away civilization's tainted brain vapors, wholly human and holy—part of God." The imagery here relates vividly to the metaphor of birth and regeneration, rather than to erotic sexuality. To Sloan, Duncan was a woman capable of producing a new race of men and women. When Sloan saw her dance again, on February 15, 1911, he remarked in his Diary: "Isadora as she appears on that big simple stage seems like *all* womanhood—she looms big as the mother of the race." His painting *Isadora Duncan* of 1911 (Milwaukee Art Center) captures his impression of that memorable day.

Recalling those paintings of women scrubbing, hanging wash, and planting, we can rightly speculate that the covert meaning of many of his paintings of women is the desire for purification, redemption, and regeneration in a world *here and now.* It was the same wish as that of idealistic socialists, to which Sloan was giving visual form.

The artistic process necessarily entails that the artist stand back from the subject in order to process that subject into an object that exists on his canvas. Physically

he needs to take the measure and proportion, to ascertain the dominant or expressive features, to fix the relative tones. Psychologically, he must deny the subject its subjectness and view it as an object integrally related to the total composition. That distancing is inherent in the creative process, although many artists try to overcome it by probing into the inner character of the subject, selecting and distorting in order to communicate their personal expression of the subject or to convey the subject's "inner essence."[42]

Sloan, more than others, needed to distance himself from his subjects. To him it was not just an aesthetic necessity but a personal, psychological one as well, based on his respect for the integrity of his subjects. He did not know the people who inhabited his scenes of everyday life. Fascinated by women, he spent much time observing them unobserved in the parks and on the streets of New York and on the tenement roofs across from his rear windows on Twenty-third Street. Referring specifically to the etching *The Women's Page* of 1905 (Whitney Museum of American Art, New York), he recalled in 1949 that period of his life: "The psychologists say we all have a little peeper instinct, and that's a result of peeping—the life across from me when I had a studio on 23rd Street. This woman in this sordid room, sordidly dressed—undressed—with a poor little kid crawling around on a bed—reading the Women's Page, getting hints on fashion and housekeeping. That's all. It's the irony of that I was putting over. No intent to make a design, in this case, but to put over this ironical attitude that my mind assumed in regard to what my eye saw."[43]

The evening of July 6, 1911, when friends were visiting, Sloan became outraged that his friends openly gawked at the rear window neighbors. He reflected: "I am in the habit of *watching every bit* of human life I can see about my windows, but I do it so that I am not observed at it. I 'peep' through real interest, not being observed myself. I feel that it is no insult to the people you are watching to do so unseen, but that to do it openly and with great expression of amusement is an evidence of *real vulgarity.*" Sloan would not condescend, would not put himself in a position of superiority. Therefore, that distancing was necessary for Sloan and, he thought, for his *art*. And the artist, to Sloan, had a right to peep—if he or she did so in a spirit of respect, without violating the humanity of the subject.

Moreover, he abhorred blatant sexuality as a motive for art: sexuality in which the woman became a mere object for men's lust. On October 24, 1908, he wrote regarding nudes in art, "The artists most of them are proud and feel that they have taken a lofty flight into the higher realms of glorious 'Art' when they paint a nude woman. A picture that could only inspire lust in a perverted mind so little is there of humanity in it." Women, too, should prudently be kept at a distance in order that they not inspire sexual interest. For a man's sexual preoccupations

with a woman would deprive them of their inner integrity, would turn them from subjects to objects. Perhaps he feared, too, the attendant violence that such a process entailed.

Viewing his times, the turn-of-the-century years, one can recall many artists who peeped as well. Indeed, part of the naturalist program was to depict a slice of life of the working classes. George Moore, whose books Sloan read avidly, quoted Edgar Degas in *Impressions and Opinions of 1891:* "Hitherto . . . the nude has always been represented in poses which presuppose an audience, but these women of mine are honest, simple folk, unconcerned by any other interests than those involved in their physical condition. Here is another; she is washing her feet. It is as if you looked through a keyhole."[44] European artists who "looked through a keyhole" and found naked women washing up, men and women in quiet conversation, and other activities, would include not only Edgar Degas but also Jean-Louis Forain and Walter Sickert, all of whom had done etchings with which Sloan no doubt was familiar.

What is important here is that Sloan's aesthetic and psychological attitudes mirrored his political practice, for indeed he sought to *distance* himself from politics as well. Even though he and Dolly were actively involved in Socialist Party politics, his Diary reveals a man who on many occasions pulled himself back.

On February 11, 1910, Sloan went to his "first Socialist Branch Business Meeting at the Rand School," which he found "rather dry," so that he entertained himself by looking at a "pretty young . . . secretary." He passed out leaflets in Battery Park on July 26, 1910, but admitted: "There is a curious kind of humor about such an affair and it seems curious I have gone into it. And yet it surely is better than to paint pandering pictures to please the ignorant listless moneyed class in this U.S." Although he was a candidate for the State Assembly in November 1911 and ran again in the primary elections in September 1912 and 1913 for the same seat, there is barely a mention of these activities in his published Diary.[45] Attending a Socialist Party fund-raising dinner, he remarked to his Diary on September 15, 1911, that "I enjoyed it much as one enjoys squeezing a painful boil and yet I think it was a good thing." And when on November 12, 1911, he attended a lecture by Emma Goldman, which drew other socialists as well, he complained: "She was good but here and there demanded too much social consciousness from the artist. For instance, she said that if the great painter (therefore revolutionist) should paint a wealthy lady he would show the parasite covered with diamonds—this is too far, takes it out of art— which is simple truth as felt by painter." These instances show symptoms of his vacillation between full partisanship in the working-class cause and his need to individualize himself. For Sloan, in arguing for simple truth *as felt by the*

Figure 15.9 John Sloan, *Sunday Afternoon in Union Square*, 1912. Oil on canvas, 26¼ × 32¼ inches. Bowdoin College Museum of Art, Brunswick, Maine, bequest of George Otis Hamlin.

painter, was rejecting the collective response and opting instead for the individual response. The working-class view would naturally be full of anger and bitterness, which Goldman understood; but in his paintings Sloan was not willing to represent those emotions—emotions that carry the threat of violence as well.

In arguing for simplicity, he was contending that aesthetically and psychologically simplicity makes for more effective images. Coincidentally, a few days later, on November 17, 1911, he wrote of reading Frank Harris's *The Bomb:* "It is a good piece of historical fiction—makes a good story which takes all the known facts of the legal murder of the Chicago Anarchists in '86 and makes a probably [sic] life story. Very simple language and true 'convincing' as they call it."[46] Indeed, the appeal of Sloan's paintings of this period lies in large measure in their convincing simplicity.

The review, thus far, of his choice of subjects in his paintings confirms his distancing from politics in his art. His everyday-life paintings of the period 1910–13 do not differ in content from the earlier ones.[47] As before, he turned to women as the primary subjects. He went to a May Day meeting in Union Square

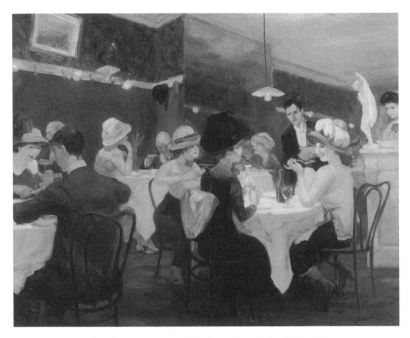

Figure 15.10 John Sloan, *Renganeschi's Saturday Night*, 1912. Oil on canvas, 26¼ × 32 inches. Copyright 1996 The Art Institute of Chicago, all rights reserved, gift of Mrs. John E. Jenkins, 1926.1580.

in 1912; what he had seen might have occasioned a painting of events at the meeting. But his painting that year of a scene of Union Square, *Sunday Afternoon in Union Square* (fig. 15.9), represents two young women strolling through the park. In 1912 Dolly was very active in the support of the strike of Lawrence, Massachusetts, mill workers and organized the housing for the Lawrence children who had been sent to New York during the strike. But instead of painting women organizers in 1912, Sloan depicted women enjoying a meal at a popular restaurant in his *Renganeschi's Saturday Night* (fig. 15.10). In these two paintings women are the focus of attention—strolling together or dining together. If aware of male attention, they choose to ignore it. These women have been emancipated by the artist through his art, and they represent the smiling aspects of what everyday life might be.

Sloan had a need to distance himself from women for his art. And his art provided a rationale against giving himself over to full involvement in politics. The either/or stance—an artist either makes art or makes politics—offered a convenient justification and was fully sanctioned by tradition, his friends, and his patrons.

The intentions and styles of artists often change in tandem with the attitudes of their critical audience—the supportive system that sanctions or condemns their innovations and progress. In the twentieth century an artist's critical audience consists of family, friends, fellow artists, and art critics (whose praise or advice affects the artist's emotional morale), as well as dealers, curators, museum directors, and art collectors, collectively called "the patrons." The patrons provide important financial support by purchasing or commissioning specific works, and as tastemakers they can influence the course of an artist's success, if not always the artist's career.

Robert Henri encouraged Sloan during the artist's early New York residence, and he and his first wife, Linda, were frequent guests at the Sloans'. Henri, as a philosophical anarchist, took a position with younger artists of championing freedom of subject and expression.[48] Because Henri eschewed organizations or philosophies that would restrict the artist's individuality, he would have encouraged Sloan's intentions not to be "doctrinaire" in his paintings. However, after Henri's second marriage in 1908, the Sloans saw less of him, and his influence on the younger painter waned.[49]

The painter John Butler Yeats, father of William Butler Yeats, replaced Henri as the central influence on Sloan following their meeting on July 22, 1909. The elder Yeats acted as a force of moderation, writing to Sloan, "Only minor artists and poets meddled with propaganda—except in their unripe youth."[50] Van Wyck Brooks, who frequented the circle of Yeats and Sloan, observed in his biography of Sloan: "Yeats saw in Sloan 'the artist and poet, solitary, self-immersed in his own thoughts,' with 'no desire to impress other people,' but with 'the kind of spontaneity which makes his pictures refreshing to the eye wearied with conventional art.' For the rest, human as Yeats was, he delighted in 'this artist's message . . . that human nature has a perennial charm.'"[51] These sentiments were expressed in Yeats's many conversations with Sloan, recorded in the latter's Diary, as well as numerous letters from Yeats to Sloan. Yeats imposed on Sloan the image of the artist as solitary, self-immersed, and by nature alienated from social and political life. The affection of Yeats for the Sloans was mutual. When Yeats died, Sloan wrote to the family in Ireland: "He was a second father to me." Helen Farr Sloan has recorded that Sloan further remarked about Yeats: "When I became too exercised about problems of social justice, losing my sense of humor and perspective on things in general, he scolded me."[52] In other words, Yeats helped Sloan distance himself from politics.

All during the period 1904–16 Sloan supported himself by the sale of his illustrations to the New York magazines, his puzzles for the *Philadelphia Press* through 1910, occasional portrait commissions, and a stint of teaching here and there. He had high hopes of selling his ten etchings of 1905–06, entitled

New York City Life, which he took around to gallery dealers and sent to the exhibition of the American Water Color Society in March 1906.[53] He did interest the influential critic Russell Sturgis in viewing them and offered a set to Sturgis. Sturgis slipped out only *Turning Out the Light* for his own collection, thereby breaking the set, to Sloan's annoyance. Frank Weitenkampf, the knowledgeable print curator of the New York Public Library, purchased a set for the library, and John Quinn, the wealthy lawyer and collector of early twentieth-century art, purchased a group of Sloan's etchings in 1910.

The critical reception of his paintings in those early years was mixed—approval from his friends and sympathetic critics, and indifference or rejection from the art establishment. Each year he sent works to the National Academy of Design annual, but their acceptance depended in large measure on whether Henri or a sympathetic friend was on the jury of selection. Although Sloan made light of his rejections, he must have felt some regrets. The exhibition of The Eight at the Macbeth Galleries and the Independents Exhibition in 1910 brought his work to public attention in a context in tune with his own aims. By 1913, events indicated a turn for the better. That year he sold his first painting, *Nude in the Green Scarf,* to Dr. Albert C. Barnes, a school chum from Philadelphia. In 1915 he received a bronze medal for an etching at the San Francisco Pan-Pacific International Exposition, and that year he met Mrs. Gertrude Vanderbilt Whitney, who gave him his first solo exhibition at the Whitney Studio from January 26 to February 6, 1916.

Such recognition did not mean that his paintings were sought after, merely that the professional art world began to recognize his merit. According to Helen Farr Sloan, he had sold only eight paintings by the time he was fifty years old; and only in that year, 1921, did he sell a painting to a museum, when the Metropolitan Museum of Art purchased *The Dust Storm, Fifth Avenue* of 1906.

On the face of it, this brief history indicates a pattern little different from that of any other artist struggling for recognition. The diaries and letters, however, disclose that one patron stood out as an important friend and shaping influence: John Quinn.

Sloan's references in his Diary before his meeting with Quinn indicate his antagonism to rich patrons. On January 11, 1910, he worried that the Independents Show would provide an opportunity for the rich to be patrons of art. The remarks imply both his antagonism toward the rich, an antagonism shared by most other socialists, and an awareness of the subtle power of patrons to subvert the political and artistic integrity of artists.

John Quinn, however, was to become to Sloan the model of the enlightened rich collector. A review of Sloan's impressions of their meetings reveals Sloan's attraction to the urbane and upright lawyer, his pleasure in being entertained by

a man of means, his awareness of his own quite different economic situation, his solicitous desire to be advised by Quinn on legal matters, and, in turn, his willingness to advise Quinn on art purchases. But an underlying and important leitmotif in his recordings is his desire, even eagerness, to have Quinn respond to his paintings.

John Butler Yeats introduced Sloan to Quinn on May 8, 1910, when both visited Quinn's Central Park West apartment to view Quinn's art collection. On June 9, Sloan invited Quinn to dinner along with William Glackens and his wife, noting in his Diary that Quinn showed an interest in Sloan's etchings and his collection of *Charivari* Daumier illustrations. Three days later, Quinn returned to view the paintings and was particularly interested in *The Dust Storm, Fifth Avenue.* Sloan quoted $350 for the work, a price he assured Quinn was $150 less than the exhibition price. Quinn responded that he would buy a painting after consulting with John Butler Yeats. Quinn then ordered a complete set of Sloan's etchings illustrating Charles Paul De Kock's novels.

Sloan's hope for a possible sale to Quinn must have preoccupied him. Two days later, June 14, he recorded with a touch of irony, "Mr. Yeats called and coaxed us to come to Petitpas' for dinner and we consented as he is now to be honored and humored by us, we tell him, on account of the fact that he is acting as Mr. Quinn's advisor in the purchase of a picture." On June 16, 23, and 26, Quinn called on the Sloans. During these ten days or so, Quinn did not buy a painting, but he did buy a number of other Sloan prints in addition to the De Kock etchings, for Sloan noted in the June 26 entry: "He said that he was pleased with the prints that I had sent him. I sent him a memorandum for the lot amounting to $340.00. This went to his office so he as yet had not received it. I can't make up my mind whether this is a large price or not. At any rate it is the smallest price I'd care to part with them for. I rated the 51 De Kock etchings at $250.00." After receiving the check two days later, Sloan added that the purchase was his first large sale, "excepting orders for illustrations which I don't count in importance."

Sloan's admiration of Quinn grew with each meeting and contact throughout the summer. On July 5, Sloan recorded: "Mr. Quinn sent me 16 reproductions from [Augustus] John's drawings in his possession. They are fine and interesting things. Quinn proves to be a good friend to me, and I admire him for a kind of broad fairness of mind. He is a good example of the 'trained' mind as he calls it and advocates it. But it does not always prove as fair and really considerate as his." Quinn, by sending Sloan reproductions, was trying to educate the artist.

Throughout August, Sloan referred often in his Diary to Quinn and his largesse. On August 2 Quinn invited Yeats and the Sloans to dinner. On August 6 Yeats called on the Sloans and read a letter from Quinn "in which Q. repeats

that he intends to buy a painting of mine." On August 13 Quinn treated Dolly, Sloan, John Butler Yeats, and Ezra Pound to an afternoon and evening at Coney Island:

> We dined and talked till nearly 10 o'clock, then went about the "shows." Rode the elephant (my first elephant ride), shot the shutes. Went in some tubs in a wild ride which Mr. Yeats found "much worse than it looked." Ate popcorn and in short did the thing up in great style. John Quinn was full of boyish enthusiasm about the whole place. He has a personal pride in all New York's good things. At about quarter of twelve he puts us all in a big touring car and while at first he intended to take it to Sheepshead there to go home by train he decided to send us all the way to 23rd St. by automobile so we had a swift ride into town (my first long ride in an auto, I see why the rich like them).[54]

Sloan apparently began to feel "rich" himself. With his savings and the recent cash from Quinn, Sloan entertained the possibility of purchasing a house in New York, thereby saving on rent. On August 16 he wrote to Quinn, soliciting his advice. Quinn replied, pointing out hidden expenses Sloan might not have anticipated. Sloan's Diary for August 17 ends with the remark "His letter weakens my idea of doing it."

There are only two brief mentions of Quinn in the Diary from August 17, 1910, to February 3, 1911, when Quinn invited Yeats and Sloan to join him for dinner, to be followed by a preview of paintings put up for auction. Sloan's passage is extensive, ending on a note of ironic realism regarding his own situation. The last phrase, no doubt, was meant to cheer Dolly:

> We saw many poor pictures by famous names sold. . . . By taxi to Mr. Quinn's home after stopping at Shanley's where he had chops and Mr. Yeats and I Irish whiskey. . . .
>
> "I can't paint to suit myself. How then can others paint to suit me." In criticism of a picture by a French Impressionist which Quinn bought lately for about $1200.00! Mr. Quinn has a portrait by Augustus John which is a good crude strong thing it seems to me. Perhaps it misses some of the nobleness of Q.'s head. Mr. Yeats says so. Q. also has a Chas. Shannon, an actress in Spanish dress in part of Donna Anna in "Superman" Shaw's play. Interesting but not great—$2000.00! Just got it. Mr. Yeats and I stepped out of this house of riches, or rather apartment, crowded with pictures and books—into a slushy wet night and home we rode in a street car, but there was a row of interesting faces opposite and a wife at home for me!

Quinn, after all, had not purchased one of Sloan's own paintings, nor would he ever.

On March 23, 1911, Quinn asked Yeats and Sloan to advise him on Manet paintings that he hoped to purchase from the Durand-Ruel exhibition in New York. Sloan's response to the Manet paintings was not wholly enthusiastic, as he frankly told Quinn. On April 15 Sloan was again a willing adviser to Quinn but was obviously aware of his manipulation by the collector: "Today in response to a 'command' from John Quinn, Mr. Yeats and I met Q. at the Union League Club to look at the exhibition. Q. liked the show and said that it was much better than the Independent Kent show, more art." Another gallery was visited by the trio that day, and Sloan urged Quinn to purchase works by Jerome Myers, a fellow painter of the New York working-class scene. Before the month was out, Sloan had sent Quinn more etchings.

As noted above, Sloan was at this time—1910 and 1911—deeply involving himself in the Socialist Party organization, cartooning for the *Coming Nation* and the *Call,* and continuing his production of magazine illustrations in order to support Dolly and himself. Eleven months passed before Sloan again mentioned Quinn in his Diary. The next entry, March 24, 1912, provides the occasion for Sloan to mull over his personal philosophy about his art:

> Mr. Yeats came, routed out of his roost by Mr. Quinn who brought him around to see us. We were glad to see Mr. Quinn who takes a very material interest in my work. He told me he had just bought two of my lithographs from the Berlin Photo Co. . . . I was glad to hear that but surprised that Q. had not known I had some few lithographs. Quinn wanted to buy from me the drawing illustration to De Kock "Madame Dubotte Callé" which I have on the wall in the hall, but I with regret told him I did not want to sell it. The truth of the matter, which I told him, is that it is one of the best drawings I ever made and I could not ask enough for it to compensate me for its absence as a sort of pace setter.

To Sloan, personally favored art was beyond the marketplace—something priceless and a measure for future progress.

Later in the fall of 1912, Sloan wrote Quinn to encourage his financial support for the *Masses.* Sloan felt obliged to assure Quinn that his own art would not be adversely affected by his involvement with this political endeavor. The letter, dated November 24, 1912, opens: "I thank you in the name of the Masses Publishing Company, of which I am a member, for your generous contribution toward the success of our idea. I hope to do my share toward making it an artistic and Socialistic success, but as it is a monthly I do not fear that the work I do for it need sap my force for better things if my paintings can be called such."[55]

Sloan continued with talk of art matters and added that the "breezes of brighter color" are sweeping the land, a reference perhaps to the upcoming Armory Show.

On December 26, 1912, Sloan thanked Quinn for his second contribution of twenty dollars and solicited his thoughts about the magazine. Quinn replied on January 2, 1913, that he "liked the art things, that is your things, better than the text. The poetry I didn't much care for."[56]

On January 23, 1913, another letter of thanks from Sloan repeated his request for an extended response: "I wonder what you think of the magazine. . . . We are trying to keep the magazine as cheerful as we can & tho' I myself cant [sic] quite fiddle while Rome burns we hope to attract some fiddlers."[57]

Quinn's immediate reply of January 24, expanded upon his earlier criticism:

You ask me what I think of the magazine. I think it is too bitter in tone to make converts. Bitterness in propagandist literature may keep those already converted but it does not bring converts. . . . If the aim of the magazine is to *make* converts, there must be argument, reasoning, statements of fact and not exaggerations in text or cartoons.

I understand of course that a person who feels that the present organization of life and business and administration of law results in injustice and cruelty can't always think of the proprieties or the niceties of literature. I'm talking of it merely from the propagandist's point of view. As a rule the more bitter the attack, the harsher the cartooning, the more repellant the thing is and the less it attracts.[58]

Quinn touched on issues that have affected all partisan writing. At what point does propaganda become so vigorous and bitter that its very exaggeration strains the credulity of its audience? Or perhaps I should recast my question: Why indeed should one modify partisan writing and tone down images in order to placate liberal sensibilities? In any event, Quinn's words were also part of the chorus intoning the "dangers" of propaganda in art.

Quinn was encouraging Sloan in the direction of "high" art, lending the artist F. T. Marinetti's Futurist Manifesto.[59] Sloan's response to the Italian avant-garde movement and to the bombast of its manifestoes is not fully known. However, in his letter to Quinn of November 21, 1914, in which he returns the pamphlet, Sloan stated he wanted Quinn to visit his studio, adding: "I'd like to show you my summer work[.] I've an idea you would like many of the things I painted[.] I have without doubt gone on in color and in other ways."[60] The paintings were of the Gloucester shore, far removed from the life and the politics of the city.

A patron's influence on an artist is a subtle affair, and an artist's favorable response should not be construed as a mere eagerness to close a sale. They both were brought close through their shared friendship with John Butler Yeats, a

source of worry as Yeats grew older. Moreover, Sloan admired Quinn's sophistication about art matters, his morally upright and intelligent stance, his sense of personal style, and his freedom to pursue his art interests. Quinn, in turn, seemed to have enjoyed Dolly's and Sloan's company and felt an obligation to encourage and broaden Sloan's artistic horizons. It is therefore not out of order to speculate that Quinn's failure to purchase a painting from Sloan might have prompted the artist to consider that his work lacked aesthetic or other qualities sought by the discerning connoisseur. Sloan's move away from politics toward an involvement with formal, artistic problems coincided with his shift of concern from the mass readership of the *Masses* to the more limited audience that frequented the galleries, including patrons such as Quinn.[61]

Sloan was, however, already moving to broaden his artistic horizons. His preoccupation with the Hardesty Maratta system of colors introduced to him by Henri in 1909 indicates that he never ignored the formal problems of art making.[62] But the important event that turned his head was the Armory Show, to which he sent two paintings and five etchings. Sloan later recalled the enormous impact on his art of the European modernist works exhibited at the Armory Show: "I began consciously to work from plastic motives more than from what might erroneously be called 'story-telling' motives."[63] And again: "The blinders fell from my eyes . . . and I could look at religious pictures without seeing their subjects. I was freed to enjoy the sculptures of Africa and prehistoric Mexico because visual verisimilitude was no longer important."[64] Not only was art not about politics, it was no longer even about life's reality; it was about art. Modernism offered to Sloan, as to many others, a retreat from the world of politics and into the detached and distanced world of formal aesthetic relationships.

Our investigation so far has been intricate, dealing with areas of Sloan's life that were not mutually exclusive. A summation of the main points considered seems to be in order before we return to women as theme.

First, there was no tradition of social criticism in painting in America—although a strong and vital one existed in the European graphic arts, with which Sloan was intimately familiar.[65]

Second, the myth persisted in those years that it was right and natural for women to be removed from commercial endeavors and politics in all its forms—that the function of women was to serve as a comfort or as an inspiration to men, and that women were pure, untouched by the stains and strains of civilization. And the myth found its expression in the art of the period.

Third, Sloan was indelibly impressed with Henri's admonitions to express in paint the élan and spirit of working people living in New York. Sloan remarked about Henri in 1948: "Henri . . . was my father in Art, I got my Whitman

through him. Whitman's love for all men, his beautiful attitude toward the phys-
ical, the absence of prudishness . . . all this represented a force of freedom. . . . I
liked what resulted from his descriptive catalogues of life: They helped to inter-
est me in the details of life around me."[66] Sloan was part of a movement that as-
serted its identity by its doggedly realistic scenes, which did not, however,
completely challenge the old myths.

Fourth, John Butler Yeats, whose influence on Sloan replaced that of Henri,
reinforced Sloan's belief that "serious" art must not be partisan, must not be
burdened with "extra-aesthetic" intentions. John Quinn, a source of patronage
for Sloan, reasoned that even in political cartoons, "the more bitter the attack,
the harsher the cartooning, the more repellant the thing is and the less it at-
tracts." Propaganda was, to be sure, unaesthetic. Moreover, *none* of Sloan's close
friends were engaged in the creation of a partisan painting; they were not even
attracted to his politics. He must have had many doubts, particularly when his
output of paintings reached a low. On August 10, 1911, he confided to his Diary:
"I'm sure my conservative artist friends would say that's what's the matter with
Sloan. Too much Socialism. I don't agree with this theory of my present poor ef-
forts at painting." He also smarted when his friends accused him of losing his
sense of humor because of his socialism. It was Yeats who pushed Sloan back to
individualism at a time when the dream of community was collapsing.

For, finally, the socialist movement at that time was failing to provide a well-
formulated ideology and determined organization to combat the growing na-
tionalism as well as individualism, because it contained serious revisionist
tendencies, including the failure to commit itself to seizing political power. The
socialist movement, one could say, also *distanced* itself from power politics.

Thus, in the years before the country entered the war, Sloan's depictions of
women mirrored a complex response to life—his commitment to the lives of the
urban working classes as well as an artistic aversion to venturing into the rela-
tively new terrain (at least for Americans) of conjoining painting with politics. In
spite of the fact that in many instances women, including his wife Dolly, fully
participated in strikes and mass meetings, Sloan shared the attitude that viewed
women as embodiments of innocence removed from the "class struggle." They
were, then, suitable subjects for Sloan's definition of art as "simple truth as felt
by the painter."

Sloan also held on to the assumption that serious art, especially painting,
must be ideologically neutral, that is, above partisanship. On August 1, 1911,
Sloan wrote to Abe Simons of the *Coming Nation,* refusing to write an article for
the magazine. He confided to his Diary, "Said that I couldn't and wouldn't write
an article such as I think he wants showing how art is being democratized. I told
him that when propaganda enters into my drawings it's politics not art—art

being merely an expression of what I think of what I see." Sloan refused to unite the two aspects of his concerns; either one made art, or one made political propaganda. And *art* to Sloan was personal expression, not social expression.

Perhaps Sloan realized that the realistic depiction of working-class men could not have avoided partisan, and even violent, themes arising out of the antiwar movement, labor strikes, and other social struggles of the time. Such themes would not, he knew, be "simple truth." Perhaps, then, he rejected men and their concerns as too complex and too inherently partisan to be appropriate subjects for his paintings, except for two or three works such as the McSorley's Bar paintings, which show men at their leisure. But it is precisely men who dominate the representation in his political illustrations.

Given the aesthetic position that the artist should stand apart and the ideological position that a socialist should avoid revolution by working instead through the polls and with methods of verbal persuasion, and given Sloan's fascination with women and his idealization of them as joyous and innocent, the choice of women as dominant subject and theme for Sloan's paintings and etchings seems inevitable.

Sloan was neither ahead of nor behind his times, and he responded much as others did. If he had focused on the contemporary struggles and aspirations of both sexes of the working class (which he understood), he might have contributed to an authentically radical, revolutionary painting—an art that finds universal significance and validity in the specific and concrete actualities of the lives of real working people, that does not view art and social consciousness as antagonistic, and that challenges the bourgeois illusion of the neutrality of art.

Notes

This essay was originally published, in an expanded form, in *Prospects* 5 (1980): 7–19. The author has updated and edited the notes for the present publication.

1. John Sloan, "Early Days," in Helen Farr Sloan, ed., *American Art Nouveau: The Poster Period of John Sloan* (Lock Haven, Pa., 1967), unpaged. Sloan made the remarks in about 1946 or 1947 according to Mrs. Sloan in conversation with the author, March 12, 1979. Joseph J. Kwiat, however, argues that Sloan was socially conscious in his paintings, in "John Sloan: An American Artist as Social Critic, 1900–1917," *Arizona Quarterly* 10 (Spring 1954): 52–64.

2. For histories of the group, see John Edgar Bullard III, "John Sloan and the Philadelphia Realists and Illustrators, 1890–1920" (master's thesis, University of California, Los Angeles, 1968); William Innes Homer, *Robert Henri and His Circle*, with the assistance of Violet Organ (Ithaca, N.Y., 1969); and Bennard B. Perlman, *The Immortal Eight: American Painting from Eakins to the Armory Show, 1870–1913* (New York,

1962). For recent histories of the group, see Elizabeth Milroy, *Painters of a New Century: The Eight and American Art*, exh. cat. (Milwaukee, 1991); Robert Hunter, "The Rewards and Disappointments of the Ashcan School," in Lowery Stokes Sims, *Stuart Davis: American Painter*, exh. cat. (New York, 1992), 35–41; H. Barbara Weinberg, Doreen Bolger, and David Park Curry, *American Impressionism and Realism: The Painting of Modern Life, 1885–1915*, exh. cat. (New York, 1994); and Rebecca Zurier, Robert W. Snyder, and Virginia M. Mecklenburg, *Metropolitan Lives: The Ashcan Artists and Their New York*, exh. cat. (New York, 1995). Although George Bellows was not one of the Philadelphia realists, he needs to be added to this group; see Marianne Doezema, *George Bellows and Urban America* (New Haven, 1992). A recent biography of John Sloan is John Loughery's *John Sloan: Painter and Rebel* (New York, 1995).

3. Frank Luther Mott, *A History of American Magazines* (Cambridge, Mass., 1957), 4: 207.

4. Gustav Stickley, "Social Unrest: A Condition Brought About by Separating the People into Two Factions, Capital and Labor," *Craftsman* 13 (November 1907): 183.

5. Charles H. Caffin, *The Story of American Painting* (New York, 1907), 367.

6. Ibid., 370, 373.

7. Ibid., 367.

8. Robert Henri, "The New York Exhibition of Independent Artists," *Craftsman* 18 (May 1910): 162.

9. For facts and dates I have relied primarily on John Sloan, *John Sloan's New York Scene: From the Diaries, Notes and Correspondence, 1906–1913*, ed. Bruce St. John (New York, 1965), referred to in the text as the Diary. Quotations given with the permission of Helen Farr Sloan. For Sloan's later remarks and comments by Mrs. Sloan published in that volume, the reference will be to *New York Scene*. For dates regarding Sloan's involvement in Socialist Party politics, see Barbara Anne Weeks, "The Artist: John Sloan's Encounter with American Socialism" (master's thesis, University of West Florida, 1973).

10. Helen Farr Sloan in her introduction to *New York Scene*, xx, stated: "When Sloan was actively interested in socialism, back in 1909 until the First World War broke out in 1914, he was often *pressed* by doctrinaire-minded party members to put political propaganda into his work."

11. The dilemma has been shared by many artists, writers, and college professors since Karl Marx first observed, "In an advanced society the petty bourgeois necessarily becomes from his very position a Socialist on the one side and an economist on the other; that is to say, he is dazed by the magnificence of the big bourgeoisie and has sympathy for the sufferings of the people. He is at once both bourgeois and man of the people. Deep down in his heart he flatters himself that he is impartial and has found the right equilibrium, which claims to be something different from the golden mean. A petty bourgeois of this type glorifies *contradiction* because *contradiction* is the quintessence of his being. He is himself nothing but social contradiction in action. He must justify in theory what he is in practice." Marx to P. V. Annenkov, Brussels, Dec. 28, 1846, in *Karl Marx and Frederick Engels Selected Works in Two Volumes* (Moscow, 1955), 2: 451.

12. Weeks, "Artist," 7, believes the roots of Sloan's socialism can be traced back to his

childhood, when he spent Saturdays reading at the Philadelphia Public Library and other days poring over his uncle's print collection of Hogarth, Rowlandson, and Cruickshank.

13. Helen Farr Sloan, Introduction, *New York Scene*, xvi.

14. Helen Farr Sloan in conversation with the author, Aug. 9, 1978.

15. On March 6, 1910, Sloan wrote in his Diary about the General Strike in Philadelphia: "To read of the trouble makes me feel really ill in sympathy for these people ground down and yet unable to see that only by united political action can they do the right thing for themselves. We are feeling the first throbs of the great Revolution. I'm proud of my old home—cradling the newer greater Liberty for America!"

16. See Rebecca Zurier, *Art for The Masses: A Radical Magazine and Its Graphics, 1911–1917* (Philadelphia, 1988), chap. 1.

17. Issues of the *Masses* can be found in the John Sloan Archives, Delaware Art Museum.

18. Regarding bohemianism at this time, see Arthur Frank Wertheim, *The New York Little Renaissance: Iconoclasm, Modernism, and Nationalism in American Culture, 1908–1917* (New York, 1976), particularly "Part One: Iconoclasm: The Revolt Against the Genteel Tradition." Richard Fitzgerald, in *Art and Politics: Cartoonists of the "Masses" and "Liberator"* (Westport, Conn., 1973), 17, maintains that the originality of the *Masses* was in part due to "the unformed nature of American socialism, with its roots in bohemian revolt, before the impact of the Bolshevik model on the United States."

19. Bullard, "John Sloan," 109.

20. The same drawing was also reproduced on the front page of the *Call*, April 25, 1914. For the July 1914 cover of the *Masses*, Sloan represented John D. Rockefeller, Jr., whose family had the controlling interest in the mine, attempting to wash from his hands the blood of the women and children murdered when National Guardsmen set fire to their tents pitched after the Ludlow miners had been evicted from their company-owned homes. See Samuel Yellen, "Bloody Ludlow," *American Labor Struggles: 1877–1934* (1936; rpt. New York, 1974), 205–50.

21. Women appear as supporters for striking men in *Direct Action* in the January 1913 issue of the *Masses*. Sloan was also preoccupied with what he considered the failure of organized religion, as noted by Lloyd Goodrich, *John Sloan* (New York, 1952), 44.

22. See Weeks, "Artist," 40, regarding Sloan's candidacy for judge. Sloan's slide away from the Socialist Party began about this time, according to Helen Farr Sloan, in conversation with the author on Aug. 9, 1978. Goodrich, *John Sloan*, 47, states that Sloan left the Socialist Party "within the next few years" after his 1916 break with the *Masses*. Goodrich adds: "But although no longer active politically, in his thinking and his emotional reactions he remained a socialist to the end of his life, and both in private and public he often expressed himself on that side of issues."

23. The circumstances of Sloan's leaving the *Masses* are discussed in Max Eastman, *Enjoyment of Living* (New York, 1948), 549–56, and Goodrich, *John Sloan*, 45–47. According to Helen Farr Sloan (letter to author, April 3, 1979), Maurice Becker also asked Sloan to attend the meeting.

24. A draft of Sloan's proposal, which enunciated a complete reorganization, is on

file at the Sloan Archives, Delaware Art Museum. The issues were not clear-cut; on the issue of financial support for the magazine, Sloan was more radical than Eastman. Sloan's last point in the proposal stated: "Let us go to our money contributors for as *little* as *possible*. Let us form a committee or ask for volunteers to do this unpleasant work. Let us lift the 'masses' out of the Organized Charity class of drains on the purses of the rich."

25. Quoted in Eastman, *Enjoyment*, 554.

26. Ibid., 555.

27. Ibid. Eastman maintained that Maurice Becker also resigned. Fitzgerald, *Art and Politics*, 38, n. 37, stated that Becker informed him on July 31, 1968, that he did not walk out, and in fact contributed to three more issues of the *Masses*.

28. Regarding the decline of the Socialist Party during the war years, see Daniel Bell, "The Background and Development of Marxian Socialism in the United States," in Donald Drew Egbert and Stow Persons, eds., *Socialism and American Life* (Princeton, 1952), 1: 291–321. The discussion about the Socialist Party is not necessarily valid about other socialist or Marxist groups of that time.

29. Sloan, *New York Scene*, 382.

30. William Dean Howells, *Criticism and Fiction* (New York, 1891), 128.

31. Caffin, *Story of American Painting*, 343–44.

32. George Santayana, "The Genteel Tradition in American Philosophy," in *Winds of Doctrine: Studies in Contemporary Opinion* (New York, 1926), 188. Address delivered in 1911; first published in 1913. I am grateful to Mary Ann Lublin, who several years ago pointed out this quotation to me.

33. I discuss painters of the "genteel tradition" briefly in *The Painters' America: Rural and Urban Life, 1810–1910* (New York, 1974) and *Turn-of-the-Century America: Paintings, Graphics, Photographs, 1890–1910* (New York, 1977).

34. Thorstein Veblen, *The Theory of the Leisure Class: An Economic Study of Institutions* (1899; rpt. New York, 1953), 126.

35. Sloan was aware of these painters and their works. On Nov. 8, 1906, he commented in his Diary on the members of the annual jury of the Pennsylvania Academy of the Fine Arts: "The Penn. Academy Jury has Glackens on it, which is fine, but oh, the rest of the list is out today. Redfield, chairman, DeCamp of Boston, Benson of Boston. Oh the poor Boston Brand of American Art! Childe Hassam, who owes debts of kindness to last year's Juries, Julian Story the temporary Philadelphian. Oh sad outlook! Redfield on the Hanging Committee!! S'death."

36. A pretentiously ambitious yet simplistic and humorless attempt to interpret much of Sloan's work as "evidence of regression to scoptophilic impulses, the original sublimation of which must have led Sloan to become an artist," is John Baker's "Voyeurism in the Art of John Sloan: The Psychodynamics of a 'Naturalistic' Motif," *Art Quarterly*, n.s., 1 (Autumn 1978): 379–95.

37. As Sloan was drawn into politics in 1909, his references to women substantially decrease in that and following years of the Diary.

38. Sloan's drawing made from this memory was "At the Top of the Swing," used as the May 1913 cover for the *Masses*.

39. These notes may later have inspired *Sunday Afternoon in Union Square* (1912, Bowdoin College Museum of Art).

40. These notes may have occasioned *Nursemaids, Madison Square* (1907, University of Nebraska, Lincoln, F. M. Hall Collection.)

41. The first quotation is from John Sloan, *Gist of Art: Principles and Practise Expounded in the Classroom and Studio,* recorded with the assistance of Helen Farr Sloan, rev. ed. (New York, 1977), xxxi. In his Diary, on Oct. 2, 1909, he wrote of seeing a parade of children: "Crowds of children merrymaking always makes me sad, rather undefined in origin—perhaps it is the thought of this youth and happiness so soon to be worn away by contact with the social condition, the grind and struggle for existence—that the few rich may live from their efforts. The struggle to be one of the rich makes the earnest working slave." The second quotation is from the original *Gist of Art,* published in 1939 by American Artists Group, Inc., New York, 244.

42. The distinction has to do with the artist's intentions. Many early twentieth-century artists, intent on expressing the "inner essence" of the thing to be represented, were drawn to theories of empathy, as formulated by the German philosopher Theodore Lipps. Henri, however, stressed personal expression—putting the emphasis on *the artist* rather than *the subject* expressed.

43. The remarks were first made on an NBC television program, May 13, 1949, and quoted in Peter Morse, *John Sloan's Prints: A Catalogue Raisonné of Etchings, Lithographs, and Posters* (New Haven, 1969), 141.

44. George Moore, *Impressions and Opinions* (London, 1891), 318. I am grateful to Alicia Faxon for bringing this reference to my attention. Sloan owned Moore's *Modern Painters* (Sloan Archives). In 1907 he bought Moore's *The Lake* and read *Leaves from My Dead Life* and *Confessions of a Young Man,* all of which were recorded in his Diary.

45. Weeks, "Artist," 40. During her research, Weeks studied the records of the Socialist Party's Branch One at the Tamiment Library, New York University.

46. Entry from Sloan's Diary, Sloan Archives, Delaware Art Museum, not published in *New York Scene. The Bomb* was published in London in 1908 and in New York in 1909. John Quinn, discussed later, owned both copies, which were sold at auction. See Anderson Galleries, *Complete Catalogue of the Library of John Quinn* (New York, 1924), Lots 3845 and 3846. In spot-checking the ellipses in the published Diary (that is, Bruce St. John's edited *New York Scene*), I found few instances as interesting as this remark by Sloan. Often the omissions have to do with addresses of artists, the food he ate, and the like; nevertheless, the serious researcher would find it necessary to peruse the original.

47. A breakdown of the kinds and numbers of paintings done by Sloan can be found in Grant Holcomb III, "A Catalogue Raisonné of the Paintings of John Sloan, 1900–13" (Ph.D. diss., University of Delaware, 1972). Briefly: between 1904 and 1908 Sloan painted 24 genre paintings, 15 portraits, and 45, mostly small, landscapes; between 1909 and 1913, he painted 31 genre scenes, 34 portraits, 9 landscapes, and 11 paintings of the female nude. Helen Farr Sloan reminded the author in a letter of April 3, 1979, that the later works are distinctly lighter in palette.

48. Henri's philosophy at this time was expressed in his article "Progress in Our

National Art Must Spring from the Development of Individuality of Ideas and Freedom of Expression: A Suggestion for a New Art School," *Craftsman* 15 (January 1909): 386–401.

49. The Sloans did not warm to Marjory Henri, whom they met on Oct. 29, 1908. At their second meeting, on Nov. 3, Sloan commented: "Mrs. H. does not seem to show any hopeful signs on second meeting. I can not see what intellectual help she could be, nor economical household assistance—nor can I even feel that she is beautiful as an ornament." Sloan was being ironic in his remark about her as "an ornament."

50. Quoted in Van Wyck Brooks, *John Sloan: A Painter's Life* (New York, 1955), 114. Brooks incorrectly states (p. 101) that the meeting took place in the summer of 1908. He emphasizes Yeats's influence on Sloan, which Helen Farr Sloan confirmed in several conversations with the author during 1978. For another detailed discussion, see Robert Gordon, *John Butler Yeats and John Sloan: The Records of a Friendship* (Dublin, 1978), a shorter version of which was published in the *Art Journal* 32 (Spring 1973).

51. Brooks, *John Sloan*, 121.

52. Quoted by Helen Farr Sloan, *New York Scene*, 339.

53. The Water Color Society rejected four of them for being "vulgar" and "indecent." See Morse, *John Sloan's Prints*, 134.

54. See also B. L. Reid, *The Man from New York: John Quinn and His Friends* (New York, 1968), 86.

55. Letter from Sloan to Quinn, dated Nov. 24, 1912, New York Public Library. Reprinted with the permission of Helen Farr Sloan and the John Quinn Memorial Collection, Manuscripts and Archives Division, The New York Public Library, Astor, Lenox and Tilden Foundations.

56. Letter from Quinn to Sloan, dated Jan. 2, 1913. All the letters quoted here are with the permission of Mrs. Sloan and/or The New York Public Library.

57. Letter from Sloan to Quinn, dated Jan. 23, 1913, New York Public Library.

58. Letter from Quinn to Sloan, dated Jan. 24, 1913, carbon copy on file in the New York Public Library.

59. Quinn, as an early patron of twentieth-century modernism, was an enthusiast interested in converting his American friends. It is not known, however, which version of the manifesto he gave Sloan. The manifesto is not listed in the Anderson Galleries' sale catalogue for Quinn's library.

60. Letter from Sloan to Quinn, dated Nov. 21, 1914, New York Public Library.

61. Sloan, in October 1913, ran an advertisement in the *Masses* offering his New York etchings for sale, but he received not one order. In February 1915 he sent about 1,600 sales-promotional brochures to institutions and individuals culled from *Who's Who*. This venture was almost equally unsuccessful, with only two sales made. See Morse, *John Sloan's Prints*, 17.

62. The Maratta system was described in Sloan's Diary, June 13, 1909: "A regularly gradated sequence; red, orange, yellow, green, blue, and purple with the same 'intervals' and a low keyed set of 'hues' of the same colors. Henri thinks there are great possibilities. The palette which a painter uses now [earth hues and mineral colors], certainly has big jumps in it." Several references to the Maratta system in his Diary were edited out of the published *New York Scene*.

63. Quoted in Brooks, *John Sloan,* 123.

64. Quoted in ibid., 134.

65. It is not known whether Sloan at this time knew of the works of Käthe Kollwitz, the preeminent early twentieth-century artist of social protest, whose etchings are biting indictments of the workers' plight.

66. Sloan in conversation with Joseph J. Kwiat on Nov. 30, 1948, quoted in Joseph J. Kwiat, "Robert Henri and the Emerson-Whitman Tradition," *PMLA* 71, no. 4, pt. 1 (September 1956): 620.

16 O'Keeffe and the Masculine Gaze

Anna C. Chave

Interest in Georgia O'Keeffe has always been keen in the United States—keen enough to rival even the extreme fervor felt for impressionism. When the Metropolitan Museum of Art presented major retrospectives of the work of O'Keeffe and the work of Degas simultaneously in the winter of 1988–89, the O'Keeffe exhibition drew almost as many visitors a day on average as the Degas show.[1] Despite her longstanding popularity, however, O'Keeffe's work has rarely received serious critical treatment; and in the seventy years since her first New York show her critical fortunes have, in general, precipitously declined. To the *New Yorker* in 1926, O'Keeffe was "a raging, blazing soul mounting to the skies"; while to Lewis Mumford, in the *New Republic* in 1927, she was "perhaps the most original painter in America."[2]

A negative review in the *New York Times* of the recent O'Keeffe retrospective betokens the more tenuous critical position her art occupies today. Michael Brenson deemed O'Keeffe "dependent upon inspiration . . . immediacy and touch" in her efforts to convey her "almost mystical feeling for the union of the human body with the body of the natural world." He described how she filled her pictures "with organic shapes and swells" that "reflected the changing colors and shapes inside her"; but he perceived in those images a "sameness" betraying an artist "only capable of limited artistic growth." It followed that O'Keeffe's paintings amounted to, at most, "skillfully designed and sometimes dramatic decor."[3]

Whereas O'Keeffe's fixation on the female body emerged as a limitation in Brenson's account, a comparable preoccupation would emerge as a magnificent

obsession in a review by Jack Flam of the Degas exhibition. In the *Wall Street Journal,* Flam marveled at how "in picture after picture Degas seems to be probing the female body for its secrets, to be reaching out toward a mystery that he sensed, longed for, and was haunted by, but that he was unable fully to grasp. The effort to do so, however, created some of the greatest art of a century remarkable for the greatness of its art." Though Degas' perspective on the mesmerizing female body was necessarily a more removed one than O'Keeffe's, that distance was deemed an advantage as the critic lauded, for instance, the late bather pictures as "awesomely impersonal."[4] Flam reaffirmed Degas' formidable stature, too, by alluding to the virility of one who could relentlessly "probe" the female body until it expelled those "secrets" which supposedly permeate great art. It matters not that we have no proof that the lifelong bachelor was ever sexually active because Degas' actual sexuality is not at issue here. Rather, a great artist is ipso facto a potent artist.

Accustomed to a narrative of art history centered on male artists who commonly created, implicitly for heterosexual male viewers, images of female bodies, the public's reflexive way of consuming the famously female O'Keeffe has been as the object of *its* desire rather than as the agent of her own. Women remain, as Teresa de Lauretis put it, "the very ground of representation, both object and support of a desire which, intimately bound up with power and creativity, is the moving force of culture and history." While "'the naked woman has always been in our society the allegorical representation of Truth,'" this is a truth that could be articulated only by the knowing probing of the phallic brush or pen—a truth that O'Keeffe might hope to embody, but never to enunciate.[5]

As to O'Keeffe's body: it was subject to intense public interest from the first, owing in part to the erotic photographs taken of her by her lover (turned husband) Alfred Stieglitz. That the literature on her is almost universally biographical—O'Keeffe being one of the most biographized artists in all art history—also indicates how the public fascination has been more with the woman than with the art. (It is symptomatic that the catalogue for the retrospective in question consisted mainly of her letters and of a personal memoir by her last assistant.)[6]

Even when O'Keeffe's work was most warmly received by critics, in the 1920s, they did not generally regard her as entirely responsible for her own achievement. When a critic for the *New York Sun* compared an O'Keeffe show favorably to an impressionist exhibition in 1923, for instance, he said of the latter pictures: "Here are masculine qualities in great variety and reserve. But as in this unfair world, though the man spends a lifetime in careful consideration of a question his answer may seem no more sure than the one the woman [O'Keeffe] gets by guesswork."[7] To critics then as now, O'Keeffe was an intuitive creature who groped her way along. A review of her first solo show, in 1917 at Stieglitz's

"291" gallery, sounds similar to (if more positive than) Brenson's: "Here are emotional forms quite beyond the reach of conscious design, beyond the grasp of reason—yet strongly appealing to that apparently unanalyzable sensitivity in us through which we feel the grandeur and sublimity of life."[8] This notion of O'Keeffe as a purely instinctual being persisted throughout the period. Waldo Frank portrayed her as "a glorified American peasant . . . full of loamy hungers of the flesh" and given to "monosyllabic speech." And Lewis Mumford conjured an image of the artist as plant, saying that "all these paintings come from a central stem . . . well grounded in the earth."[9] By extension, O'Keeffe's art was often seen as evincing some primitive organism's native habitat: "there are canvases of O'Keeffe's that make one to feel life in the dim regions where human, animal and plant are one, undistinguishable, and where the state of existence is blind pressure and dumb unfolding," wrote Paul Rosenfeld.[10]

But O'Keeffe was no plant, no amoeba, and no dimwit: she was a self-possessed, literate individual who formulated with great deliberateness often eloquent visual descriptions of her ideas, perceptions, and feelings.[11] O'Keeffe saw art precisely as a means of saying what she wanted to say in a way that suited her. As she observed in a public statement for her first major exhibition, in 1923 at the Anderson Galleries, she knew that as a woman her social freedom was strictly limited: "I can't live where I want to—I can't go where I want to—I can't even say what I want to." Her art was therefore prompted by the realization that "I was a very stupid fool not to at least paint as I wanted to and say what I wanted to when I painted. . . . I found that I could say things with colors and shapes that I couldn't say in any other way—things that I had no words for."[12] O'Keeffe further explained her motivations when she wrote the same year to her friend Sherwood Anderson of her deep "desire to make the unknown—known." Using the then-standard male pronoun, she explained, "By unknown—I mean the thing that means so much to the person that he wants to put it down—clarify something he feels but does not clearly understand. . . . Sometimes it is all working in the dark—but a working that must be done."[13]

For a woman to find an effective way of picturing her desires was (and remains) an extraordinary feat.[14] That O'Keeffe accomplished that feat was appreciated initially by her closest friends,[15] and slightly later by Stieglitz, who, legend has it, sensed in the first work he saw by her (late in 1915) that he had encountered "at last, a woman on paper." The critics and the public—especially, it is said, the female public[16]—marveled in their turn at this phenomenon. Henry Tyrell, critic for the *Christian Science Monitor,* wrote of her first solo show, in 1917: "Artists especially wonder at [her art's] technical resourcefulness for dealing with what hitherto has been deemed the inexpressible—in visual form, at

least. . . . Now, perhaps for the first time in art's history, the style is the woman." Rosenfeld exclaimed in 1921, "It is a sort of new language her paint speaks. We do not know precisely what it is we are experiencing. . . . Here speaks what women have dimly felt and uncertainly expressed." And Mumford declared in 1927: "What distinguishes Miss O'Keeffe is the fact that she has discovered a beautiful language . . . and has created in this language a new set of symbols; by these means she has opened up a whole area of human consciousness which has never, so far as I am aware, been so completely revealed in either literature or in graphic art."[17]

For some critics, certainly, this "woman on paper" (or canvas) was merely a kind of freak. But to others, O'Keeffe's distinctive art opened vital new territories in the visual realm and brought credit and honor to a nascent American modernist culture. To Edmund Wilson, writing in 1925, O'Keeffe "outblazed" the work of the men around her, while Henry McBride exulted that "in definitely unbosoming her soul she not only finds her own release but advances the cause of art in her country."[18] As events transpired, however, O'Keeffe would be ushered briskly out of the limelight once the victory of that "cause" was in sight. To Clement Greenberg, mouthpiece of the New York School during its rise to international prominence after World War II, O'Keeffe was merely a "pseudo-modern" whose work "adds up to little more than tinted photography . . . [or] bits of opaque cellophane."[19] By what became the normative modernist standards, the art of O'Keeffe fell short; and her abortive relation to abstraction and her manifest indifference to cubism have long since rendered her persona non grata among critics prone to certain modernist orthodoxies.

O'Keeffe was neither ignorant nor contemptuous of European experiments in abstraction, however. She had studied Braque and Picasso drawings at 291 as early as 1914, had pored over issues of *Camera Work,* and had read Kandinsky's *On the Spiritual in Art* carefully at the outset of her career. The "errors" her art was prone to—not only its sometime literalism, but also a flatfooted way with oil paint, an occasionally cloying palette, and a shallowness of surface—might be taken as a sign less of provincialism than of her search for a voice distinct from the European masters'. This difference emerges, for instance, in O'Keeffe's confession that she longed to be "magnificently vulgar . . . if I could do that I would be a great success to myself."[20]

In O'Keeffe's day, painting as an American, like painting as a woman, meant working from a shallow cultural and historical background. Her pictures accordingly tend to express their values on the surface, collapsing depth and focusing on the surfaces of objects. Avoiding telltale references to Cézanne or Picasso, O'Keeffe attempted to develop a voice that would speak, comprehensibly and

vividly, of her own experience: a midwesterner's, an American's, a woman's experience. To realize her ambition, O'Keeffe knew she had to paint the "wrong" way, as the approved visual languages were developed in other contexts to serve other ends. It seems that this is what she meant when she wrote: "I just feel I'm bound to seem all wrong most of the time—so there is nothing to do but walk ahead and make the best of it."[21] In the process, she admitted that she felt at times "not steady"[22] or "rather inadequate," and would "wish that I were better," but she knew all along she was a pioneer. And in 1945 she proudly claimed, "I think that what I have done is something rather unique in my time and that I am one of the few who gives our country any voice of its own."[23]

While Stieglitz and his followers proselytized for the development of a native American vision, O'Keeffe noted wryly that, among them, she "seemed to be the only one I knew who didn't want to go to Paris. They would all sit around and talk about the great American novel and the great American poetry, but they all would have stepped right across the ocean and stayed in Paris if they could have. Not me. I had things to do in my own country."[24] In attempting to devise an American idiom, she learned from other artists in Stieglitz's sphere, especially Arthur Dove and Paul Strand. But she managed to formulate a language that, even in its most abstract moments, had a more vernacular tone, and proved more popularly accessible and commercially viable than theirs did.[25]

In developing (a woman's) visual language of desire, however, O'Keeffe was on her own. Her solutions to that problem were, admittedly, uneven: now crude and obvious, now elegant and ingenious. She rejected from the first the dominant mode of invoking desire; that is, she did not depict in a literal way the site of desire itself, the human body.[26] Not only did she deny viewers the opportunity to look in a sexually predatory way at images of female anatomy (though critics proved remarkably inventive even so in their voyeuristic readings of her art's metaphorical content), but she also disdained the obvious, if self-defeating, countermove of inviting viewers to gaze at the male body. Instead, O'Keeffe portrayed abstractly her experience of a feminine body, her body, alluding especially to areas that are invisible (and unrepresented) due to their interiority. She devised for viewers an ever-expanding catalogue of visual metaphors for the experience of space and of penetrability generally.

A revisionist model of sexuality and of sexual development, one centered around voids (vaginas, wombs) and penetrability, has lately been posited by Luce Irigaray in her critique of Freud and Lacan.[27] O'Keeffe's imagery—with its myriad canyons, crevices, slits, holes, and voids, its effluvia, as well as its soft swelling forms—complements Irigaray's vision, as it visualizes abstractly what differentiates female bodies: the roundness, the flows and above all the spaces. In certain paintings O'Keeffe depicted spaces penetrated by long, rigid forms

Figure 16.1 Georgia O'Keeffe, *Black and White,* 1930. Oil on canvas, 36 × 24 inches. Whitney Museum of American Art, New York, copyright 1997 the Georgia O'Keeffe Foundation/Artists Rights Society, New York.

(fig. 16.1), and these works may be and often were read as images of the experience of coition (their abstractness notwithstanding). Wrote Lewis Mumford: "She has revealed the intimacies of love's juncture with the purity and the absence of shame that lovers feel in their meeting; . . . she has, in sum, found a language for experiences that are otherwise too intimate to be shared."[28] Said McBride, "It was one of the first great triumphs for abstract art, since everybody got it."[29]

Significantly, O'Keeffe first developed such an imagery when the campaign for the sexual self-determination of women through access to contraception was at a peak—a campaign that reflected a growing acceptance of women's sexual expression by unfastening the instrumental link between sexual activity and procreation. As John d'Emilio and Estelle B. Freedman have documented, "By the 1920s Americans were clearly entering a new sexual era [distinguished by] . . .

Figure 16.2 Georgia O'Keeffe, *Flower Abstraction*, 1924. Oil on canvas, 48 × 30 inches. Whitney Museum of American Art, New York, copyright 1997 the Georgia O'Keeffe Foundation/Artists Rights Society, New York.

the new positive value attributed to the erotic, the growing autonomy of youth, the association of sex with commercialized leisure and self-expression, the pursuit of love, the visibility of the erotic in popular culture, the social interaction of men and women in public, [and] the legitimation of female interest in the sexual."[30]

O'Keeffe's abstract and highly sensual images of often labialike folds, sometimes rendered in pastel shades, invoked associations not only with the body but with skies and cloud formations, as well as with canyons and the anatomy of flowers (fig. 16.2). She had intense feelings for certain natural elements, especially the open skies and spaces of the plains, and she found in natural configurations, large and small, homologies for the felt experience of the body. Her distinctive visual language first took shape when she was living in Canyon, Texas

Figure 16.3 Georgia O'Keeffe, *City Night*, 1926. Oil on canvas, 48 × 30 inches. The Minneapolis Institute of Arts, copyright 1997 the Georgia O'Keeffe Foundation/Artists Rights Society, New York.

and struggling to paint the Palo Duro Canyon nearby. The invisibility of the beautiful canyon fascinated her; she said, "It was a place where few people went. . . . We saw the wind and snow blow across the slit in the plains as if the slit didn't exist."[31] Later, even in painting the built environment of New York City, she often focused on architectural canyons or on the spaces between and over buildings as much as on the buildings themselves (fig. 16.3). Further, O'Keeffe moved to the top of a New York City skyscraper, as close as possible to the sky, as soon as such accommodation became available.[32] As a native of the rolling Wisconsin landscape who later chose to move to the open plains of Texas and New Mexico, she sometimes wrote to friends out west (when personal circumstances kept her in the city) asking them to "kiss the sky" for her.

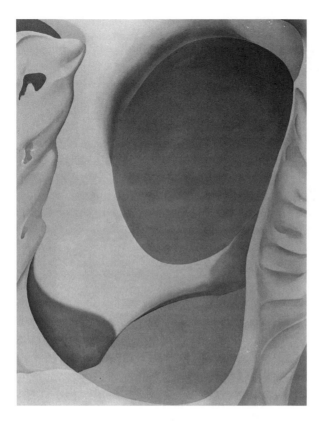

Figure 16.4 Georgia O'Keeffe, *Pelvis II,* 1944. Oil on canvas, 40 × 30 inches. The Metropolitan Museum of Art, New York, George A. Hearn Fund, 1947 (47.19), copyright 1997 the Georgia O'Keeffe Foundation/Artists Rights Society, New York.

In a statement to accompany an exhibition of the bone paintings that she did late in her active career, O'Keeffe described herself as "the sort of child that . . . ate around the hole in the doughnut saving . . . the hole for the last and best so probably—not having changed much—when I started painting the pelvis bones I was most interested in the holes in the bones—what I saw through them— particularly the blue from holding them up in the sun against the sky" (fig. 16.4).[33] Her renderings of the empty space framed by pelvic bones made literal what some critics had seen as an oblique reference in many of her earlier pictures: the relation of their voids to the space of the uterus. Critics rhapsodized that "the world [O'Keeffe] paints is maternal," that her pictures' "profound abysses" evinced "mysterious cycles of birth and reproduction."[34] O'Keeffe's art was not the exalted vision of maternal plenitude that many critics like to imagine, how- ever, but was instead, if anything, a report on the experience of childlessness; of the unoccupied womb. When Helen Appleton Read declared in 1924 that "the psychoanalysts tell us that fruits and flowers when painted by women are an un-

conscious expression of her desire for children," O'Keeffe replied defensively, "But what of it, if it is children and love in paint?"[35]

O'Keeffe's earliest exhibited work supposedly prompted Willard Huntington Wright to complain to Stieglitz: "All these pictures say is 'I want to have a baby,'" to which Stieglitz reportedly replied, "That's fine."[36] Stieglitz considered it "fine" because he believed that a woman experiences the world through the womb, "the seat of her deepest feeling," and he wanted to see that feeling visualized.[37] At the same time, he refused to father a child by O'Keeffe, insisting that his decision was in the best interests of her work and of refuting the prejudice that women are capable of creating only babies, not art. (He evidently preferred not to contemplate their ability to do both.)[38]

Stieglitz's denial of his wife's wish to have a child was only one of numerous ways he thwarted her in life as in her art. Though he is widely regarded as responsible for her success, the record now shows that Stieglitz's effect on O'Keeffe was more destructive than not, and that the efforts he made, supposedly on her behalf, were often self-serving.[39] The prerogative of giving birth, which he refused his wife, Stieglitz in effect arrogated to himself, saying that he had given birth to her, and that together they had given birth to her art—those much admired pictures being his progeny.[40] Yet to hear O'Keeffe tell it, her dealer and husband discouraged her innovative moves throughout her career, including the decision to render that priapic urban icon, the skyscraper, and the idea of magnifying the scale of her flowers.[41]

The subject with which O'Keeffe has mostly been identified, of course, is flowers—historically a relatively minor subject, and one often relegated to female and amateur painters. Eschewing those artists' customary innocuous bouquets, however, O'Keeffe selected one or two blooms with particularly suggestive forms and inflated their proportions until they pressed against the pictures' edges (fig. 16.5). The effect could be intensely, disquietingly sexual. McBride described *Dark Iris* of 1926, for instance, as "an innocent flower, but which now presents abysses of blackness into which the timid scarcely dare peer."[42] O'Keeffe took offense at the sexual readings of her flower paintings (as well as of her abstractions), however. And, taking their cue from the artist, numerous critics in recent decades have skirted or minimized her pictures' sexual content. Stieglitz had represented O'Keeffe and her art in sexual terms from the first, however—introducing her to a wider viewing public (in 1921) not directly through her own work but through his many sensual photographs of her, where her paintings sometimes served as hazy backdrops to her voluptuous, nude or lightly clothed body.[43]

O'Keeffe's objection to the sexual readings of her art probably had more to do with the degrading forms those readings took than with any naiveté about her

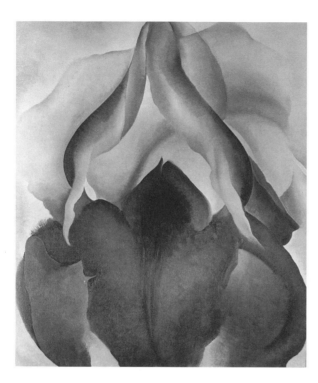

Figure 16.5 Georgia O'Keeffe, *Black Iris*, 1926. Oil on canvas, 36 × 29⅞ inches. The Metropolitan Museum of Art, New York, the Alfred Stieglitz Collection, 1949 (69.278.1).

work's sexual overtones. Her own and others' recollections (of her painting in the nude, for instance) suggest that she had an acute awareness of her sexuality, and that she wanted to express that sense in her art. In a letter to her closest friend in 1916 she said, however tentatively, that her work "seems to express in a way what I want it to . . . it is essentially a womans feeling—satisfies me in a way—. . . . There are things we want to say—but saying them is pretty nervy"[44] Some years later, hoping to find a woman who might write about her art more perceptively than the male critics, O'Keeffe wrote to Mabel Dodge Luhan: "I have never felt a more feminine person—and what that is I do not know—so I let it go at that till something else crystalizes. . . . What I want written . . . I have no definite idea of what it should be—but a woman who has lived many things and who sees lines and colors as an expression of living—might say something that a man cant—I feel there is something unexplored about women that only a woman can explore—Men have done all they can do about it."[45]

Year after year, Stieglitz issued pamphlets for O'Keeffe's shows with excerpts from reviews and essays by Hartley, Rosenfeld, McBride and others—critics who, as the dealer's friends and supporters, were all influenced by his vision of her art. These accounts that Stieglitz elicited, and that he used to promote

O'Keeffe, generally left her "full of furies." She wrote to Sherwood Anderson, "I wonder if man has ever been written down the way he has written woman down—I rather feel that he hasn't been—that some woman still has the job to perform—and I wonder if she will ever get at it—I hope so."[46] The moral of the story of the reception of O'Keeffe's art could be encapsulated by the axiom that "'sexuality is to feminism what work is to Marxism: that which is most one's own, yet most taken away,' . . . most personal, and at the same time most socially determined, most defining of the self and most exploited or controlled."[47] O'Keeffe's expressions of her sexuality were appropriated and exploited by critics for their own ends, made over into mirrors of their own desires.

The sensual qualities of O'Keeffe's art range widely, from the subdued or controlled to the lavish or vulgar depending in part, in her representational images, on the motif she employed: flowers, leaves, shells, bones, canyons and mesas, skyscrapers, and barns. The critics habitually homogenized or reduced the sensual aspects of her work into something lurid and literal, however. In the 1920s, Hartley proclaimed that her images "are probably as living and shameless private documents as exist, in painting certainly, and probably in any other art. By shamelessness I mean unqualified nakedness of statement. . . . Georgia O'Keeffe pictures are essays in experience that neither Rops nor Moreau nor Baudelaire could have smiled away." Rosenfeld wrote, "All is ecstasy here, ecstasy of pain as well as ecstasy of fulfillment." And Kalonyme declared that, in a "sensationally straightforward, clear and intimate" way, O'Keeffe "reveals woman as an elementary being, closer to the earth than man, suffering pain with passionate ecstasy and enjoying love with beyond good and evil delight."[48]

The problem with these accounts of O'Keeffe's art is not that her pictures are not sexual, but that the difficult exercise she set herself, and the now muted, now declamatory visual poetry it yielded, were crudely transposed by critics into a fulsome, clichéd prose. Her art was not described as the vision of someone with real, deeply felt desires, but as the vision of womanhood *tout court* or that depersonalized Woman who obligingly stands for Nature and Truth. To the painter Oscar Bluemner (as to many others), O'Keeffe was the "priestess of Eternal Woman," her art "flowering forth like a manifestation of that feminine causative principle."[49] What we find here, in other words, is what Klaus Theweleit has aptly described in another context as "a specific (and historically recent) form of the oppression of women—one that has been notably underrated. It is oppression through exaltation, through a lifting of boundaries, an 'irrealization' and reduction to principle—the principle of flowing, of distance, of vague, endless enticement. Here again, women have *no names* . . . [And] Exaltation is coupled with a negation of women's carnal reality."[50]

In most critics' eyes, O'Keeffe's art conveyed principles: of maternity, purity,

and, paradoxically, enticement. This contradictory image of the artist as chaste and lustful, as child, seductress, and mother, permeated and permeates the writing on her work. An article on O'Keeffe in *Time* in 1946 was headlined "Austere Stripper," while in 1987 *Vanity Fair* gushed: "Vast and virginal, O'Keeffe's space is one of ecstatic possibility. . . . O'Keeffe is sexy, heartless, canny, wise, stylish, resigned, slatternly, intelligent, pixieish . . . [and] Pretty cocky."[51] As early as 1918, for that matter, Stieglitz described the artist to herself as "the Great Child pouring out some more of her Woman self on paper—purely— truly—unspoiled."[52] In the 1920s, Hartley found O'Keeffe at once "shameless" and near to "St. Theresa's version of life" in its ecstatic mysticism.[53]

Rosenfeld wrote provocatively that in O'Keeffe's pictures, "shapes as tender and sensitive as trembling lips make slowly, ecstatically to unfold before the eye. . . . It is as though one had been given to see the mysterious parting movement of petals under the rays of sudden fierce heat. . . . She gives the world as it is known to woman . . . rendering in her picture of things her body's subconscious knowledge of itself. . . . What men have always wanted to know, and women to hide, this girl sets forth."[54] But what was this tantalizing knowledge that women presumably concealed? Rosenfeld was more explicit on another occasion: "Her art is gloriously female. Her great painful and ecstatic climaxes make us at last to know something the man has always wanted to know."[55]

Why would Stieglitz so relish seeing O'Keeffe's art described in these terms—as reports on her wondrous climaxes—that he invariably used just such phrases to promote her work, despite the intense dismay it caused her?[56] Because those "great painful and ecstatic climaxes," as the public well knew, were given to O'Keeffe by none other than Alfred Stieglitz; her art itself, he liked to intimate, issued out of those experiences. In a review of her first major show, McBride said flatly that O'Keeffe and her art were Stieglitz's creations; that he had fomented the sexual liberation that enabled her (however "subconsciously") to paint: "Georgia O'Keeffe is what they probably will be calling in a few years a B.F., since all of her inhibitions seem to have been removed before the Freudian recommendations were preached upon this side of the Atlantic. She became free without the aid of Freud. But she had aid. There was another who took the place of Freud. . . . It is of course Alfred Stieglitz that is referred to. He is responsible for the O'Keeffe exhibition in the Anderson Galleries . . . and it is reasonably sure that he is responsible for Miss O'Keeffe, the artist."[57]

On one level, no doubt, this relentless stress on Stieglitz's Svengali role, on O'Keeffe's sexuality, and on her art's sexual content is or ought to be puzzling. Much art that is far more explicitly erotic—Matisse's famed odalisques, for instance—is rarely described in such a sexualized way. Whereas art (by a man) that is literally sexual may be discussed in terms of beauty, purity, the sacred,

line-color-and-form, or in relation to the transgressions of the avant-garde, art by O'Keeffe that is only metaphorically sexual gets described in the most lurid terms imaginable: where the literal gets metaphorized, the metaphorical gets literalized. In a review of a show featuring the flower paintings (in which he advised O'Keeffe to get herself to a nunnery), McBride said of her earlier, supposedly lewd abstractions: "To this day those paintings are whispered about when they are referred to at all."[58]

The woman strange and brazen enough to make public such supposedly explicit reports on her sexual satisfactions would inevitably be viewed, whether mockingly or admiringly, as a creature apart. "Psychiatrists have been sending their patients up to see the O'Keeffe canvases," gossiped the *New Yorker* in 1926. "If we are to believe the evidence, the hall of the Anderson Galleries is littered with mental crutches, eye bandages, and slings for the soul. [People] limp to the shrine of Saint Georgia and they fly away on the wings of the libido." Moreover, "one O'Keeffe hung in the Grand Central Station would even halt the home-going commuters. . . . Surely if the authorities knew they would pass laws against Georgia O'Keeffe, take away her magic tubes and her brushes."[59]

Just what is so subversive or so therapeutic or both about the sensual art of Georgia O'Keeffe? The critics of the time might have it that O'Keeffe's art was illicit and potentially censurable owing to its, at best, thinly disguised lewdness. But O'Keeffe's work may have been experienced as treacherous for other, less consciously perceived reasons as well. As she spent so much of her long career picturing the not-there, "the sky through the hole" and the "slits in nothingness" (to use her own phrases) more than beings and things, O'Keeffe might be said to have plumbed the "*hole* in men's signifying economy," to take a passage from Irigaray. That hole or "nothing" which augurs "the break in their systems of 'presence', or 're-presentation' and 'representation.' A nothing threatening the process of production, reproduction, mastery, and profitability, of meaning, dominated by the phallus—that *master signifier* whose law of functioning erases, rejects, denies . . . a *heterogeneity* capable of reworking the principle of its authority."[60]

So who might find such a treacherous exercise, or such contraband, a salve; and who might stand to profit by it? In the first instance, no doubt, it was Stieglitz who profited: he successfully marketed O'Keeffe's art as a kind of soft-core pornography or as a sop to male fantasies by perverting her images into reifications of male desire, of the pleasure men imagine themselves giving women. There are more significant and more salutary benefits to be had from O'Keeffe's improper pictures, however. "Since women has had [sic] a valid representation of her sex/organ(s) amputated," as Irigaray put it,[61] O'Keeffe's pictures may appeal to women by articulating the sensation of crevices and spaces

not as an experience of lack and absence but as one of plenitude and gratification. O'Keeffe described her sexuality in a personal but resonant way, and—without necessarily making any reductive equations of Woman to Nature to Truth—she created in the same stroke a vivid record of her consoling sense of her relation to nature.

For male viewers, too, O'Keeffe's art may potentially be liberating. There is, after all, that lingering question about the pleasure men give women. Lacan suggested that this question lingers because men yearn for that privilege, conventionally reserved for women, of being the cause and the object of desire: "For each partner in the relation, the subject and the Other, it is not enough to be the subjects of need, nor objects of love, but they must stand [also] as the cause of desire. This truth is at the heart of all the mishaps of sexual life which belong in the field of psychoanalysis."[62] In opening up the possibility for the representation of women as agents of their own desire, O'Keeffe opened up new possibilities as well for the sexual positioning of heterosexual men; and the commotion raised by male critics over her "shameless" imagery might be explained, in part, by their glimpsing of those possibilities. Since women have not been constituted as subjects under patriarchy, they have had no legitimate basis for experiencing, let alone describing, their own desire; and it follows that men have had relatively little basis for experiencing themselves as the cause or objects of desire. Insofar as she presumed to describe her desire, articulating a female erotics and claiming a full sexual citizenship, O'Keeffe was indeed an "outlaw." And insofar as her art endeavored to position itself outside the existing visual economy where "woman is constituted as the ground of representation, the looking-glass held up to man,"[63] it was, in a sense, both subversive and hygienic.

If O'Keeffe has been seen as a shamanistic figure, like many important modern artists, and if her art is construed as a transgressive exercise such as avant-garde artists are supposed to perform, then what can explain the shabby treatment she receives at the hands of critics and art historians? O'Keeffe was an inconstant modernist, disinclined to use hermetic languages (however well she understood them) and so bound to remain a comparatively parochial or marginal figure. But just as important, the nature of the project she pursued and the way it has been consumed would prevent her from attaining a major historical position, because art history has been constructed not around women's desires but around men's; not around a model of permeability or mutuality but around one of closure and domination. The body of the artist, O'Keeffe, has thus inevitably been more the object of interest and exchange than the body of her art. O'Keeffe "serves too usefully as an icon for the pictures to be seen as anything other than a gloss on the life," one critic opines.[64]

Even if, in her case, the attractions of the art and those of the artist may

never be prised apart, O'Keeffe should be allowed to become another kind of icon. O'Keeffe pursued and achieved an elusive goal: a popular art that is also a feminist art,[65] enjoyed not exclusively by women. In this country, if not internationally, she excites an interest outreaching that in any other pre–World War II American artist, and rivaling that in most postwar artists as well. If we want to apprehend O'Keeffe's art anew as a worthwhile, complex, even daring endeavor, it is time that the enduring appeal of her work be taken seriously, and the political content of her art be recovered, in all its specificity, its ingenuousness, and its ingenuity, in a different art history.

Notes

This is a revised version of an essay first published in *Art in America* 78 (January 1990).

1. At the Metropolitan, the O'Keeffe show was open to the public for 68 days (Nov. 19, 1988–Feb. 5, 1989), drawing an average of 5,411 visitors a day; the Degas show was open for 97 days (Sept. 27, 1988–Jan. 8, 1989), drawing around 5,561 visitors a day.

2. Murdock Pemberton, "The Art Galleries," *New Yorker,* Feb. 20, 1926: 40; Lewis Mumford, "O'Keefe [sic] and Matisse," *New Republic,* March 2, 1927: 41.

3. Michael Brenson, "How O'Keeffe Painted Hymns to Body and Spirit," *New York Times,* Nov. 8, 1988.

4. Jack Flam, "The Master on View at New Met Galleries," *Wall Street Journal,* Dec. 27, 1988.

5. Teresa de Lauretis, *Alice Doesn't: Feminism, Semiotics, Cinema* (Bloomington, Ind., 1984), 13; and Yann Lardeau, cited in ibid., 26.

6. Jack Cowart, Juan Hamilton, and Sarah Greenough, *Georgia O'Keeffe: Art and Letters,* exh. cat. (Washington, D.C., 1987).

7. Allan Burroughs, *New York Sun,* Feb. 3, 1923; rpt. in *Alfred Stieglitz Presents Fifty-One Recent Pictures: Oils, Water-colors, Pastels, Drawings, by Georgia O'Keeffe, American,* exh. brochure, Anderson Galleries (New York, 1924), n.p.

8. Wm. Murrell Fisher, "Georgia O'Keeffe Drawings and Paintings at '291,'" *Camera Work* 1917; rpt. in *Camera Work: A Critical Anthology,* ed. Jonathan Green (Millerton, N.Y., 1973), 328.

9. Search-Light [pseud. Waldo Frank], *Time Exposures* (New York, 1926), 32; and Mumford, "O'Keefe [sic] and Matisse," 41.

10. Paul Rosenfeld, "Georgia O'Keeffe," *Port of New York* (1924; rpt. Urbana, Ill., 1961), 204.

11. As it conflicts with her image as an intuitive, O'Keeffe's appetite for books tends to be suppressed in the literature. In a recent volume of early correspondence most of her many references to what she was reading (in 1915–17) were excised from the published versions of her letters. Her reading at the time included the *Masses,* Aldous Huxley, Kandinsky, H. G. Wells, Willard Huntington Wright, Clive Bell, Synge, *The*

Trojan Women, Chekhov, Shelley, the *Divine Comedy, Faust,* the *Seven Arts,* the *Fore-runner,* Charlotte Perkins Gilman, Ibsen, and Nietzsche, among other things. See Anita Pollitzer, *A Woman on Paper: Georgia O'Keeffe: The Letters and Memoir of a Legendary Friendship* (New York, 1988).

12. Statement by O'Keeffe in *Alfred Stieglitz Presents,* exh. brochure.

13. O'Keeffe, letter to Sherwood Anderson, September 1923 [?] in Cowart et al., *O'Keeffe,* 174. (The artist's imperfect punctuation has been left intact throughout.)

14. Within feminist film theory especially, a discourse has emerged that describes this errand of giving form or voice to desire as a particularly vital one for women; see Mary Ann Doane, *The Desire to Desire* (Bloomington, Ind., 1987), as well as de Lauretis, *Alice Doesn't.*

15. Anita Pollitzer wrote excitedly to O'Keeffe (then nicknamed Patsy, Pat, or occasionally Patrick) about her most experimental work to date: "they made me feel—I swear they did—They have emotions that sing out or holler as the case may be . . . They've all got *feeling* Pat—written in red right over them—no one could possibly get your meanings . . . but the Mood is there everytime." Oct. 14, 1915, Pollitzer, *A Woman,* 27.

16. Henry McBride observed, "There were more feminine shrieks and screams in the vicinity of O'Keeffe's work this year than ever before. I begin to think that in order to be quite fair to Miss O'Keeffe I must listen to what women say of her—and take notes." "Modern Art," *Dial,* May 1926: 437.

17. Henry Tyrell, "Esoteric Art at '291,'" *Christian Science Monitor,* May 4, 1917; quoted in Laurie Lisle, *Portrait of an Artist: A Biography of Georgia O'Keeffe* (New York, 1981), 106; Rosenfeld, "American Painting," *Dial,* December 1921: 666–67; and Mumford, "O'Keefe [sic] and Matisse," 41–42.

18. Wilson was comparing O'Keeffe favorably to Marin, Hartley, Dove, and Demuth in a review of a group show called "Seven Americans." "The Stieglitz Exhibition," *New Republic,* March 18, 1925: 97; Henry McBride, "Georgia O'Keeffe," *New York Herald,* Feb. 4, 1923; rpt. in *The Flow of Art: Essays and Criticisms of Henry McBride,* ed. Daniel Catton Rich (1975; rpt. New Haven, 1997), 168.

19. Clement Greenberg, "Review of an Exhibition of Georgia O'Keeffe," *Nation,* June 15, 1946; rpt. in *Clement Greenberg: The Collected Essays and Criticism,* ed. John O'Brian (Chicago, 1986), 2: 87.

20. O'Keeffe, Jan. 10, 1927 letter to Waldo Frank, in Cowart et al., *O'Keeffe,* 185.

21. O'Keeffe, September 1929 letter to Mabel Dodge Luhan, ibid., 199.

22. O'Keeffe, Jan. 10, 1927 letter to Waldo Frank, ibid., 185.

23. O'Keeffe, June 11, 1945 letter to James Johnson Sweeney, ibid., 241.

24. Quoted in Blanche Matthias, "Stieglitz Showing Seven Americans," *Chicago Evening Post, Magazine of the Art World,* March 2, 1926; cited in Lisle, *Portrait,* 162.

25. An unnamed *Camera Work* reviewer wrote of the first showing of O'Keeffe's work, in 1916 (an exhibition with two other artists at 291, arranged by Stieglitz without her knowledge), "In spite of the lateness of the season . . . this exhibition, mainly owing to Miss O'Keeffe's drawings, attracted many visitors and aroused unusual interest and discussions." Quoted in Pollitzer, *A Woman,* 138. The *New York Sun* reported that her first major solo show, in 1923, drew 500 people daily; ibid., 183. When Stieglitz mounted a gallery retrospective of her work in January 1934, 7,000 people attended;

Lisle, *Portrait,* 269. In her lifetime, O'Keeffe had major museum retrospectives in Chicago in 1943, at the Museum of Modern Art in 1946, at the Amon Carter Museum of Western Art in Fort Worth in 1966, and at the Whitney Museum in 1970.

Given his antipopulist bent, Stieglitz's difficulty with his other artists was often building a sufficient public to assure them of a living, but with O'Keeffe he had the opposite problem—keeping the public at bay. From 1927 on, she supported herself entirely on the sales of her work (Mary Lynn Kotz, "Georgia O'Keeffe at Ninety," *Art News,* December 1977: 44). By 1935 or 1936 she was fully supporting Stieglitz as well (just as his first wife had—though on an inherited income); see Sue Davidson Lowe, *Stieglitz: A Memoir-Biography* (New York, 1983), 52–53.

O'Keeffe's paintings have always brought high prices. Because she and Stieglitz both disliked parting with her work, he preferred to sell fewer paintings at higher prices rather than the other way around. "[T]hree thousand dollars' worth [of pictures] were sold" from her 1923 show, "perhaps adding up to half a dozen pictures"; Lisle, *Portrait,* 142. In 1927 she exhibited 36 paintings, and in the first few days six were sold for prices up to $6,000. In 1928, a French collector bought six small calla lily paintings (of 1923) for $25,000, and the tabloids picked up the story. In more recent history, at auction in 1987 two O'Keeffes went for $1.9 and $1.4 million; Rita Reif "Record Price for a Work by O'Keeffe," *New York Times,* Dec. 4, 1987.

26. The exception is a series of watercolors of her own body done in 1917 and sent to Stieglitz. O'Keeffe despised life drawing, finding the customary use of the model by artists mortifying and degrading. See O'Keeffe, *Georgia O'Keeffe* (New York, 1976), n.p.

27. Luce Irigaray, *Speculum of the Other Woman,* trans. Gillian C. Gill (Ithaca, 1985), 22–23, 29, and passim. Significantly, around the time O'Keeffe began painting, Karen Horney was already challenging Freud's phallocentric view of women's sexuality in favor of a specifically feminine, vaginal sexuality.

28. Mumford, "O'Keefe [sic] and Matisse," 42 (Stieglitz reprinted this passage in the brochure for an O'Keeffe exhibition at the Intimate Gallery in 1928). Not everyone was so direct: the effusive Rosenfeld described how "rigid, hard-edged forms traverse her canvases like swords through cringing flesh. Great rectangular menhirs plow through veil-like textures; lie in the midst of diaphanous color like stones in quivering membranes." "The Paintings of Georgia O'Keeffe," *Vanity Fair,* October 1922: 112.

29. McBride, "O'Keeffe," 167.

30. John d'Emilio and Estelle B. Freedman, *Intimate Matters: A History of Sexuality in America* (New York, 1988), 233. The battle for the political self-determination of women through suffrage is of course no less a factor in the 1910s. As for O'Keeffe's role in the women's movement, although some feminists complained in the 1970s of her poor feminist consciousness, she was for several decades a vociferous feminist. She read feminist literature, belonged to the National Woman's Party from 1913 through World War II (and was a featured speaker at their convention in 1926), and lobbied for the Equal Rights Amendment. See Lisle, *Portrait,* 73, and O'Keeffe, Feb. 10, 1944 letter to Eleanor Roosevelt in Cowart et al., *O'Keeffe,* 235. Why O'Keeffe elected to distance herself from the 1970s feminists who would so ardently have embraced her is an interesting question, addressed briefly by me in "O'Keeffe's Body of Art," in *Of, For, and By Georgia O'Keeffe* (Stamford, Conn., 1994), and in an unpublished paper, "O'Keeffe and Feminism."

31. O'Keeffe, *O'Keeffe*, n.p.

32. See Anna C. Chave, "'Who Will Paint New York?': 'The World's New Art Center' and the New York Paintings of Georgia O'Keeffe," *American Art,* (Winter–Spring 1991): 86–107.

33. O'Keeffe, "About Painting Desert Bones," in *Georgia O'Keeffe: Paintings, 1943,* exh. brochure, An American Place (New York, 1944), n.p.

34. Kalonyme, "Georgia O'Keeffe," *Creative Art,* January 1928: xl; and Rosenfeld, "O'Keeffe," 203–4.

35. Helen Appleton Read, "Georgia O'Keeffe—Woman Artist Whose Art Is Sincerely Feminine," *Brooklyn Sunday Eagle Magazine,* April 6, 1924: 4.

36. Lisle, *Portrait,* 93.

37. See Stieglitz, Notes on "Woman in Art," 1919; quoted in Dorothy Norman, *Alfred Stieglitz: An American Seer* (Millerton, N.Y., ca. 1973), 137.

38. Lisle, *Portrait,* 160. See also Lowe, *Stieglitz,* 247–48.

39. O'Keeffe complained, "I think I would never have minded Stieglitz being anything he happened to be if he hadn't kept me so persistently off *my* track" in a letter to Dodge Luhan, July 1929 (Beinecke Rare Book and Manuscript Library, Yale University). After Stieglitz died she disclosed, "Alfred once admitted that he was happiest when I was ill in bed because he knew where I was and what I was doing" (Lowe, *Stieglitz,* 323), and she became ill rather regularly on the occasion of her annual shows. In 1932, O'Keeffe suffered a severe breakdown after Stieglitz interfered with her executing a commission she had eagerly accepted to paint murals in the women's powder room at Radio City Music Hall (he reportedly told the designer in charge of the decoration for the project that O'Keeffe was "a child and not responsible for her actions" in agreeing to the commission); Lisle, *Portrait,* 258–61.

40. Ibid., 189. When Stieglitz closed 291 in 1917, giving O'Keeffe the final show there, he declared, "Well I'm through, but I've given the world a woman"; ibid., 107. O'Keeffe once suggested that a curator working on a catalogue essay "put in a sentence to the effect that he [Stieglitz] did not know me personally when he gave me the 2 shows at 291—It often sounds as if I was born and taught to walk by him—and never thought of painting till he worked on me"; April 1944 letter to Carl Zigrosser, Cowart et al., *O'Keeffe,* 236. What galled her most, as Lowe describes it, was "the continuing suggestion that she was a Galatea brought to life by Alfred's Pygmalion, a suggestion to which . . . Alfred himself seemed secretly to subscribe" *(Stieglitz,* 258)—or not so secretly. When he organized major shows of O'Keeffe's work at the Anderson Galleries in 1923 and 1924, the brochures were headlined "Alfred Stieglitz Presents . . . Pictures . . . By Georgia O'Keeffe . . . ," with his name in letters the same size as her's.

41. By O'Keeffe's account, Stieglitz initially refused to show the skyscraper paintings on the grounds that she should keep to subjects more befitting her gender (O'Keeffe, *O'Keeffe,* n.p.). The first enlarged flower was done in 1924, shown in 1925; Stieglitz reportedly said of it: "I don't know how you're going to get away with anything like that—you aren't planning to show it, are you?" (Lisle, *Portrait,* 171).

42. McBride, "Georgia O'Keeffe's Recent Work," *New York Sun,* Jan. 14, 1928; rpt. in *Flow,* 236.

43. Stieglitz staged his own comeback as a photographer with this 1921 exhibition featuring the ongoing study of O'Keeffe that he had begun in 1917. These photographs fueled the public perception that O'Keeffe was "oversexed" and the gossip about the artists' liaison. (Stieglitz, who enjoyed a reputation as a libertine, was not only much older than O'Keeffe but was at this time still married to his first wife.) What is now publicly available of O'Keeffe's private correspondence, including accounts of relationships with some men other than Stieglitz (the letters to him remain sealed), reveal a passionate woman, but certainly not, by present standards, a pathologically sexual one. Yet sensationalized attention to, and speculation regarding, O'Keeffe's sexuality persists.

44. O'Keeffe, letter to Pollitzer, Jan. 4, 1916, in Cowart et al., *O'Keeffe,* 147. A subsequent letter closed with the confession: "I want real things—live people to take hold of . . . Music that makes holes in the sky—and Anita—I want to love as hard as I can and I can't let myself—When he is far away I cant feel *sure* that he wants me to—even though I know it—so I'm only feeling lukewarm when I want to be hot and cant let myself"; O'Keeffe, letter to Pollitzer, Jan. 14, 1916, ibid., 149 ("sure" underlined three times in the original).

45. O'Keeffe, 1925? letter, ibid., 180. The essay Dodge Luhan wrote was never published. The four-page manuscript (Beinecke Rare Book and Manuscript Library, Yale University) represented O'Keeffe's art, in extravagant prose, as the unknowing excrescences of a repressed woman in thrall to Stieglitz.

46. O'Keeffe, September 1923? letter to Anderson, in Cowart et al., *O'Keeffe,* 174.

47. De Lauretis, quoting and amplifying a phrase of Catherine MacKinnon's, *Alice Doesn't,* 184.

48. Hartley, "Some Women Artists," *Adventures in the Arts* (New York, 1921), 116–17; Rosenfeld, "American Painting," 666; and Kalonyme, "O'Keeffe," xl. The notion, suggested by Kalonyme, that in representing women's sexuality, she was also imaging their masochistic nature—the idea that women characteristically take pleasure from pain—is another topos of the O'Keeffe literature.

49. Oscar Bluemner, "A Painter's Comment" (1927), rpt. in *Georgia O'Keeffe: Exhibition of Paintings (1919–1934),* exh. brochure, An American Place (New York, 1935), n.p.

50. Klaus Theweleit, *Male Fantasies,* vol. 1: *Women, Floods, Bodies, History,* trans. Stephen Conway (Minneapolis, 1987), 284.

51. "Art: Austere Stripper," *Time,* May 27, 1946: 74; Mark Stevens, "Georgia on My Mind," *Vanity Fair,* November 1987: 72, 76.

52. Stieglitz, March 31, 1918 letter to O'Keeffe, quoted in Pollitzer, *A Woman,* 159.

53. Hartley, "Some Women Artists," 116–17.

54. Rosenfeld, "O'Keeffe," 202, 205.

55. Rosenfeld, "American Painting," 666. This notion that women do not, will not, and so, perhaps, cannot describe their orgasms became an idée fixe also of Jacques Lacan, who told how he had begged women analysts on his knees "to try to tell us about it, well, not a word! We have never managed to get anything out of them"; Lacan, "God and the Jouissance of The Woman," in *Feminine Sexuality: Jacques Lacan and the Ecole Freudienne,* ed. Juliet Mitchell and Jacqueline Rose, trans. Jacqueline Rose (New York, 1985), 146. For Lacan as for Stieglitz, women's "jouissance" represented a moment of

experience potentially "over and above the phallic term." Woman served in a mystical way as an epigone of nature and so as a site of truth.

56. When O'Keeffe first saw Hartley's article about her, she recalled, "I almost wept. I thought I could never face the world again"; Grace Glueck, "'It's Just What's In My Head,'" *New York Times,* Oct. 18, 1970. In a fall 1922 letter to Mitchell Kennerley, she said she felt embarrassed by Hartley's and Rosenfeld's articles, that she did not recognize herself in them, and, significantly, that they gave her "a queer feeling of being invaded"; Cowart et al., *O'Keeffe,* 171.

57. McBride, "O'Keeffe," 166.

58. Ibid., 167.

59. Pemberton, "The Art Galleries," *New Yorker,* March 13, 1926: 36–37 and Feb. 20, 1926: 40.

60. Irigaray, *Speculum,* 50.

61. Ibid., 105.

62. Jacques Lacan, "The Meaning of the Phallus," in *Feminine Sexuality,* 81. As Irigaray describes it "woman does not so much choose an object of desire for herself as she lets herself be chosen as an 'object'"; *Speculum,* 104.

63. De Lauretis, *Alice Doesn't,* 15.

64. Janet Hobhouse, "A Peculiar Road to Sainthood," *Newsweek,* Nov. 9, 1987: 74.

65. O'Keeffe was both self-identified and identified by others as a feminist from the outset. "If Georgia O'Keeffe has any passion other than her work, it is her interest and faith in her own sex. . . . She believes ardently in woman as an individual—an individual not merely with the same rights and privileges of man but . . . with the same responsibilities. And chief among these is the responsibility of self-realization," observed Frances O'Brien, "Americans We Like: Georgia O'Keeffe," *Nation,* Oct. 12, 1927: 362. Her cohort Paul Strand wrote of "that kind of intensity which burns [in] women like Carrie Nation, Pankhurst, and Emma Goldman, which has become organized and philosophic in the paintings of O'Keeffe"; "Georgia O'Keeffe," *Playboy* 9 (July 1924): 19.

17 The Open Window and the Empty Chair: Charles Sheeler's *View of New York*

Carol Troyen

The year 1931 was an extraordinary one for Charles Sheeler (1883–1965). During that period, he completed many of the pictures now heralded as his greatest achievements—*Classic Landscape, Home Sweet Home, Americana, View of New York*—and with such elegant conté crayon drawings as *Ballet Mechanique* and *Portrait (Katharine)* embarked upon almost a decade of brilliant production in that medium.[1] At the end of that year, he had exhibited—to the acclaim of such astute critics as Henry McBride—at the Downtown Gallery (in his first solo show there), at the Julien Levy Gallery, at the Museum of Modern Art, and at the inaugural exhibition at the Whitney Museum of American Art, which opened in November.

Yet Sheeler did little to extol those achievements. He laconically described *Classic Landscape,* for example, as the result of "opening the other eye" while photographing Henry Ford's River Rouge plant near Detroit.[2] And in 1935, when the Museum of Fine Arts, Boston, purchased *View of New York* (fig. 17.1) and approached Sheeler for his thoughts about it, he replied, "I wish that I could give you an interesting story in connection with *View of New York,* but alas it would have to be drawn from imagination and I am a realist. It was painted in 1931 in a studio which I had at that time in New York. So you see the title really is authentic."[3]

When it was acquired by the Museum of Fine Arts, *View of New York* was found to exemplify Machine Age modernity ("he displays how his design is motivated by standardized forms conditioned by machines. The modulations . . . which are induced by feeling and the personal margin are wanting altogether"[4]),

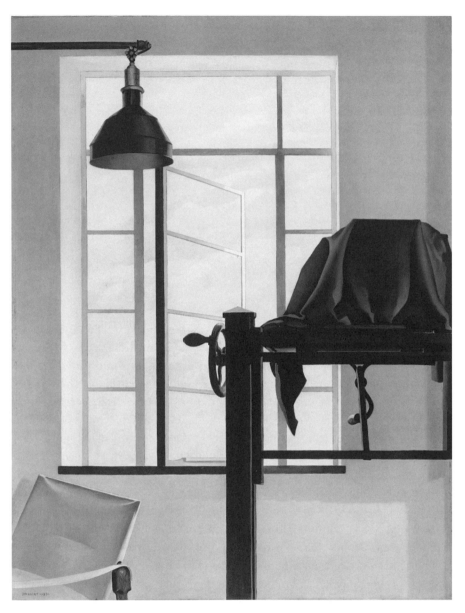

Figure 17.1 Charles Sheeler, *View of New York,* 1931. Oil on canvas, 47¼ × 36¼ inches. Courtesy of the Museum of Fine Arts, Boston, the Hayden Collection.

and indeed the picture may be seen as the embodiment of the "modern look" in interior design. Sheeler's comment to his biographer, Constance Rourke, reflects this attitude: "I know that 'View of New York' may be called a cold picture, it is very uncompromising: some might call it inhuman. It is the most severe picture I ever painted."[5] That statement, while acknowledging the austerity and restraint of the work, gives no clue to the rich pictorial tradition behind it, or to the critical episode in Sheeler's history that it reflects. *View of New York* is a complex and evocative picture, one that points the way to a better understanding of Sheeler, generally seen as remote and classical, at his most personal and romantic moment.

Sheeler's own surroundings had long provided fodder for his art. His small weekend house in Doylestown, Pennsylvania, was the subject of numerous photographs and later of works in tempera, oil, and conté crayon. But being devoid of figures or of obviously personal objects, these works provide little direct, biographical data. Even admittedly autobiographical pictures demonstrate Sheeler's reluctance to be known through his work. An ironic reserve lies beneath the literal truth of such images as *Stairway to the Studio* (1924, Philadelphia Museum of Art), where the viewer's access to Sheeler's workplace (and thus to him) is barred by a fence stretched across the head of the stairs, or *Self-Portrait* (1923, Museum of Modern Art), where an inanimate object, a telephone, mediates between artist and viewer.[6] In the latter picture (which shows a telephone on a table and, in the window behind, the headless reflection of a figure, presumably the artist), Sheeler used a neutral title to further distance himself from the image. It was originally called, simply, "Still Life," and subsequently "Audubon 451—," which only Sheeler's closest friends would have recognized as all but the final digit of his own telephone number.[7]

In *View of New York,* Sheeler employs much the same program as he used for the 1923 *Self-Portrait:* a faithfully rendered yet puzzling accumulation of objects; a title which, on the surface, gives nothing away; and an interior view that focuses on a mundane mechanical object. Nothing in the title or the contents of the picture identifies the interior as Sheeler's studio, or the cloud-filled vista as the view he enjoyed through his window.

By 1931, Sheeler had moved forty miles northeast of New York City, to South Salem, New York, but maintained work space at 310 East Forty-fourth Street in Manhattan. He occupied a studio in the newly completed Beaux-Arts Apartment Hotel, a few blocks from the headquarters of his employer, Condé Nast, and produced much of his commercial work there.[8] His studio probably was located on an upper floor of the east side of the building (fig. 17.2), where single and double casement windows opened out over a series of low-rise structures

Figure 17.2 East facade of the Beaux-Arts Apartment Hotel, 310 East Forty-fourth Street, New York. Photograph by the author.

and afforded a view of the East River and beyond. As he said, his title really was authentic.

In depicting his own studio, Sheeler drew upon a subject that artists had been using for centuries both to advertise their talents to potential patrons and to dramatize their own artistic concerns and interests. Vermeer, Rembrandt, Velázquez, Courbet all had painted images of themselves before their easels in their own or in imaginary studios; many of these masterworks Sheeler knew firsthand from his trips to Europe. The subject of the artist's studio had been a continual preoccupation of Sheeler's teacher, William Merritt Chase, who clearly used his numerous images of his sumptuous studio as a form of personal as well as professional self-advertisement, as in *The Tenth Street Studio* (fig. 17.3). Sheeler had long since rejected what he considered to be the self-aggrandizing manner of his teacher, and *View of New York* owes little to Chase's kind of studio self-portrait. The work of another mentor was far more stimulating: in 1929, Edward Steichen published in *Vanity Fair* his *Steichen with Photographic Paraphernalia—Self-Portrait* (fig. 17.4). In that picture, a camera, a lamp, and the photographer himself are paired with their shadow profiles. Steichen's image is as lively and witty as Sheeler's is sober and ironic; nonetheless, the two works have much in common in their active use of shadows and in their identification of a photographer with his equipment.

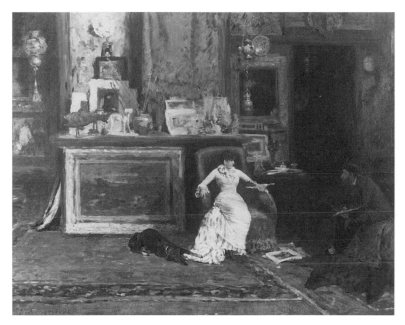

Figure 17.3 William Merritt Chase, *The Tenth Street Studio,* 1880. Oil on canvas, 36 × 48 inches. St. Louis Art Museum, St. Louis, Mo., bequest of Albert Blair.

Figure 17.4 Edward Steichen, *Steichen with Photographic Paraphernalia—Self-Portrait,* 1929. Gelatin-silver print. 13³⁄₁₆ × 9³⁄₁₆ inches. Reprinted with permission of Joanna T. Steichen. The Museum of Modern Art, New York, gift of Samuel M. Kootz, copy print copyright 1997 the Museum of Modern Art, New York.

In the early 1930s, Sheeler produced at least two photographs of his studio, and three larger works—*View of New York, Cactus,* and *Tulips*—each of which is a kind of artistic self-portrait. The simplest in composition is the large conté crayon drawing *Tulips* (fig. 17.5). It shows three tulips in a glass vase placed on a tall, cylindrical pedestal, with a photographer's lamp, unplugged, at the right. Conté crayon enabled Sheeler to work with warm, sensuous textures and subtle gradations of black and white—qualities which, he said, came closest to the feeling of his photographs.[9] Here, the carefully orchestrated tones create shadows whose presence is as vivid as the actual forms. The exchange between advancing and receding spaces, between flat and curved surfaces, between the realistically rendered tulips and their ghostly shadows on the wall creates an energy that belies the ordinariness of Sheeler's subject.

In the large painting *Cactus* (fig. 17.6), Sheeler uses similar motifs and the same compositional formula, although the strict symmetry of *Tulips* is relieved here by pushing the pedestal to the left. A second lamp, also unlit, has been added overhead, and at the upper left edge are lowered Venetian blinds whose zigzag edges and alternating stripes of light and dark create a lively staccato pattern.

View of New York shows another view of the same space, now featuring the window (without the blinds) seen at the left in *Cactus.* As in that painting, the overhead lamp is unlit. But now Sheeler has added his camera and, at lower left, a chair in which a model or client might sit. All three images indicate that the contents of Sheeler's studio were of the moment, and the furnishings depicted

Figure 17.5 Charles Sheeler, *Tulips,* 1931. Conté crayon on paper, 29 × 19 inches. Collection of Mr. and Mrs. James Fisher.

Figure 17.6 Charles Sheeler, *Cactus*, 1931.
Oil on canvas, 45¼ × 30 inches. Philadelphia
Museum of Art, Louise and Walter Arensberg
Collection.

reflect Sheeler's admiration for clear, utilitarian, unembroidered design. The Art
Deco pedestal is perfectly cylindrical and has a metallic sheen; the cactus is per-
ceived as "a streamlined form," "almost machine-like in its suggestions of tough-
ness and durability";[10] the lamps are functional and without ornament; and the
chair in *View of New York*, a prototype of the famous "safari" chair by Danish
craftsman Kaare Klint, was one of the most advanced furniture designs of its
day.[11] Just as Chase's studio was filled with German lamps, Persian rugs, Egypt-
ian pots, and other exotica of the Victorian age, so Sheeler's studio is spare,
sleek, and modern: the functional yet chic workspace of a successful commercial
photographer.

Compared to more conventional renderings of artists in their studios,
Sheeler's pictures of his studio are extraordinarily reticent and ironic. In none of
these images is the artist himself in the picture, and the surrogate he chooses,
the narrative and compositional focus, is an inanimate, ordinary object: the cac-
tus, the tulips, or the camera on its stand. Furthermore, it is a photographer's,
and not a painter's, studio that Sheeler shows us, the setting for his commercial
work and not for the medium—painting—that he claimed was closest to his
heart. The original subjects he exhibited as works of art were not made here; in-
stead, the Forty-fourth Street studio was the location for the work on which
Sheeler was financially most dependent. Finally, and most intriguingly, Sheeler
chose to present his studio as inoperative: the lights are unplugged, in *Cactus*

the blinds are lowered, and in *View of New York* the model or client is gone and the camera covered.

In *View of New York,* these ironies are enriched by a formal program that is equally enigmatic. At first glance, the picture appears soothingly passive and serene: Sheeler has used an elegantly balanced geometric structure, a muted, nearly monochromatic palette, and a smooth, seemingly unarticulated surface. Yet odd distortions of scale and alignment undercut that geometric stability. The enormous silhouette of the camera and stand dwarfs the undersized chair, and its rotation off axis and its jagged profile disrupt the composition's grid structure. Sheeler's cool palette of blue-gray and maroon and the silvery light coming from the window create a placid environment. At the same time, the forms in the picture resonate against the back lighting, and seem to hover in space. The silhouetting of the camera, lamp, and stand flattens them, creating lively linear patterns, and the clever balance of the window frames and the crossbar of the camera stand creates the kind of surface tension that Mondrian recently had evolved in his abstractions. Sheeler's smooth, controlled paint application contributes to the image's measure and restraint, but this relatively austere treatment is reserved for the interior of the studio only. Outside the window, the clouds are luminous and richly brushed, a contrast in rendering that sets up a visual tension between the interior and exterior spaces.

In *View of New York*, as in *Cactus* (and quite possibly in *Tulips* as well), a photograph preceded the larger picture. The compositional changes made from the photograph *Cactus and Photographer's Lamp* to the large oil were relatively minor: the painting is cropped a little more tightly at each side, so that only a fragment of the blind is visible, and the spines have been eliminated from the cactus. Sheeler edited the plant's outline in the painting so that it more precisely echoes that of its shadow. Its contour becomes more streamlined and abstract, but at the same time, without its spines the cactus appears vulnerable.

The photograph preceding *View of New York* (fig. 17.7), on the other hand, is rather different from the oil.[12] Its composition is more frontal, more formally balanced. The vacant chair in the lower left corner of *View of New York* has replaced a small table and lamp in the photograph. The wooden stand has been cranked down so that the camera itself is less dominant, but because Sheeler evidently placed a strong light just behind him when making this picture, the camera throws a large shadow on the Venetian blind behind. The most important difference is that in the photograph the blind has been lowered, blocking out what gives the painting its title, the view of New York. This change underscores the painting's greatest irony, for Sheeler provides the viewer with no conventional panorama of the city—none of the hurtling vehicles, busy streets, or elegant skyscrapers that he depicted so exuberantly in paintings, photographs,

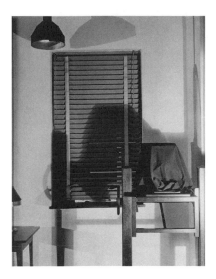

Figure 17.7 Charles Sheeler, *Studio Interior*, c. 1931. Gelatin-silver print. 9⁵⁄₁₆ × 7¼ inches. Courtesy of the Museum of Fine Arts, Boston, the Lane Collection.

and film in the 1920s—but rather a view out a simple, modern window onto an ordinary cloud-filled sky.

Just as Sheeler's depiction of his own studio recalls similar subjects addressed by innumerable artists before him, so his focus on the window allies his composition with another important iconographic tradition. The representation of a window, with a figure or significant object placed before it, has roots in seventeenth-century Dutch genre painting, where the domestic interior was a popular subject. But for Sheeler's work, a more pertinent antecedent was the theme as developed by a group of French and German artists early in the nineteenth century. These artists rejected the heroic grandeur of the aristocratic portraiture and history painting of the previous generation (much as Sheeler had rejected what he viewed as the theatrical, bravura performances of Homer, Eakins, and Chase),[13] and revived the seventeenth-century Dutch tradition of intimate scenes of domestic life, and the sharply realistic, detailed manner in which they were presented. However, these early nineteenth-century artists tended to avoid anecdotal content and elements of the picturesque. Their images were curiously passive in mood, and in them the window assumed increased importance—far greater than was required by its normal role in a domestic interior—for it opened onto a poetic vista. As discussed by Lorenz Eitner, this theme, so fertile for artists turning from the classical style toward the new romantic manner, had two principal variants: one that showed a figure in front of the window, gazing out, and the other in which the window (often in an artist's studio) is the sole motif, as, for example, in Caspar David Friedrich's *View from the Artist's Studio, Window on the Left* of about 1805–06 (fig. 17.8).[14]

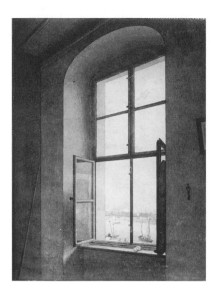

Figure 17.8 Caspar David Friedrich, *View from the Artist's Studio, Window on the Left,* c. 1805–6. Pen and sepia on paper, 12¼ × 9½ inches. Kunsthistorisches Museum, Vienna.

In these pictures, domestic snugness is opposed by the outside world. Tensions between inside and outside, between the familiar and the exotic, between the measurable and the infinite are expressed through dark-light contrasts, or through the juxtaposition of passages handled with enamel-like precision with those treated more atmospherically (just as Sheeler sets off the smooth, nearly invisible brushwork of the studio interior against the looser, richer handling of paint in the sky). For the protagonist, whether an actual figure, a surrogate (like Sheeler's camera), or a presence merely implied by the proximity of the window to the picture plane, the window functions both as a barrier, separating him from the temptations of the outside world, and a threshold, beckoning him from his narrow, confining existence to a more active, if uncertain, life. As Eitner explains, by the 1820s the window image was widely understood as a symbol of romantic ambivalence about nature, about the future, and about the comforts of a familiar, domestic world.

Although popular in Europe, the window image with its romantic associations was not much favored by nineteenth-century American artists, but it was revived by several of Sheeler's contemporaries. Marsden Hartley, for example, treated the theme repeatedly: in such paintings as *Summer, Sea, Window, Red Curtain* (1942, Addison Gallery of American Art, Phillips Academy), the contrast between the plain still life on the window ledge and the vigorously painted choppy sea beyond suggests a longing for a more rugged and exciting world. Edward Hopper, in *Room in Brooklyn* (fig. 17.9), transforms the ambivalence often associated with the motif into a more obvious expression of alienation and

melancholy, for the view through the window—of a blank, unmodulated sky and monotonous, boxy buildings—is here as bleak and devoid of promise as the interior.

Both Hartley's series and Hopper's painting tend to be strongly emotional, which Sheeler's *View of New York* is not in the same obvious way. The portrait-like intimacy and modest scale demanded by this domestic subject was also disregarded by Sheeler, who deliberately chose a large format—at approximately 48 × 36 inches, it was the largest picture he had ever painted—for his interpretation of the theme. He also avoided the lush handling of many contemporary examples, applying his paint thinly and almost imperceptibly everywhere except in the sky, and even the warm, glowing palette of his earlier New York paintings is transformed into an austere, near-monochrome. Finally, Sheeler's imagery—the shrouded camera and undefined view—although within the iconographic canon of the open window motif, is still rather ambiguous, for the interior world with its familiar objects provides little comfort. As Sheeler has shown it, the artist's studio is shut down, not in use; the light is turned off; and the open window does not afford the expected, energizing glimpse of New York, but rather a nonspecific view. Sheeler's *View of New York* is rather severe and uncompromising; its puzzling imagery, assertive scale, tense geometric organization, and sober palette combine to produce a vivid yet enigmatic image.

In its irony Sheeler's *View of New York* is comparable to a construction by the modern master Sheeler most admired, Marcel Duchamp. Sheeler's friendship with Duchamp dated from the late teens and blossomed about 1920, shortly

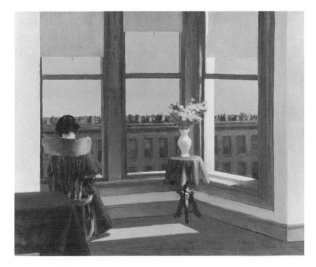

Figure 17.9 Edward Hopper, *Room in Brooklyn,* 1932. Oil on canvas, 29 × 34 inches. Museum of Fine Arts, Boston, the Hayden Collection.

after he settled in New York and Duchamp returned to the city after a two-year absence. Both artists enjoyed the affection and support of the avant-garde art patrons Walter and Louise Arensberg. The two artists met frequently at the Arensbergs' soirées, Duchamp generally dominating the conversation and hijinks. Sheeler, by his own account, was very much a spectator, but the two were nonetheless drawn together and collaborated on several minor projects in the 1920s.[15] Sheeler had great respect for Duchamp's intellect, was deeply impressed by *The Large Glass* and *Nude Descending a Staircase* (both now Philadelphia Museum of Art), and aspired to the French master's skill in making the "statement . . . all important and [skillfully concealing] the means by which it was presented."[16]

One of the first works Duchamp created upon returning to New York in 1920 was *Fresh Widow* (fig. 17.10), a construction of a miniature (30 inches high) French window, painted blue-green, its panes covered with black leather. The title is clearly a pun and is conceived as an integral part of the work, for it is stenciled along the base of the construction along with the name of Duchamp's feminine alter ego, Rose Sélavy. Although threatened sexuality is generally seen as its principal theme,[17] Duchamp's work is richly suggestive, and among other allusions offers a witty gloss on the romantic theme of the open window. As such, it is a visual as well as verbal pun, for the windows are blocked: instead of opening onto a vision of the outside world containing one's dreams and fears, the polished black leather covering them reveals only one's own reflection.

By presenting windows through which one cannot see, Duchamp in *Fresh Widow* seems to deny the thematic tradition from which his work descends. *View of New York* is, in its own way, equally ironic: purporting to offer a view of a great modern city, its windows open onto a cloud-filled sky. The painting is a representation of the artist's studio in which no art is being made. It is a romantic image of an open window with no one present to see anything and no promising scene visible beyond. Even the camera, with its all-seeing eye, is shrouded. As is the case with *Fresh Widow*, the ironic content of *View of New York* provides a screen for a critical episode in Sheeler's career. His insistence on the picture's realism extends beyond an accurate description of the contents of his studio, to a portrayal of his personal and artistic concerns.

In November 1931, an important group of Sheeler's photographs was shown at the Julien Levy Gallery's inaugural exhibition. That same month, Sheeler would have the first major solo exhibition of his paintings at the Downtown Gallery, which by then had become the most exciting gallery for contemporary American art in New York. Its director, Edith Gregor Halpert, became Sheeler's exclusive dealer, adviser, and close friend; both their professional and their personal relationship would continue for the rest of the artist's life. During this

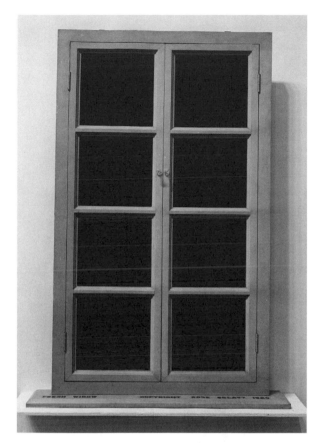

Figure 17.10 Marcel Duchamp, *Fresh Widow*, 1920. Miniature French window, painted wood frame, and eight panels of glass covered with black leather, 30½ × 17¼ inches. Museum of Modern Art, New York, Katherine S. Dreier Bequest. Photograph copyright 1997 the Museum of Modern Art, New York.

period, Sheeler was also enjoying enormous financial success as the result of commercial work for various advertising agencies and for Condé Nast, enabling him to move first to South Salem and subsequently to a larger house in Ridge-field, Connecticut, and to drive a Lincoln Continental, whose luxurious comfort and sophisticated engineering he clearly enjoyed.[18] But just at this time, acting on Halpert's recommendation, Sheeler curtailed his career in photography, which had brought him both critical acclaim and financial security, to concentrate on his painting, a field in which rewards, both critical and monetary, seemed far less certain.[19] By 1932, he had given up his commercial work for Condé Nast and had virtually ceased making photographs to exhibit and sell as works of art.[20] The show at the Julien Levy Gallery would be the last in his lifetime devoted exclusively to photography. It is this turning point in his career, and his ambivalent feelings about it, that Sheeler documents in *View of New York*.

With his camera covered, the lamp off, the chair empty, Sheeler is bidding farewell to a nearly twenty-year career as a commercial photographer. Although he confessed that at times the work bored him,[21] he clearly enjoyed both the financial benefits and the prominent people with whom it brought him in contact. Furthermore, he was setting aside an art form that he had always found stimulating and rewarding in favor of a medium in which his success, both critical and financial, had thus far been modest. It was, moreover, a medium in which he had been slow to mature, slow to find his way.[22] The closed-down studio, and the empty, undefined view, seem to express Sheeler's uncertainties about his future as a painter, and create an image poignantly autobiographical and demonstrative of his artistic concerns. The abstract tensions of the picture, as well as the contemporaneity of the objects depicted, give *View of New York* its modernity. That modernity—what Sheeler feared some might see as distant, as "inhuman"—is tempered by a poetic form—the open window—in order to evoke feelings with which the viewer can identify. For by reviving the image of the open window, which since the romantic era had served as a metaphor for ambivalence about the future, Sheeler found a vehicle for his own thoughts that could be universally understood.

Notes

This is a revised version of an essay first published in *American Art Journal* 18 (1986). The author would like to express her gratitude to Mrs. William H. Lane, as well as her thanks to Olive Bragazzi, Trevor J. Fairbrother, John T. Kirk, and Theodore E. Stebbins, Jr., for their helpful suggestions.

1. These works are in the following collections: *Classic Landscape* (Mr. and Mrs. Barney Ebsworth Foundation), *Home Sweet Home* (Detroit Institute of Arts), *Americana* (Yale University Art Gallery), *View of New York* (Museum of Fine Arts, Boston; see fig. 1), *Ballet Mechanique* (Memorial Art Gallery of the University of Rochester), and *Portrait (Katharine)* (private collection).

2. Charles Sheeler, quoted in Garnett McCoy, "Charles Sheeler—Some Early Documents and a Reminiscence," *Archives of American Art Journal* 5 (April 1965): 4.

3. Charles Sheeler to Charles C. Cunningham, letter of April 7, 1935, Paintings Department files, Museum of Fine Arts, Boston.

4. D. A., "Museum Acquisitions," *Christian Science Monitor,* April 8, 1935.

5. Charles Sheeler, quoted in Constance Rourke, *Charles Sheeler, Artist in the American Tradition* (New York, 1938), 156.

6. See ibid., 96, and Susan Fillin Yeh, "Charles Sheeler's 1923 Self-Portrait," *Arts Magazine,* 52 (January 1978): 106–09.

7. In 1924, the drawing was exhibited at the Whitney Studio Galleries under the title, "Audubon 451-."

8. The Beaux Arts Apartment Hotel—actually twin buildings facing one another at 307 and 310 E. Forty-fourth Street between First and Second Avenues—was designed by the New York firm Murchison and Hood, Godley and Fouilhoux. These buildings were completed in 1930 and Sheeler moved in shortly thereafter. They are still standing. See Cervin Robinson and Rosemary Haag Bletter, *Skyscraper Style: Art Deco New York* (New York, 1975), pl. 48.

9. Sheeler autobiography, Archives of American Art, Smithsonian Institution, Washington, D.C. Sheeler noted that he preferred conté crayon because it allowed "the possibility of attaining the richest of blacks." See also his statement of 1936 (as quoted in *Art News* 45 [March 1936]: 30): "My conté crayon drawings, which most closely approach photographs, were made to see how much exactitude I could attain."

10. Susan Fillin Yeh, "Charles Sheeler and the Machine Age" (Ph.D. diss., City University of New York, 1981), 239–40 and 235. See also Martin Friedman, *Charles Sheeler* (New York, 1975), 91.

11. Klint, whose works laid the foundation of modern Danish furniture design, called his creations "tools for living," and his philosophy of design emphasized utility and timelessness—values akin to Sheeler's own. Esbjorn Hiort, *Modern Danish Furniture* (New York, 1956), 8.

12. There were most likely other photographs closer in composition and detail to *View of New York*, but these seem not to have survived.

13. Sheeler autobiography, Archives of American Art.

14. Lorenz Eitner, "The Open Window and the Storm-Tossed Boat: An Essay in the Iconography of Romanticism," *Art Bulletin* 37 (December 1955): 281–87.

15. Sheeler served as resident photographer for many of the projects generated by Duchamp and others in the Arensberg circle. He photographed the Baroness Elsa von Freytag-Loringhoven's *Portrait of Duchamp* for the Winter 1922 number of the *Little Review*, and that same year provided the photographs for Duchamp's witty paean to the *New York Sun* critic, "Some French Moderns Say McBride" (Philadelphia Museum of Art).

16. Sheeler autobiography, Archives of American Art.

17. Arturo Schwartz, *The Complete Works of Marcel Duchamp* (New York, 1969), cat. 265.

18. "Most of the work being the photographing of the new Lincoln before the New York show. May I say that one of them never did get to the show—it moved up to South Salem!!!! . . . It is to begin over again. The feel and sound of the engine is something to wake up in the middle of the night and think about. My pleasure in it is akin to my pleasure in Bach or Greco and for the same reason—the parts work together so beautifully." Charles Sheeler to Walter Arensberg, Feb. 6, 1929, Arensberg Archives, Philadelphia Museum of Art.

19. Halpert's concern that Sheeler's photography not overshadow his painting is indicated by her refusal, on his behalf, of a commission to make a huge photographic mural for the Ford Building at the 1934 Chicago World's Fair: "While Mr. Sheeler has [made] . . . a large series of photographs . . . of the Ford Plant, he is so completely engrossed in painting these days he does not wish to continue his photographic work." Edith Gregor

Halpert to Edsel Ford, March 7, 1934, Downtown Gallery Papers, 1936–57, Archives of American Art. Halpert proposed that Sheeler provide paintings for that space instead. Ford did not accept the offer.

20. Sheeler's work for *Vanity Fair* documents the curtailing of his commercial career. In 1926, he published thirty-four photographs in the magazine, of which all but one were fashion illustrations or celebrity portraits. In 1927, sixteen Sheeler photographs appeared; in 1938, eleven. But from 1929 through 1931 he published only three. His last photograph for *Vanity Fair*—a portrait of the actress Helen Menkin—appeared in October 1931.

21. Sheeler to Walter Arensberg, Feb. 6, 1929: "I become increasingly bored with the work I have to do and the fact that I seem incapable of making life more enjoyable than it is"; Arensberg Archives, Philadelphia Museum of Art.

22. Sheeler was forty-six years old when he painted what he considered to be his first mature work, *Upper Deck* (1929, Harvard University Art Museums, Cambridge, Mass.). For him this painting represented a breakthrough, "the beginning of a procedure which has continued in effect." Quoted in Abigail Booth Gerdts, "Catalogue of the Exhibition and Biographical Notes," *Charles Sheeler* (Washington, D.C., 1968), 18.

18 The Birth of a National Icon: Grant Wood's *American Gothic*

Wanda M. Corn

Everyone knows the image: the stern midwestern couple with a pitchfork, standing in front of a trim white farmhouse, their oval heads framing the little building's Gothic window (fig. 18.1). Though simple, plain, and nameless, the man and woman in *American Gothic* have become as familiar to Americans as the *Mona Lisa*. Their image, mercilessly caricatured and distorted, pervades our culture; greeting card companies use it to wish people well on their anniversaries; political cartoonists change the faces to lampoon the country's First Family; and advertisers, substituting a toothbrush, calculator, or martini glass for the pitchfork, exploit the couple to sell us merchandise (fig. 18.2).

These parodies may tell us what some Americans think the painting is about, but they say little about what Grant Wood (1891–1942) intended when in 1930 he painted this relatively small (30 × 25 inches) picture. Did Wood want us to laugh at his deadly serious couple? Was he satirizing rural narrow-mindedness, as many critics and historians have claimed? If so, then what motivated this loyal son of Iowa to mock his countrymen? Who, in fact, are the man and woman in the painting and why do they look as though they could have just stepped out of the late nineteenth century? And, as modern Americans had shown little or no interest in midwestern themes, how did Wood, midway through his career, come to paint *American Gothic* at all?

The literature on the painting is not extensive and offers little help in answering our questions.[1] It makes two principal claims about *American Gothic*, the first being that the painting's most important sources are European. Nearly every historian and critic credits the artist's visit to Munich in the fall of 1928,

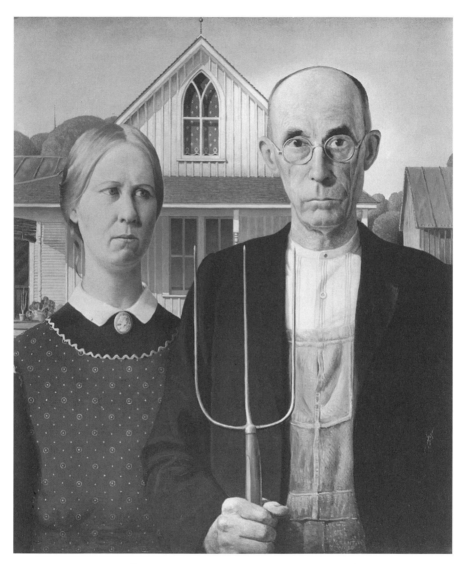

Figure 18.1 Grant Wood, *American Gothic*, 1930. Oil on composition board, 30 × 25 inches. Friends of the American Art Collection, all rights reserved by the Art Institute of Chicago and VAGA, New York, 1930.934.

and his study of the northern Renaissance masterpieces in the Alte Pinakothek, as decisive. There is no doubt that the artist's imagery and style changed around the time of this trip. For the previous fifteen years Wood had been painting loose, quasi-impressionist landscapes. After Munich he inaugurated a new style, one characterized by static compositions, streamlined forms, crisp geometries, and repeating patterns. By Wood's own admission, the Flemish painters were

Figure 18.2 *Poster Pot,* 1972. Sebastopol, Calif.

an important stimulus. But historians and critics have tended to glamorize the tale, writing of Wood's Munich visit as if it were a kind of religious conversion experience.

The second claim made about *American Gothic* is that the work is satirical, that Wood is ridiculing or mocking the complacency and conformity of midwestern life. This interpretation seems to have originated in the early 1930s on the East Coast and has been conventional historical wisdom ever since. Reviewing the work in 1930 when it was shown at the Art Institute of Chicago, a critic for the *Boston Herald*, Walter P. Eaton, found the couple "caricatured so slightly that it is doubly cruel, and though we know nothing of the artist and his history, we cannot help believing that as a youth he suffered tortures from these people."[2] In the 1940s H. W. Janson came to a similar conclusion: Wood intended *American Gothic* as a "satire on small town life," in the caustic spirit of Sinclair Lewis and H. L. Mencken.[3] In more recent times art historian Matthew

Baigell considered the couple savage, exuding "a generalized, barely repressed animosity that borders on venom." The painting, Baigell argued, satirized "people who would live in a pretentious house with medieval ornamentation, as well as the narrow prejudices associated with life in the Bible Belt."[4] In his book-length study of the artist, James Dennis characterized Grant Wood as a "cosmopolitan satirist" and *American Gothic* as a "satiric interpretation of complacent narrow-mindedness."[5]

For the moment, let us set aside the characterization of *American Gothic* as neo-Flemish and satirical and ignore the many parodies of the image so as to see the work afresh. By looking at Grant Wood's midwestern background and his process of creation, we shall find that American sources—not European ones— best explain his famous painting. It will become clear that Iowa architecture, frontier photographs, and midwestern literature and history are much more relevant to an understanding of Wood's painting than are the Flemish masters. Furthermore, a close study of American materials refutes the notion that Wood intended to satirize his couple-with-pitchfork.

The immediate genesis of the painting occurred while Wood was visiting friends in the tiny southern Iowa town of Eldon and came across a little Gothic Revival wooden farmhouse (fig. 18.3).[6] Not having a word to describe it—the term "Gothic Revival" was not yet current—Wood called it an "American Gothic" house to distinguish it from the French Gothic of European cathedrals.[7] Modest in its size, this house belonged in kind to the hundreds of cottage Gothic homes and farmhouses built throughout Iowa in the latter half of the nineteenth century, when the state was being settled. What caught the artist's eye about this particular example was its simple and emphatic design—its prominent, oversized neo-Gothic window and its vertical board-and-batten siding. The structure

Figure 18.3 House in *American Gothic*, 1881–82. Photograph. Eldon, Iowa.

immediately suggested to him a long-faced and lean country couple—"American Gothic people to stand in front of a house of this type," as he put it.[8] He made a small oil study of the house, had a friend photograph the structure, and went back to Cedar Rapids, where he persuaded his sister Nan and his dentist, Dr. McKeeby, to become his models.

The couple, Wood tells us, looked like the "kind of people I fancied should live in that house."[9] This is a fact missed by almost all of the painting's interpreters: the painting does not depict up-to-date 1930 Iowans, but rather shows people who could be of the same vintage as the 1881–82 house.[10] To make the couple look archaic, Wood turned to old photographs as sources. He dressed his two models as if they were "tintypes from my old family album," a collection which Wood greatly valued and which today is on display in Iowa at the Davenport Museum of Art.[11] His thirty-year-old sister became transformed from a 1930s woman into a plausible stand-in for one of his nineteenth-century relatives. On his instructions, Nan made an old-fashioned apron trimmed with rickrack taken from an old dress and pulled her marcelled hair back tightly from her face. Wearing the apron with a brooch and a white-collared dress, her appearance now recalled the photographs in Wood's family album. For Dr. McKeeby, the male model in *American Gothic,* Wood found an old-fashioned collarless shirt among his painting rags, to be worn with bibbed overalls and a dark jacket.[12]

Wood adapted not only the dress from late nineteenth-century photographs, but also the poses and demeanor: the stiff upright torsos, the unblinking eyes, and the mute stony faces characteristic of long-exposure studio portraits. In placing the man and woman squarely in front of their house, he borrowed another popular late nineteenth-century convention drawn from the itinerant photographers who posed couples and families in front of their homes (fig. 18.4). This practice, common in the rural Midwest through World War I, produced untold numbers of photographs, all recording the pride of home as much as a likeness of the inhabitants.

It is common in these photographs to see potted plants decorating the porches and lawns. Indoor plants moved to an outside porch during the spring and summer gave evidence of a woman's horticultural skills and were also a source of pride; in the Midwest it was hard to keep plants alive during the long and bitter winters. When Wood put potted plants on the porch of the house in *American Gothic,* just over the right shoulder of the woman, he was providing her with an appropriate attribute of homemaking and domesticity.

The man's attribute, of course, is the pitchfork. Wood's initial idea was to have the man hold a rake; this was the way he rendered the scene in a preliminary pencil study hastily sketched on the back of an envelope.[13] For reasons of design he discarded the rake for the pitchfork to emphasize the verticality of the long

Figure 18.4 Solomon D. Butcher, *Mr. Story, 1 mile N.E. of Miller on Wood River, Buffalo County, Nebraska,* 1909. Photograph, courtesy of Nebraska State Historical Society.

faces and the slender Gothic window. But it was also because the artist wanted to use a tool clearly associated with farming—not gardening—and with late nineteenth-century farming at that. This offended one Iowa farmer's wife who, viewing the picture in 1930, objected: "We at least have progressed beyond the three-tined pitchfork stage!" [14]

Whether rake or pitchfork, the idea of the man holding a tool came from old frontier photographs in which men and women, in keeping with an even older painting convention, held objects appropriate to their status and occupation. Men held shovels, rakes, or pitchforks, while women leaned on brooms or chairs. In photography, of course, the long-handled tool was more than an occupational emblem; it helped steady the holder during the long exposure necessitated by slow films and cameras. A classic photograph of this type, dating from the 1880s and showing the man holding a pitchfork and the woman leaning on a chair, is by the Nebraskan itinerant photographer Solomon Butcher (Nebraska State Historical Society). The couple's home is prairie sod rather than American Gothic, but the convention is precisely the one used by Grant Wood, right down to the pioneer woman's potted plants in tin cans on the table by the doorway.

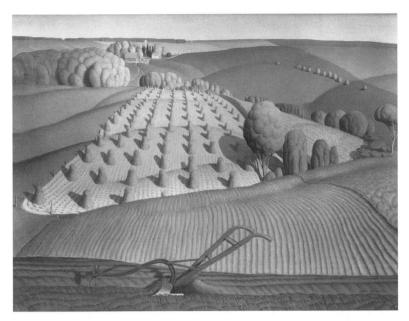

Figure 18.5 Grant Wood, *Fall Plowing,* 1931. Oil on canvas, 30 × 30¾ inches. Deere & Co., East Moline, Ill.

Wood responded to all kinds of old visual sources besides photographs: furniture, china, glass, quilts, popular prints, maps, and atlases. Some of these things were handed down to him as family treasures; other items he bought. He valued objects in keeping with his own aesthetic of simple design and pattern—Victorian oval frames or braided rugs—as well as things that reflected Iowa history. Blue Willow china was important to him because it had been one of the precious luxuries pioneer families had brought with them from the East; he also gave prominent places in his home to the hand-made wooden neo-Gothic clock and sewing box, and the piecrust table that his family had used on the farm.[15]

He borrowed omnivorously from these sources for all of his important paintings. *Fall Plowing* (1931) and other landscapes hark back, in their bird's-eye views and quilted fields, to the primitive prints of farms and villages in nineteenth-century regional atlas (figs. 18.5, 18.6). In 1930, the same year *American Gothic* was painted, Wood made a work that blended a complex range of historical sources. For the Stamats family of Cedar Rapids he painted a five-and-one-half-foot-long overmantel to go above a fireplace, reviving the late eighteenth- and early nineteenth-century taste for large painted landscapes as

Figure 18.6 "Residence of J. W. Richardson." Lithograph. From *A. T. Andreas'*
Illustrated Historical Atlas of the State of Iowa (1875).

Figure 18.7 Grant Wood,
Overmantel Decoration,
Stamats house, Cedar
Rapids, 1930. Oil on com-
position board, 42 × 65
inches. Cedar Rapids Mu-
seum of Art, gift of Isabel R.
Stamats in memory of
Herbert S. Stamats.

Figure 18.8 F. F. Palmer, for Currier and Ives, *Life in the Country—Evening,* 1862. Lithograph.

wall decorations (fig. 18.7). He took, he said, the elliptical shape of the painting from an old oval china platter; the stylized bulbous trees from his mother's Blue Willow china; and the floral border, as well as the composition of the family strolling in front of its house, from Victorian prints, particularly from ones by Currier and Ives (fig. 18.8).[16] To add a final touch of historicism, Wood painted the family in nineteenth-century costumes.

Wood's collecting habits and enthusiasm for antiques were part of a nationwide enthusiasm in the late 1910s and the 1920s for old American art and artifacts. This new pride in American things and in national history reflected the country's confidence as it emerged as a world power after World War I. Where Americans had been embarrassed before by their provincial history, now they began to treasure and research their past. Furniture and paintings that had once seemed awkward and second-rate now became charming and quaint—on their way to becoming valuable antiques. Signposts of this antiquarian movement dot the decade: the first exhibitions of nineteenth-century American folk art occurred in 1924; the American Wing opened at the Metropolitan Museum of Art in New York in that same year; in 1926 the nation celebrated its 150th birthday; the restoration of Colonial Williamsburg began in 1927; and in 1929 Henry Ford dedicated the Henry Ford Museum and Greenfield Village in Dearborn, Michigan. It was in the 1920s, as Russell Lynes has observed in his book on

American taste, that "wagon wheels became ceiling fixtures; cobbler's benches became coffee tables; black caldrons and kettles hung on irons in fireplaces."[17] "The last touch of absurdity" in the public's embrace of old artifacts, Lewis Mumford caustically observed, was a government bulletin which "suggested that every American house should have at least one 'early American' room."[18]

The passion for early Americana centered on colonial and federal period antiques and architecture. Neocolonial houses, appearing first on the East Coast during the eclectic revivalism of the late nineteenth century, now became popular throughout America, in Iowa and California as well as in New England. Wood painted the overmantel for Mr. and Mrs. Herbert Stamats for just such a house: in that overmantel one can see the 1929 neocolonial structure with its Cedar Rapids family standing in front (see fig. 18.7). But the fact that Wood painted the overmantel in a neo-Victorian style rather than a neocolonial one is significant, for it suggests that Wood's appreciation of the American past was much broader than that of the period's tastemakers. For most people in the 1920s the arts of Victorian America were ugly, unimaginative, and too reliant upon revival styles.[19] But Wood, self-taught as a connoisseur of Iowa artifacts, came to see that his midwestern heritage was of the nineteenth century, not the eighteenth; Victorian, not colonial. It was for this reason that Wood put a very plain neo-Gothic house behind his couple (see fig. 18.3). As a close observer, he recognized that Gothic Revival architecture was one of the oldest building styles in the Midwest, and that it provided the same distinctive flavor in his region that saltbox houses gave to New England.

Although Wood seldom talked about his tastes, they fell into patterns. First, as we have already seen, he enjoyed certain pieces of Victoriana such as old photographs, Currier and Ives prints, and oval frames. His strong preference, however, was for objects which had a "folk" look to them, things which were handcrafted or homespun, simple in design, clean in line, or boldly patterned. He liked stenciled country furniture, punched tinware, braided rugs, quilts, and the look of white cupboards with black handwrought iron fixtures.[20] In this he was the midwestern counterpart of those East Coast artists—Charles Sheeler or Hamilton Easter Field, for example—who in the 1910s and 1920s collected American primitives, Pennsylvania German illuminations, and country furniture.[21]

What distinguished Wood's taste from that of eastern artists, however, was his intense interest in items that were not only well designed but reflected the particulars of midwestern history. Sheeler collected Shaker furniture and painted it because he liked its "modern" aesthetic, its functional lines, and its simple geometries. When Wood collected or painted regional artifacts, it was because of their historical significance as well as their aesthetic qualities. In *Fall Plowing* (see fig. 18.5), he depicted one of the steel plows used by midwestern pioneers

to turn the tough prairie sod into farmland. Invented by John Deere around 1840, this kind of plow cut the heavy sod easily and self-scoured itself in the Midwest's moist, sticky soil. It replaced the unsuitable equipment pioneers brought with them from the East. Grant Wood relished the crisp, abstract curves of the steel plow, but at the same time he celebrated its centrality in Iowa's history. In his painting the plow stands alone, without a man to guide it or a horse to pull it, like a sacred relic.[22] A similar conjunction of abstract design and historical association explains Wood's attraction to the farmhouse in *American Gothic*. Even as he greatly admired the formal and repeated verticals of its board-and-batten walls and the mullions of the windows, Wood believed that the structure, in its modest proportions, stark neatness, and unembellished lines, evoked the character of the Midwest. "I know now," Wood said in 1932, "that our cardboardy frame houses on Iowa farms have a distinct American quality and are very paintable. To me their hard edges are especially suggestive of the Middle West civilization."[23]

Wood's interest in clean lines and patterns reflects the modernism of the period. But how, one wonders, did he develop the notion that "hard edges" were distinctively midwestern? Why was he even interested in midwestern buildings, people, and landscapes at a time when every painter of importance considered the middle states an artistic wasteland?

In fact, it was American writers who led Wood to discover and believe in the artistic worth of the Midwest as a subject.[24] When Grant Wood painted *American Gothic* in 1930, writers had been defining the uniqueness of midwestern life for almost half a century. One of the first of these was Hamlin Garland. With *Main-Travelled Roads* (1891), *Prairie Folks* (1892), and *Boy Life on the Prairie* (1899), Garland gained international recognition for his depictions of pioneering and farm life in Iowa, Wisconsin, and the Dakotas, the region he called the "Middle Border."[25] These local-color stories featured vivid descriptions, thick dialects, and idiosyncratic characters and events. Many recounted prairie living as harsh and bleak, giving, Garland said, "a proper proportion of the sweat, flies, heat, dirt and drudgery" of farm life.[26] He was among the first to create a literary notion of the midwesterner as rural, raw, and tough—as "hard-edged."

Even if they hated his harsh views—or the fact that he wrote about the prairie while living in Boston—every subsequent native artist of Garland's "Middle Border," whether painter or writer, would be indebted to him for defining the Midwest as having a distinct regional character. Furthermore, Garland's success conveyed to future generations a clear message: the open land, farm culture, and small towns of the Midwest were not a wasteland but a rich source of artistic material. It is hard to imagine Wood's career—and that of a score of writers—without Garland's example.

In imagery, however, Wood's work depends even more on the next genera-
tion of midwestern writers, those of the 1920s, who rejected the highly descrip-
tive prose of Garland and other local colorists to write more crisply and
emphatically about what they viewed as archetypical of their region. The most
famous of these was Sinclair Lewis, a Minnesotan, whose delineations of the
midwestern small town in *Main Street* (1920) and of its booster and materialist
mentality in *Babbitt* (1922) became best-sellers. Wood greatly admired these
books and publicly credited Lewis for the new "yearning after the arts in the
corn-and-beef belt."[27]

Typically, Wood was not very precise regarding what he liked about Lewis's
books other than that they were about the Midwest. But one quality surely im-
pressed him: *Main Street* and *Babbitt* were about general character types, not
about specific individuals. Carol Kennicott, for example, the central figure in
Main Street, is a college-educated, idealistic crusader for culture and social re-
form. Lewis drew her portrait in such a general way that she, along with every
other denizen of Gopher Prairie, Minnesota, could be recognized as types
found in small towns across the United States. In 1936–37 Wood paid tribute to
Lewis by doing the illustrations for a special limited edition of *Main Street.*[28]
The names Wood assigned to his nine drawings, all but two of which depict
characters in the book, are not of those individuals but of types—The Booster,
The Sentimental Yearner, The Practical Idealist.

The man and woman in *American Gothic,* of course, also constitute a type;
they are definitely not individualized portraits. But it is an oft-made mistake to
compare Wood's couple with the "solid citizen" types featured in Lewis's novels.
Sinclair Lewis wrote about modern Americans who lived in towns, traveled in
trains and cars, listened to the radio, and went to the movies. While many of
them were complacent, conformist, and narrow-minded—traits often attrib-
uted to the couple in *American Gothic*—they were not pitchfork-carrying,
country types. Grant Wood's folks live in town—you can just catch sight of a
church steeple rising over the trees to the left—but it is clear from their dress,
their home, and their demeanor that their orientation is rural and behind the
times. Their values are Victorian ones, not the modern ones of a Carol Kennicott
or a George Babbitt.

It was East Coast critics who first compared Wood's work to that of Sinclair
Lewis. Local Iowans knew better; the literary parallels they drew were to con-
temporary Iowan writers, most particularly Jay Sigmund and Ruth Suckow.[29]
Wood, they said, was doing in paint what Sigmund and Suckow for some years
had been doing in words: creating significant art out of regional materials. This
comparison was apt, for Wood was a great admirer of both writers. Jay Sigmund
lived in Cedar Rapids and he and Wood had become close friends a few years

before the creation of *American Gothic*. Making his living as an insurance sales-man, Sigmund was also an accomplished outdoorsman, a historian of the Wap-sipinicon River Valley, and a writer, publishing books of Iowa verse and prose: *Frescoes* in 1922 and *Land O'Maize Folk* in 1924. Sigmund's literary reputation was regional; Ruth Suckow's writing, on the other hand, won her a national fol-lowing. Her short stories about Iowa were published in H. L. Mencken's *Smart Set* and *American Mercury,* and her novel *The Folks* appeared in 1934 and be-came a best-seller. Most influential on Wood were probably her first novel, *Coun-try People* (1924), and her collection of short stories, *Iowa Interiors* (1926).[30]

As suggested by titles such as *Land O'Maize Folk* and *Country People,* Sig-mund and Suckow wrote about country types, not Sinclair Lewis's *Main Street* types. The farmer, the villager, and the rural family are their protagonists; the couple in *American Gothic* could have stepped out of their pages. The man might well have belonged to what Suckow termed the "retired farmer element" in the town, men who were "narrow cautious, steady and thrifty, suspicious of 'culture' but faithful to the churches."[31] And the woman might have been one of Sigmund's "drab and angular" midwestern spinsters whose moral propriety and excessive duty to family kept her at home caring for a widowed parent.[32] It may come as a surprise that Wood's intention from the outset was to paint an unmar-ried daughter and her father in *American Gothic,* not a man and wife. In seek-ing models for the painting, he wanted, he said, to ask an "old maid" to pose but was too embarrassed.[33] So his thirty-year-old married sister agreed to play spin-ster and to stand next to the sixty-two-year-old dentist playing the father. When the painting was completed and the couple interpreted as man and wife, Wood rarely went to the trouble of explaining otherwise, undoubtedly pleased that it could just as easily be read as a married couple. Indeed, thereafter he himself occasionally referred to the couple as man and wife.[34]

The man and woman in *American Gothic* are "Victorian survivals," more at home in the rural world Grant Wood had known as a child than in the modern Iowa of his adulthood. During the first years of his life, from 1891 to 1901, Wood had lived on a country farm, attended school in a one-room schoolhouse, walked behind the horsedrawn plow, and endured spinster aunts, one of whom, he remembered, pulled her hair back so tightly that he wondered "how she could close her eyes at night."[35] The most exciting event of each childhood year was threshing day, when the big machines and neighboring farmers arrived to help thresh the grain. The threshers' noontime meal was a feast, brimming the little farmhouse over with people, smells, and activity.[36]

Thirty years later, Grant Wood began to paint those scenes. Sitting in his Cedar Rapids studio with a telephone at his elbow and cars going by the window, he painted the spinster in *American Gothic,* the walking plow in *Fall Plowing*

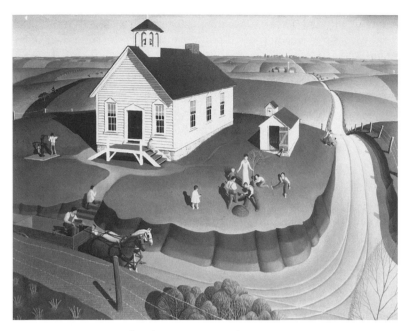

Figure 18.9 Grant Wood, *Arbor Day,* 1932. Oil on masonite panel, 25 × 30 inches. Private collection.

(see fig. 18.5); the one-room schoolhouse on an unpaved road with its hand pump, woodshed, and outhouse in *Arbor Day* (fig. 18.9); and the noonday harvest meal in *Dinner for Threshers* (Fine Arts Museums of San Francisco). Like *American Gothic,* each of these was on its way to becoming a relic when Wood painted it. By 1930 children rode on motor buses over paved roads to consolidated schools with modern plumbing, tractors plowed the fields, combines made threshing days obsolete, and spinster aunts no longer dominated the family stage as they had in Victorian America.

One wonders, then, about the spirit in which Wood painted. Did he work out of a deep sense of regret about contemporary life, or, as his most recent biographer has suggested, out of a disposition to "withdraw from industrial-urban society"?[37] Neither formulation seems adequate. The facts are that Grant Wood lived contentedly in the modern world and never complained of Cedar Rapids and Iowa City, the two cities in which he lived. He never attempted to farm or to live in the country. His friends were city people like himself. But having experienced a bifurcated life, ten years on a farm followed by thirty in Cedar Rapids, Wood recognized that the insular, rural world into which he had been born was slowly disappearing, that in his own lifetime the telephone, tractor,

automobile, radio, and cinema were bringing that era to an end. Here, too, he may have been sensitized by the dominant theme of Ruth Suckow's writing— the gulf between modern, 1920s lifestyles and the nineteenth-century patterns still followed by older rural and country people. Suckow, who always used regional materials to explore broad human issues, made of midwestern generational conflict a vehicle with which to discuss the toll of social change on families. Over and over she wrote of the sadness and incomprehension that result from the horse-and-plow farmer confronting the lifestyles and values of his car-driving, city-dwelling children.[38]

Wood's response to this confrontation was different. Only occasionally, as in *Victorian Survival*, did he paint it head-on. In Wood's other "ancestor" paintings, as we may term them, he sought to capture the uniqueness of his past and to memorialize his midwestern heritage. Ignoring the technological changes occurring around him, Wood painted his "roots." He wanted to know where his culture had come from, not where it was going. In the same spirit that motivated Americans to collect and restore discarded American folk paintings, or to rehabilitate eighteenth-century colonial villages, Wood painted "bits of American folklore that are too good to lose."[39]

Indeed, the best way to think of this artist is as a kind of folklorist searching out indigenous legends. On two occasions he painted national folktales. In *The Midnight Ride of Paul Revere* of 1931 (Metropolitan Museum of Art), Wood depicted the famous nocturnal gallop warning New Englanders that the British were coming. Later in the decade he painted *Parson Weems' Fable* (1939, Amon Carter Museum, Fort Worth, Texas), a large work retelling the famous tale of the young George Washington cutting down the cherry tree. What challenged Wood most, however, was regional folklore, particularly that of the common farmer, whose culture, Wood believed, formed the bedrock of midwestern life.[40] Farm folklore had never become an integral part of America's national self-image. In the 1920s, indeed, many Americans often thought of the farmer as a "hayseed" or "hick," fortifying the belief that the nation's breadbasket had no history of any interest or consequence. Wood thought otherwise. In *American Gothic* he honored the anonymous midwestern men and women who tamed the prairie, built the towns, and created America's "fertile crescent"—and who, in the process, became insular, set in their ways, and fiercely devoted to home and land. In *Fall Plowing*, Wood celebrated the farmer's harvests, while in *Arbor Day* and *Dinner for Threshers* he transformed annual rituals of rural life into quaint and colorful folktales.

In all of Wood's historical paintings, whether of national or regional themes, the legendary qualities are never bombastic or heroic. Unlike other American regionalists who painted rural life, Wood rarely aggrandized his figures through

exaggerated scale, classical idealization, or old master grandiloquence.[41] His paintings tend to be small, his figures closer to puppets or dolls than gods and goddesses. Indeed there is a levity about Wood's work that rescues it from sentimental heroism or strident patriotism. Paul Revere appears to ride a child's hobbyhorse through a storybook landscape constructed of papier mâché and building blocks. In *Dinner for Threshers,* a panel modeled after a religious triptych, the participants look like clothespin dolls in a Victorian dollhouse, not like saints. And the man and woman standing in front of their "cardboardy frame house" in *American Gothic* are so flat and self-contained they could be children's cut-outs.

Sometimes these whimsical, storybook qualities shade into humor, a fact that has confused Wood's critics and led many to think Wood is ridiculing or making fun of his subjects. This is not the case; Wood's use of humor was gentle and good-natured, not mocking or contemptuous. It was a device he used to convey charm and quaintness and to give his works the light-hearted quality of storybook legends. And most important, he found that humor helped create convincing character types. In *American Gothic* we cannot help but smile at the ways Wood emphasized the "hard-edged" midwestern character of his rural couple. He expressed the man's maleness—and rigid personality—in the cold, steely tines of the pitchfork, then playfully mimicked these qualities in the limp seams of his overalls and in the delicate tracery of the Gothic window. To suggest the spinster's unfulfilled womanhood, Wood flattened her bosom and then decorated her apron with a circle-and-dot motif, a form he might well have thought of as a kind of miniature breast hieroglyph. And to underline the controlled and predictable nature of the couple's life, Wood allowed a single strand of wayward hair to escape from the woman's bun and snake mischievously down her neck. It is the only unruly element in an otherwise immaculate conception.

Though he was quiet, slow of speech, and somewhat shy, Grant Wood was one of the finer wits of Cedar Rapids. But until *American Gothic,* his humor surfaced only in conversation, at parties, or in the gag pieces he made for friends and for his studio-apartment.[42] His art was of a different order, serious and reserved. One can argue, in fact, that only when Wood harnessed his gentle wit and made it an integral part of his art did he arrive at a personal and mature style. When he had struggled in 1928 and 1929 in *John B. Turner, Pioneer* (Cedar Rapids Museum of Art) and *Woman with Plants* (fig. 18.10) to create images of the pioneer, the results were heavy-handed, the types not clearly drawn. For these works Wood chose Iowa settlers as models, people whose faces, he thought, recorded the pioneer experience. Wood painted John B. Turner as a successful Cedar Rapids businessman, but to indicate his personal history the artist posed him against an 1869 map of the area in Iowa where Turner had settled in

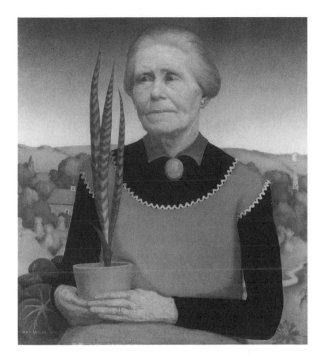

Figure 18.10 Grant Wood, *Woman with Plants*, 1929. Oil on composition board, 20½ × 18 inches. Cedar Rapids Museum of Art, Art Association Purchase.

the 1880s as a young man.[43] The model for *Woman with Plants,* Hattie Weaver Wood, was the artist's seventy-one-year-old mother, who had been born in Iowa during its early settlement; taught school in a prairie town, and farmed with her husband until his early death in 1901.[44] Experimenting with ideas that would become central to *American Gothic,* Wood dressed his mother as a country woman and had her hold a pioneer woman's attribute, the hardy sansevieria plant popular on the frontier. At either side of her he placed other houseplants, a begonia and a geranium. Though she by now lived with the artist in Cedar Rapids, he depicted her expressionless and still against an emblematic background of farmland, barn, and windmill. In its tightly focused realism and stylized line, *Woman with Plants* reflects the artist's study of the northern Renaissance masters the previous year. It is the most "Flemish" painting Wood ever did. He simulated the translucent qualities of a Flemish work by patiently building up the painted surface with oil glazes. From Flemish portraits he borrowed the close-up, half-figural composition, the body filling the lower frame, the sitter's hand pushed close to the picture plane.

Woman with Plants, however, was still an individualized portrait. It did not come close to the streamlined generic type that the artist finally achieved in *American Gothic.* After this breakthrough Wood never again traveled abroad in

search of the old and picturesque or to study the old masters. In midwestern farmlore he had finally discovered his own subject matter. In old American architecture, prints, photographs, and artifacts he had found his sources. And in humor he had found a device to make his paintings light-hearted and accessible, as easy to assimilate as a storybook fable. In the tradition of regionalist writers such as Sinclair Lewis, Wood created a character type both lovable and laughable, one with virtues as well as foibles. "These people had bad points," Wood said of his famous couple, "and I did not paint them under, but to me they were basically good and solid people. I had no intention of holding them up to ridicule."[45]

Wood was also grappling in *American Gothic* with one of the basic tenets of modern painting: the belief that form and content should be one. The imagery and style of his early work had been diffuse and eclectic—trees, barns, cathedrals, old shoes, back alleys—painted sometimes with the thick brush of a Van Gogh, at others with the gentle touch of an impressionist. But as he came to conceive of himself as a painter of midwestern history and legend, of "cardboardy frame houses," *American Gothic* couples, and quilted farmlands, Wood realized he had to create a style consonant with his subject matter. He was groping toward such a synthesis in *John B. Turner, Pioneer* and *Woman with Plants*, but found it only in *American Gothic.* There he used every formal element of the composition to say something about the Midwest and the couple's character. The static composition and immaculate forms expressed the couple's rigid routines and unchanging lives. The repeated verticals and sharp angles emphasized the couple's country hardness, while the blunt palette of white and black, brown and green, echoed their simplicity. To make the couple look entombed, as if relics from another age, the artist bathed the scene in a dry white light, crisply embalming every little detail of the pair and their home. Even the profusion of patterns in *American Gothic*—the dots, circles, stripes, and ovals—Wood saw as a midwestern component of his new style. Decorative patterns abounded in his region, Wood believed, in wire fences, ginghams, rickrack, patchwork quilts, lacy curtains, and cornfields.[46]

In its style, imagery, and sources, then, *American Gothic* grew out of Wood's midwestern experience and earned him the title of "regionalist" painter. To the artist's considerable surprise, the painting won immediate fame, a fame that continues unabated today. It is not hard to understand why. In the best tradition of regionalist art, Wood began with local materials but ultimately transcended time and place. *American Gothic* has matured into a collective self-portrait of Americans in general, not just of rural Victorian survivals. Proof of the point is that even the visually untutored perceive the image as Mr. and Ms. American. So, too, the admen and cartoonists, who find *American Gothic* an infinitely vari-

able mirror in which to portray Americans. In parody, Wood's simple, plain, and nameless couple can be rich or poor, urban or rural, young or old, radical or redneck. The image can be used to comment upon puritanism, the family, the work ethic, individualism, home ownership, and the common man.[47] Rich in associations running deep in myth and experience, *American Gothic* has become a national icon.[48]

Notes

This is a shortened version of an essay that appeared previously in *Art the Ape of Nature: Studies in Honor of H. W. Janson* (New York, 1981), 749–69. Locations are provided for works that were illustrated in the original publication but are not reproduced here.

1. *American Gothic* is treated at some length in Darrell Garwood, *Artist in Iowa: A Life of Grant Wood* (New York, 1944); Matthew Baigell, "Grant Wood Revisited," *Art Journal* 26 (Winter 1966–67): 116–22; Baigell, *The American Scene* (New York, 1974), 109–12; James M. Dennis, *Grant Wood* (New York, 1975).

2. *Boston Herald*, Nov. 14, 1930. For this review and many others see the Nan Wood Graham *Scrapbooks*, Archives of American Art, Smithsonian Institution, Washington, D.C., no. 1216/279–88. *American Gothic* was first exhibited in the 1930 Annual Exhibition of American Painting and Sculpture at the Art Institute of Chicago, where it won the Harris Bronze Medal and a $300 prize. It has been in the permanent collection of the Art Institute ever since.

3. H. W. Janson, "Benton and Wood, Champions of Regionalism," *Magazine of Art* 39 (May 1946): 199.

4. Baigell, *American Scene*, 110. Baigell basically reiterates the interpretation of *American Gothic* given by Garwood, *Artist in Iowa*, 119–20.

5. Dennis, *Grant Wood*, 120.

6. Wood tells in various lectures and interviews of discovering the Eldon house. See newspaper clippings quoting Wood in the Nan Wood Graham *Scrapbooks*, Archives of American Art.

7. Kenneth Clark's pioneering study *The Gothic Revival: An Essay in the History of Taste* first appeared in 1928, but it was not until after World War II that a historical appreciation flourished for Victorian architecture and decorative arts.

8. Letter to the editor from Grant Wood, printed in "The Sunday Register's Open Forum," *Des Moines Sunday Register*, Dec. 21, 1930.

9. "Iowans Get Mad," *Art Digest* 5 (Jan. 1, 1931): 9.

10. See Calder Loth and Julius Trousdale Sadler, Jr., *The Only Proper Style: Gothic Architecture in America* (Boston, 1975), 104, where they give the 1881–82 date for the Eldon house and attribute the building of it to Messrs. Busey and Herald, local carpenters.

11. This comes from a newspaper account of a lecture Wood gave in Los Angeles, reported in an unidentified, undated newspaper in the Cedar Rapids Public Library Clipping File on Grant Wood.

12. Interview with Nan Wood Graham, Oct. 14, 1977. See also Nan Wood Graham, "American Gothic," *Canadian Review of Music and Art* 3 (February–March 1941): 12. Mrs. Graham on several occasions answered my questions about *American Gothic* and about her brother's life and work. I am grateful for her interest in my work.

13. Reproduced in Dennis, *Grant Wood*, 86.

14. Letter from Mrs. Ray R. March of Washta, printed in "The Sunday Register's Open Forum," *Des Moines Sunday Register*, Dec. 14, 1930.

15. Wood's home furnishings, photographs, and books are preserved in the Grant Wood Collection of the Davenport Municipal Art Gallery.

16. Reported to the author by Mrs. Herbert Stamats, in a telephone interview Aug. 19, 1976.

17. Russell Lynes, *The Tastemakers* (New York, 1955), 239.

18. Lewis Mumford, *American Taste*, 1929, excerpted in Loren Baritz, ed., *The Culture of the Twenties* (New York, 1970), 402.

19. See, for example, the perfunctory treatment of Victorian furniture in Walter A. Dyer, *Handbook of Furniture Style* (New York, 1918) and in W. L. Kimerly, *How to Know Period Styles in Furniture*, 7th ed. (Grand Rapids, Mich., 1928).

20. My deductions about Wood's taste are based on a study of his own furnishings, visits to the houses he decorated, and interviews with people who knew him.

21. See this author's "The Return of the Native: The Development of Interest in American Primitive Painting" (M.A. thesis, Institute of Fine Arts, New York University, 1965).

22. There is a display of the steel plow and its role in opening up the prairie at the John Deere and Company headquarters, Moline, Ill.

23. Irma Koen, "The Art of Grant Wood," *Christian Science Monitor*, March 26, 1932.

24. I share here the viewpoint of Matthew Baigell, who argued in "Grant Wood Revisited" that Wood's work "has stronger literary than artistic antecedents." We cite, however, different antecedents and come to different conclusions.

25. Hamlin Garland, *Main-Travelled Roads* (New York, 1891); *Prairie Folks* (New York, 1892); and *Boy Life on the Prairie* (New York, 1899). Two useful sources for midwestern regional literature are Benjamin T. Spencer, "Regionalism in American Literature," in Merrill Jensen, ed., *Regionalism in America* (Madison, Wis., 1951); and Clarence A. Andrews, *A Literary History of Iowa* (Iowa City, 1972).

26. Hamlin Garland, *A Son of the Middle Border* (New York, 1917), 416.

27. In the Paris edition of the *Chicago Tribune*, sometime in July 1926; Nan Wood Graham, *Scrapbooks*, Archives of American Art, no. 1216/271.

28. The Limited Editions Club edition of Sinclair Lewis, *Main Street* (New York, 1937). All nine of Wood's *Main Street* illustrations are reproduced in Dennis, *Grant Wood*, 123–27.

29. See newspaper clippings in the Nan Wood Graham *Scrapbooks*, Archives of American Art, nos. 1216/278, 283, 308. Hazel Brown, in *Grant Wood and Marvin Cone* (Ames, Iowa, 1972), 66, recalls that Wood and friends would sit around and discuss "Frank Lloyd Wright, Ruth Suckow, and Jay Sigmund."

30. Jay G. Sigmund, *Frescoes* (Boston, 1922) and *Land O'Maize Folk* (New York, 1924); Ruth Suckow, *Country People* (New York, 1924), *Iowa Interiors* (New York, 1926), and *The Folks* (New York, 1934).

31. Ruth Suckow, "Iowa," *American Mercury* 9 (September 1926): 45.

32. The phrase "drab and angular" is used by Jay Sigmund to describe a spinster in his short story "First Premium," in *Wapsipinicon Tales* (Cedar Rapids, Iowa, 1927). Also see Sigmund's poems "The Serpent" (*Frescoes*, 40–42), and "Hill Spinster's Sunday" (in Paul Engle, ed., *Jay G. Sigmund* [Muscatine, Iowa, 1939]). Ruth Suckow describes how a very promising young girl ends her life as a lonely spinster in "Best of the Lot," *Smart Set* 69 (November 1922): 5–36.

33. The first public statement claiming that Wood's couple were father and daughter appeared in a letter to the editor by Nan Wood Graham, the model for the picture: see "The Sunday Register's Open Forum," *Des Moines Sunday Register*, Dec. 21, 1930. Mrs. Graham gave a fuller account of Wood's original ideas for the painting in "American Gothic," *Canadian Review of Music and Art* 3 (February–March 1941).

34. See, for example, "An Iowa Secret," *Art Digest* 8 (Oct. 1, 1933): 6.

35. Park Rinard, "Return from Bohemia: A Painter's Story," Archives of American Art, no. D24/161–295, 78. Although this biography is always attributed to Grant Wood, it was Park Rinard's master's thesis in the Department of English, University of Iowa, August 1939. Rinard was an extremely close friend and associate of Wood's and wrote the thesis in close consultation with the artist.

36. Rinard, "Return from Bohemia," 45–46, 76f.

37. Dennis, *Grant Wood*, 213.

38. See, for example, Suckow's novel *Country People*, and her short stories "Four Generations" and "Rural Community" in *Iowa Interiors*.

39. Grant Wood, quoted in the *New York Times*, Jan. 3, 1940. Wood was speaking here about his painting *Parson Weems' Fable*. Denying any intent to debunk, Wood claimed to be preserving "colorful bits of our national heritage." James Dennis discounts this statement, arguing that the artist was a debunker and a satirist (*Grant Wood*, 109–29). Dennis is more on target, I think, when he discusses Wood as a mythologizer, as a maker of fantasy and make-believe (pp. 87–107).

40. Wood's view that the farmer is "central and dominant" in the Midwest is best expressed in his 1935 essay "The Revolt Against the City," republished in Dennis, *Grant Wood*, 229–35.

41. The major exceptions to this statement are the federally funded murals Wood designed in 1934 for the library of Iowa State University in Ames. In other murals, such as those done for the dining room of the Montrose Hotel in Cedar Rapids, Wood could be just as playful and light-hearted as in his easel paintings.

42. Wood's sense of humor was such a vital part of his personality that everyone who knew him comments on it. Numerous stories of his pranks and jokes can be found in Garwood, *Artist in Iowa*, and Brown, *Grant Wood and Marvin Cone*. See also Park Rinard's essay in *Catalogue of a Loan Exhibition of Drawings and Paintings by Grant Wood* (Chicago, 1935). The Cedar Rapids Museum of Art owns many pieces that Wood made for fun—a "mourner's bench" for high school students who were being disciplined; flower pots decorated with flowers made of gears, bottlecaps, and wire; and a door to his studio with a movable indicator telling whether the artist was in, asleep, taking a bath, etc.

43. For information about the Turner family I interviewed John B. Turner II in July

and August 1976. His father, David Turner, was Wood's chief patron during the artist's early career; his grandfather was the model in *John B. Turner, Pioneer*. Wood dated this painting twice: "1928" in the lower left *under* the oval frame, and "1930" at the edge of the frame in the lower right. Although historians have considered this work to be post-Munich, I suspect this is wrong. Based on the early date and the style of the piece, Wood probably began the portrait sometime in 1928 and dated it before leaving that fall for Munich, where he stayed until Christmas. In 1930 he made revisions to the painting, and dated it anew when he added the oval frame, a shape in keeping with the neo-Victorian features of *American Gothic*.

44. Mrs. Wood's early biography appears in Rinard, "Return from Bohemia," chap. 1.

45. Dorothy Dougherty, "The Right and Wrong of America," *Cedar Rapids Gazette*, Sept. 5, 1942.

46. See Koen, "Art of Grant Wood," and quotations from Grant Wood's lectures and interviews in the clippings in the Nan Wood Graham *Scrapbooks*, Archives of American Art.

47. There are several major collectors of *American Gothic* caricatures. I am grateful to Nan Wood Graham, Edwin Green, and Price E. Slate for having made their large collections available to me. My own collection, begun only in the early 1970s, already numbers hundreds of items.

48. For an extended discussion of the image in American culture, see my "*American Gothic:* The Making of a National Icon," in *Grant Wood: The Regionalist Vision* (New Haven, 1983), 128–42.

19 The Question of Difference: Isabel Bishop's Deferential Office Girls

Ellen Wiley Todd

I didn't want to be a woman artist, I just wanted to be an artist. *Isabel Bishop, December 16, 1982*

I hope my work is recognizable as being by a woman, though I certainly would never deliberately make it feminine in any way, in subject or treatment. But if I speak in a voice which is my own, it's bound to be the voice of a woman. *Isabel Bishop, 1978*

Both "masculine" and "feminine" are not essences, but social categories formed through changing social experiences. They are not only imposed from outside us, they are also experienced subjectively as part of our understanding of who we are. But in a patriarchal culture it is clearly the case that women are forced to adopt a masculine viewpoint in the production and consumption of images far more often than men are required to adopt a feminine one. *Rosemary Betterton, "How Do Women Look?" (1987)*

For Isabel Bishop, the middle years of the Depression brought a succession of professional and personal milestones. Following her first one-woman show at the new Midtown Galleries in New York in 1933, she met and married Dr. Harold Wolff in 1934. She left her studio living quarters at 9 West Fourteenth Street, facing Hearn's Department Store; moved with her husband to a residence in the Riverdale section of the Bronx; and leased a new studio at 857 Broadway, with a view of the northwest corner of Union Square. In 1936 she gained considerable attention when the Metropolitan Museum of Art purchased *Two Girls* (fig. 19.1). Reviews of her one-woman exhibition in that year and again in 1939 acknowledged her independence of the influence of Kenneth Hayes Miller (Bishop's teacher and mentor at the Art Students League) and proclaimed her well on her way to being one of America's best women artists. By 1941 she was elected to the National Academy of Design—the establishment of the American art world.[1]

Bishop's shift away from Miller's sphere of influence occurred when she set aside the Milleresque shoppers, women at their toilettes, and still lifes. By 1936,

Figure 19.1 Isabel Bishop, *Two Girls,* 1935. Oil and tempera on composition board, 20 × 24 inches. The Metropolitan Museum of Art, Arthur H. Hearn Fund, 1936 (36.27).

when Raphael Soyer painted *Shop Girls,* Bishop had begun to paint Union Square's other working women—the office workers who made up the clerical staffs of the banks, public utilities, insurance companies, and small offices in the district. Whereas the view from her old studio had inspired such early works as *Dante and Virgil in Union Square* and *Department Store Entrance,* her new studio looked down on the square itself, populated by those she called its "regular denizens": the unemployed men congregating at the base of monuments who became the subject for paintings like *The Club* and for many drawings and etchings, and the young working women, occasionally waitresses but more often than not office girls, who worked nearby. Bishop frequently sat in the park and sketched these girls as they relaxed during their noon-hour break, or she asked them to come to her studio and pose.

Bishop's paintings of youthful, female office workers in the 1930s are sometimes bust-length portraits of individual girls in work clothes, often wearing the exaggerated hats popular in the second half of the decade. A work like *Tidying Up* (ca. 1938; fig. 19.2) is a penetrating close-up study of character, physiognomy, and mood. In other works, such as *Lunch Hour* (1939; fig. 19.3) or *At the*

Figure 19.2 Isabel Bishop, *Tidying Up,* c. 1938. Oil on canvas, 15 × 11½ inches. Copyright Indianapolis Museum of Art, Delavan Smith Fund.

Noon Hour (1939; fig. 19.4), two office workers appear together, usually outdoors and always in shallow, undefined settings. Stylistically, these works combine the artist's respect for established artistic traditions with her modernist practice of structuring and articulating the picture plane. Arranged against a faint grid and thick repeating horizontals, Bishop's studied surface compositions are animated by fully realized figures, modeled in a soft chiaroscuro, and painted with pale amber tints reminiscent of old master paintings. At the same time, her images also draw together conventions of genre paintings—as evidenced by quiet scenes of everyday life around Union Square—and figure studies, in which posed models assume the burden of pictorial expression. Placed in shallow, minimally defined settings outside the working environment, Bishop's relaxed young office workers remain self-absorbed or interact with one another but never directly engage the viewer. They lean on walls, eat ice-cream cones, converse quietly, share a book, or discuss a letter. Often they touch or link arms during their interchanges, suggesting a womanly closeness or camaraderie. Dressed in slightly wrinkled office attire, the women themselves are neither glamorous nor unattractive. Although Bishop's pictures of neighborhood women

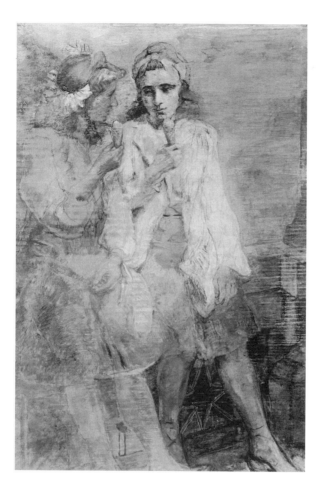

Figure 19.3 Isabel Bishop, *Lunch Hour,* 1939. Oil and tempera on gesso panel, 27 × 17½ inches. Courtesy of the Estate of Isabel Bishop and D. C. Moore Gallery, New York.

were frequently compared to those of her teacher Miller and their close friend, the artist Reginald Marsh, the comparisons had more to do with their common urban site and the old master origins of their figures than with the types of women they painted. None of Bishop's women become sexualized stereotypes, and none are old enough to be matrons. Her sedate young women bear little resemblance to Marsh's Union Square workers, the blonde bombshells found in images like *Hudson Bay Fur Company* (Columbus Museum of Art, Columbus, Ohio). And, though stocky rather than svelte, Bishop figures are not made up of the repetitious rounded forms and idealized faces of Miller's shoppers. These are quiet, pleasant genre pictures; nothing about these young women seems striking, garish, unusual, or confrontational.

Bishop's representations of young working women depict a less sexually charged feminine ideal, one deemed more appropriate for the workplace. By

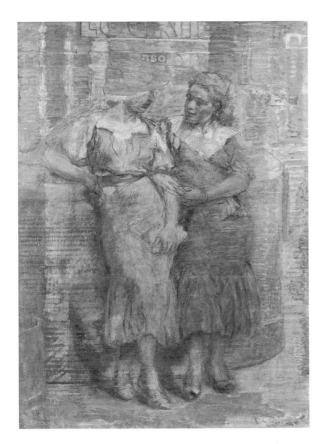

Figure 19.4 Isabel Bishop, *At the Noon Hour*, 1939. Tempera and pencil on composition board, 25 × 18 inches. Museum of Fine Arts, Springfield, Mass., James Philip Gray Collection.

embodying in her pictorial language a middle-class ideology of office work that prescribed business conduct proper for women in the 1930s, the artist simultaneously constituted and negotiated class and gender difference. A growing number of interwar publications on women and work championed this same ideology. Statistical surveys and government reports set out the facts about the office worker's job, charting institutional, social, and economic changes brought about by new office technology and the upheaval of the Depression and predicting the office worker's future.[2] These studies were less sanguine in assessing the constant changes in her occupation than were the popular periodical studies and advice manuals that helped to define the ideal office worker and contributed to the myth of occupational and social mobility connected to office jobs.

No matter what the focus of their study, writers for all these publications, many of them women social scientists, social workers, or job counselors, offered women a competitive model of success grounded in a discourse of gender difference and social mobility. Specifically, they argued that if a woman served her

superiors with wifely loyalty, behaved deferentially, and dressed modestly, she might advance in her job. More important, in bringing her "natural" caretaking and homemaking skills to the office, she would be preparing herself for the successful marriage that both she and society considered her ultimate achievement.[3] Like the literature of the period, Bishop's pictures constructed an ideal of a modest, deferential office worker without reference to the material circumstances of the typical office worker's life. Her paintings can be aligned with mainstream 1930s thinking on women's roles that was part of the moderate discourse of the revised new woman. Within that discourse, Bishop's works also embody notions of female achievement and class mobility that can be linked to an ideal of liberal individualism. This ideal shaped the way Bishop characterized her subjects and perceived her own role as an artist.

"Difference," Griselda Pollock reminds us, "is not essential but understood as a social structure which positions male and female people asymmetrically in relation to language, to social and economic power and to meaning. . . . To perceive women's specificity is to analyze historically a particular configuration of difference."[4] According to Pollock, such gender imbalance in a particular social structure and its supporting ideology fosters a variety of possible and contradictory positions for an individual, all subject to constant conflict and negotiation. Many of these negotiations are played out in visual and verbal texts, themselves products and producers of ideology that are subject to the codes and conventions of their own institutional practice. As a female artist viewing her female subjects, Bishop—sometimes unwittingly—participated in contemporary discussions about women's roles and office work in the 1930s. The way she presented her subjects, within the range of representational practices available to her, simultaneously blurred and clarified the sites where gender and class difference were debated in the 1930s. To paraphrase Rosemary Betterton on the engendered practices of looking, I also wish to suggest that Bishop moved between a masculine and a feminine viewpoint in producing her images, thereby carving out a more prominent viewing position for the middle-class female viewer of her work.

By the time Bishop introduced the female office worker into the iconography of American scene painting, she had become, like the saleslady, a highly visible member of the workforce. One out of every three New York City working women held some kind of clerical position. Union Square's four neighborhood banks, the Guardian Life Insurance Company, Consolidated Edison, and all the smaller offices alone provided close to ten thousand clerical jobs. Bishop herself observed that "there were an awful lot of small businesses around," and she believed that many of her models and clerical subjects were from these smaller offices.[5]

According to contemporary statistical surveys the women who filed, sorted mail, and typed were usually white, native-born, unmarried, and recently out of high school; Bishop's office girls confirm the demographic profile. In clerical work, the field that had expanded most rapidly for women between 1890 and 1920, native-born white women had always taken approximately 90 percent of the jobs.[6] These women tended to be under twenty-five years of age. A number of polls from the 1920s suggest that white middle-class female workers preferred marriage to a career, and many dropped out of the work force when they married or, more frequently, when their first child was born.[7]

In the 1930s the young female clerical worker continued to dominate the business work force. A 1934 survey of New York office workers found that the median age ranged from twenty-four to twenty-seven, with women in banks, insurance companies, and utilities on the low side of the median. A number of businesses, particularly insurance companies that required substantial clerical help, preferred to hire inexperienced workers. Employers usually liked to train and promote from within the organization as upper-level vacancies occurred. Because an immediate superior could rapidly instruct a beginner in routine tasks, most businesses found it uneconomical to search for a worker with particular job skills.[8]

To judge from the extreme youth of most of Bishop's office workers, they were beginners and were probably unmarried. The 1930 census reported that only 18.3 percent of women in clerical jobs were married, as against dramatically higher percentages for women in trade, domestic service, and manufacturing and mechanical industries. By 1934 the percentage had dropped even further.[9] Observers of occupational trends analyzed the statistics in several ways. The economist Grace Coyle, who looked to the economic and psychological states of the women, argued that in agriculture, industry, and domestic service women continued to work after marriage from economic need, whereas women professionals had a desire for "independence, self expression and the use of expert skill."[10] Clerical workers fell somewhere between: they usually married men who could support them, and the work was not challenging enough to keep them in the work force.

At the same time, however, employer and fellow employee pressure against the married clerical worker was stronger than in almost any other occupation. It was much easier, for example, for married women to acquire and retain department store sales positions than office jobs. Some of the pressure was exerted by the traditional ideology of woman's proper place. Coyle suggested that both husbands and employers wanted "to defend the 'American home' from subversive tendencies," and therefore to keep married women at home. Other pressure came from female coworkers. With increased competition for jobs in the

Depression, single women workers wanted married women to leave the jobs to those who needed them. In any case, many of the larger institutions had such strict policies against the employment of married female workers that women chose not to report their marriages or retained their maiden names to avoid losing their jobs.[11]

The place of Bishop's women in the office hierarchy is difficult to generalize. Although occupational categories varied with the type of business, larger offices had more specialized and stratified positions; in smaller offices where there were fewer workers—and where Bishop believed many of her subjects worked— office girls shared several tasks. Because the categories of office work required different levels of education and skill, each had a different status. File clerks and junior clerks were at the bottom of the clerical ladder. These were the youngest, least experienced, and least educated, some of whom had left school to take their positions. Next came file and general clerks; Bishop probably painted some of these women, since insurance and utility companies employed vast numbers. For these jobs a general high school education was sufficient.[12]

Office machine operators, followed by typists, were next in the occupational hierarchy, making up but a small proportion of the clerical population. Since most women who learned typing also took high school or business school shorthand, they moved into the next higher and more populous category of stenographer. These women, especially in smaller offices, usually performed a variety of

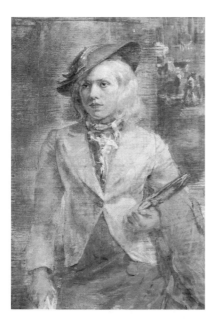

Figure 19.5 Isabel Bishop, *Young Woman*, 1937. Oil and egg tempera on masonite, 30¼ × 22¼ inches. Courtesy of the Pennsylvania Academy of the Fine Arts, Philadelphia, Henry D. Gilpin Fund.

tasks beyond taking and transcribing dictation. Bookkeepers, cashiers, and general telephone operators were also at the level of the stenographer. Finally, the secretary was at the top of the occupational scale. She had mastered all the skills of the occupations below her, was given more responsibility, and usually had the privilege of working for a single employer. She was often a woman who had worked her way up from a stenographic position in the company.[13]

From the information compiled, one can begin to draw a composite of Bishop's office worker. She was a young high school graduate, unmarried, on the job for only a year or two. The figure in *Young Woman* (1937; fig. 19.5), however, is on her own, poised and self-confident. Middle- to upper-middle-class urban viewers of this work, familiar with the business world, might well have identified her as a stenographer working her way up the office ladder.

Bishop's pictorial strategies and her depiction of the appearance and behavior of these women suggest that both her attitude toward the working girl and her conception of that girl's life and job differed from those of Raphael Soyer. Bishop's paired office workers, in *Lunch Hour* and *At the Noon Hour* (see figs. 19.3 and 19.4), seem more relaxed than those in Soyer's *Office Girls* (fig. 19.6). Unlike Soyer's figures—cropped at the waist, placed against the picture plane, and packed closely together—Bishop's are complete, placed on shallow stage-like settings with enough room to move. Soyer's women move quickly through the environment; Bishop's women are still; they either lean against a wall or sit or stand in relaxed contrapposto poses.

Both Soyer and Bishop depict ordinary women, and both individualize their models. They define the self-presentation of femininity as emotional expression. But Soyer's women are uniformly melancholy or serious. The directness with which they confront the viewer or go about their business suggests further that they have acquired some measure of knowledge and experience. The emotional range—from joy to wistfulness—that Bishop observed in her women was broader and her depiction of moods more subtly nuanced than Soyer's, thanks to the complex transitions between light and dark through which Bishop explores the characterizing topographies of these young women's faces.

While Soyer's women are psychologically isolated from one another, Bishop regularly painted physically and emotionally intimate interchanges between women. In *At the Noon Hour* two women lean against the wall chatting, and one links her arm companionably through the other's. Their shoulders and thighs also touch. The same closeness appears in *Lunch Hour*, where two women rest against the edge of a Union Square fountain, their shoulders touching as they turn toward one another, sharing secrets over the pleasure of an ice-cream cone.

Bishop's emphasis on the warmth of these interchanges and the degree of her subjects' engagement with one another overrides, without fully obliterating, the

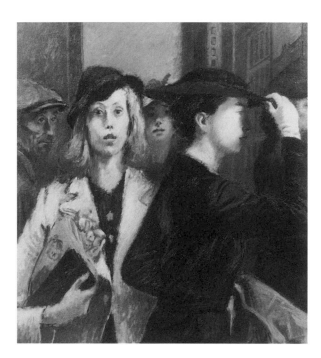

Figure 19.6 Raphael Soyer, *Office Girls,* 1936. Oil on canvas, 26 × 24 inches. Whitney Museum of American Art, New York.

sensuous projection of their femininity toward the viewer. In this aspect of her female imagery, Bishop differs from Soyer, and even more from Miller and Marsh. Where Soyer's models seem "gently sexualized" on one level, his sympathetic response to them as individuals remains stronger than any projection onto them of masculine desire. With Marsh such a projection is overt to the point of exaggeration; with Miller it is somewhat less obvious. Even where Bishop's models assume more self-conscious poses of display, their provocativeness is never depicted as assertive, nor are they blatantly sexualized. The taller woman in *At the Noon Hour* (see fig. 19.4), for example, stands with her right foot before her left, her left hip slightly forward, her right arm akimbo. But her looser dress (almost all of Bishop's women wear softly draped or loosely tailored costumes) masks the curves of her figure. And her energies are directed as much toward her friend as toward an unseen masculine viewer for whom she puts herself on display.

While it is part of the structure and economy of looking that women in art are available to the masculine spectator, Bishop's paintings construct a larger space for the feminine viewer.[14] Paintings of paired working women also envision a same-sex sphere so circumscribed, thanks to the intimacy between the women, that a female viewer—another woman—may comfortably be drawn into the intimate circle. Finally, the space in which looking occurs is itself intimate. Be-

cause of the fluid surfaces and a close-value palette employing a narrow range of pastel colors, a viewer is made to draw closer to the works both to distinguish the figures and to observe the intricate surfaces that surround them. Within this closer range the gender-specific transactions occur.

In fact, when these works began to be exhibited in the late 1930s, some of the critical discussion—concerning viewing itself as well as the relative "strength" of Bishop's women—broke down along gender lines. Where Emily Genauer praised Bishop's "clearly defined faces and figures," her "superb draftsmanship and modelling," and her "sensitivity," other critics faulted her "indistinct, nebulous manner" of defining forms. Edward Alden Jewell of the *New York Times* complained of the need for "an uncommon amount of squinting" to see figures that were themselves too "pallid and frail and washed out to emerge." James Lane, who later spoke of Bishop's "unconventional and glorious" women, initially found them shy, "bloodless and lacking in vigor." Forbes Watson felt that Bishop's "extremely close searching for subtle values" sometimes led to a "neutrality approaching timidity."[15] As male critics described her, Bishop's young woman was a descendant of the fragile steel-engraving lady.

Late nineteenth-century images of women in interiors portrayed the social phenomenon of women's separate, often ritualized, activities; the term *homosocial* has been used to describe this separate, predominantly domestic realm of female interaction. In Bishop's paintings, women are depicted carving out a similarly separate and intimate arena, now in the modern urban environment— where women are most susceptible to the masculine gaze. Seen in this light, the works impart a degree of quiet strength to these female intimacies.

In Bishop's as in Soyer's works, women are "in transit," outdoors, suspended between environments. But Bishop's environments are so ambiguously defined by her intricate painting techniques that her women are potentially anywhere and nowhere within the settings. *At the Noon Hour* shifts constantly between foreground, background, and figures, with value shifts and horizontal brushstrokes suggesting several spatial interpretations. No matter how the picture is finally read, the space is ambiguous, and the women potentially relate to more than one environment.

Although the appearance of Bishop's youthful workers corroborates the historical profile of Depression era office workers, a tension exists between the depiction of ordinary women posed in a seedy neighborhood and the beauty of light, color, and carefully manipulated surfaces that eradicate all references to work. Bishop's firmly modeled figures in works like *At the Noon Hour* occupy spatially ambiguous settings created either by thick globs of paint that accentuate the surface of the canvas or by soft veils of horizontal strokes that blur contours and link figures to one another or to their background. Though formally

posed, her women are surrounded and overlaid by this fluid, constantly shifting atmosphere. Such an abstraction of pictorial setting disguises her female subjects' specific identity as workers outside the home and suggests that their spatial and temporal positions are tentative rather than fixed. The figures themselves are equally dynamic, their hands and arms animated by quavering pencil strokes. The fragility and transience resulting from this technique are heightened by the warm light and close gradations of pastel colors that illuminate the women's youthful faces.[16]

There are other things we need to know about these women. What, for example, did their jobs allow them to do, and what did their appearance and behavior signify in the late 1930s? They are outdoors, away from their working environments, looking pleasant and content and seeming to suffer little from their jobs. But there is also a sense that they renew themselves through repose, quiet conversation, or the refreshment of an ice-cream cone. Their clothing, generally fashionable, looks rumpled, owing to Bishop's scumbled surfaces and sketchy pencil marks. In *Lunch Hour,* for example (see fig. 19.3), the wrinkles and limpness of the jacket worn by the figure at right detract from an overall impression of tidiness. Such naturalistic touches keep these predominantly optimistic works from being overidealized or overromanticized representations of office workers' lives.

Well-established perceptions about office work help us situate Bishop's pictorial language in the broader discourse of women and work. By the 1930s popular books like *If Women Must Work, Manners in Business,* and *She Strives to Conquer* celebrated office work as the ideal stopgap for young women between school and marriage; in offices, hours were shorter than in factories or stores or domestic service, the surroundings more pleasant, and the pay better.[17]

Clerical jobs were valued not only because offices were quieter and cleaner than factories but also because office work provided a chance to get ahead—to achieve what Grace Coyle defined as "the rise to business success so highly esteemed among us."[18] Within the office a young woman could rise to the top of the stenographic pool or even, in rare cases, achieve executive status. The social interaction in an office was considered superior to that in a factory or department store. In a small office a young woman whose parents had been manual laborers could transcend class and social background through interaction with better-educated superiors. The work itself remained free of the stigma of manual labor, allowing the office worker to achieve a middle-class standard of femininity. Interpersonal relationships in an office could stimulate a woman to greater personal achievement and loyalty to her institution. The institution in turn could reward her with promotions and better pay.[19]

Given this situation, the fluidity of Bishop's surfaces can be read in two ways: it destabilizes the position of the woman as a worker with access to economic power even as it unfixes the boundaries of gender and class to project the possibility of such access.

In fact, the blurring of boundaries seems to have been Bishop's goal. As early as 1939 the artist equated her formal quest for "painterly mobility," manifested in her intricate painted surfaces, with the possibility of social betterment for her subjects. Bishop viewed the continuous horizontal strokes in her works as the web that links her figures to the environment and thereby suggests mobility in these otherwise still figures. In extensive discussions of her 1930s imagery held prior to her 1975 retrospective exhibition, Bishop reiterated her goal of showing these office workers' potential for upward mobility in American society. Her theory of painterly mobility as a metaphor for social mobility was also based on her sense that one could identify the lower classes.[20] "It seemed to me that in order to say what I felt I wanted to say about them, girls or men had to be classifiable. I don't think you can classify the upper middle class. The upper middle class is not definable in our society, but these young people are class-marked in the sense that you understand they are socially limited. But what I feel about them—and I really do feel strongly about these things—is that I know so many instances where, if they want to move, in a social sense, they can . . . and it's that mobility that connected for me."[21] Bishop amplified her statement, emphasizing her optimistic view of upward mobility. "I was conscious of their being class-marked, but not class-fixed. If I succeeded in making them seem to the onlooker that they could turn and move in a physical sense, this opened up a subjective potential which could include the mobility of content. I mean it made it possible to suggest, or at least the suggestion was already there, to my mind, that if a physical movement takes place who can tell what other kind of movement might take place."[22]

Bishop's concern with her subjects' potential came in part from her own early awareness of class and gender difference. The artist's childhood home was located next to the urban working-class neighborhood in Detroit where her father was a poorly paid high school Latin teacher. Because both parents were from upper-middle-class families and wished to maintain the appearance of that position, social contacts with the neighbors were minimal. Bishop recalled in a 1975 interview that "though we didn't have the money, we identified with the big houses on the next block. I wasn't supposed to play with the children on my block or be connected with them but I wanted to be. I thought, 'Oh they have a warmer life than I do—they all know each other and see each other and we are isolated.'"[23]

Caught between two social classes, Bishop learned about the restrictions and exclusions of each and acquired her own attitudes about social limitation and social mobility. When she came to New York in 1920, her fortunes changed. She received a monthly stipend from a well-to-do relative that allowed her to concentrate on her education and to move in circles with artists of her own social, educational, and now economic circumstances. This economic support continued until 1934, when she married Wolff, a prominent neurologist.[24] Bishop recognized that her changed economic situation allowed her greater occupational and social mobility—advantages not accessible to her subjects—but she was nonetheless optimistic about the relation between social mobility and individual initiative. The artist credited much of her own success to a rigorous six-day-per-week work schedule and to her slow, thoughtful production of images. Her story, and the one she envisioned for her subjects, was, in some ways, a version of the Horatio Alger success story, now told with female characters.

A 1936 newspaper article characterizing the artist-model dynamic involved in the production of *Two Girls* defines the professional distance Bishop maintained in interactions with her subjects. She asked a waitress from Childs', where she regularly had breakfast, to model. Miss Riggins agreed and brought a friend, Miss Abbott, with her to the studio. Almost every day for six months the two waitresses sat for Bishop. As Miss Riggins described it, she and Miss Abbott—the two women married and lost touch with each other until the newspaper piece brought them together—talked about everything from movies to boyfriends to fashion while Bishop worked. Bishop wrote of the period, "I never did know their first names. They'd come up from Childs' and just sit and talk. I don't know what about. I couldn't tell if I had to. I made dozens of sketches of them. Finally I thought I had something."[25] Although Bishop's same-sex interest in her subjects enabled her to depict a relationship of female intimacy, class and professional distance kept her from forming bonds with her subjects. This distance can be read as respect, professionalism, or neutrality, but it is also consistent with objectifying the models in terms of class. Though class distance in Bishop's works is never what it is in Marsh's, it remains, now strongly modulated by the commonality of gender.

Even so, Bishop wished to blur class and gender divisions, to infuse her imagery with her own optimism about the possibilities for working women. Though she idealized her ordinary models through the use of pastel tones and light, she never wished to divest them of their individuality. A comparison of photographs of her models for *Two Girls* (fig. 19.7) with the painting (see fig. 19.1) demonstrates that she retained the look of the actual women while suffusing their features with a soft light that emphasized their youthful seriousness.

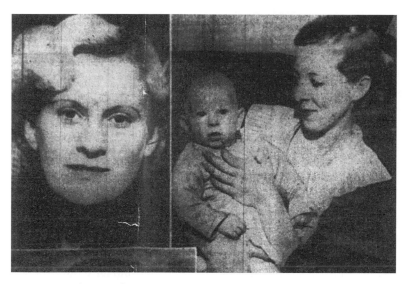

Figure 19.7 Photographs accompanying William Engle, "Portrait of *Two Girls Bought by Metropolitan, Reunites Two Ex-Waitresses Who Posed for It," *New York World-Telegram,* Feb. 27, 1936: 3.

By seeing her women as self-sufficient individuals in a subtly shifting environment rather than as sexual stereotypes, Bishop conveyed her own optimism about working women and American life in general toward the end of the 1930s. She also attempted to suggest that these women could transcend the limitations of class, sex, and occupation, much as she had by achieving success from a marginalized position as a woman artist in the mid-Depression. She believed that they had freedom of choice, even if economic evidence suggested the contrary. Bishop's professed attitudes and her general liberal humanist stance can be read in terms of women's potential for achievement and in light of the broader political assertions of individual rights in the Popular Front movement. Bishop's late participation in the Artists' Congress and her secession from it to join the more pluralist Society for Modern Artists suggest her awareness of her own social and political agenda.[26]

As a consequence of her upbringing, her experience as a woman artist in a male-dominated set of art institutions, the value humanism placed on an old master tradition, the discourse of new womanhood that celebrated the virtues of individual achievement, and her place within a specific political context of ideas, Bishop brought middle-class values and expectations to the studio, where she produced her "realist" representations of working women without engaging

them in situations that spoke about their lives. In Bishop's view neither the working women nor Union Square's unemployed men, who also became subjects in her paintings, were the victims of society, or of an inegalitarian culture, or of ideology. Bishop wrote or spoke about this often in conjunction with the unemployed men she painted. She denied that she was socially conscious in painting these men in the Depression, claiming that they were "aliens by temperament," eccentric and not to be pitied: "I don't say their economic disadvantages haven't something to do with their condition but essentially they are persons who are eccentric. They are really hedonists. I got to know them as I had a series of them come up here [to her studio]. They would bring each other and they would take anything they could lay their hands on." She also acknowledged that her intent in her images of these men was nothing like that of Soyer, who sympathetically portrayed men unemployed as a result of the Depression, whereas Bishop's men were a regular feature of any society. As a genre painter preoccupied with the characteristic movements of the human figure, she endeavored to capture their routines. Her more "generalized" intent allowed her to position herself outside the debates on art and politics that frequently intruded on discussions of subjects connected to the Depression.[27]

In his 1975 article on Bishop, the critic Lawrence Alloway faulted Bishop's upper-middle-class worldview, in which social mobility results from diligence. The artist's theory of painterly mobility as a metaphor for social mobility remained unconvincing, Alloway argued, because "the fact that you can cross the street does not mean that you can cross social barriers in the same way."[28]

In fact, by 1936, just as Bishop began painting office workers, many of the occupational advantages that had once made clerical work seem a path to upward mobility were rapidly disappearing. The economists, social scientists, and job counselors who compiled statistical studies and wrote the rapidly growing body of advice literature for women entering the working world came to recognize that office workers' lives and expectations had altered drastically. Wages dropped dramatically with the Depression, and socially conscious researchers, aware of the cost of living for workers, claimed that reports of high wages had been exaggerated even before the crisis.[29] *Fortune* magazine, in its lengthy analysis of the office worker's life, attributed low office wages to the youth of most office workers, who were under thirty and retired from the workplace with marriage: "The American office, to a great part of its female workers, is not a career but a device by which a woman works her own way through maidenhood" and into marriage.

> Capitalistic economy, which takes into account not only economic but social factors, has profited from this circumstance as might be expected. If

the great majority of office girls were in business not for the business but for their lingerie then there would seem to be no particular reason why business should not reciprocate in kind. The girls, since their ambition was elsewhere, would not complain and business, since its ambition was itself, would profit. The consequence is a low, sluggishly rising, and generally despondent wage scale paid by business with a fairly clear conscience and accepted by the young ladies *faute de mieux*.[30]

In short, the ideology of office work, buttressed in part by statistical evidence, operated with that of woman's proper place to justify keeping the wage scale low.[31] Underscoring employers' views on women's lack of economic and career motivations was evidence that males in clerical positions earned twice as much as women and advanced more rapidly.[32]

Apart from diminished wages, working hours during the Depression were frequently extended in smaller offices and jobs combined. While some institutions failed during the crisis, creating an ever-diminishing job pool, others stopped hiring. Of all the low-level white-collar fields, except sales, office workers suffered most from unemployment.[33] When businesses started to hire again following the brief economic upturn in 1936, there was a new problem—an oversupply of office workers. "Business at its rosiest could not possibly absorb all these girls," wrote Helen McGibbon. Many job counselors faulted the high schools for overdeveloping office-training programs and for failing to counsel women away from the standard feminized occupations like office work and teaching.[34] Since competition for these jobs was keen, women accepted low wages and beginning positions rather than have no job at all. As one writer observed, "Too many girls everywhere are still walking into employment agencies, vague and untrained, with the hopeless statement: 'I'll take anything.'"[35]

Technological change and the reorganization of offices bred dissatisfaction among those who found jobs. With more sophisticated office machines and the scientific application of mass production, workers who had previously executed a variety of related activities now performed repetitive tasks in stenographic pools, supervised by an office manager who distributed projects like a factory foreman. With increasing centralization and specialization, some offices adopted methods of payment used in factories, setting piece rates for typing, billing, and transcribing.[36]

The streamlined procedures that helped businesses reduce higher-level staff and distribute work more efficiently had negative effects on the office girl. Because they reduced the number of coveted secretarial positions, they necessarily altered her expectations for improving her status. Work became boring, and offices reported more illness among those engaged in single repetitive tasks. The

office machine operator lost track of how her job contributed to the business as a whole, and as a result her loyalty to the institution diminished and she felt alienated from coworkers and superiors alike. As job mobility diminished—one contemporary survey reported that 88 percent of office managers sought clerks who would be satisfied to remain clerks—the office girl became another cog in a vast production machine.[37]

In luminous outdoor settings, away from the workplace, Bishop's youthful office workers seem impervious to changes in the office environment. The only possible markers of labor and class are their costumes and occasionally sober expressions. More than other Depression era images, Bishop's paintings appear to preserve a disappearing ideal of female labor. This ideal was foreign to Soyer, even though he, like Bishop, used everyday outdoor settings, sketched on site, and arranged figures in studio poses. But with his spatial configurations, lighting, and palette in a work like *Office Girls* (see fig. 19.6), Soyer conveys some of the tension, monotony, and fatigue of women in routine jobs. They are crowded in an urban setting, placed directly against the picture plane, and surrounded by other figures. The pace of urban life prevents human interaction and repose. One figure rushes quickly by and another looks out, engaging the viewer with her weariness. Soyer's backdrop, unlike Bishop's soft veils of color and light, is one of dark, roughly painted office buildings. Finally, the figure of an unemployed man, at left, serves as a reminder that the economic crisis continues.

Though Soyer was more cognizant than Bishop of the effects of the workplace, his image, like hers, avoids direct engagement with the socially problematic issues of women's labor. Drawings from the Communist periodical the *New Masses* use the direct, sketchy conventions of graphic media to show the clerical workers as exhausted, or at least hardworking—conventions that since the turn of the century had come to be associated with images of social protest.[38] In M. Pass's 1926 drawing of a typist (fig. 19.8), the monotony, fatigue, and meager rewards of repetitive clerical work are crystallized in the image of a typist agonizingly bent over her machine. By contrast, Bishop's paintings avoid negative social commentary or any expression of a need for dramatic change. Instead, the clerical worker relaxes in an obscured outdoor milieu. Having fashioned a deliberate construction of womanhood according to her interpretation of artistic conventions, Bishop contributed to what in turn became part of the rhetoric defining the exemplary office worker.

Bishop's idealization of young women using an established model of artistic beauty assumed a particular meaning in the 1930s, when the office worker's prettiness became increasingly important to her job. Job counselors suggested what job applicants should wear and how they should behave, resorting to strategies that capitalized on conservative ideas about women and their role.

Figure 19.8 M. Pass, drawing of a typist. *New Masses* 1 (May 1926): 27.

They encouraged the practice of sex-typed behavior—the occasional use of flattery or sex appeal—but more often advocated modest dress and deferential manners.[39]

If Bishop's young women look reasonably fashionable, it is because they had to be. Dozens of job advice manuals contained some version of the following counsel: "A business girl may be a mental giant with every qualification for the job she seeks, but that won't help her half so much as wearing the right clothes and make-up and looking clean. Theoretically, one's appearance should have nothing to do with getting a job, but it actually counts 75%. . . . Gone are the days when a girl could look dowdy at the office and get away with it. You no longer hear an employer say of his secretary 'she doesn't look like much but how can she type!' He is more apt to say, 'I've an A-1 secretary now, and *is* she a looker!'"[40]

"Prettiness" depended more on good grooming than on glamour or sex appeal. Bishop focused on this particular preoccupation in *Tidying Up* (see fig. 19.2). With a light touch, she captured the young new woman "revising" herself in that most awkward of grooming moments, when she grimaces into her compact to check for lipstick on her teeth. Job manuals in the 1930s, forerunners of 1970s and 1980s dress-for-success guides, advocated moderation in all details of dress and fashion. Writers recommended against large flashy jewelry, bright makeup, and bright-colored clothes. Recognizing that most business girls operated on small salaries (and marveling at the clerical worker's ingenuity at dressing

Figure 19.9 Advertisement for American Express Travel Service, *Harper's Bazaar*, Sept. 1, 1937: 159.

well for so little), counselors suggested conservative clothes, coordinated around a single color (preferably black, navy, gray, brown, or dark green), that would last for several seasons. Most appropriate were tailored dresses and suits in plain colors with white or matching blouses. Ornate trim belonged on afternoon dresses, which were out of place in the office. The higher women went on the occupational scale, the more simply they dressed.[41]

By such standards, many of Bishop's office workers appear appropriately fashionable. The subject of *Young Woman* (see fig. 19.5) is the very model of fashion success. Her short jacket with its single button and wide lapels resembles styles from the middle of the decade. With her tailored suit, neatly brushed blond hair, and poised demeanor, she looks like the self-confident business woman about to be met by an American Express travel representative in a 1937 advertisement that reads, "A lady alone enjoys the luxury of American Express Travel Service" (fig. 19.9). Other Bishop women seem less well turned out, like one young woman in *Lunch Hour* who wears a blouse with puffy sleeves. In *At the Noon Hour* (see fig. 19.4), the women wear dresses with flounces—the kind of sheer, fluffy dress deemed inappropriate for office work.

Besides trying to be pretty, fashionable, and well spoken, the young office girl competed for jobs by cultivating a modest, deferential manner. She adopted

the new womanhood exemplified by Dorothy Bromley's "feminist-new style," her voice and gesture demonstrating the "feminine" qualities intended by "nature."[42] Bishop's pictures show a narrow range of behavior in pose, gesture, and expression. Often serious, these women appear gentle and straightforward in their attentiveness to one another. Many stand in relaxed poses, confining their gestures to subtle inward motions. Their demeanor seems passive and responsive rather than provocative. When the subjects seem flirtatious, they are charming, never raucous or overtly sexual. Fundamentally, they are more receptive than argumentative, and they never affront.

The right personality supposedly had everything to do with obtaining, keeping, and advancing in one's job. Counselors devised recipes, which included a dash of polyvalent charm mixed with the right blend of efficiency. Hazel Cades, in *Jobs for Girls*, defined this "right attitude" as a perfect balance of irreconcilable polarities. "It is difficult to define charm, and popularly it is not supposed to be a factor in business, but it is and if you have it you are apt to stand a better chance of getting the job you want. . . . Sometimes in business it is called the right attitude and it is really a combination of friendliness and reticence, of assurance and modesty, of ambition and willingness to do anything, of today's accuracy and tomorrow's vision. It is the ideal attitude of the girl who is willing to take any job and work hard at it while she admits no ultimate limitations."[43]

Job counselors recognized that women were relegated to mechanical and boring jobs. They no longer hid the nature of clerical work. Now, however, they encouraged women to show an interest in their menial tasks, strengthening the chain of production through personal dedication to the company and its goals.[44] By encouraging the right attitude, job counselors perpetuated a myth of easy advancement even as a decrease in the number of skilled secretarial positions lessened the possibilities for rapid upward mobility.

From all quarters women were advised to defer to everyone else's needs. In a book implausibly titled *She Strives to Conquer*, Frances Maule advised women to surrender their will and freedom to the interests of superiors. Other writers advised women to dust a male boss's desk, run his wife's errands, and perform a host of other domestic tasks—no matter what the cost in overtime or the personal sacrifice—to get ahead. *Fortune* magazine's long 1935 article on women in business was the most overt attempt to validate women's subordinate role in the workplace. Its author claimed that a woman's intention to marry and her willingness to be directed by a man relieved her of the ambition that would have made a man restless in her job.[45] Moreover, the boss needed her in this job because social and economic change had created a "new woman," one vastly different from the dutiful upper-class Victorian model. A man, instead of being master in his home, was now the mate of "a more or less unpredictable woman," and

he "resented it." The new office worker (especially the private secretary) repli-cated the woman his father had married, a daytime wife who knew "all the affairs, all the friends, all the friends' voices, all the idiosyncrasies, all the weakness of one man."[46]

A woman's "power" in the workplace came from her ability to behave in a def-erential "womanly" manner according to an ideology that valued her subordi-nation to the demands of male superiors. Since office work depended on a woman's extending her reputedly natural domestic skills to the public sphere—where she made the work environment more pleasant and inviting and managed the office efficiently—she achieved a success with which men could not com-pete, one that, as the *Fortune* author concluded, "was a triumph for [her] wom-anhood and not for [her] ambition."[47]

The pictorial narrative structure of Edward Hopper's *Office at Night* (fig. 19.10), one of the few paintings of the period that shows a secretary in an office, encapsulates the contradictions in popular advice literature. It gives visual form to the ambiguous power and gender relations embodied in the boss-and-private-secretary or male-and-female relationship. The secretary has power. A fully re-alized figure, she towers above her boss and controls not only the access to and organization of office information (the filing cabinet) but also office "produc-tion." In the visual field, Hopper emphasizes the secretary's desk and type-writer. They protrude into the lower lefthand corner of the painting, and along with the filing cabinet and the boss's desk they become an important third term in the painting's triangular configuration of work. The secretary's power is sub-verted, however, by the very stance that affirms it. She is the ultimate office or-nament, a male painter's construction of objectified womanhood; her impossibly twisted seductive posture displays her breasts and buttocks simultaneously for both the male viewer and, should he look, the boss. She "controls" the office dé-cor with her beauty and her simple attire—a plain blue dress with a white collar. But her dress clings to her body, whose curves are emphasized by the chair arm that insinuatingly penetrates the space beneath her buttocks. With her pose and her dramatic black hair and makeup she oversteps the boundaries of charm to overtly sexual, and therefore questionable, behavior, which the fair-haired male checks by not meeting her gaze. Ironically, her eyes are so shaded by heavy makeup that her mysterious gaze can be (as Victor Burgin points out) either di-rected and predatory (hence filled with power) or downcast and modest (hence deferential). Although she appears able to move freely in the office, pictorially everything blocks her access to the seat of power behind the man's desk: the fil-ing cabinet and desk intersect to create an unbridgeable gap. Another gap exists between her desk and his. She generates no activity but waits for instructions. Because the narrative is in suspension, the contradictions are not resolved.[48]

Figure 19.10 Edward Hopper, *Office at Night*, 1940. Oil on canvas, 22³⁄₁₆ × 25³⁄₁₆ inches. Collection of the Walker Art Center, Minneapolis, gift of the T. B. Walker Foundation, Gilbert M. Walker Fund, 1948.

Male artists like Hopper focus on the office worker as ornamental and sexual, available to the male; Bishop refused to sexualize her models. Even though a degree of objectification occurs that can be read as a difference of class, Bishop still sees them as modest, pleasant young workers. Deferential behavior, it was argued, allowed women either to compete for jobs and rise through the ranks *or* to attract a man and retire from the workplace, the other avenue of success for the office worker. Against all feminist arguments that women worked for personal fulfillment and from economic need, the *Fortune* author asserted that the *imitation* of marriage explained and justified the existence of the female secretary, whereas the *probability* of marriage made women willing to work at low wages in positions where advancement was almost impossible.[49]

In the 1930s job counselors urged women to engage in social activities "with an eye out always for a satisfactory marriage." No one wanted to pound a typewriter forever, and women entering the field were encouraged to overlook the tediousness of the work since it would be temporary. Writers warned women against obvious office romances, and one counseled them not to set their sights on

men beyond their own social station, for the rising executive was more interested in the "junior leaguer or the society girl outside."[50] Comments like these suggest that a persistent stigma—grounded in class bias—attached to the woman who worked.

Still, it was frequently argued that office girls made ideal wives. A woman office worker had studied the male temperament firsthand. Borrowing a page from the "companionate marriage" and professionalized homemaker manual, she understood that marriage resembled a business partnership. She also knew the importance of her husband's business relationships and would willingly entertain on short notice to further them. The wife, who had all the advantages of sharing a home with a man, could learn a great deal from the secretary, who did everything to make life easier for him: "A fault-finding wife who thinks only of her own selfish interests and what she can get out of her husband for herself or the children, is little better than the gold-digging stenographer whom she fears. Often a man becomes so fed up with discord at home . . . that he naturally turns to the girl who stands by him eight hours a day with praise instead of blame. . . . You very seldom see the wife who works shoulder to shoulder with her husband, who keeps herself pretty and attractive for his sake if not for her own, losing him to his secretary, or to any other woman."[51]

The ideology of woman's proper place permeated the advice literature for office workers and other job holders in the 1930s. Work was a preparation for marriage, a vehicle for finding a husband, and even a permissible pursuit for a wife if an economic necessity. But it was rarely seen as a substitute for marriage. In *Letters to Susan,* an example of a popular form of advice literature in the 1930s, a middle-class mother responded to her college-age daughter who had been offered a training-level position in a chemistry lab. Susan was engaged to Mark; although her mother urged her to accept the position because economic conditions remained uncertain, marriage, she insisted, ought to be a woman's main job. "She ought to give it most of her time and the best of her energy, and she can't do it if she's employed and being paid to give just those same things to her employer. . . . A man needs his courage restored and a woman who works 8 hours can't do that. In marriage either husband or wife must be willing to make the outside the home needs of the other predominant."[52]

Preceding the letters in this volume, each of which addressed a different issue, was a preliminary essay entitled "The Situation," detailing the changed conditions in women's lives in the postwar world and offering some suggestions on how women should prepare for them. A woman's destiny was less clear than a man's because she had now to earn her own living and "manage her life successfully if someone else earns it for her." Unlike a man's life, hers was a gamble be-

cause she had to wait until her emotions "reached fulfillment" or until they were "permanently channeled into the pursuit of some major interest."[53]

Unlike a man, who actively selected his interests and goals from an array of possible choices, a woman was presumed to be concerned primarily with domestic life. Consequently, she had to await the right opportunity and react to it. She had to learn to respond to external stimuli—whether a male superior's work assignment or his social invitation—rather than develop skills that would allow her to initiate and direct her own behavior. To be selected by men for work and marriage and to be successful on the job and in the home, she had to display compliant, womanly qualities, and she had to wait. Furthermore, what she waited for was still dictated by an ideal of womanly service. Woman's work, at home or in the workplace, enhanced the lives of those around her: "Some kinds of women's work lead to the creation of beautiful things, some to the relief of distress and soothing of pain, some to the training of little minds, while still others go to the making of laughter or to the comfort and pleasure of all."[54]

Bishop's paintings often portray a young woman, in repose and relaxed, who waits or responds to stimuli around her. In such works as *Laughing Head* (Butler Institute of American Art, Youngstown, Ohio), a solitary woman gazes at something beyond the confines of the picture and smiles or laughs. Within the picture plane she is unfettered because an ambiguous, shifting setting places no limits on her options; but these are the options of a temporary and transitional working life. The warm shimmering illumination that distinguishes the artist's painterly surfaces and sets her subjects' faces aglow suggests optimism, but it is so generalized that it in fact belies the inegalitarian conditions of office workers' lives during the Depression. Bishop's paintings also avoid the tawdrier features or downtrodden side of Union Square that Marsh and Soyer more readily acknowledged.[55]

In devising strategies by which women could succeed in the white-collar business world, writers of advice manuals promoted a contradictory set of instructions. They perpetuated a patriarchal model of individual success based on competition—a model that was particularly strong in white-collar businesses in large cities like New York. This model assumed equal access to opportunity through hard work, thus downplaying both gender and class difference. Yet these writers also relied on and ultimately reinforced well-established conceptions of gender difference, particularly attitudes about a woman's nature, her capabilities, and the roles she could be expected to fill. The belief that a woman needed to be more womanly to get ahead, even if such behavior restricted her to feminized occupations, was held by men and women alike. Thankful for jobs during hard times, many women were willing to dress in the prescribed fashion, behave

modestly, and ultimately ignore their fellow office workers' collective demands for better wages and working conditions. Writing in the *Woman's Press* and in *Independent Woman,* 1930s activists who struggled to improve the clerical worker's situation often met resistance from women schooled in the traditional models of "success" perpetuated in the advice literature.[56] As one writer summed up the situation, "Women who hope to be cooking their lunches in their own homes before the year is out are not women to be organized in unions for the improvement of their pay."[57]

Bishop's post-franchise generation of professional women believed that equality was a matter of individual responsibility achieved within established institutions. Although Bishop herself believed strongly in "women" (many of her close friends were women artists), she did not advocate "feminism" in the sense of women's collective endeavors. She never participated in any women's organizations or separate exhibitions for women. Attempting to downplay gender difference in favor of individual achievement, she claimed she wanted to join the art world, not "to be a woman artist" but "just . . . to be an artist."[58]

Though she earned early critical and financial success in the mainstream art world—jurors for important national exhibitions awarded her prizes for both graphics and painting, and major museums purchased her works—she was always characterized as America's best *woman* artist. Moreover, critics placed careful limits around her achievement. Most reminded the public that she was Kenneth Hayes Miller's "pupil" and had made "slow" progress. Henry McBride spoke of Bishop working "the *little* plot of ground she has preempted" and of her "restricted" range. In 1937, one critic even claimed that Bishop's most obvious qualities were "modesty and charm."[59] Critics, colleagues, and friends alike attributed to her the very prerequisites for success that she had inscribed in her subjects.

Bishop became one of the first artists to give the office worker a place in the urban iconography of easel painting. Her images of these clerical types—stocky and unglamorous yet ennobled through artistic conventions that focused on a woman's figure and face—negotiate gender and class difference according to an ideology of office work whose sometimes contradictory notions of mobility and femininity were shared by the artist. Although she depicted her women as self-possessed individuals rather than sexualized objects, she never envisioned them as productive workers in the society in which she saw (and had herself seized) great opportunity. Nor did she see them suffering from an entrenched set of attitudes about roles and occupations. Both the occupational and social spaces of her lower-level workers remained distant from her own and she interacted with her subjects only as studio models. The ambiguous spatial envelope around her casually posed figures, however, suggests a contested middle-class ideal of femi-

ninity that has been destabilized by the Depression, a time when the demands of work and family were particularly acute. If Bishop's painterly suggestion of mobility and potential remains unconvincing as a metaphor for women's social or economic progress, it nonetheless embodies 1930s perceptions of mobility and femininity assigned to the young, deferential office worker whose proper working life was lived in a transitional space between the public and the domestic spheres. As visual representations of the contradictory discourse on women and work, Bishop's paintings helped to reinforce the belief that even outside the home, a woman had her proper place.

Notes

This is an abridged version of chapter 7 in Ellen Wiley Todd's *The "New Woman" Revised: Painting and Gender Politics on Fourteenth Street* (Berkeley, Calif., 1993). Locations are provided for paintings that were illustrated in the original publication but not here.

The first epigraph is from an interview with the author, Dec. 16, 1972. The second is from a 1978 interview with Patricia Depew for the film *Isabel Bishop: Portrait of An Artist,* distributed by Films Inc., Chicago, as quoted in Helen Yglesias, *Isabel Bishop* (New York, 1989), 36. The third is from Rosemary Betterton, "How Do Women Look? The Female Nude in the Work of Suzanne Valadon," in *Looking On: Images of Femininity in the Visual Arts and Media,* ed. Rosemary Betterton (London and New York, 1978), 221.

1. See, for example, "Isabel Bishop Finds Critics Receptive," *Art Digest* 13 (Feb. 1, 1939): 21; "New York Criticism: A Miller Pupil's Shackles Loosen," *Art Digest* 10 (March 1, 1936): 16; and Bernard Myers, ed., *"Sleeping Child,* by Isabel Bishop," Scribner's American Painters Series 9, *Scribner's* 122 (November 1937): 32; and "New Paintings Shown by Isabel Bishop," *New York World-Telegram,* Jan. 21, 1939: 16.

2. See, for example, Grace L. Coyle, "Women in the Clerical Occupations," *Annals of the American Academy of Political and Social Science: Women in the Modern World* 143 (May 1929): 184; Orlie Pell, "Two Million in Offices," *Woman's Press* 33 (June 1939): 256; and Ethel Erickson, *The Employment of Women in Offices,* U.S. Department of Labor, Women's Bureau Bulletin 120 (Washington, D.C., 1934), 3, 7. For important historical overviews, see Lorine Pruette, ed., *Women Workers through the Depression: A Study of White-Collar Employment Made by the American Woman's Association* (New York, 1934); Margery Davies, *Woman's Place Is at the Typewriter: Office Work and Office Workers, 1870–1930* (Philadelphia, 1982); and Lois Scharf, *To Work and to Wed: Female Employment, Feminism, and the Great Depression,* Contributions to Women's Studies 15 (Westport, Conn., 1980).

3. See, for example, Loire Brophy, *If Women Must Work* (New York, 1936); Hazel Rawson Cades, *Jobs for Girls* (New York, 1928); Dorothy Dayton, "Personality Plus— or Minus," *Independent Woman* 15 (November 1936): 343, 362; Frances Maule, *She*

Strives to Conquer: Business Behavior, Opportunities, and Job Requirements for Women (New York, 1937); Elizabeth Gregg MacGibbon, *Manners in Business* (New York, 1936); and Ruth Wanger, *What Girls Can Do* (New York, 1926).

4. Griselda Pollock, "Modernity and the Spaces of Femininity," in *Vision and Difference: Femininity, Feminism, and the Histories of Art* (London and New York, 1988), 56.

5. Interview with the artist, Dec. 16, 1982.

6. Scharf, *To Work and to Wed*, 11–12. U.S. Department of Labor, Women's Bureau, *The Occupational Progress of Women*, 17, as quoted in Coyle, "Women in the Clerical Occupations," 180.

7. Scharf, *To Work and to Wed*, 13, 41.

8. For hiring policies, see MacGibbon, *Manners in Business*, 26; Erickson, *Employment of Women*, 14, 27.

9. In the 1934 New York survey of 14,025 clerical workers, only 10.1 percent reported that they were married. Erickson, *Employment of Women*, 12–13, 29.

10. Coyle, "Women in the Clerical Occupations," 183.

11. Ibid., 183; and Erickson, *Employment of Women*, 13.

12. Erickson, *Employment of Women*, 5–8; and Wanger, *What Girls Can Do*, 112.

13. Erickson, *Employment of Women*, 5–7; and Wanger, *What Girls Can Do*, 113.

14. John Berger, *Ways of Seeing* (London and New York, 1972); and Rosemary Betterton, ed., *Looking On: Images of Femininity in the Visual Arts and Media* (London and New York, 1987), 10–14.

15. Emily Genauer, "Miss Bishop Rates High as Painter," *New York World-Telegram*, Feb. 15, 1936: 15; Edward Alden Jewell, as quoted in *Art Digest* 13 (Feb. 1, 1939): 21; James W. Lane, "Bishop," *Art News* 41 (June 1942): 42, and Lane, "Canvases by Isabel Bishop, Painter of Subtle Tonalities," *Art News* 37 (Jan. 21, 1939): 12; and Forbes Watson, "Isabel Bishop," *Magazine of Art* 32 (January 1939): 52.

16. Bishop's technique was complicated, and she took many months to complete a single painting. She worked in either oil or tempera, building up meticulously crafted layers of paint. The pencil strokes, which she added toward the end of the process, often to a surface still wet, suggest where a contour might appear without really defining it. As a result, the pencil strokes seem to hover above the surface, implying motion.

17. In most New York offices women worked a thirty-nine-hour week, seven hours a day with four hours on Saturday mornings, except during the summer. In large offices good benefit packages might include two weeks of paid vacation, one week of paid sick leave, some group insurance, and small bonuses. Erickson, *Employment of Women*, 29–33.

Clerical wages seem to have been considerably better than those of domestic, industrial, and sales workers. In the early 1930s a beginning file clerk in a large institution seems to have made about a dollar a week more (or around $17) than a beginning saleswoman in a major department store, and a secretary two to five dollars a week more than an upper-level saleswoman (or around $42.50). My own estimate is based on an evaluation of several median wage charts in Erickson, *Employment of Women* (20–23), modified by reports of somewhat lower salary ranges in "Women in Business II," *Fortune* 12 (August 1935): 85.

18. Coyle, "Women in the Clerical Occupations," 181.

19. Erickson, *Employment of Women*, 1.

20. In "Isabel Bishop, the Grand Manner, and the Working Girl," *Art in America* 63 (September 1975): 63, the art critic Lawrence Alloway identified this technique as a metaphor. The artist's own statement was from her article "Concerning Edges," *Magazine of Art* 32 (January 1939): 57–58.

21. Sheldon Reich, *Isabel Bishop*, introduction by Martin H. Bush (Tucson, 1974), 23.

22. Reich, *Isabel Bishop*, 24.

23. Cindy Nemser, "A Conversation with Isabel Bishop," *Feminist Art Journal* 5 (Spring 1976): 15.

24. "Isabel Bishop," *Current Biography Yearbook* (New York, 1977), 63; and Karl Lunde, *Isabel Bishop* (New York, 1975), 169.

25. William Engle, "Portrait of Two Girls Bought by Metropolitan Reunites Two Ex-Waitresses Who Posed for It," *New York World-Telegram*, Feb. 27, 1936: 3.

26. For information on the Popular Front, the Artists' Congress, and the Society for Modern Artists, see the introduction to Matthew Baigell and Julia Williams, *Artists Against War and Fascism: Papers of the First American Artists' Congress* (New Brunswick, NJ, 1986).

27. Interview with the artist, Dec. 16, 1982. Quotations from Cindy Nemser, "Conversation with Isabel Bishop," 18; and Reich, *Isabel Bishop*, 14, 25.

28. Alloway, "Isabel Bishop," 63. Alloway also argued that Bishop's fully articulated theories about mobility were a way for her to assuage her conscience for her remarks about the social limitations of these figures, a judgment that may have been unfair given Bishop's values and her position in particular social and political discourses in the 1930s.

29. Grace Hutchins, *Women Who Work* (New York, 1934), 84. Hutchins, a writer with a Marxist perspective, quoted a 1926 National Industrial Conference Board report that showed 39 percent of all clerks received less than twenty dollars per week. Her study is an excellent foil for Lorine Pruette's study of white-collar workers on large salaries.

30. "Women in Business II," 55.

31. In New York, where employers generally paid the highest wages, stenographers dropped from $20-$40 per week to $15–25; typists, who earned $18-$30 in 1935, received $16-$18; "Women in Business II," 55. Grace Hutchins quotes a different, still lower scale and looks to some of the lower clerical occupations. In 1929 clerks earned $10-$22 per week; in 1931 their wages dropped to $8-$18 per week.

32. Hutchins, *Women Who Work*, 84; "Women in Business II," 50; and Elizabeth Gregg MacGibbon, "Exit—the Private Secretary," *Occupations* 15 (January 1937): 300.

33. A bookkeeper might absorb the jobs of a saleswoman, stenographer, and general clerical worker and work six days, eleven to fourteen hours each, for half her former wage. She dared not complain for fear of losing her job. Hutchins, *Women Who Work*, 84.

34. MacGibbon, *Manners in Business*, 165. Eunice Fuller Barnard, "Girl Graduate, 1936," *Independent Woman* 15 (July 1936): 203.

35. Barnard, "Girl Graduate," 203.

36. Caroline Ware, "The 1939 Job of the White Collar Girl," *Woman's Press* 33 (June 1939): 254–55; and Coyle, "Women in the Clerical Occupations," 184.

37. MacGibbon, "Exit—the Private Secretary," 296, reported that in one enormous

New York office, seventy-seven private secretaries, each of whom had served an executive, were replaced by twenty-two workers. See also Coyle, "Women in the Clerical Occupations," 185–86; and Ware, "1939 Job," 254–55.

38. Rebecca Zurier, *Art for "The Masses": A Radical Magazine and Its Graphics, 1911–1917* (Philadelphia, 1988), 126–32.

39. Scharf, *To Work and to Wed,* 100–101.

40. MacGibbon, *Manners in Business,* 12, 28.

41. In "Women in Business II" it was estimated that more than a fifth of an office girl's salary was spent on clothing. The most expensive items were silk stockings, at the rate of a pair a week (p. 85). See also MacGibbon, *Manners in Business,* 29; and Maule, *She Strives to Conquer,* 125.

42. Dorothy Dunbar Bromley, "Feminist—New Style," *Harper's Monthly Magazine* 155 (October 1927): 552–60.

43. Cades, *Jobs for Girls,* 16; Dayton, "Personality Plus—or Minus," 343. Dayton wrote that personality was about 75 percent of getting a job, brains and technical training less than 25 percent. Her article discusses the increasing reliance on experts to help a girl change her voice and improve her personality, first by testing, then through a series of classes.

44. Brophy, *If Women Must Work,* 35–41.

45. Maule, *She Strives to Conquer,* 6; MacGibbon, *Manners in Business,* 66–72; and "Women in Business II," 55.

46. "Women in Business II," 55; Eugenia Wallace, "Office Work and the Ladder of Success," *Independent Woman* 6 (October 1927): 16–18.

47. "Women in Business II," 86.

48. For an extended discussion of this painting, see Ellen Wiley Todd, "Will [S]he Stoop to Conquer? Preliminaries Toward a Reading of Edward Hopper's *Office at Night,*" in Norman Bryson et al., eds., *Visual Theory: Method and Interpretation in Art History and the Visual Arts* (New York, 1990); Victor Burgin, *Between* (Oxford, 1986), 184.

49. "Women in Business II," 55. The persistent belief that these jobs were temporary was buttressed by the departure of four out of five women from clerical occupations when they married.

50. MacGibbon, *Manners in Business,* 61, 116–27.

51. Ibid., 127.

52. Margaret Culkin Banning, *Letters to Susan* (New York, 1936), 92, 94.

53. Ibid., 7.

54. Wanger, *What Girls Can Do,* 4.

55. Unlike her nineteenth-century predecessors Mary Cassatt and Berthe Morisot, who would never have thought of entering the cafés, nightclubs, and brothels that emblematized modern life for their fellow impressionists, Isabel Bishop accompanied Marsh to the burlesque and to striptease joints on occasion. But as a proper upper-middle-class female viewer and producer of representations of women, she could not "properly" or "publicly" (through paintings) enter those spaces or envision female sexuality in that way for herself or her female viewers.

56. By the 1930s there were a few small local unions that combined bookkeepers, stenographers, accountants, and occasionally saleswomen. In May 1934 the legislative

body of the YWCA, along with representatives of business and professional clubs, adopted resolutions identifying the welfare of office workers with that of other workers and proposing study and educational groups to help office workers prepare for unionization. Neither the movement nor the organization was widespread in the 1930s. Marion H. Barbour, "The Business Girl Looks at Her Job," *Woman's Press* 30 (January 1936): 18–19; Clyde Beals, Pearl Wiesen, Albion A. Hartwell, and Theresa Wolfson, "Should White Collar Workers Organize?" *Independent Woman* 15 (November 1936): 340–42; and Ware, "1939 Job," 255.

57. "Women in Business II," 85.

58. Interview with the artist, Dec. 16, 1982.

59. Henry McBride, "Some Others Who Arouse Interest," *New York Sun,* Feb. 15, 1936: 28; Bernard Myers, "*Sleeping Child,*" 32.

20 Jackson Pollock: Representing the Unconscious

Michael Leja

One way to pose the problem addressed by this paper is to describe three works by Jackson Pollock, from different phases of his career, juxtaposing each with a precisely contemporary statement of his artistic commitments. *Guardians of the Secret* from 1943 (fig. 20.1) is a work of his early maturity; it was reproduced alongside his first published statement about his work, a February 1944 interview in *Arts and Architecture*. Reflecting upon the impact of the European painters recently arrived in New York, Pollock remarked that he had been influenced more by an idea they promoted than by their work: specifically, "their concept of the source of art being the unconscious." *Guardians* is a relatively conventional modernist easel painting: the forms have been drawn with brushes and sticks, and the rough, vigorous handling combines with a tight pictorial structure to yield an expressionistic variant of cubist figuration.

Four years later, Pollock painted *Full Fathom Five* (fig. 20.2), arguably one of the works to which he was referring when he wrote in a draft of a statement for the magazine *Possibilities* in 1947, "the source of my painting is the unconscious."[1] In his paintings from this time, fluid and elegant poured lines generate a viscous and turbulent surface, encrusting studio detritus such as nails, cigarettes, and paint-tube caps. Now no figuration is apparent.

Just two months before he died in 1956, Pollock told an interviewer: "I'm very representational some of the time, and a little all of the time. But when you're painting out of your unconscious figures are bound to emerge. We're all of us influenced by Freud, I guess. I've been a Jungian for a long time."[2] *Portrait and a Dream* of 1953 (fig. 20.3) is a good contemporary point of reference for

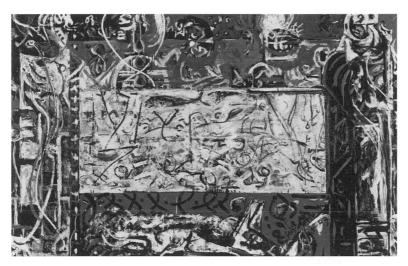

Figure 20.1 Jackson Pollock, *Guardians of the Secret,* 1943. Oil on canvas, 48⅜ × 75⅜ inches. San Francisco Museum of Modern Art, Albert M. Bender Collection, Albert M. Bender Bequest Fund Purchase, copyright 1998 Pollock-Krasner Foundation/Artists Rights Society, New York.

these remarks. The right (portrait) side of the painting comprises delicate and deliberate drawing, juxtaposed with the semifigurative linear network stained into the left side of the canvas.

The point of these comparisons is to demonstrate the persistence of Pollock's interest and difficulty in "painting out of the unconscious." Throughout his mature career, from first published statement to last, Pollock asserted that the source of his painting was the unconscious, yet there is considerable diversity among the pictorial materials he presented as unconsciously generated. If, as he apparently believed, the sources of *all* these paintings, with their various approaches to imagery and paint handling, were in the unconscious, then what can we say about his conception of the unconscious? What sort of understanding of the unconscious should we impute to Pollock in order to be able to take his assertions seriously?

The way I have phrased the question reveals some of my premises. Wondering about Pollock's *conception* of the unconscious proposes that taking Pollock seriously does not mean taking him literally. The idea of painting out of the unconscious may have been a productive fiction for Pollock, but it will not suffice as an explanation for the forms of these paintings. In recent decades, theorizing about the unconscious has yielded grounds for skepticism toward some of the most fundamental and obvious propositions about mental process implied

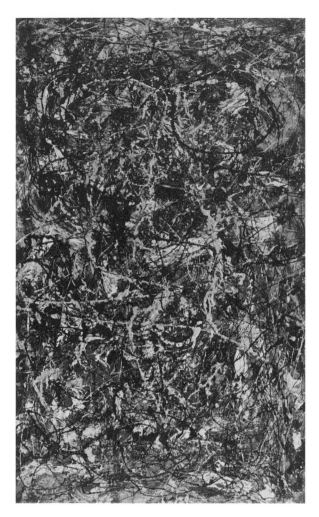

Figure 20.2 Jackson Pollock, *Full Fathom Five,* 1947. Oil on canvas with nails, tacks, buttons, keys, coins, cigarettes, matches, etc., 50⅞ × 30⅛ inches. Museum of Modern Art, New York, gift of Peggy Guggenheim. Photograph copyright 1997 the Museum of Modern Art, New York.

in Pollock's paintings and statements. His confidence in the accessibility of the unconscious—its susceptibility to automatic and spontaneous exposure—is suspect by any standards. Likewise, there is reason to doubt not only that Pollock's version of the characteristic imagery of the unconscious is the correct one, but that the unconscious has *any* characteristic imagery. Models of the unconscious devised by Jacques Lacan as well as Gilles Deleuze and Félix Guattari employ different metaphors and consequently offer a base from which to appraise prior models.[3] Such alternative conceptions help to illuminate the metaphorical eccentricities of the Freudian and Jungian models, many of which inform and structure Pollock's work.

Moreover, from a historical and anthropological point of view, the uncon-

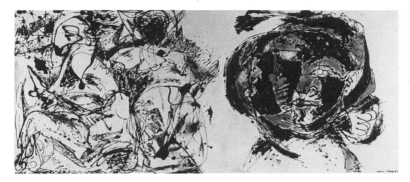

Figure 20.3 Jackson Pollock, *Portrait and a Dream,* 1953. Oil on canvas, 58⅛ × 134¼ inches. Dallas Museum of Art, gift of Mr. and Mrs. Algur H. Meadows and the Meadows Foundation, Inc., copyright 1998 Pollock-Krasner Foundation/ Artists Rights Society, New York.

scious has come to be understood as a constructed category, its particular form always contingent upon social and historical conditions. The unconscious is not a fixed, transhistorical, preexistent entity whose structure and contents can be discovered by scientific investigation. It is rather, as Peter Berger has emphasized, a conceptual construction socially determined, originating in social processes of identity production and confirmation.[4] The individual experiences the unconscious, and all of psychological reality, in a form defined and shaped by a culture and its models of self, subject, and identity. Therefore, even if it were true that Pollock was painting (out of) his unconscious—and indeed he was, insofar as one's psychological reality is determined by prevailing psychological models—we would still need to know *which* unconscious he was painting, that is, the unconscious as constructed in what manner, involving what historical and social determinants.

Pollock's project—painting out of the unconscious—is best described and understood as *representing* the unconscious.[5] He was engaged in a revision of modernist artistic practice consciously directed at accommodating the unconscious, giving it rein, or space, or voice—whatever "it" preferred so long as its presence and force were signified. The uncertainty owed in large part to the difficulty of the concept, but it was compounded by the fragmentary and inconsistent character of his learning; he had absorbed disparate bits and pieces of information concerning psychic structures, operations, and contents. If they were to add up to anything it would happen in the process and imagery of his art, where those fragments became the flint he hoped would set his unconscious firing.

Three sets of questions should be asked in a study of Pollock's representa-

tion of the unconscious. First, what was "painting out of the unconscious" for Pollock? (Some of the ambiguities are contained in this single phrase. For example, how should we understand that "out of"? On one hand the unconscious is imaged as a well or paint bucket, into which one's brushes may be dipped. But on the other, it is something to be escaped or transcended, as one gets—or paints—oneself out of a corner or out of trouble.) When we put his statements and work together, how clear a picture can we get of the beliefs and assumptions about the unconscious and its operation implicit in them? Second, how are these beliefs figured in the work? Can his wide range of forms, imagery, and handling be related productively to some set of notions of the unconscious? And third, how were Pollock's representations of the unconscious related to the social and historical circumstances of wartime and postwar America?

My subjects, then, are Pollock's assumptions, conceptions, drawings, and paintings, without separation between beliefs and forms. He was in no sense illustrating preformed ideas, but rather forming, assimilating, and testing propositions in representation—whether mental or pictorial. Both beliefs and forms were highly synthetic—made up of bits and pieces of information collected and absorbed from sources of all sorts. But there were two basic models around which his thinking and work turned: a symbolic model and an energic or electrodynamic model. Each had a continuous role in Pollock's artistic theory and practice from the early 1940s on, although one or the other usually predominated. The two models are diametrically opposed in some respects, but both have origins in Freudian and Jungian theory, both were in wide circulation in American culture in the 1940s and 1950s, and both were doing specific kinds of ideological work in that culture.[6]

The first model is best seen in its formative stages, in the so-called psychoanalytic drawings from 1939–40. This set of eighty-three drawings dates from the period of Pollock's first sustained analysis, motivated by alcoholism and depression which had recently become so acute as to require hospitalization. The story goes that Pollock was having difficulty communicating with Dr. Joseph Henderson and so offered to bring to their sessions some of his work for discussion. This suggestion is the earliest indication that Pollock had begun to believe that his work contained psychologically revealing material. He was struggling artistically as well as emotionally at this time; he had begun to move away from his early style and imagery, indebted to Thomas Hart Benton, and toward the manner (seen in *Guardians of the Secret*) that would bring him his first public success at Peggy Guggenheim's Art of This Century gallery in 1943. The psychoanalytic drawings document a crucial stage in this evolution. They record his early efforts to come to terms with the idea of the unconscious and to lay the groundwork for an artistic practice that offered the unconscious the prominence

it compelled. The psychoanalytic drawings apparently were not done specifically or exclusively for the analysis but were entirely continuous with Pollock's contemporary public work.

What do these drawings tell us, then, about Pollock's early active engagement with the idea of the unconscious? They indicate that in this stage of his career, Pollock's representation of the unconscious was grounded in Jungian theory. By looking at the specific character of the debts to Jungianism, we can ascertain something of the latter's particular functions and appeal.

There are documents related to the psychoanalytic drawings and dating from the same years that indicate Pollock's engagement with Jungian concepts was quite direct and explicit. One is a list in Pollock's handwriting of ten articles on Jungian psychology by members of the Analytical Psychology Club of New York, the Jungian association in which Pollock's first two analysts, Joseph Henderson and Violet Staub de Laszlo, were active.[7] These papers were published informally by the APC-NY and had a very limited, largely internal circulation. They were collected in four bound volumes, and Pollock's list corresponds precisely to the sequence of their publication. If this list is what it seems—that is, a collection of titles Pollock intended to peruse either at someone's recommendation or by his own discovery—its significance is clear. It documents an initiative to pursue psychological knowledge well beyond the exigencies of his own treatment, and it records his exposure and access to the discourse of the APC-NY. In and around his therapy Pollock would have learned about depth psychology through the Jungian lens ground in the discourse of the APC-NY.

The effects of this exposure are evident in other documents. A drawing from 1939 (O'Connor and Thaw, *Jackson Pollock*, vol. 3, cat. 469r) contains a faint notation beneath a slender phallic form and beside a biomorphic cluster: "passive fantasy, active [fantasy]." It refers to the Jungian distinction between fantasies that erupt into consciousness and those that require action from the ego to bring them into consciousness. Jung described passive fantasy as the product of a dissociated psyche and a completely passive consciousness in the subject. Active fantasies, in contrast, are produced by healthy psyches and are among the highest forms of psychic activity, since they involve the positive participation of consciousness with unconscious materials. They are, furthermore, "the principal attribute of the artistic mentality," according to Jung.[8] One can imagine Pollock pondering this distinction as he conjured the forms on the page, and although this imagining is no more than a hypothetical narrative, it offers, I think, a plausible model of the dynamic between ideas and visual imagery in Pollock's "work" on the unconscious.

Another example of direct engagement (fig. 20.4) is a sketch Pollock made for a gouache he gave to Henderson as a going-away present, when Henderson

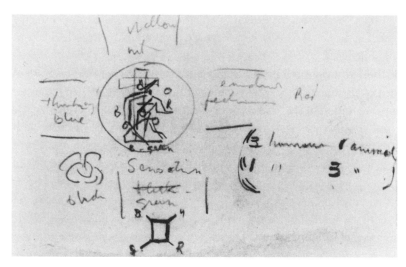

Figure 20.4 Jackson Pollock, untitled drawing (sketch for crucifixion gouache; O'Connor and Thaw, *Jackson Pollock*, vol. 3, cat. 556), 1940. Pencil and charcoal pencil on paper, 5¼ × 7⅞ inches. Private collection, copyright 1998 Pollock-Krasner Foundation/Artists Rights Society, New York.

moved to San Francisco in 1940. It shows Pollock using explicitly Jungian concepts in the construction of an image. The notations on it refer to Jung's distinction of four properties or functions of consciousness: thinking, feeling, sensation, and intuition. To these functions Pollock has assigned colors: red for emotion/feeling, green for sensation, blue for thinking, yellow for intuition. This color coding for these functions was a fixed and familiar feature of Jungian theory, as diagrams from contemporary Jungian texts illustrate.[9] Another notation at the right of Pollock's diagram—"3 humans 1 animal, 1 human 3 animals"— may be related to Jung's belief that conflict is built into the totality of human life in a three-to-one ratio. Totality, according to Jung, includes the trinity of the good world along with the black substance of evil. In the finished gouache,[10] red and blue human figures try to subdue a brown/black animal form; behind them a yellow human looks heavenward from a green cross.

This evidence of Pollock's direct and explicit engagement with particular Jungian concepts prepares us to recognize less exact and circumscribed evidence of Jungian debts in the drawings. The drawings reveal that Jungian theory colored Pollock's early efforts to come to terms with the idea of the unconscious in some profound and lasting ways. His first, symbolic model of the unconscious had a strongly Jungian character. This model viewed the unconscious as a dark, primordial, subterranean realm populated by mythic and religious symbols. Two

features of the Jungian component in Pollock's version of this model are of particular interest—the exotic symbolic vocabulary and thematics, and the drive toward synthesis or unification of opposites. These features will be central to my explanation of the particular appeal of Jungianism to Pollock and many of his contemporaries; I will try to document them briefly without becoming mired in Jungian theory and symbolism.

A symbolic vocabulary for the unconscious was securely established in the discourse of the Analytical Psychology Club of New York around 1940; it featured a small cluster of fundamental symbols typically discovered in patients' drawings and in ancient narratives and inscriptions, and taken to represent key components of Jungian theory. The snake, for example, was commonly interpreted as representing the baser part of human nature—the passions, the "lower man," the "dark part." Several drawings by analysands reproduced in an influential essay by Jung himself featured snake imagery analyzed in these terms. The snake, in Jungian interpretation, is less a sexual, phallic symbol than a symbol of the lower, baser part of human nature. Lowness is usually one of its literal attributes in symbolic configurations. The same applies to most of the snake imagery in Pollock's psychoanalytic drawings. A common motif in these drawings is the so-called ritual figure, composed of various symbols arranged symmetrically or asymmetrically across a vertical axis. In many of these figures (including in figure 20.5 the two figures flanking the central skull), the bottom levels are composed of snakes, while the higher levels contain sun and moon or eye-forms—symbols, generally, of higher psychic states. Other drawings, in which human and animal figures are stacked or entangled, also assign the snake a subordinate position suggestive of psychic or moral inferiority.[11]

There are, of course, various other possible sources for such snake symbolism and syntactic practices; the case for Jungianism's relevance rests in large part on the larger symbolic matrix. The disk and crescent, or sun and moon symbols, seen at the top of the ritual figure, are another part of this matrix. They, too, were standard elements of the Jungian visual vocabulary, highlighted in patients' drawings and ancient inscriptions. The sun disk was taken to stand for the conscious mind and psychic wholeness, while the crescent moon represented the unconscious. Pollock's drawings reveal a persistent interest in these symbols, sometimes in forms strongly reminiscent of Jungian examples (figs. 20.6 and 20.7).[12] The direction of Pollock's experimentation with sun and moon forms—toward synthesis—provides a good illustration of the second prominent feature of Jungianism that I see in the drawings. Several full pages of drawings reveal Pollock to be determined to make the disk and crescent integral parts of a greater form—face, figure, bull's head, flower, ritual figure, symbol cluster, and so on.[13] Sun and moon are yoked together in these drawings in all manner of

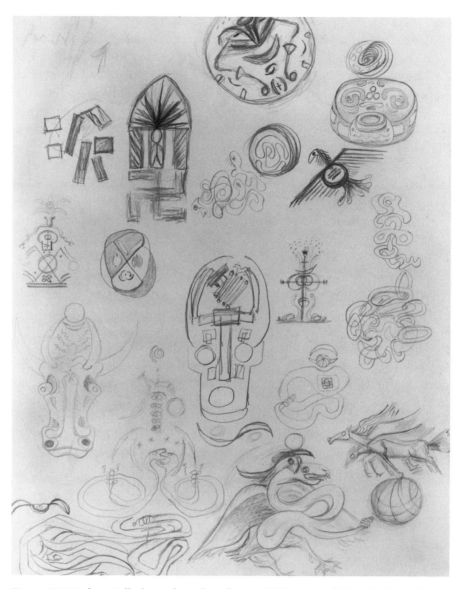

Figure 20.5 Jackson Pollock, psychoanalytic drawing (O'Connor and Thaw, *Jackson Pollock*, vol. 3, cat. 520r), 1939–40. Pencil on paper, 14⅛ × 11 inches. Photograph courtesy Nielsen Gallery, Boston, copyright 1998 Pollock-Krasner Foundation/Artists Rights Society, New York.

combination, including copulation.[14] The unification of opposites, frequently effected on the symbolic level, was a fundamental principle of Jungian theory; the primary opposition was that of consciousness and unconsciousness, and the ultimate goal of Jungian analysis was a harmonious and balanced synthesis of these two at a higher psychic level. Jung and his followers tended to discover this same relation and dynamic in a number of other dualities—sun/moon, male/female, hot/cold, dry/wet, dark/light, gold/silver, round/square, water/ fire, physical/spiritual, and so on. Opposition came to seem to Jung a structural principle of the psyche. The commitment to the synthesis of opposites into transcendent unity is a noteworthy point of contact between Jungian psychology and certain mysticisms, such as theosophy—one of Pollock's youthful enthusiasms.

Pollock seems to have internalized the unification of opposites as a theme in his work. Dualistic imagery, often interdependent with symmetrical structure, is a prominent feature of the psychoanalytic drawings and some contemporary paintings. One of the characteristic Jungian vehicles for achieving synthesis was the mandala—a circular form often subdivided into four parts. Jungian theory used the mandala as a model of the psyche, the four mental functions surrounding the psychic center, the anima. Pollock used this form frequently in the psychoanalytic drawings; in other drawings, the mandala functions to contain sun, moon, and cross symbols or abstract biomorphic shapes.[15] The drive toward integration and unification takes other forms as well in Pollock's drawings. Human and animal, male and female, creature and creature are joined together via various formal strategies, often with two distinct individual figures merging into a quite different figurative totality. In figure 20.8, the triangulated woman at the top center and the blocky figure at the middle of the right edge are built from twin figures facing one another in profile. The "ritual figure" forms described

Fig. 28

Fig. 30

Fig. 29

Fig. 31

Figure 20.6 Phoenician moon emblem. Fig. 29 from M. Esther Harding, *Woman's Mysteries* (New York, 1935), p. 196.

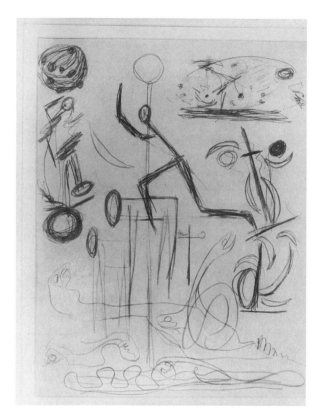

Figure 20.7 Jackson Pollock, psychoanalytic drawing (O'Connor and Thaw, *Jackson Pollock*, vol. 3, cat. 519r), 1939–40. Orange pencil on paper, 14⅛ × 11 inches. Photograph courtesy Nielsen Gallery, Boston, copyright 1998 Pollock-Krasner Foundation/Artists Rights Society, New York.

earlier (see fig. 20.5) should also be recalled here as totalizing aggregates of individual symbolic forms.

Jungianism's rich symbolics and its orientation toward transcendent unification provided Pollock with more than artistic materials; they also participated, principally through his therapy, in recasting notions of self and mind faltering under personal stresses and cultural pressures. His bouts with depression, alcoholism, and violent behavior—experiences of self beyond conscious control—found explanation here. And although Pollock's case may have been exceptionally acute and somewhat idiosyncratic, he was far from alone in finding relief of more or less this sort in Jungian theory at this time.

Jungianism served the same purposes for Pollock that depth psychology, to use the contemporary terminology, was serving for wartime American culture generally: that is, it provided new explanations for modern forms of evil and for collective and personal distress. Anomie, disorientation, and destructive or violent behavior were, in a variety of cultural materials, being attributed to the workings of the unconscious, as was the appearance of fascism, war, and mass

Figure 20.8 Jackson Pollock, psychoanalytic drawing (O'Connor and Thaw, *Jackson Pollock*, vol. 3, cat. 522r), 1939–40. Graphite and colored pencil on paper, 14⅛ × 11 inches. Courtesy of the Museum of Fine Arts, Boston, gift of Jessie H. Wilkinson.

brutality on the international stage. Depth psychology was thus doing serious ideological work: shoring up middle-class ideology with a new improved model of the human subject; overshadowing competing accounts that emphasized social, political, or economic causes for current problems; and rationalizing and introjecting the sensation of powerlessness and victimization experienced by individuals faced with cataclysmic world-historical events.

Supporting these claims will require first of all some definition of "American middle-class ideology," as well as some evidence that it was under stress at this time. I mean the term to designate the beliefs, categories, and assumptions that underpinned the basic propositions about people and the world endorsed generally by members of the American middle classes during the interwar period—regardless of their explicit political commitments—and dominant in contemporary cultural discourses. At the most fundamental level—at the level, that is to say, at which this particular version of middle-class ideology is most clearly a subset of bourgeois ideology broadly formulated—there is a belief in the essentially individual basis of human responsibility and behavior; a belief

in the morality of industriousness, ingenuity, efficiency, and other traits whose effects include the maximization of profit; and an assumed ethics of private ownership. The middle-class ideology that flourished in America in the 1920s, the decade of Sinclair Lewis's *Babbitt,* had particular emphases and priorities; at its core was a bullish confidence in the power of the individual to control his/her own well-being and fate, an updated version of the Christian self-control that was "the moral imperative around which the northern middle class became a class" in the early decades of the nineteenth century.[16] Other prominent characteristics were faith in scientific and technological progress; a strong sense of the American nation and its superiority over others; and excessive valuation of material possessions and comforts—amounting, indeed, to a belief in self-fulfillment through acquisition. This latter belief merged with an assumption that the particular conception of and desire for the good life embedded in this ideology was innate and universal, so that every individual, of whatever culture, race, or gender, would strive toward it rationally and systematically if given the opportunity.

This ideology was by no means monolithic and seamless; nor was its hegemony in America in the 1920s uncontested.[17] It was, nonetheless, securely dominant and effectively self-sustaining. Its fundamental propositions were taken to be natural and obvious facts, never discussed but generally assumed by political liberals as well as conservatives. Through the new and expanded vehicles of mass culture—mass-circulation magazines, radio, movies, advertising—as well as through violent state offensives, such as the Palmer raids,[18] it infiltrated and homogenized the local and ethnic cultures of working-class, immigrant, and marginalized groups.

The robust ebullience of this ideology, however, was not long-lived: world-historical events of the 1930s and 1940s shook some of its foundations and revealed the contingent nature of some of its components. Doubts about the individual's ability to control his/her fate, or about the primacy of essentially rational and directed behavior, or even about the naturalness of the assumed ethics, accompanied large-scale, structural, economic and political failures. Newspapers, magazines, and mass-market nonfiction publications devoted more and more space to hand-wringing lamentations over the loss of the sense of individual power and autonomy and to exhortations to rethink fundamental beliefs about human nature, mind, and behavior. "The unconscious," along with its cousin, "the primitive," played direct and important parts in this process, providing new sources and explanations for the behavior responsible for the current crises. Together they were the principal agents in the rescue of the dominant ideology's notion of the subject.

As I noted earlier, virtually all depth psychology—Freudian, Jungian, and

other varieties—was enlisted in this project. How should we account for the particular strength of the Jungian model of the unconscious to the young Pollock, his audience, and a large segment of American culture—artists, writers, and so on—at this historical moment?[19] Part of its appeal for Pollock in particular no doubt resided in the graphic orientation and the rich, visual vocabulary offered by Jungian discourse. It was, in a sense, the version of the unconscious best suited to visual representation—to the project of "visualizing" the unconscious—and it seemed a marked improvement over Freudian dream illustration. But more important generally, I think, were its elements of mysticism and transcendentalism, precisely those qualities highlighted in the features that attracted Pollock. The Jungian unconscious was the most magical, esoteric, religious, and mysterious on offer. It turned the unconscious into a vehicle for the reenchantment of the individual and the world, returning mystery, transcendent reality, even divinity to them. As such, it played upon certain widespread and deep misgivings about rationalism, science, and technology—overdependence upon which was widely proposed as a primary cause of the modern chaos. An antirationalist critique of American society and culture was flourishing within that culture, and some New York School artists evidently sympathized with the critique. The particular symbolic model of the unconscious I have been describing was the one best suited to satisfy the "urgency for transcendent experience," as Mark Rothko phrased it in 1947.[20] Pollock had embraced mysticism and theosophy as a very young man before turning to social and political explanations for collective and personal problems in the mid-1930s. After the collapse of the left in the late 1930s, this early predilection returned and colored his psychological preferences in the late 1930s; he was attracted to that version of depth psychology deeply concerned with mysticism, astrology, occultism, alchemy, religion, and the lore of the East—interests which have led Freudians to view Jungianism more as a religious philosophy than as a psychology.[21] Pollock was drawn to a construction of the unconscious directly involved in the critique of modern rationalism as that critique was being articulated by some contemporary cultural critics and popular philosophers. Philip Wylie's *Generation of Vipers* may stand as an illustration of the tendency. In this book, which spent six weeks of 1942 on the *New York Times* nonfiction best-seller list, Wylie presented Jungian theory as a vital corrective to the American faith in the progress of science and in the unequivocal goodness of human nature. The thesis of the book, which draws heavily upon Jungian theory, is that "Americans have lost their moral sensibilities by living too objectively and with too little subjective awareness. Or, as the Bible puts it, 'What is a man profited, if he shall gain the whole world, and lose his own soul?'"[22]

Jungian theory was appreciated by Wylie and others for its difference from

Freudianism and ego psychology. Unlike these two, Jungianism was not principally concerned with extending and applying rational analysis to the workings of the unconscious; rather, it imbued the unconscious with a spiritual mystery essentially alien to the Freudian approach. The dominant ideology's reductive model of the individual subject could be enriched and mystified through Jungian theory as a means of restoring explanatory power and viability to it. Wylie's text is representative of a tendency apparent among various cultural productions of this moment to embrace Jungian theory and apply it, with specific emphases, to contemporary preoccupations. The Jungian unconscious had a distinct and specifiable role in the ideological readjustments underway, and popular texts such as Wylie's joined the art of some New York School painters to serve as medium and vehicle for the work.[23]

Pollock's Jungian symbolic model of the unconscious underwent considerable evolution in his works of the early 1940s. It merged with modernist pictorial concerns and with a symbolic visual vocabulary and syntax derived from the politically committed work of José Clemente Orozco and Pablo Picasso—in Pollock's hands thoroughly depoliticized and transferred to a cosmic frame. All of these ingredients participated in the development of a style that conveyed struggle, opacity, violence, and inaccessibility. If we look again at *Guardians of the Secret* (see fig. 20.1), its differences from the psychoanalytic drawings will become evident. The painting is still rooted, arguably, in Jungian theory. The title and imagery may have been inspired by Jung directly; his analysis of the theosophical doctrine of the "Guardians of the Threshold" places the animus and anima in the role of the guardians: "These two twilight figures of the dark hinterland of the psyche (they are the true, half-grotesque 'Guardians of the Threshold,' to use the pompous theosophical jargon) can assume an almost inexhaustible number of aspects."[24] Whether or not Pollock knew this description by Jung, his painting can be read as a metaphorical representation of the problem posed by the unconscious and its guarded, inaccessible, secret meanings. A somewhat literal reading might see the mind's censorship mechanisms as personified by the figures flanking and behind the central tablet, which is filled with illegible marks. Pollock has resisted inscribing the secret tablet—metaphor for the unconscious as well as for the canvas—with Jungian archetypal symbols, opting instead for suggestive but indecipherable markings. Marks ordinarily function in painting to yield or elicit meanings, but here they refuse legibility at precisely that site in the picture where legibility seems most important. By thwarting meaning production at this level, the marks come to stand for the meaning-effect; they signify illegibility. What is clear, however, is that the production of the markings has entailed difficulty and struggle; the thick, labored,

overwrought surface functions as guarantee of this. Legibility in the painting is further restricted by the dark gray areas surrounding the central tablet. Although these appear at first to be the ground of the picture, closer examination reveals them to be painted over figurative passages that had been visible at earlier stages in the work.[25] Access to this content is now blocked. *Guardians* may be read as evidence that Pollock was exploring ways of enlisting modernist pictorial strategies (equivocation between figuration and abstraction, inversion of figure and ground) in his effort to forge a visual language that could signify "painting out of the unconscious." By conveying many of the characteristic features of the unconscious—illegibility, inaccessibility, struggle—through modernist pictorial dynamics, Pollock was able to reduce the burden carried by explicit Jungian symbols.

Rather than chart this evolution through the work of the early and mid-1940s, I want to use the space remaining to introduce the other, competing model of the unconscious represented in Pollock's work. This model is strikingly different from the symbolic one, yet it too has origins in Jungian and Freudian metaphors. In this case, however, the metaphors were extended commonly by writers of popular psychology, philosophy, and miscellaneous nonfiction, some of whom may have mediated the idea for Pollock. The metaphors in this version were energic and electrodynamic. They pictured the unconscious as a source of energy impulses, the unimpeded release of which was the precondition of mental balance and harmony. The model originated in Freud's conception of the mind as a drive-discharge structure, that is, as a mechanism within which perceptions or innervations accumulate until release can be effected through remedial action. It also drew upon the economic dimension of psychoanalytic theory, which envisions mental processes as involving the circulation and distribution of a quantifiable energy. In Jung's writing this notion was directly linked to Bergson's *élan vital,* and members of the APC-NY used energic metaphors routinely in their analyses of patients' drawings. Consider, for example, the description by H. G. Baynes, Henderson's teacher and friend, of a drawing by an analysand (fig. 20.9): "It had been suddenly revealed to him [the analysand] that the essential activity of the mind was a dancing, flowing circuit of emotional energy, leaping from one node to the next in a living stream. . . . In the whirling convolutions of her rope the anima seems to be exulting in the fact that the purposive unity of the psychic process has been restored, and that the brittle, soulless artificiality of a world governed by mechanism and rigid law has given place to the free dance of life."[26] Henderson's notations regarding the drawings he discussed in analysis with Pollock indicate that he sometimes used energic metaphor and language, both of which might well have figured in his exchanges with Pollock.[27]

The energic metaphor was extended to the point of caricature in some texts

Figure 20.9 Patient's drawing, no. 12. From H. G. Baynes, *Mythology of the Soul* (London, 1940), part 2, p. 602.

DRAWING 12.

belonging to the genre described above—popular nonfiction engaged in refashioning prevailing beliefs about human nature. Pollock's library contained several of these books, and while this certainly should not lead us to assume that he read them, neither can we ignore them as potential sources for Pollock and as valuable documents for our analysis of the model. One of the books Pollock owned, Harvey Fergusson's *Modern Man: His Belief and Behavior,* published in 1936, contains formulations very close to later statements by Pollock. Fergusson wrote, for example: "A spontaneous impulse, working through the artist, gives form to amorphous elements in human being, and he typically feels as though he were but a passive medium for that particular manifestation of creative energy. . . . It is evident that a work of art in which the energy of the artist is completely projected into a symbol has this essential quality of action. A great work of art is a great action and has the objectivity which all action requires."[28]

These views dovetail neatly with positions that Pollock articulated around 1950. In a radio interview that year he said: "The modern artist, it seems to me, is working and expressing an inner world—in other words—expressing the energy, the motion, and other inner forces.[29] And there are notes he scribbled on the back of a photograph at about the same time:

energy and motion made visible
memories arrested in space
human needs and motives
acceptance[30]

Pollock's conjoining of energy and motion with an inner world and memories suggests that his idea of the unconscious was at this time closer to some sort

of dynamic model than to an eerie realm of mysterious figures and elusive symbols.

It was quite common for texts belonging to the genre of Fergusson's *Modern Man* to advance an energic model of the unconscious and to link it to artistic production. Lin Yutang's *The Importance of Living,* also owned by Pollock, offers another sort of example. Lin wrote: "In order to understand the essence of art at all, we have to go back to the physical basis of art as an overflow of energy."[31] Often this energy was given an explicitly sexual aspect, with sexual repression presented as a damming up of vital energies and natural impulses in need of release.

It is not difficult to see how Pollock's pouring and flinging process would have seemed a solution accommodating the energic model, by recording energy impulses precisely and without impediment from the drag of brush over canvas. As Michael Fried put it in his famous description of the abstract poured paintings, line is detached from its traditional functions of defining contour, shape, and figure; as a result of this liberation, it becomes "responsive to the slightest impulse of the painter": "Line, in these paintings, is entirely transparent both to the non-illusionistic space it inhabits but does not structure, and to the pulses of something like pure, disembodied energy that seem to move without resistance through them."[32] For Fried the lines embody energy—in their spiraling, doubling back, and interweaving, their paths seem undetermined except by the pulses of energy that produce them. But in many of the poured paintings, the lines can be read as signifying the energic unconscious in another way as well. Not only do they evoke physical traces of the unconscious, records or indexical signs of its involvement in the work, they also signify the unconscious metaphorically. They continue to *depict* by showing us an image of the dynamic unconscious as vortex (fig. 20.10): a whirling rush of energy both refusing to yield its own contents—pulling them back ever further from the reach of consciousness—and threatening to swallow the viewer who dares to peer in too closely. In some works, in other words, Pollock's poured line is both an indexical and iconic signifier of the energic unconscious.

Some of the reviewers of Pollock's first exhibition of the poured paintings noted the energic references. Robert Coates, for example, wrote in the *New Yorker:* "The main thing one gets from his work is an impression of tremendous energy. . . . I can say of such pieces as *Lucifer, Reflection of the Big Dipper,* and *Cathedral* only that they seem mere unorganized explosions of random energy, and therefore meaningless."[33] Coates's judgment that the pictures are meaningless is surprising, following as it does such a revealing description. One wonders whether his readers were more alert than he to the meanings that "explosions of random energy" evoked in 1948. In the years after the war, the energic model of

Figure 20.10 Jackson Pollock, *Vortex*, 1947. Oil on canvas, 20½ × 18⅛ inches. Private collection, Washington, D.C., copyright 1998 Pollock-Krasner Foundation/Artists Rights Society, New York.

the unconscious acquired colorations and distortions from intersection with the current discourse on energy in the wake of the atrocities at Hiroshima and Nagasaki. In the catalogue for Pollock's 1951 exhibition at Parsons Gallery, Pollock's friend Alfonso Ossorio wrote that "energy sustains and is the common denominator of the phenomena among which we live." This remark is indicative of a developing pan-energism which itself sustained and was the common denominator of influential contemporary representations of nuclear destruction and the unconscious. The two inscrutable, fearsome powers became blurred, mapped onto common terrain, consolidating somewhat the anxiety they aroused. To my knowledge, the blending was never explicit; Coates was representative in this respect.

One result of the merging of these discourses was that the force of the unconscious was naturalized, but at the same time it was cast in a form apparently susceptible to scientific work. Just as scientists were learning to liberate and control the immense energy contained within the atom, so were psychoanalysts discovering ways to release and channel unconscious energy. The rationalism of this view played upon an embattled but persistent confidence in science, reason, and technology. In this respect we are at the opposite end of the spectrum from the mystical, mysterious, symbolic model of the unconscious, which participated in the antirationalist critique of American culture. The energic model of

the unconscious, therefore, gratified cultural desires diametrically opposed to those that sustained the symbolic model. The prominence and utility of the idea of the unconscious in 1940s American culture was due in large part to its remarkable elasticity; it encompassed representations that reenchanted the individual alongside representations that portrayed the individual as a battery-driven mechanism.

At that moment in American cultural history, the unconscious was, like "the primitive," an essential ideological construction, mobilized in the effort to cope with the trauma and perplexity induced by recent historical events. In a broad array of cultural productions, fascism and modern evil were portrayed as products of the mysterious depths of the unconscious or of the unnatural functioning of the mind—the absence of reason or the overdependence upon it. In either case, the unconscious was demanding the attention it had too long been denied. The terms of the literature and art are clear: if modern man's faith in reason, science, and technology had failed him, it was likely because their opposites— emotion, instinct, unreason, the part of his nature that had been strictly repressed—had begun to intrude into his affairs. This other side of human nature had to be attended to, had to be recognized, imaged, and released; but these processes would have to be carefully controlled, so the renewal and fertility they offered could be tapped without releasing a modern deluge. One of the most revealing statements of the case comes from M. Esther Harding's *Woman's Mysteries*, a text by a Jungian analyst from the mid-1930s (some illustrations from which are reproduced as figure 20.6): "If once let loose in the world these forces of nature may grow and spread leading one knows not where. They may sweep aside all established rule and order and flood the known civilized world with a deluge which could break all bounds. The rise of instinct released from ancient taboos, the flood of emotion or of ecstasy rising from the unconscious depths of the psyche, the unleashed powers latent in the masses, where these things will stop if once let loose, we cannot tell." [34]

Even a professional analyst, presumably more comfortable with the unconscious than most, was susceptible to fantasies of dystopia inspired by unconscious outpouring. The unleashed powers latent in the masses were evident and terrifying enough in fascism and communism to give anyone pause, and "the unconscious" became an effective category for representing them. Theorization about the unconscious may at times justly claim intellectual radicality, but in this period its historical effects were paradoxically conservative. By helping to psychologize and individualize the violence and brutality of modern experience, it dehistoricized that experience. Pressure upon the socio-economic and political orders and the nationalism, imperialism, and authoritarianism they fostered was dissipated as efforts to refurbish the culture's prevailing model of

subjectivity came to dominate the cultural agenda. This reconstructed subject—modern man as locus of the interaction of complex forces and drives, the site of the conflicts at the center of modern life's crises—took form in art, literature, Hollywood films, essays, and journalistic reports, all of which drew heavily upon one form of depth psychology or another. Psychological theory has a capacity to become a totalizing form of explanation, a capacity from which American middle-class ideology has benefited more than once.[35]

Like many of his contemporaries, Pollock internalized constructions of the unconscious as the form and substance of conflict in his life. The unruly experience of a confused young man was given shape and order in his encounter with powerful institutions and discourses of the unconscious. Cultural forces helped him to recognize and conceive of his own problems as psychological, and his own troubled experience led him to accept psychological explanations for social and political problems. Pollock thus became both subject and agent of ideological mechanisms. His sense of self and identity was shaped by the powerful models of the unconscious circulating in American culture, and his development of a modernist art accommodating those models contributed to the articulation and consolidation of those models. His paintings served the function that Clifford Geertz has attributed to works of art in general: "They materialize a way of experiencing, bring a particular cast of mind out into the world of objects, where men can look at it."[36] And "they generate and regenerate the very subjectivity they pretend only to display."[37]

Pollock was able to keep two influential but contradictory models of the unconscious in productive tension in his work. His determination to represent the (unrepresentable) unconscious, an ambition that led to sustained engagement with some of the most powerful models available—despite the fact that those models stood in a relation of indistinct and unstable opposition to one another—helps explain both the striking variety in his representations of the unconscious and their cultural influence.

A few concluding observations will help to put this case study into a larger frame and to address some of its limits.

First of all, as is no doubt clear by now, my principal goal in this work is to reconstruct the discursive fields that shaped and were shaped by New York School art. Reading that art as participating in dialogues with contemporary intellectual and cultural productions—all engaged in ideological processes—should help us see and account better for its specific forms, its trajectory, and its reception. But by concentrating my efforts in this direction, I have underemphasized idiosyncrasies in Pollock's representations—the ways in which they do not match evolving dominant notions of the unconscious. I do not want to give the impression of

believing that Pollock's works are transparent to psychological theory, modern-man discourse, or American middle-class ideology, or that these latter *precede* his representations. In the process of representing—the process by which ideology comes into being—gaps, breaks, and inconsistencies with other representations develop. I have given priority to reconstituting the discursive structure and setting Pollock's art within it; to complete the story, it will be important to isolate disjunctions and oppositions.

My second point is that just such a subsequent stage of work is prerequisite to the development of a post-Freudian reading of the unconscious in Pollock's work. Only when we have an account of the ruptures between the art and its discourses will it become possible to determine what counts as an interruption of the more or less deliberate imagery of Pollock's paintings. Then, perhaps, we will look for "Pollock's unconscious" in heretofore unexamined aspects of his imagery and handling.

Third, this case study has implications for our understanding of how a powerful idea—"the unconscious"—becomes shaped by the ideological exigencies of a particular social formation and history as the idea crosses the boundaries between one culture and another—whether those boundaries separate nations or classes. In America between the world wars, the unconscious underwent various transformations in the representations of it produced for various audiences at various moments.

Finally, what can be said, in light of this case, about relations between intellectual or artistic work and a dominant ideology? Although New York School art has traditionally been characterized as essentially radical, oppositional, and disruptive, and although it received a cool welcome from large segments of the educated middle class, it is, in my view, fundamentally imbricated in the culture's dominant ideology. Pollock, like the other New York School painters, was a modern-man subject, constituted by the discourses and institutions of the prevailing ideology and its model of subjectivity. By taking that subjectivity as thematic in their work—representing it or, in Barnett Newman's words, "making cathedrals of ourselves"—New York School artists contributed to its recuperation and revitalization. In this sense, the achievement of New York School art lies not in any resistance to the constraints in which it developed, but in the ingenuity of its engagement with those constraints.

Notes

This is an abridged version of an essay that originally appeared in *Art History* 13 (December 1990): 542–65.

1. Reprinted in Francis V. O'Connor and Eugene V. Thaw, *Jackson Pollock: A Catalogue Raisonné of Paintings, Drawings, and Other Works,* 4 vols. (New Haven and London, 1978), 4: 241. Pollock edited this sentence from his published statement, perhaps because its point was made in his description of his process.

2. Quoted in Selden Rodman, *Conversations with Artists* (New York, 1957), 82.

3. See Jacques Lacan, "The Freudian Unconscious and Ours," *The Four Fundamental Concepts of Psycho-Analysis,* ed. J.-A. Miller, trans. A. Sheridan (New York, 1981), 28; Gilles Deleuze and Félix Guattari, *Anti-Oedipus,* trans. Robert Hurley, Mark Seem, and Helen R. Lane (New York, 1977), 53, 180, 296.

4. "Towards a Sociological Understanding of Psychoanalysis," *Social Research* 32 (Spring 1965): 26–41.

5. By "representing the unconscious" I do not mean to suggest that Pollock was attempting to depict some preexisting conception or contents of the unconscious. Quite the contrary: representation is understood here as a complex process which in this case yields not only paintings and drawings believed somehow to derive from the unconscious but also conceptions and contents of the unconscious.

6. Note that the models are not opposed along Freudian vs. Jungian lines. Such a distinction is one that Pollock appears to have been unable or disinclined to make, as his statement to Rodman, quoted above, indicates.

7. The list, transcribed below, is contained in the Jackson Pollock Papers, Archives of American Art, Smithsonian Institution, Washington, D.C., no. 3046: 254–255.

The Analytical Psychology Club of N.Y.C.—

The Concept of the Collective Unconscious, C. G. Jung

Redemption Ideas in Alchemy, M. Esther Harding

The Individual and the Group, Eleanor Bertine

The Eranos Conference, Hildegard Nagel

The Mother Archetype and Its Functioning in Life, M. Esther Harding

Early Concepts of Jahweh, Jane Abbott Pratt

Initiation Rites, Joseph L. Henderson

The Psychological Aspects of War, Eleanor Bertine

Two Papers—The Shadow of Death, and The Self-Analysis of Emanuel Swedenborg, Kristine Mann

Picasso, C. G. Jung, Alda F. Oertly

8. Carl G. Jung, *Psychological Types,* trans. H. G. Baynes (New York, 1923), 580.

9. See, for example, Jolande Jacobi, *The Psychology of C. G. Jung* (London, 1942), pl. 1.

10. O'Connor and Thaw, *Jackson Pollock,* vol. 4, cat. 940.

11. For example, ibid., vol. 3, cat. 550.

12. It wouldn't be surprising if the illustration reproduced as fig. 20.6, from M. Esther Harding's *Woman's Mysteries* (New York, 1935), were Pollock's point of departure in fig. 20.6. The same book seems to have been an immediate source for a moon swastika in another drawing, as Philip Leider has already noted. See "Surrealist and Not Surrealist in the Art of Jackson Pollock and His Contemporaries," in Paul Schimmel, ed., *The Interpretive Link* (Newport Beach, Calif., 1986), 43–44. Furthermore, Harding's de-

tailed examination of the moon/female/unconscious idea-chain might have been an influence in Pollock's *Moon-Woman* paintings from the early 1940s.

13. For example, O'Connor and Thaw, *Jackson Pollock*, vol. 3, cats. 518v and 519v.

14. Ibid., cat. 521r.

15. Ibid., cats. 521v and 537r.

16. Paul Johnson, *A Shopkeeper's Millennium: Society and Revivals in Rochester, New York, 1815–1837* (New York, 1978), 8.

17. The notion "dominant middle-class ideology" has generally been used without recognition of the significant differences in the ways such an ideology is experienced from different positions within the social formation—positions determined by race, sex, or class, for example. This critique—developed in recent feminist work—is one with which I am sympathetic. See Judith Newton, "History as Usual?: Feminism and the 'New Historicism,'" *Cultural Critique* 9 (Spring 1988): 87–121. What is striking about the ideology under discussion here—imbricated in what I will be calling "Modern-Man" discourse—is the overtness of its gendering and the difference in the subject positions it constructs for men and women. I have taken up these aspects elsewhere.

18. During the Red Scare following World War I, U.S. Attorney General Mitchell Palmer ordered the arrest of thousands of suspected Communists in raids conducted often without warrants and without respect for the rights of the accused.

19. By no means should it be taken for granted that clear distinctions between these various models were commonplace. As the 1956 statement by Pollock quoted at the start of the paper indicates, being simultaneously a Freudian and a Jungian apparently did not seem problematic to him. It was not so much a matter of Pollock embracing a coherent Jungian model as of his favoring of elements from Jungian theory. A representative sampling of contemporary performers, writers, and artists also committed to Jungianism (outside of other New York School artists) would include Martha Graham, Philip Wylie, and Irene Rice Pereira.

20. Mark Rothko, "The Romantics Were Prompted," *Possibilities* 1 (Winter 1947–48): 84.

21. Reuben Fine, *A History of Psychoanalysis* (New York, 1979), 86.

22. Philip Wylie, *Generation of Vipers* (New York, 1942), xxii.

23. Wylie's work reached not only a broad popular audience, as the sales records indicate, but also the Analytical Psychology Club of New York, which reviewed his work in its *Bulletin* 6 (January 1944), and Clement Greenberg, who found *Generation of Vipers* banal but sparked by a valid impulse. See *Clement Greenberg: The Collected Essays and Criticism*, ed. John O'Brian (Chicago, 1986), 2: 158. An excerpt from *Generation of Vipers*, translated into French, immediately precedes Greenberg's "L'art américain au XXe siècle" in Sartre's special USA issue of *Les Temps modernes* 2 (August–September 1946).

24. Jung, *Two Essays on Analytical Psychology*, trans. H. G. and C. F. Baynes (London, 1928), 231.

25. Some of the underlying figurative passages are visible in photographs of the unfinished painting; see, for example, O'Connor and Thaw, *Jackson Pollock*, 4: 229.

26. *Mythology of the Soul* (London, 1940), 613, 615.

27. See, for example, Henderson's notations concerning O'Connor and Thaw, *Jackson Pollock*, vol. 3, cat. 531: "All energy seems to have been drawn from the upper 'conscious' region, which appears lifeless, wooden and anguished. The life force or psychic energy is represented by the huge snake (lower center) which denotes the unconscious and upon which the human figure is completely and dependently attached." Quoted in C. L. Wysuph, *Jackson Pollock: Psychoanalytic Drawings* (New York, 1970), 15.

28. Harvey Fergusson, *Modern Man: His Belief and Behavior* (New York, 1936), 154, 183.

29. From the transcript of a taped interview conducted in 1950 by William Wright, published in O'Connor and Thaw, *Jackson Pollock,* 4: 250.

30. From a handwritten note on the back of a photograph in the artist's file, Museum of Modern Art, New York. Published in O'Connor and Thaw, *Jackson Pollock*, 4: 253.

31. Lin Yutang, *The Importance of Living* (New York, 1937), 368.

32. Michael Fried, *Three American Painters* (Cambridge, Mass., 1965), 14.

33. Robert Coates, "The Art Galleries," *New Yorker,* Jan. 17, 1948: 44.

34. Harding, *Woman's Mysteries,* 300.

35. See, for example, Virgil Jordan, "The New Psychology and the Social Order," *Dial,* Nov. 1, 1919: 367; also my *Reframing Abstract Expressionism: Subjectivity and Painting in the 1940s* (New Haven, 1993).

36. Clifford Geertz, "Art as a Cultural System," in *Local Knowledge* (New York, 1983), 99.

37. Clifford Geertz, "Notes on the Balinese Cockfight," in *The Interpretation of Cultures* (New York, 1973), 451.

Contributors

Nancy K. Anderson
Associate Curator of American Art
National Gallery of Art

Kirsten P. Buick
Lecturer
Art Institute of Chicago

Anna C. Chave
Professor
Department of Art History
Queens College and The Graduate School and
 University Center of The City University of New York

Wanda M. Corn
Professor
Art Department
Stanford University

Wayne Craven
Henry Francis du Pont Winterthur Professor
Department of Art History
University of Delaware

Todd S. Gernes
Senior Lecturer
Department of English Language and Literature
University of Michigan

Kathryn S. Hight
Lecturer
Norton Simon Museum, Pasadena, CA

Patricia Hills
Professor
Art History Department
Boston University

David Jaffee
Assistant Professor
History Department
City College of New York

Elizabeth Johns
Silfen Term Professor in the History of Art
Department of History of Art
University of Pennsylvania

Joy S. Kasson
Professor of American Studies and English
 Curriculum in American Studies
Department of American Studies
University of North Carolina, Chapel Hill

Michael Leja
Associate Professor of Art History
Department of Architecture
Massachusetts Institute of Technology

William T. Oedel
Associate Professor and Director
Art History Program
University of Massachusetts, Amherst

Griselda Pollock
Professor
Department of Fine Art
University of Leeds

Jules D. Prown
Paul Mellon Professor of the History of Art
Department of the History of Art
Yale University

Paul Staiti
Alumnae Foundation Professor
Department of Art
Mount Holyoke College

Roger B. Stein
Professor
McIntire Department of Art
University of Virginia

Ellen Wiley Todd
Associate Professor
Departments of History and Art History
George Mason University

Alan Trachtenberg
Neil Grey Professor of English and American Studies
Departments of English and American Studies
Yale University

Carol Troyen
Associate Curator of American Art
Museum of Fine Arts, Boston

Alan Wallach
Ralph H. Wark Professor of Art and Art History
 and Professor of American Studies
American Studies Program
The College of William and Mary

Acknowledgments

Chapter 1: Wayne Craven, "The Seventeenth-Century New England Mercantile Image: Social Content and Style in the Freake Portraits," in *Colonial American Portraiture: The Economic, Religious, Social, Cultural, Philosophical and Aesthetic Foundations* (New York: Cambridge University Press, 1986), pp. 38–54. Reprinted with the permission of Cambridge University Press.

Chapter 2: Paul Staiti, "Character and Class," in *John Singleton Copley in America,* exhibition catalogue (New York: Metropolitan Museum of Art, 1996), pp. 53–77. Copyright © 1995 by the Metropolitan Museum of Art. Reprinted with permission.

Chapter 3: Roger B. Stein, "Charles Willson Peale's Expressive Design, *The Artist in His Museum,*" *Prospects* 6 (1981): 139–85. Reprinted with the permission of Cambridge University Press.

Chapter 4: Alan Wallach, "Thomas Cole and the Aristocracy," *Arts Magazine* 56 (November 1981): 94–106. Reprinted with the permission of the author.

Chapter 5: David Jaffee, "'A Correct Likeness': Culture and Commerce in Nineteenth-Century Rural America," in John Michael Vlach and Simon J. Bronner, eds., *Folk Art and Art Worlds* (Logan: Utah State University Press, 1992).

Chapter 6: William T. Oedel and Todd S. Gernes, "*The Painter's Triumph:* William Sidney Mount and the Formation of a Middle-Class Art," *Winterthur Portfolio* 23 (Summer/Autumn, 1988): pp. 111–28. Reprinted with the permission of the University of Chicago Press. © 1988 Henry Francis DuPont Winterthur Museum, Inc.

Chapter 7: Kathryn S. Hight, "'Doomed to Perish': George Catlin's Depictions of the Mandan," *Art Journal* 49, no. 2 (Summer 1990): 30–45. Reprinted by permission of the College Art Association, Inc.

Chapter 8: Joy S. Kasson, "Narratives of the Female Body: *The Greek Slave*," chap. 3 of *Marble Queens and Captives: Women in Nineteenth-Century American Sculpture* (New Haven: Yale University Press, 1990), pp. 46–72. Reprinted by permission of the publisher.

Chapter 9: Kirsten P. Buick, "The Ideal Works of Edmonia Lewis: Invoking and Inverting Autobiography," *American Art* 9, no. 2 (Summer 1995): pp. 4–19. Reprinted by permission of the National Museum of American Art.

Chapter 10: Nancy K. Anderson, "The Kiss of Enterprise": The Western Landscape as Symbol and Resource," in William H. Truettner, ed., *The West as America: Reinterpreting Images of the Frontier,* exhibition catalogue (Washington: Smithsonian Institution Press, 1991), pp. 237–83. Copyright © 1991 by the Smithsonian Institution, Washington, D.C. Used by permission of the publisher.

Chapter 11: Elizabeth Johns, "*The Gross Clinic,* or *Portrait of Professor Gross,*" in *Thomas Eakins: The Heroism of Modern Life* (Princeton: Princeton University Press, 1983). Copyright © 1983 by Princeton University Press. Reprinted by permission of Princeton University Press.

Chapter 12: Jules D. Prown, "Winslow Homer in His Art," *Smithsonian Studies in American Art* 1 (Spring 1987): 30–45. Reprinted by permission of the National Museum of American Art.

Chapter 13: Griselda Pollock, "Mary Cassatt: Painter of Women and Children," in *Mary Cassatt* (London: Jupiter Books, 1980), pp. 7–19. Copyright © 1980 by Jupiter Books (London) Ltd. Reprinted by permission of HarperCollins Publishers, Inc.

Chapter 14: Alan Trachtenberg, "Image and Ideology: New York in the Photographer's Eye," *Journal of Urban History* 10, no. 4 (August 1984): 453–64. Copyright © 1984 by Sage Publications. Reprinted by permission of Sage Publications.

Chapter 15: Patricia Hills, "John Sloan's Images of Working-Class Women: A Case Study of the Roles and Interrelationships of Politics, Personality, and Patrons in the Development of Sloan's Art, 1905–16," *Prospects* 5 (1980): 157–96. © 1980 Cambridge University Press. Reprinted with permission.

Chapter 16: Anna C. Chave, "O'Keeffe and the Masculine Gaze," *Art in America* 78 (January 1990): 114–24. Originally published in *Art in America,* Brant Publications, Inc., January 1990.

Chapter 17: Carol Troyen, "The Open Window and the Empty Chair: Charles Sheeler's *View of New York*," *American Art Journal* 13, no. 2 (1987): 24–41. Reprinted by permission of the *American Art Journal*.

Chapter 18: Wanda M. Corn, "The Birth of a National Icon: Grant Wood's *American Gothic*," in *Art the Ape of Nature: Studies in Honor of H. W. Janson*. Published by Harry N. Abrams, Inc. New York. Reprinted with permission of Harry N. Abrams, Inc. All rights reserved.

Chapter 19: Ellen Wiley Todd, "The Question of Difference: Isabel Bishop's Deferential Office Girls," chap. 7 of *The "New Woman" Revised: Paintings and Gender Politics on Fourteenth Street* (Berkeley: University of California Press, 1993), pp. 273–311. Copyright © 1993 The Regents of the University of California.

Chapter 20: Michael Leja, "Jackson Pollock: Representing the Unconscious," *Art History* 13 (1990): 542–65. Copyright Association of Art Historians.